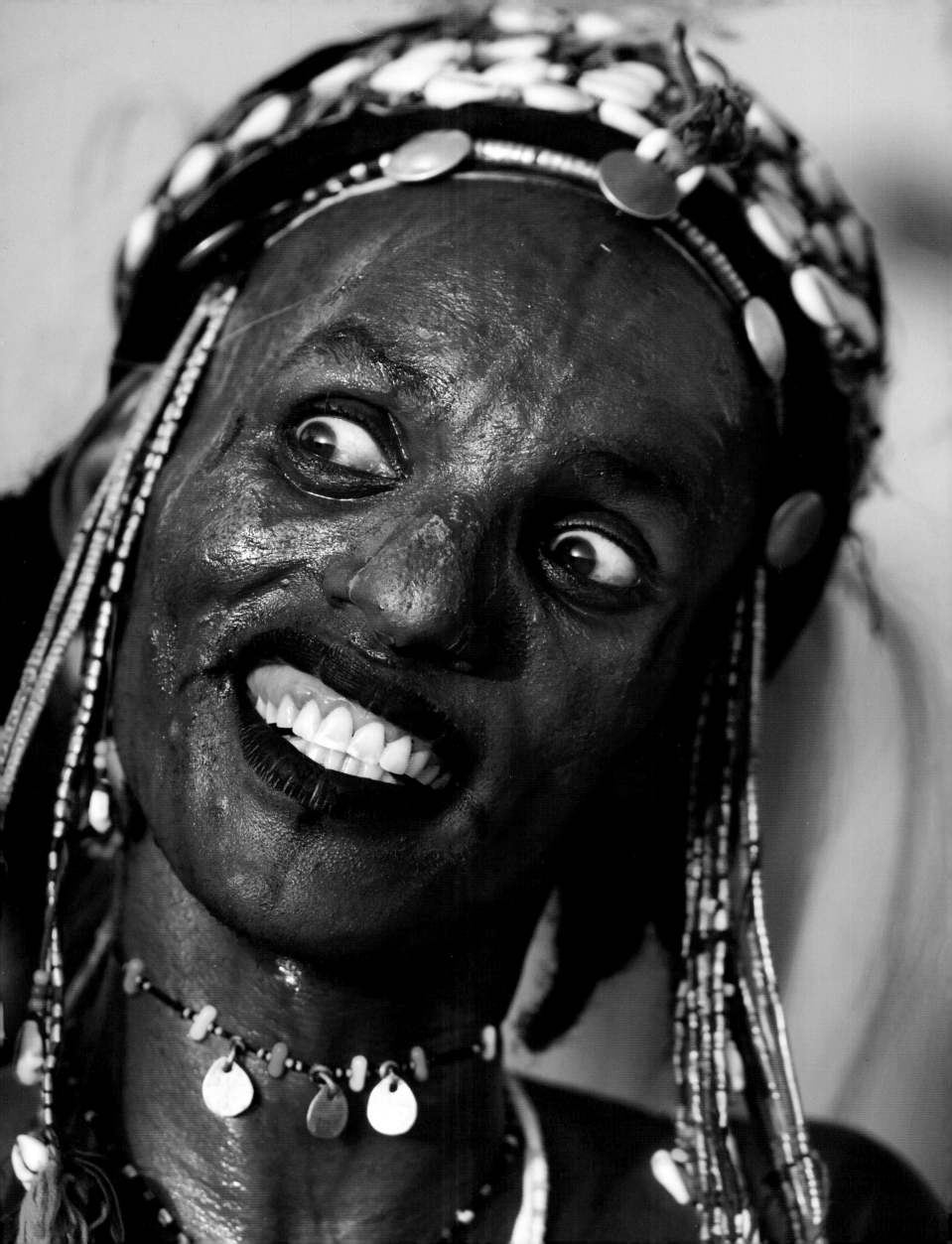

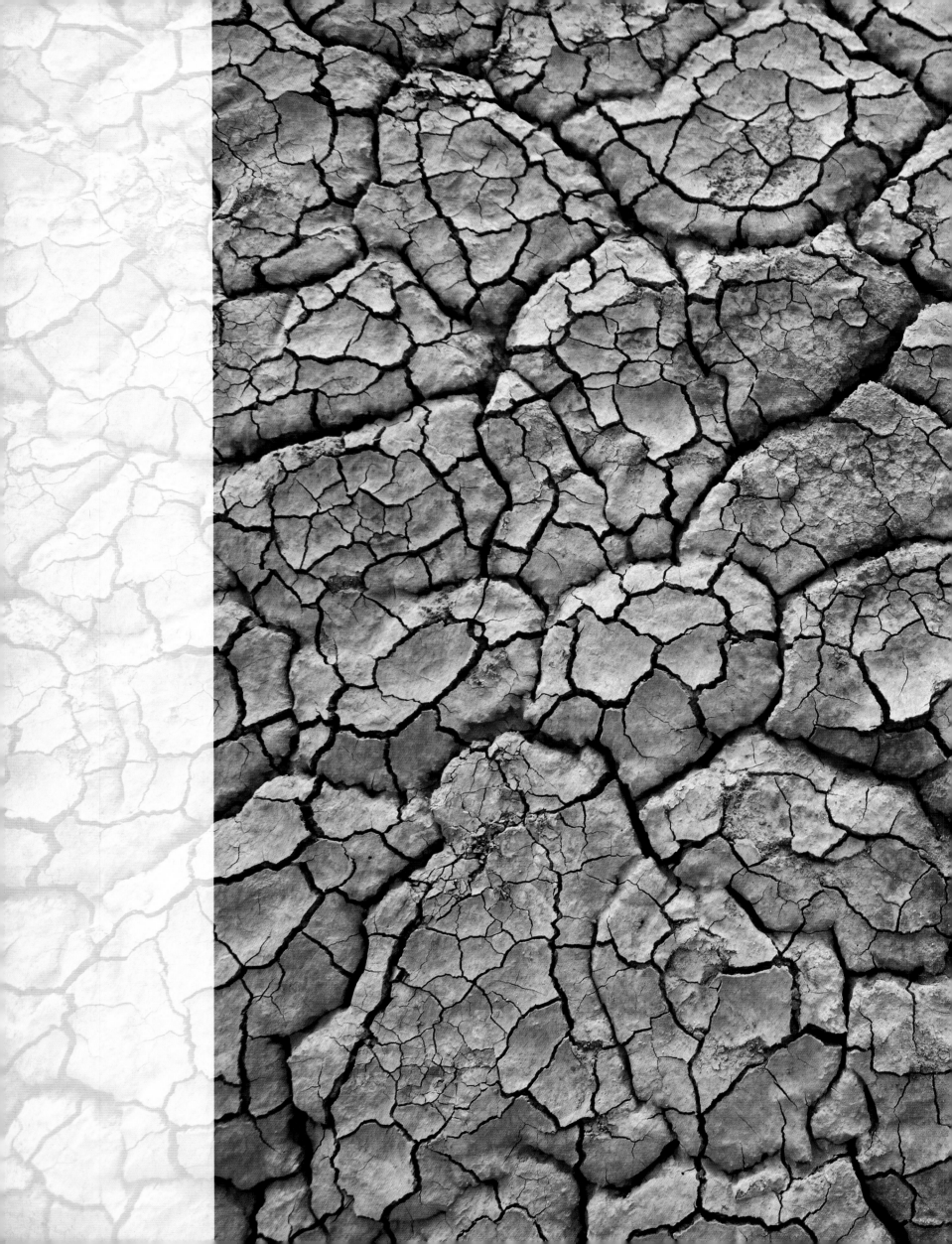

STEVE BLOOM

LIVING AFRICA

With 236 photographs

Thames & Hudson

PAGE 1
Wodaabe youth, Gerewol Festival, Niger

PAGES 2—3
Cracked earth, Chalbi desert, Kenya

THIS PAGE
Victoria Falls, Zimbabwe

FOR KATHY

First published in the United Kingdom in 2008 by Thames & Hudson Ltd, 181A High Holborn, London WC1V 7QX

www.thamesandhudson.com

© 2008 Steve Bloom
Photographs and Text: Steve Bloom
Picture Commentaries: Kathy Bloom
Research: Heather Doherty and Janice Wickenden
Photograph page 9 top right: Bob Nelson
Author photograph on jacket: Seamus Ryan
www.stevebloom.com

British Library Cataloguing-in-Publication Data
A catalogue record for this book is available from the British Library

ISBN 978-0-500-51427-6

Printed and bound in China by C&C Offset Printing Co., Ltd

CONTENTS

INTRODUCTION MY AFRICA

I woke each morning in the shadow of Table Mountain. Our apartment lay on the western side of the mountain which loomed high above, a towering presence that held back the sunrise until after breakfast when it was time to go to school.

Throughout those childhood years, I spent many an hour gazing up at the rocky slopes, my head filled with idle thoughts. I contemplated the thriving Malay community who lived over on the eastern side of Signal Hill. We were separated by the laws of Apartheid then, but united by the fact that our homes lay on opposite slopes of the same mountain and its surrounding hills. We shared the colours, the smell of vegetation, and the wind. I thought, too, about the many wild animals who once roamed freely over its windswept rocks and gullies. Long before Europeans colonized Africa, Table Mountain was a source for reflection and inspiration, and it still is.

Nowadays, the suburbs of Cape Town creep further and further up the mountainside, encroaching onto what has always seemed to me to be hallowed ground. Yet despite twenty-first-century changes in modern Africa, Table Mountain is still omnipresent, dwarfing all the city's skyscrapers. It is more powerful than any of us; a perfect and unconquerable monument to the continent that stretches five thousand miles to the north.

Table Mountain can take on many appearances, like a living organism. Sometimes it is green and verdant, sometimes brown, and sometimes scorched black from devastating fires. The rocky gorges can be veiled by sheets of rain, shimmer in the haze of summer heat, or be crisply clear after cleansing thunderstorms. When the wind blows from the south-east, white clouds pour over the top like an endless billowing tablecloth. The view is always different, always invigorating. Just when I think I have learned all the mountain's secrets, it surprises me with new ones. Table Mountain, as dangerous and challenging as it is magnificent, is a microcosm of all that the vast continent of Africa embodies.

In 1977, aged twenty-four, I emigrated from South Africa to make a new life in England. I recall how I craned my neck

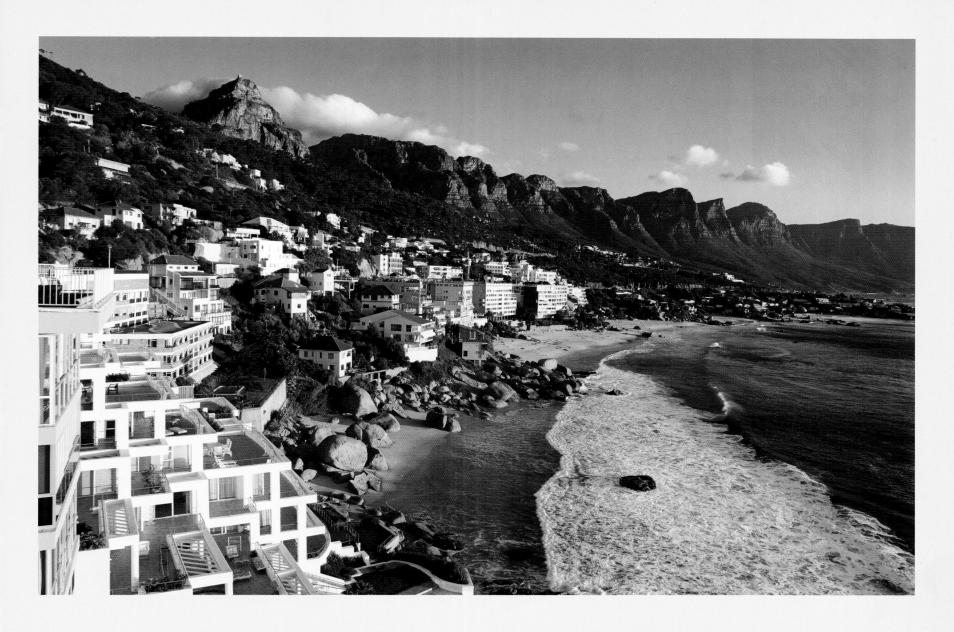

to peer through the scratched plane window as my eyes clung desperately to the diminishing image of the mountain. Then the wing rose and we turned away.

I did not return to Africa until the collapse of Apartheid, thirteen years later. Throughout that period of absence, the image of Table Mountain remained firmly etched in my mind, a symbol of the Africa I had left behind. Seeing it once again through the aeroplane window, growing larger as we approached Cape Town, was a special moment of reunion. The mountain looked fresh and resplendent as ever. When I walked on it and smelled the fynbos, the wild shrubs of the Cape, it was as if we'd never parted.

I have been back to Africa many times since then, and have travelled widely throughout the continent. Africa, for me, is like a love lost, but always re-found. It brings both joy and pain that remain forever within me. Each time I return, my senses rediscover this land – the tingle of dust in my nostrils and the raw smell of earth when the first rains begin to fall. The warm glowing light of the morning and the vast open spaces draw me back again and again to try to capture, in photographic image, the spirit of the land and the many people and animals who live in it. Africa always leaves its trace, its imprint on the memory. Individual experiences may differ from person to person, but the sense of primeval energy lingers within every visitor.

Part of Africa's appeal is the diversity of the people, the places and the wildlife. I have encountered warmth and friendship in distinctly Western-style cities with their highways and wine bars, as well in the most inaccessible of tribal villages. But, paradoxically, there are also high levels of violence in both such places, together with extreme poverty and great human suffering. Populations are expanding, diseases such as Aids and malaria are spreading, and water supplies diminishing. Despite these grave problems, the peoples of Africa face the adversities of life with great dignity.

Although Africa uses less fossil fuel per person than much of the rest of the world, it suffers inequitably from the burden of global climate change. Temperatures are expected to rise by half a degree Celsius every decade over the next century, with disastrous consequences for those most vulnerable. The poorest countries have become victims of the pollution of the industrialized nations. Global warming alters the frequency and intensity of rainfall, making the availability of water hard to predict. As a result, agricultural production falls, food becomes scarce, and conflict, disease and poverty inevitably rise. When water temperature rises, so does the incidence of malaria, especially in East Africa.

I visited Kenya's Masai Mara Reserve during a drought, and barely recognized the lush green place I had explored a

year earlier. I saw with my own eyes the suffering and stress the wildlife was enduring. Hippos leave the water to graze at night, and during a drought they are forced to go further than usual to find food. I came across hippos who had ventured too far from the water and lay baking in the midday sun, too weak to return.

On another occasion I looked out over Lake Turkana, the largest desert lake in the world, on the border between Kenya and Ethiopia. The edge of the lake was some distance from where I stood, where merely a year earlier the water would have lapped at my feet. The lake is evaporating at an alarming rate. Tensions between tribes are increasing as the water recedes, shifting traditional boundaries and putting pressure on diminishing resources.

During my travels in Africa, I was privileged to encounter many different local customs, some of which are threatened by the encroachment of Western ways. This is hard to avoid in our global world of satellite television, cell phones and t-shirts bearing the images of football heroes. Throughout the world, cultural erosion has been accompanied by social problems such as alcoholism as people lose their tribal identity. So where I was able to see traditions proudly flourishing, it brought me great pleasure. This does not diminish the necessity for change in certain circumstances, as long as that change emerges from within the community.

In Northern Kenya, for example, I encountered a Gabbra woman who is campaigning to end female circumcision and has started a school for girls in her village where education for females is forbidden. She has been ostracized and expelled from her community, but time after time she returns to mobilize more of the women to her cause. Her strength and courage are truly inspirational. When our small chartered Cessna landed on the dusty airstrip, she was waiting to greet us with her story, and to raise awareness of her struggle.

In South Africa I visited Ndebele women running community workshops. Their vibrant tribal art and traditions have, to a large extent, been abandoned in favour of a Western lifestyle, as young adults leave in search of opportunity and adventure in cities such

LEFT
Dyed cloth, Marrakech souk, Morocco.

OPPOSITE
Steve Bloom with guides in northern Botswana (left) and the Samburu region in Kenya (right).

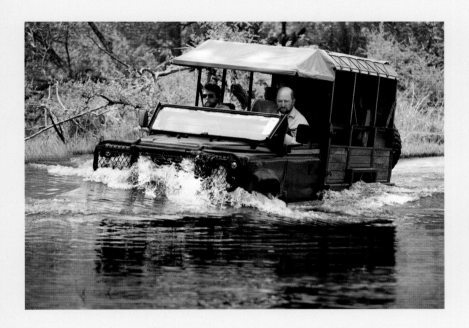

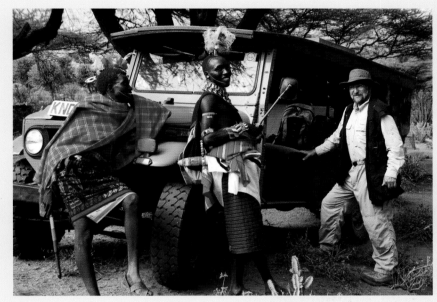

as Johannesburg. But the women continue to teach the traditions to younger children, and support their families by selling their artwork.

Back in Kenya I photographed a Samburu community at the time when all the boys from the surrounding villages were being circumcised together, without anaesthetic. Tradition demanded that they show great strength and not cry out or betray their pain. And in Ethiopia I met strong Hamar women with deep scars on their backs because tradition decrees that they volunteer to be whipped in order to prove devotion to their men-folk. The Suri and Mursi women have giant plates inserted in their lower lips, enduring pain and discomfort in order to uphold traditions and assert their individuality.

While some Westerners may be horrified by such customs, many Africans are equally appalled by certain Western values, such as placing old people in retirement homes. The elderly are venerated in African cultures, and children are seen as security for old age. The practice of sending the elderly to special homes is viewed with abhorrence.

I went down one of the deepest gold mines in the world, and came across migrant workers enduring unimaginably harsh working conditions, toiling in the dark to earn money to support their families. Elsewhere in Johannesburg I met Johnny Dumas, an athlete who has run more than thirty marathons. As a young man he was blinded in a senseless, violent attack, but now, despite his advancing years and handicap, he is totally committed to his next race.

Such people are a great inspiration: individual Africans with immense fortitude and stamina. My portrayal of Africa is as much about the resilience of the human spirit as it is about the wildlife's battle for survival. I don't want to present a bleak picture, because despite great hardships, this is also a continent of hope, life and vibrancy.

The sheer variety of life and light across Africa are irresistible to a photographer. The tallest sand dunes in the world are found in the Namibian desert. Bright orange, surreal, they dwarf the occasional tree and springbok. In the wetlands of Botswana's Okavango Delta, immense herds of zebra graze in lush green grass. The Ugandan countryside in the morning can appear intensely colourful, a vivid rainbow. And the markets of Addis Ababa and Marrakech are a potpourri of swirling light and colour.

The frozen chill of an African dawn can quickly become searing heat as the equatorial sun rises and burns its way into the

morning air. All too suddenly the fierce sunshine is obscured by black storm clouds disgorging torrential rain, creating temporary pools that quench the thirst of the land. The animals and the land sometimes present strange mysteries. Elephants are the world's largest land mammals, yet a herd of seventy will walk through the landscape in a silence that defies belief. Hunting dogs run tirelessly for hours, driving their prey to exhaustion. Cheetahs are capable of awe-inspiring bursts of speed during a chase.

The birth of an animal in the dangerous environment of the open savannah is a reminder of our own vulnerability and physical weakness. A newborn springbok is totally odourless, making it virtually undetectable to the hypersensitive nostrils of its enemies. The ecological balance of Africa is maintained by the constant interplay of survival strategies, as the many species perpetually strive to outwit each other.

Compared to wildlife, we humans are flagrantly conspicuous as we rumble along in our vehicles, noisy and obtrusive. A leopard has the power to become almost invisible at will and most animals are aware of us long before our skilled trackers can detect them. We are intruders in their territory.

Whenever I return, I gain a deeper insight into Africa. Sometimes I want to remain forever in just one place, trying to learn all that there is to know. At other times I want to spread myself widely across the land, experiencing something of everywhere. More and more I realize that my hunger can never be fully satisfied.

This book is a fleeting glimpse of the Africa I love. It is not intended to be an encyclopaedic or comprehensive study of its inhabitants. The continent is so vast and varied that such a goal is unattainable. This is a personal impression, an attempt to capture something of the heartbeat that throbs across the continent. I hope that within these pages you will find flashes of that spark of life connecting us all, celebrating moments of joy, moments of sadness and some of the magic in between.

OPPOSITE
Table Mountain, Cape Town, South Africa.

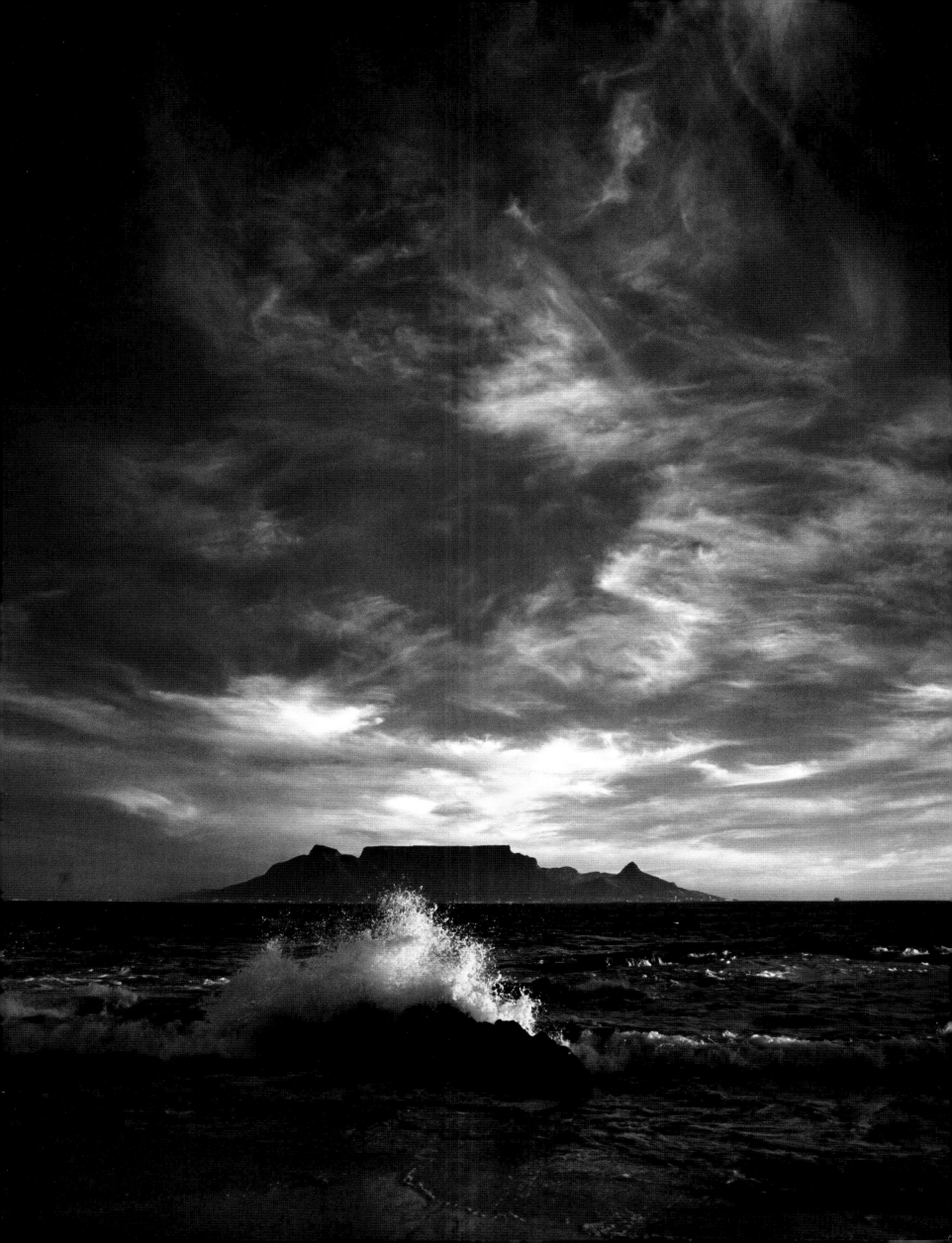

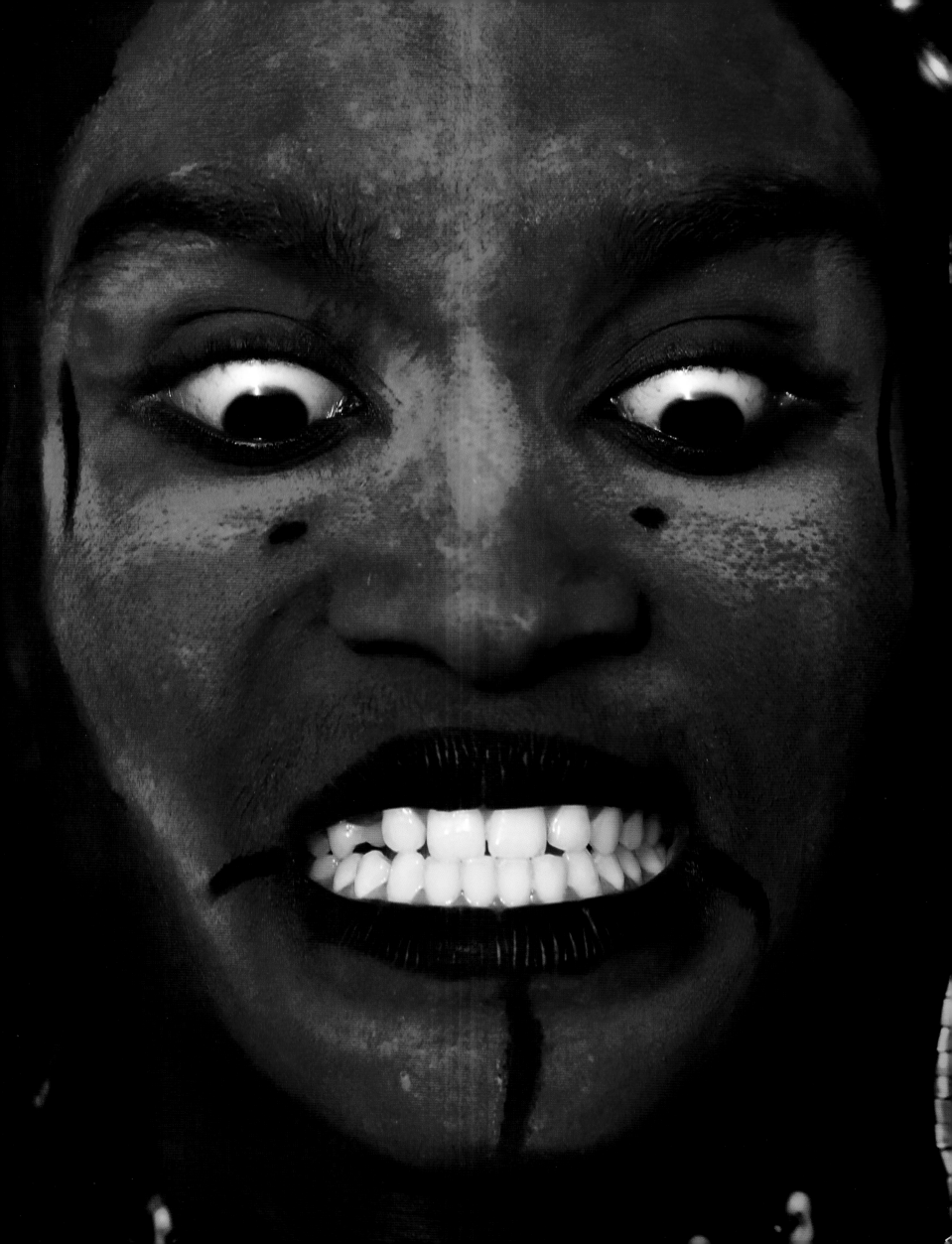

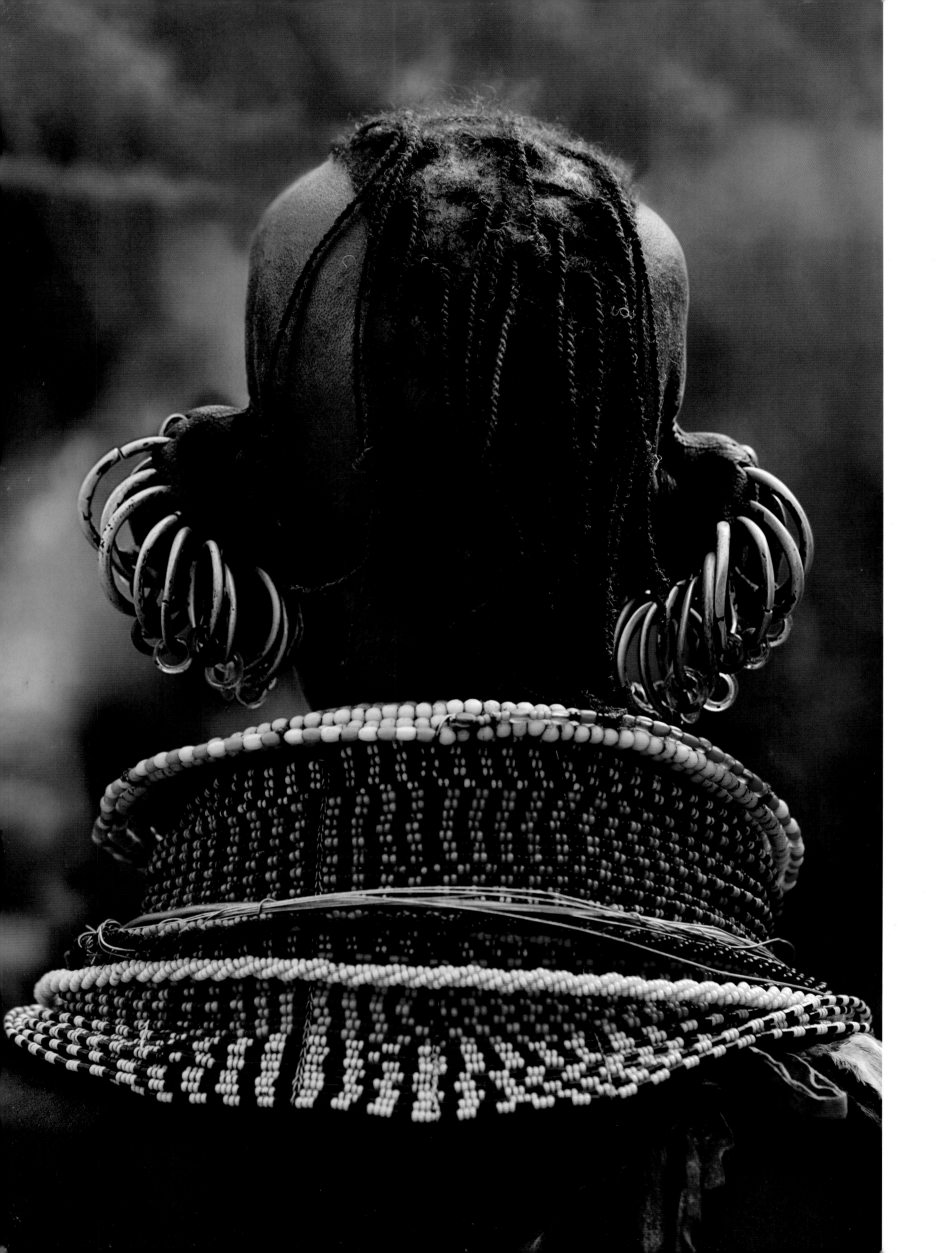

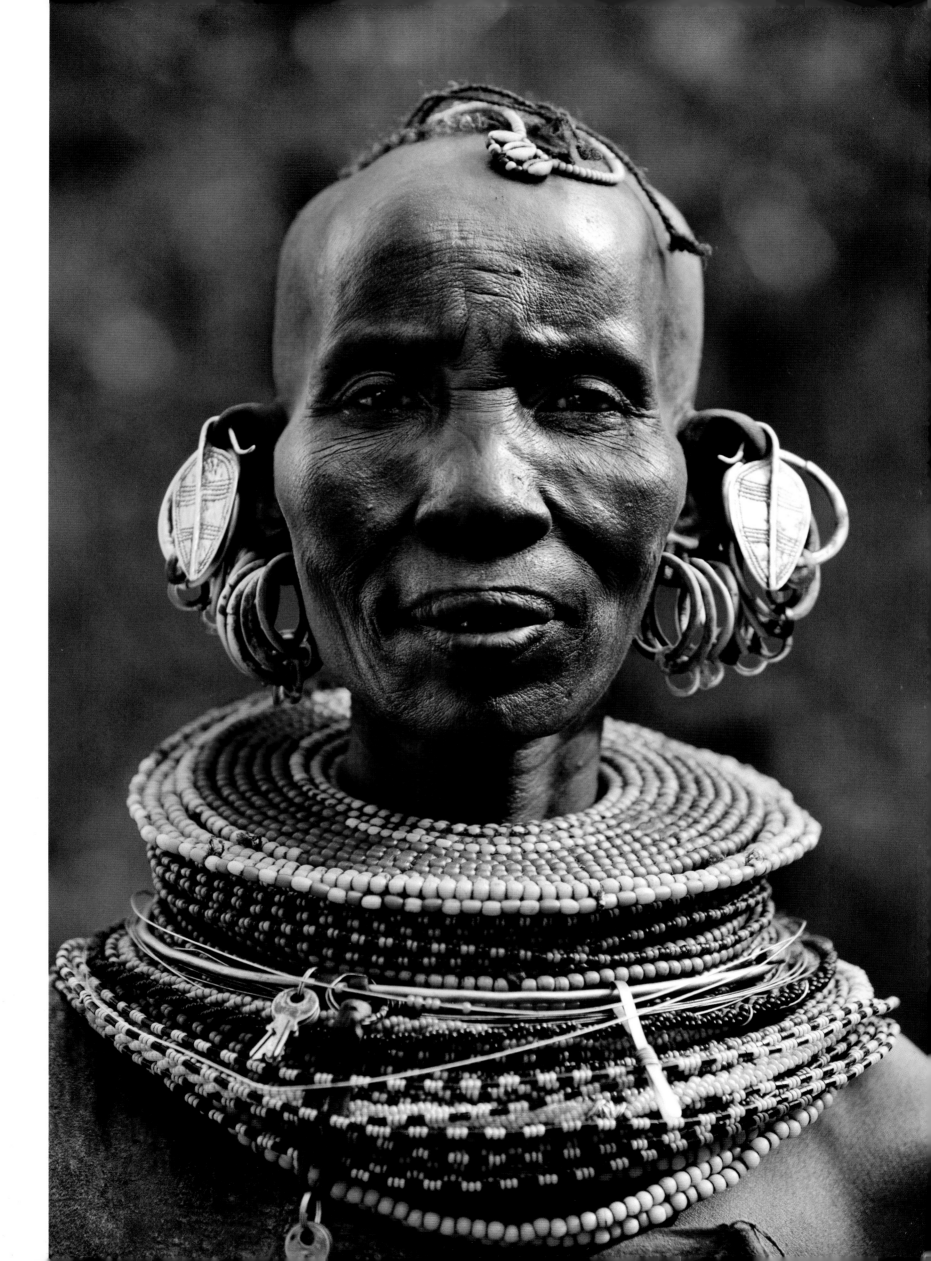

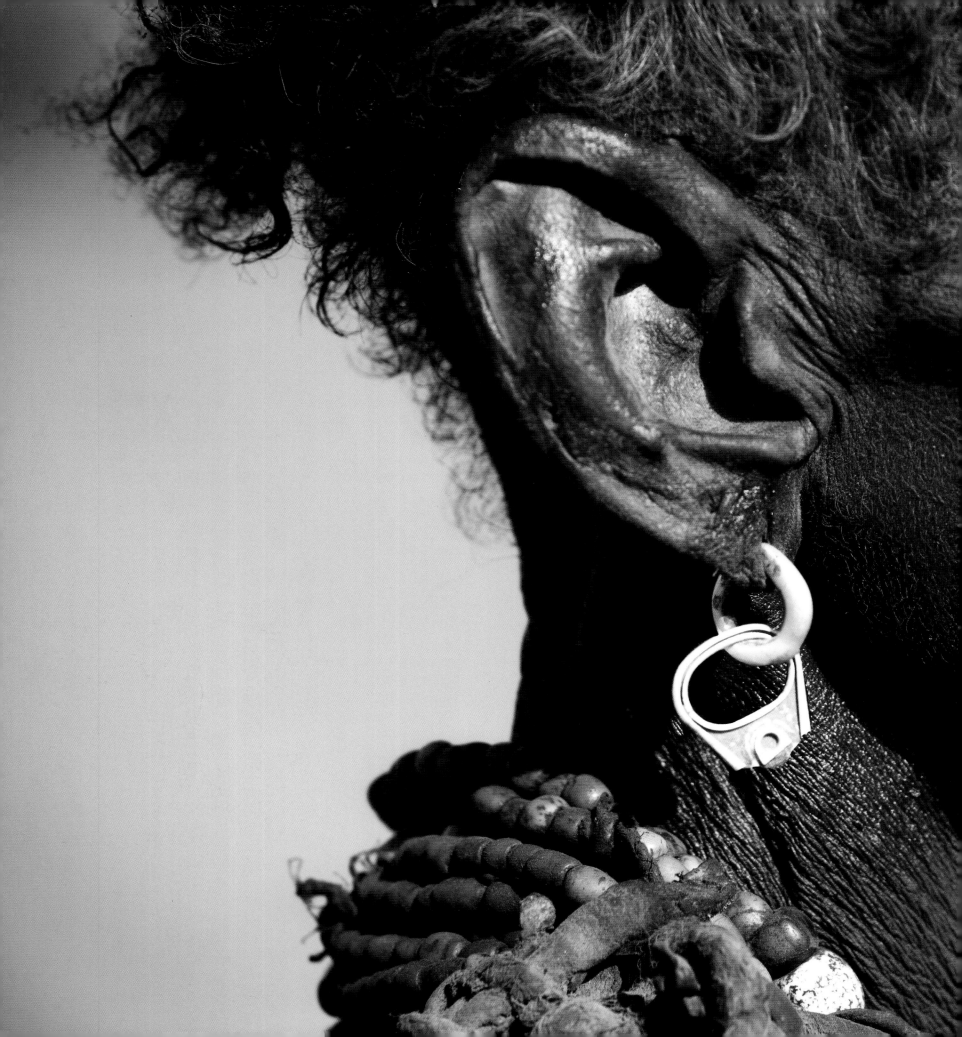

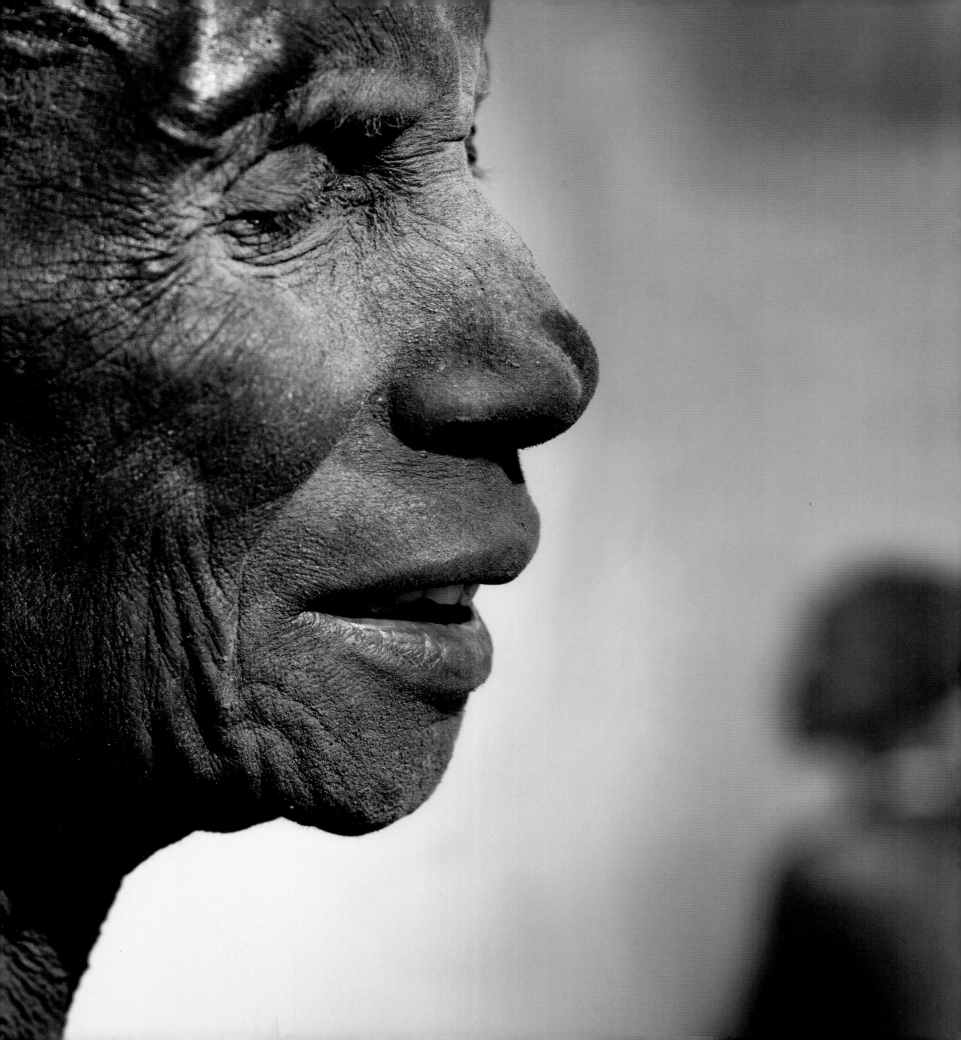

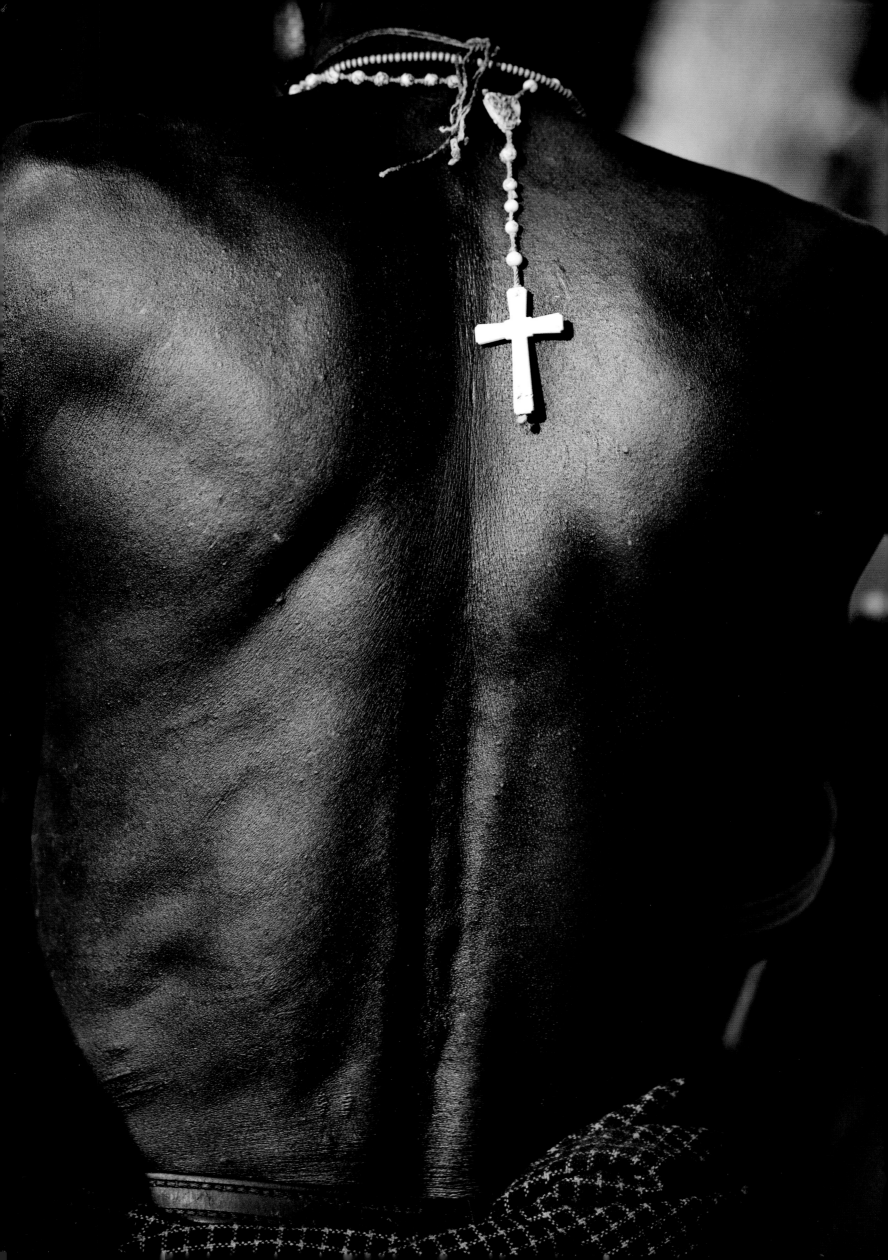

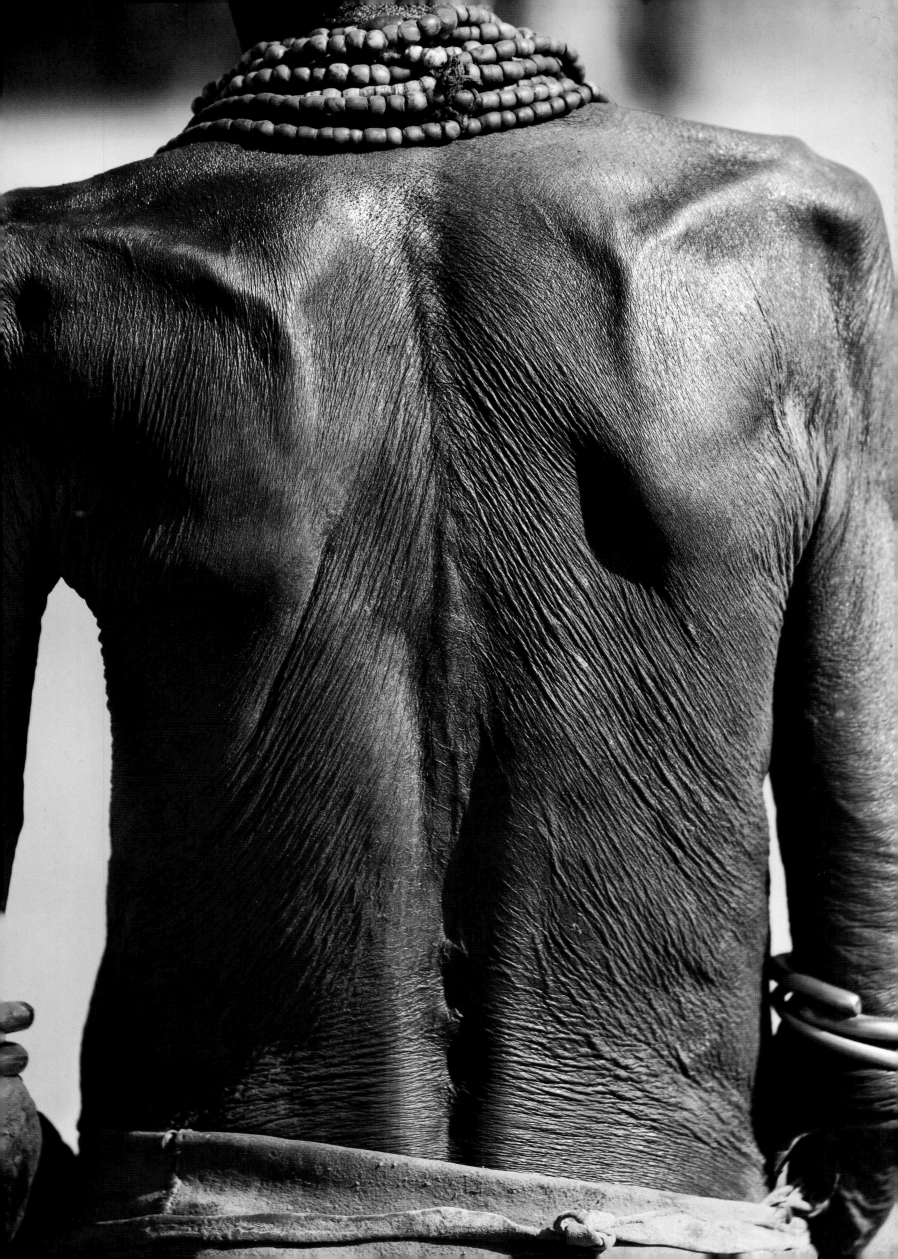

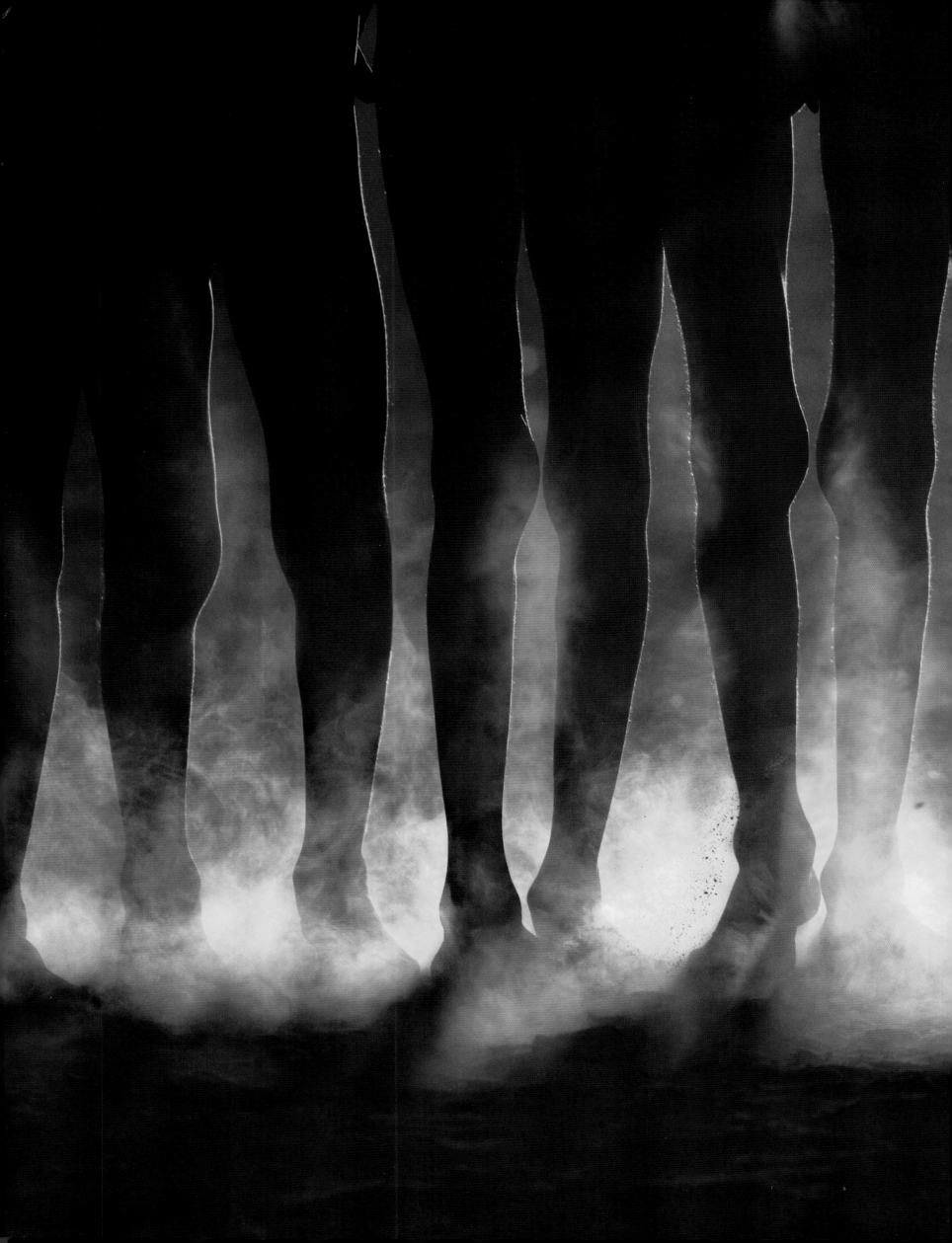

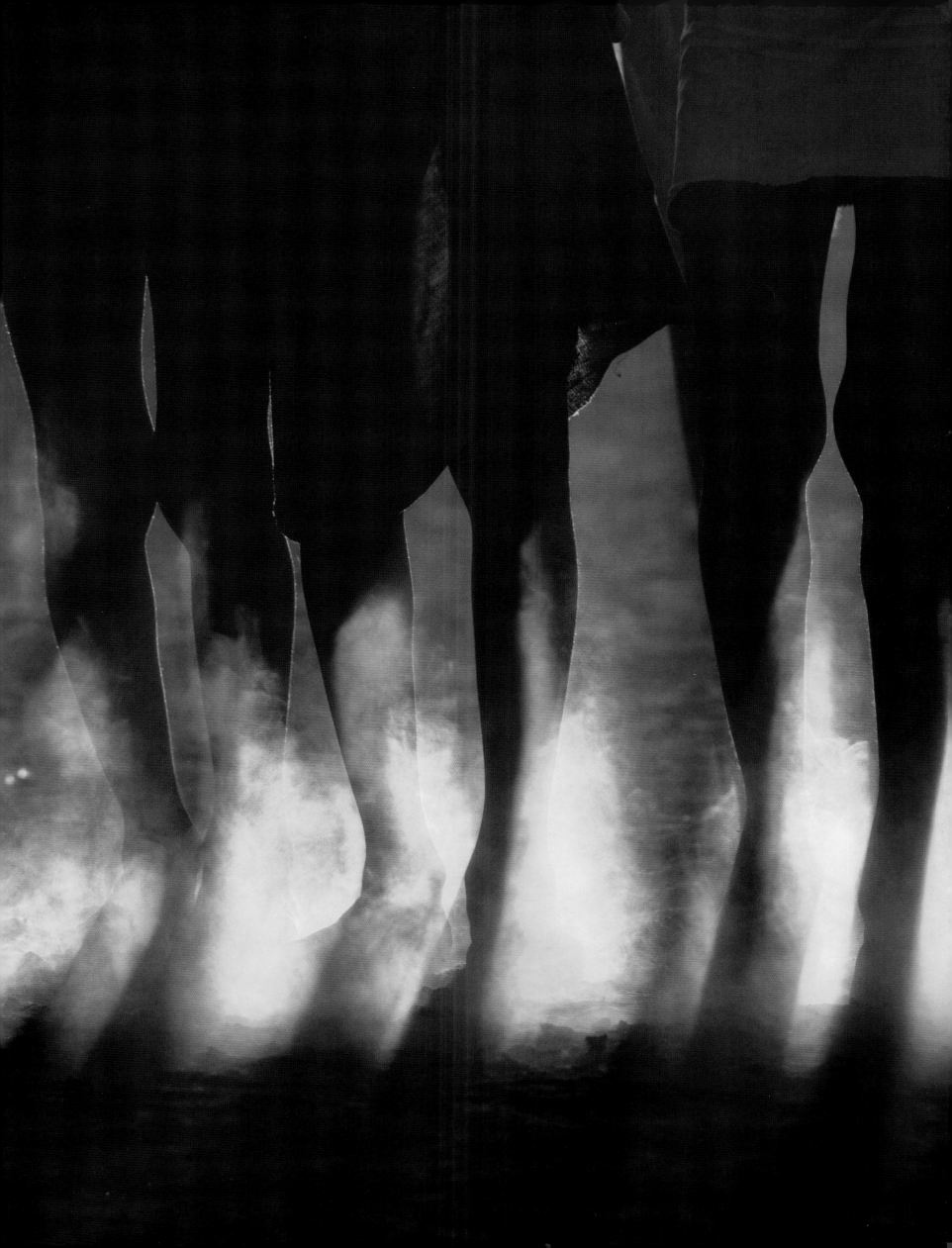

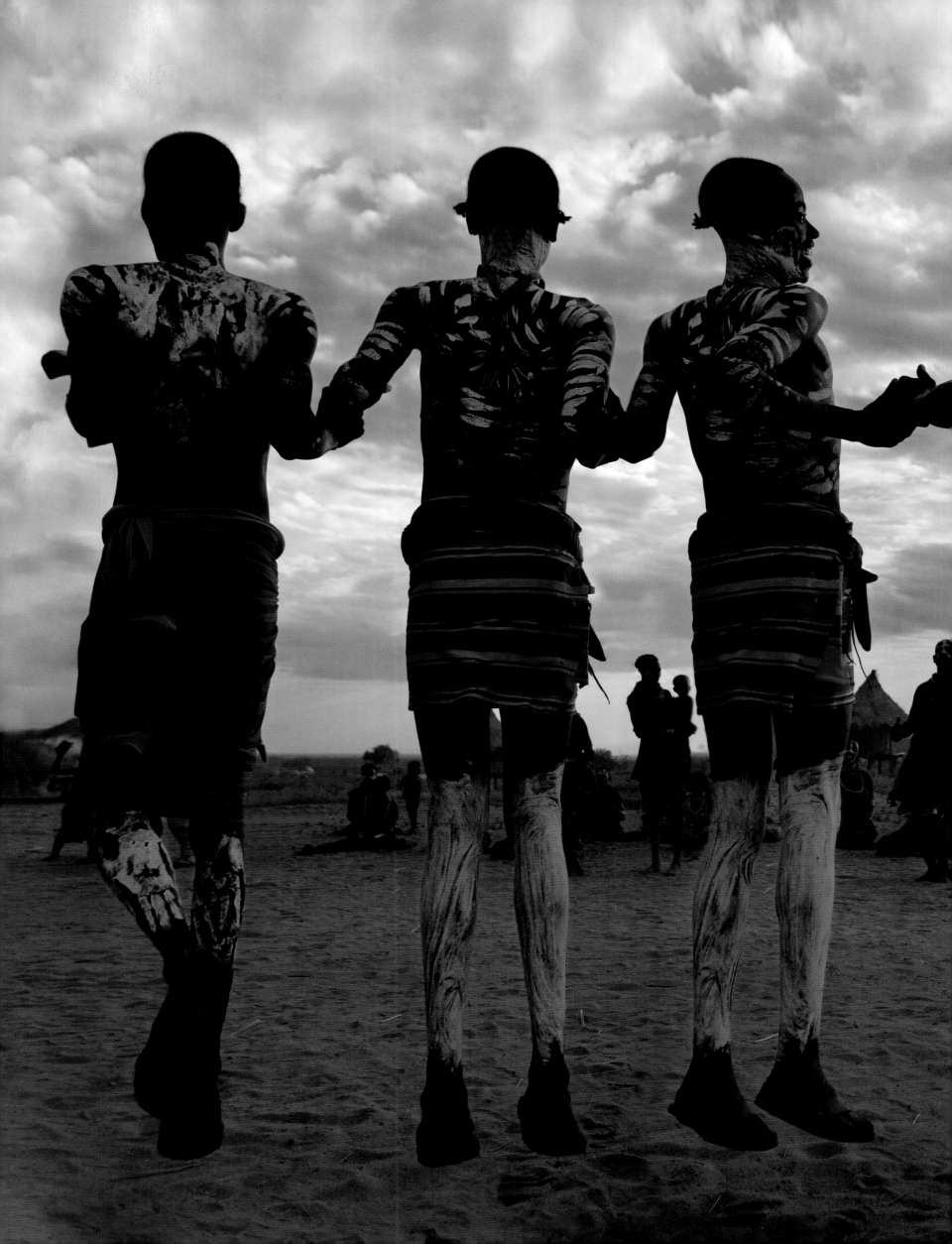

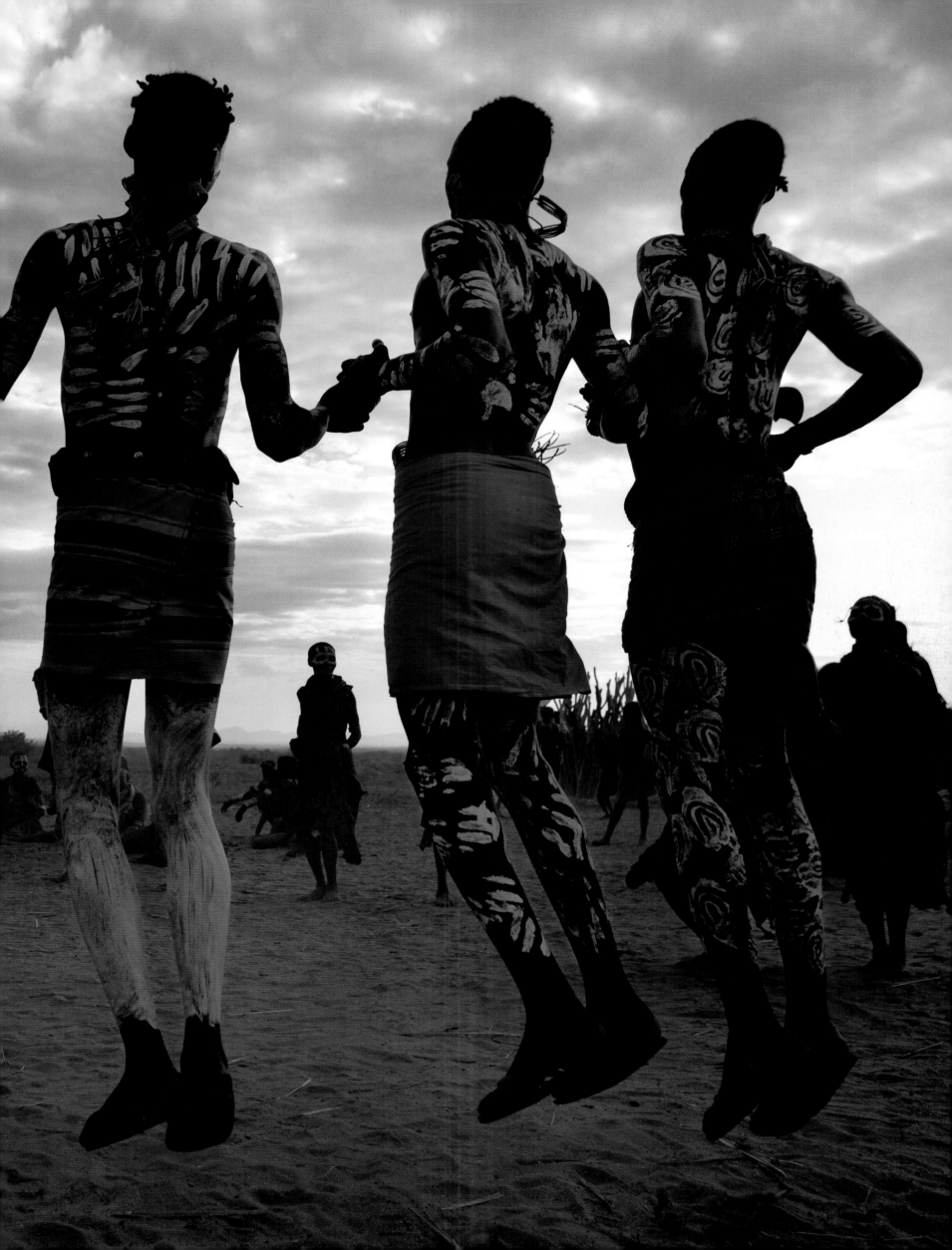

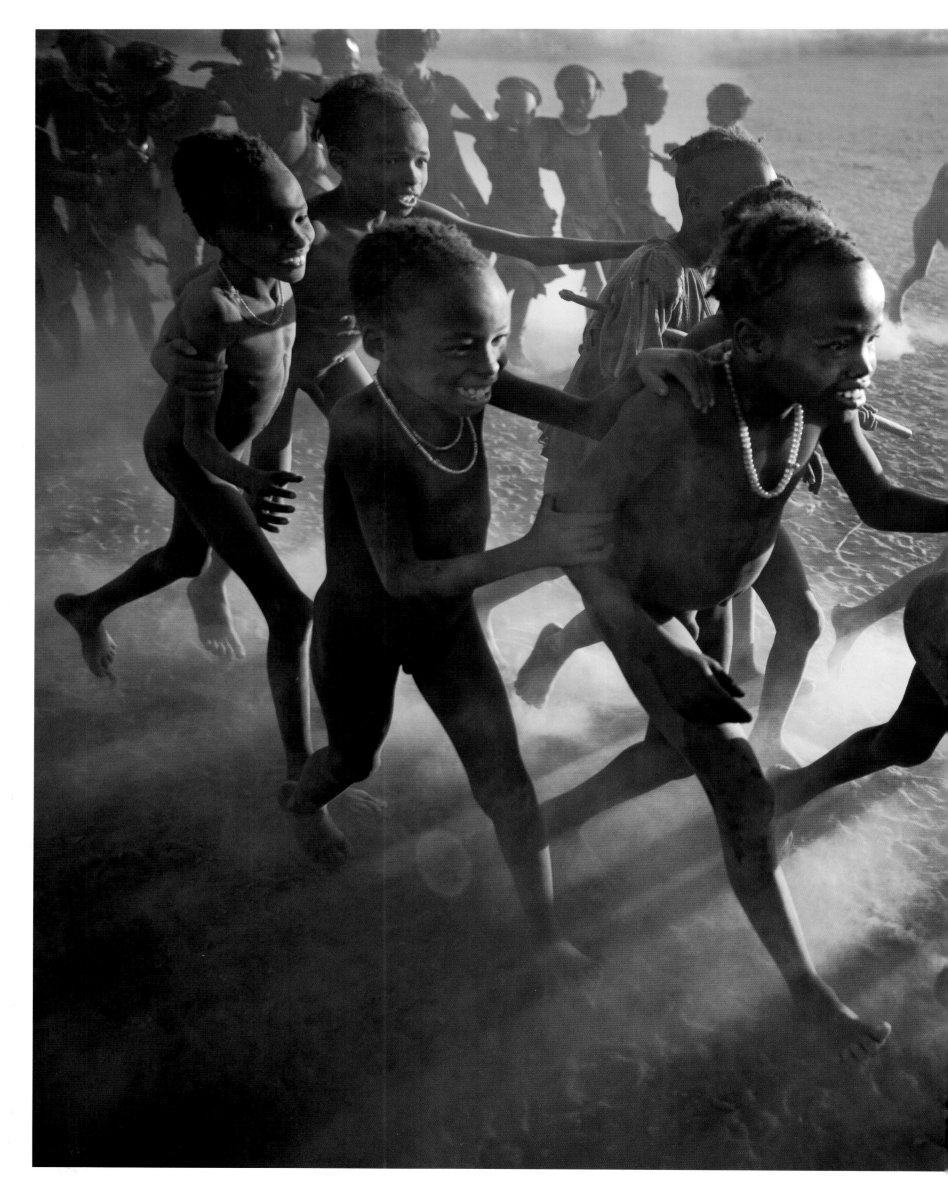

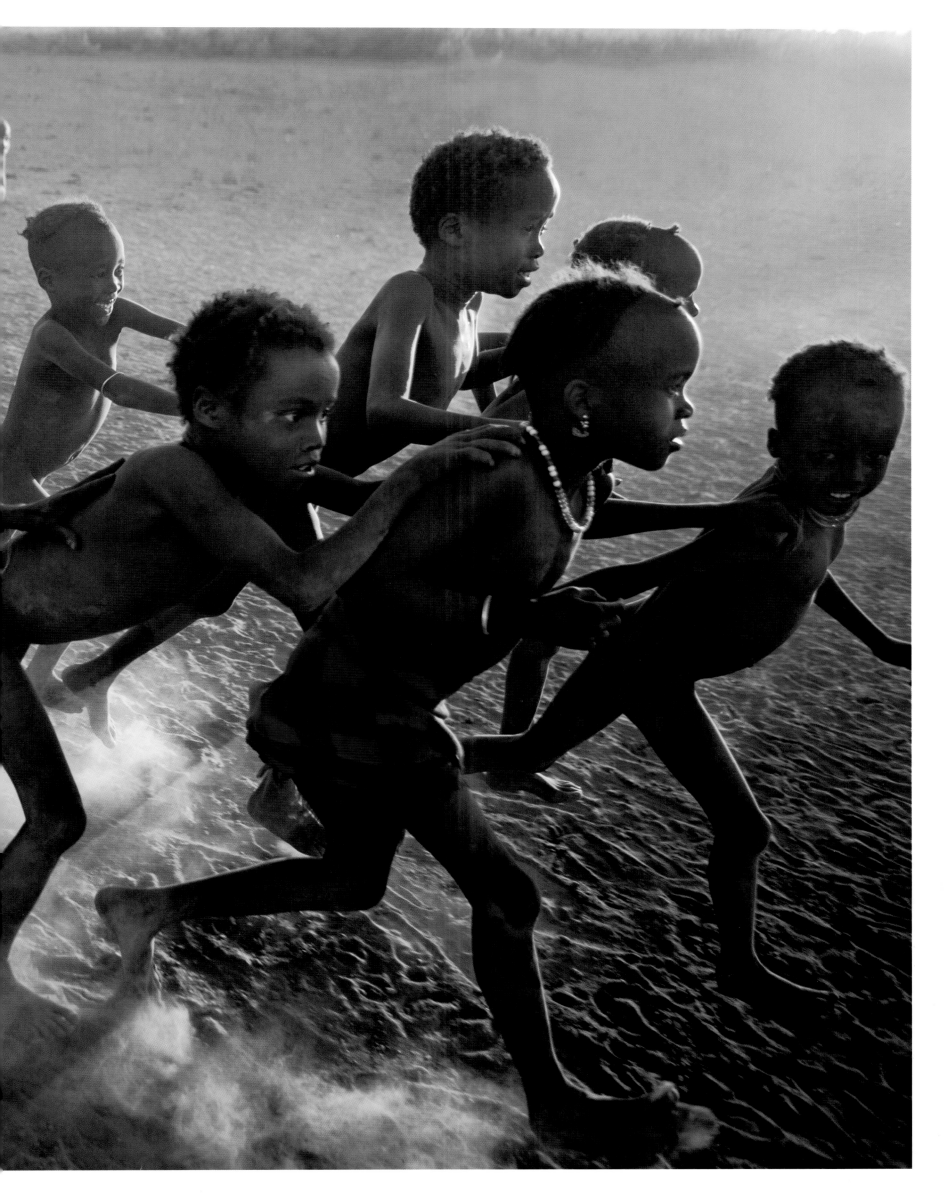

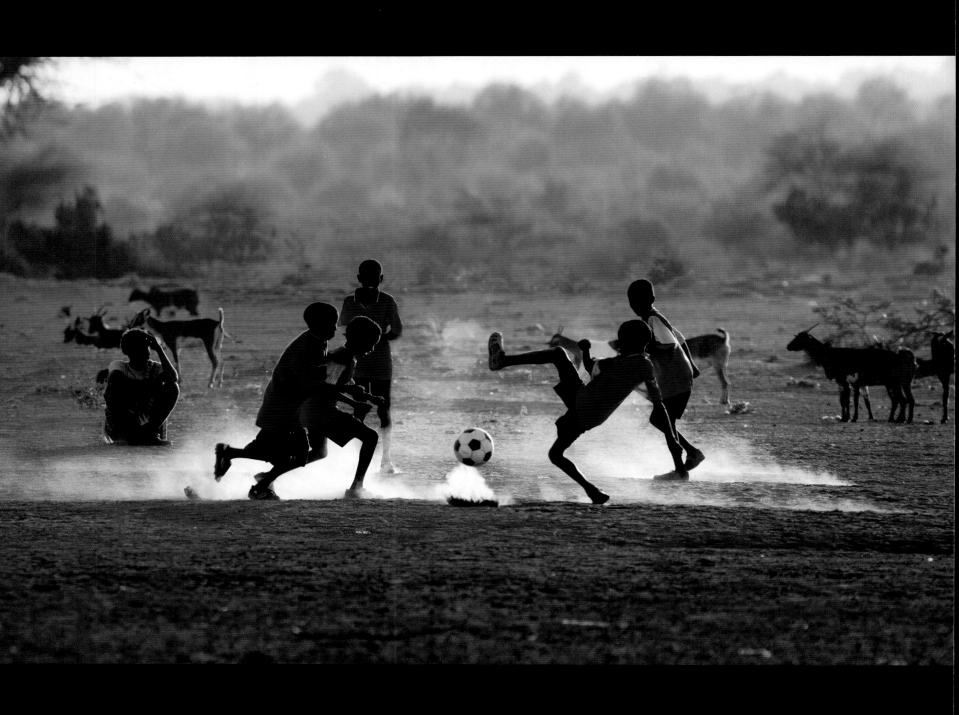

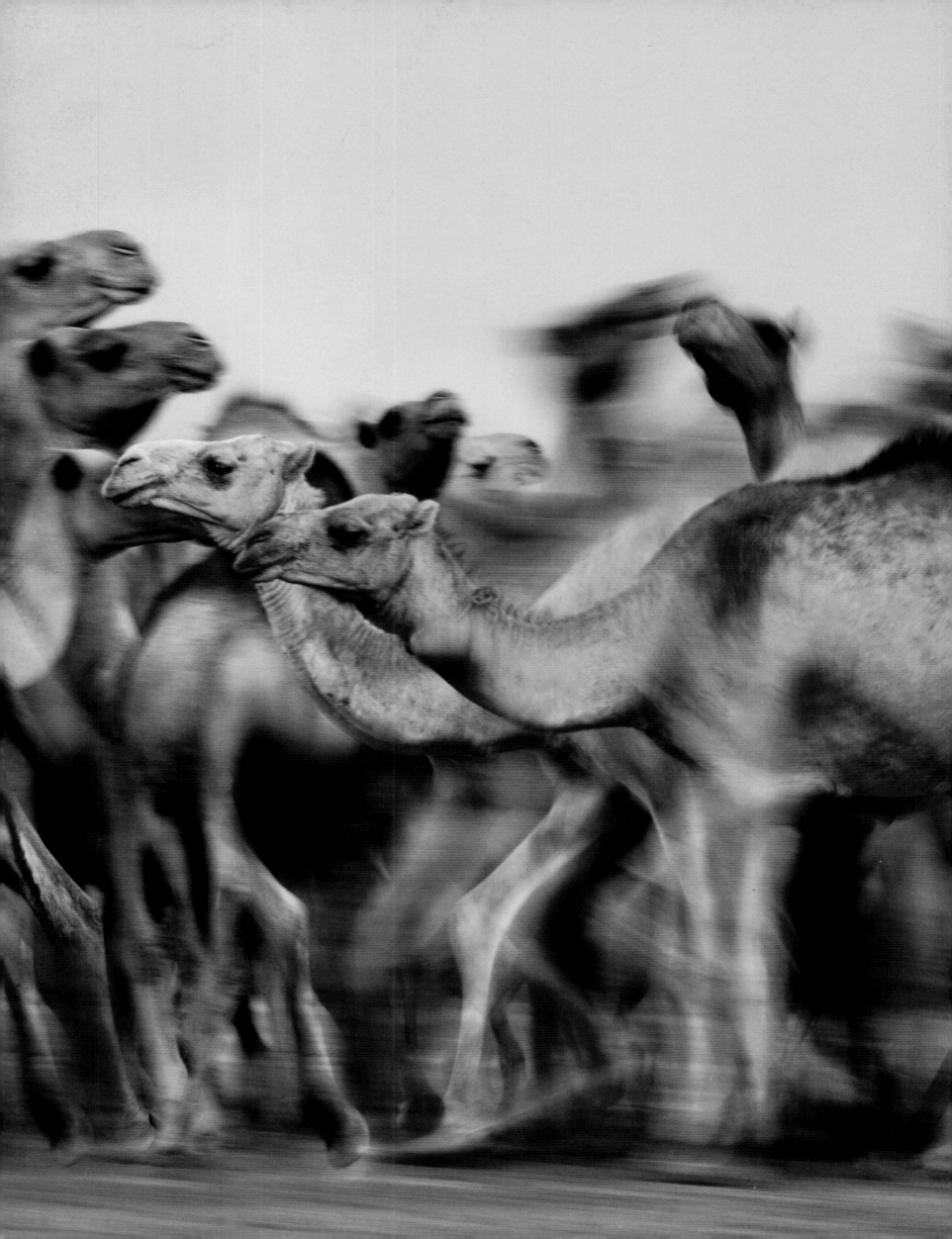

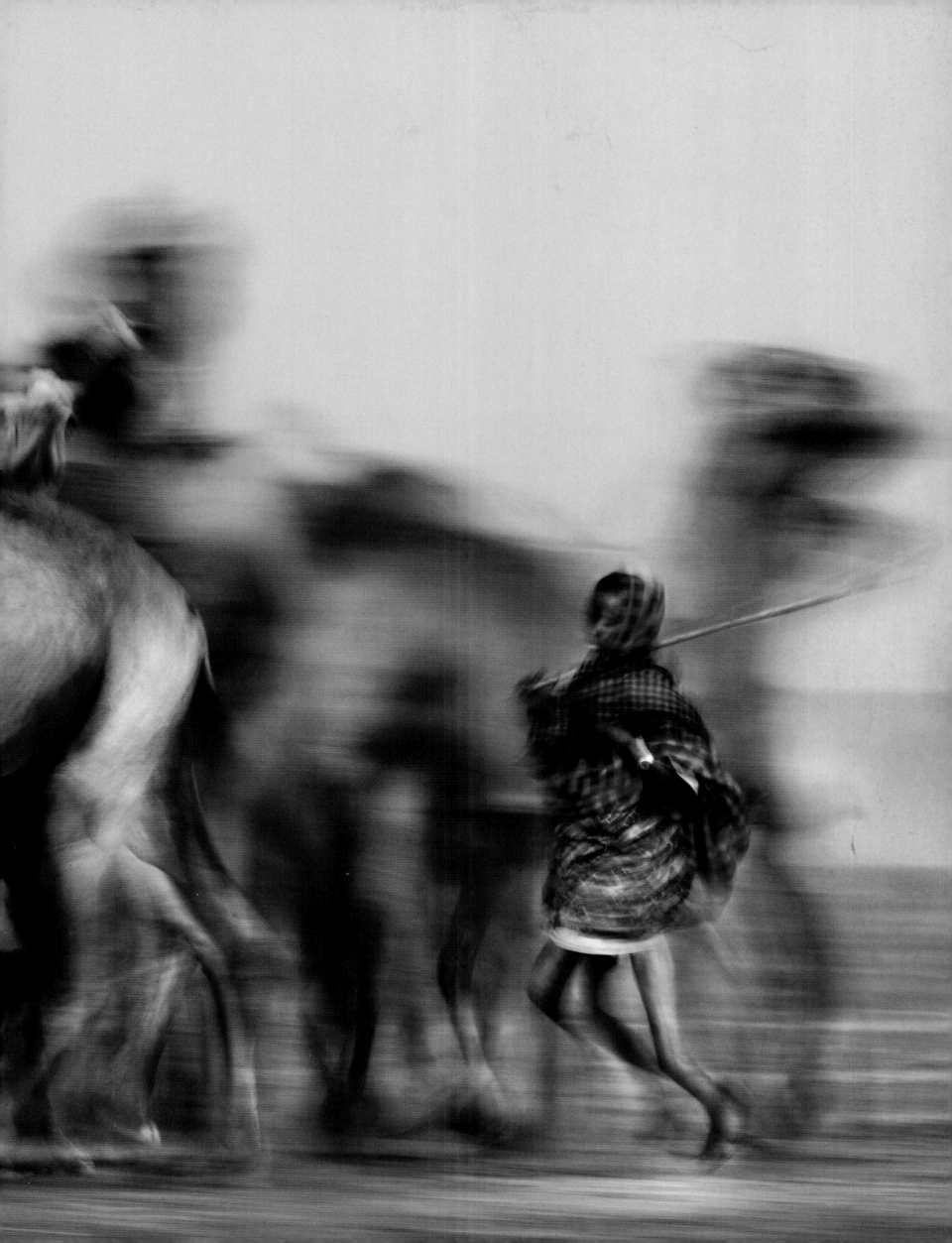

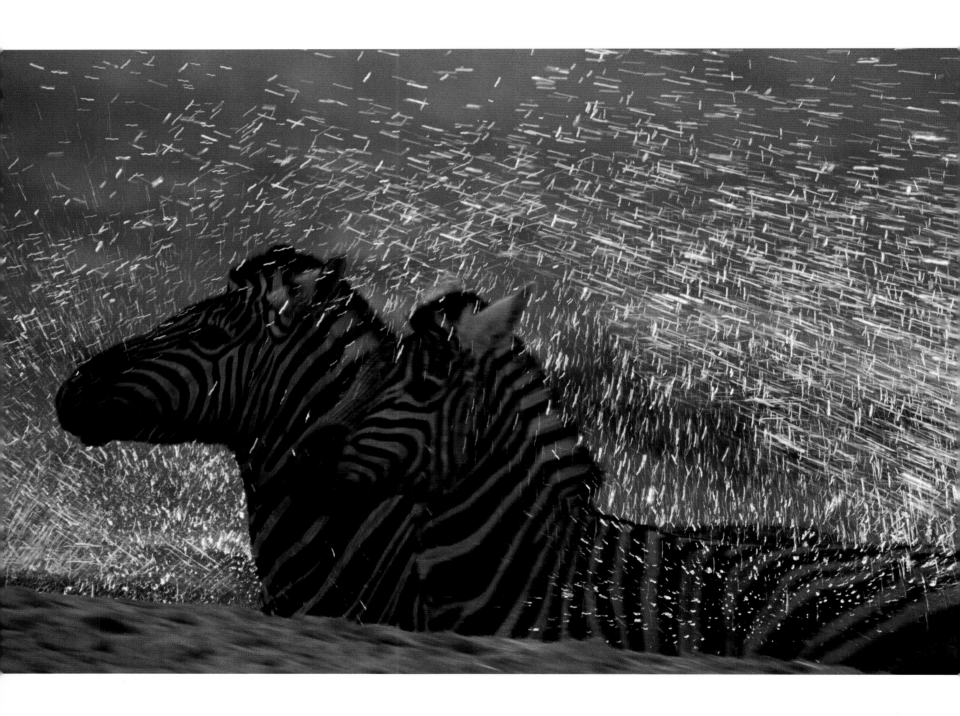

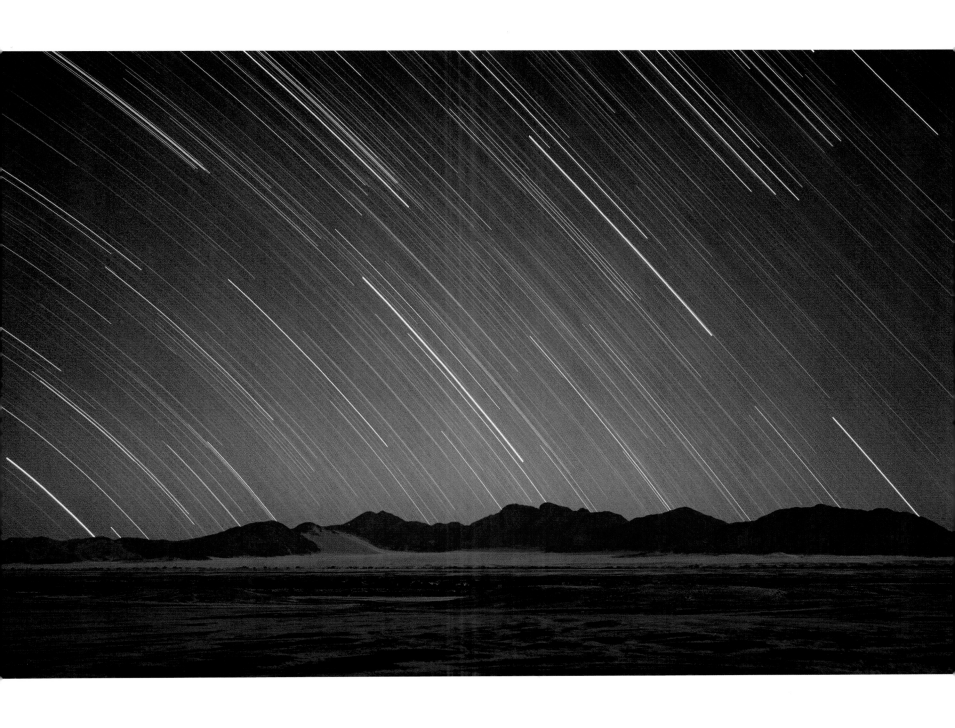

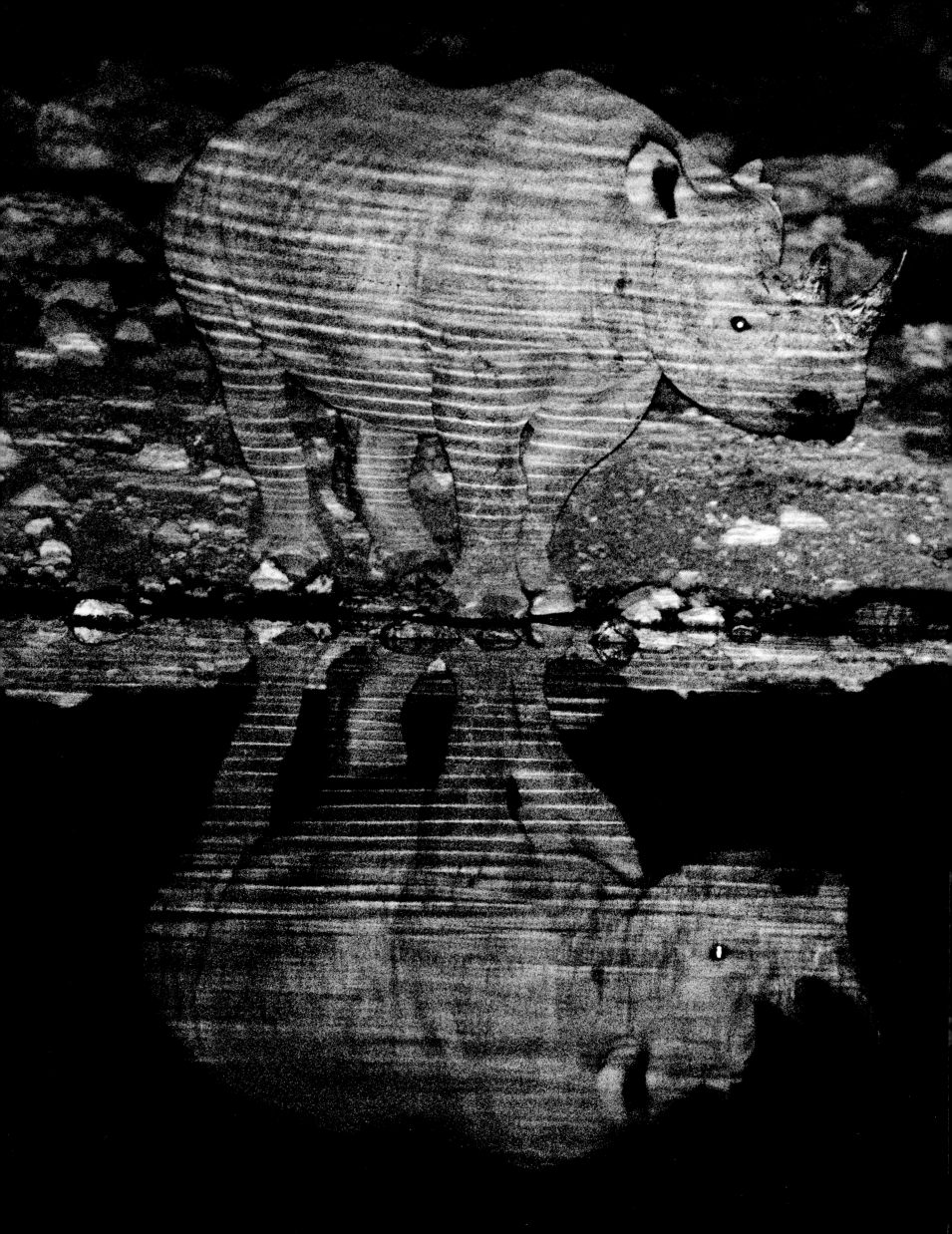

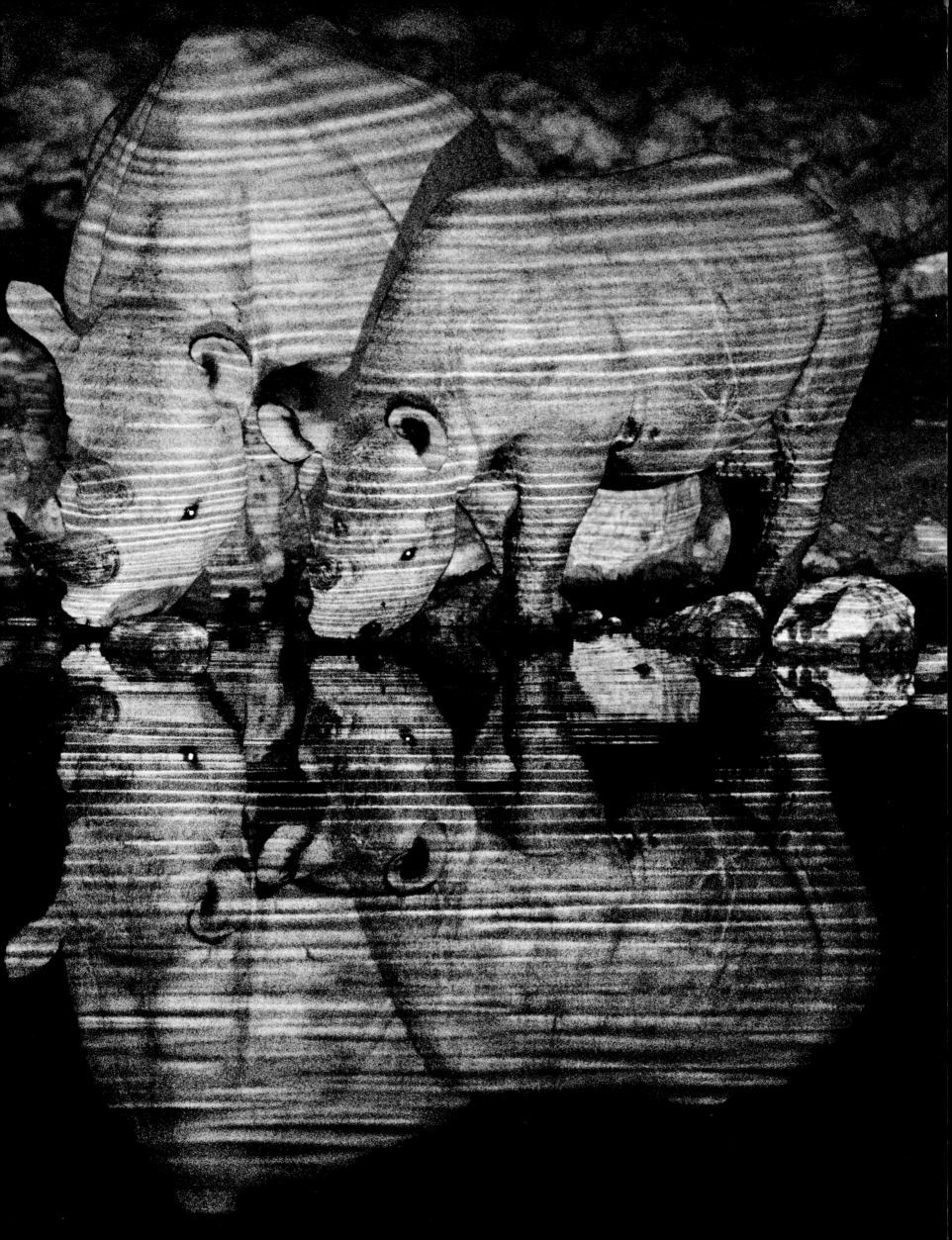

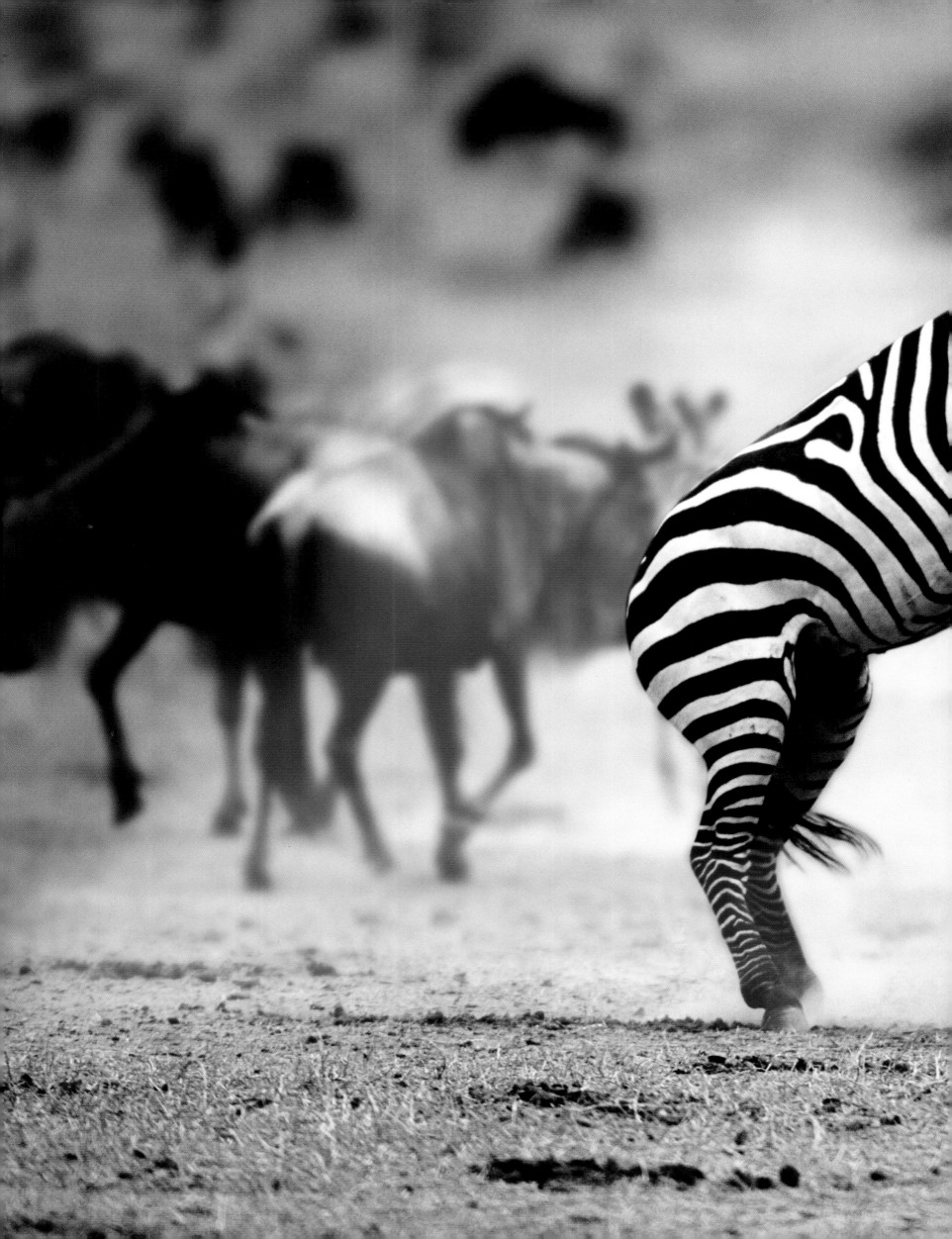

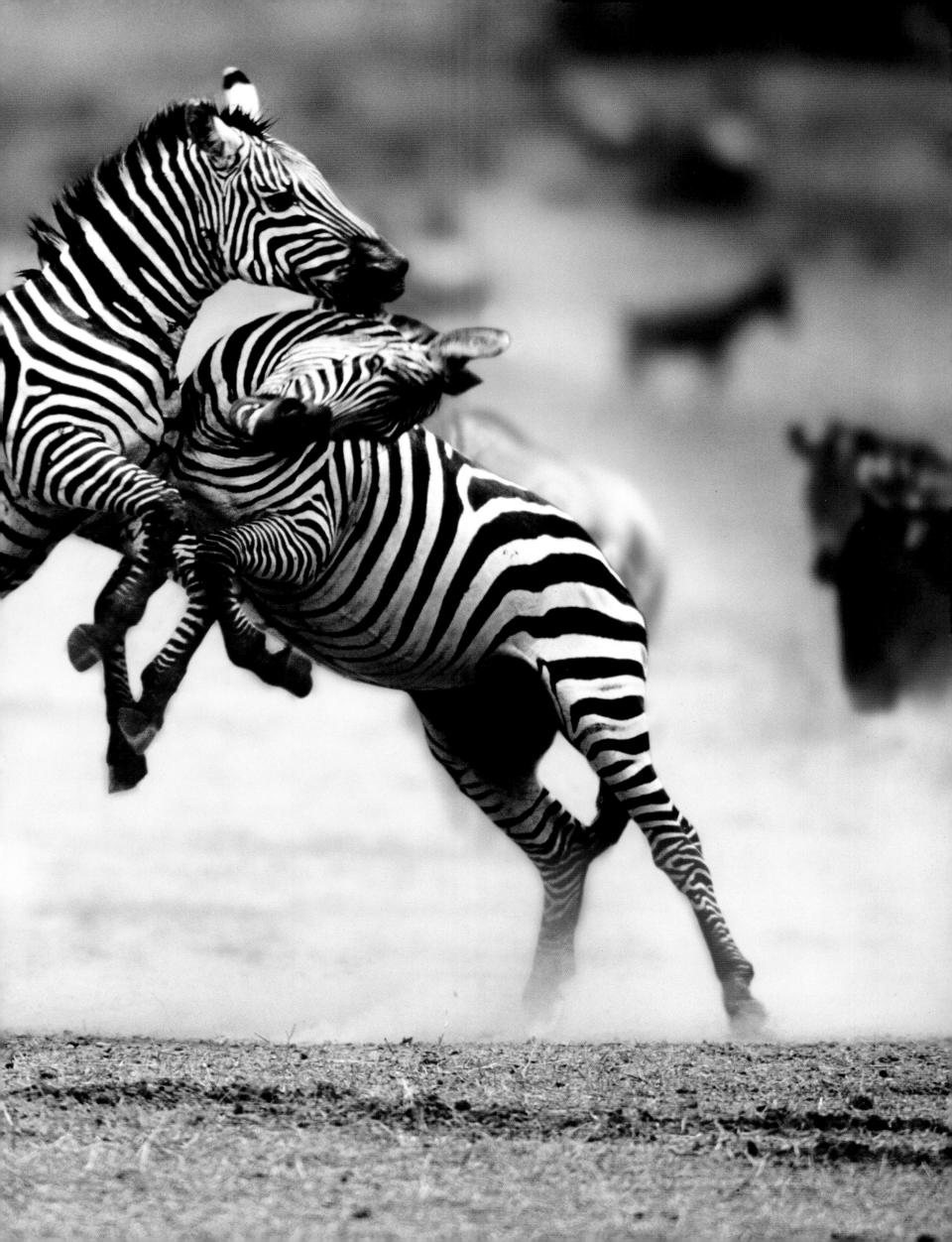

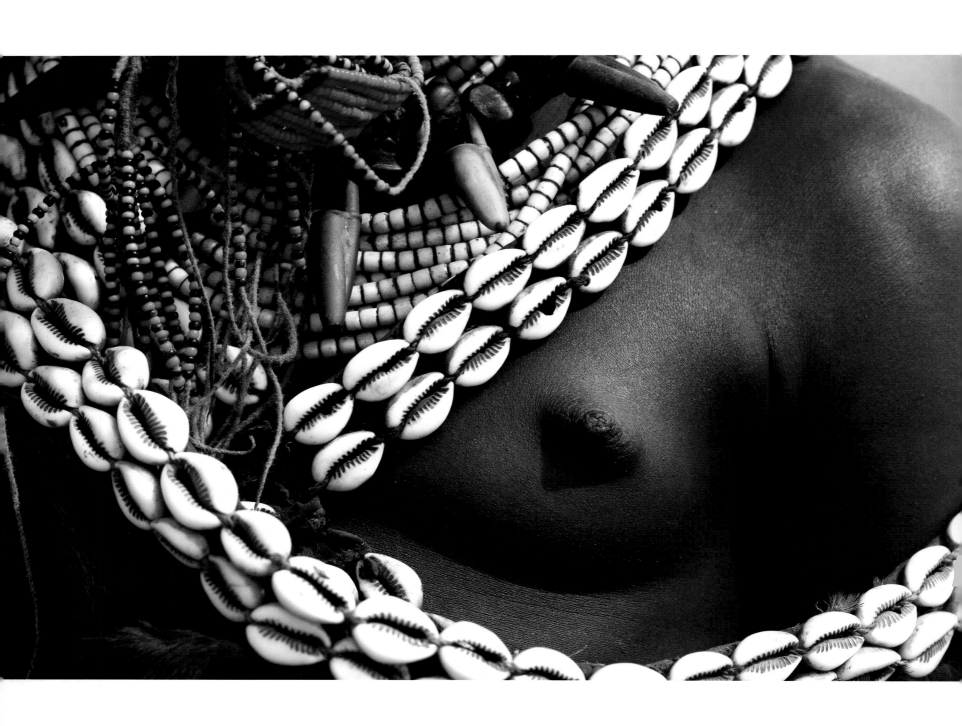

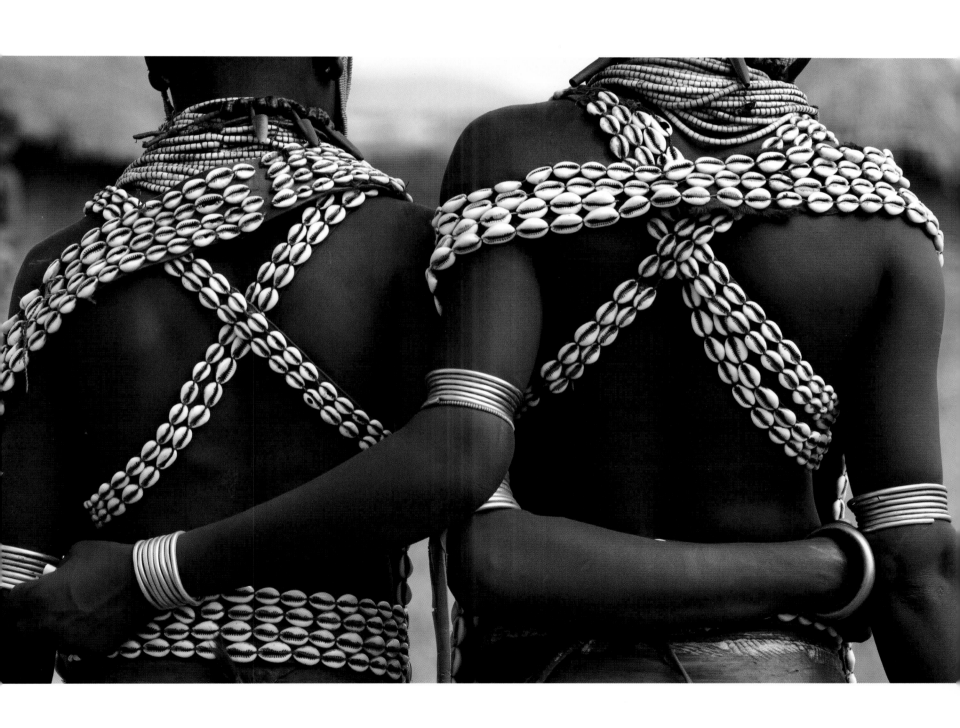

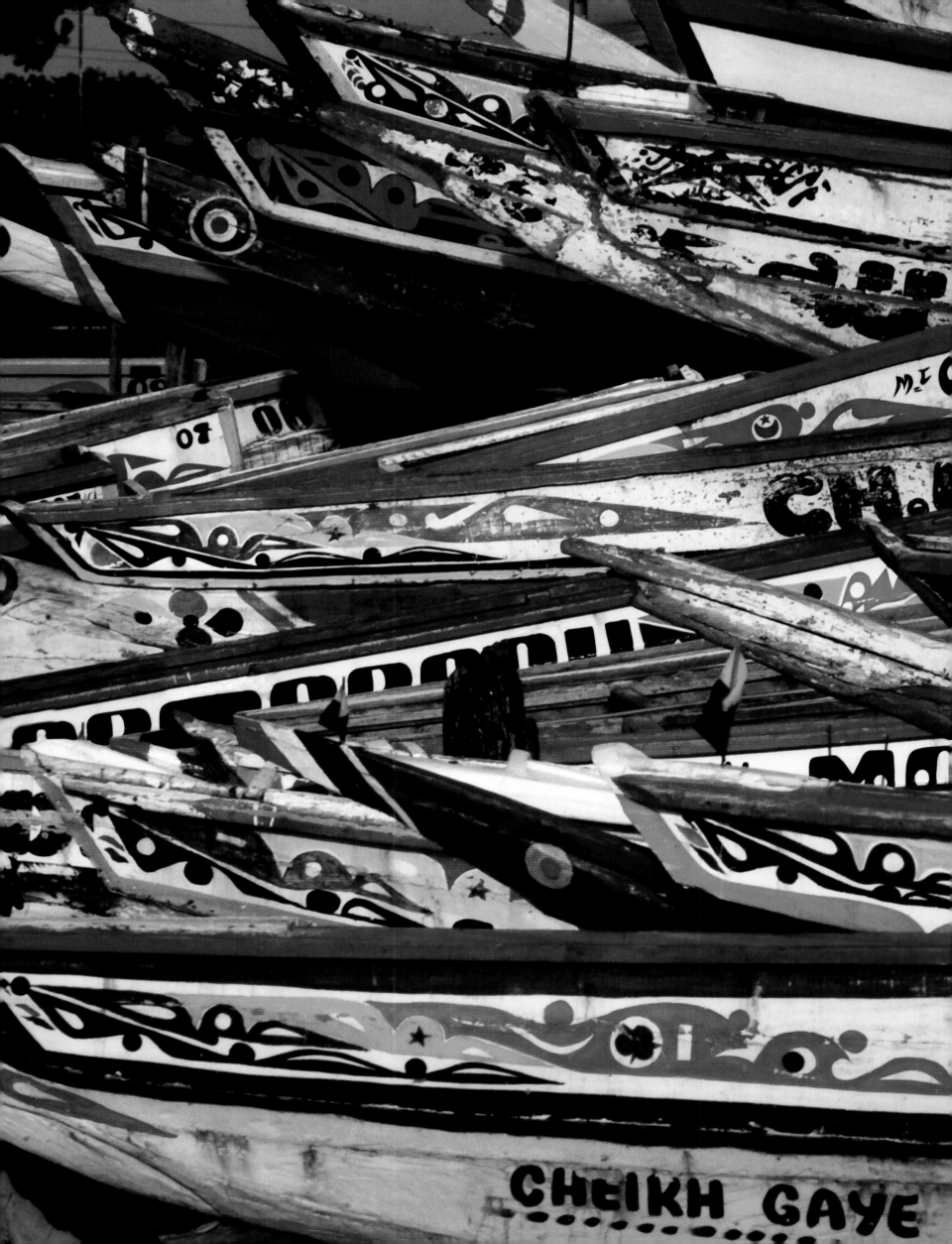

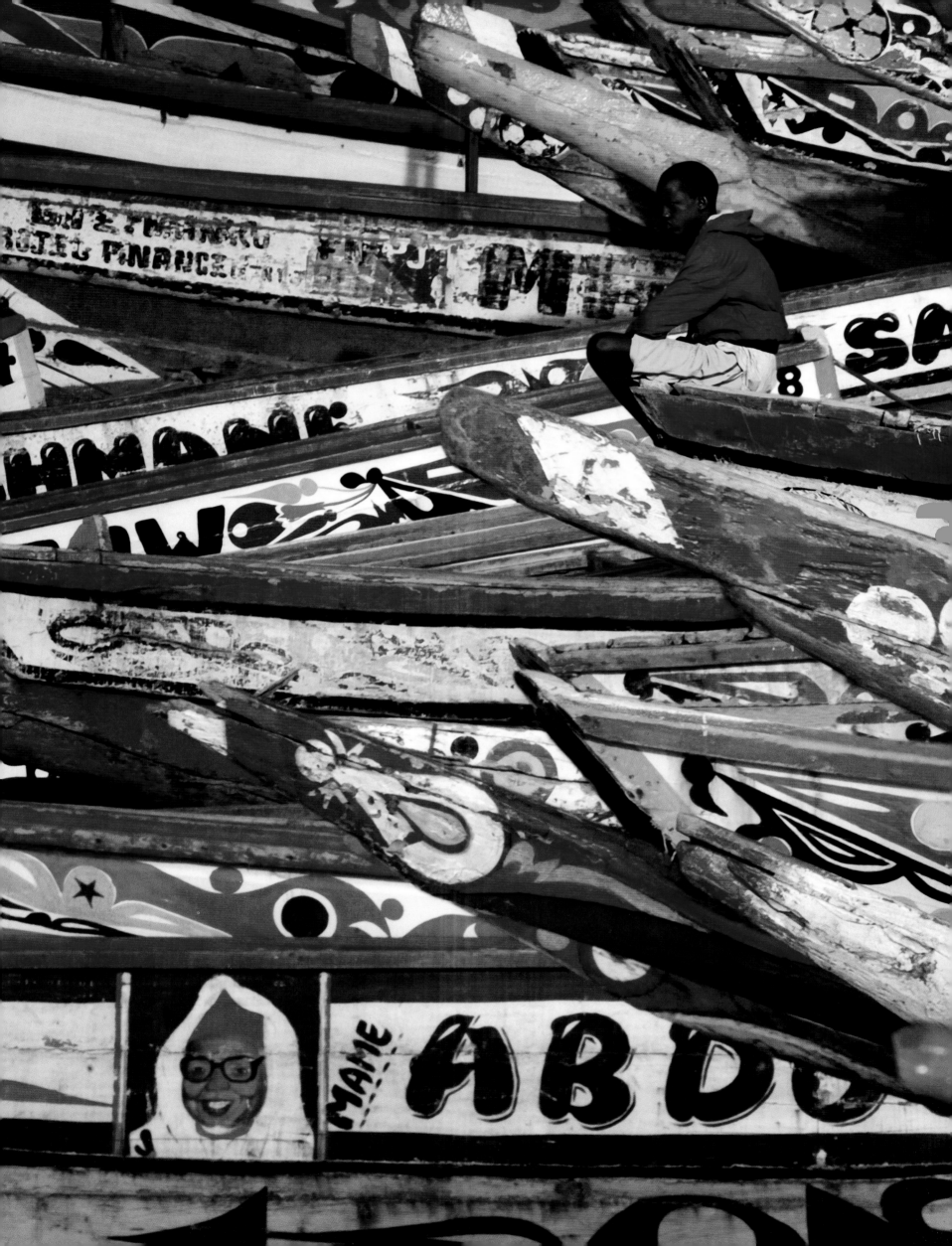

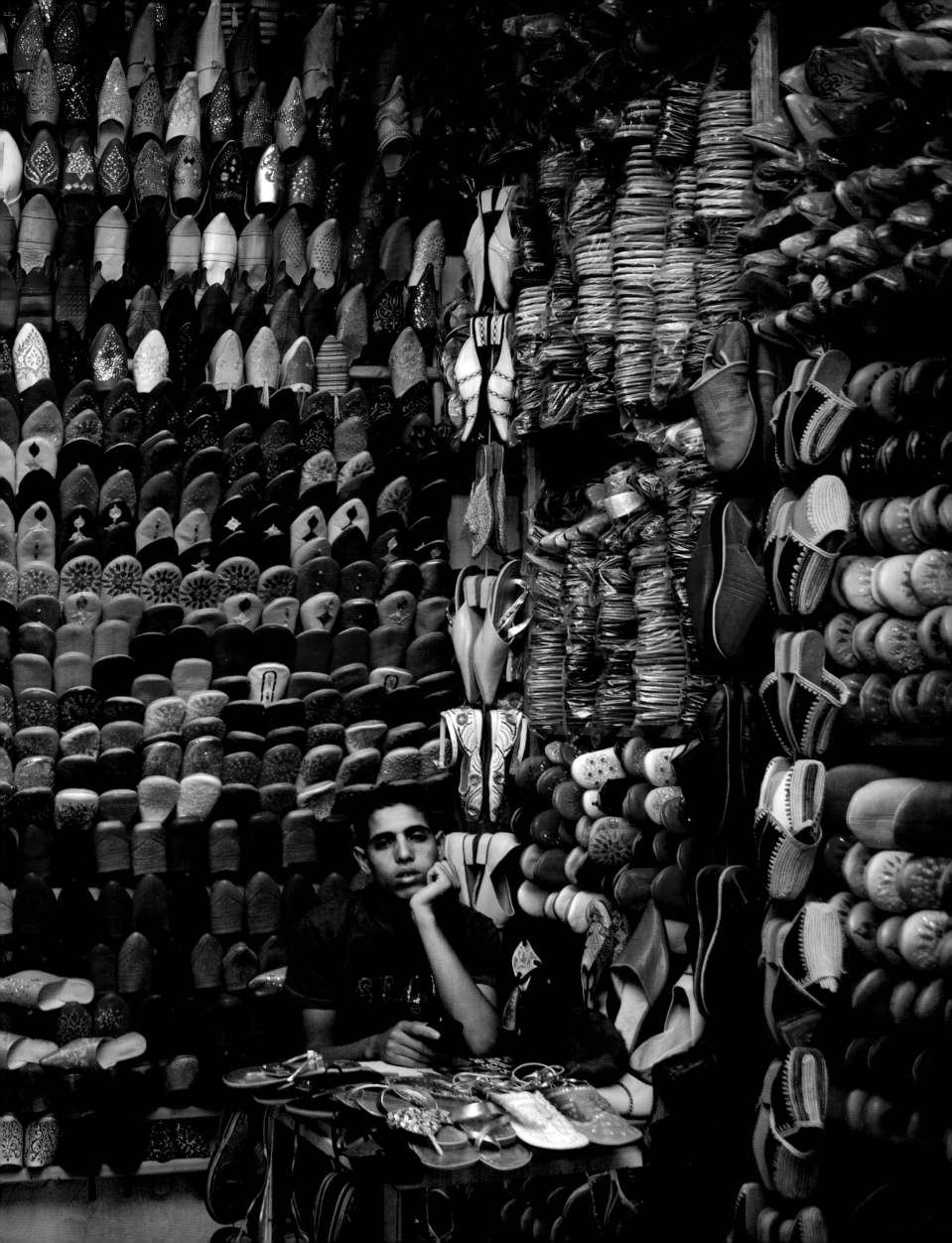

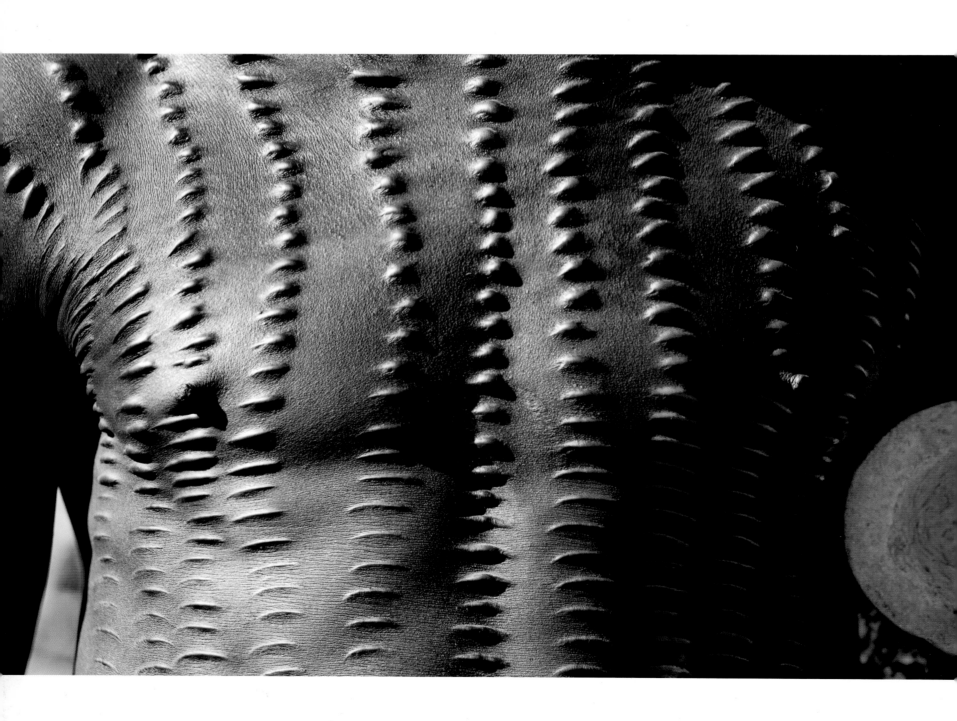

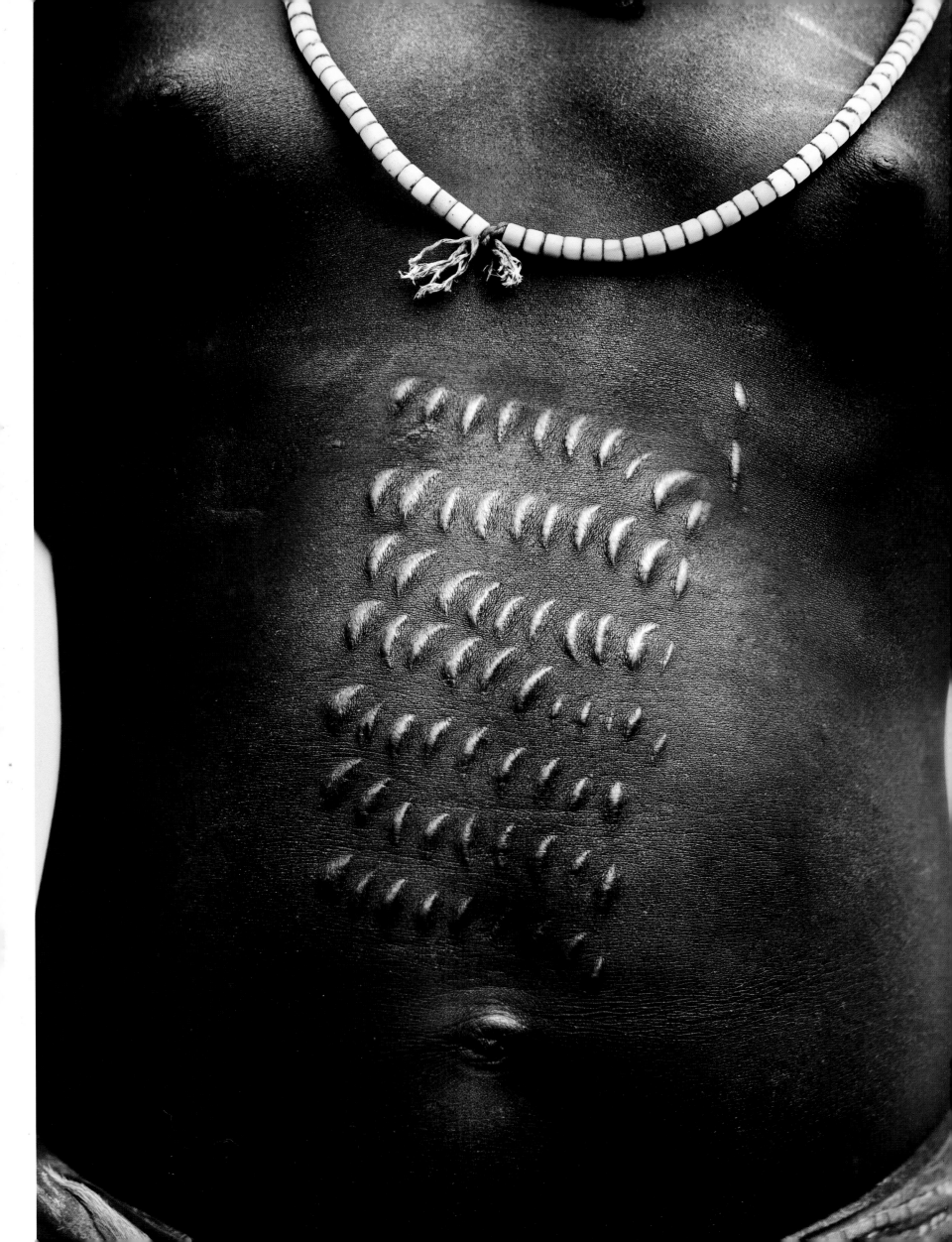

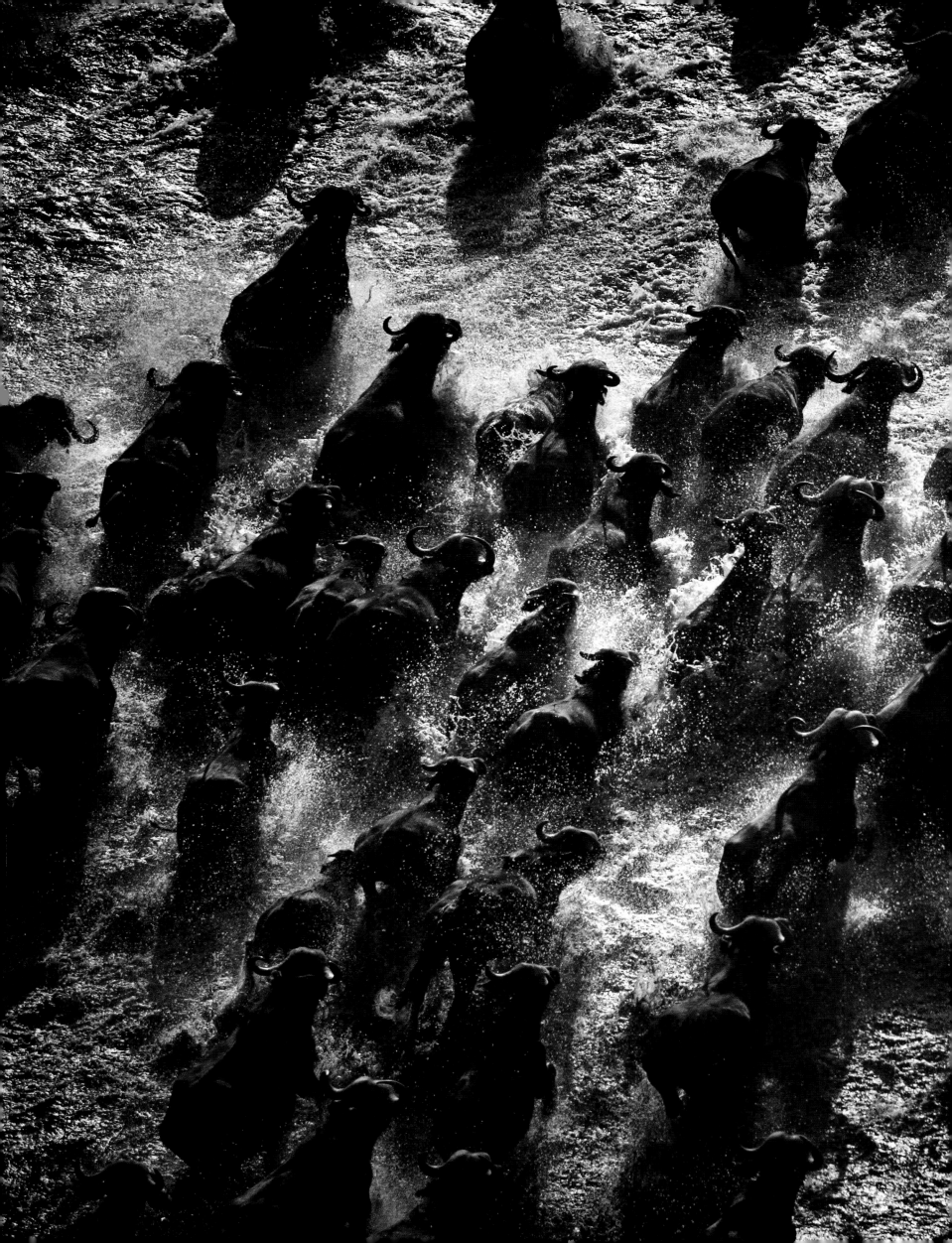

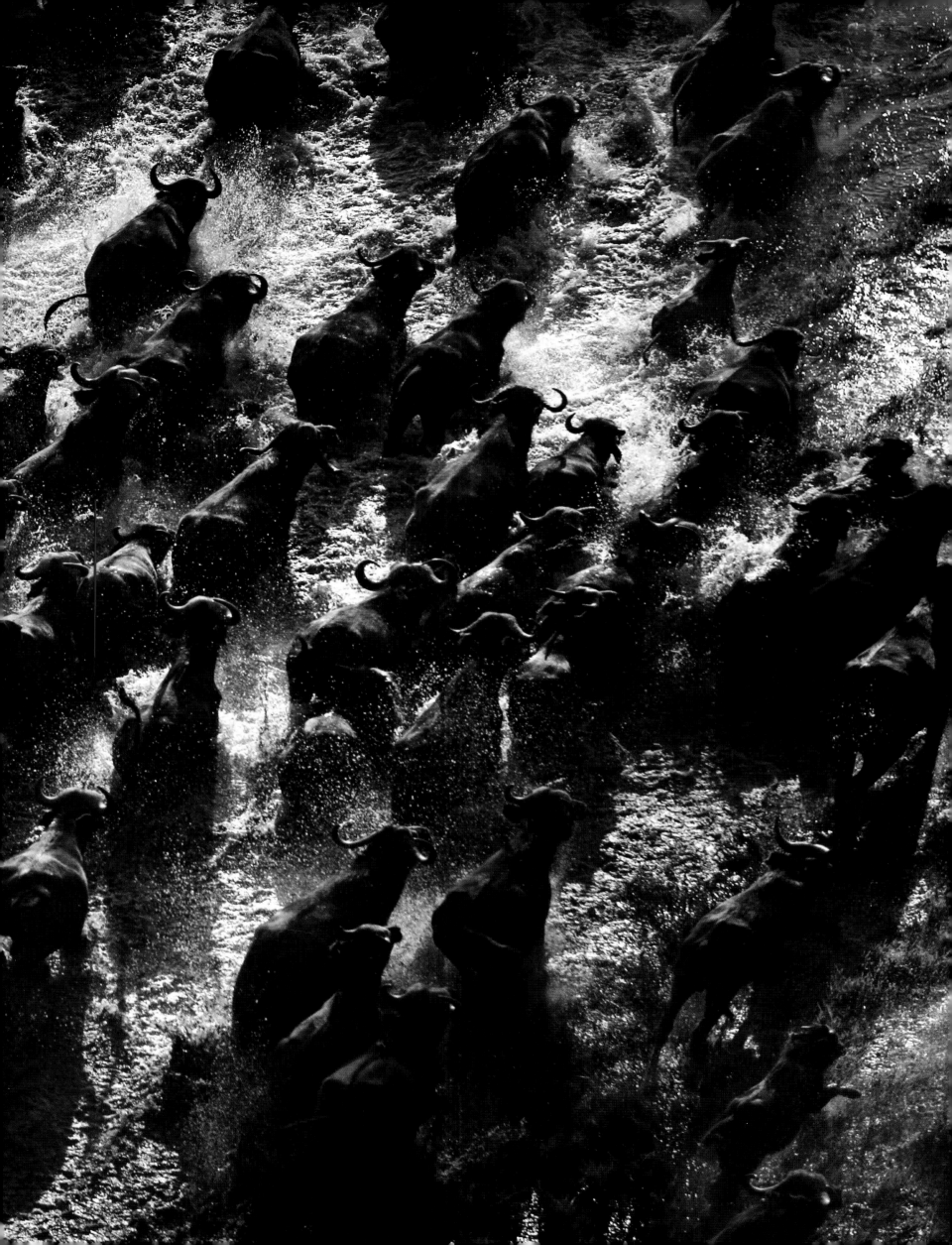

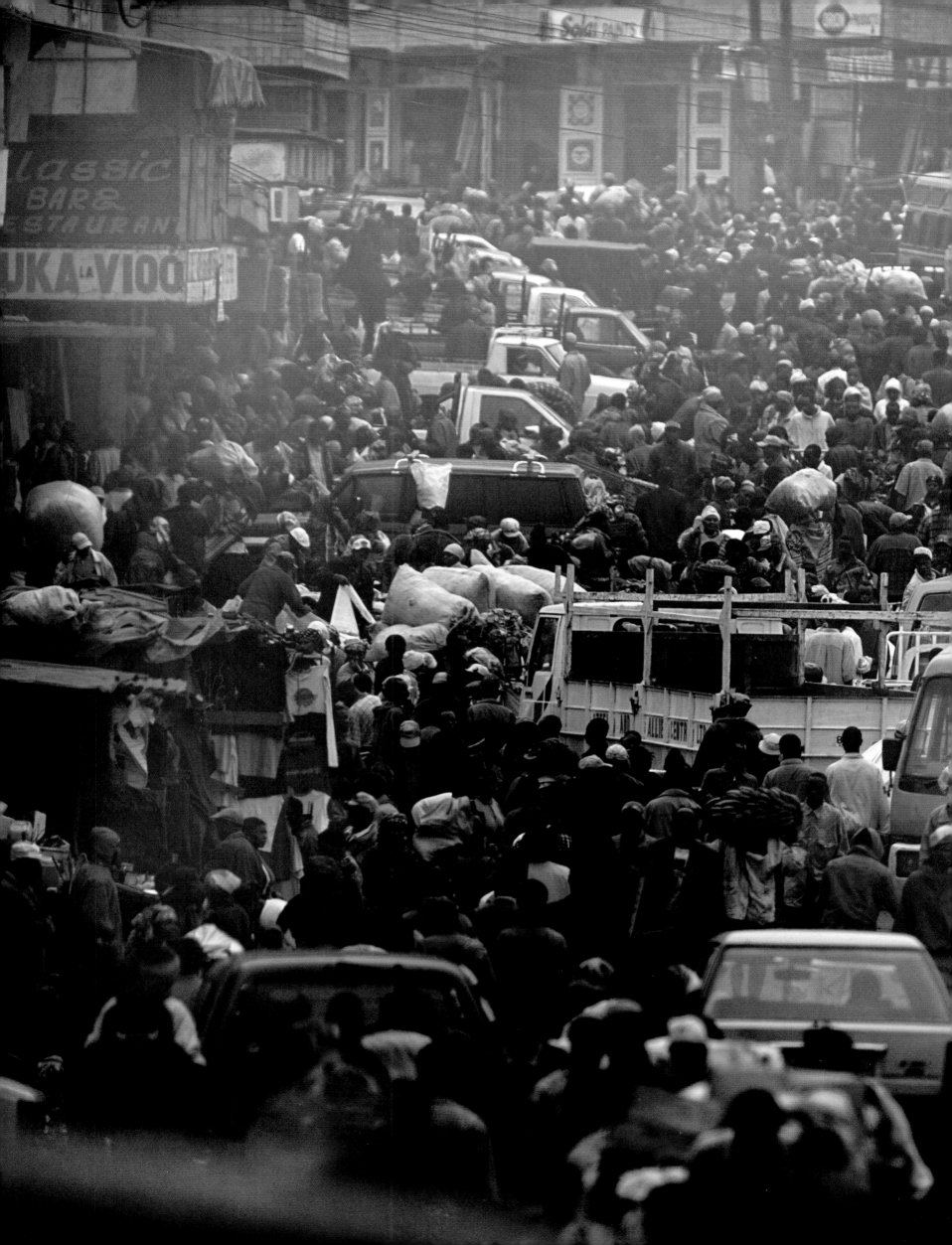

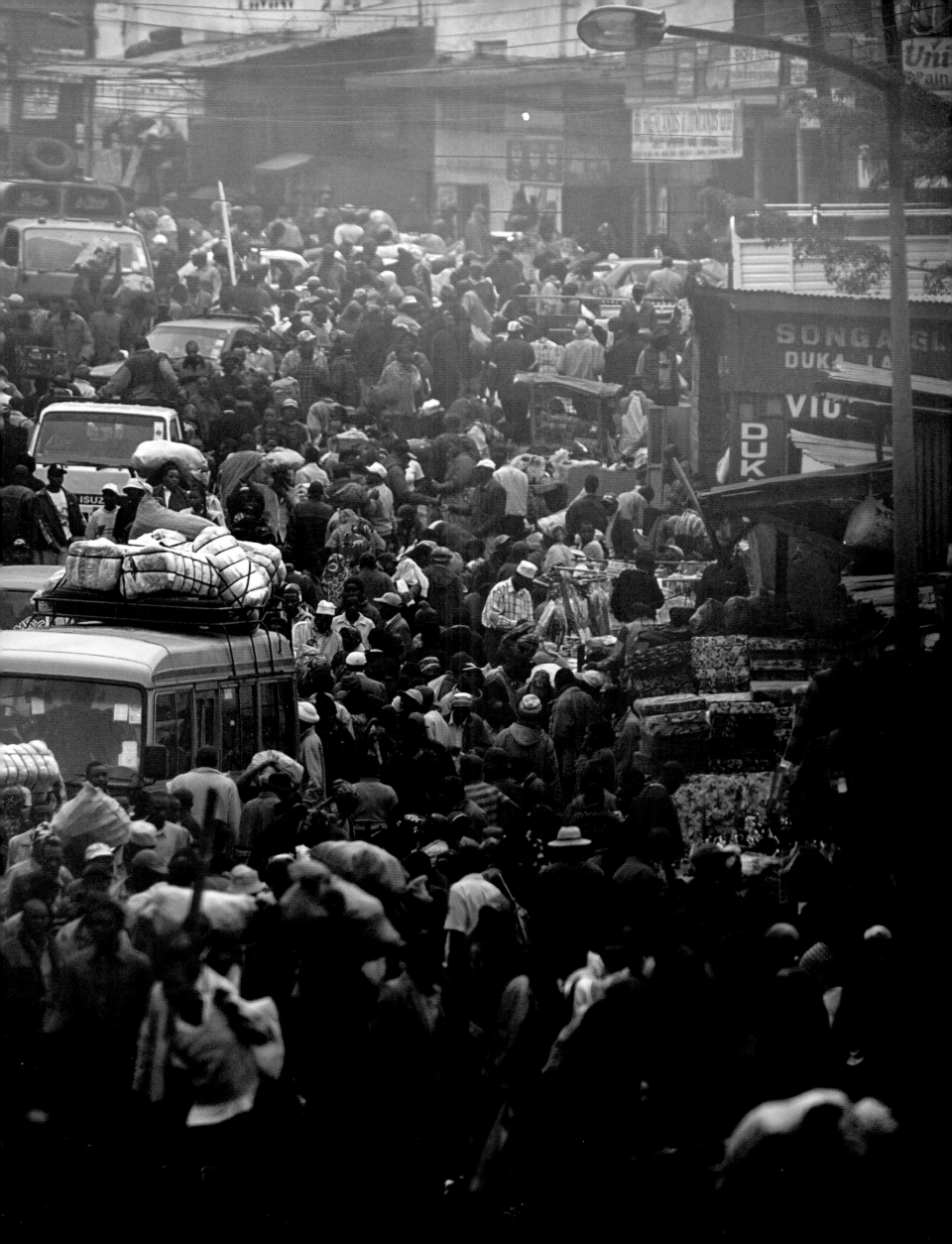

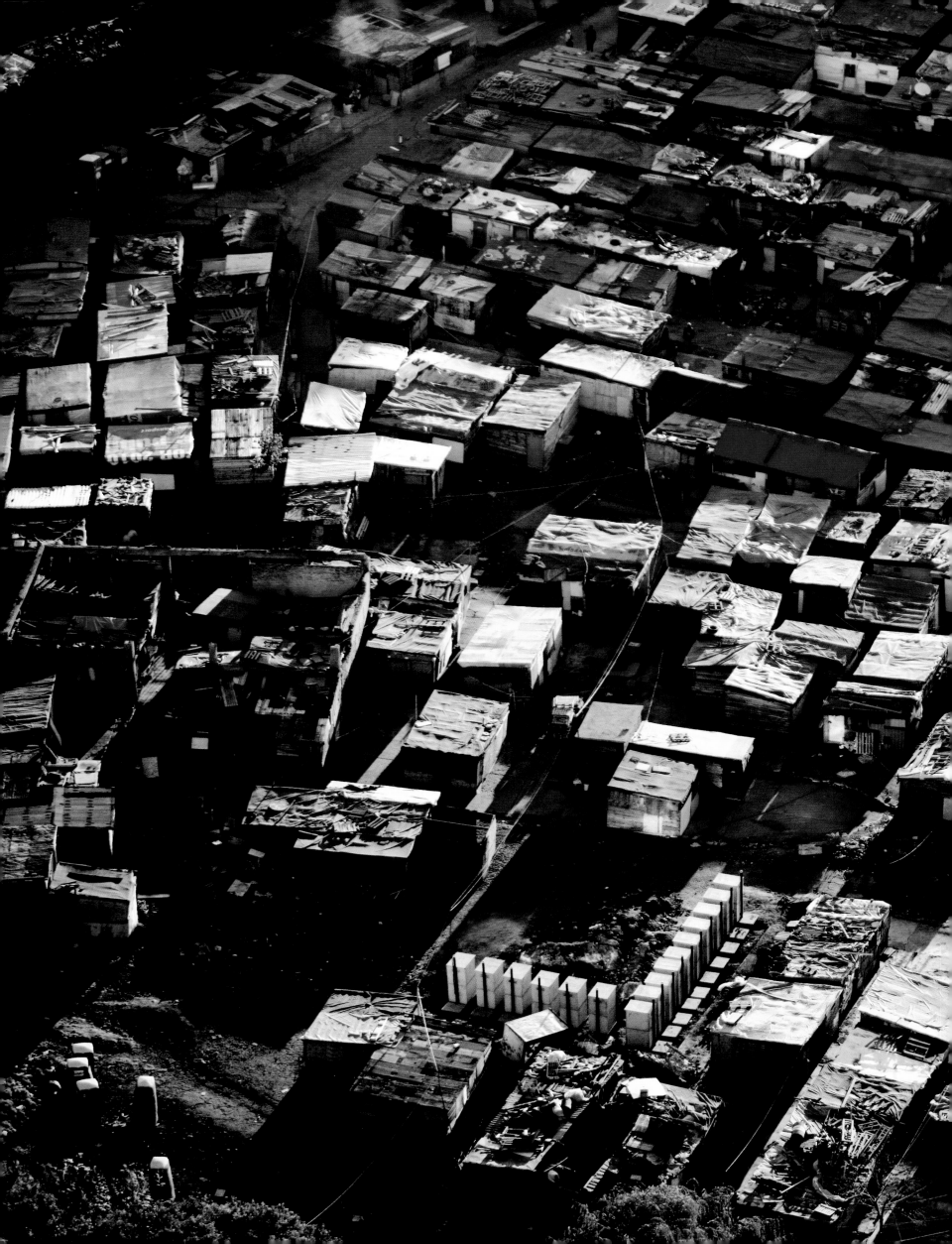

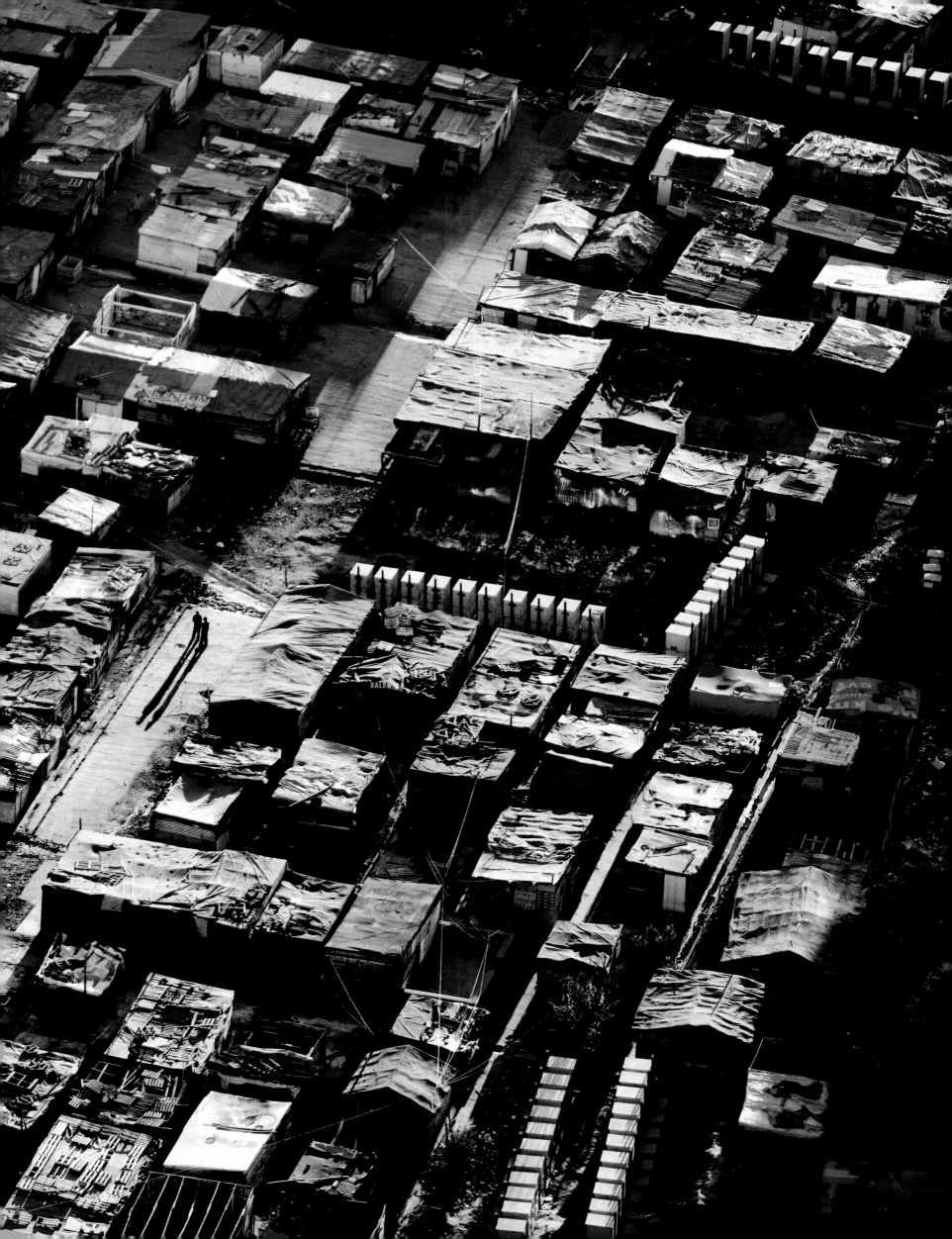

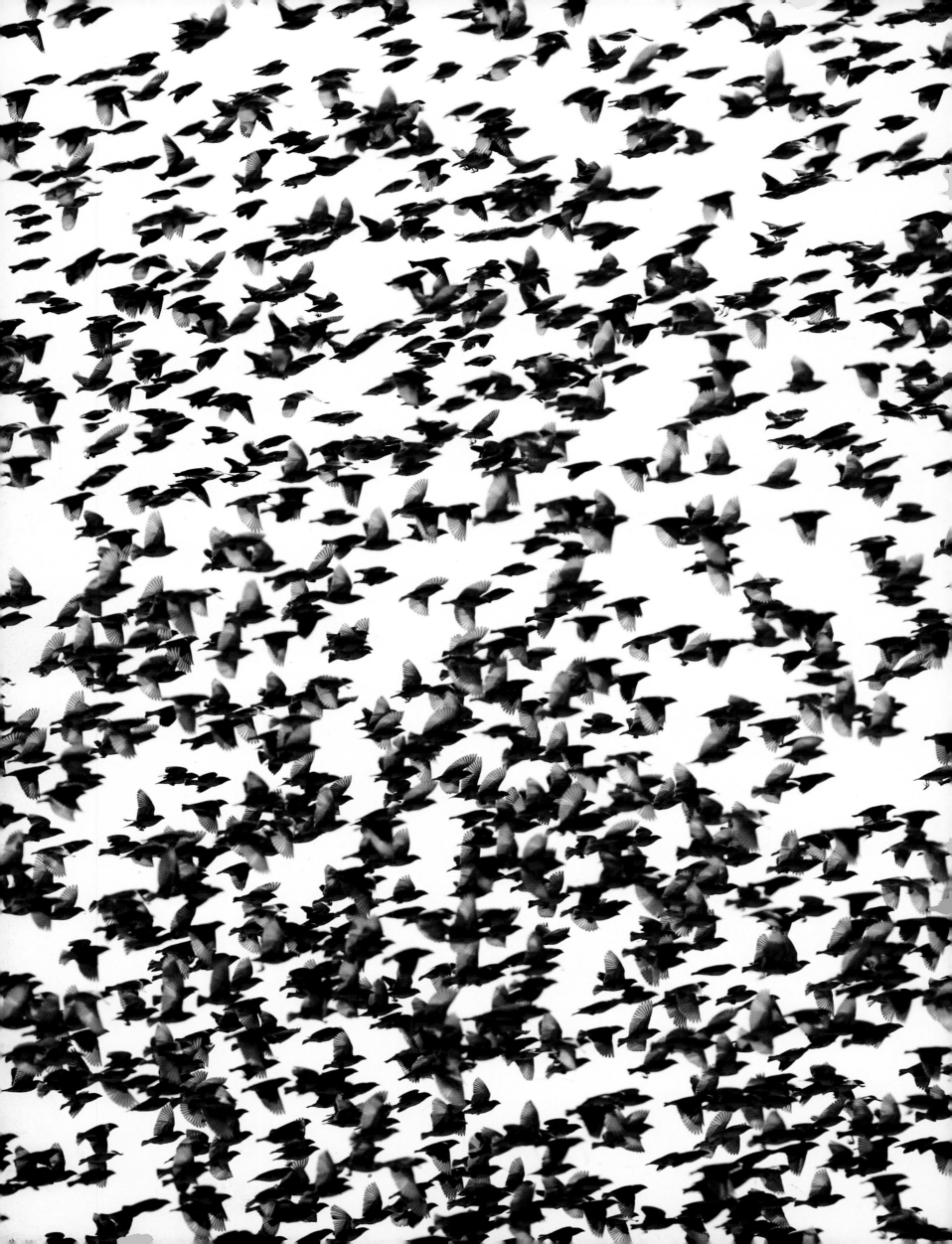

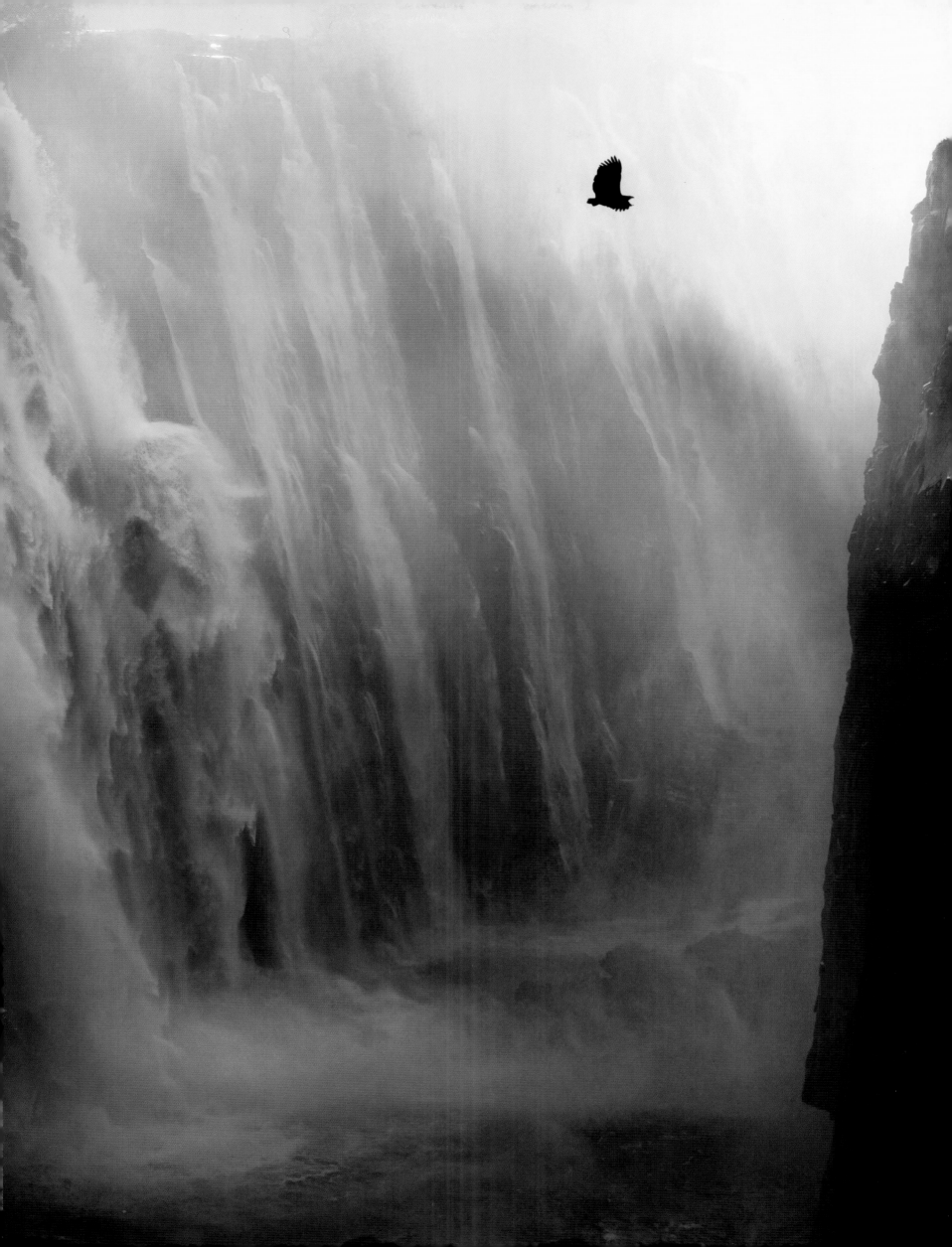

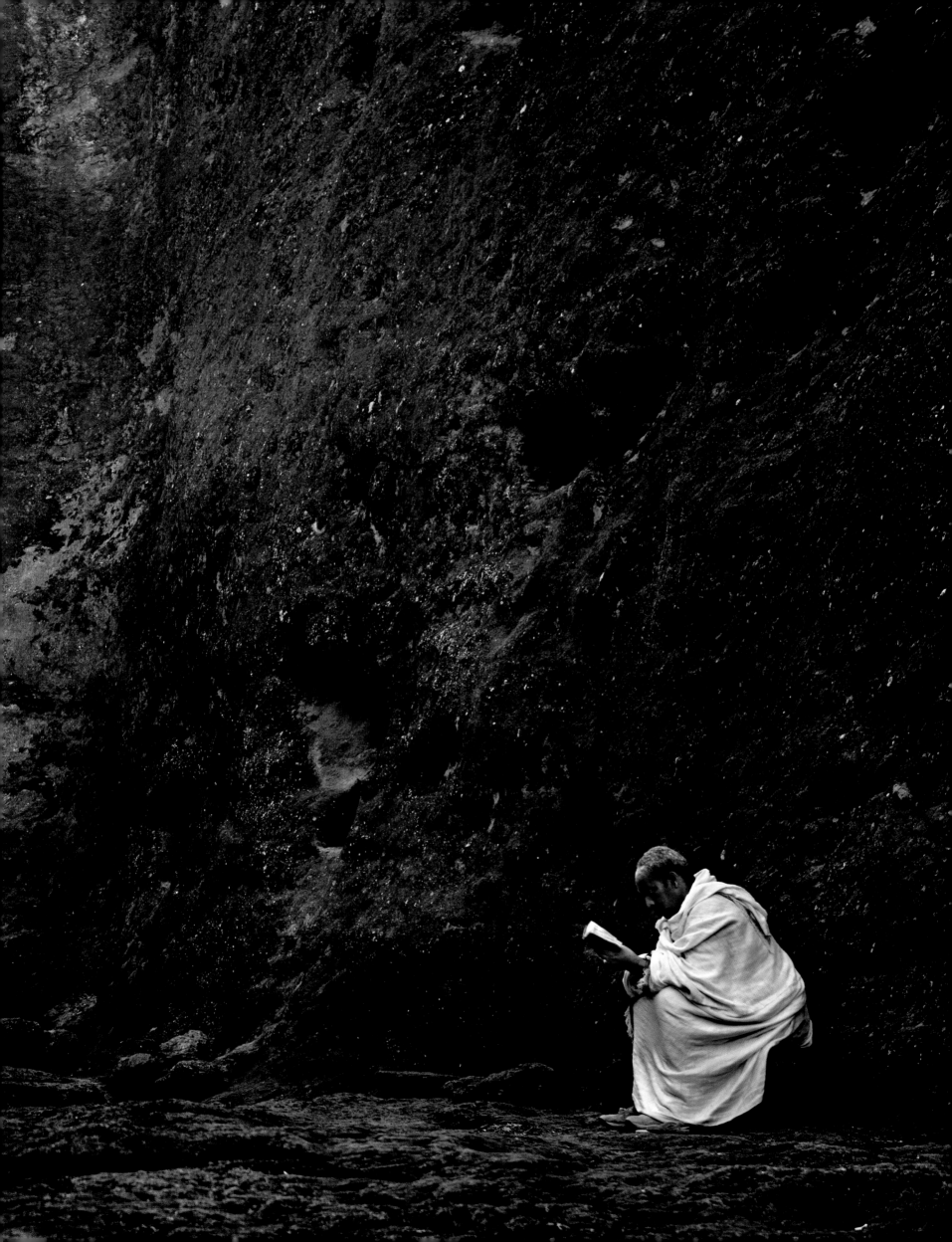

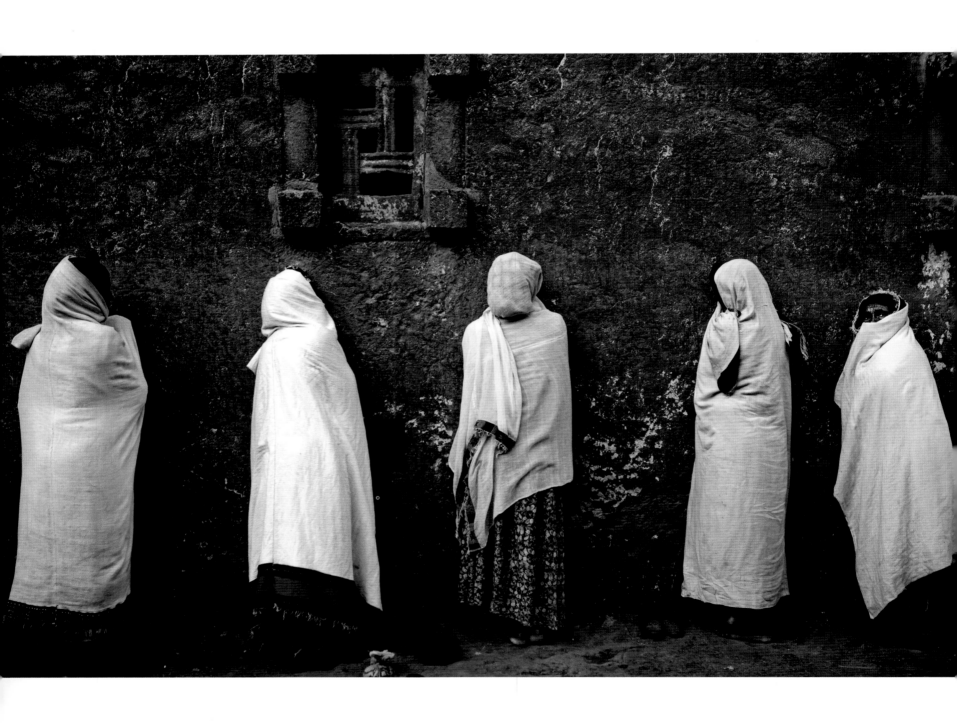

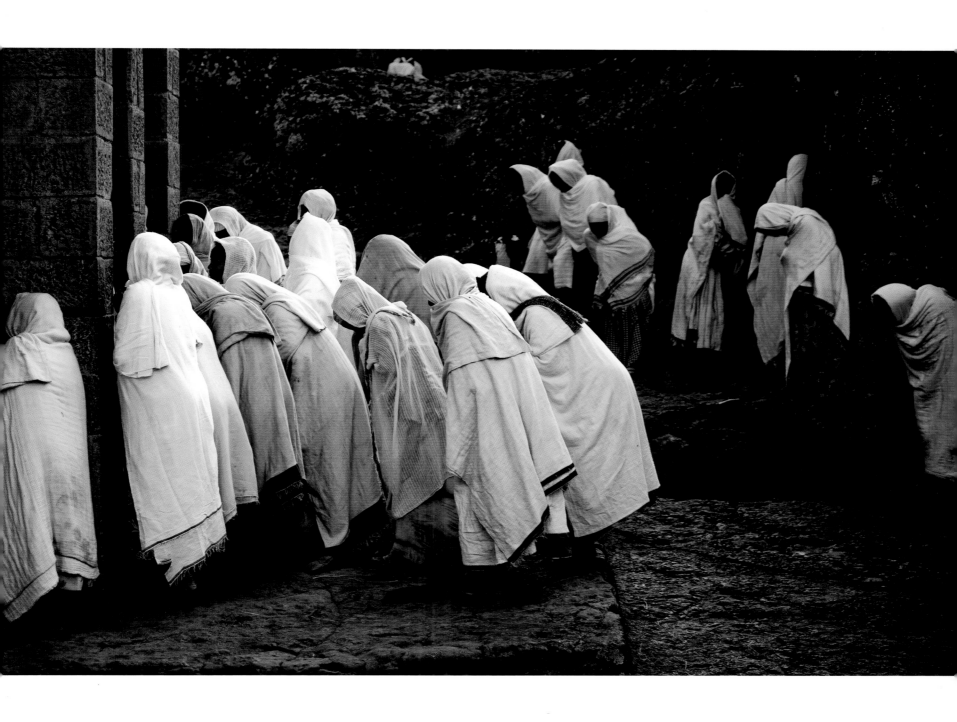

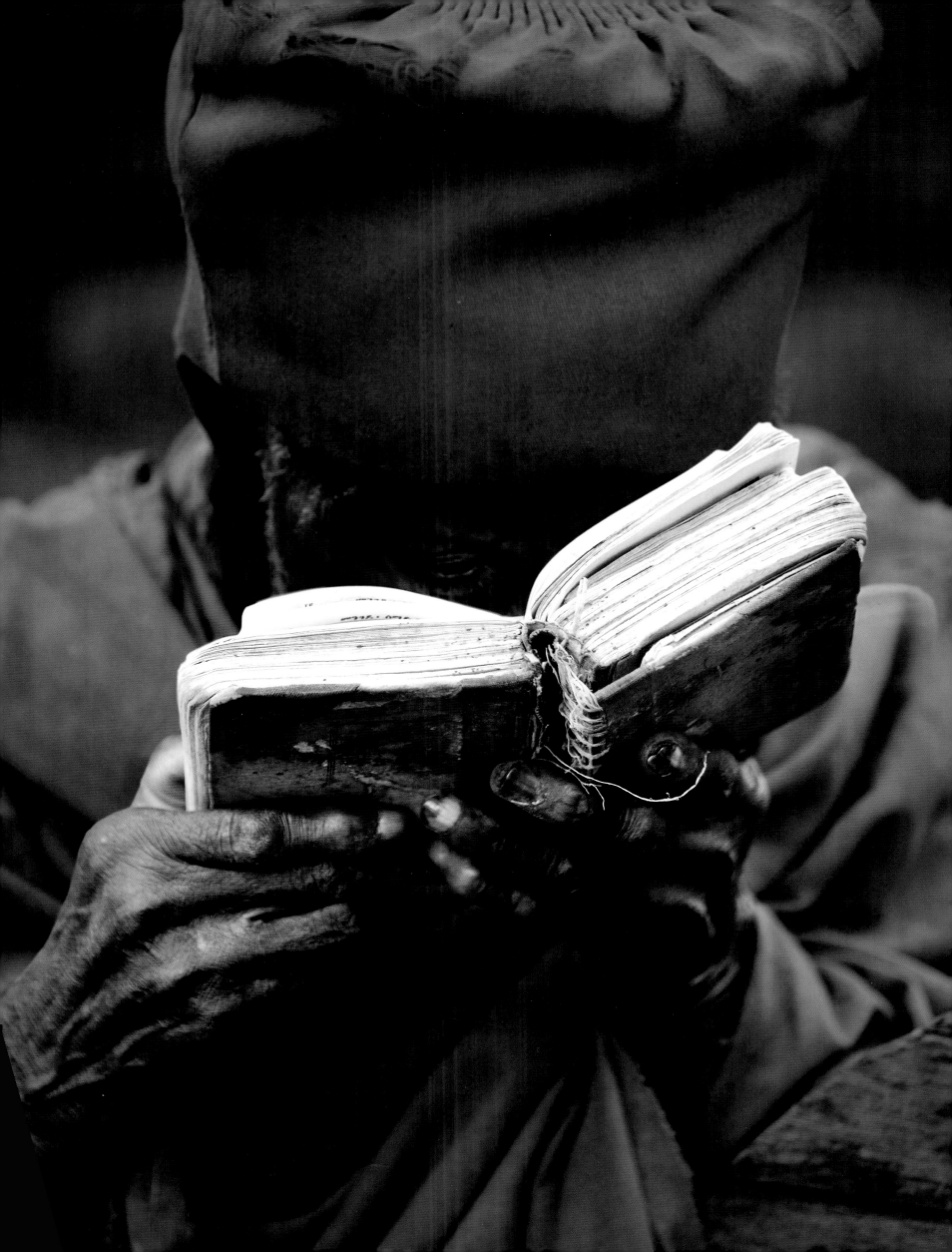

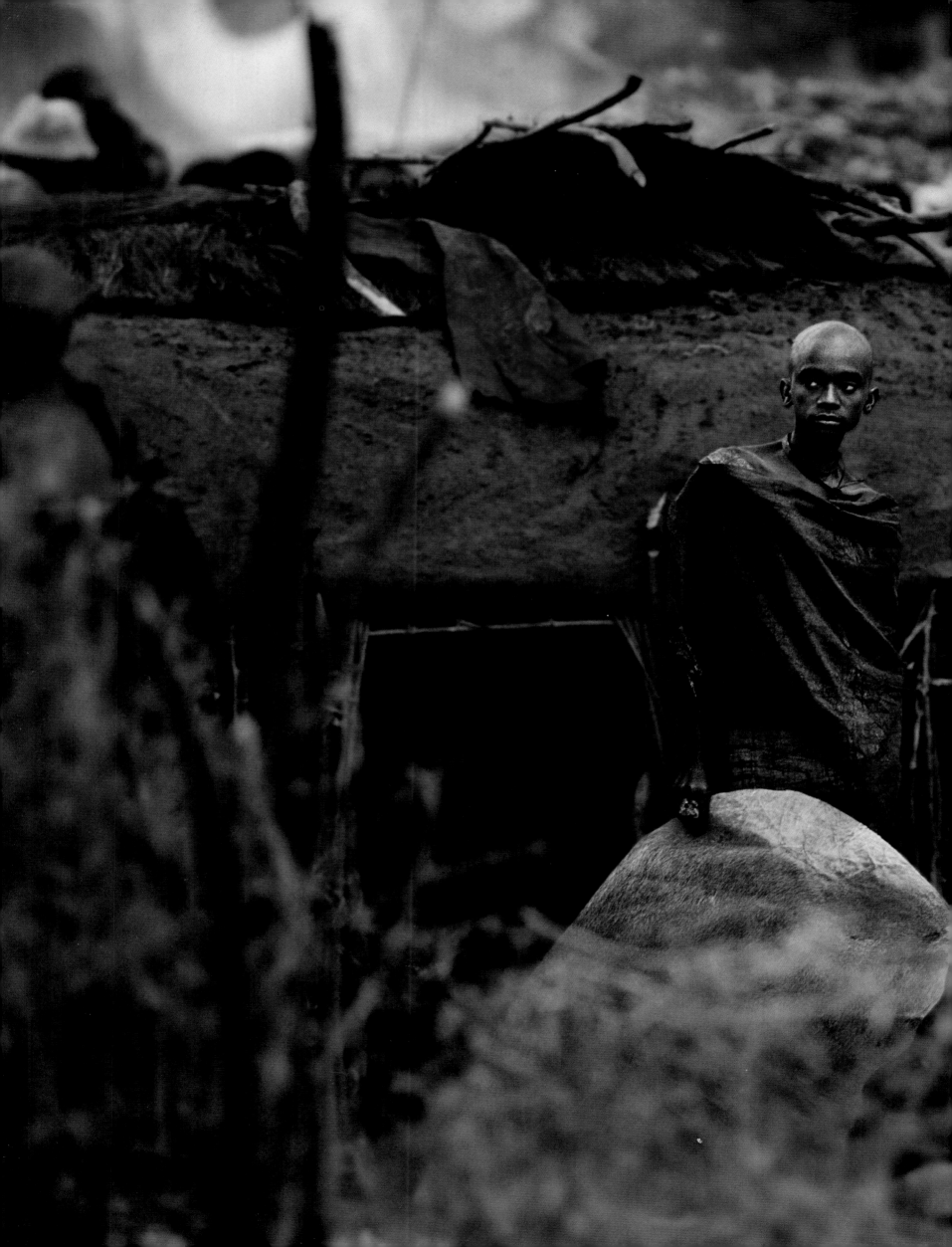

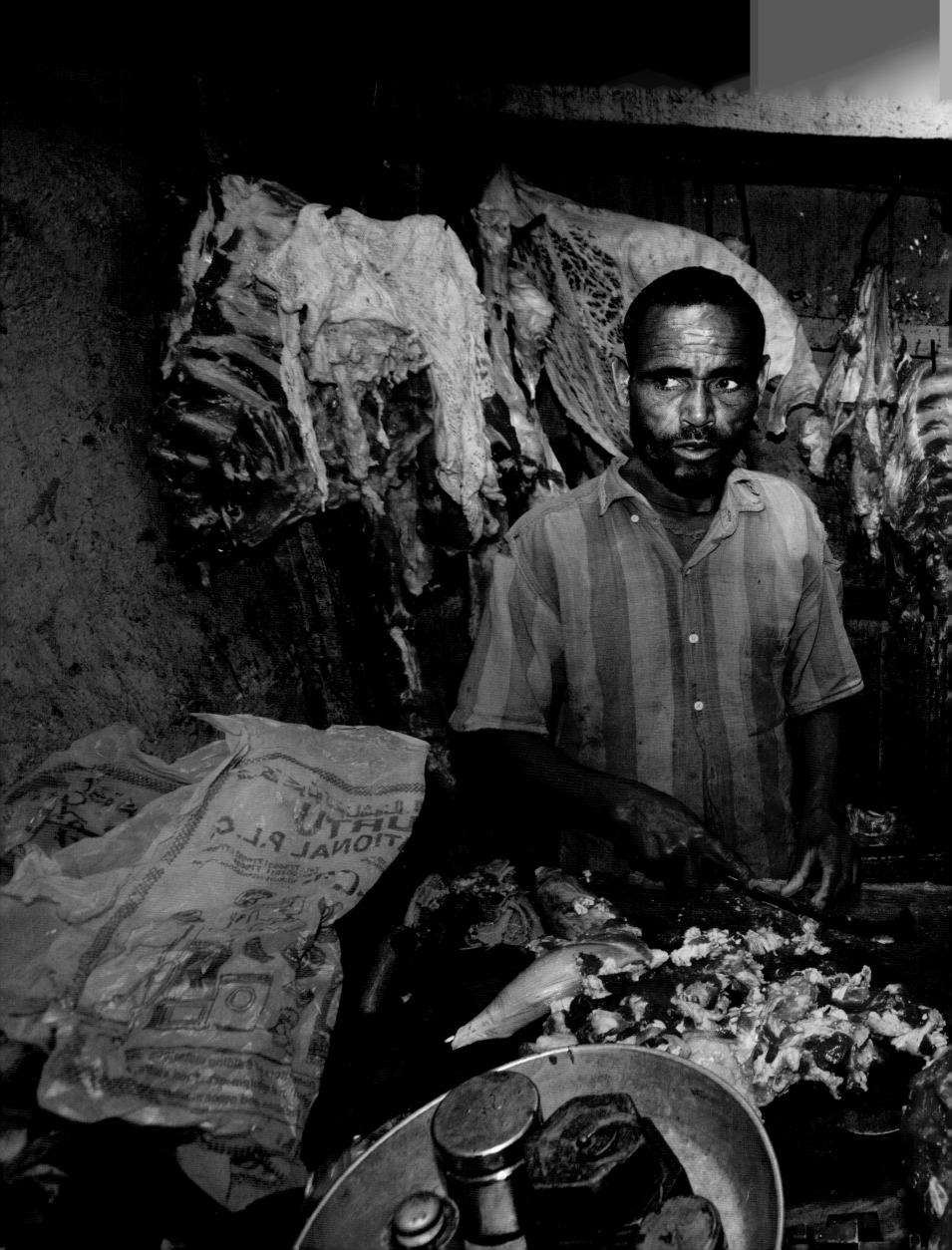

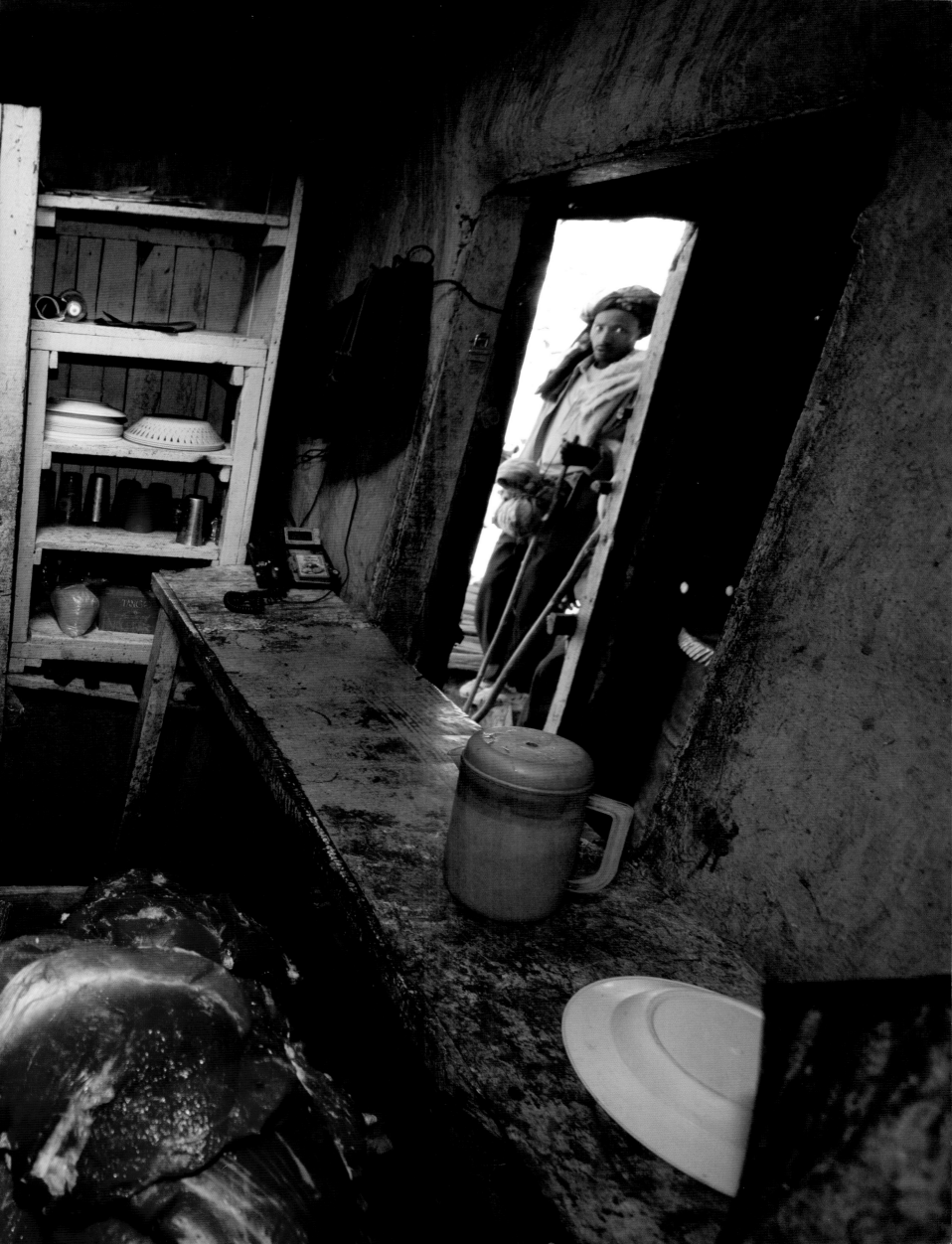

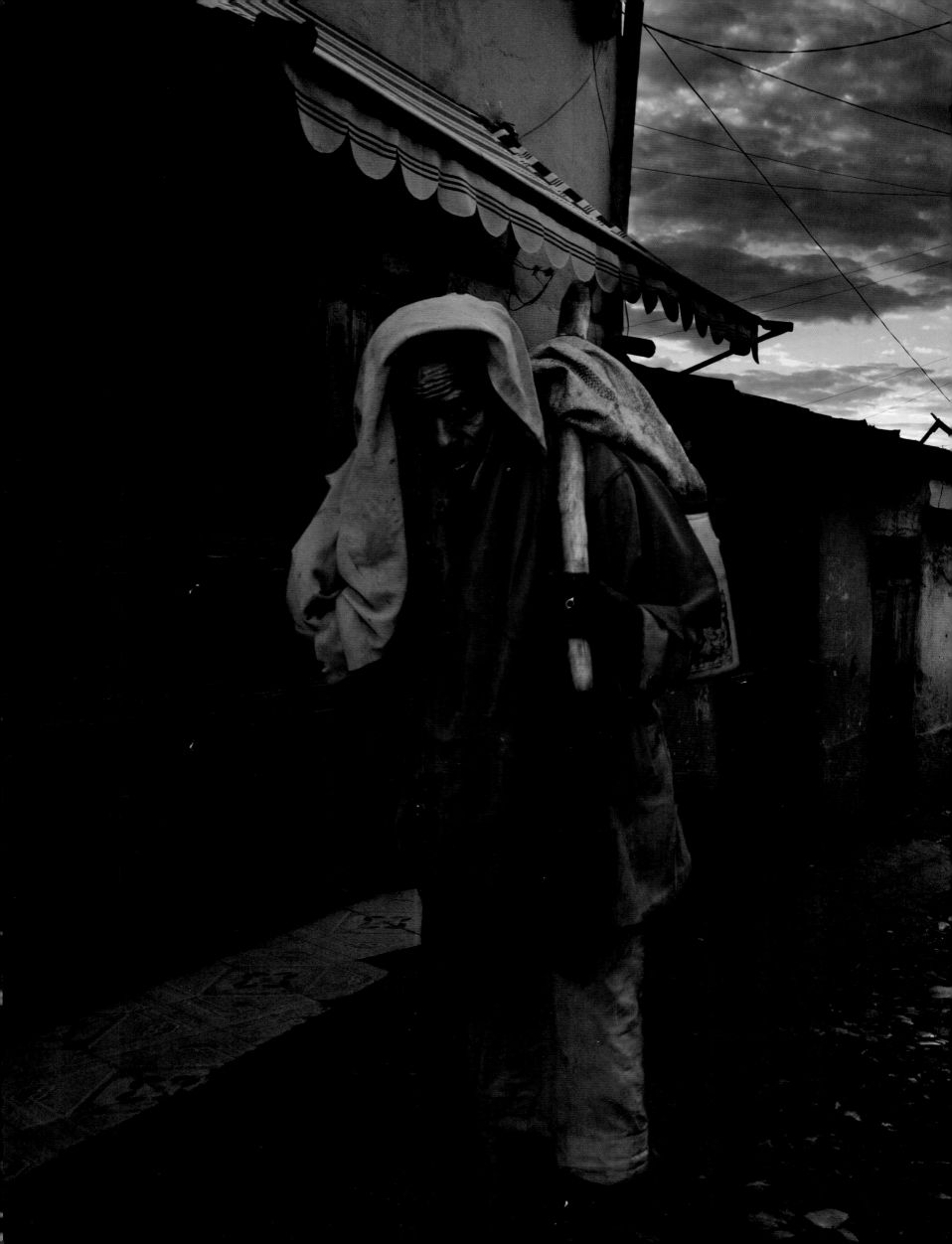

THE NEW DAY

The morning is long overdue. I lie awake in the dark, restlessly anticipating the dawn while listening to the cacophony of a long night in the African bush. The cloth wall that surrounds me offers no refuge from the mix of animal sounds filling the air. The drone is almost soothing in its monotony.

The primeval howl comes without warning – a pulverizing explosion of sound. I sit bolt upright, terrified. A hippopotamus behind the flapping canvas of my tent is embroiled in a fight with a belligerent rival intent on annihilating him. The deafening bellow resonates through my bed like a reverberating foghorn, plunging me into a turmoil of fear. I peer through the gauze window and into the moonlight, where two huge blurred shapes tear at each other in mortal combat. I am convinced they will roll onto my tent, locked in a hostile embrace, and crush me with their enormous bodies. My life's work is about to be left unfinished.

They pass like a tornado, leaving as quickly as they came; their argument settling with the dust. Slowly the drone of the night returns. An uneasy peace hangs in the air as dawn draws closer and I start to contemplate the day ahead. I unzip my tent and raise my head towards the sky. Through groggy eyes I make out tiny pinpricks of stars and I know there's a good chance of warm light for photography in the morning.

I indulge in a ritual cup of lukewarm coffee and three biscuits before loading our Land Rover with cameras and film. I see Tomanka, my driver and guide, bringing food and drink for the day. We exchange greetings before he breaks the peace with the clatter of the starter motor. It's five in the morning in the Masai Mara, a time of contemplation. Nobody feels like talking.

As we make our way through the darkness, loose stones rattle against the sides of the vehicle and I open the window to let the morning air chill my face. Such coolness is to be treasured. It is a transient gift that will quickly vanish when the day comes. I look out, dreamily, as dark and fleeting shapes whiz by, and wonder what I am doing here, at this hour, and how I can possibly capture the drama of Africa with my heavy machinery. Unnerved by the

LEFT AND OPPOSITE
Hippopotamus, Okavango Delta,
Botswana.

72

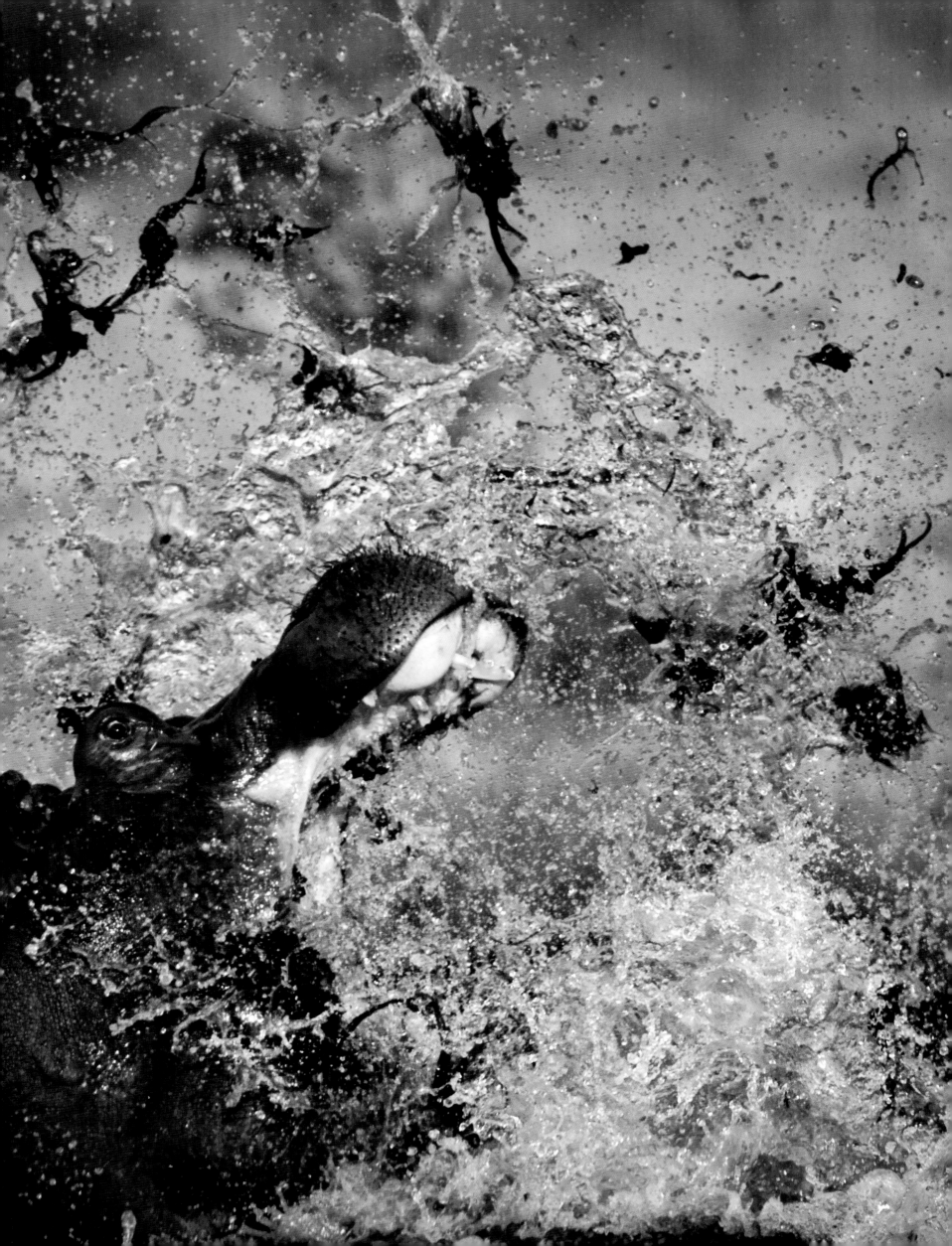

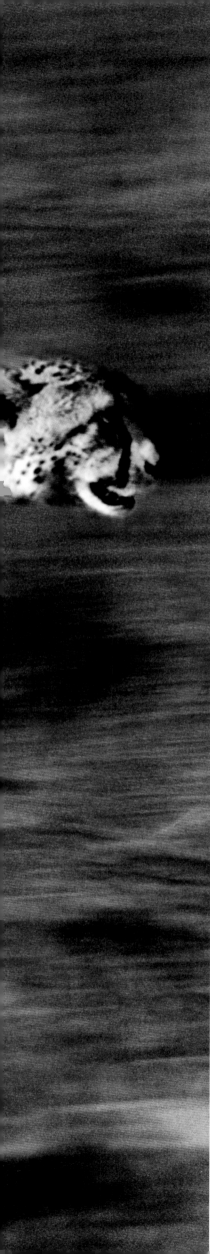

photographic challenge ahead, I hope for something miraculous to appear in spectacular light, something which will give me the adrenalin surge I so desperately seek. But my anxieties soon evaporate in the morning air and I feel immensely privileged to be here.

Our headlights illuminate an ocean of glowing eyes – thirty thousand wildebeest, all running towards the distant Mara River. They pound the earth, stirring up a veil of fine dust which then hangs like a low mist. They surge through, a continuous procession of shadowy bodies rumbling on in semi-darkness. We approach cautiously. The mass forms a wave which parts to let us through; another wave seals the path behind us. We become a tiny island amidst a stampeding storm, on ground trembling beneath thousands of hooves. Eyes glint in the dimness like children's sparklers, and all around we hear persistent grunts, 'gnu, gnu'.

The black sky turns deep blue and the stars are fading. A thin red line on the horizon becomes an orange band and, as the last grey star dissolves, we see the distant silhouette of a single male lion walking towards the marsh.

We follow him down the hill. His belly hangs full and heavy, swaying from side to side as he saunters along with a superior air. He stops and turns his head to the rising sun. Slowly he exhales a white misty cloud of pungent lion breath. The flies around his head glow.

The day bursts open. This is prime time for photographers, a race against the clock in the warm, fleeting light of the morning. Here, near the equator, the rising sun never lingers; the red jewel on the horizon quickly becomes a white ball of searing heat.

Hyenas roam in packs, searching for scraps that the night has left behind. We stop by a group scavenging a dead wildebeest. One hyena suddenly appears in front of us with a baby wildebeest in his mouth as another tries to snatch it away. The body snaps like a twig with a loud cracking sound.

We find more wildebeest moving across the plains. A pregnant female runs across the sparse grassland. She is about to give birth, yet seems filled with boundless energy. We keep a discreet distance as she aimlessly runs in a large circle. Where is she going?

LEFT
Running cheetah, Masai Mara, Kenya.

OPPOSITE
Wildebeest mother and newborn calf, Masai Mara, Kenya.

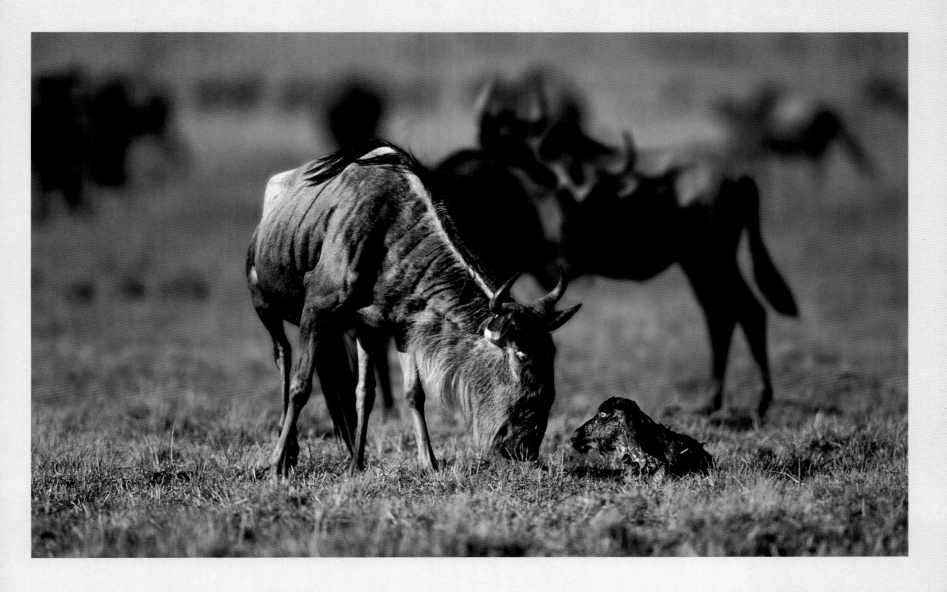

Her nervousness grows as she approaches her most vulnerable moment. A group of females encircle her, all running in unison, their hooves churning up dust. Eventually she lies down and the other females form a protective ring. For a moment the dust settles and an infant emerges, bewildered and dazed. His mother rises, turns and gently lowers her head to meet her newborn baby. They make eye contact and, in an instant, they bond. Within seconds he is on his feet; spindly legs shakily negotiating gravity for the first time. They must keep moving. The infant suckles for a moment before his mother slowly walks away. He struggles to keep up as she quickens her pace and then he breaks into a desperate run.

He falls a couple of times, but quickly gets up and then bursts into a sprint. The African plain is no place to linger.

Far to the south in Namibia the hot air shimmers as it rises above the scorched white sand, the ghost of a great lake which dried up thousands of years ago. A herd of zebras wobble in a mirage on the horizon, individual shapes gradually materializing as they move closer. We wait near a waterhole.

A giraffe appears against the morning sun. She spreads her long stick-like legs, cautiously lowering her head towards the water. She drinks for a few seconds and then, recalling her vulnerability, throws her head into the air to look for predators. The sparkling

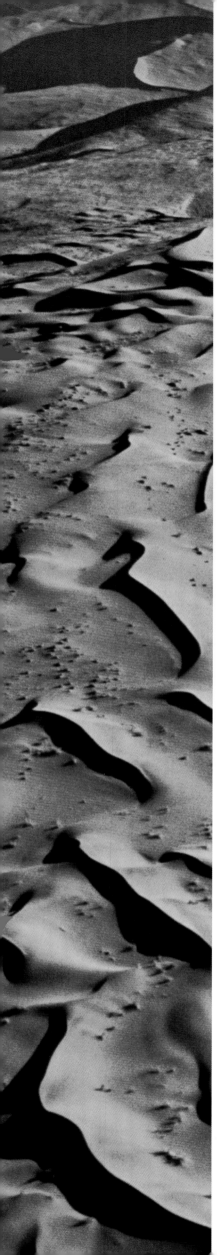

diamond-like droplets of flying water create a curved arc. Reassured, she gently lowers her head again past her knobbly knees, her long tongue lapping up the precious liquid. Then her head and neck shoot up to paint another mid-air question-mark. She repeats this movement again and again, each time with perfect precision and rhythm. There is a security in rituals.

In Botswana's Savute, the summer rains have not yet come. The parched air is fraught with the tension of thirst. Twenty bachelor elephants walk towards a small waterhole. A lone jackal frantically drinks all he can before fleeing at the last moment, his departure hastened by the dismissive flick of an approaching trunk. The guineafowl are less timid, moving between the elephants who now dominate the waterhole. These colourful birds are tightly packed, forming a large spotted carpet with bobbing blue heads protruding above the surface. The elephants' legs tower above the undulating floor covering, like giant table legs in a surreal living room.

A flock of doves moves in and descends on the busy waterhole. They flap their way down and dissipate among the guineafowl and elephants. It is very crowded and everyone is uneasy. The guineafowl move away and more doves arrive.

The elephants form a tight circle around the small pool of water. Their heads meet in conference as they push and shove each other's bodies. One tired and thirsty young bull stands isolated from the group. He cautiously approaches the mass of bodies and attempts to nudge his way in towards the water, but is unceremoniously shoved aside. In desperation he tries once again, but this time thrusts his small tusk into the backside of an old bull. In an explosion of furious trumpeting, the old bull swings around, stamping the dusty earth. The other elephants scatter in a chaotic scramble to avoid the wrath of the angry old man. The air is filled with the frantic flapping of hundreds of doves as they flutter in all directions to escape the pandemonium. The young protagonist seizes his moment amidst the chaos and darts in for a drink.

Each day begins with new energy. Now is time to run, play, eat, kill, and give birth before submitting to the lethargy of the relentless

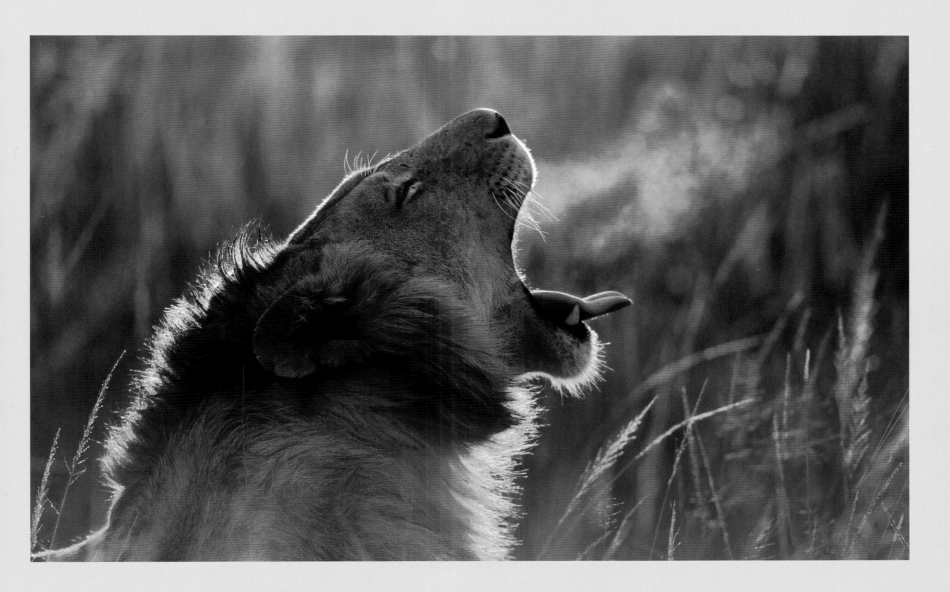

heat of the day. Soon the sun's fire will burn and all sensible creatures will seek refuge in cool burrows and the shade of trees. The African morning is a time for renewal and replenishment.

In South Africa I see ten thousand spider's webs jewelled with morning dew. The shifting beams of early light carve yellow shafts through the trees, illuminating billions of tiny water droplets. Each droplet refracts a distorted world while clinging to a silk strand – each strand forms an intricate part of a complex web. And at the centre is a supreme monarch, a golden orb, blissfully oblivious to the ephemeral nature of her world. She waits patiently for something tasty to entangle itself in her sticky trap, sitting in

the centre of her own universe where survival depends on a fellow creature's misfortune. For every winner, there is a loser.

I am reminded that we all inhabit two universes. There is one in which we are all mere building blocks in the grand scheme of things; and there is the intensely private one in which we seek to fulfil our dignity, our hopes, and our dreams; striving to reconcile our inner experience with all that is happening outside us. As I watch the spiders, I marvel at the simplicity of their lives – their blessed freedom from existential musing. I wonder if I should be making such presumptions on their behalf. I discover that the dew has evaporated and wonder if it's time for breakfast.

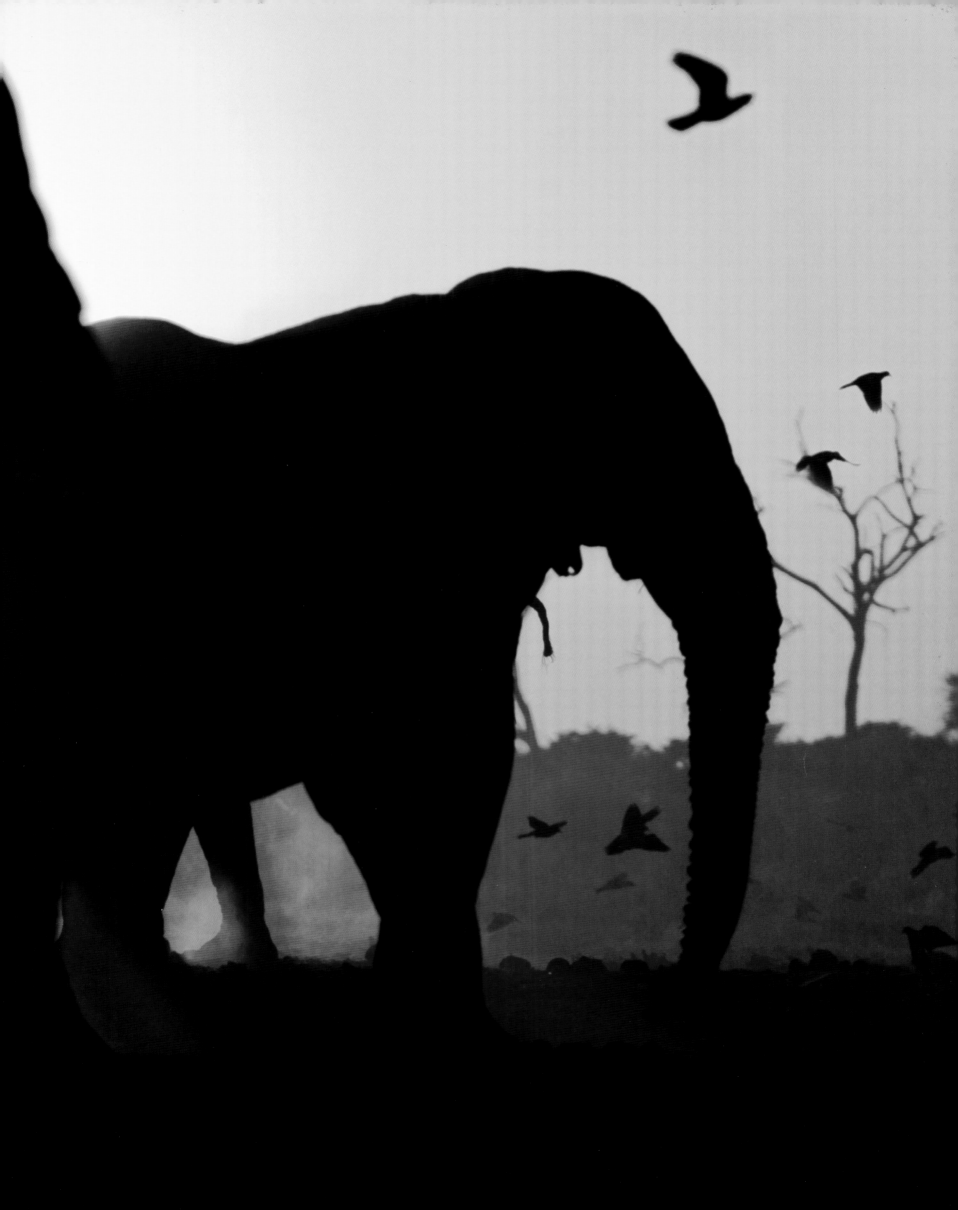

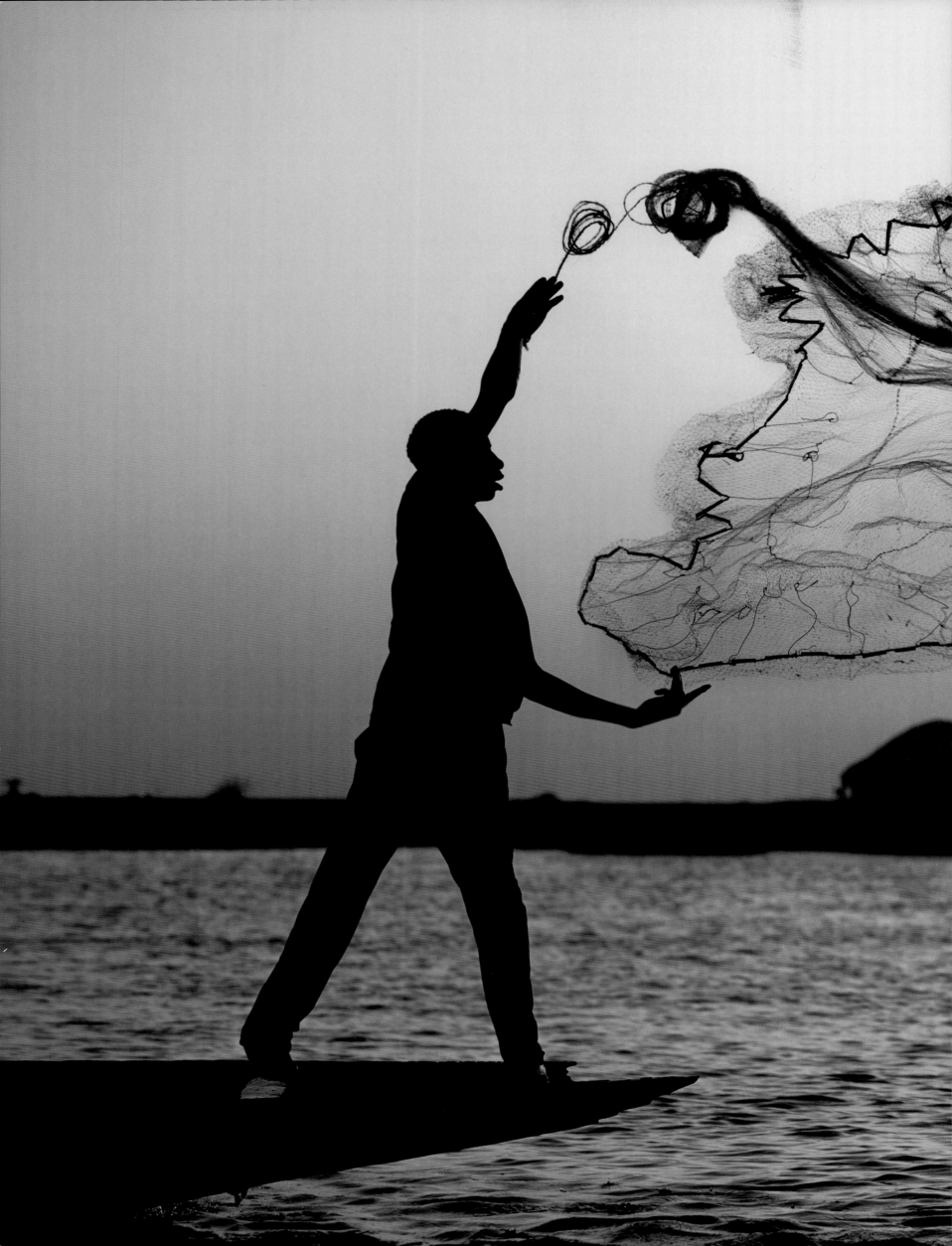

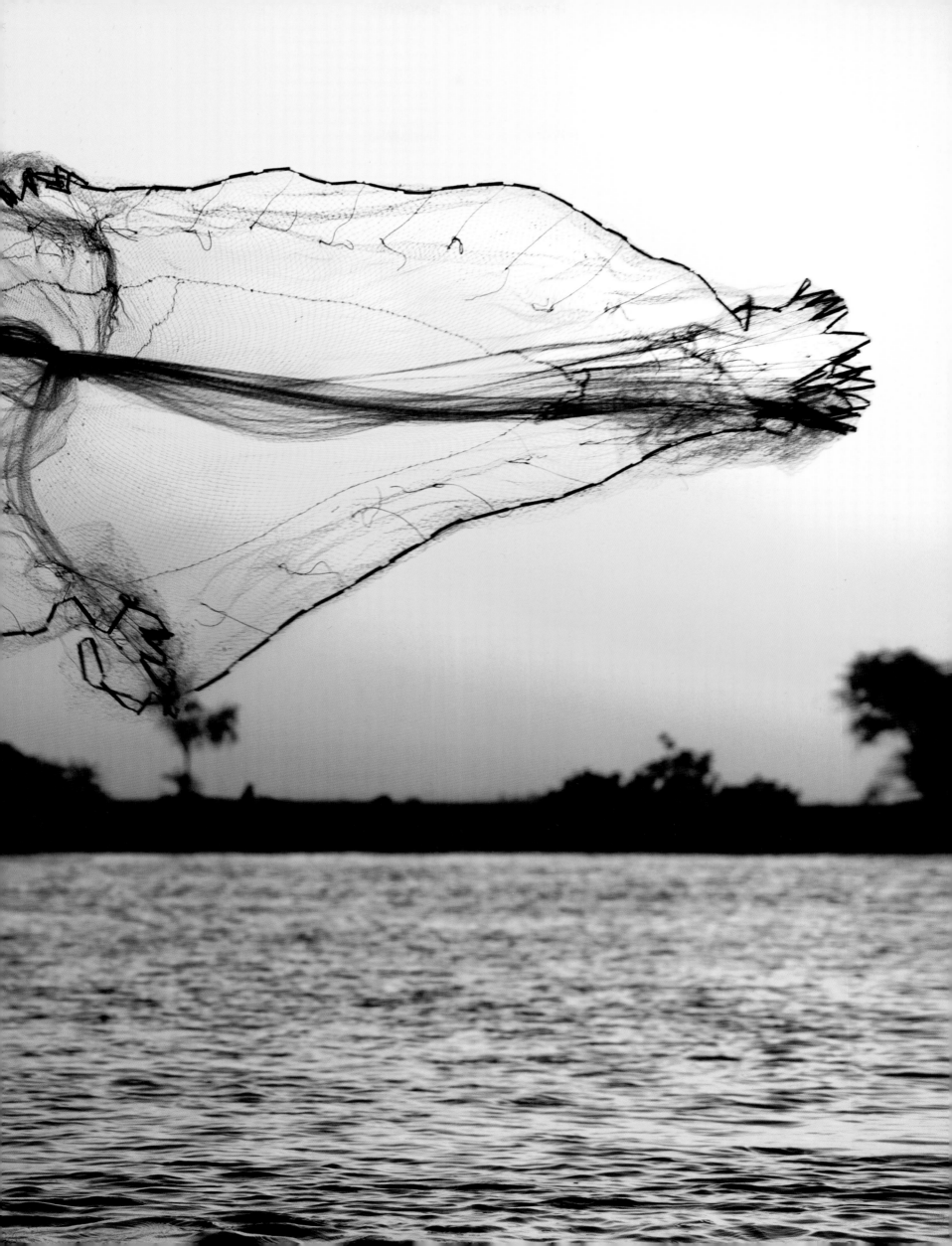

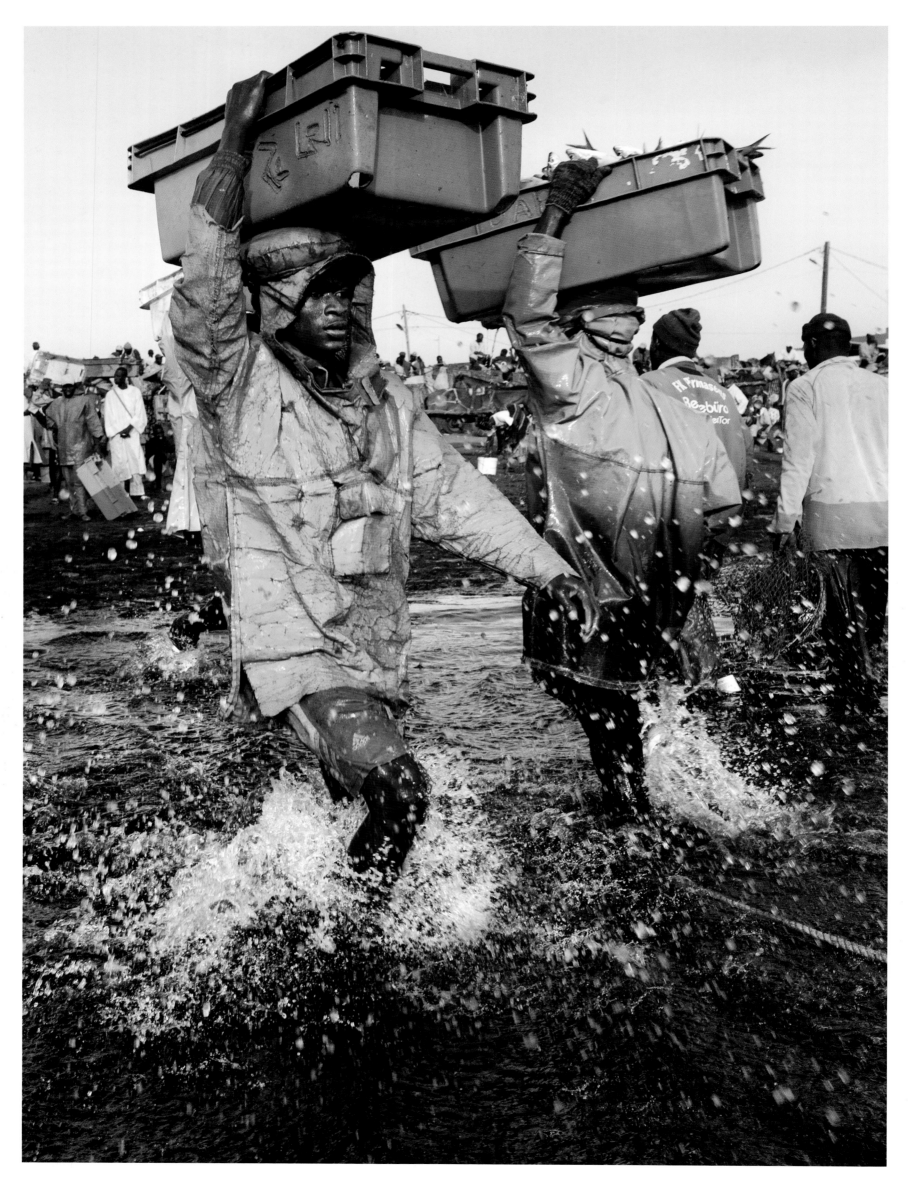

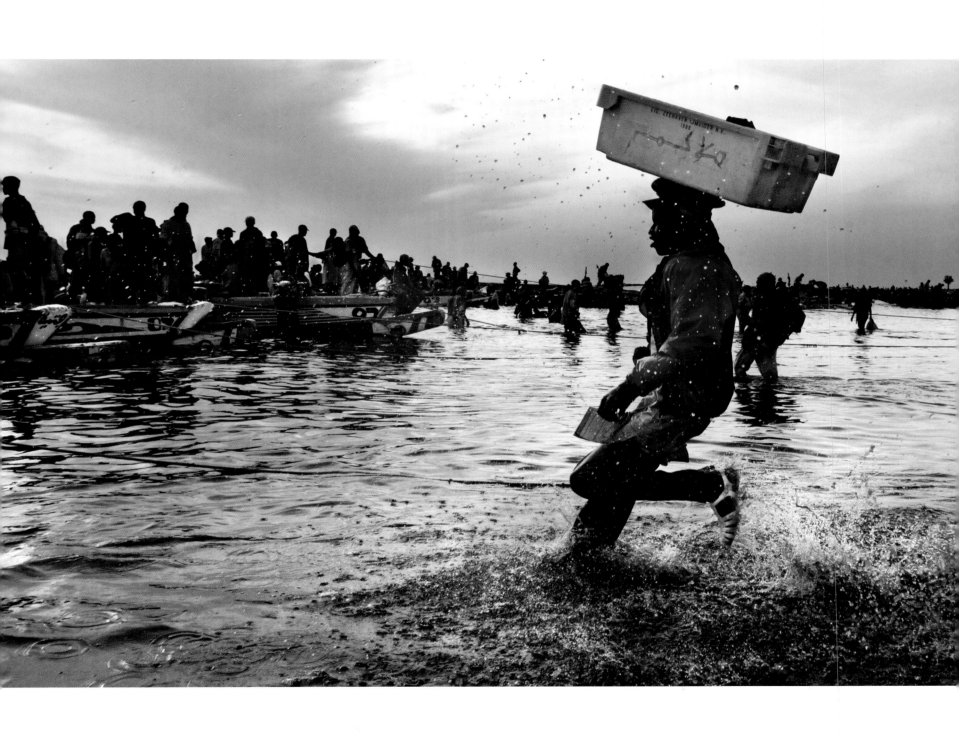

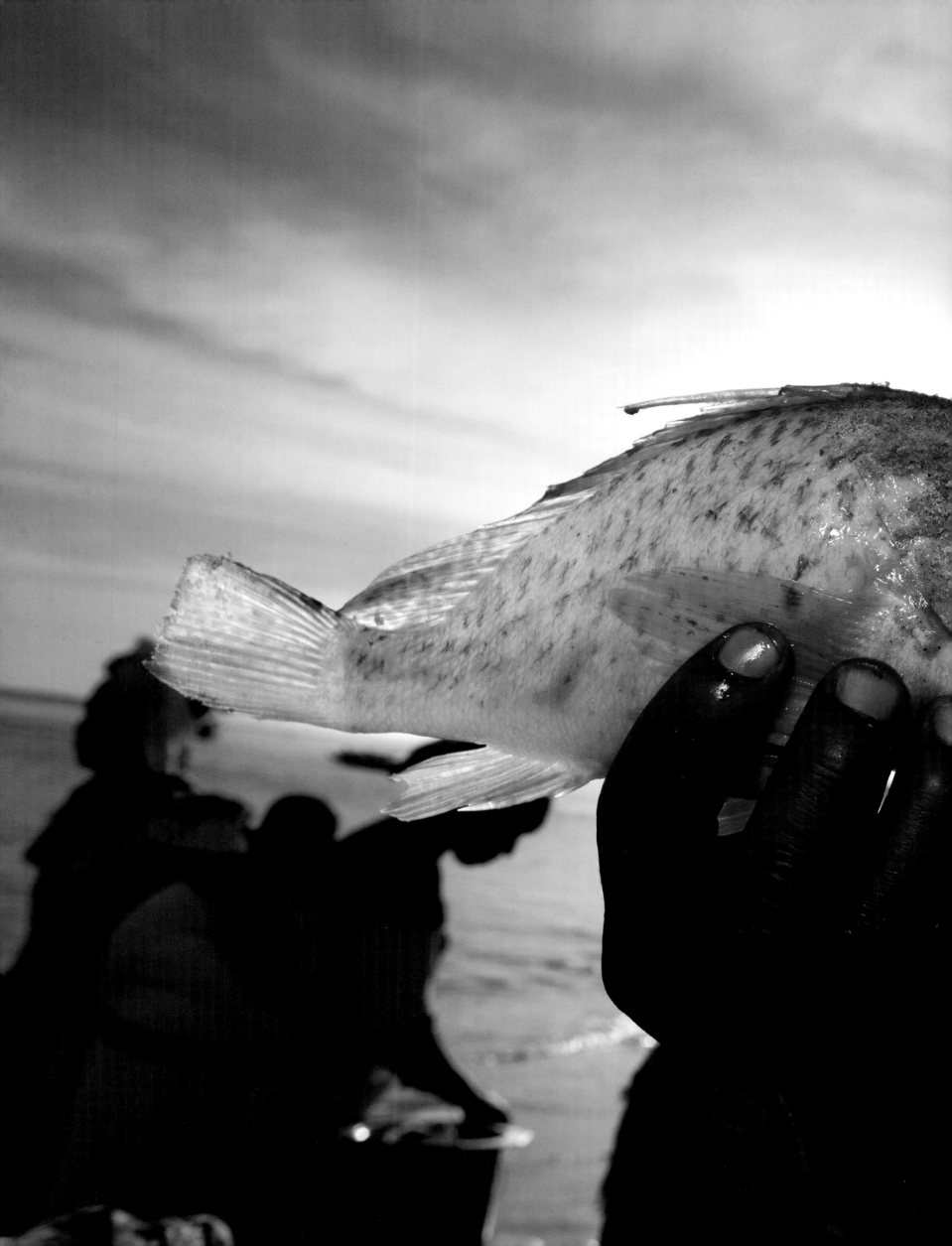

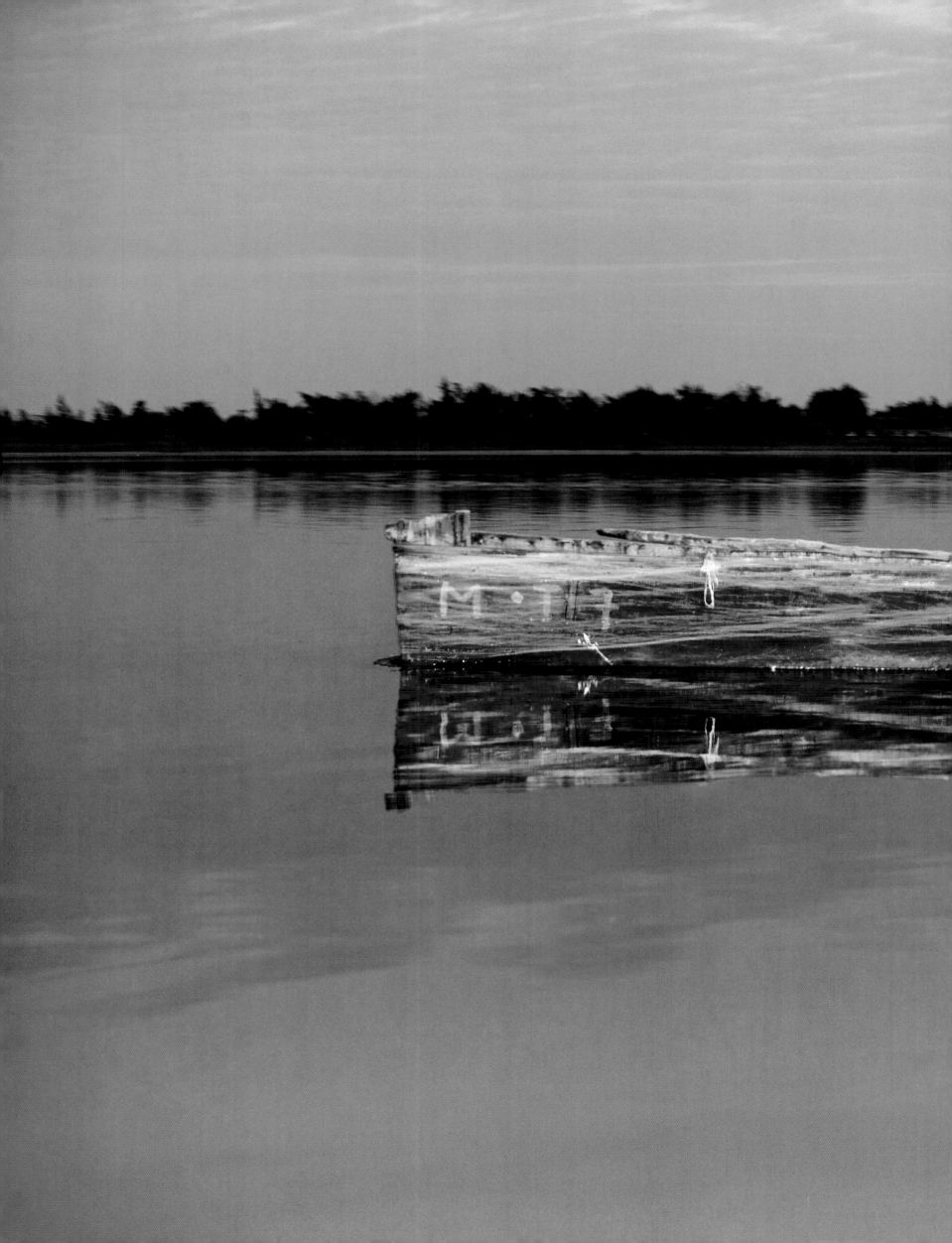

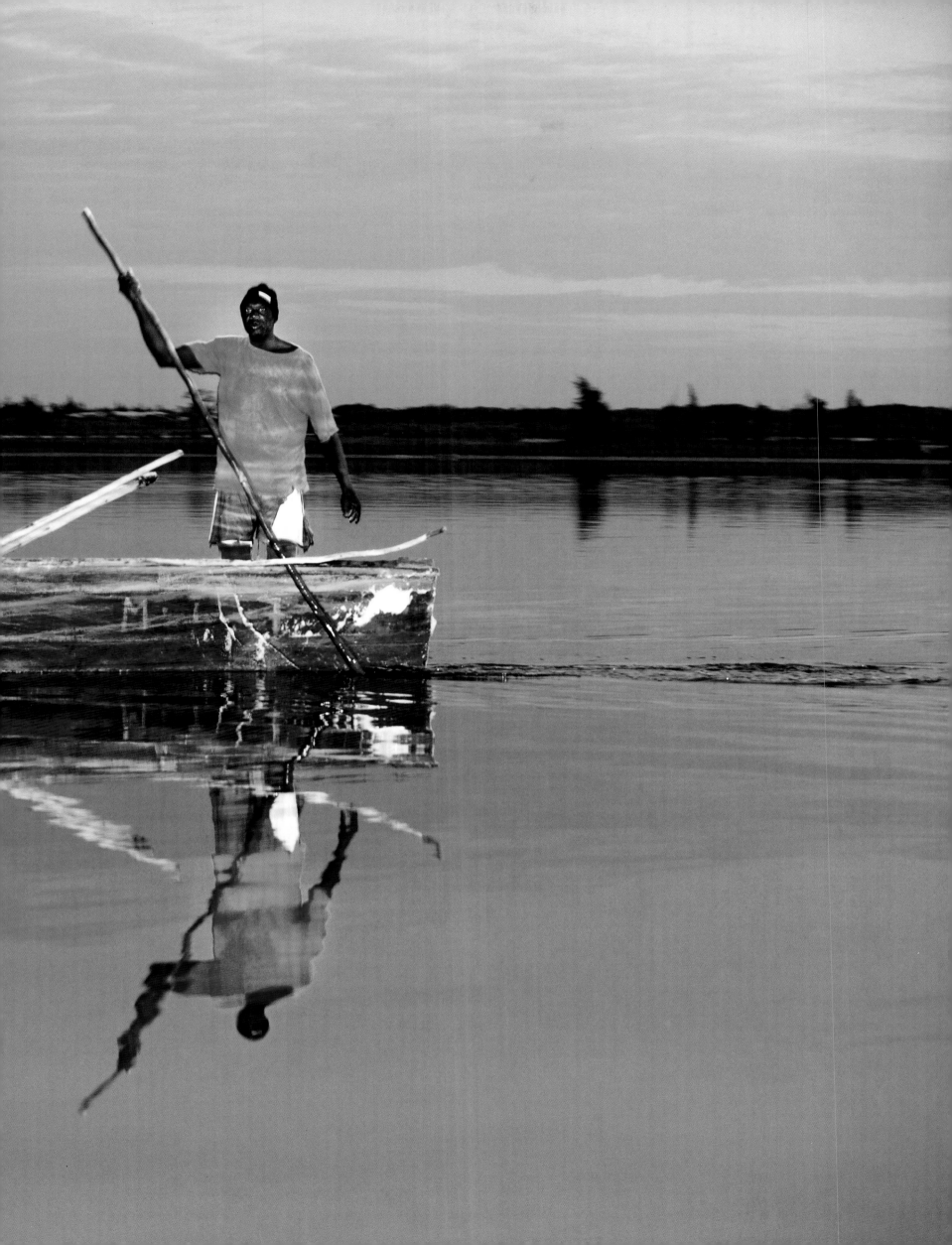

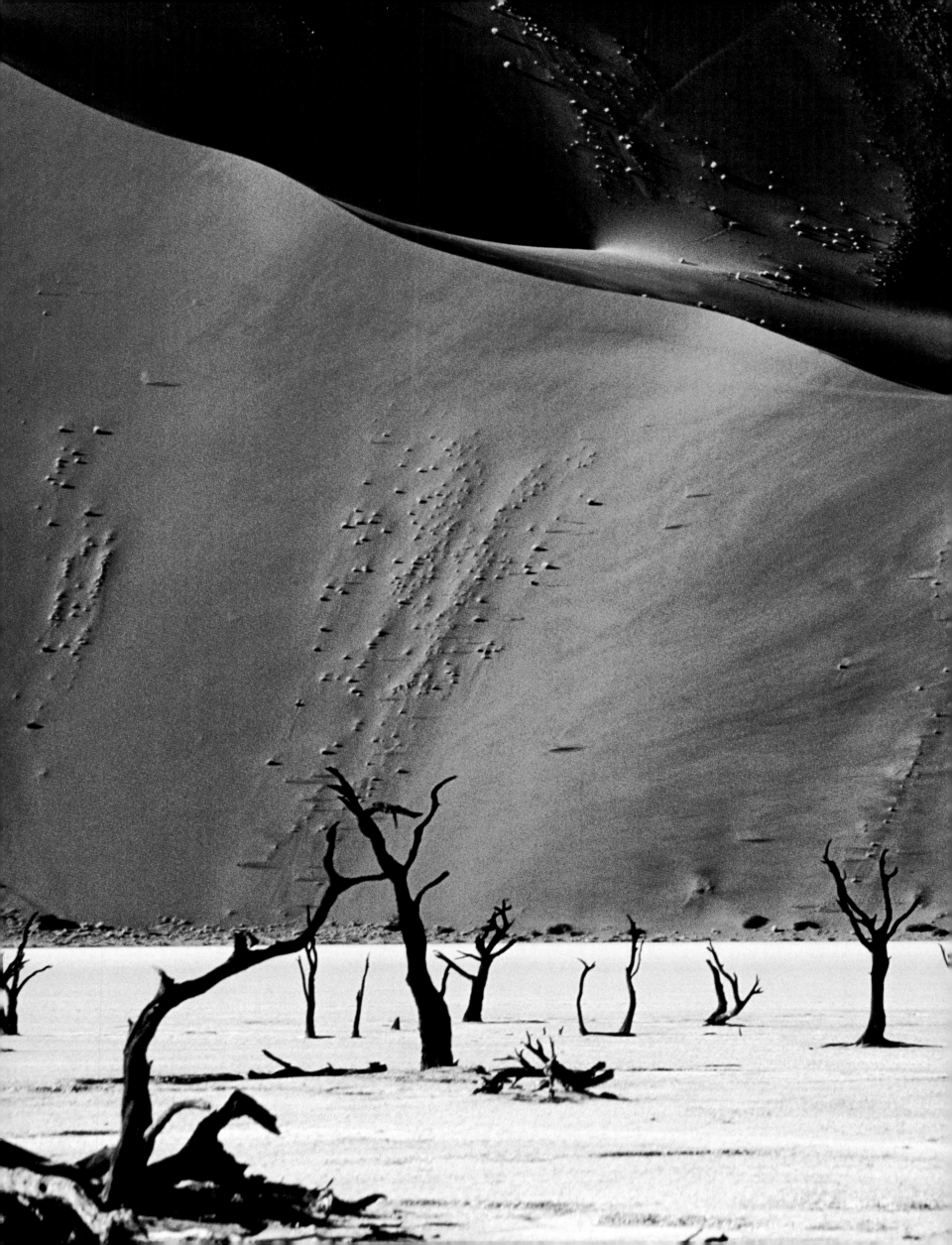

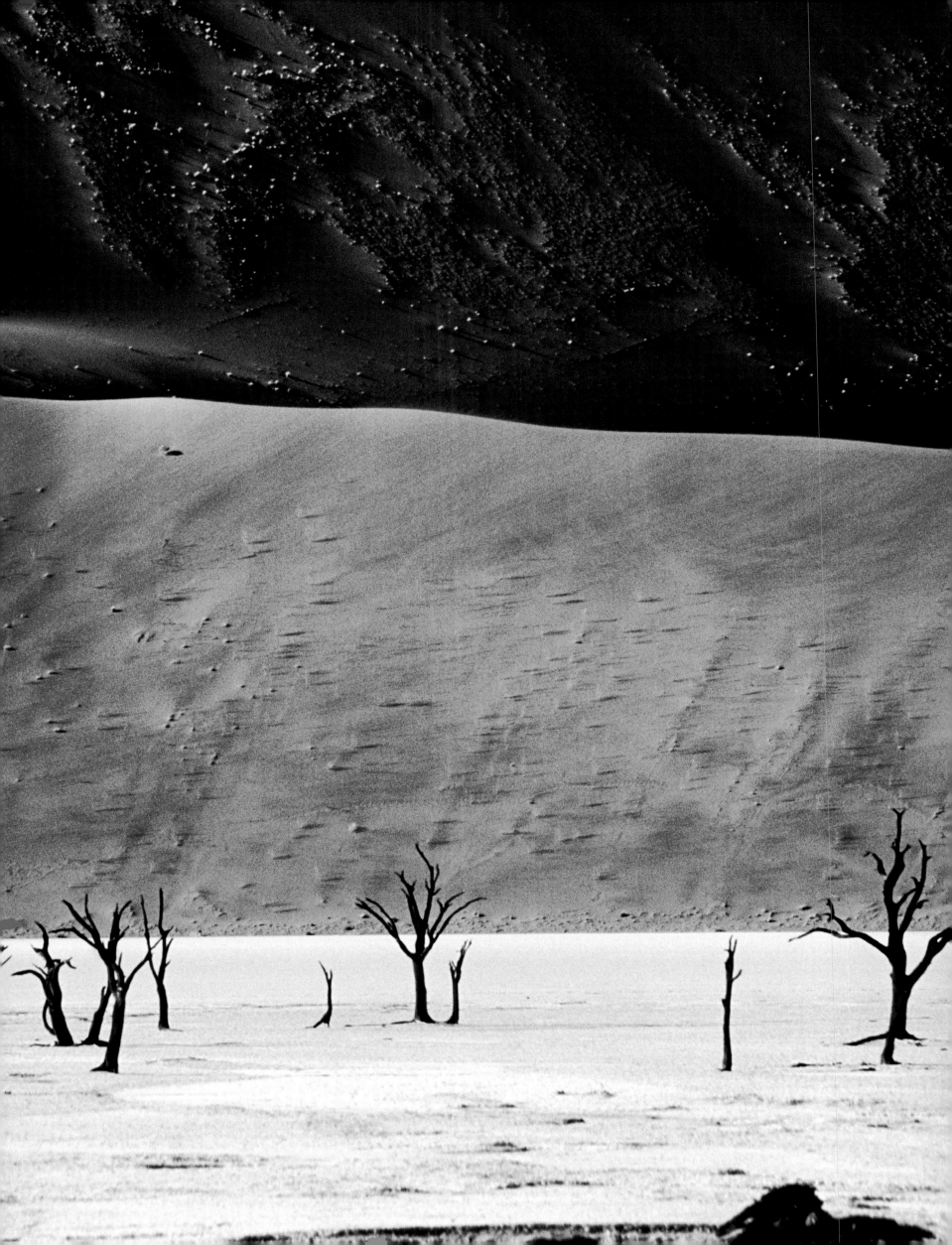

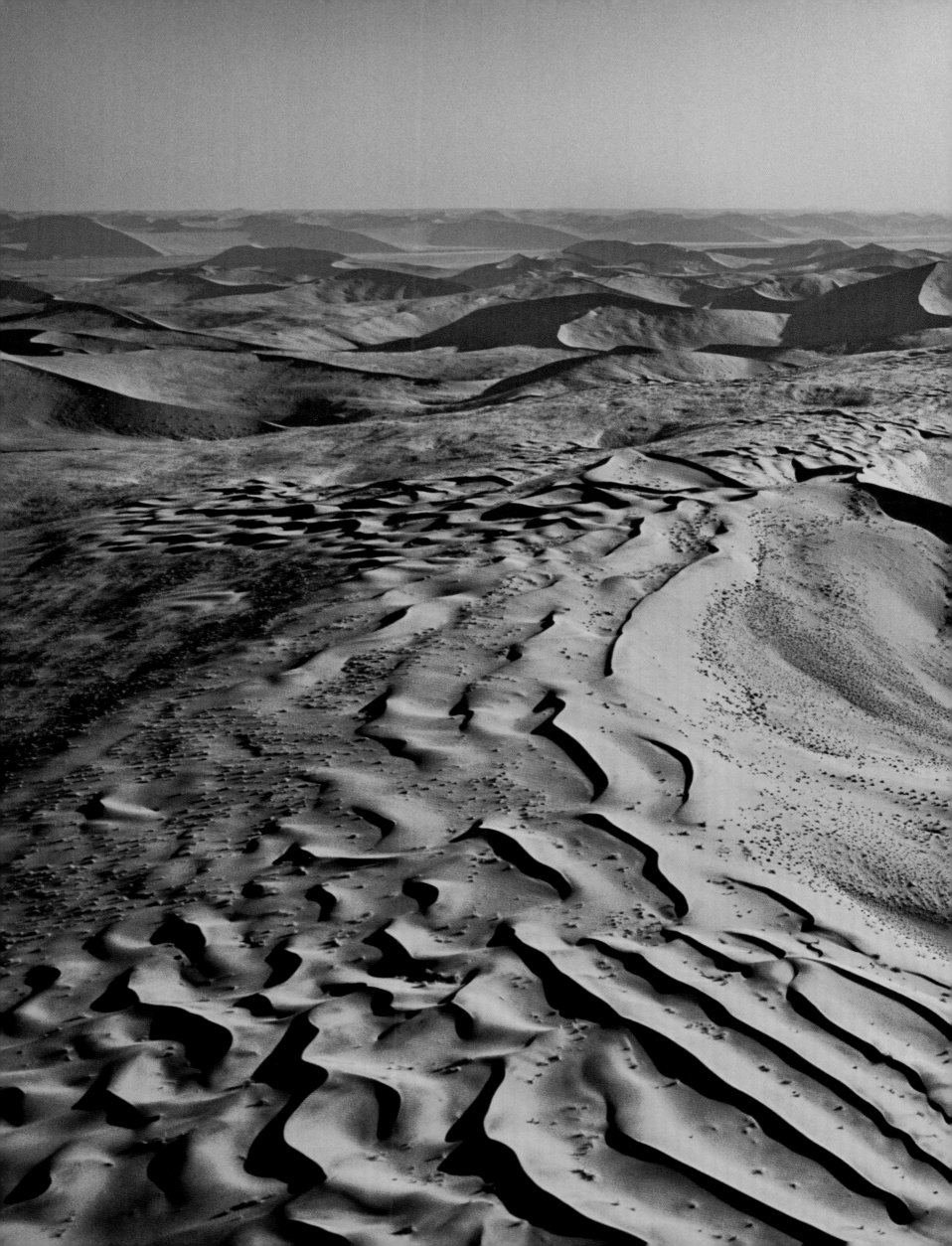

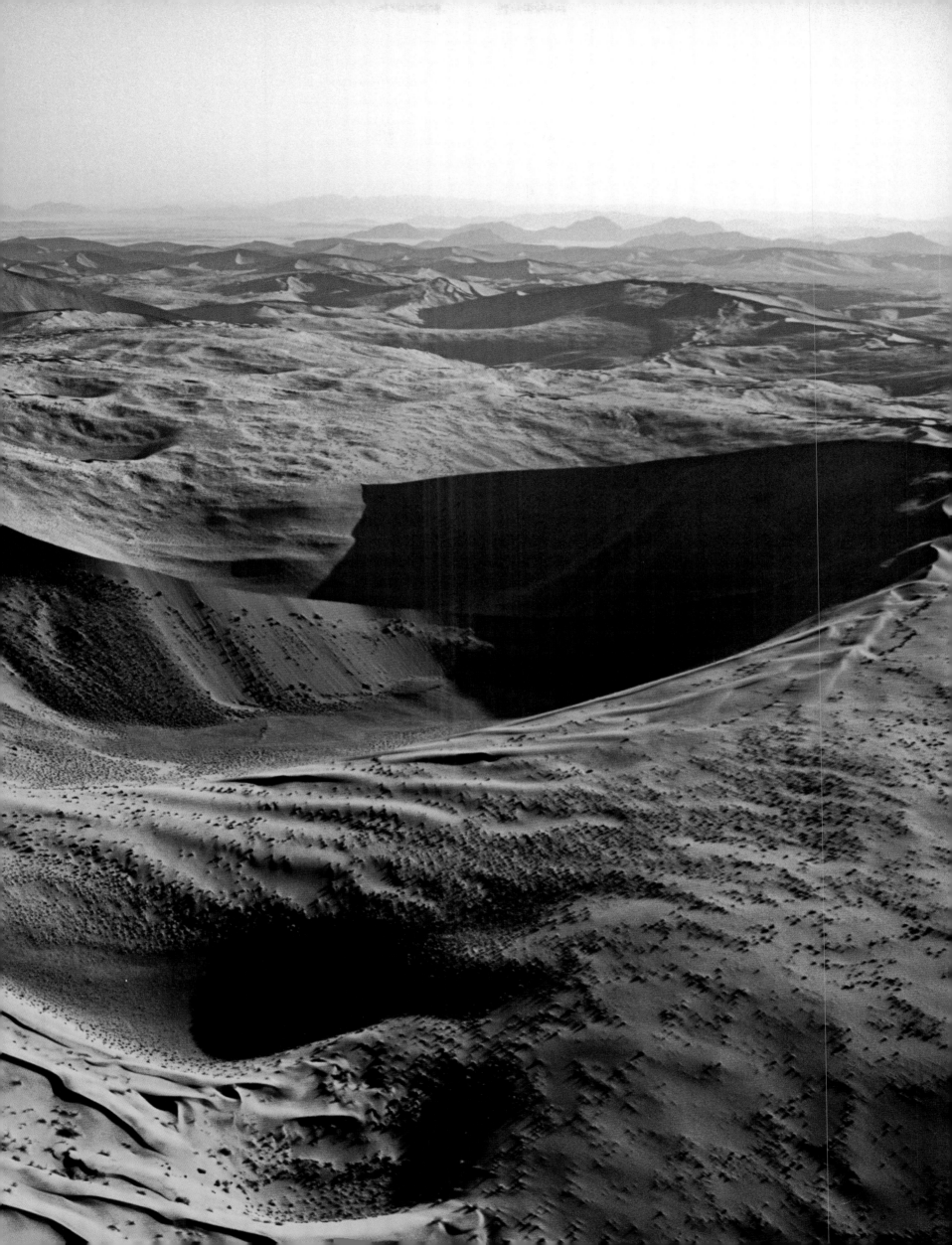

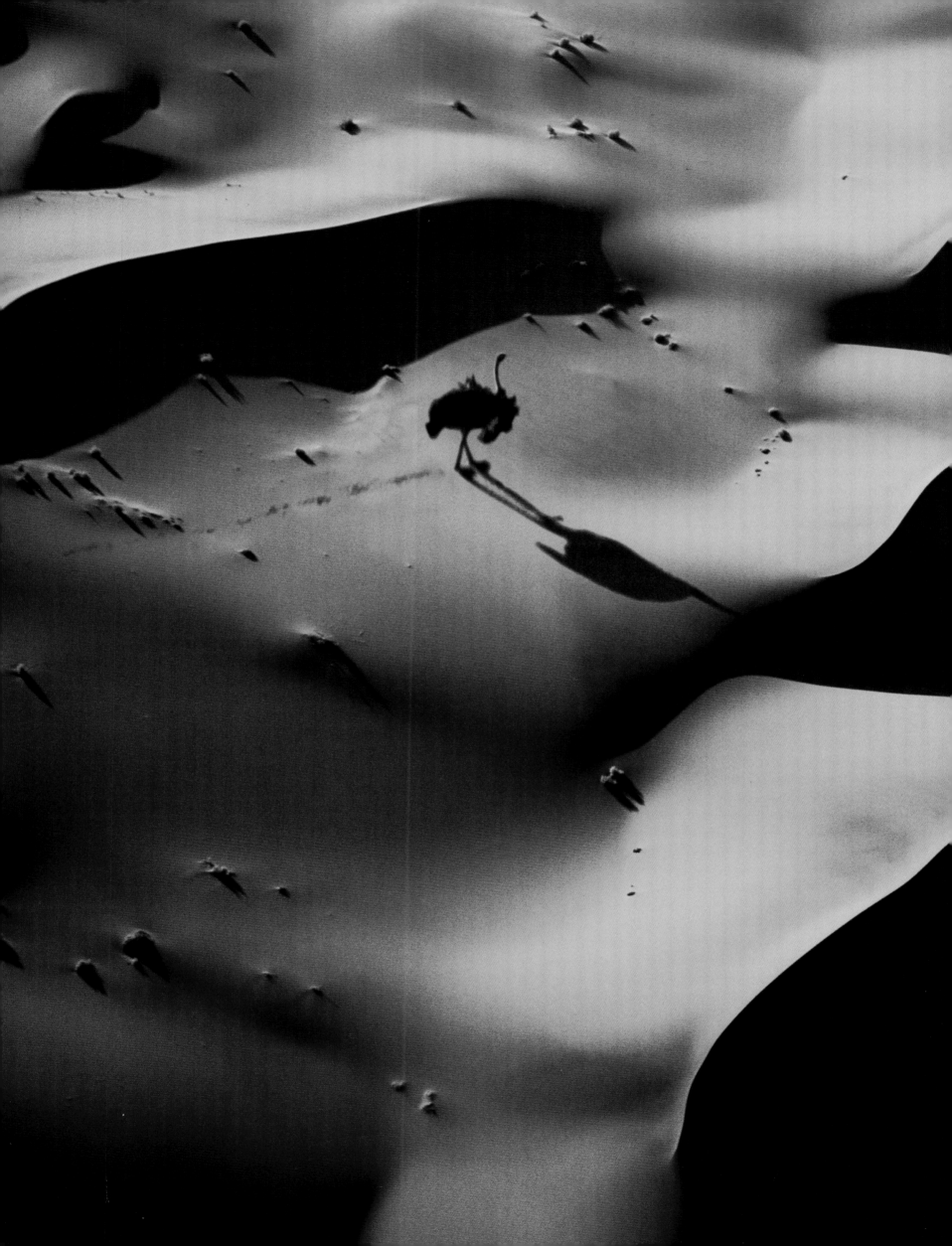

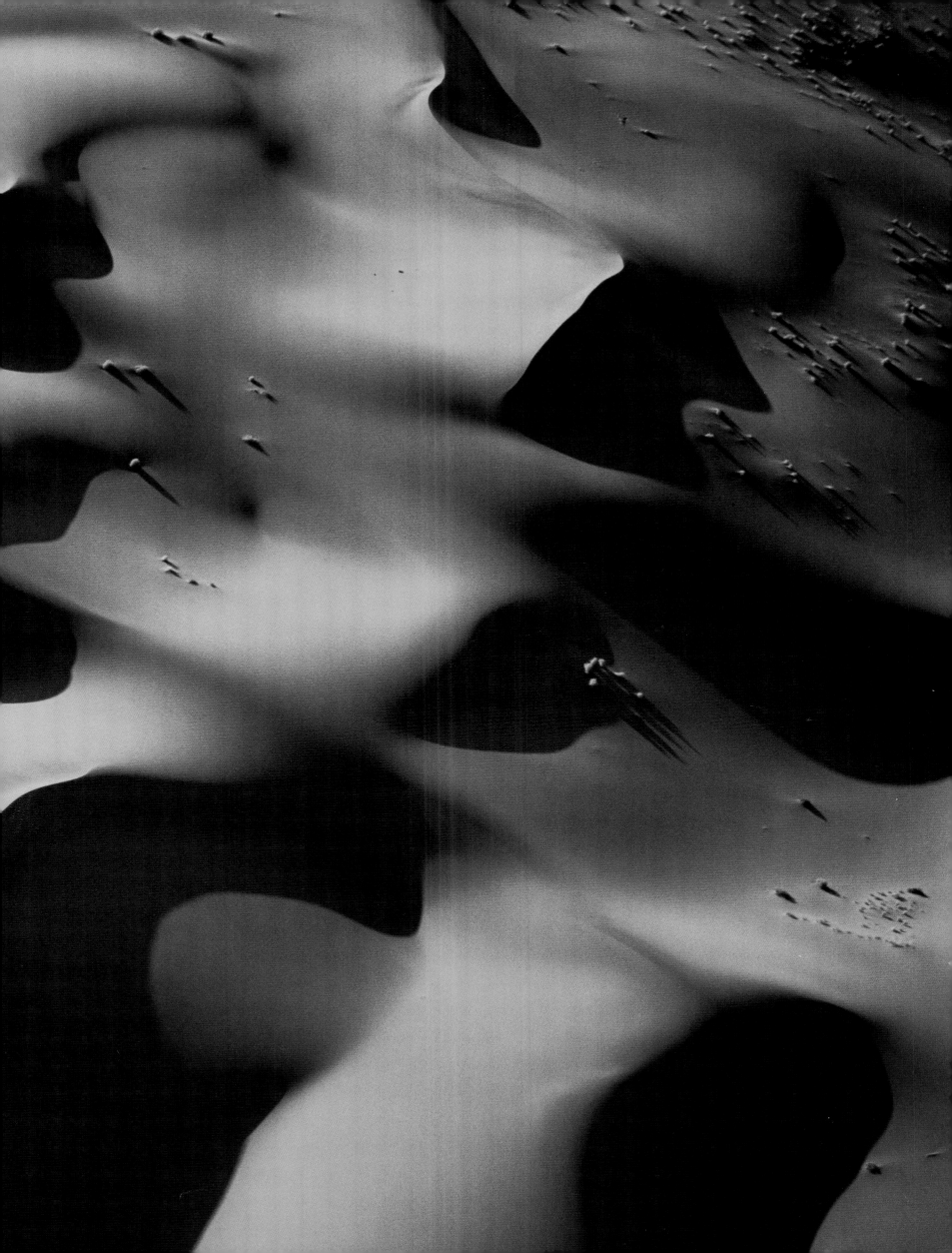

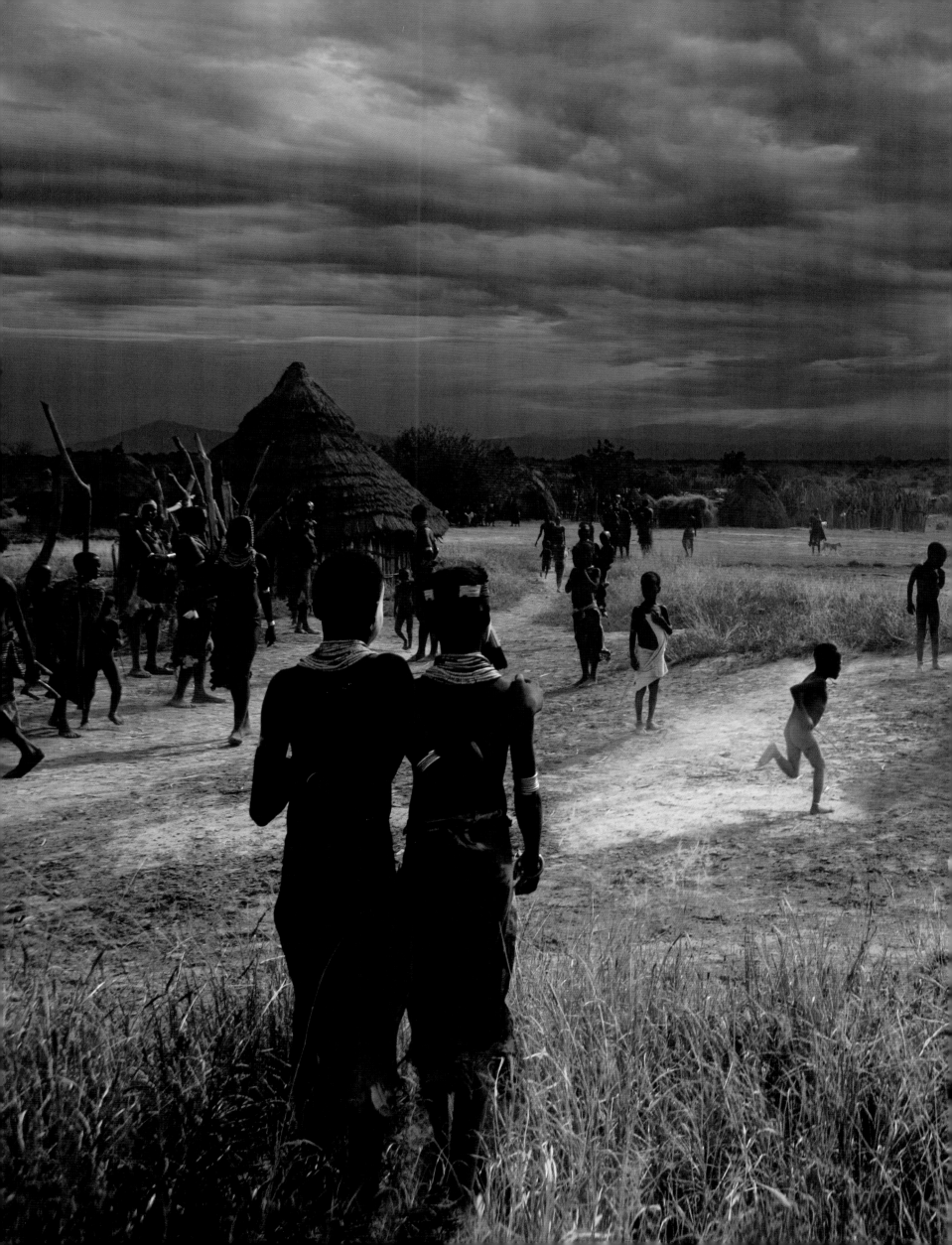

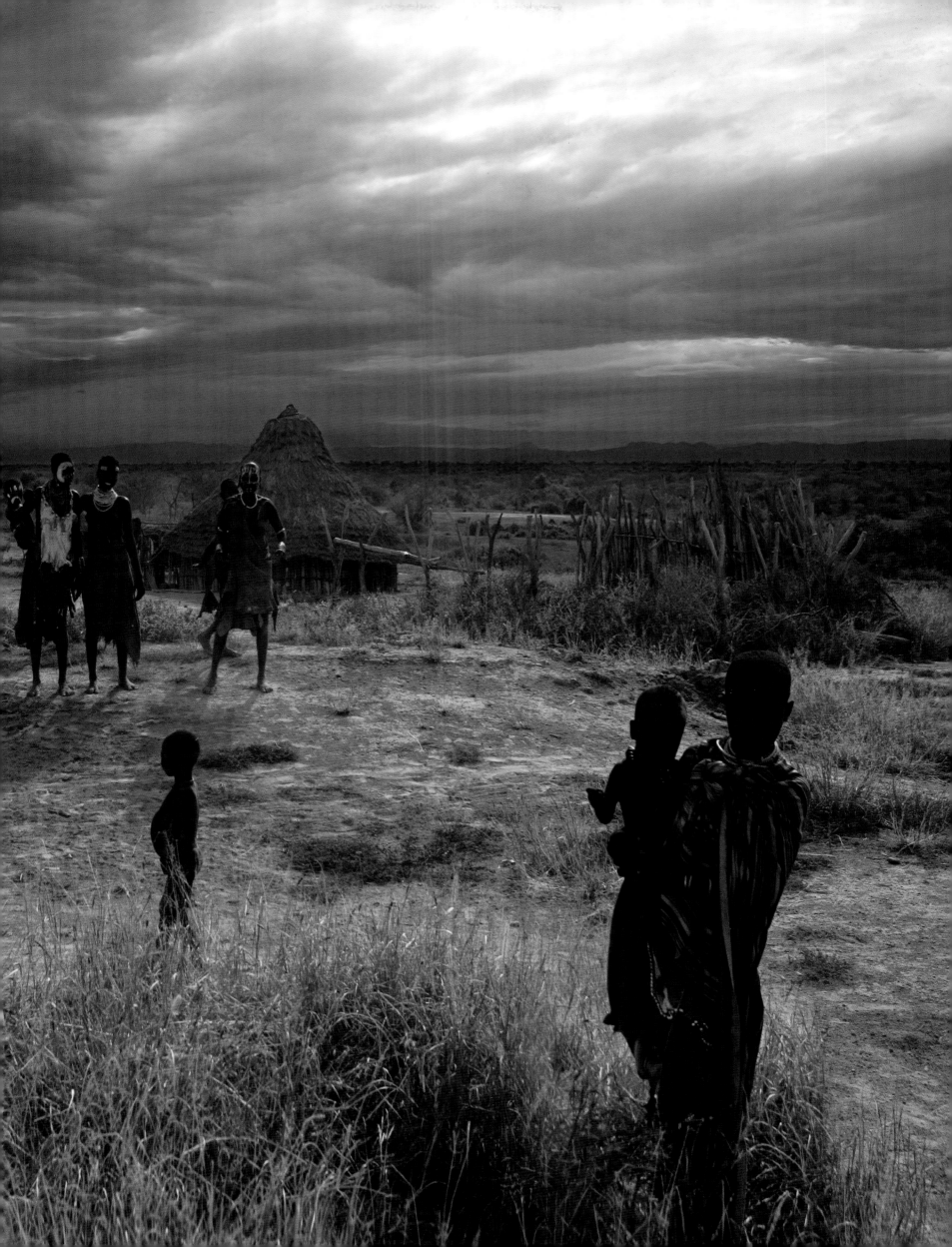

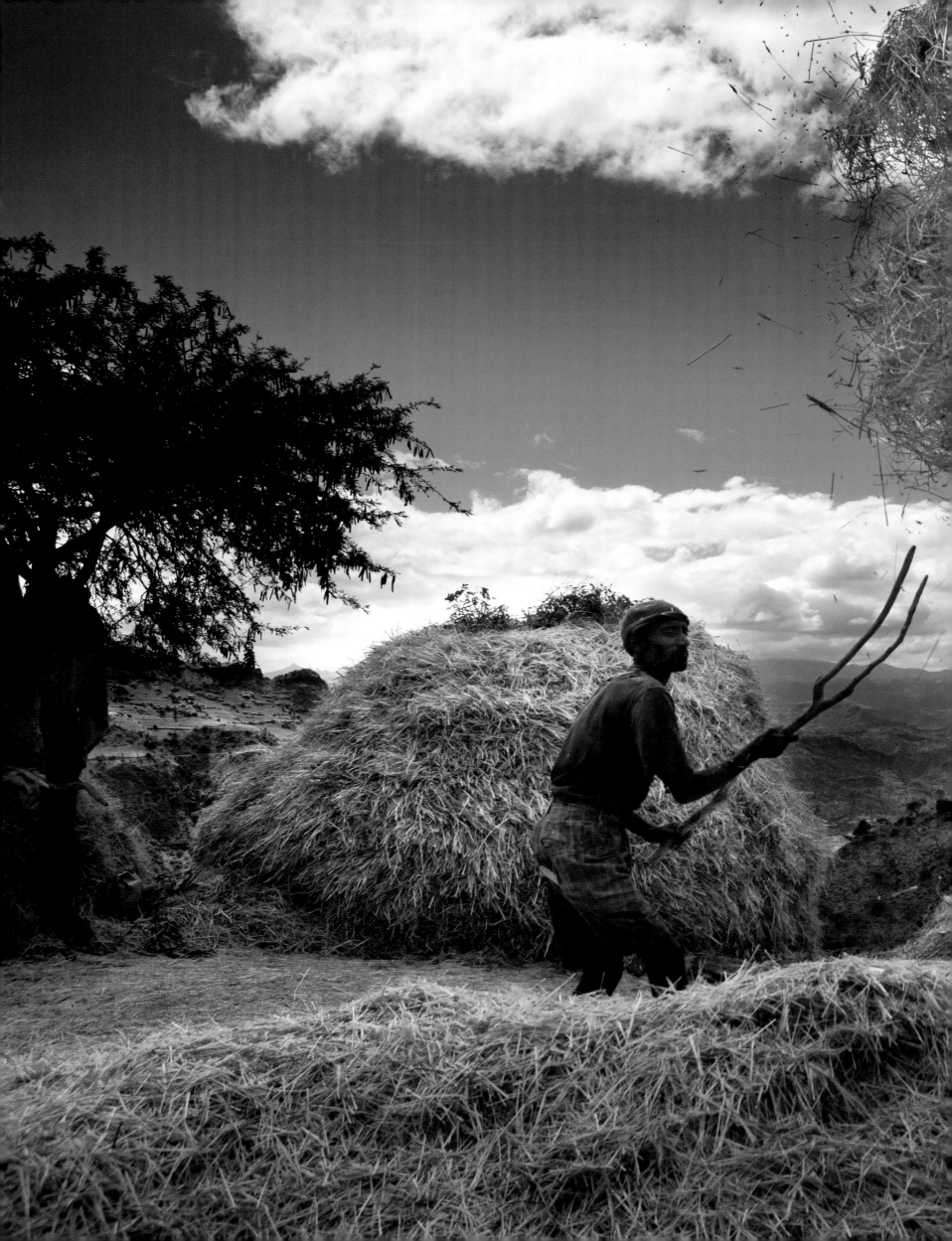

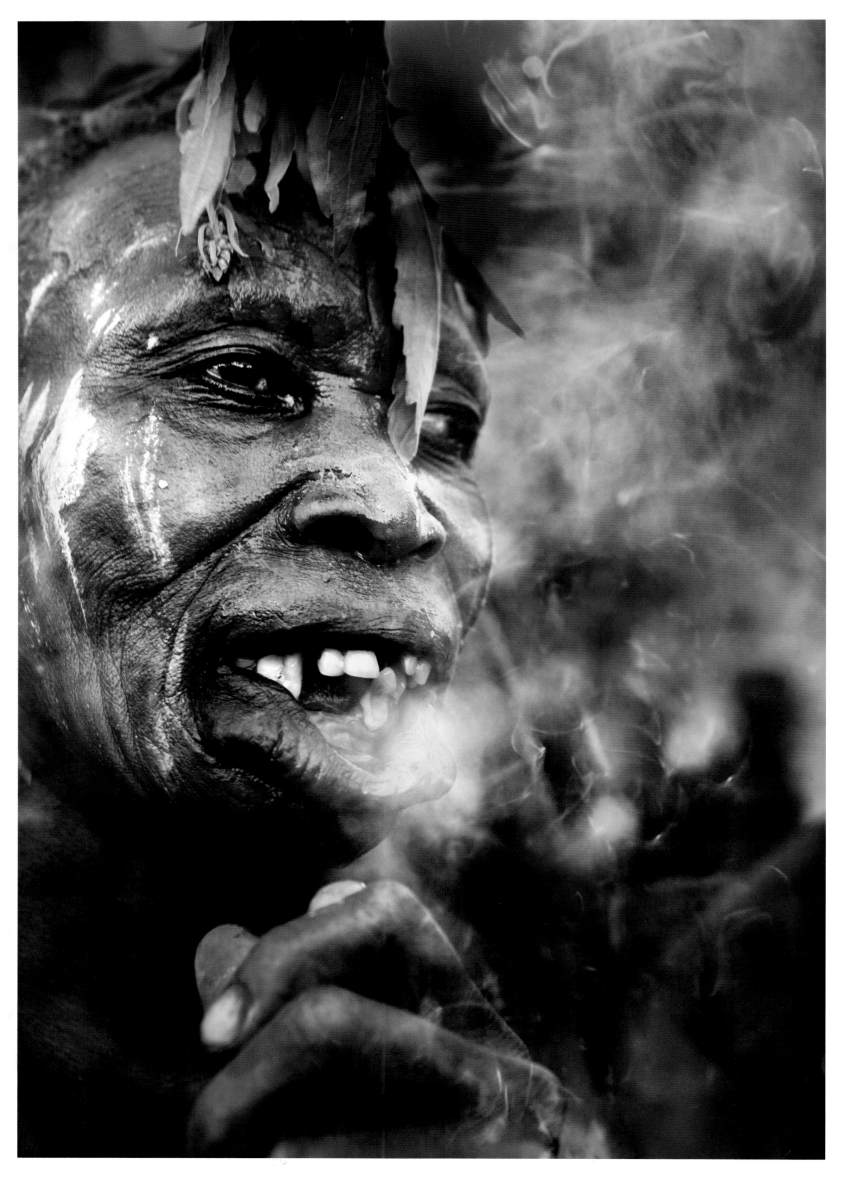

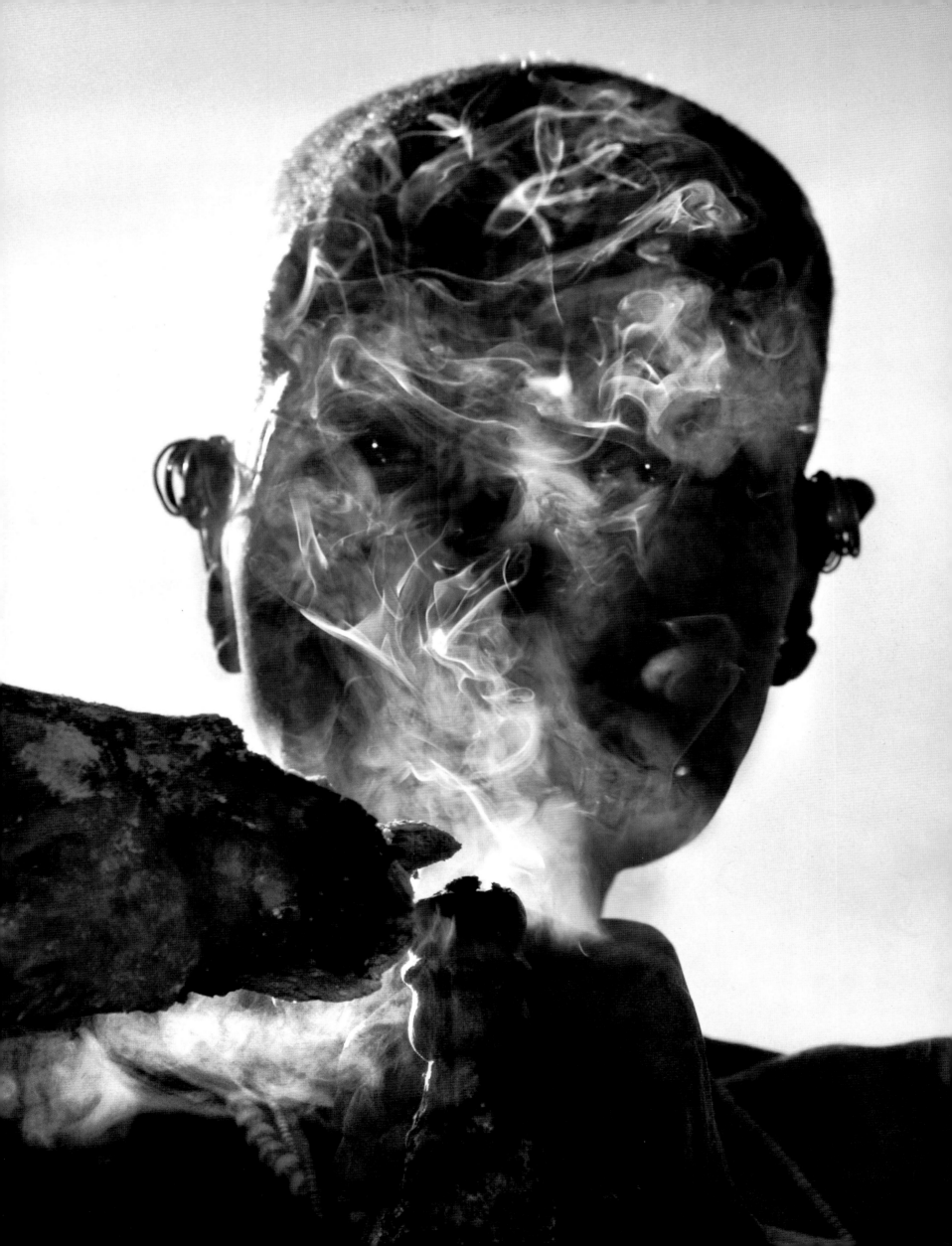

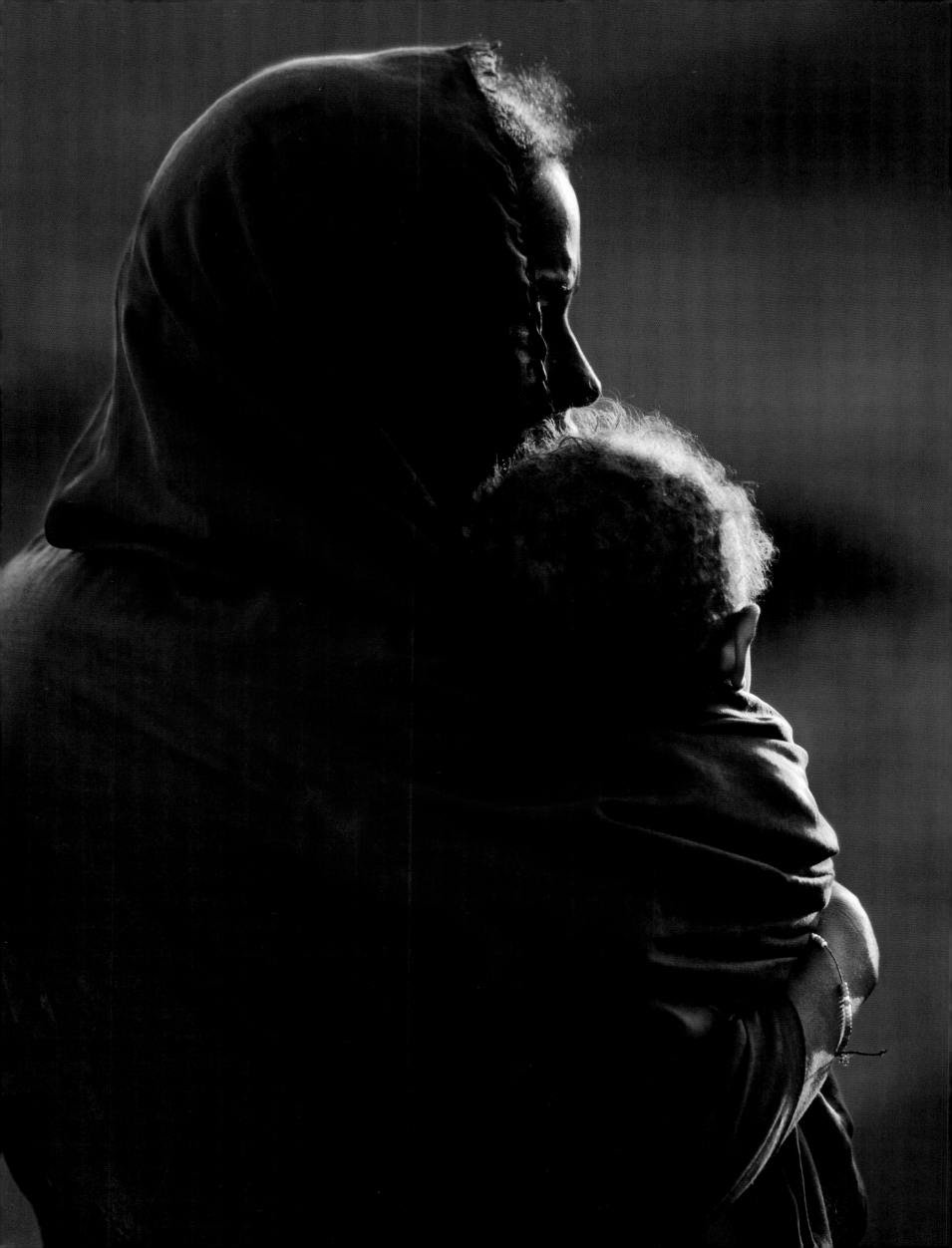

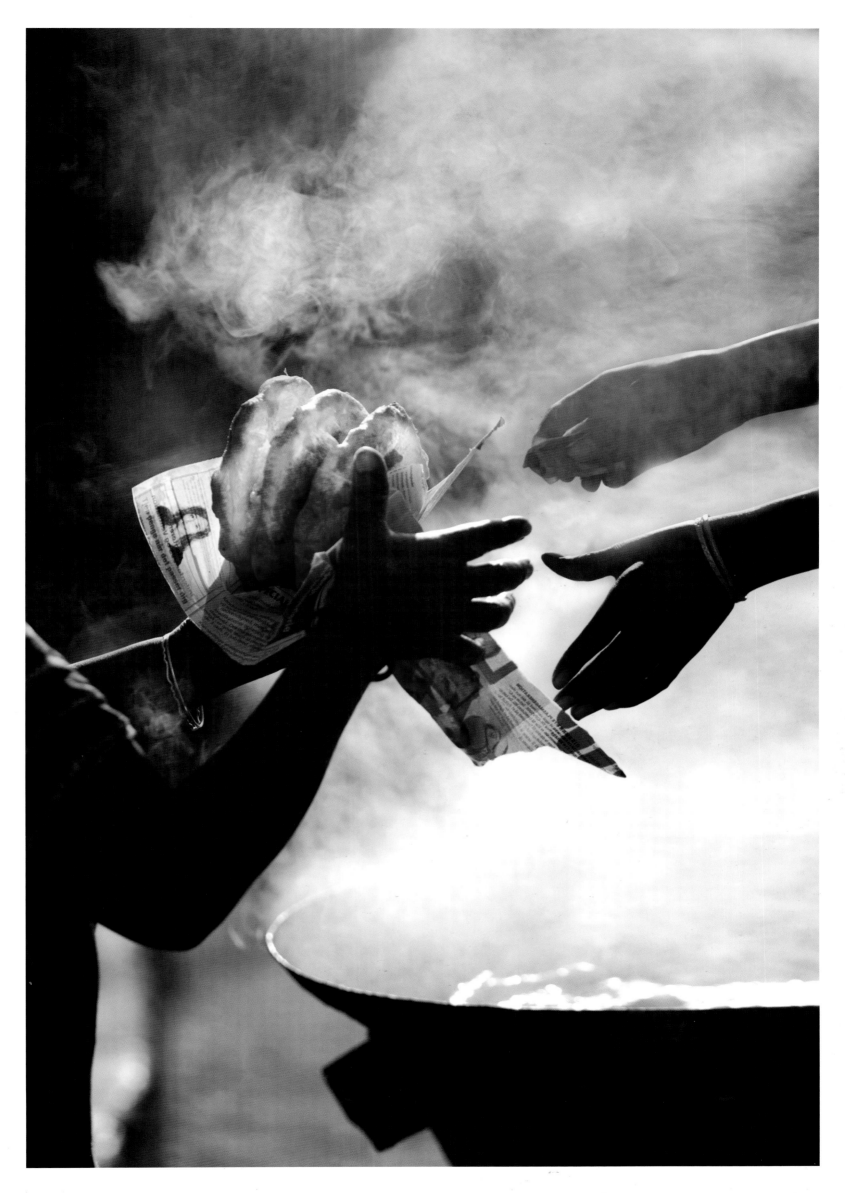

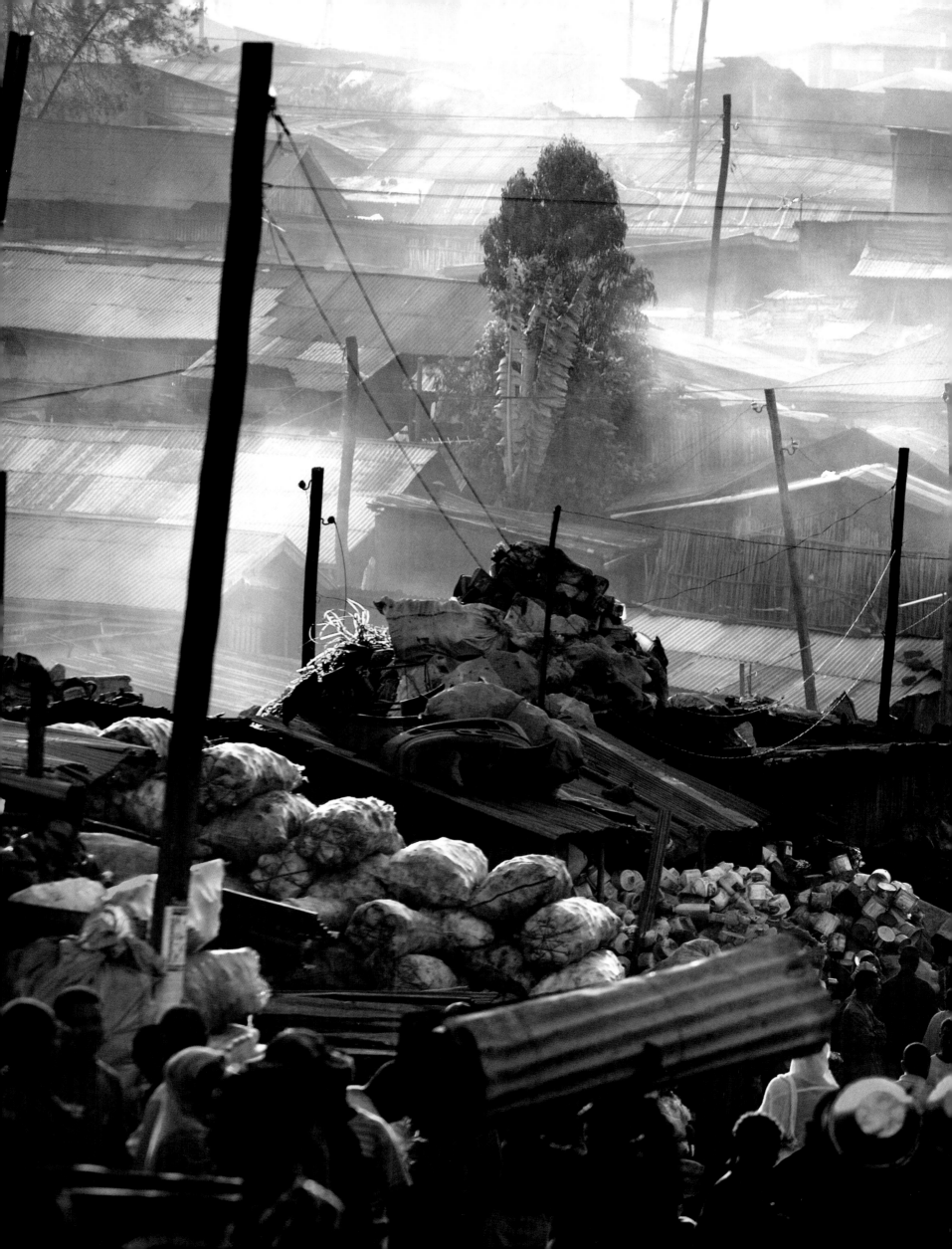

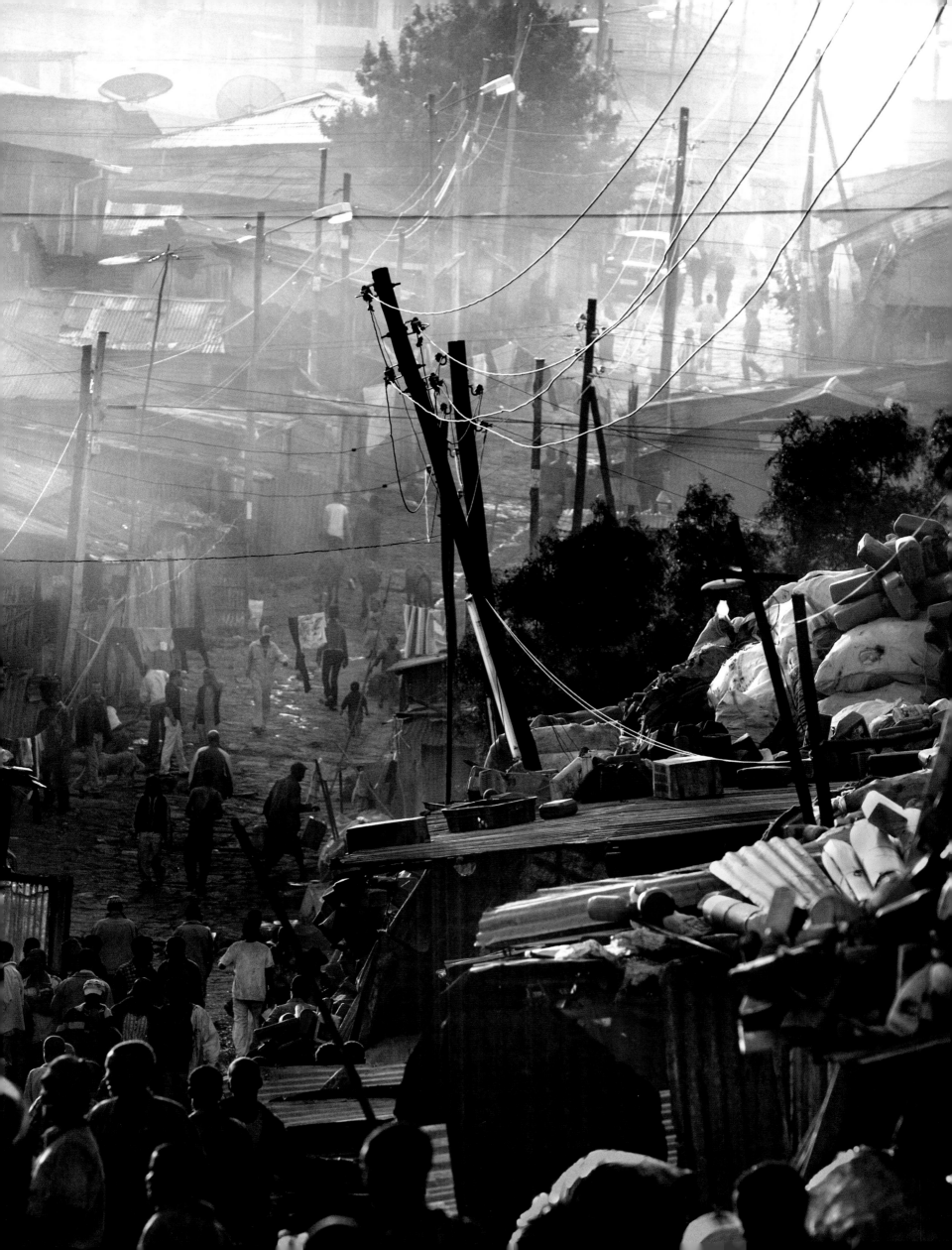

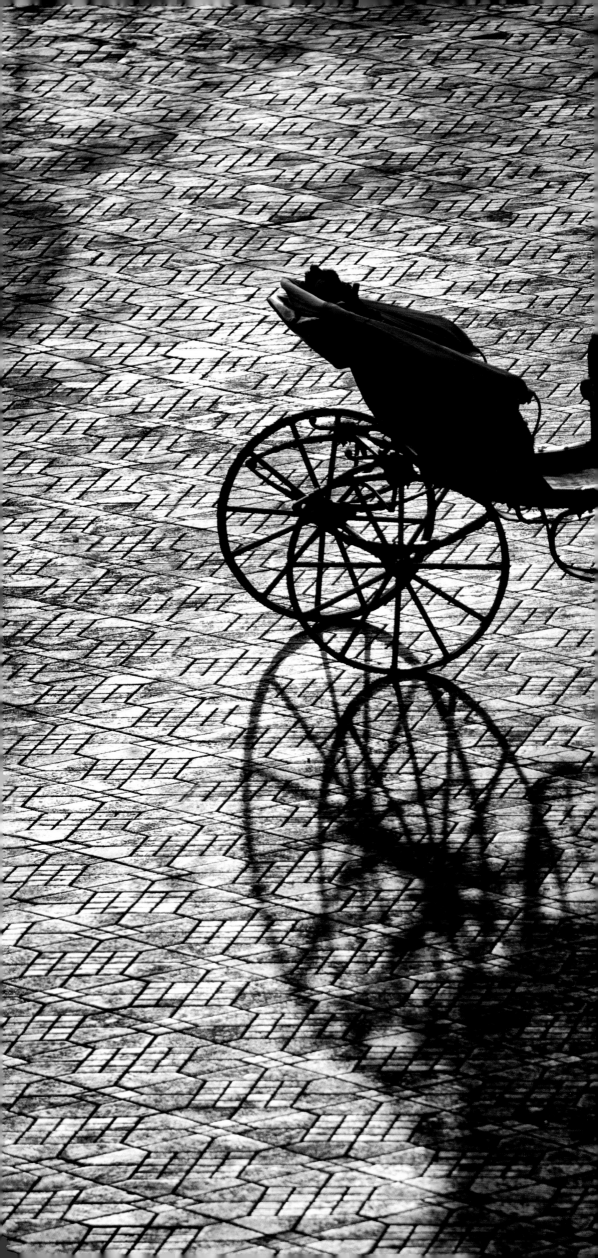

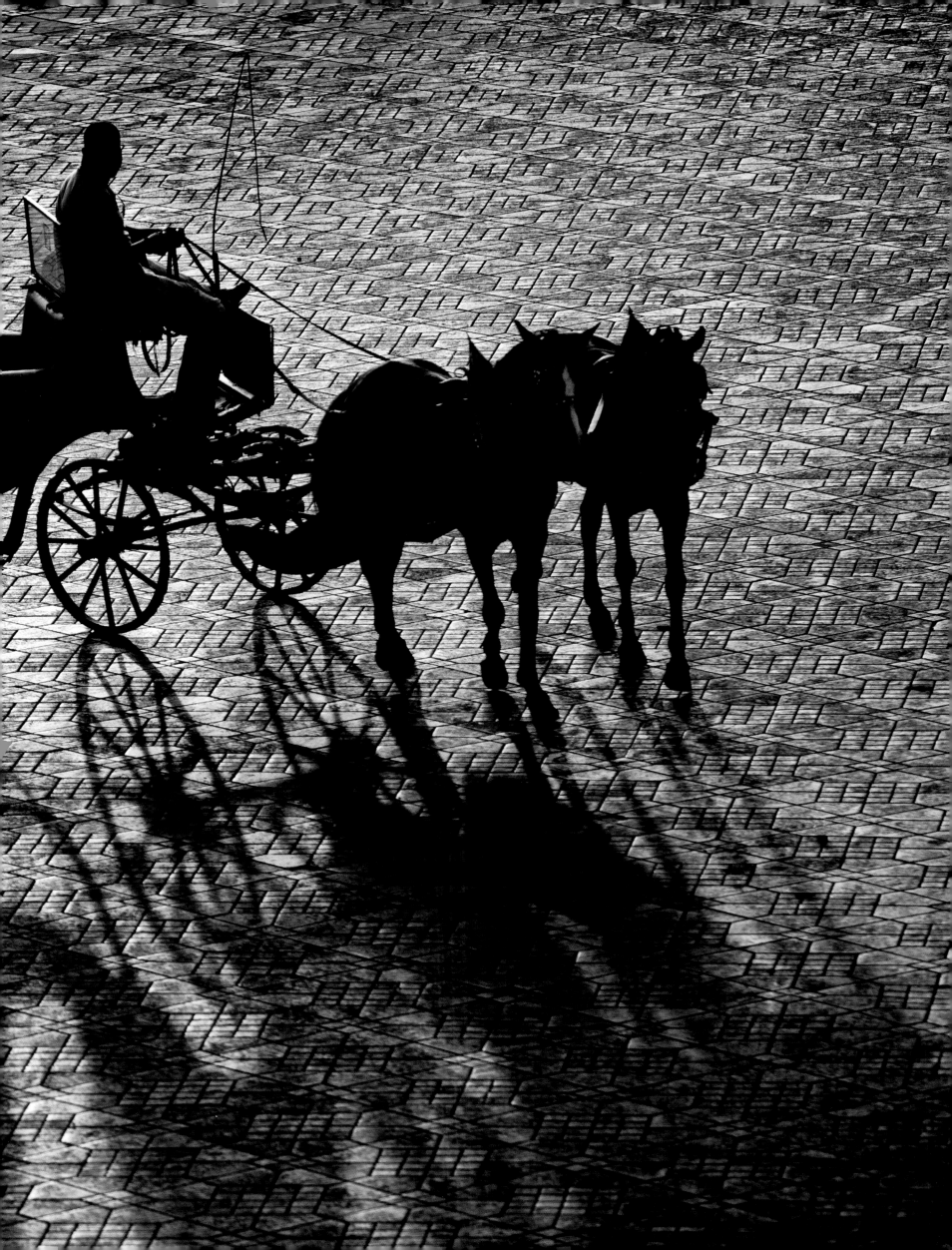

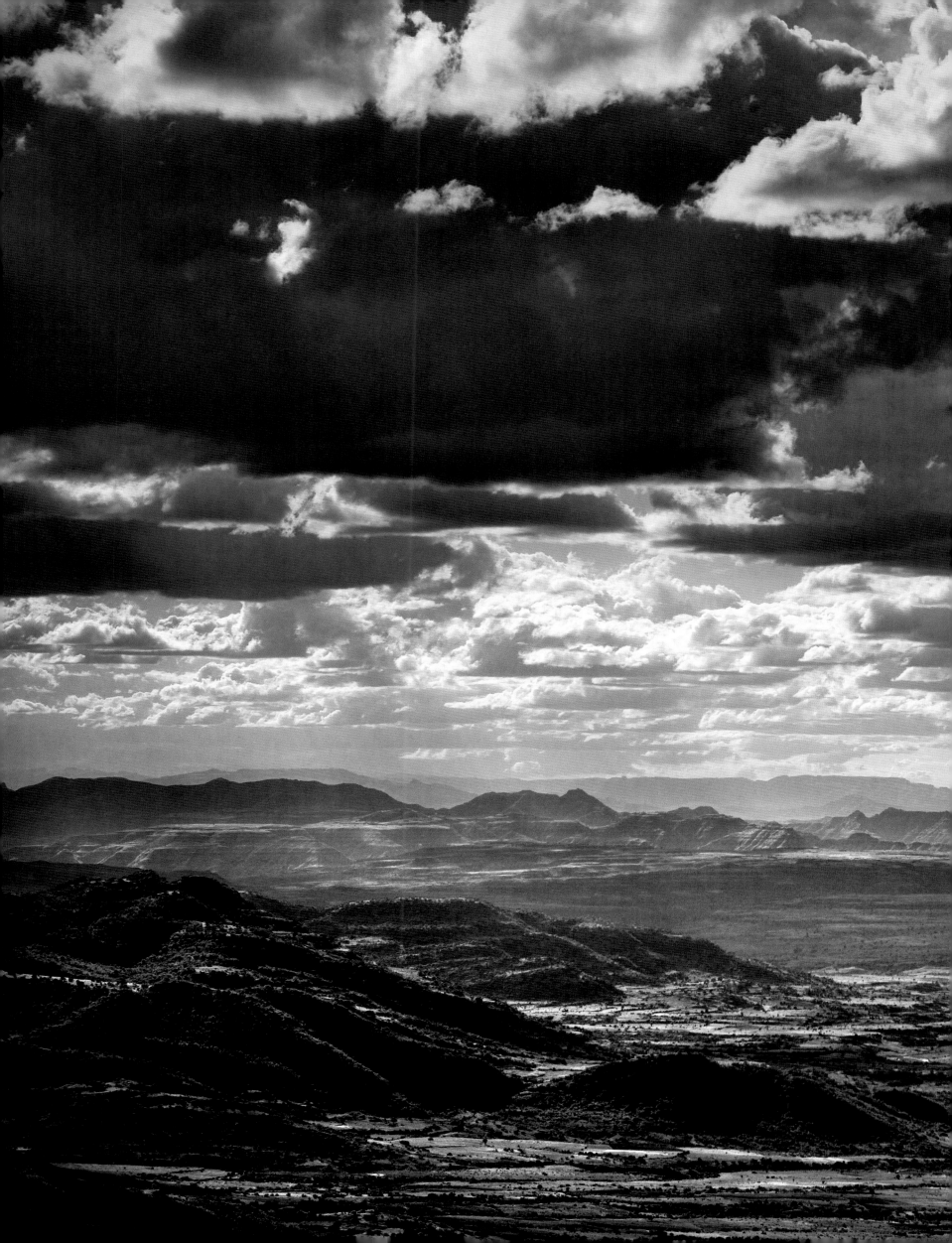

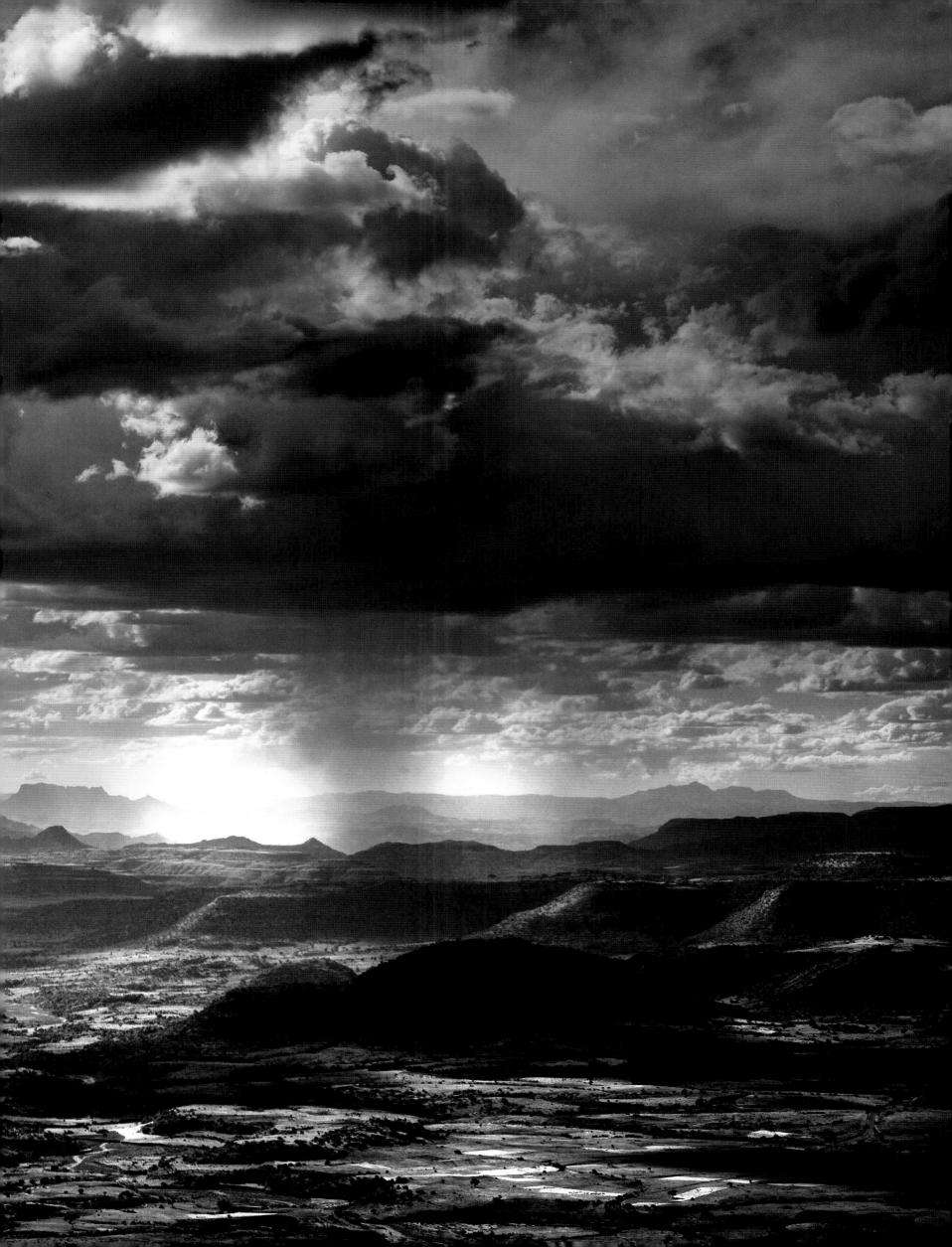

IN THE OMO VALLEY

The stillness in the valley ends when the sun goes down. The night air fills with a pulsing drumbeat and rhythmical voices as bodies dance ecstatically in the firelight. Alone in my dark tent on the bank of the river, I listen to the chanting in the distance.

I am in the Omo Valley in southern Ethiopia, near the borders with Kenya and Sudan; home to remote tribes who live in close and sometimes uncomfortable proximity to each other. Often referred to as vanishing tribes, these are among the most threatened cultures in Africa. Peoples such as the Dassanech, Karo, Nyangatom, Mursi, Hamar and Suri each express their own distinctive culture in a harsh and challenging environment.

Karo people are renowned for body decoration. In preparation for dancing ceremonies they adorn themselves with white chalk, ochre, charcoal, iron ore and yellow minerals; painting motifs such as hands, stripes and guineafowl plumage. Women enhance their sex appeal by scarifying their skin. They make incisions with blades, then rub ash into the open wounds, which become raised as they heal. Men scar themselves to indicate the number of enemies they have killed, with a line of scars representing each slain member of an opposing tribe. These badges of honour command respect from the community, and instil fear in their foes. Courtship and dancing rituals are vibrant and mesmeric, lasting well into the night.

The Hamar are semi-nomadic cattle farmers. Both the Karo and Hamar mark young men's coming of age with a performance known as the 'jumping of the bulls', which takes place after harvest. Cattle are lined up in a row, side by side, and a young man runs across their backs without falling, in a rite of passage which confirms his eligibility for marriage. During this ceremony the men's unmarried sisters offer themselves up to be whipped by male members of their family who have successfully completed the initiation. These women bear their scars with pride, and the consensual whipping creates a lasting bond between young men and their sisters.

The Dassanech live in the drier, more desert-like area to the south where the Omo River runs into Lake Turkana. Life in this inhospitable terrain is harsh, drought alternating with occasional

LEFT
Scarification on a Karo woman, Omo Valley, Ethiopia.

OPPOSITE
Painted face of a Hamar warrior, Omo Valley, Ethiopia.

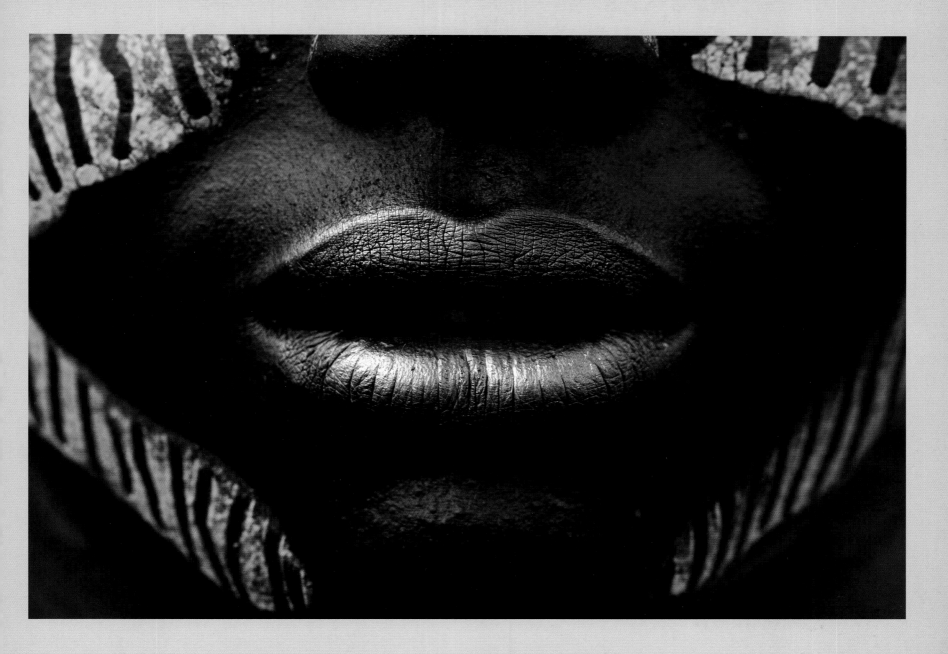

flood. Sometimes tribesmen lose all their cattle to thirst or theft, and consequently have to fish and hunt crocodile in order to survive. Set apart from the tribe and dismissed as 'poor people', they only regain their status once they manage to build enough wealth to own cattle again.

The Nyangatom people are renowned for their singing and storytelling. They are crop farmers and cattle herders who also live in semi-desert regions. Raising cattle here is made a consistent challenge by scarcity of water and grazing resources, infestations of tsetse flies, and theft. Under ceaseless threat from their many enemies among neighbouring tribes, including the Mursi, Dassanech and Karo, they are among the most feared warriors in the Omo Valley. In the 1980s they began to acquire Kalashnikov rifles, replacing their traditional spears, bows and arrows. Now all tribes have access to rifles, and it's rare to see unarmed men outside the villages. When a warrior kills an enemy he makes incisions in his chest to release bad blood. One man I come across bore countless such scars across his torso.

The Mursi are best known for their lip plates, made from clay or wood. When a girl is in her teens, her incisors are removed, her lower lip is pierced and a small wooden plug inserted into the hole. When it heals, a slightly larger plug replaces the smaller

one, and this is done progressively, stretching the lip until a girl is able to wear a plate as large as five inches in diameter. The plates were said to originate as a deterrent to slave traders, but the Mursi themselves do not attach credence to this theory. Today the plates serve as assertions of their pride and self-esteem.

Suri women also wear lip plates and scar their bodies with decorative patterns. The skin is lifted with a thorn and sliced with a blade, leaving a flap that will create a raised scar when it heals. Aggressive, dangerous stick fighting takes place between the men of different Suri villages, usually after the harvest. These fights have a sporting element to them, but also harden young men to the skills of combat, essential for survival in their threatened world.

* * *

'When we land,' says the pilot, 'I will not have enough fuel to take you back to Addis Ababa, so even if your cars have not arrived to meet you, I must leave you behind. And I warn you, the landing will be bumpy.'

Our light aircraft touches down on a grass strip high up in Surma country, in the southern part of the Omo Valley, one of the remotest parts of Ethiopia. The dark heavy sky looks ready to fall on us. The landing is rough, as promised, the drone of the engine obliterated by banging and clattering. Mud flies up, splattering

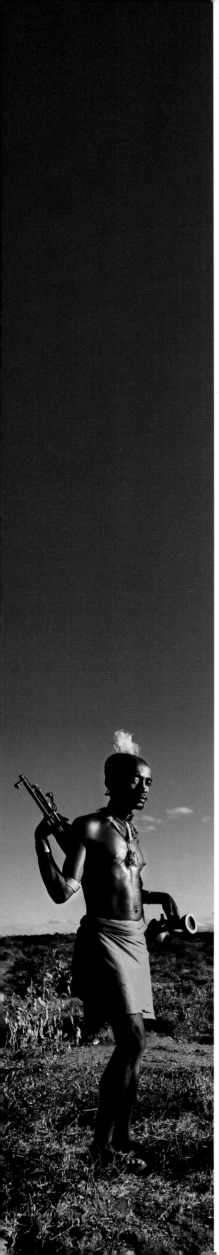

the windows as we bounce and rattle along the clearing. We finally come to a stop where the grass grows long on the edge of a hill. The pilot leaps out, pulls our bags from the luggage compartment and drops them on the wet grass. I manoeuvre down the step into the damp air. He climbs back into his plane, quickly, as if making a getaway from a bank robbery, and re-starts the single engine, taking it to full power as the first drops of rain spit down on us. By the time he is airborne the rain is heavy, rapidly becoming torrential.

The plane is a shrinking speck that disappears into a cloud. Drenched, we are now surrounded by half-naked people with Kalashnikovs, and, indeed, our cars are not here to meet us.

Firew Ayele is our perpetually calm and resourceful guide. He leaves our small party standing in the downpour while he heads into the forest in search of the vehicles. An hour later he returns with the news that one of the four-wheel-drives is struggling through thick mud, and the other, carrying our tents and food, is nowhere to be seen. The Suri people sling their rifles over their shoulders and help carry our bags to the single car which has finally arrived. The river we must cross is now swollen by the rain and the vehicle is too heavy to risk it with passengers. We stand on the bank as the driver boldly accelerates across in a few tense moments, emerging on the other side. We follow, waist-deep, struggling against the flow, until we reach the far shore. Sodden, we climb back in. There is still no sign of the car carrying our provisions, but the driver knows of a government-controlled police compound where we can seek accommodation for the night.

In the morning the supply car turns up, a day late due to waterlogged tracks. It is something of a miracle that it arrives at all. A few days ago we had to abandon our attempts to send supplies to a region to the east of our current position. The driver had battled in the mud for eight days to make what should have been a ten-hour journey, only to face a river so swollen that he had to abort the trip completely and spend another eight days driving back.

Now at last we have set up camp and are heading on foot for a Suri village, only an hour away. We walk along the path, and each

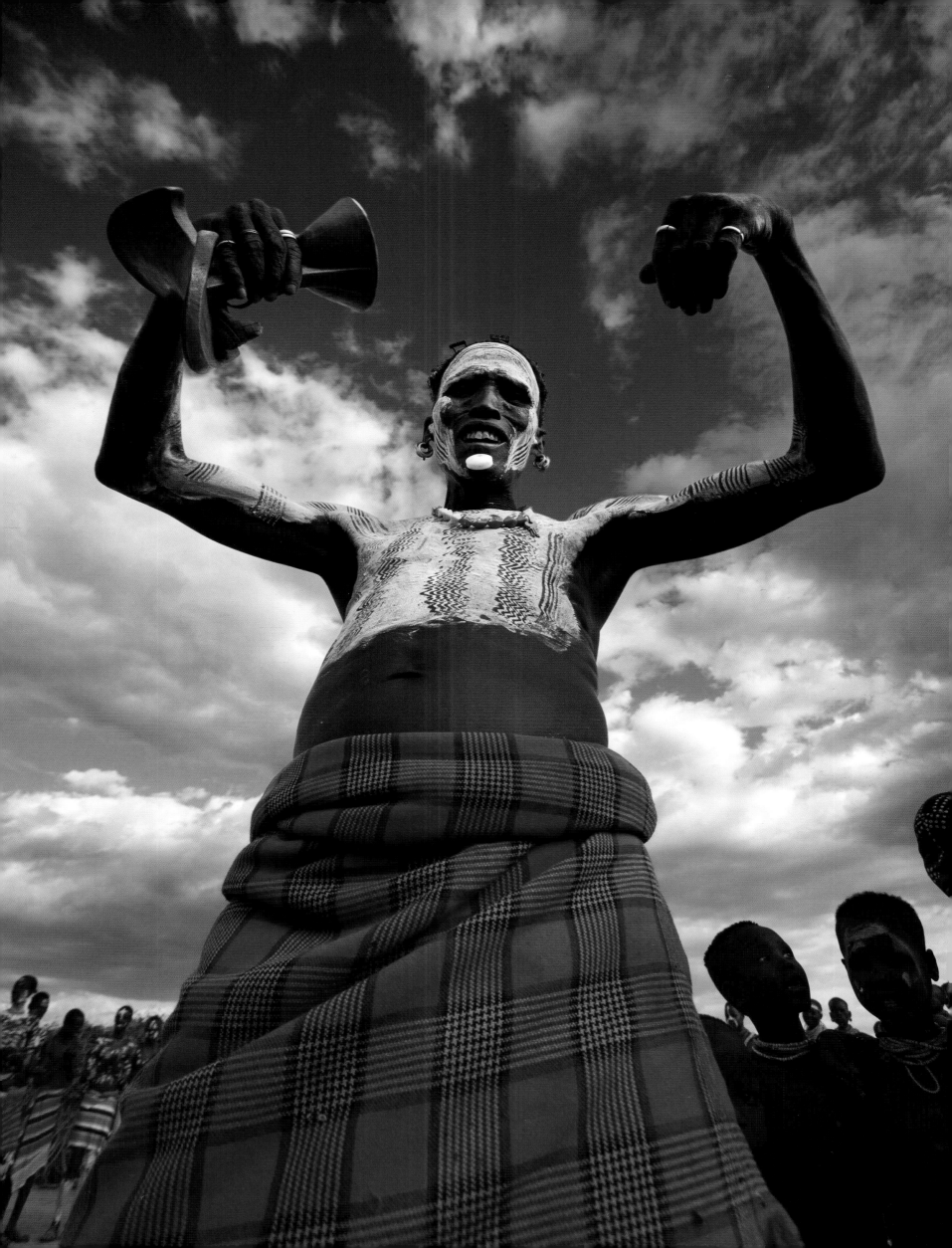

stranger I pass turns towards me, extends a hand and greets me warmly with the word 'ah-chalie'. Women approach and ask if I have razor blades to use for scarification. Children ask for pens; the caps make great jewelry. We negotiate a fee with the elders, and I pay each person for the privilege of taking their picture. Candid photography is a challenge, for once a fee is agreed, the model usually stands rigid until the session is over. A large man sits on a log, brandishing a whip which he cracks at children or dogs who misbehave.

On a separate trip, I am with a small group of hardy travellers and we set off by boat to visit the Mursi, searching for them along the banks of the Omo River. All we find are traces of hurried departures, and we learn that the Nyangatom have been threatening, firing shots from the other side of the river. So we leave the next morning at dawn for the long drive through the bush to a more isolated Mursi village. The journey in our open vehicle is exceptionally rough, hot and unpleasant, aggravated by swarms of tsetse flies, hungry for foreign blood. I brush them away constantly, but all too often I feel the sharp burning sensation of a bite: defeat. The bites later become infected.

We stop at an army post and pick up a soldier to provide us with protection, and by the time we arrive in the village it is midday. Permission to photograph is granted, and immediately the Mursi people live up to their notoriety for harassing visitors, hustling for money, and jostling in an intimidating way. This 'difficult' behaviour is for them simply a means to extract the maximum fee in the minimum time. It is they who decide the terms, and whether or not they will be photographed.

The tribal traditions in the Omo Valley are vanishing quickly. Nobody can blame these people for embracing some of the conveniences of modern life. But with change comes loss – loss of that side of Africa that has forever been self-reliant, surviving independent of outsiders' charity, ideology or technology. Like all of us, they have their own troubles and challenges, but there is a real danger that they will soon inherit many of ours, while losing

much of the cultural identity that is still a huge source of strength.

We leave the Omo Valley on a day that begins mundanely enough. Photography is over for this trip, so we start with an early breakfast, then the routine of packing up camp, and finally a relaxing riverboat journey to look forward to. We plan to ride down the Omo River and cross Lake Turkana to the Kenyan shore, known as the Cradle of Mankind, where the earliest human fossils were found. The journey should take about eight hours.

The air is still as we chug along the quiet river that leads into the lake, and I feel a sense of sadness as we leave behind the tribes of the Omo Valley. After half an hour, the boat pulls up on the bank of the river and I disembark at the remote border control to have my exit visa stamped. The office is a small building, lonely and out of place in the landscape. The uniformed immigration officer greets me with a beaming band of teeth. He recognizes me from two weeks ago when I first entered the country.

'Hello Mr Bloom,' he says, remembering my name, 'I am ready to stamp your papers.' I take my passport out of my shirt pocket and hand it to him. He has few customers, and relishes the brief encounter. We talk of politics and international terrorism. News reports of bombings in London are coming in, reaching him by radio, me by satellite phone. He shows concern for my countrymen, and enquires about the safety of living in England. I am surprised and touched, and thank him for his thoughtfulness.

Our flat-bottomed riverboat enters Lake Turkana; one hundred and sixty miles by twenty, it opens out before us like an ocean. The lake is an exciting place, alleged to have the highest crocodile population in the world and Nile perch weighing as much as three hundred pounds. Numerous species of venomous snakes inhabit its shores. But the crocodiles intrigue me most. Famed for their record size, they bask on the windswept margins of the lake.

We are about six miles from the shore when the wind picks up and the boat begins to rock. The spray on my face is cool and refreshing in the heat of the morning. My feet are wet and I am glad I opted for sandals instead of trainers, pleased too that my

cameras are well protected by tarpaulins. The spray is stronger, harder now and fleetingly I think of my children playing with hosepipes at home in the garden. Suddenly, unexpectedly, I am blasted by a squall as if with a firemen's hose, and I cannot see through my dripping sunglasses. My legs are submerged in water halfway up to my knees.

'The tarpaulin,' shouts the skipper, 'throw the tarpaulin overboard, pull it off and throw it overboard. Do it now. Quickly! NOW!' An American traveller in our group, Stan, hastily unties the tarpaulin and does as he is told, with a bewildered look on his face, as if doubting the wisdom of throwing away shelter in Africa.

'God! The bilge pump can't cope. Quick, throw out the fuel cans!' A thousand dollars' worth of fuel is tossed into the lake, tightly sealed in blue containers.

We turn away from the wind and gradually stabilize. The boat is lighter now, and the water level falls as the bilge pump kicks in. No one speaks, each of us shaken, wrapped in our private thoughts. Never have I longed so much for dry land. We limp towards an island where we can wait for the wind to drop.

On the island we eat the picnic lunch which surprisingly survived the journey. I am thankful for my simple hat that protects me from the scorching sun. Thankful, too, that I did not have to throw out my camera bag with the pictures I had worked so hard for. I think about the painted faces of the Karo people, the dancing Dassanech children, the scars of the Hamar women and the Mursi with their lip plates. But most of all, I think of my wife and children.

When the wind dies down we set off again for the opposite shore. Our charter plane flies in to collect us from the dusty runway and we head for Nairobi's Wilson Airport. I walk into the immigration room where my passport is taken by a thickset, uniformed man. He bends back the pages with stubby fingers and spreads a greasy palm across them, leaving a stain. I hand over cash for my visa. A large box with a hole in its lid is attached to the wall next to him, bearing the label 'Corruption Complaints'. I am back in civilization.

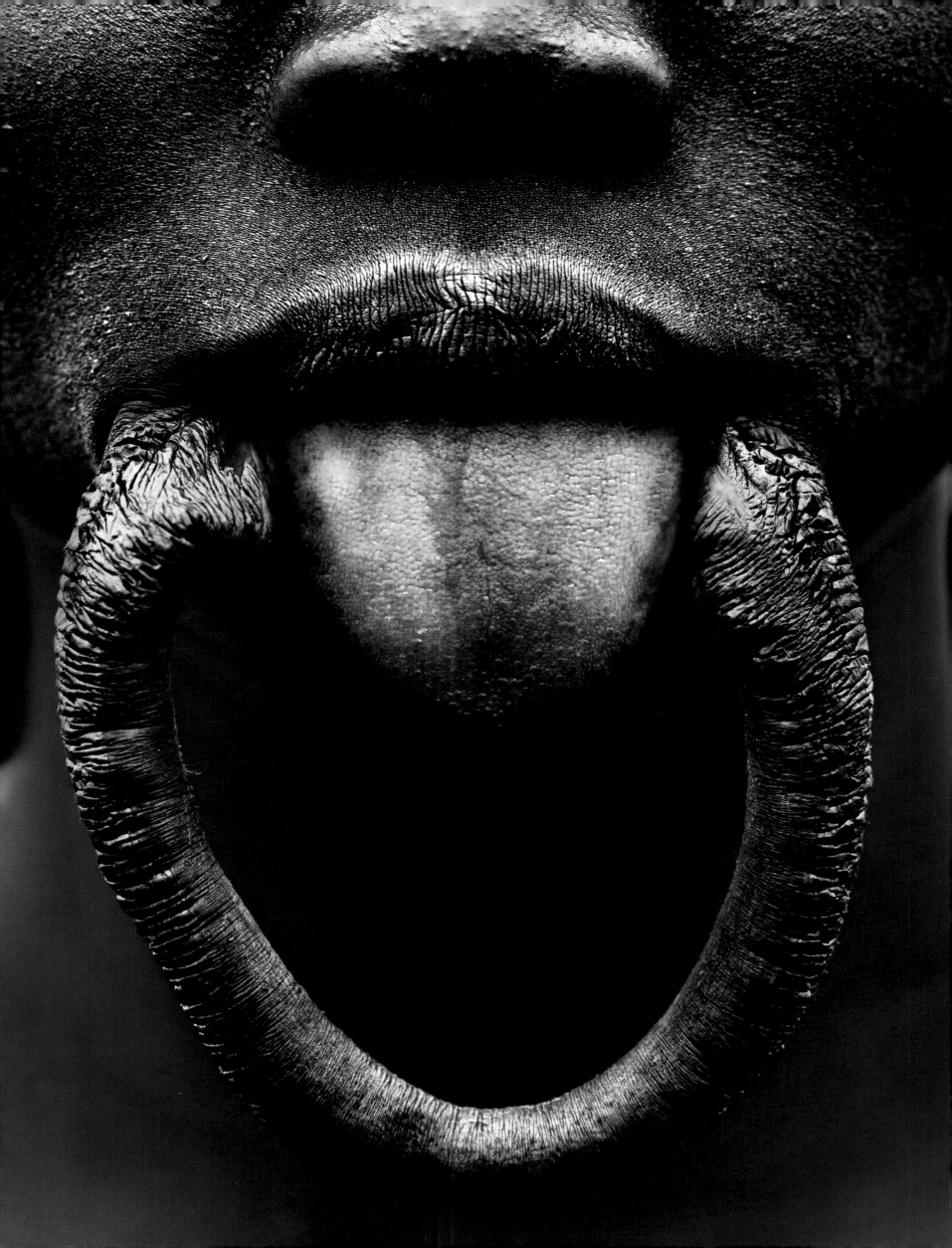

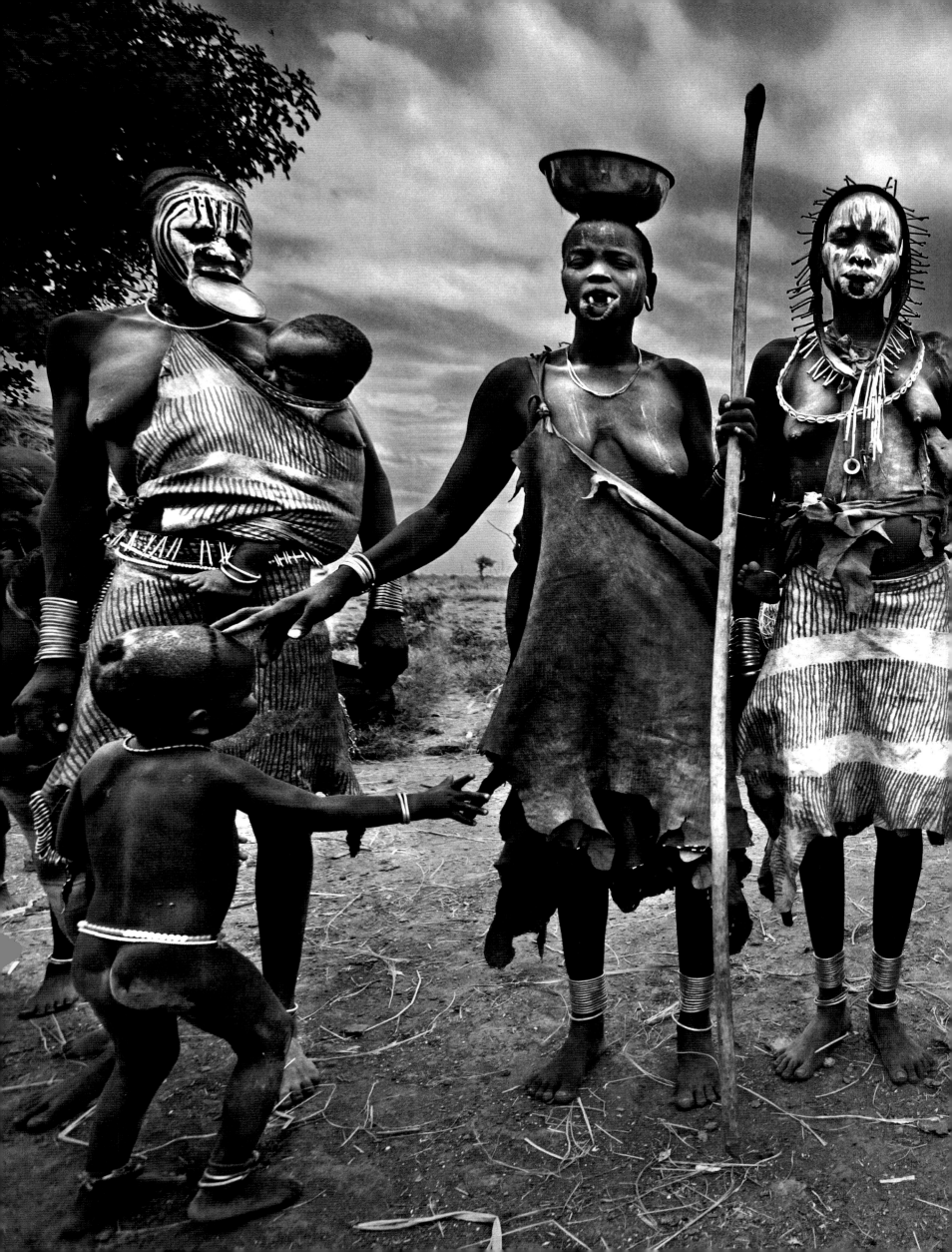

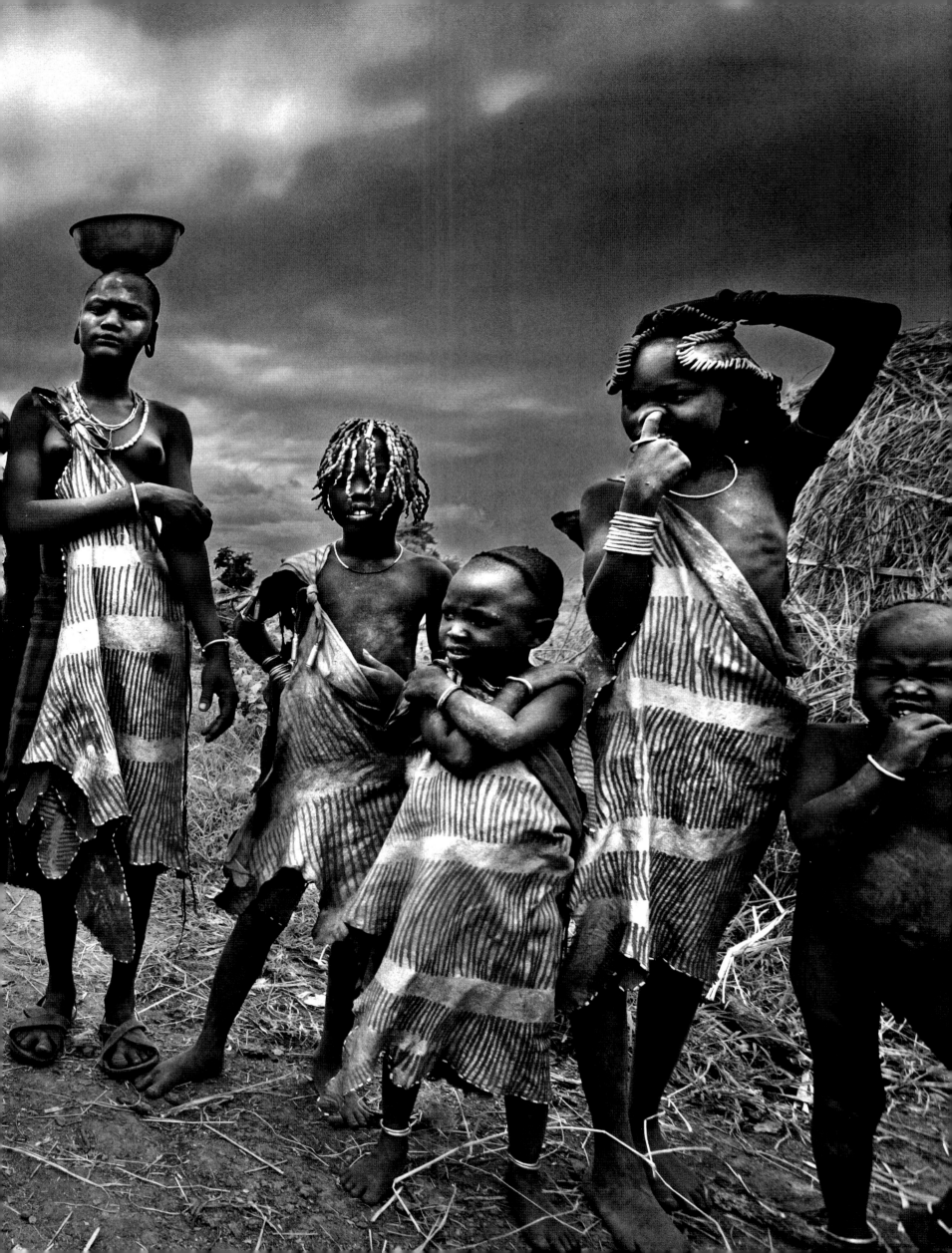

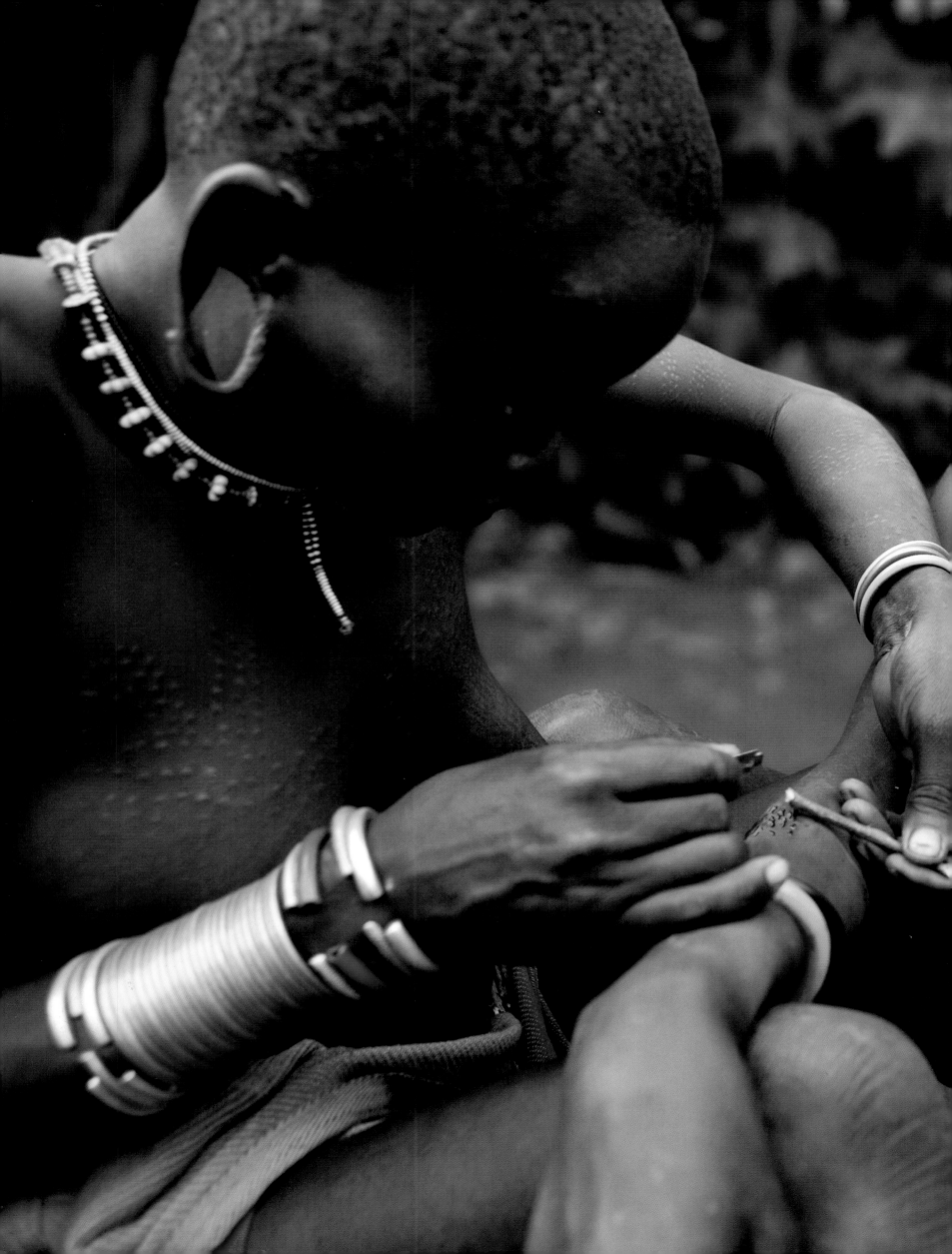

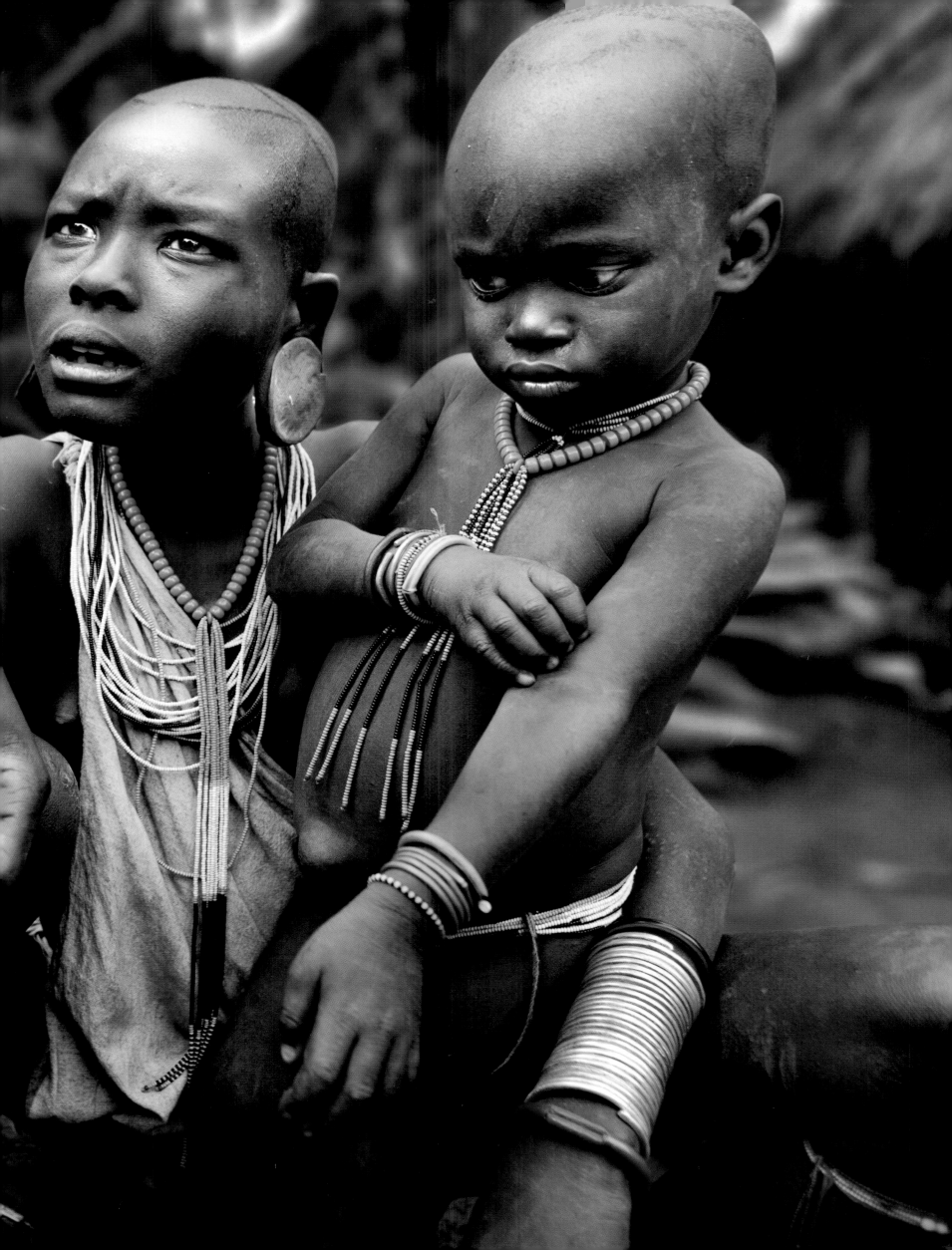

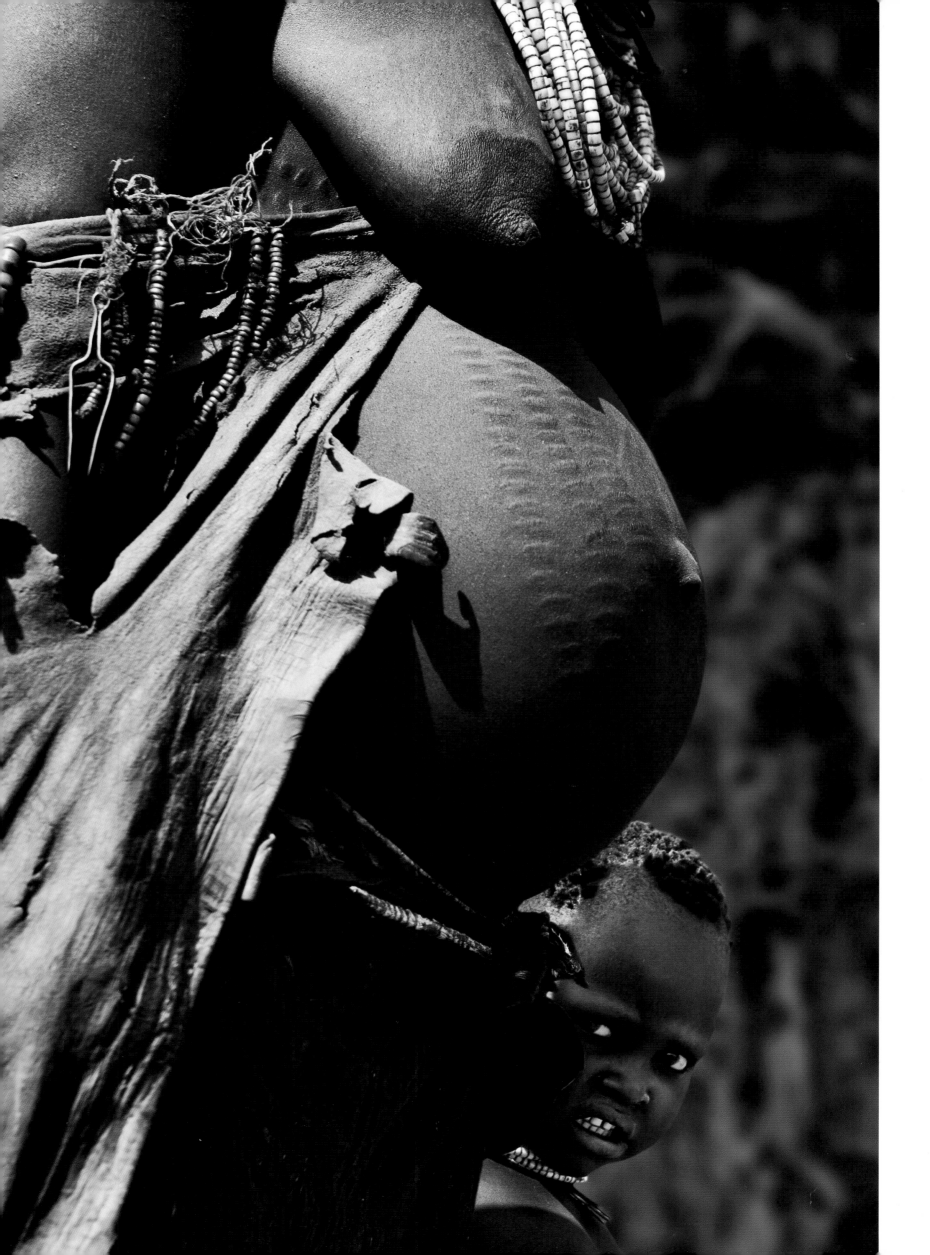

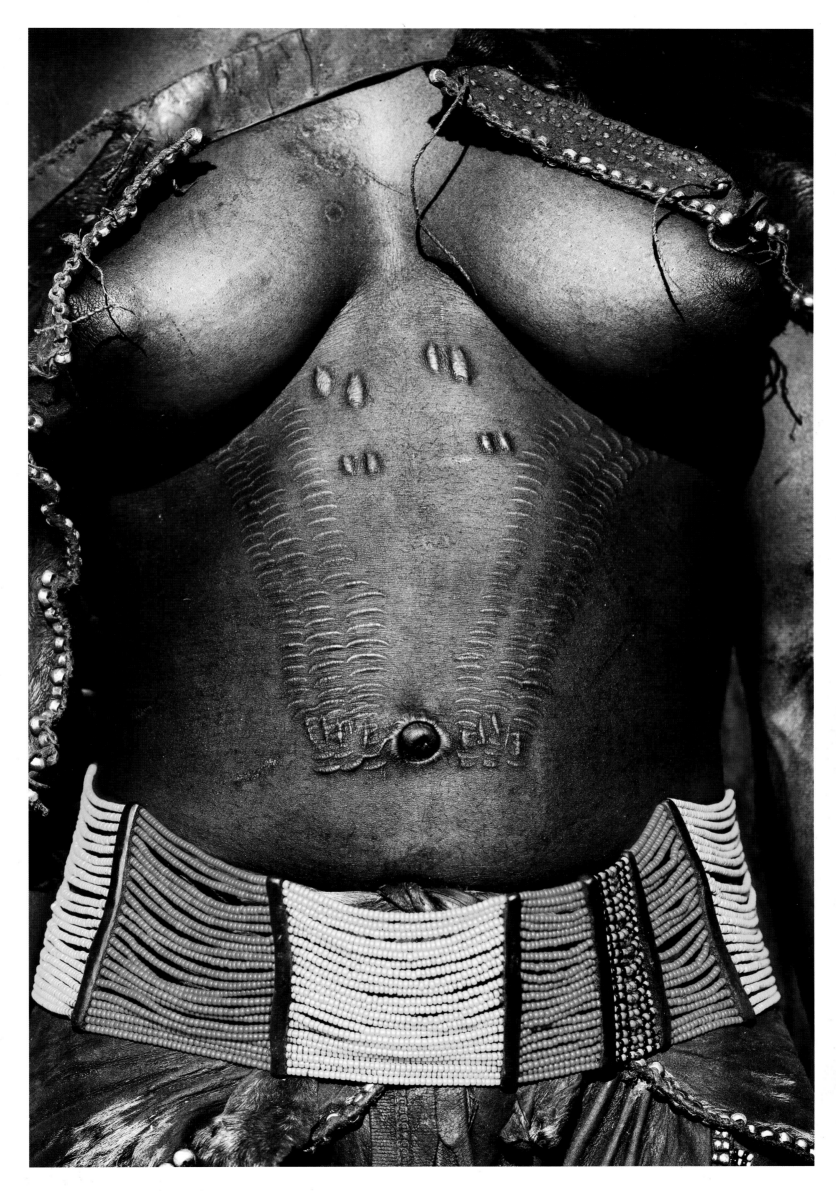

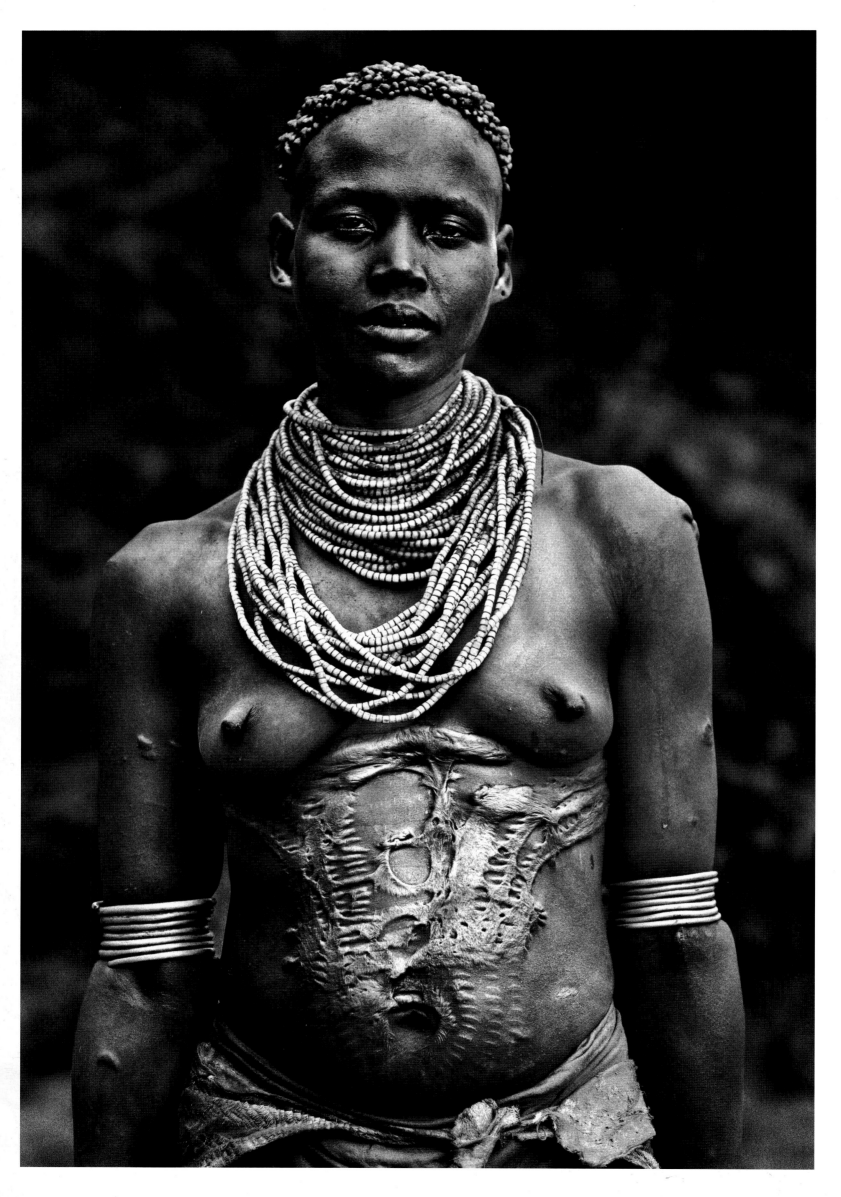

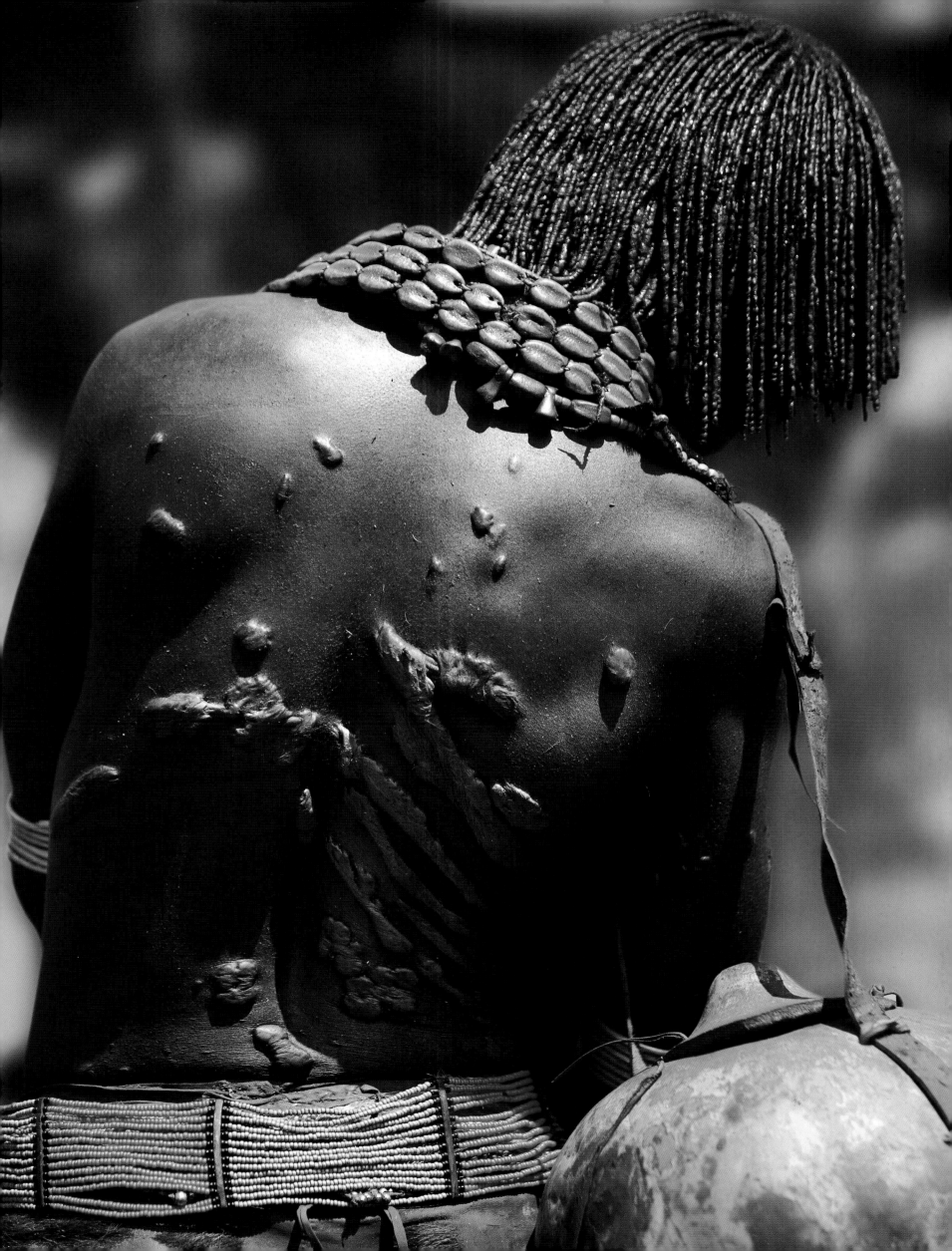

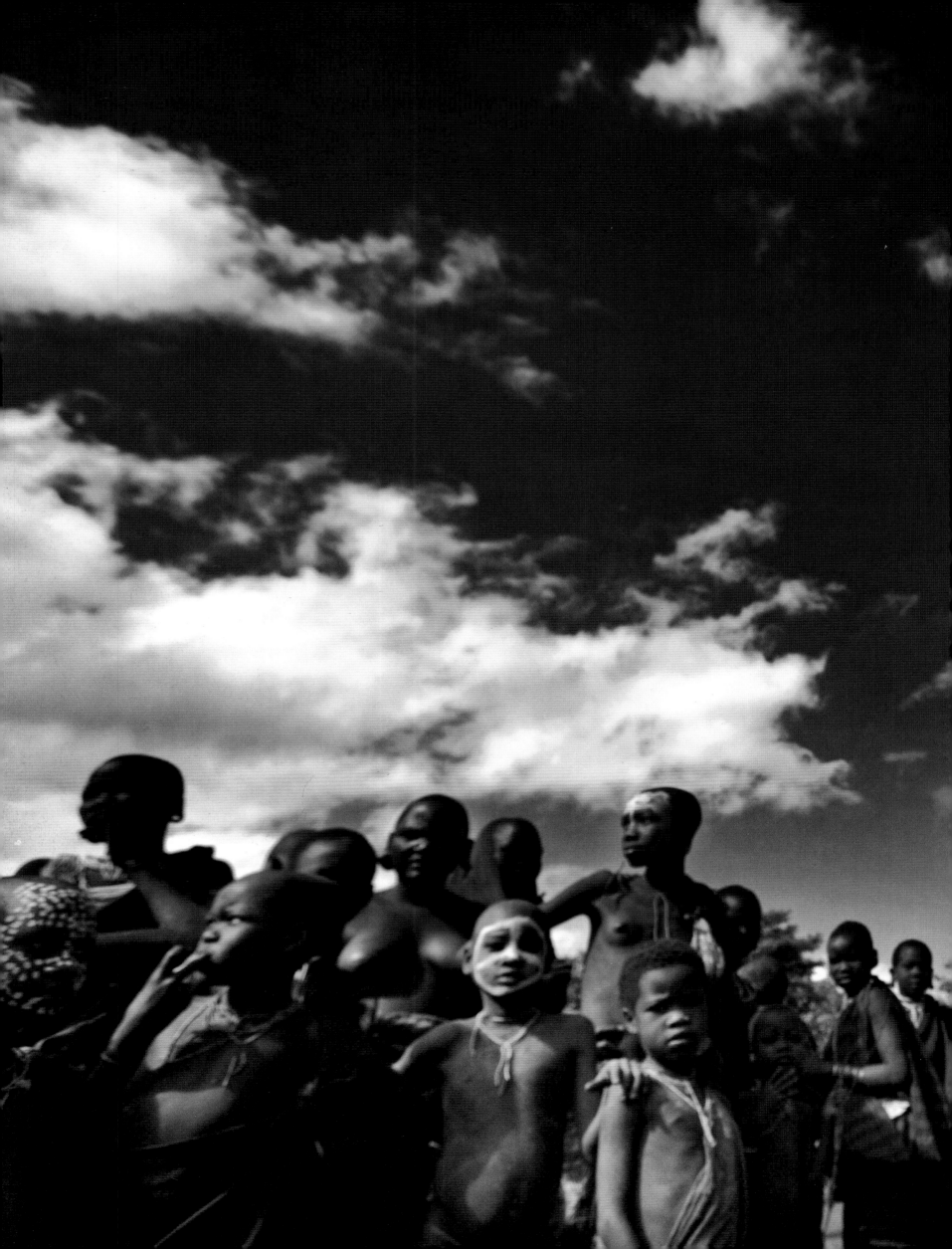

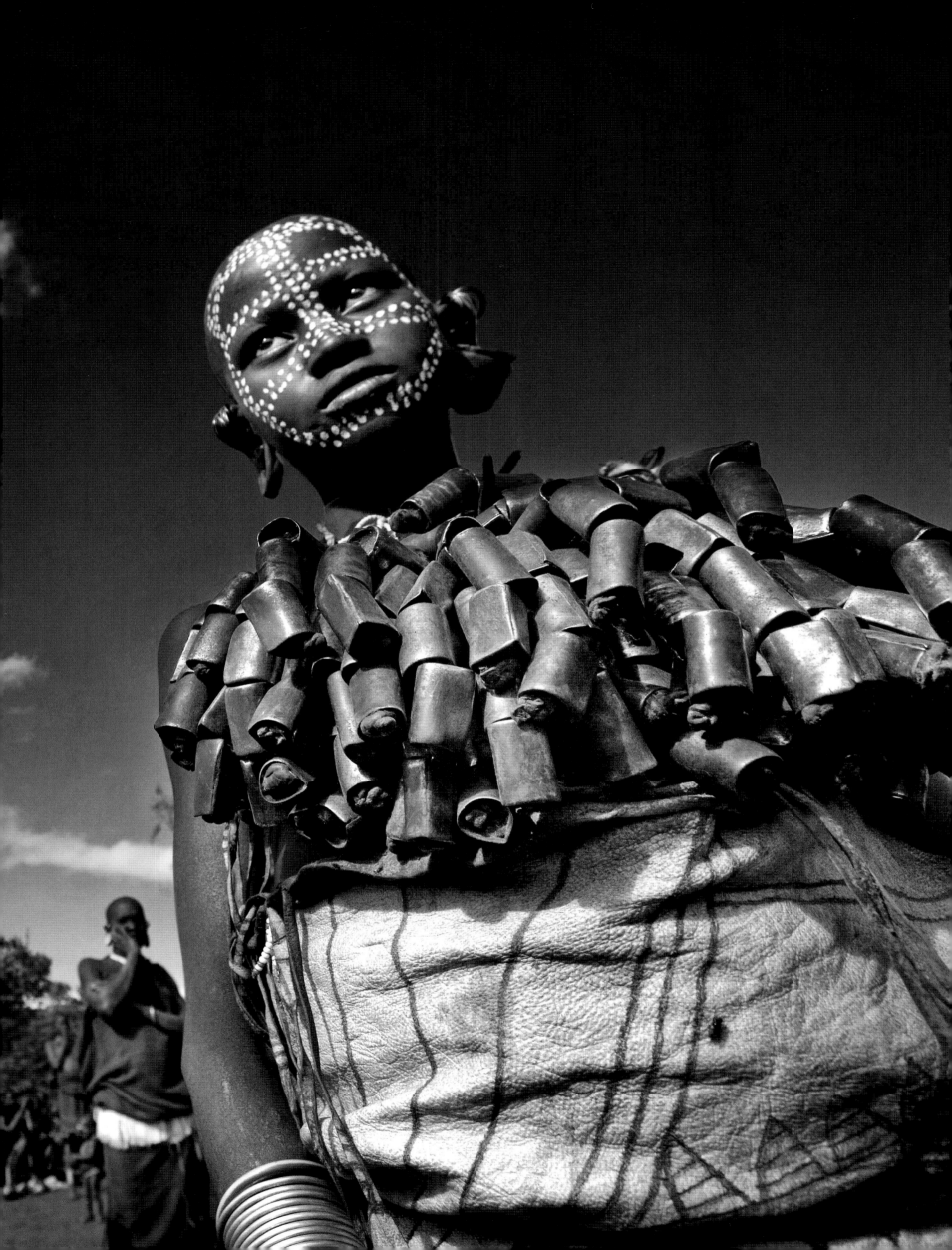

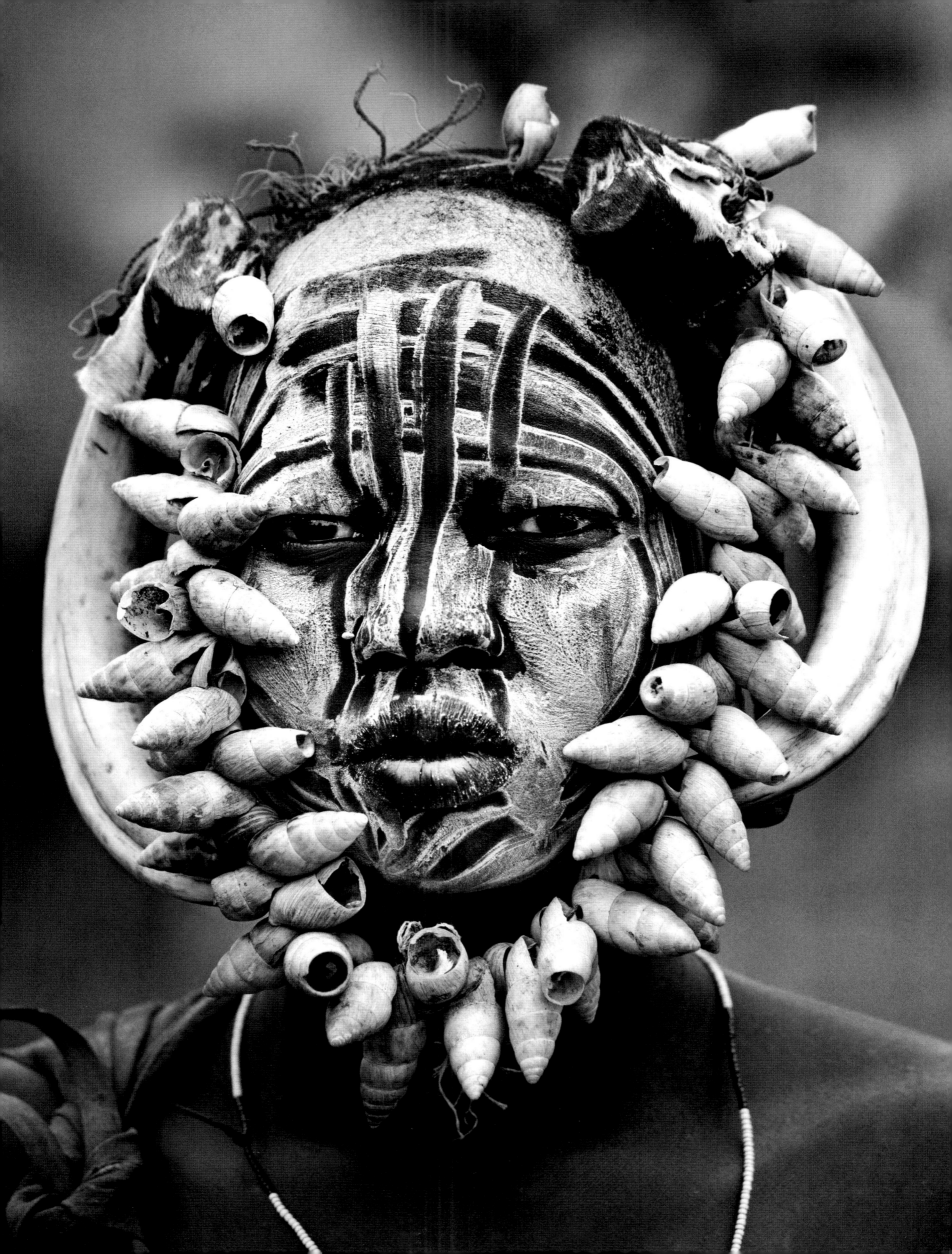

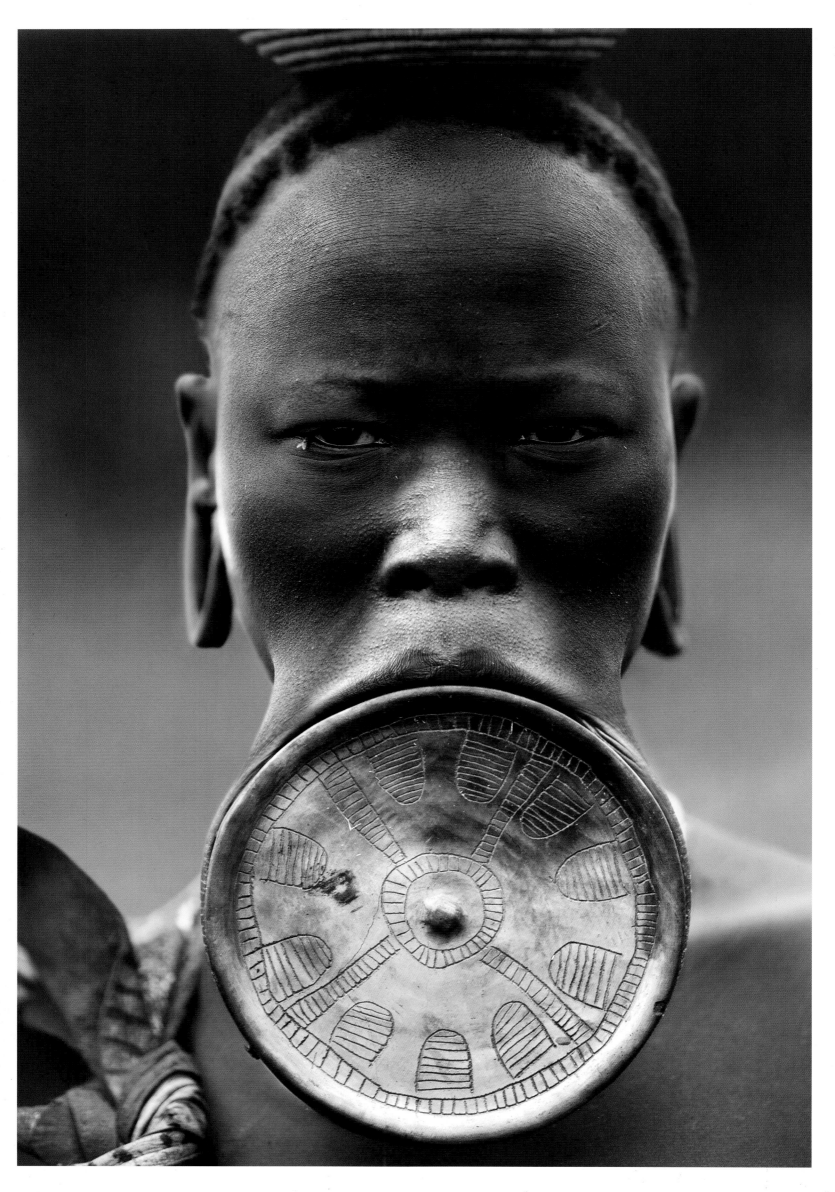

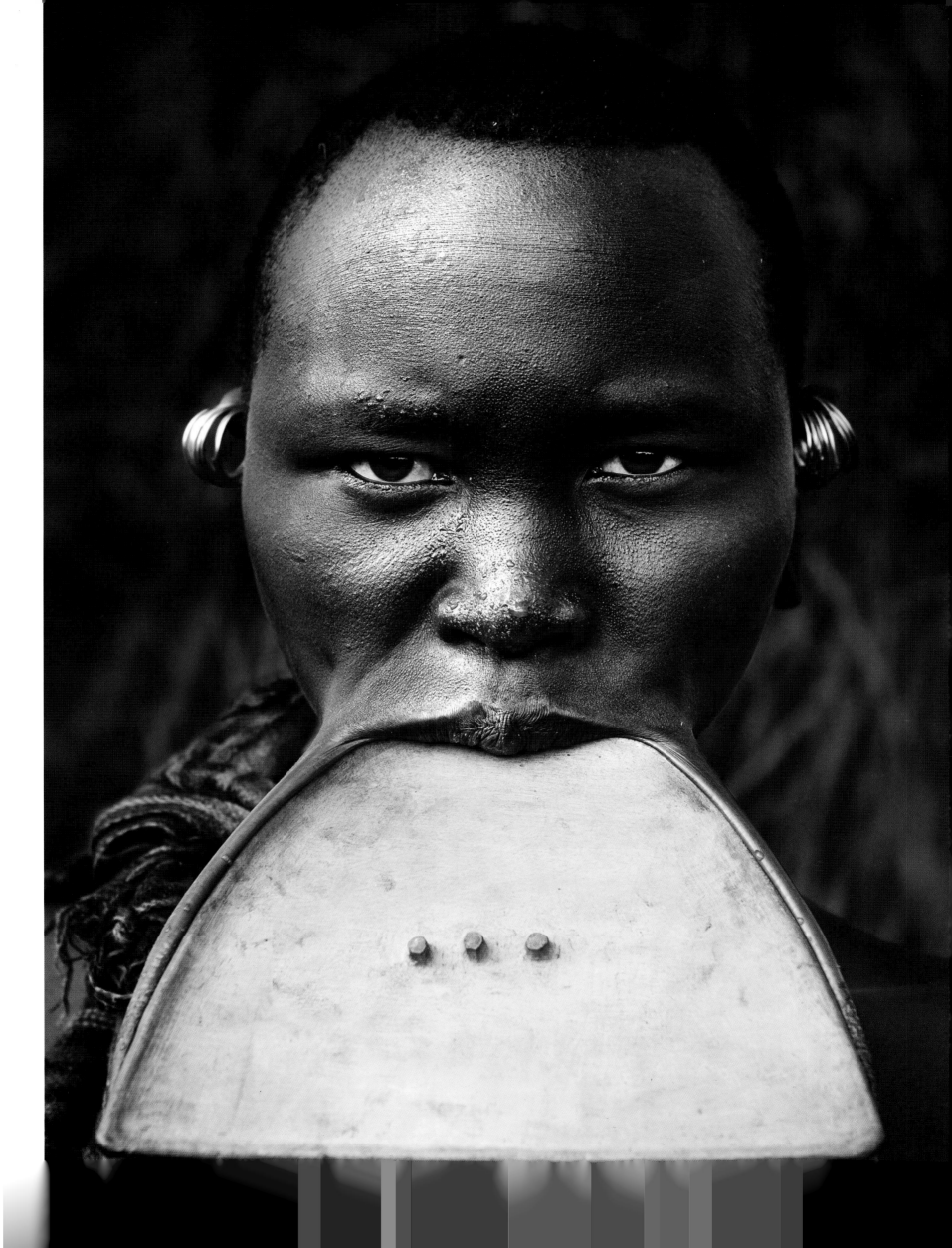

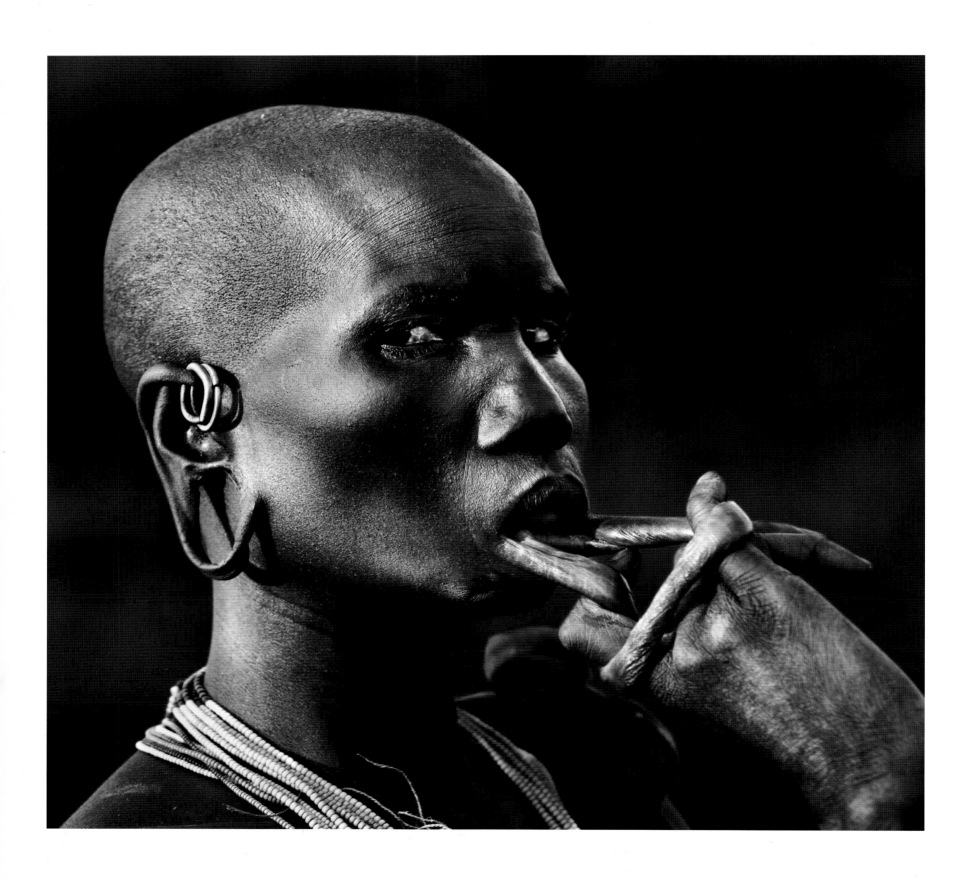

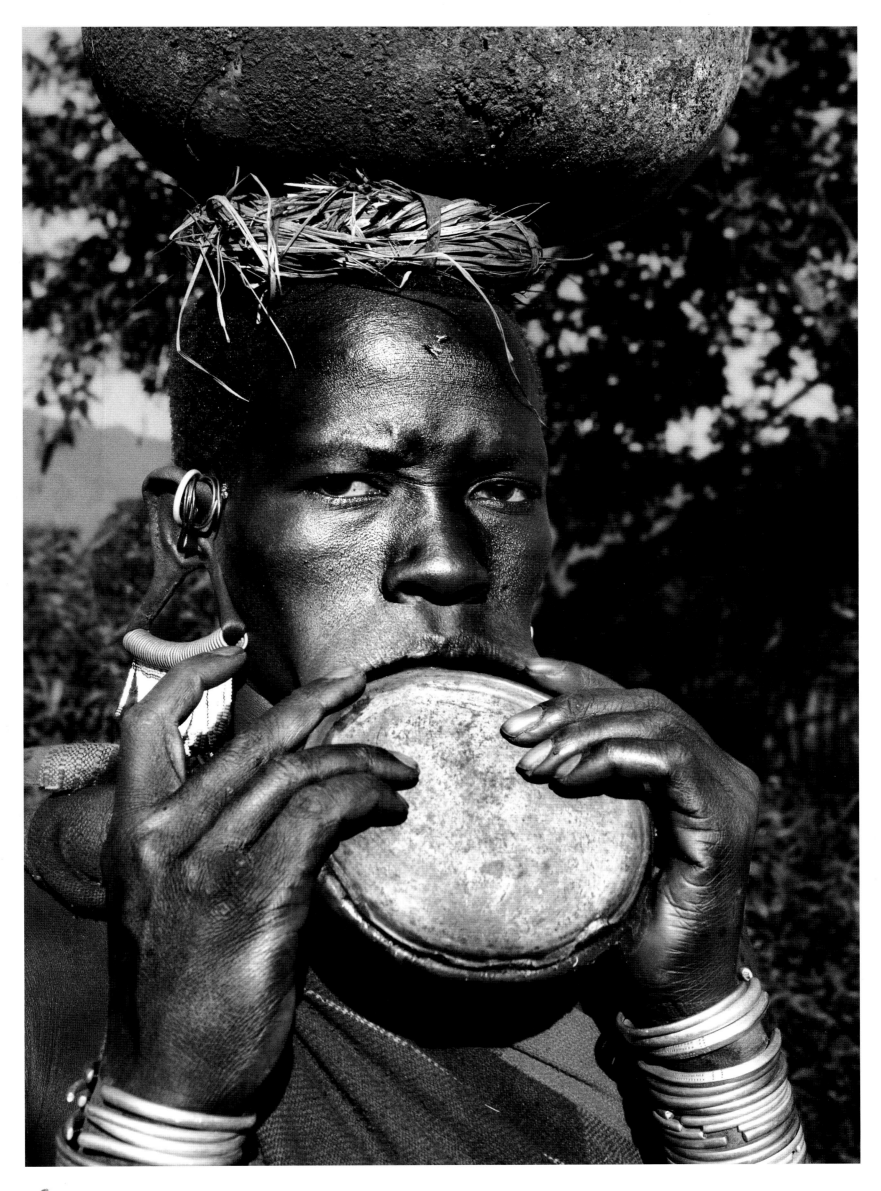

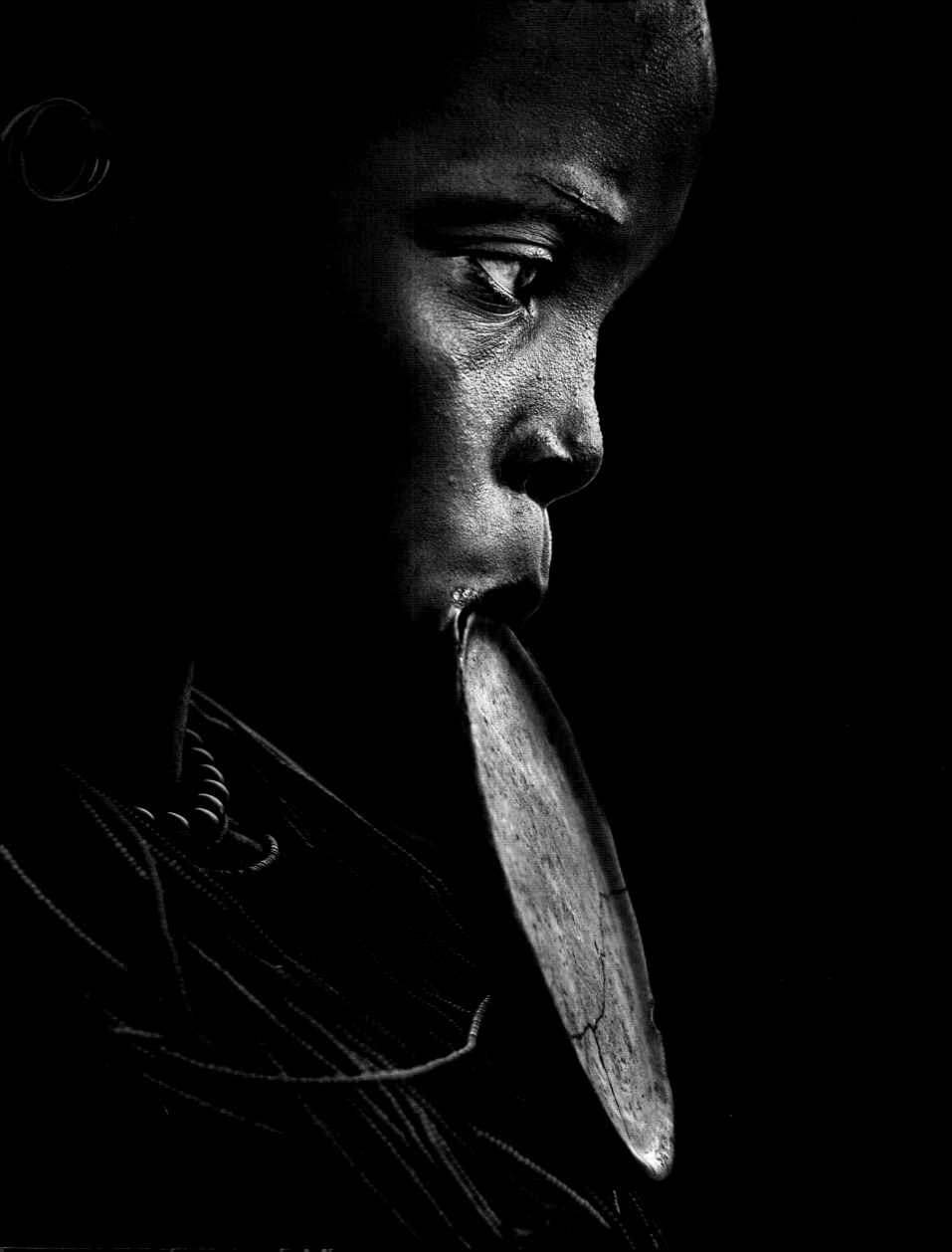

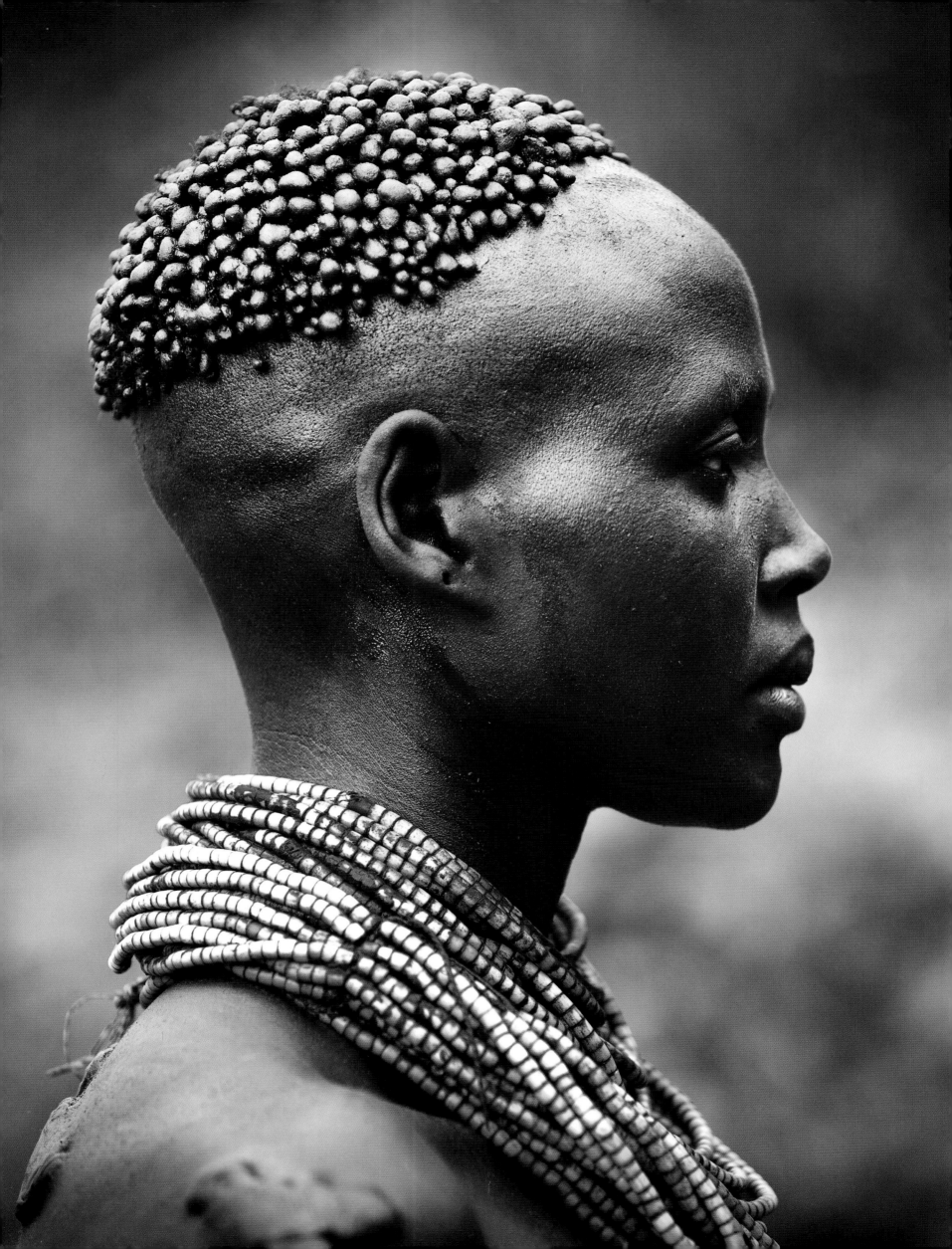

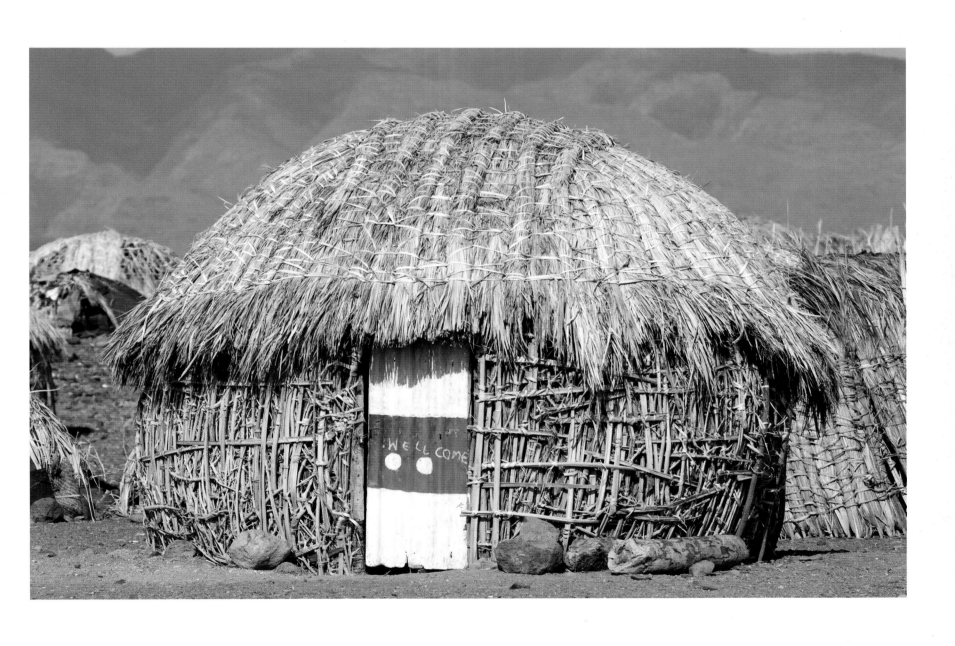

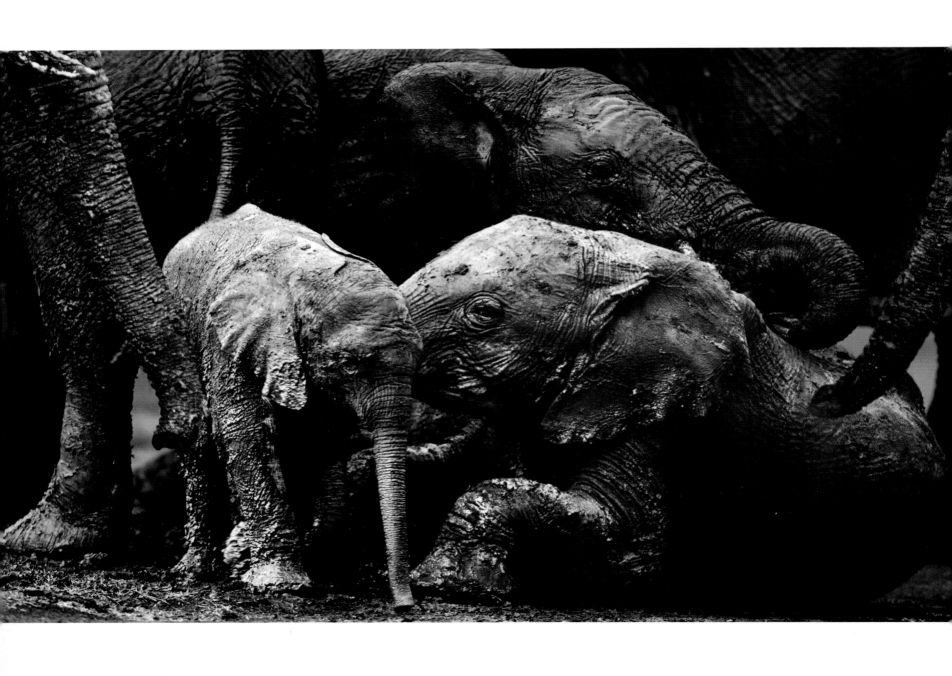

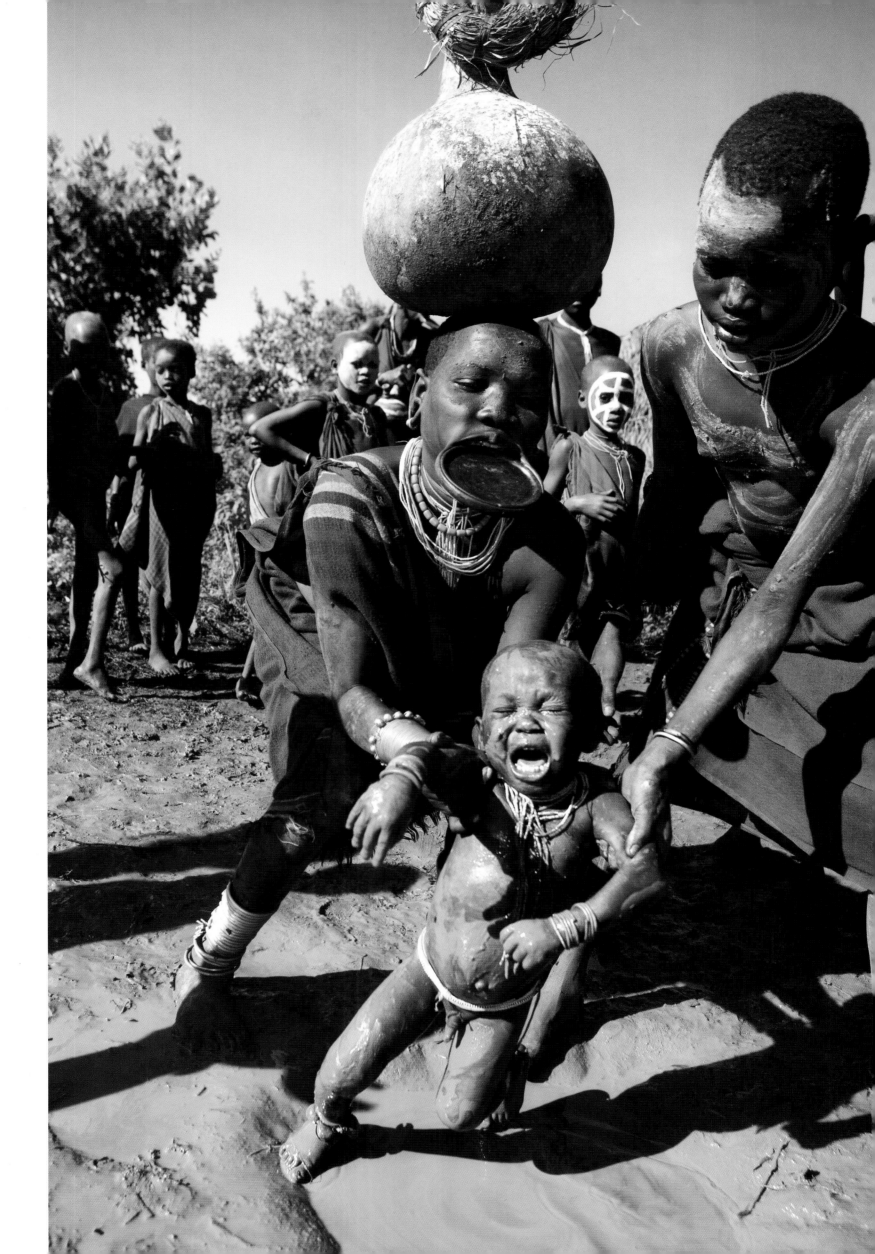

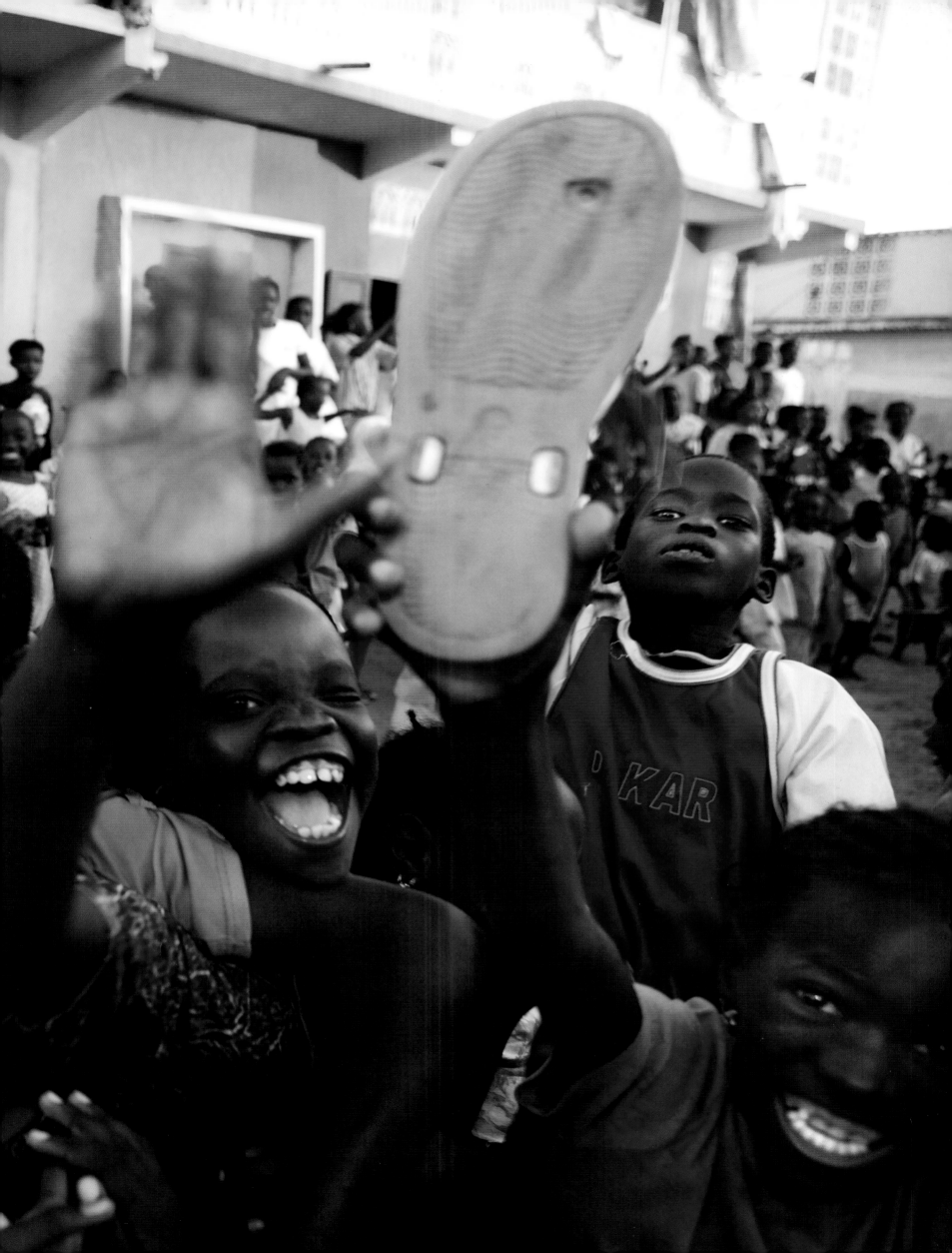

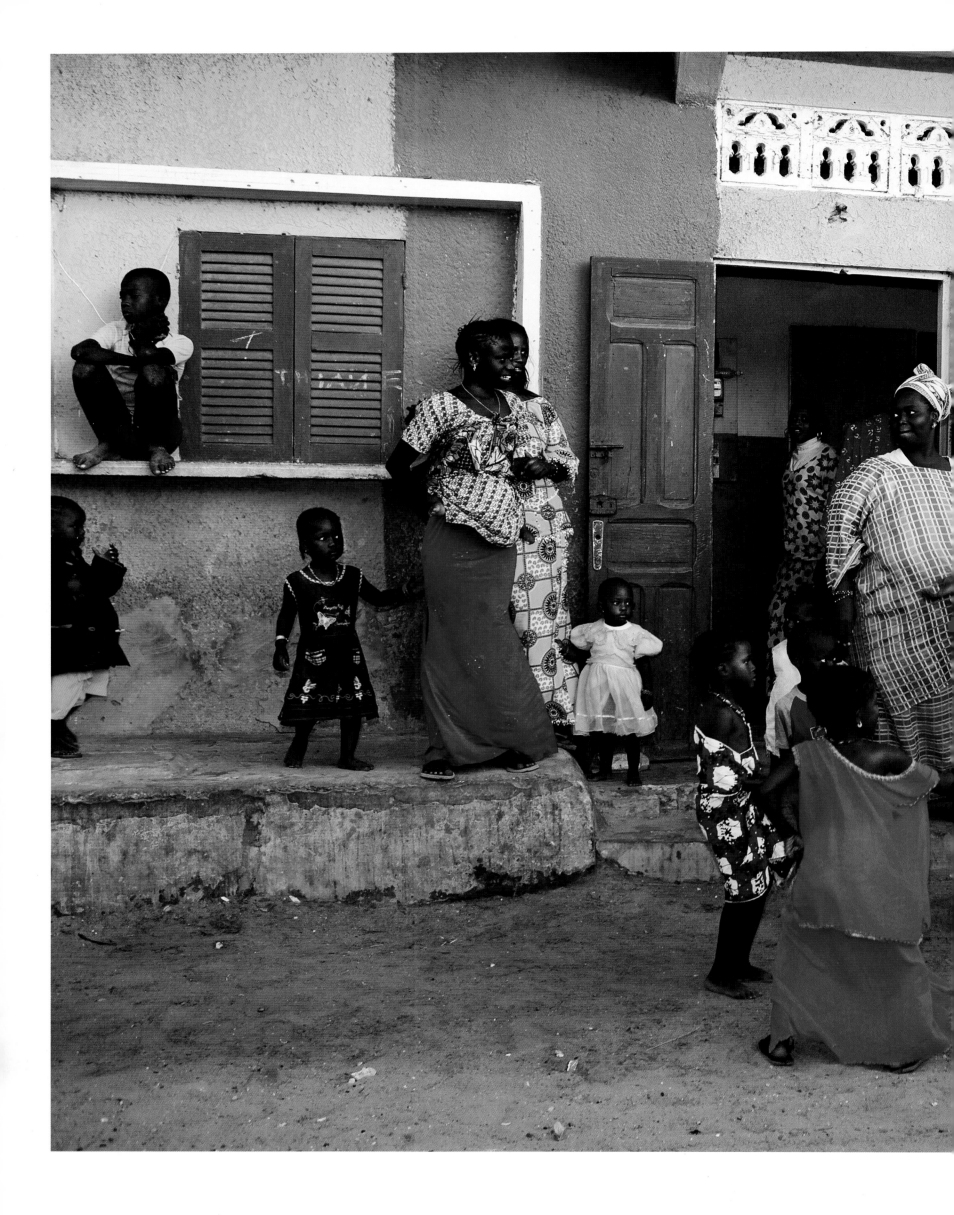

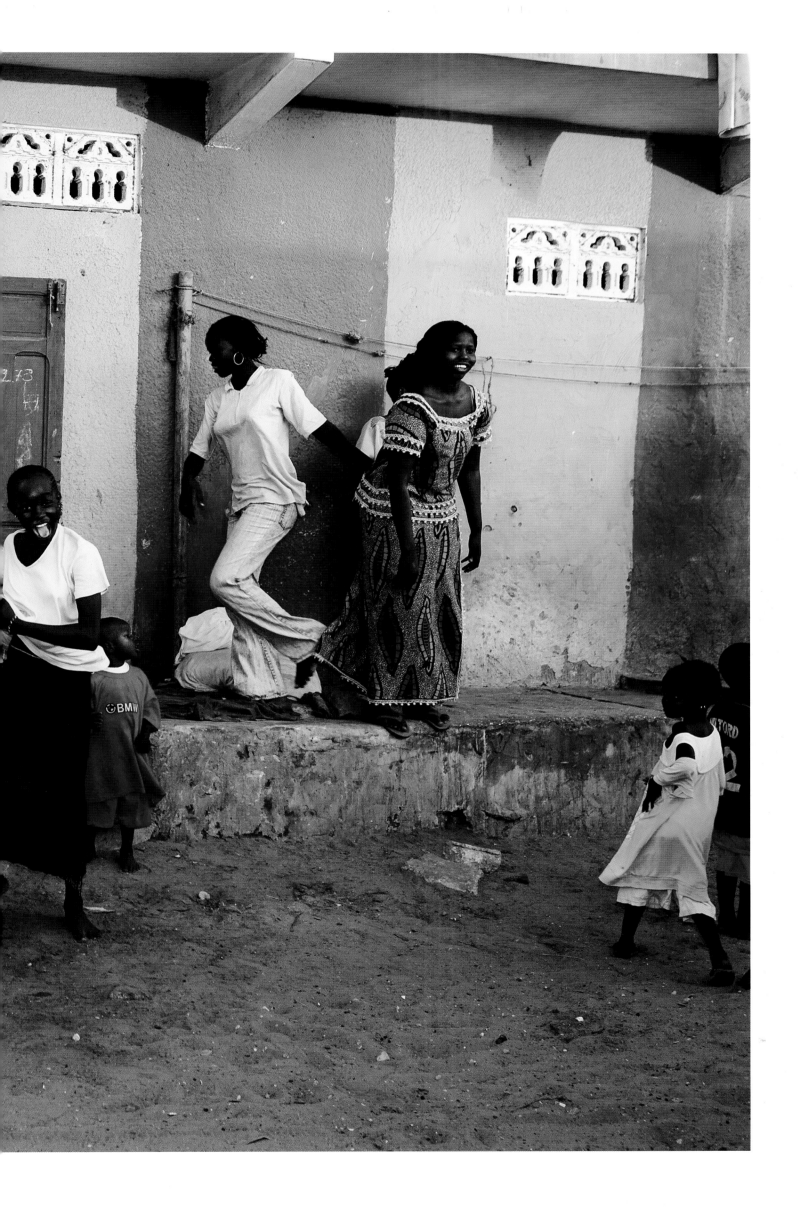

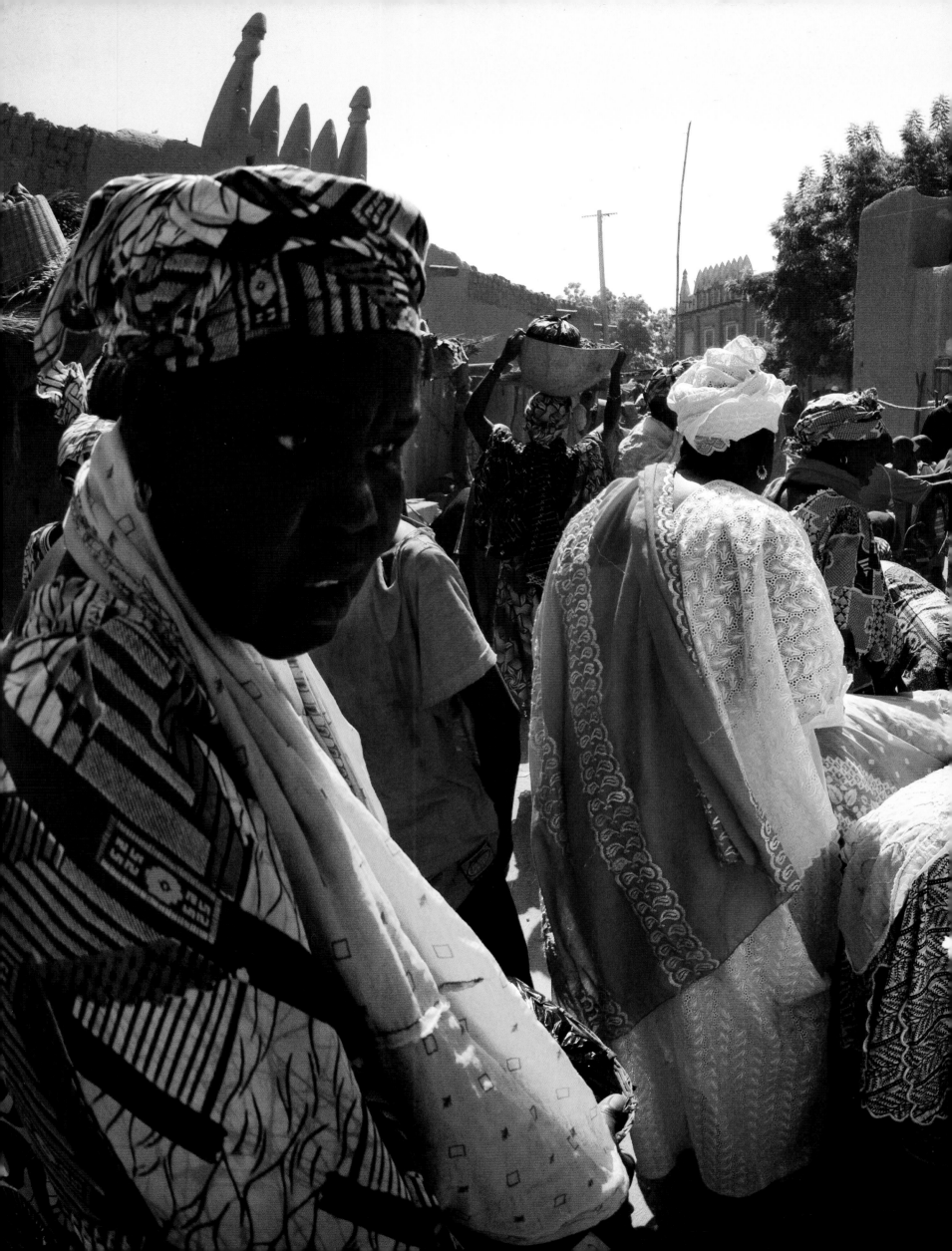

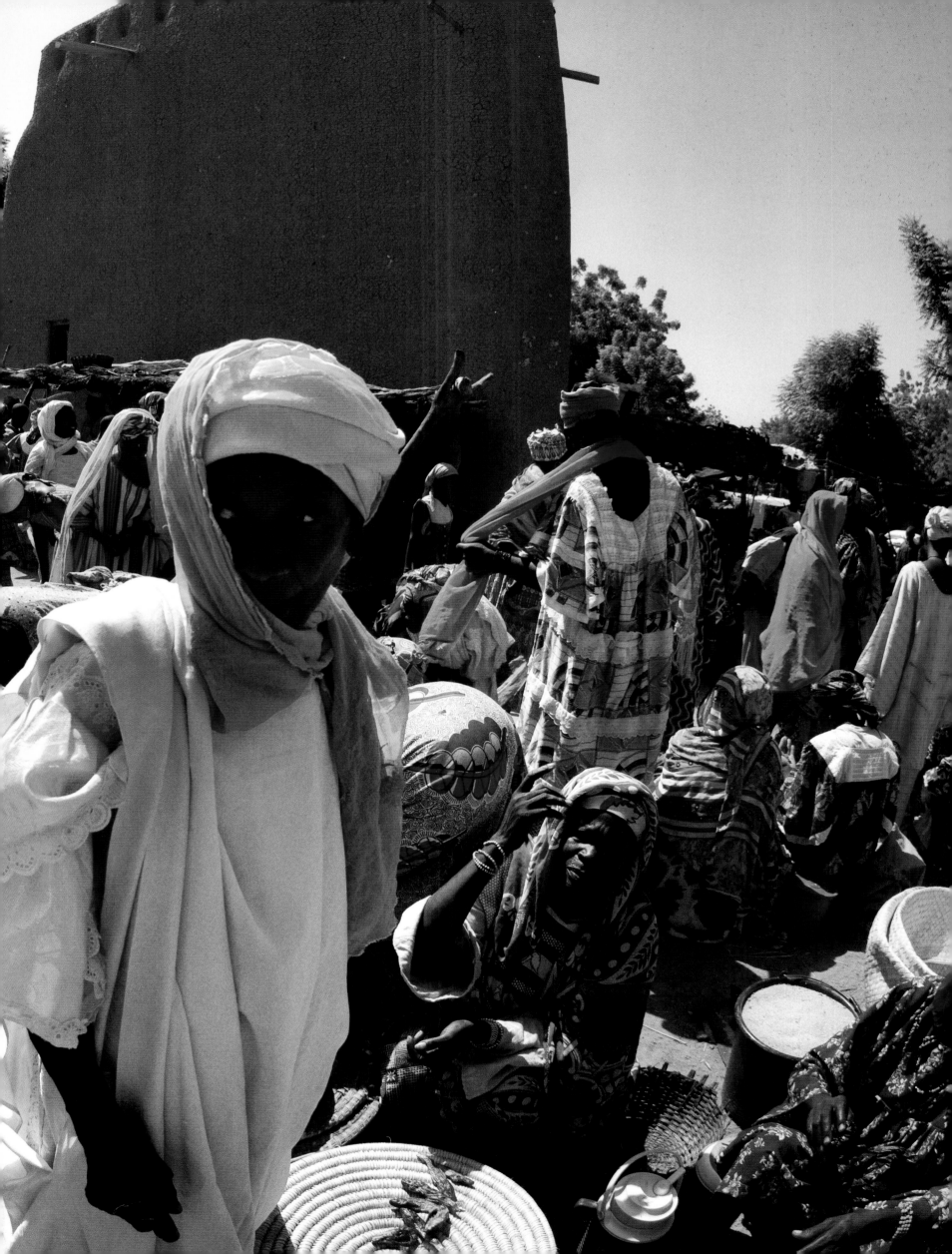

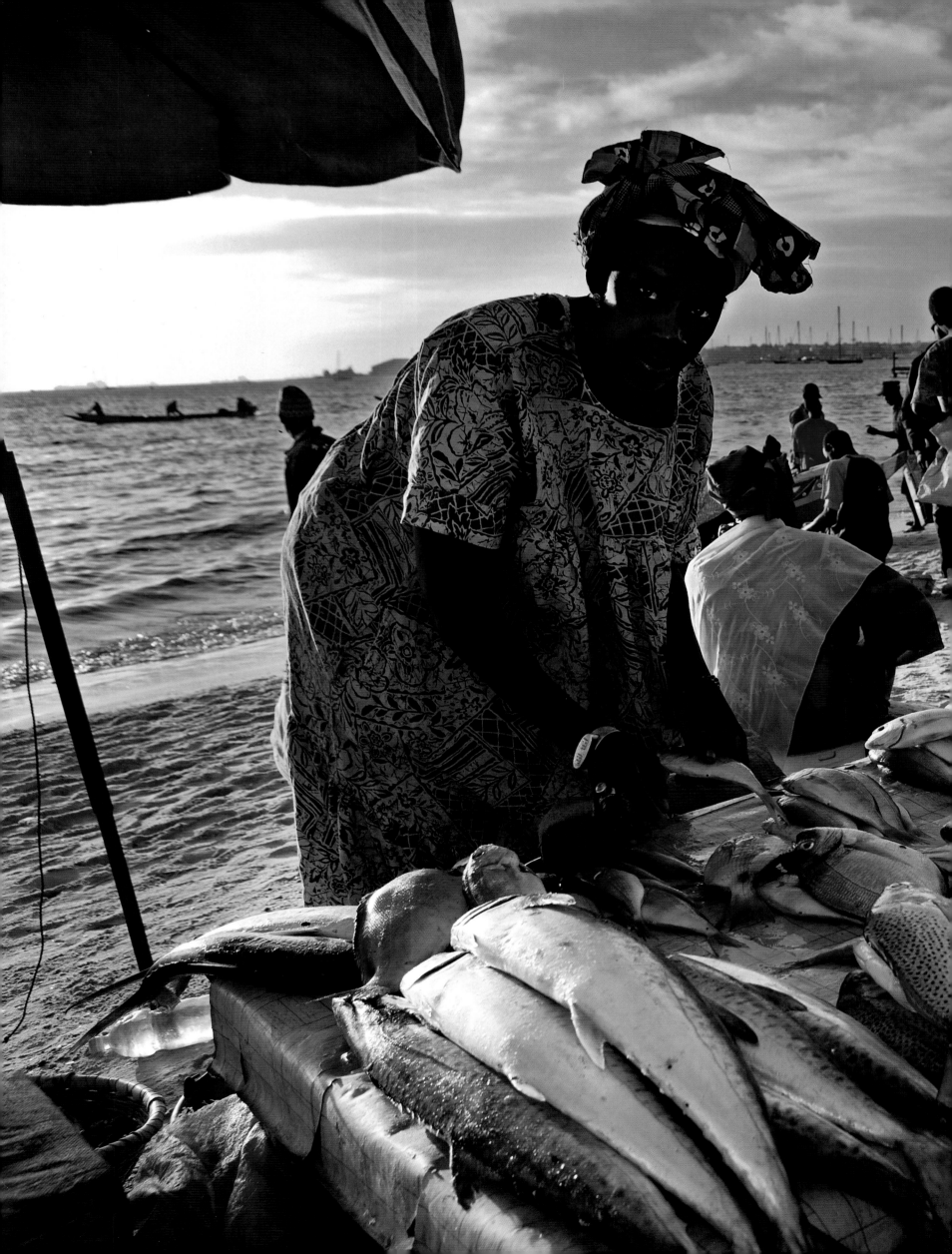

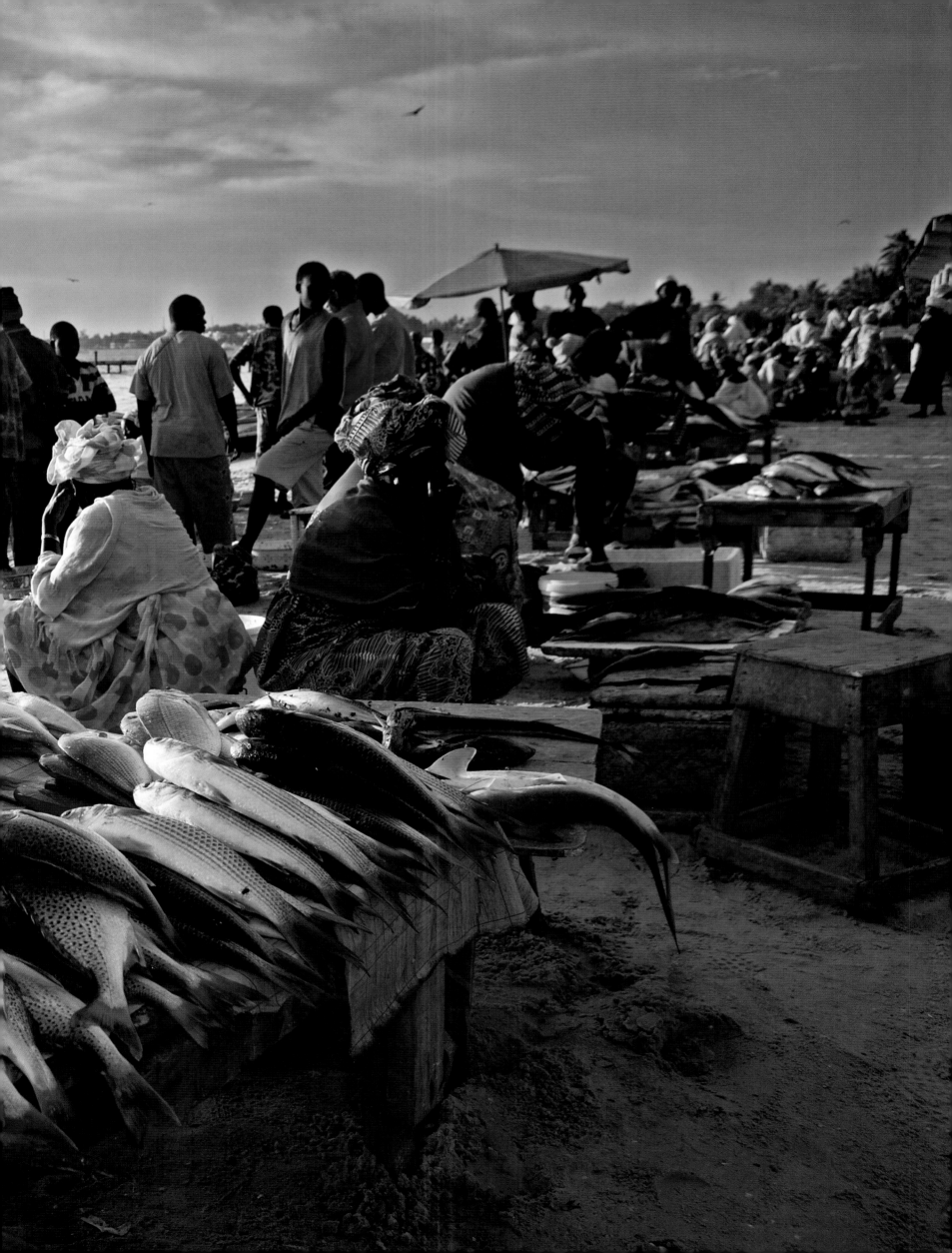

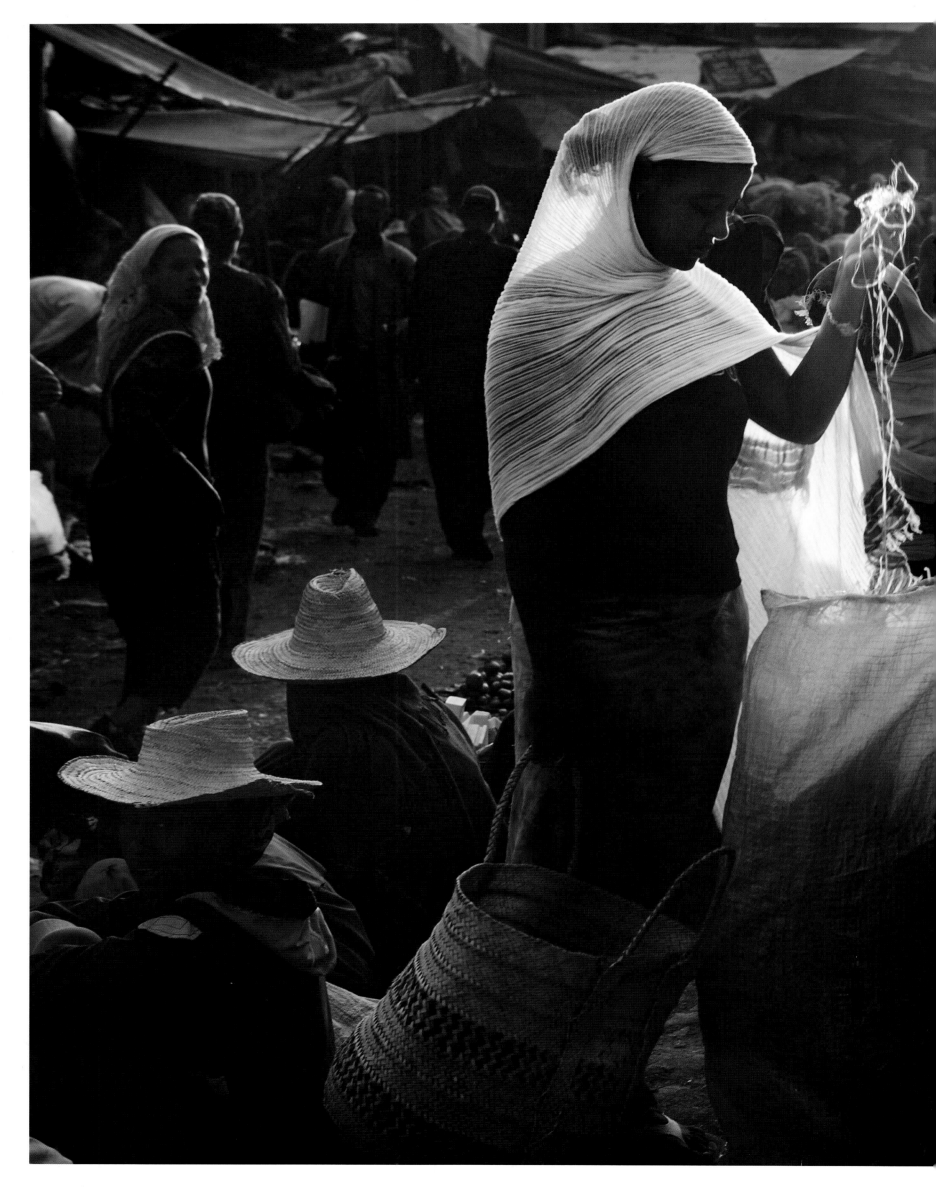

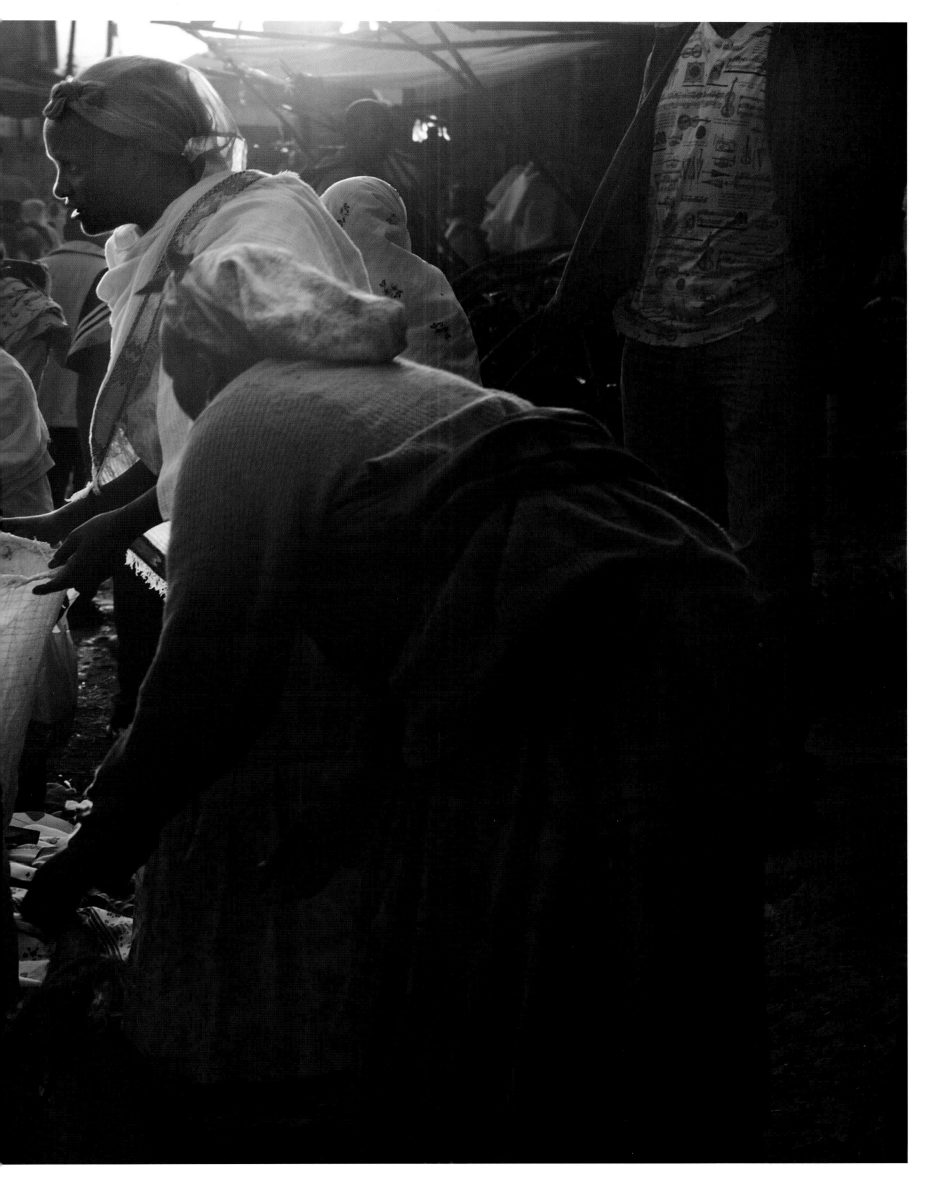

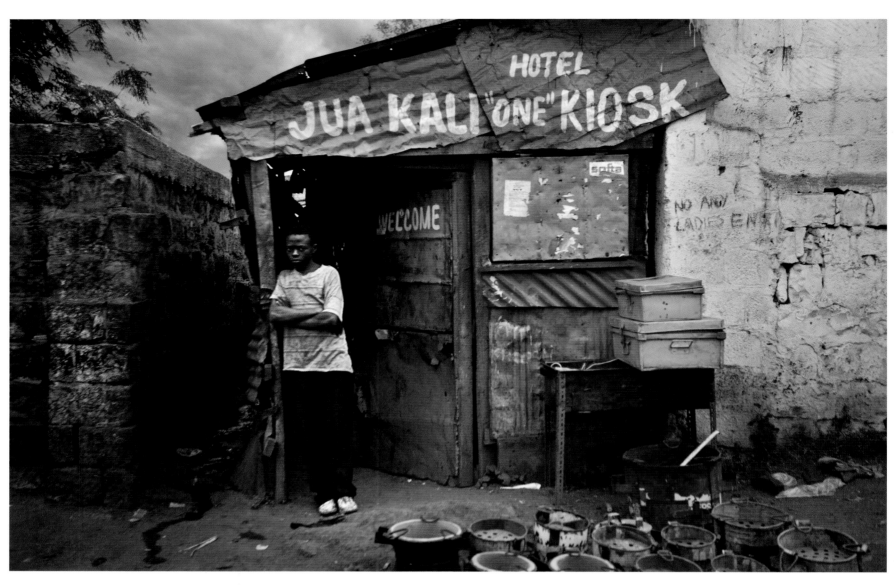

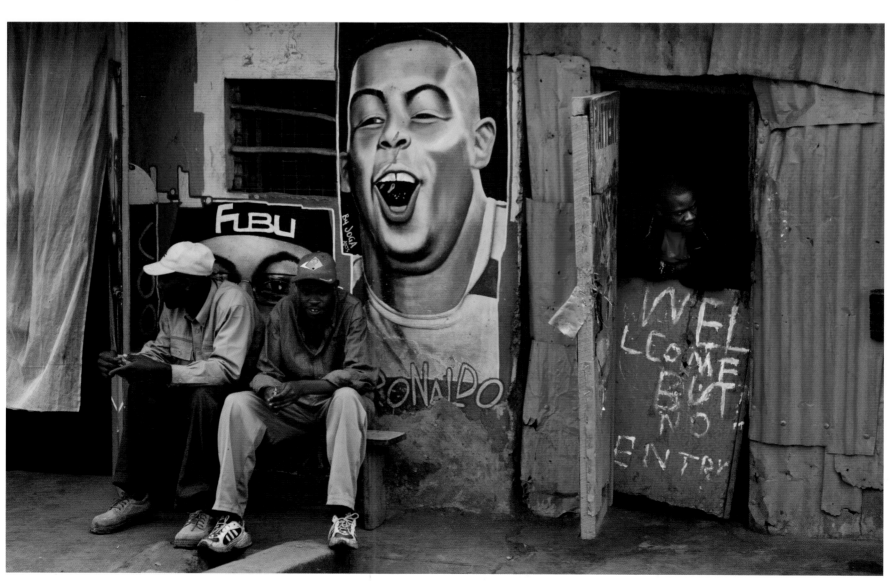

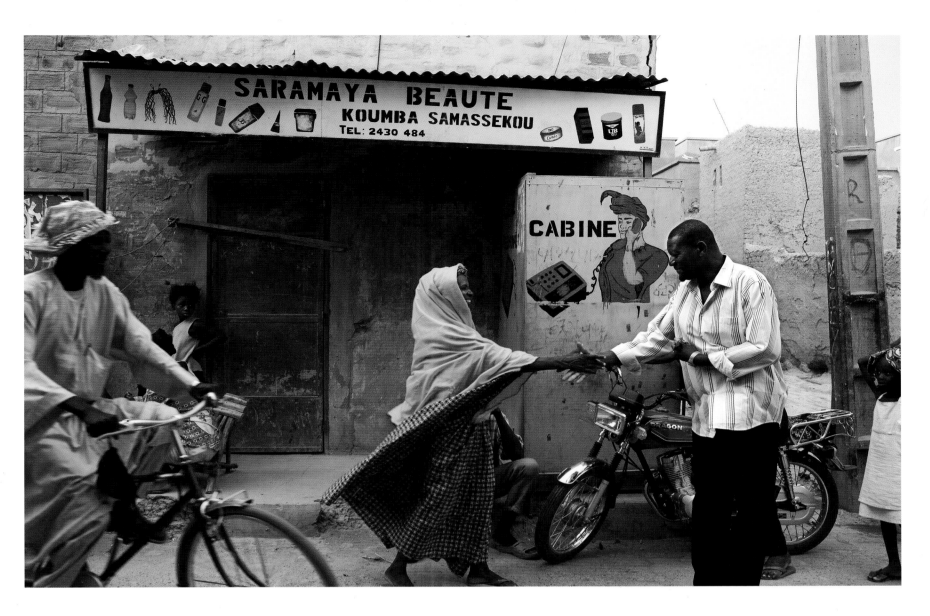

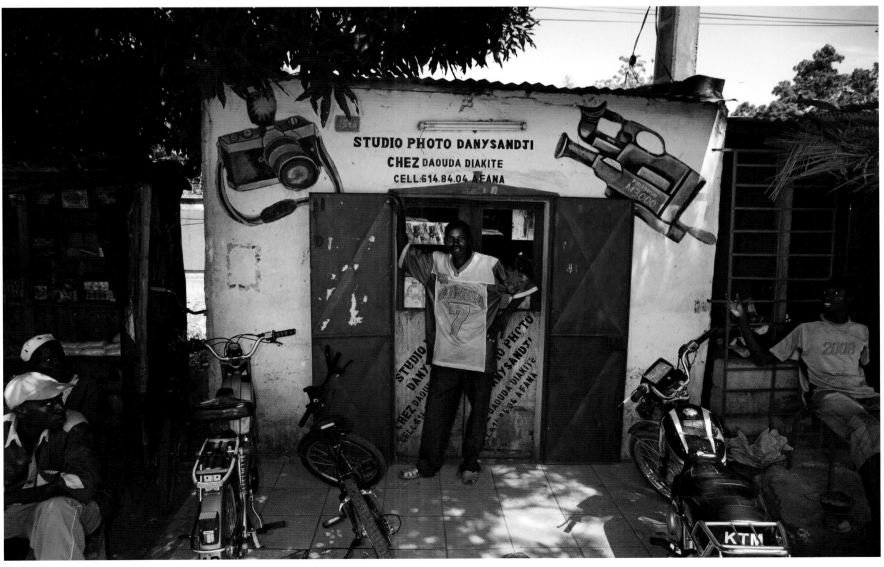

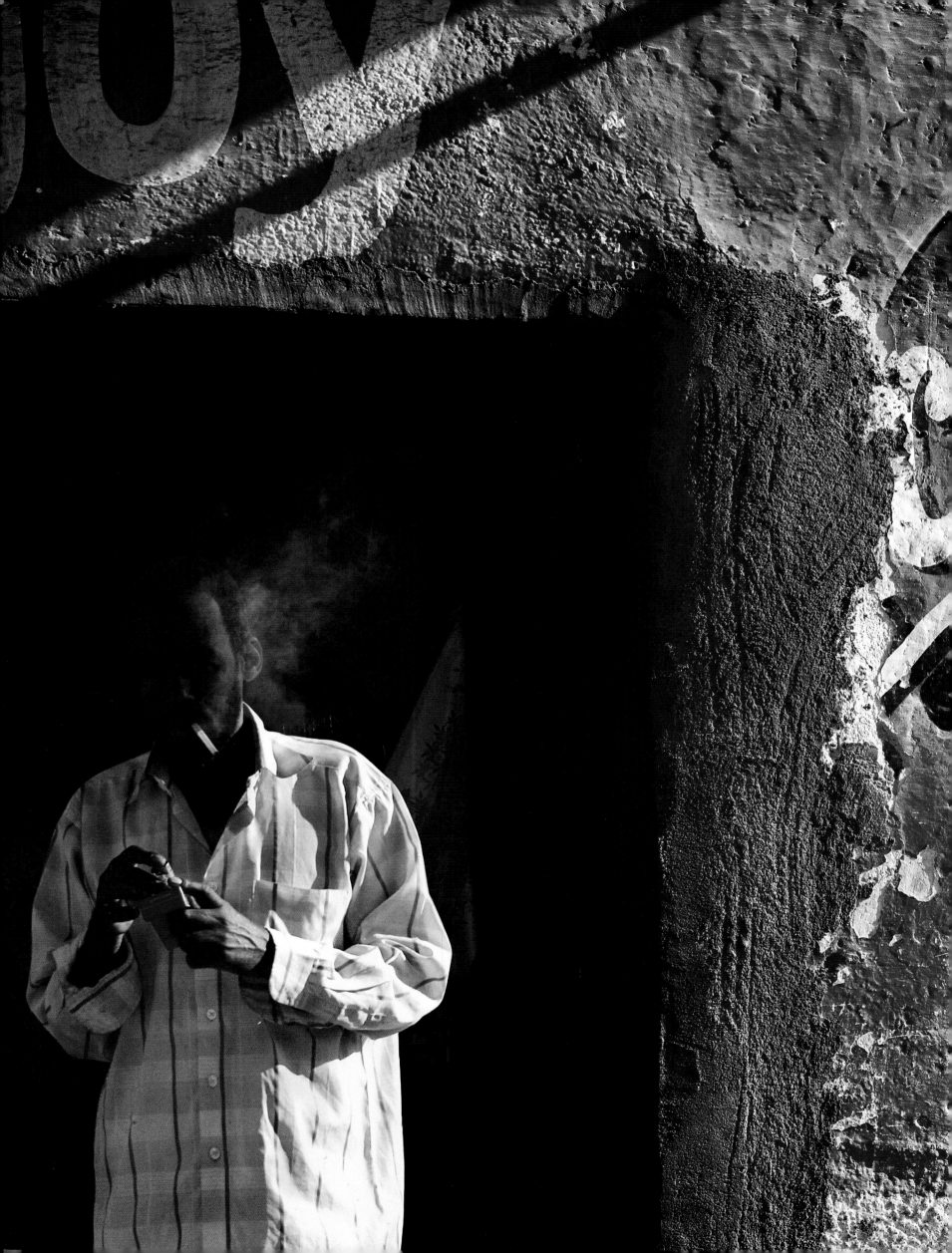

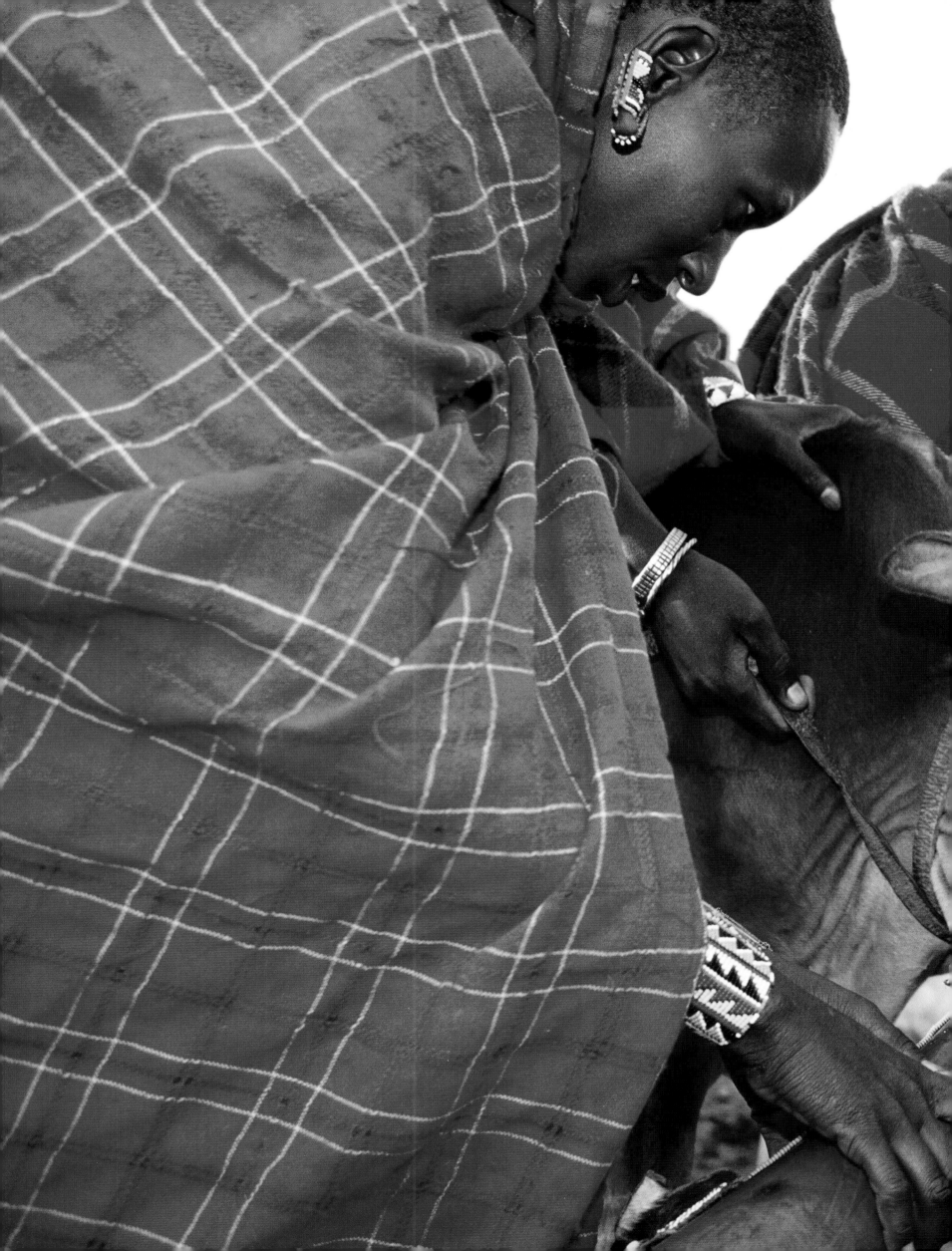

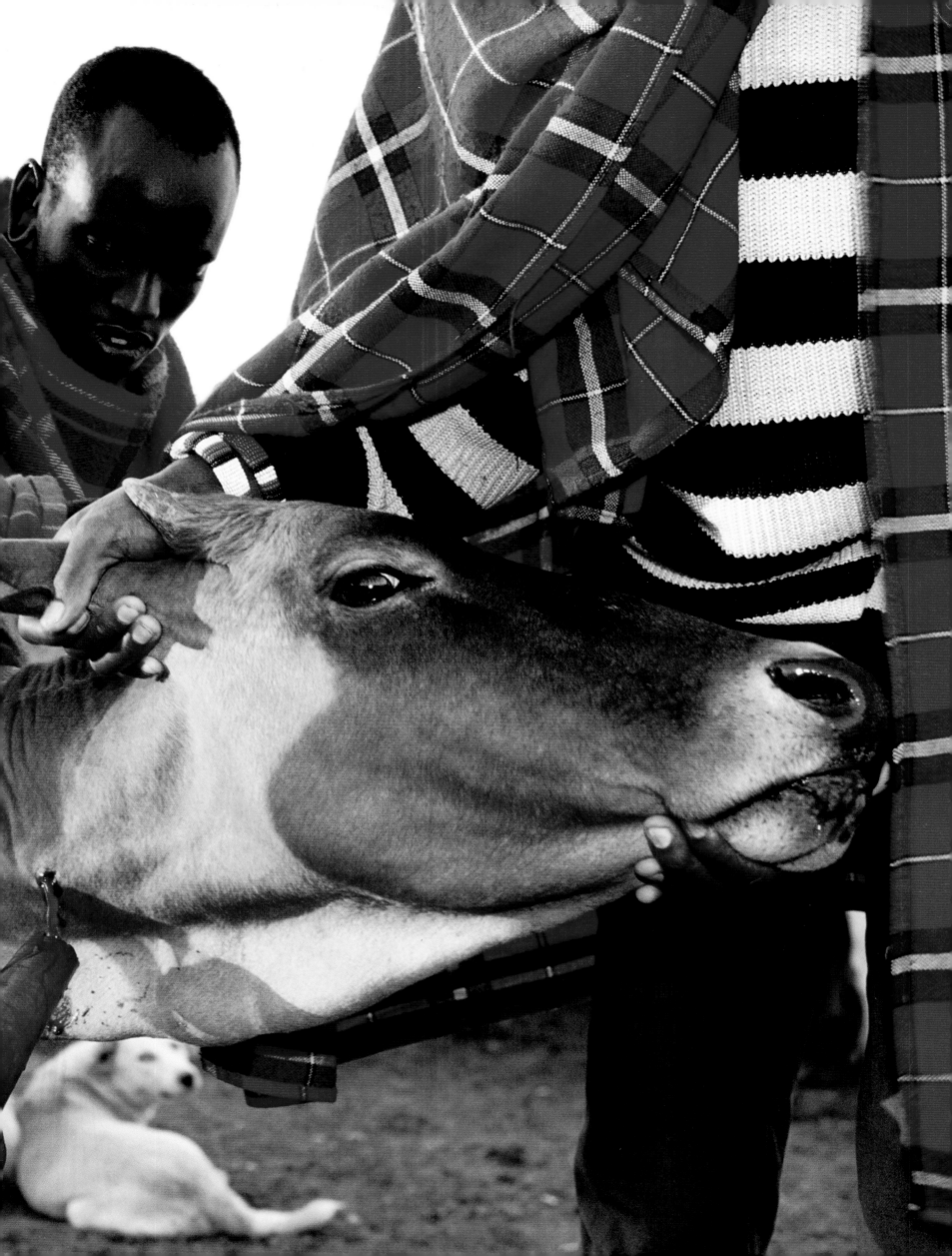

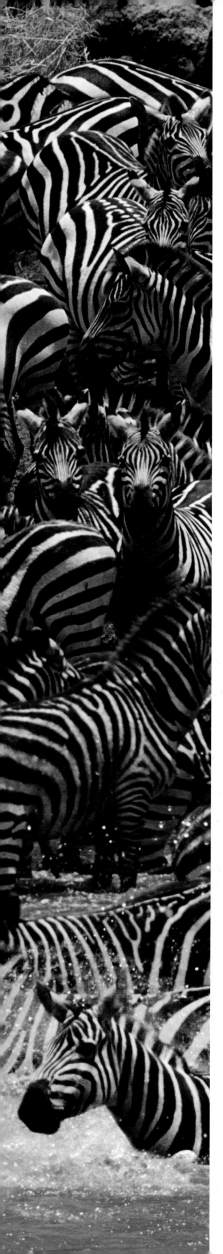

STRUGGLE FOR SURVIVAL

The Mara River is reposing. We wedge our Land Rover between dried-out shrubs on a cliff and look down at the lazy water. For ten days we've been coming here; munching sandwiches in the sun while waiting, wearily. A crocodile lies on the opposite bank, motionless as a corpse. Morning teatime comes and goes, then lunchtime, but he does not move. Just when I begin to believe that he is dead, he slips into the water and disappears.

I recognize some rocks from an old documentary film and replay the chaotic scenes in my head. The crocodile catches the wildebeest, over and over again – a continuous film loop, bright and flickering, same old scratches in the same old places. We are spectators in a deserted amphitheatre, yearning for action.

The Masai Mara is scorched by drought. Lush green pastures are long gone, replaced by sandy patches of sparse brown grass, mown to stubble by countless teeth. Yet far out on the distant plain, still beyond view, the zebras and wildebeest approach relentlessly in their thousands, refusing to surrender as they attack the bare patches, grinding them further and further down, until they will be ground down no more. Driven by raw instinct and hunger, they are moving towards the treacherous river which they must cross to continue their search for life-giving food.

Through the glare I search with screwed-up eyes and decipher a single zebra on the horizon. I glance away briefly, then back again to see ten zebras in the haze. Soon they become twenty, fifty, a thousand. Now the wildebeest appear and keep on coming until they outnumber the zebras. A dark mass of heavy bodies, heads to the ground, grows denser as it slowly rolls down to the river. An artillery line of teeth wearily attacks the dying land.

The crocodile returns to the bank. He positions himself to face the approaching horde and opens his mouth wide, optimistic of an easy dinner.

In clusters they come closer – an endless procession of grunts and honks growing louder as they fill the landscape. They push and shove until there is nowhere left to go. An invisible barrier forms around the crocodile, an empty space they will not enter. He raises

160

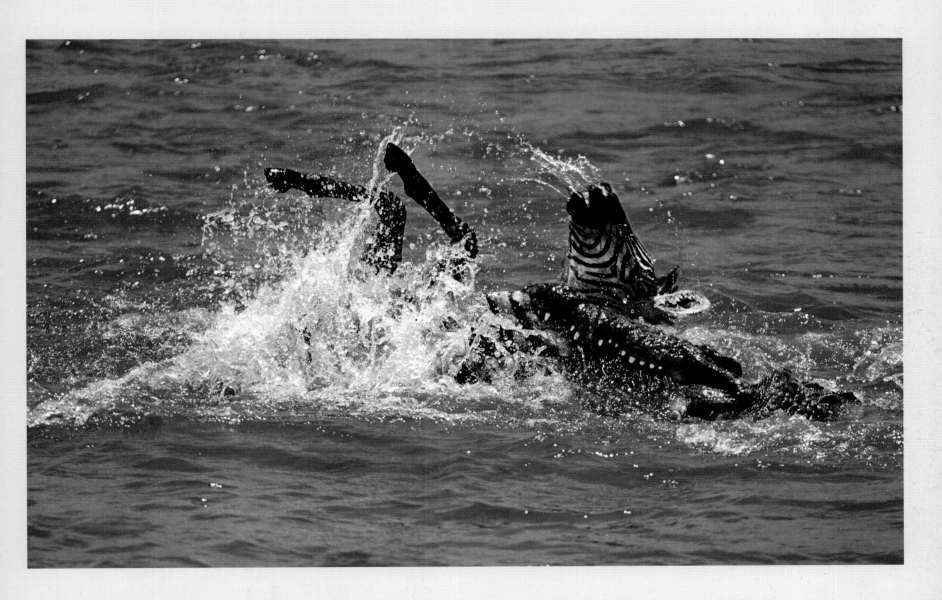

his body and slips silently into the water. Cautiously, the zebras cross the line, one timid step at a time, until the entire landscape is painted with their bodies. We watch from our lonely spot across the river, empty savannah stretching behind us.

At the river's edge, heads drop down to drink. Babies stay close to their nervous mothers who lap the water with great urgency. They look intently at the opposite bank, eyeing the grand prize of survival. One zebra wades in until he is immersed to his shoulders, then panics, splashing and kicking his way back to the shore. For a brief moment the area is cleared in the pandemonium.

For three long hours they cling to the river's edge, crippled by inertia, unable to take the plunge. Fear and hunger fight it out in an internal conflict.

Then one lone zebra mysteriously breaks through the fear and rushes across the river. He reaches the far bank and cavorts up the hill – a euphoric conqueror in drunken celebration. He has not yet noticed that he now moves in the dust of a barren new land, just like the land he left behind; grazed to stubble by hungry armies before him. Such is the injustice of drought.

He forges a path for others to follow, one by one at first, until they form a column that surges through the water in a frenzy of

kicking, splashing and loud honking. The river quickly fills with multiple processions snaking their way towards the opposite bank. They rumble down from the plains, stirring up thick clouds of dust as they pour onto pathways that lead down to the water. Soon the paths are all filled, but the animals keep on coming in greater and greater numbers, overflowing onto cliffs and into gullies. In their thousands they leap off crumbling ledges, crash through air opaque with dust, and tumble into a river now bubbling and boiling with excitement.

Two crocodiles arrive: sinister submarines, their periscope eyes float on the surface. With all the patience in the world, they scan for the softest, sweetest and youngest morsel on the conveyer belt now passing before their eyes.

A baby zebra swims close to her mother: a crocodile shoots towards her like a torpedo, then snatches her in his jaws. Water explodes in a swirl of jagged teeth and spinning flesh. She is pulled down into an underworld where sounds are muffled in an eruption of bubbles. Round and round she is rolled, her head gripped by blades in a deathly embrace. She kicks out feebly before spinning dizzily into a whirlpool of death. Murky red globules float up from her torn body. Her struggle now concluded, she is towed gently to a cosy corner larder near some rocks upstream, her upturned legs stiff as a floating table.

Somewhere on the river's edge a bewildered mother cries out for her child.

Downstream a steep bank of slimy mud rises up. Known locally as the cul-de-sac, its forbidding wall confronts a procession of wildebeest who stream out of the water and clamber upwards. With blind perseverance they climb over each other, forming an entangled pyramid over which one lucky escapee scrambles to the top and runs off, never looking back. The pyramid collapses into a mess of tangled limbs and groaning bodies, writhing in the glistening mud. Still they keep coming. The dead and dying pile up, forming slippery stepping stones which darken intermittently beneath the shadows of vultures circling above. The wildebeest

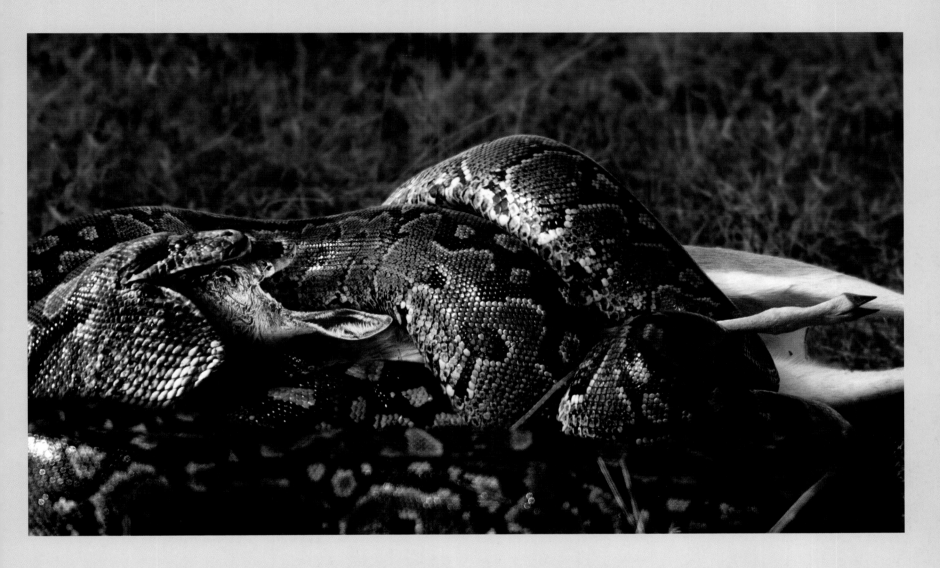

will soon merge into a single rotting mass of bodies, their thick stench overpowering. A blanket of hissing vultures will descend onto the putrid pile, first plucking out soft eyes, before burying their grubby heads deep into fleshy holes.

Thick dust becomes a thin mist which finally settles to leave the air clear. The last of the straggling wildebeest sprints across the water. The dead and maimed lie draped over rocks as the tired river washes over broken limbs. Every now and then a body breaks loose and floats like a log, past crocodiles now too bloated to move.

Along the shore a few lonely zebras and wildebeest run up and down, calling out to babies who look across helplessly from the other side of the river. They call until the shadows grow

too long and they must move on. Grief is a luxury not afforded to these animals in their tense world where avoidance of death dominates their lives. There are many ways to die in Africa. One of the rarest is old age.

How long does it take to be eaten, to be completely and totally consumed, to be fully assimilated into another being? How long does it take for the prey to become the predator? When do the atoms of the lamb become those of the human?

The proud antlers of a Thomson's gazelle offer no defence against the snake's thick suffocating coils which squeeze out his life. The python slowly places his mouth over the gazelle's mouth and, with a deathly kiss, sucks the head in. He dislocates his jaw to

slowly squeeze the antlers. Miraculously they somehow vanish down his throat. He coils his long body around the gazelle and crushes it while easing the torso further into his mouth. Legs bend and snap as they are folded into position, and the whole body is consumed until the snake raises his head, as if triumphant, to reveal the tips of two hooves. He slides heavily back into his hole, bulging and barely mobile, where he will slowly digest his meal. The gazelle's journey from sunlight into the dark burrow lasts a few hours.

In northern Botswana the morning light is soft and an impala runs with all her strength from a pack of wild dogs in hot pursuit. The high-speed chase ends when the lead dog sinks his fangs into her thigh, brutally stopping her in her tracks. Others join the affray, ripping open her belly and hindquarters. For a moment she stands suspended between life and death, then disintegrates in a frenzied red blur, the air filled with loud squeals of delight. Soon only a few scattered bones and red wet patches remain, with scant leftovers for the vultures. The impala's journey from life to obliteration lasts only four minutes.

Two zebra stallions rise up; their hind hooves stamp the dusty Kenyan earth and their front legs lash at each other. Bodies lock in a towering embrace – two heads high above the swirling dust. They chase through a parting sea of striped bodies, down into the shallow pool where the battle continues. They thrash in the water with violent energy, each encounter a new attack in an ongoing battle. Back on dry land defeat finally comes – a dripping wound, an injured leg. All the zebras, except for the vanquished stallion, move on, trailing their new leader. The defeated zebra limps away from the herd, occasional drops of blood staining his path. He stops, turns, and watches the others disappear over the horizon.

The single black rhinoceros is a clumsy refugee from an ancient time. Hunted almost to extinction for his prehistoric horn, he is one of the last survivors of his kind in the Masai Mara. He clings to his meagre existence, bad-tempered and suspicious of the world. Lonely, with little hope for the future, even his thick skin cannot hide his vulnerability.

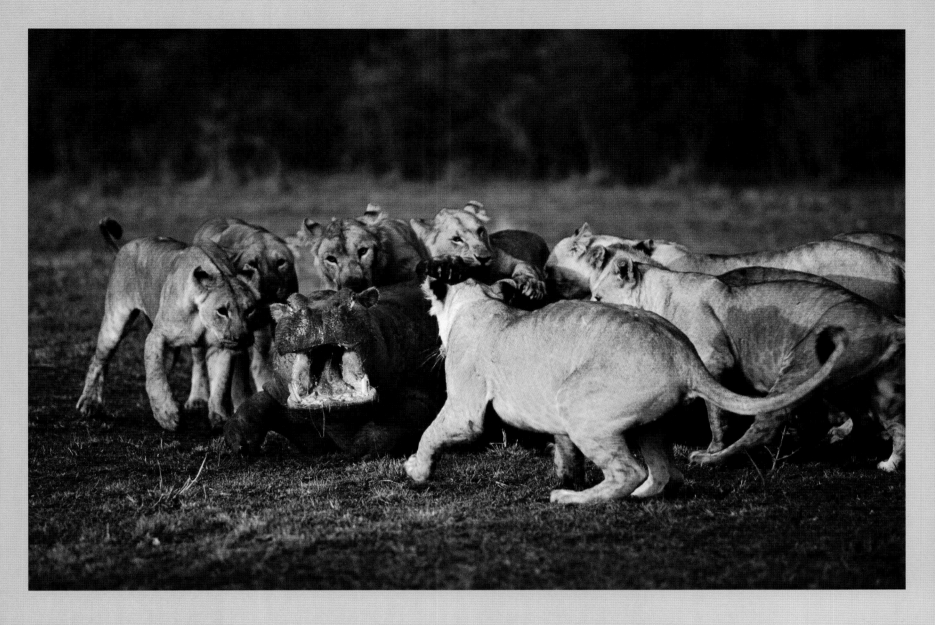

The hippo is late coming home to the river. He wanders along into the morning. The cruel drought has driven him far from the water; further than he's ever been before. Last night he grazed alone among the ghosts of a million wildebeest who passed before him on their journey. He walks with his head hung low, unaware of the lioness who hides, transfixed. She pounces like a released spring. He glimpses her leaping body before feeling her weight clamp on his back. Sharp pain surges through his neck as razor teeth sink in and claws slide as they try to carve a firmer grip into his tough skin. He hurls himself around to see what is attacking him, throwing the lioness onto the ground with a whimpering crash. She swiftly rolls to her feet and cowers away, only to return a moment later with seven of her sisters.

They all attack, leaping upon his body, biting and tearing his back. Desperately he turns his massive jaws on his attackers, missing each time. As he raises his head to the sky, white tears of fear and pain stream down his face. With every savage blow he grows weaker, but still manages to drag himself and his assailants closer to the river.

Suddenly, the lionesses lose interest and run away. Lions do not usually eat hippos and were merely having sadistic fun.

The crippled hippo lies a short distance from the river; his flesh torn, bleeding and burning fiercely in the growing heat of the day. His white tears harden like paint. For a full day and night he drags himself painfully towards the quiet river, inch by desperate inch, before finally reaching the water where he drifts into unconsciousness from which he will never recover.

The Mara River has seen the last vulture leave. The water, cleansed of blood and bodies, flows idly past resting crocodiles. Over the hill, another wave of zebras and wildebeest gather, preparing to follow the clouds which float effortlessly overhead. Just as the earth obeys the sun, orbiting in accordance with the natural laws, so these animals obey the call of the clouds, driven in a hard-wired cycle of annual migration. Instinct, it seems, is unconquerable.

The turbulent journey into death becomes new food for new life – a constant regeneration in which pain and suffering ultimately blossom into the newborn.

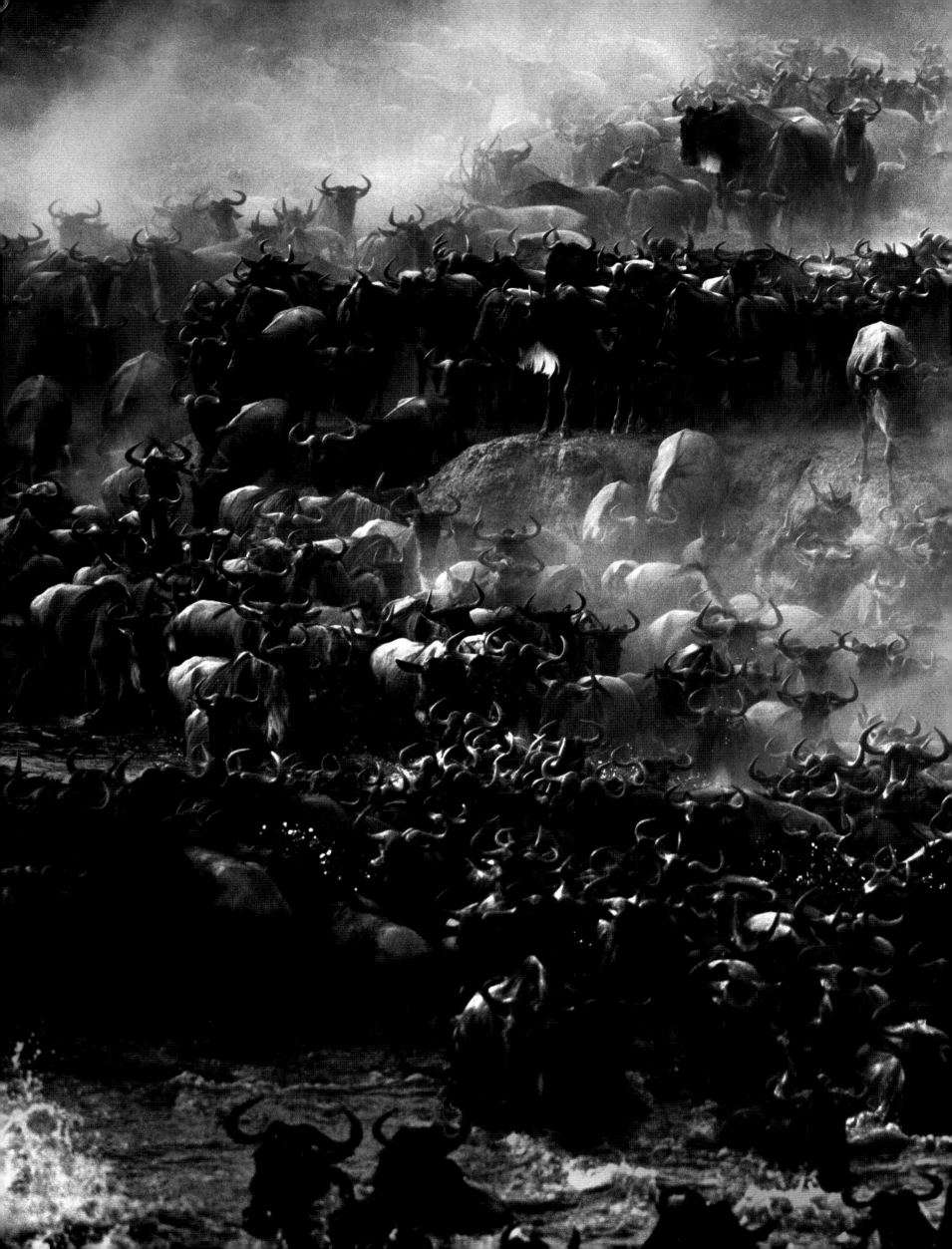

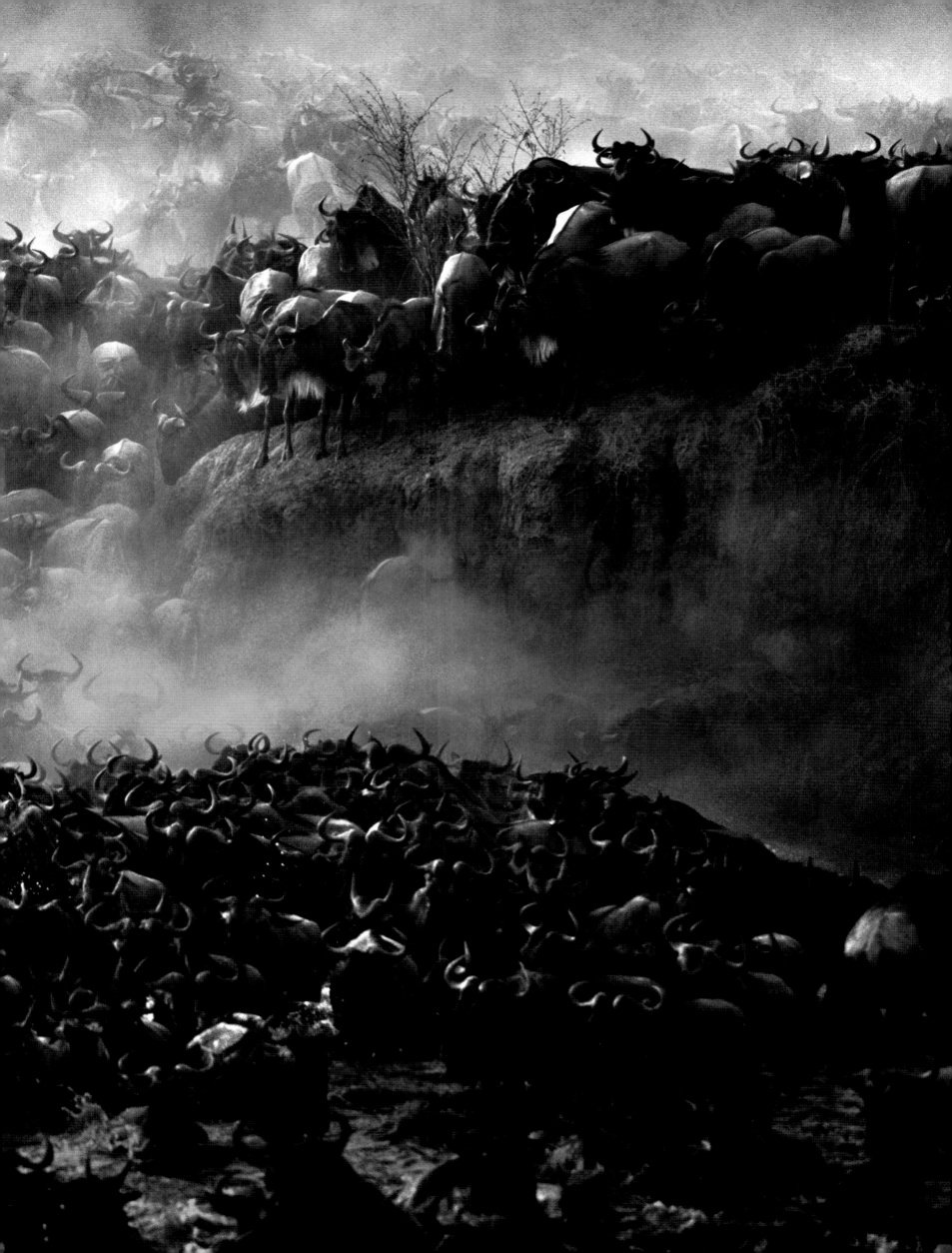

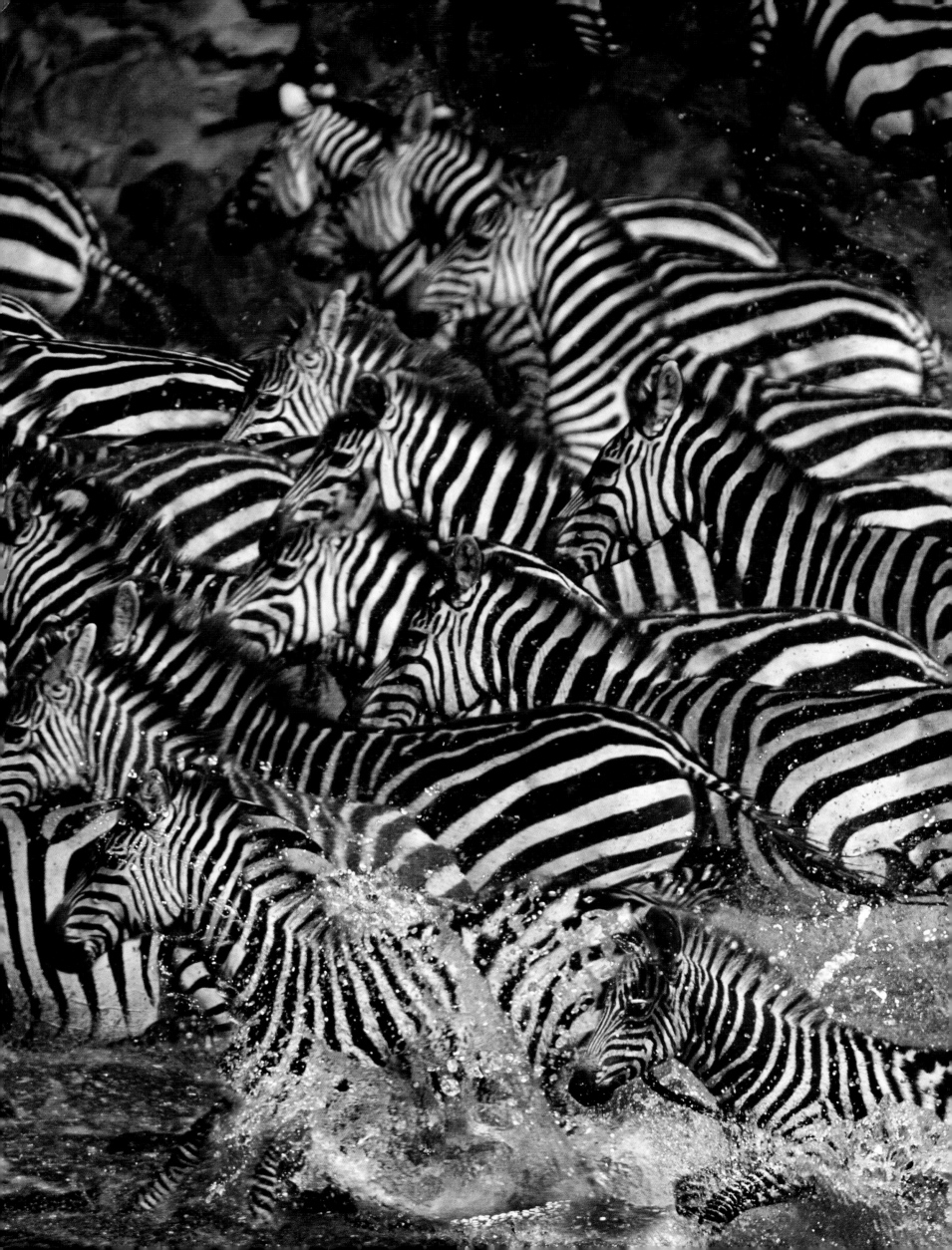

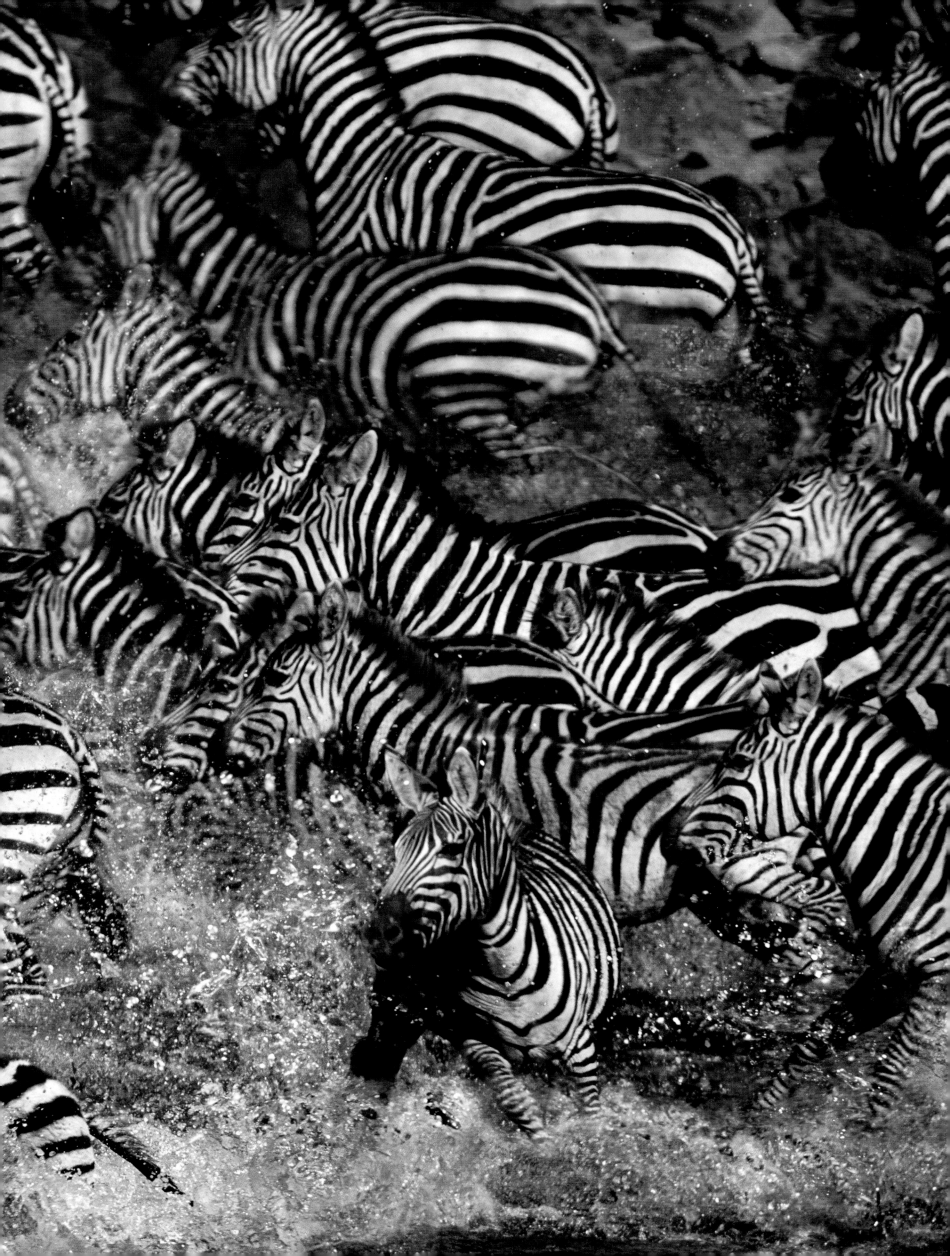

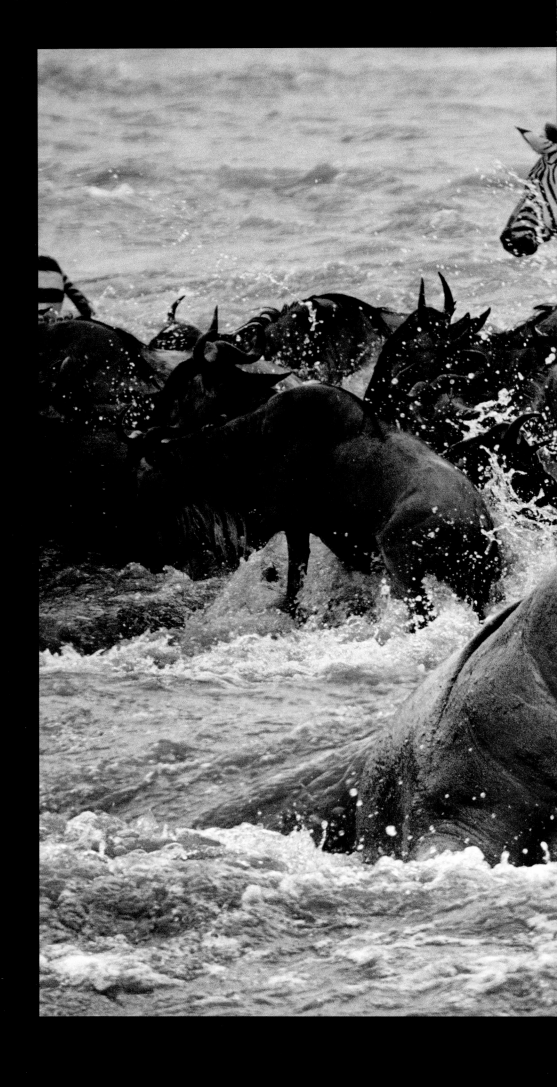

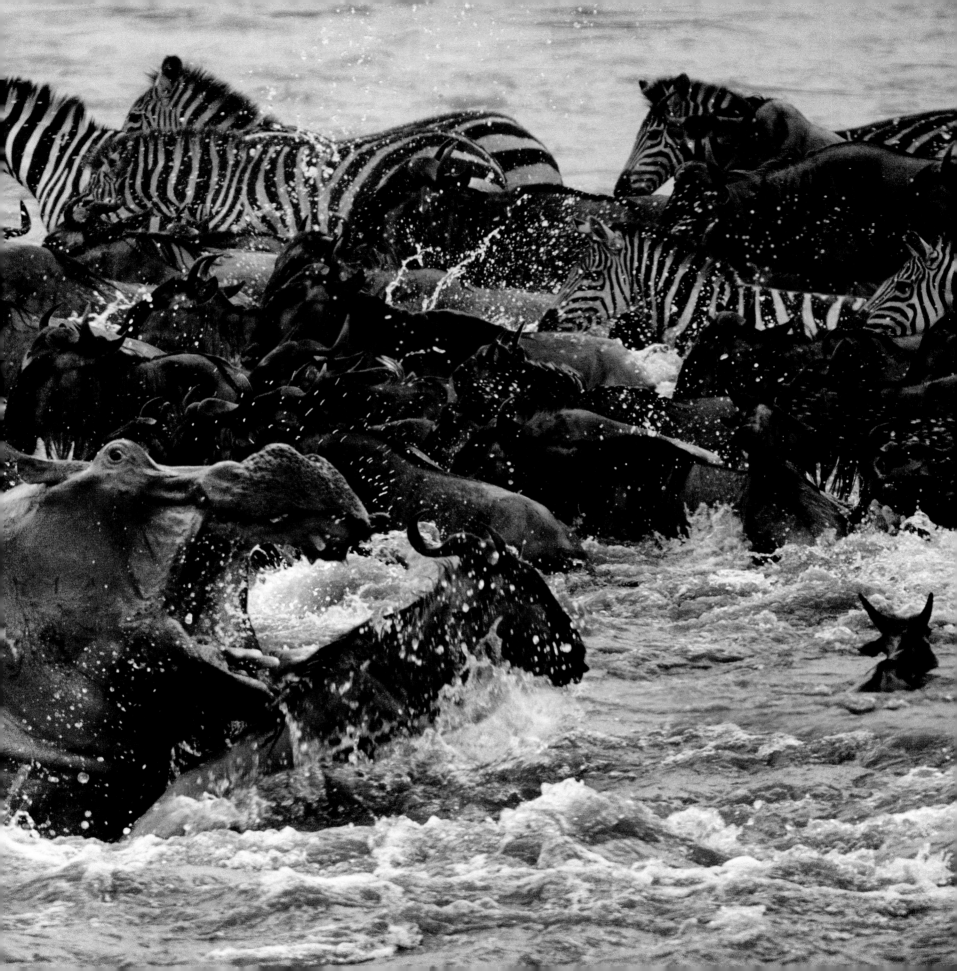

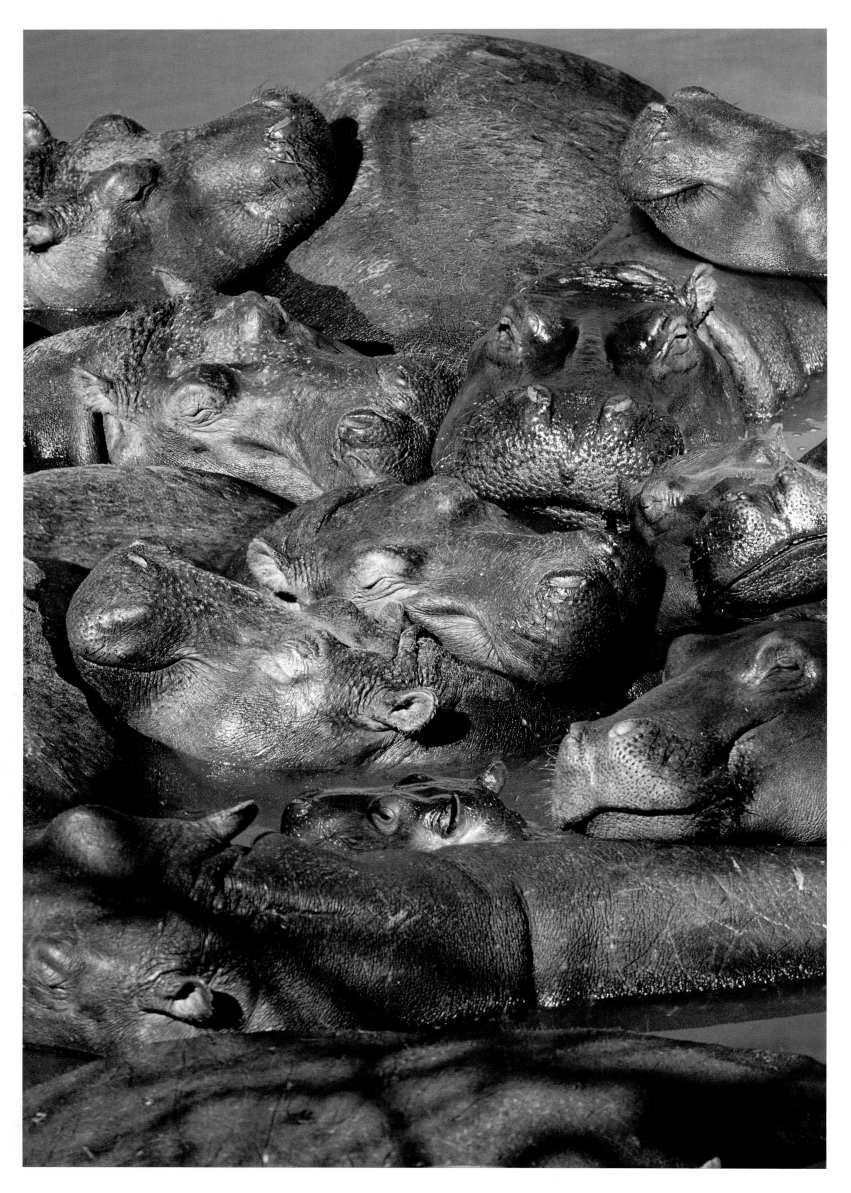

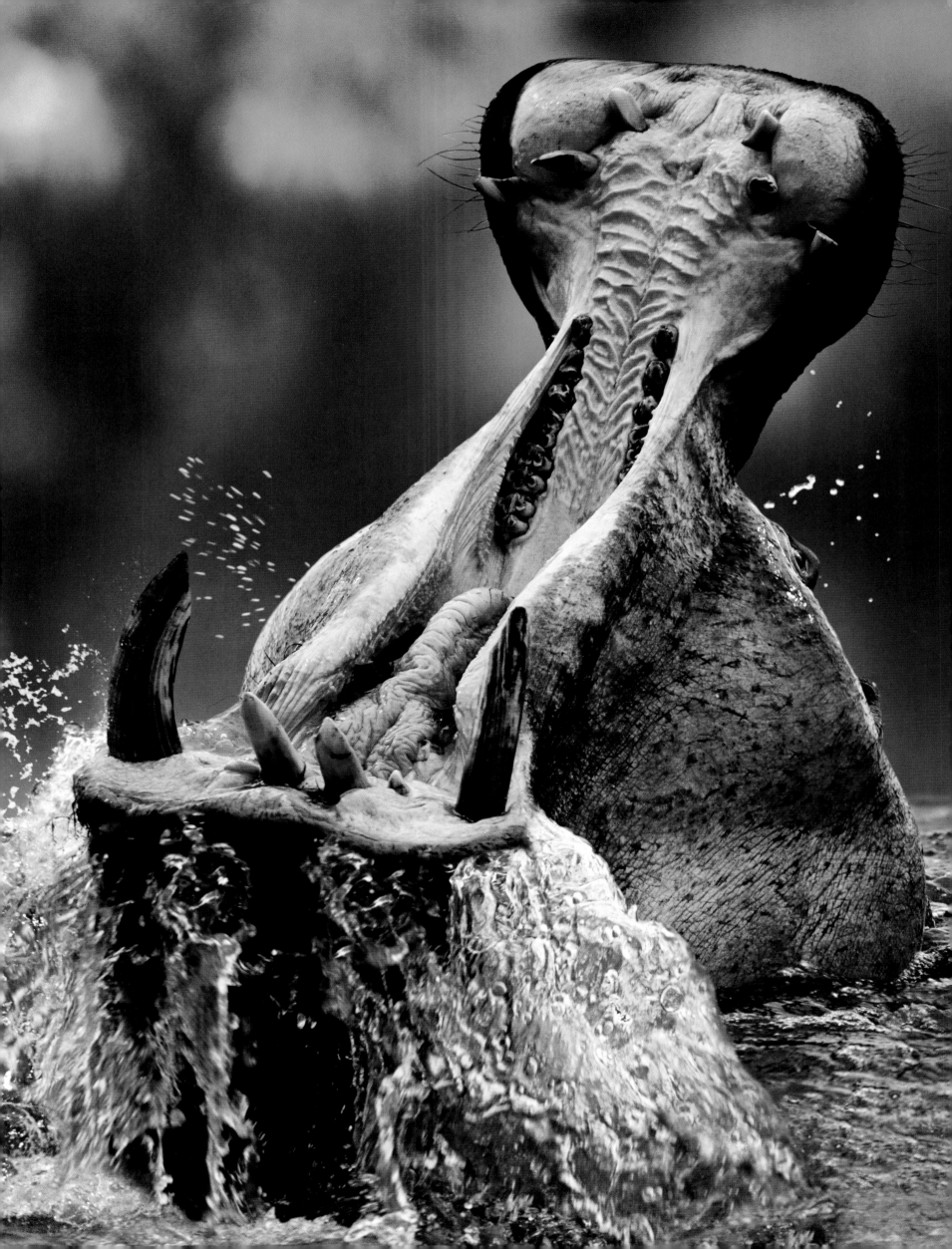

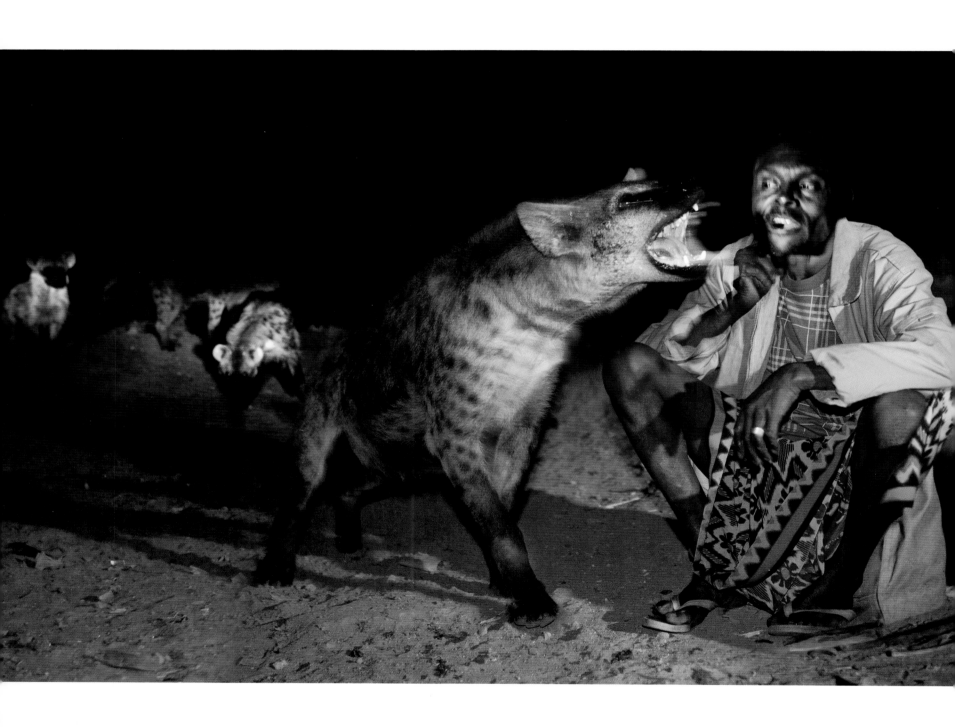

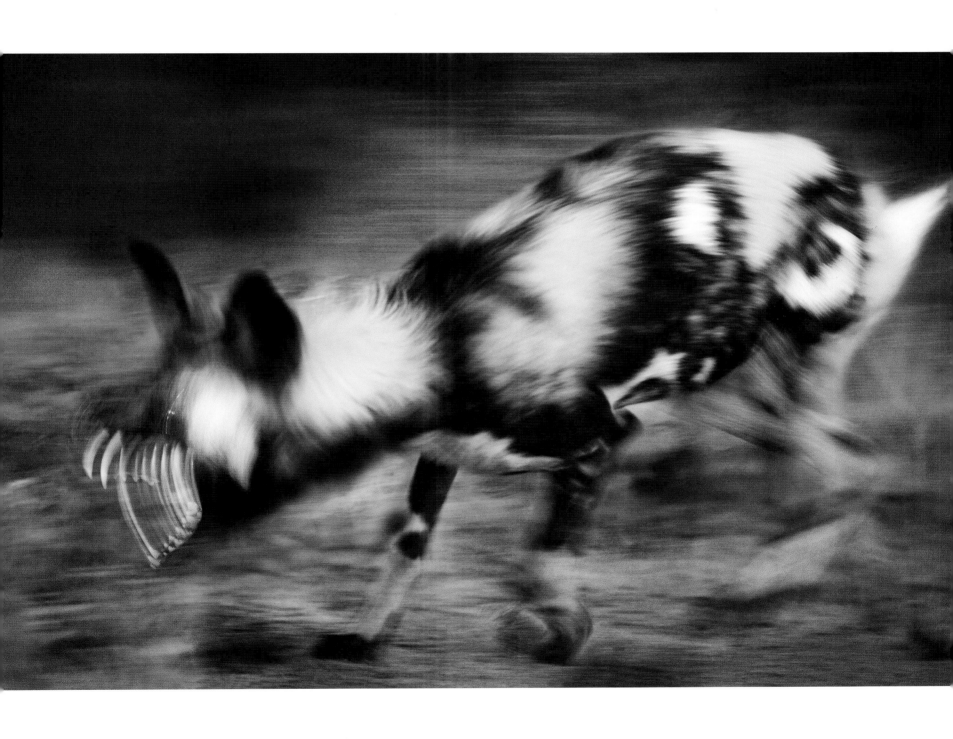

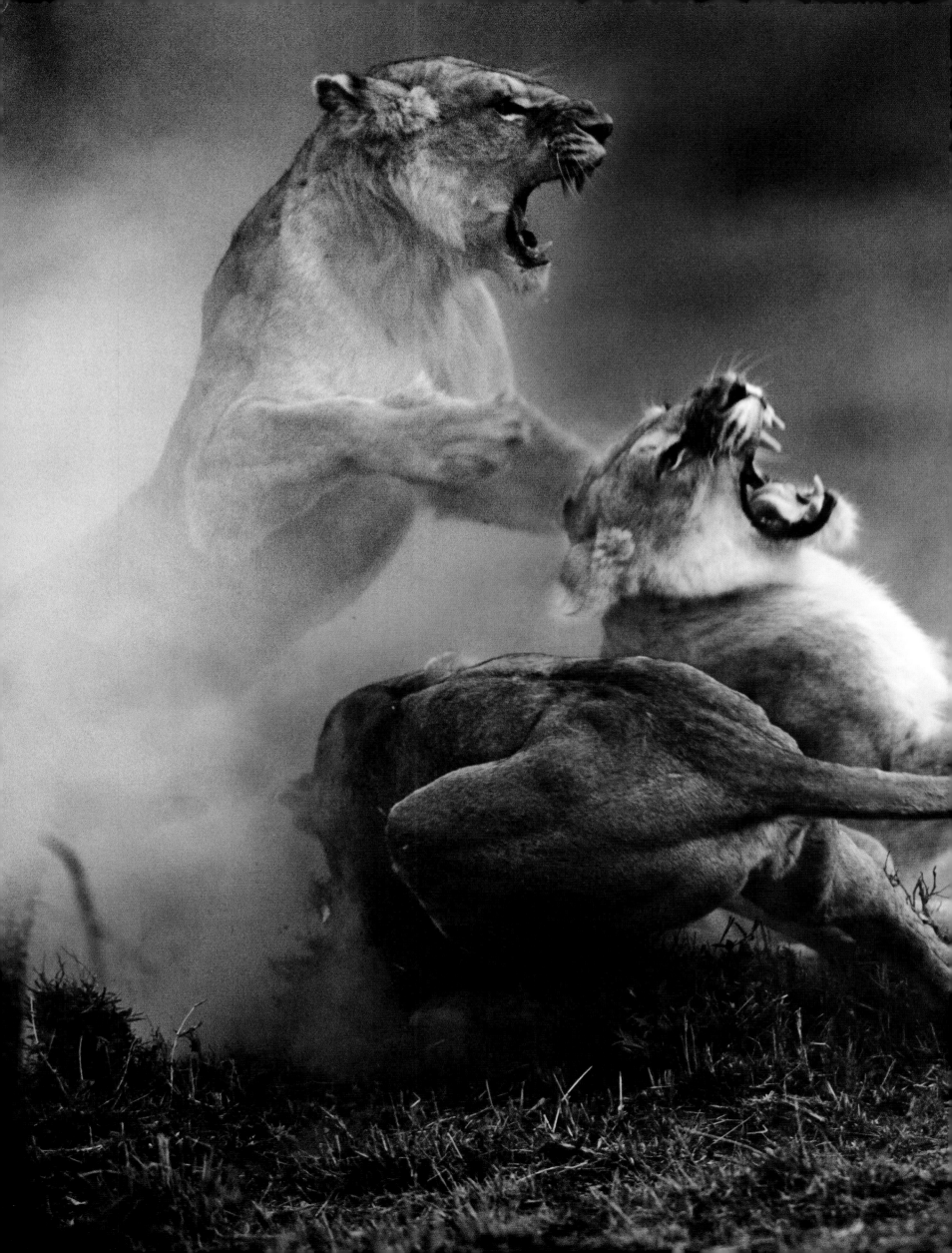

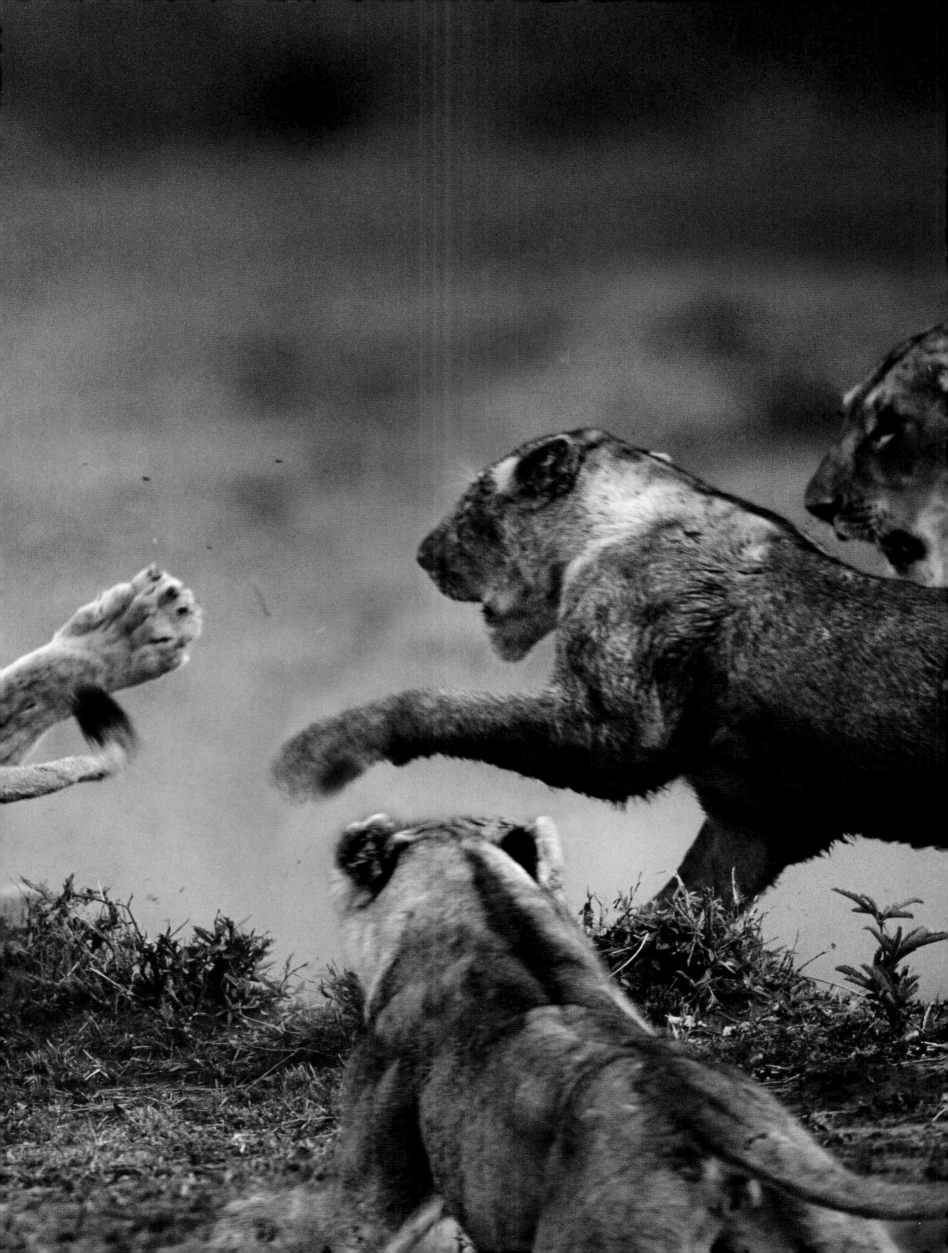

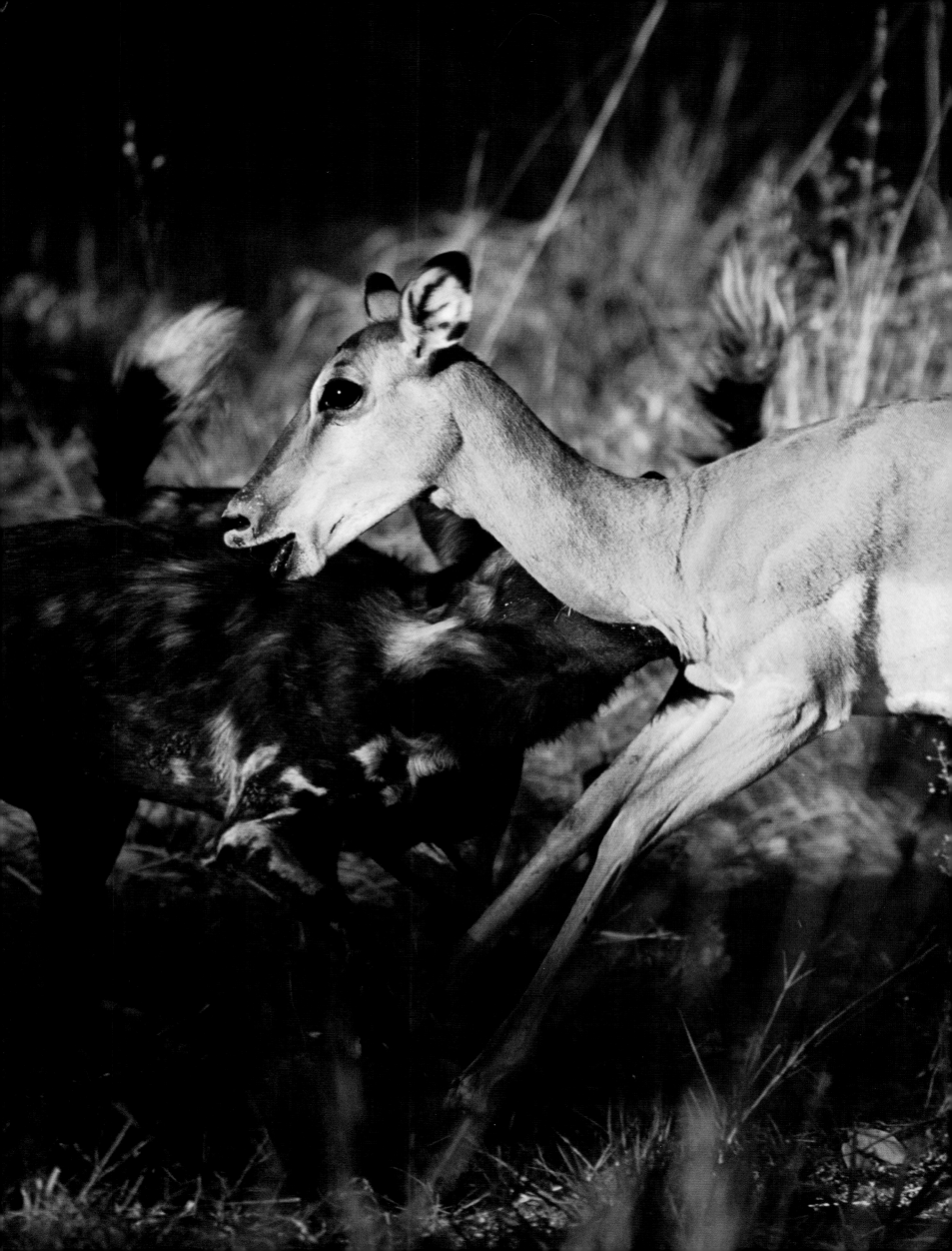

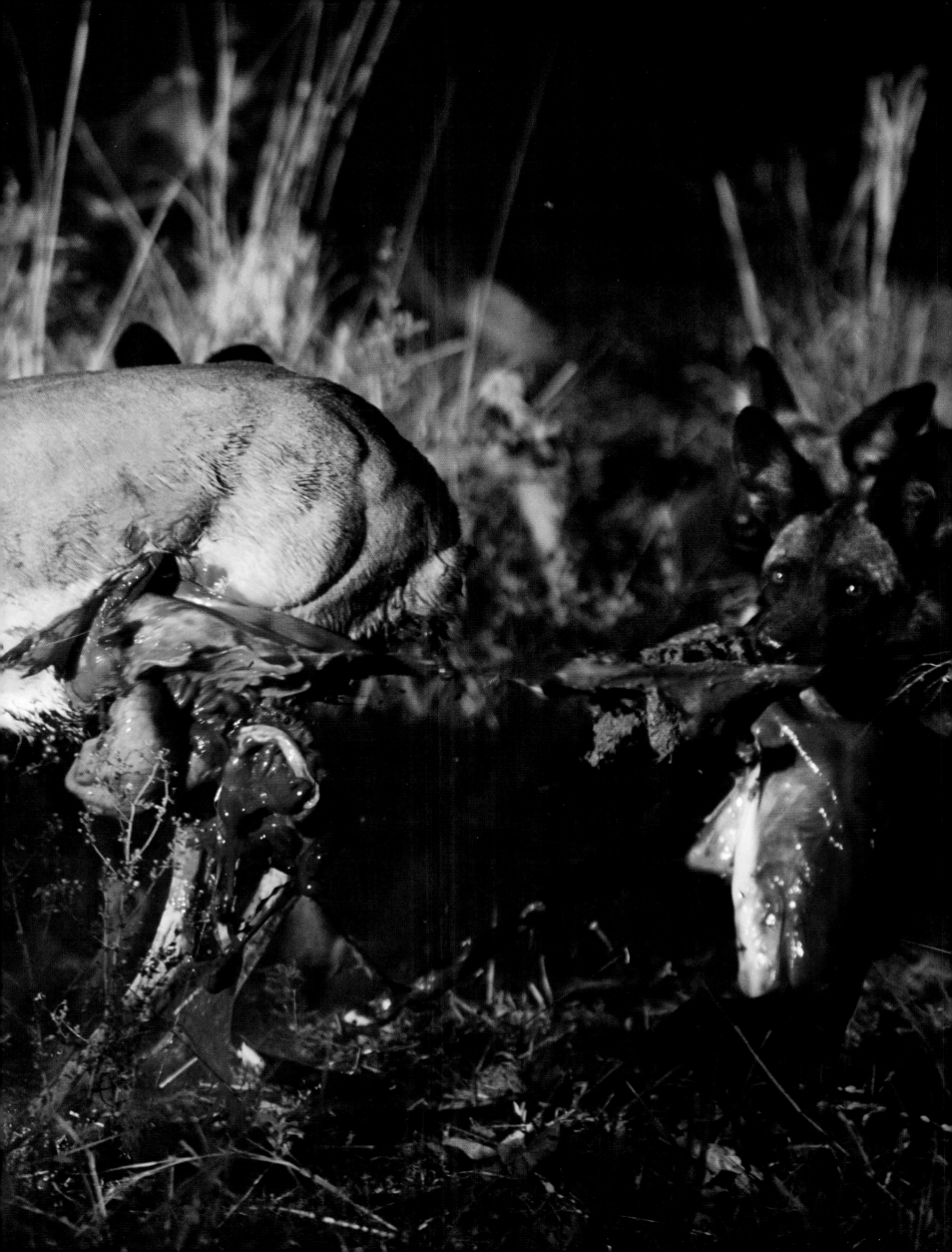

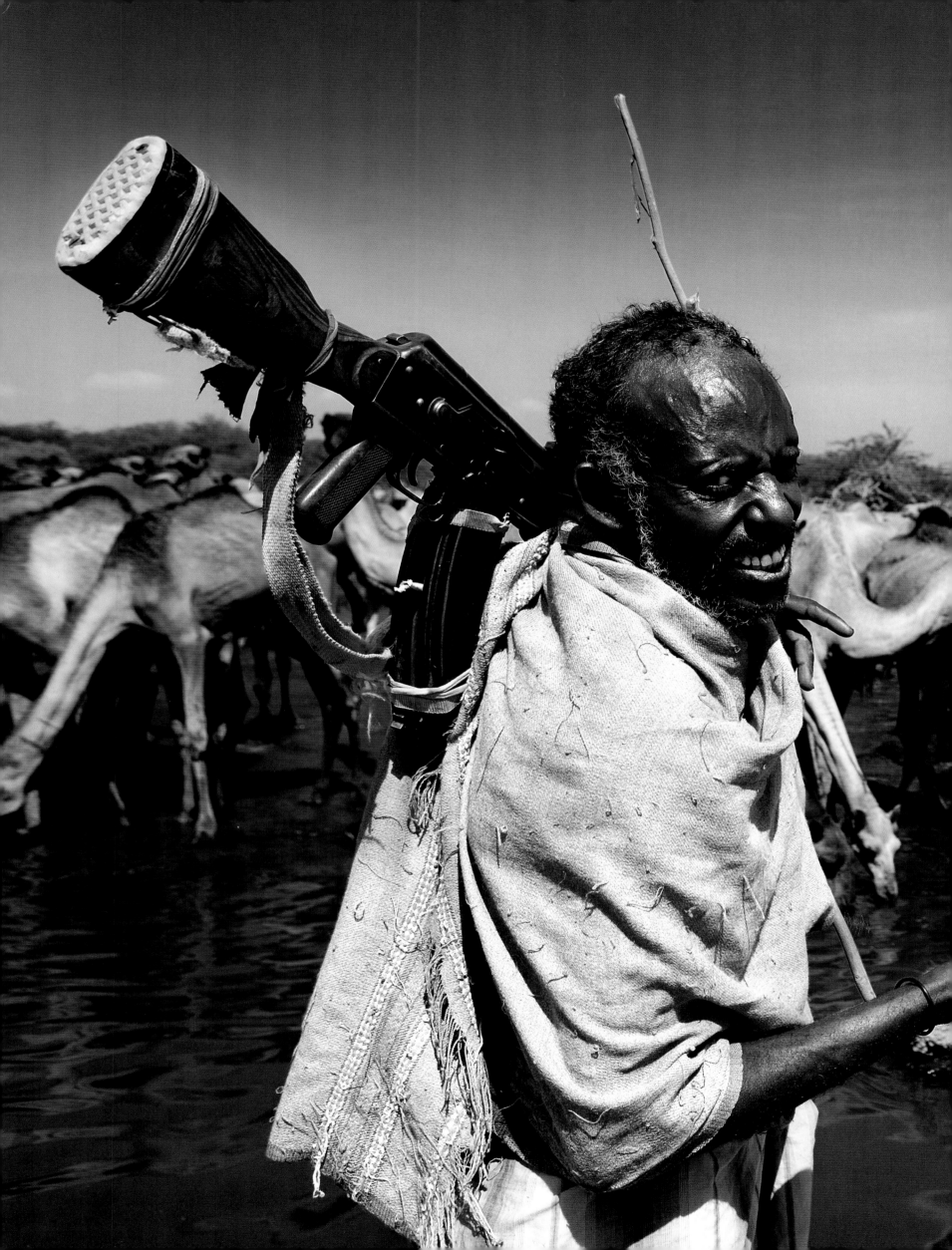

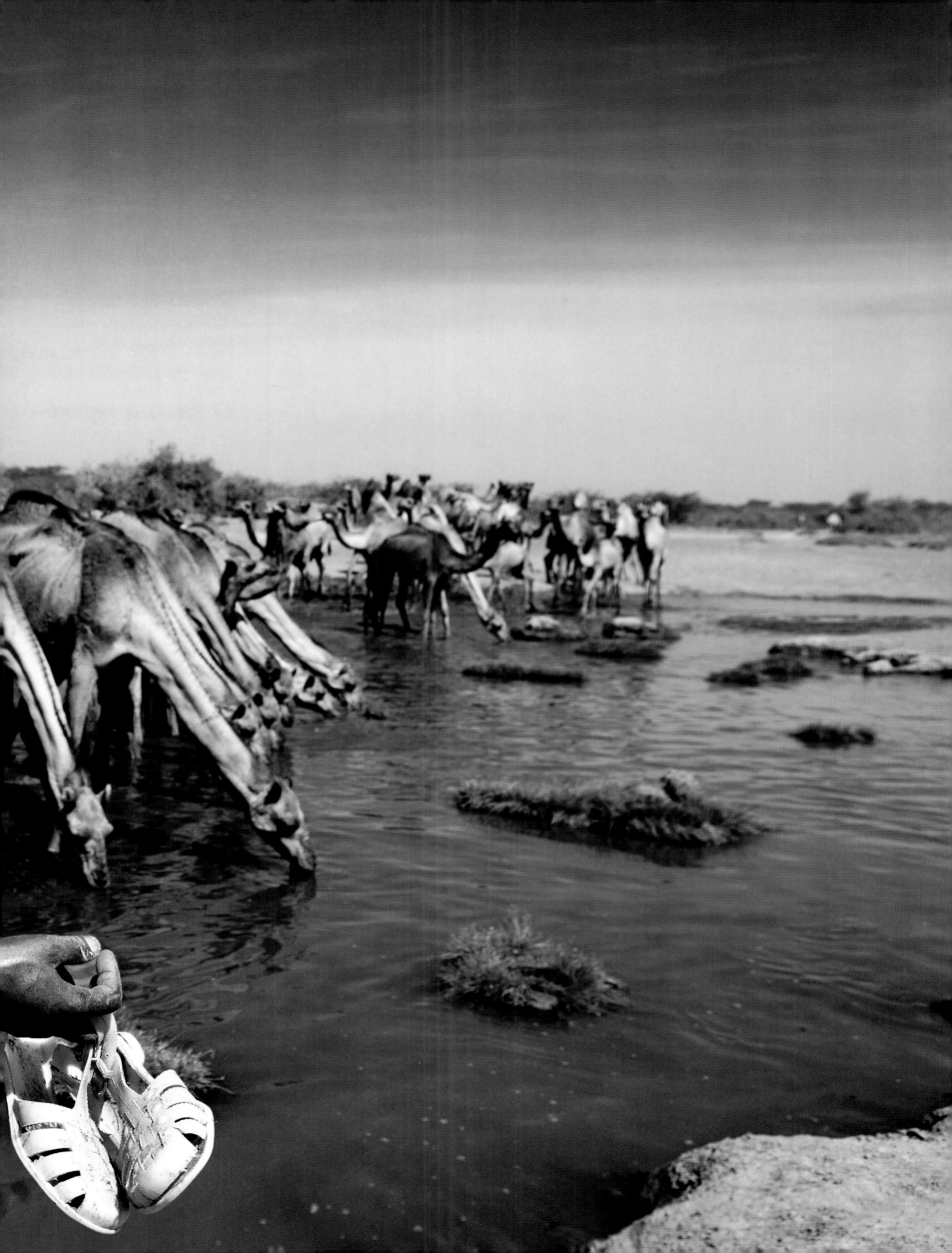

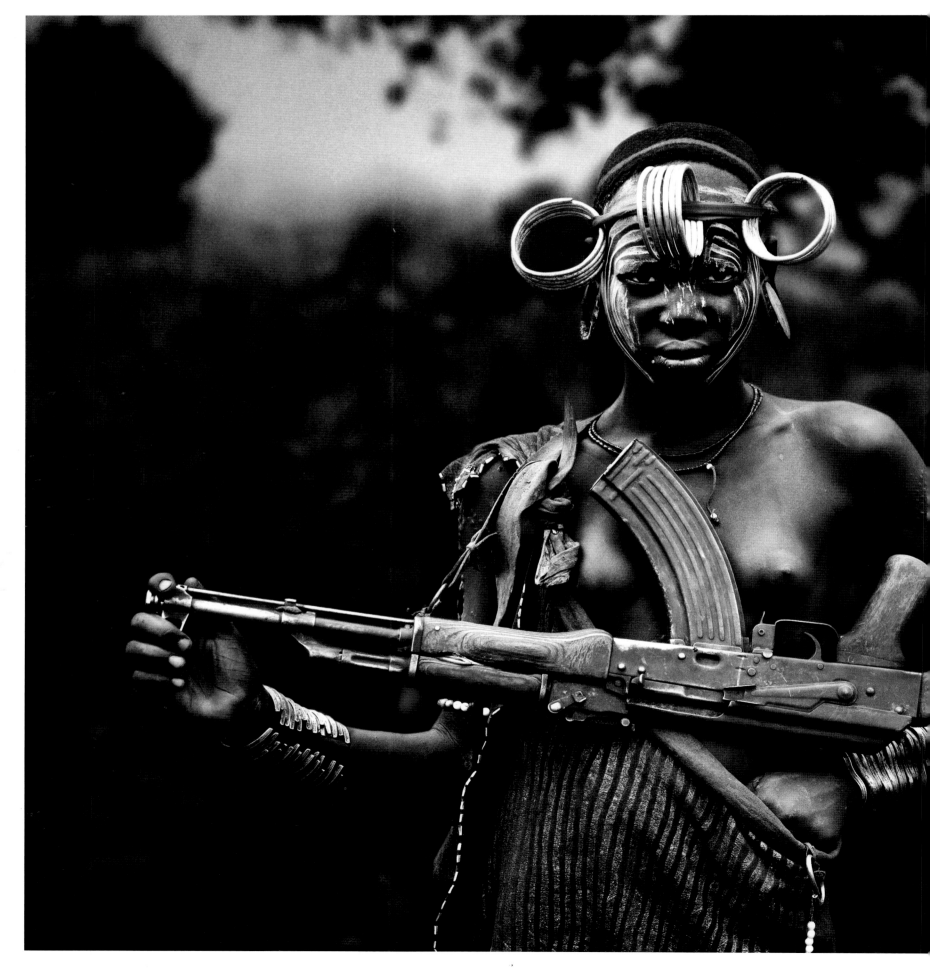

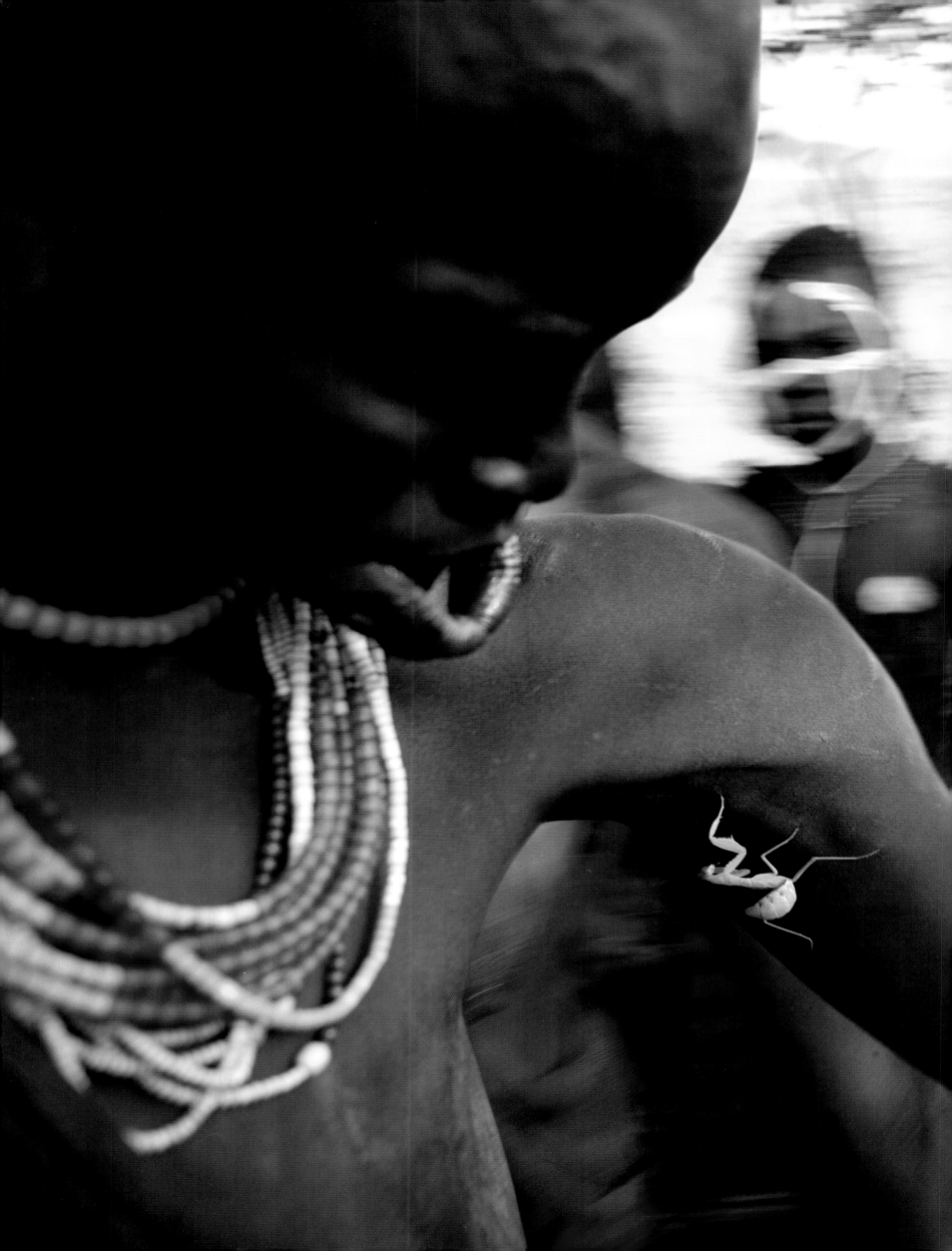

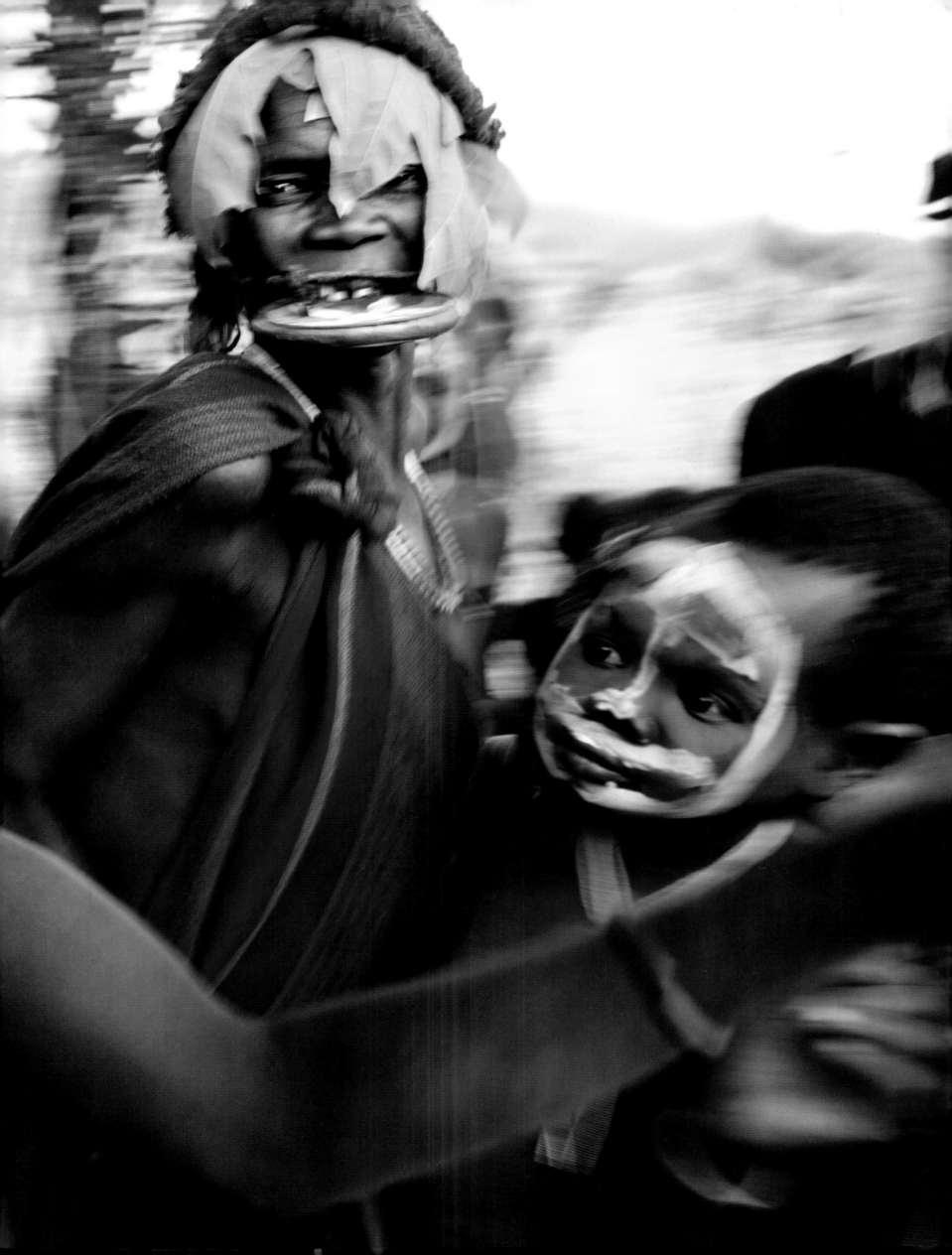

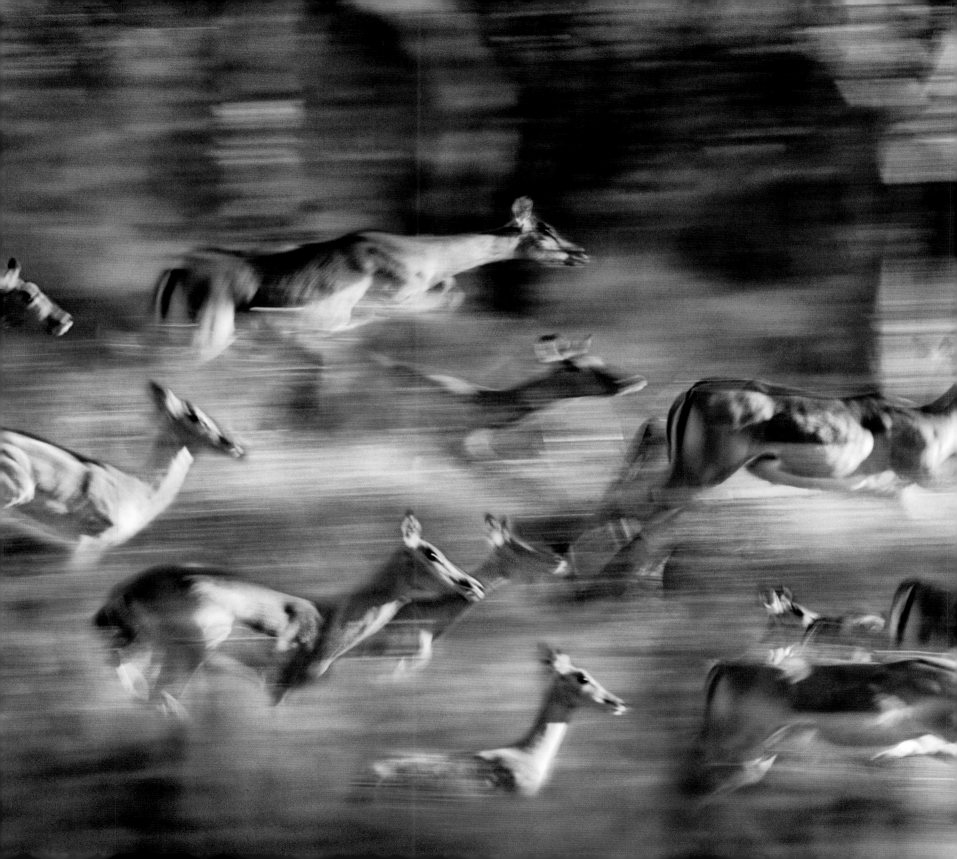

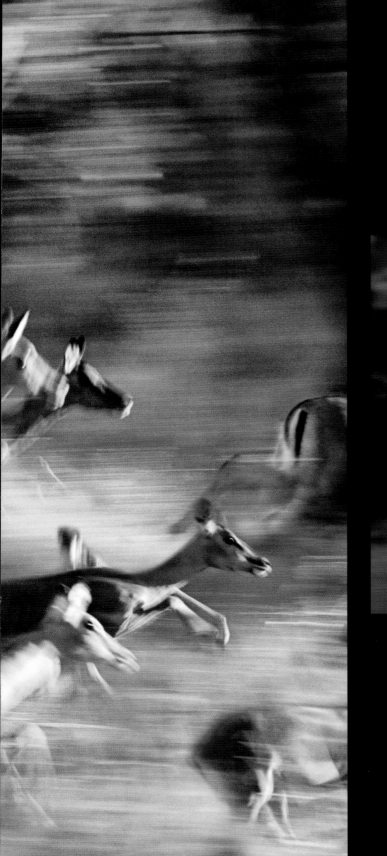
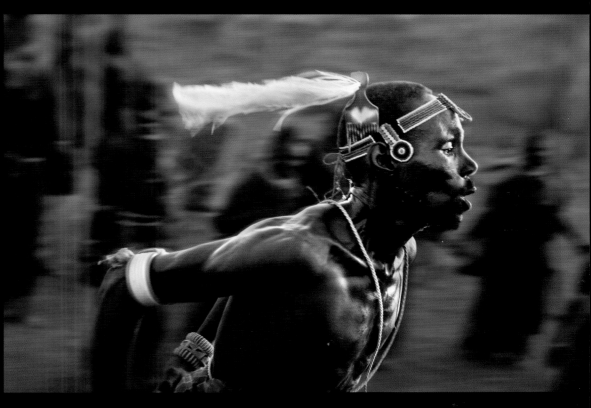

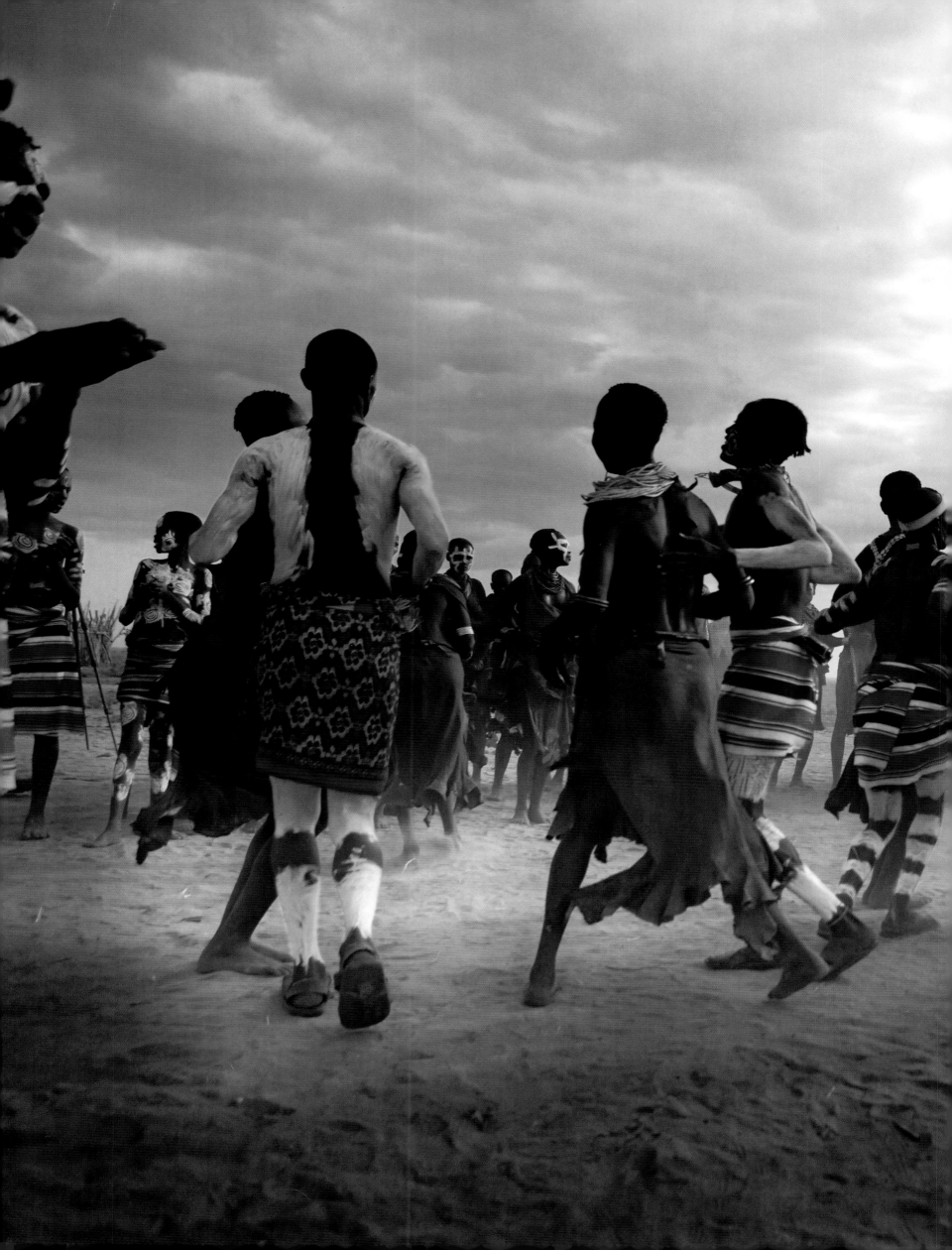

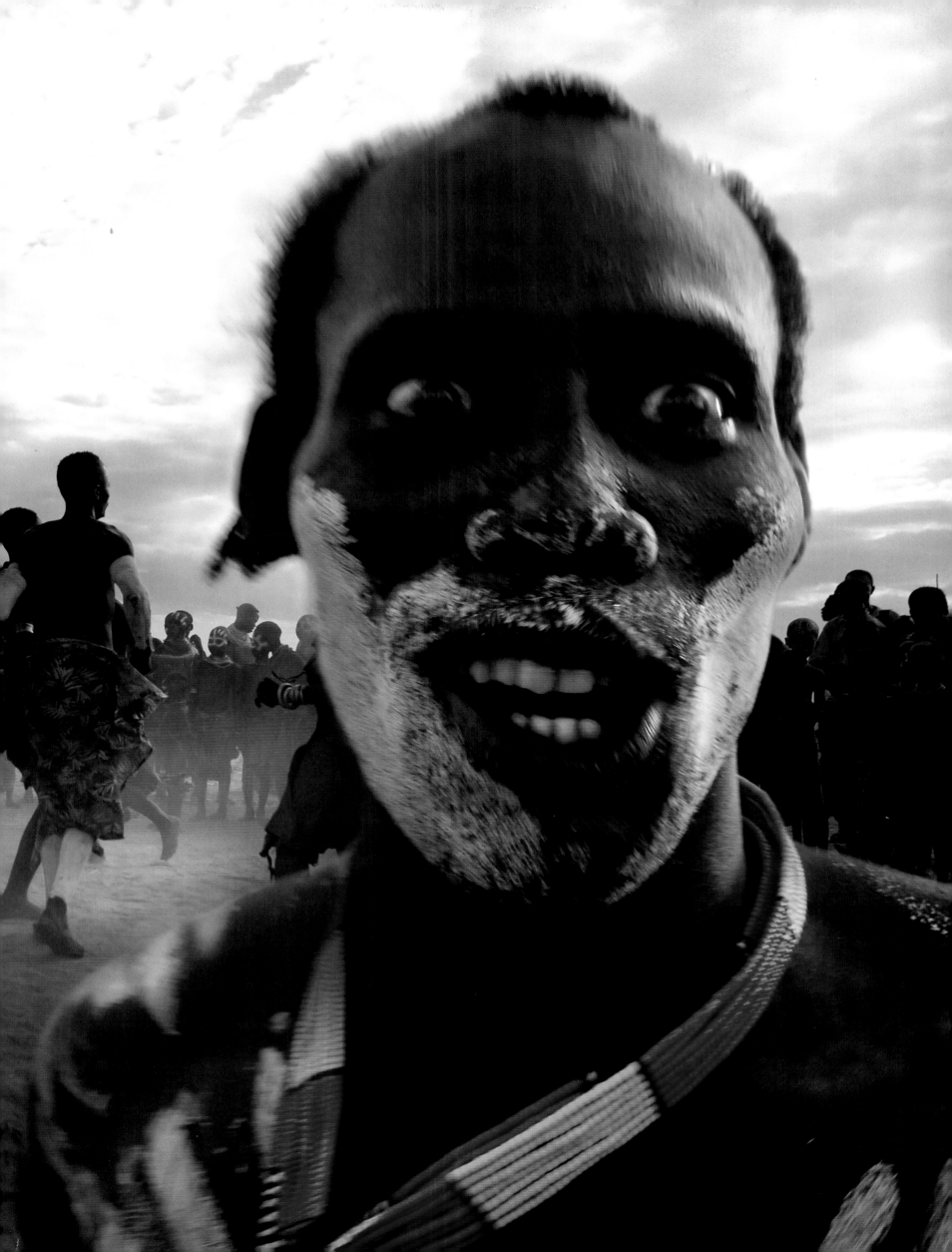

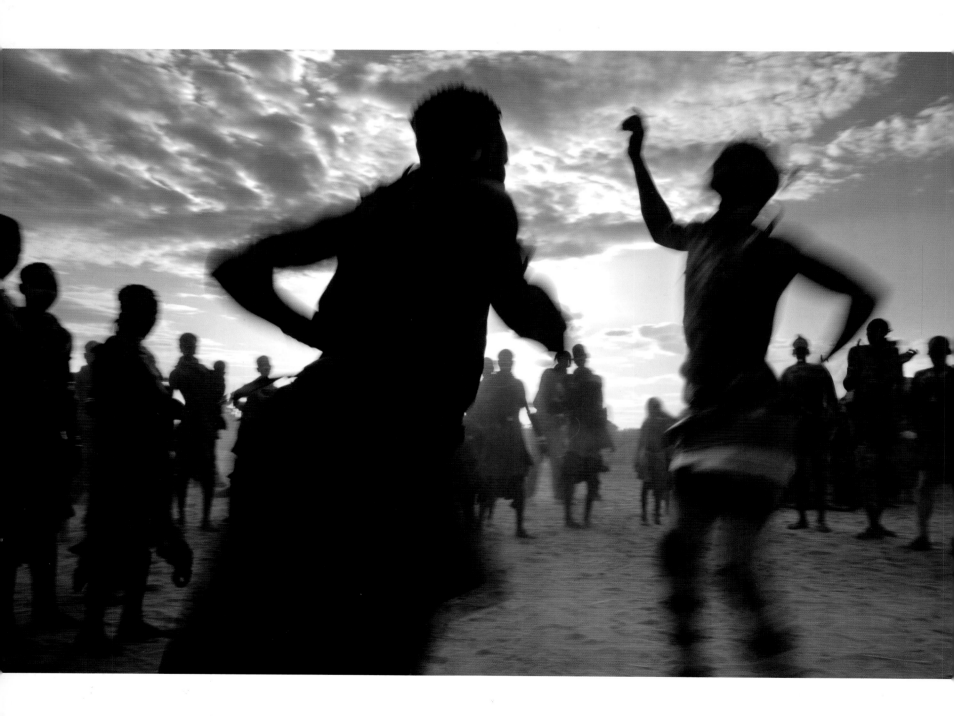

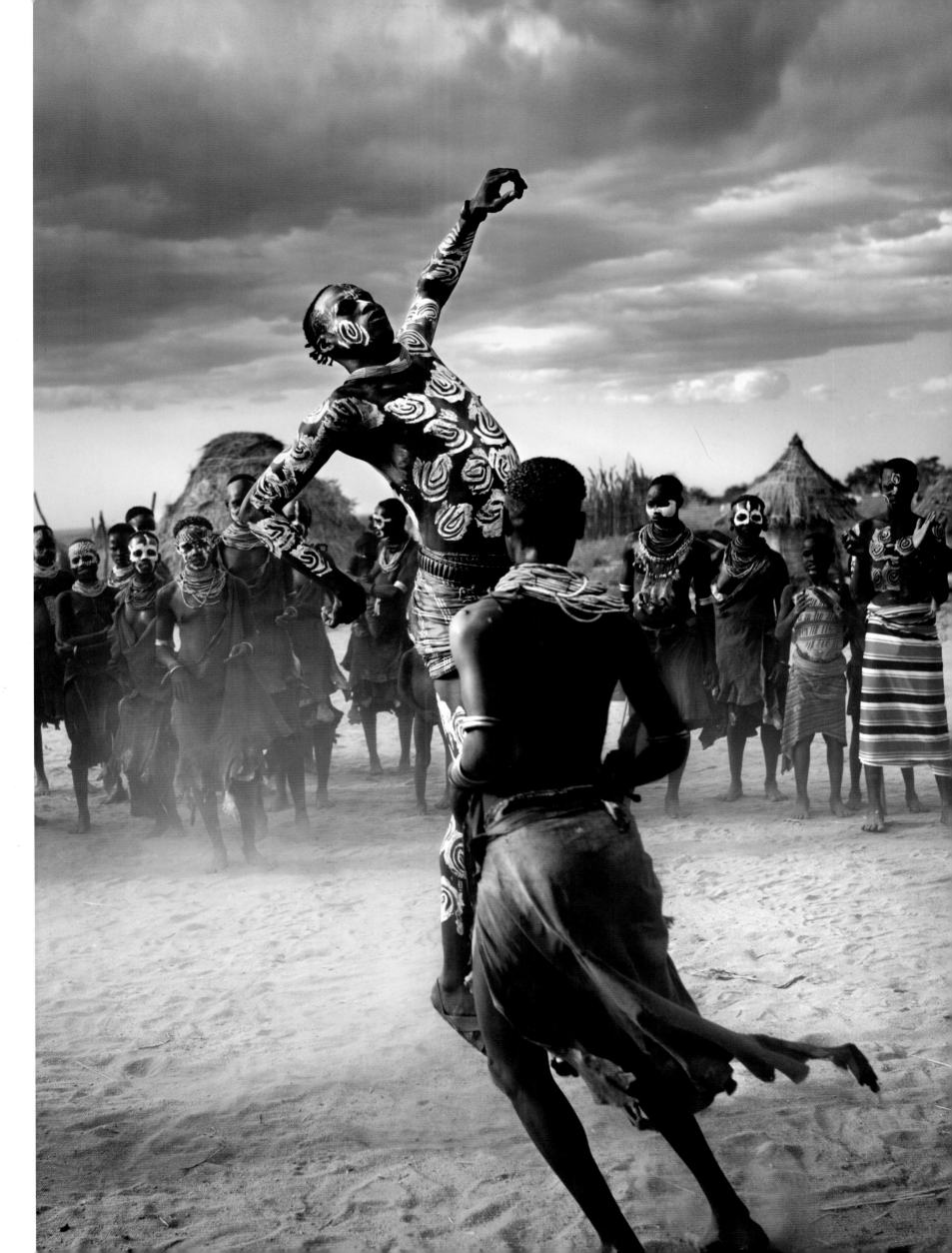

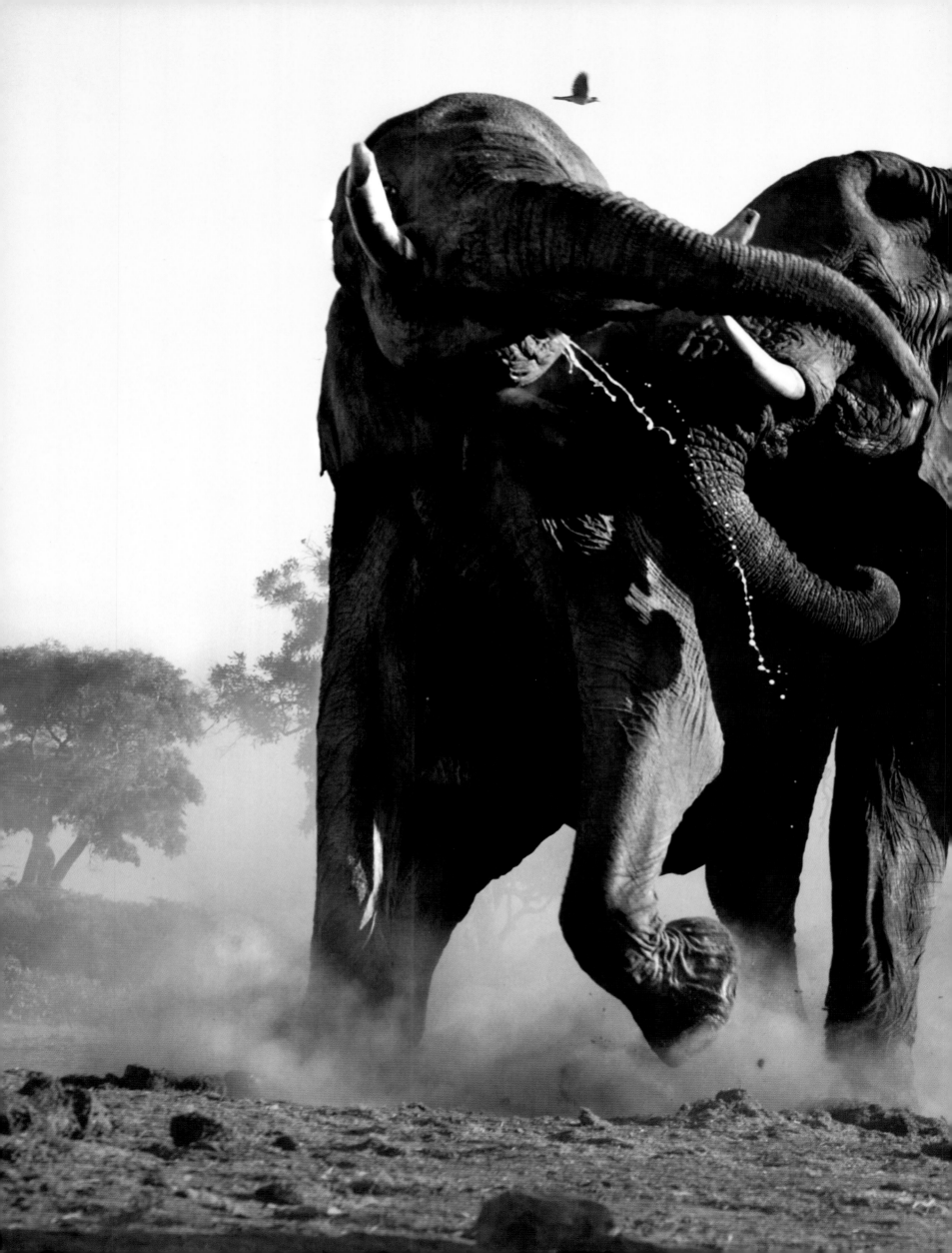

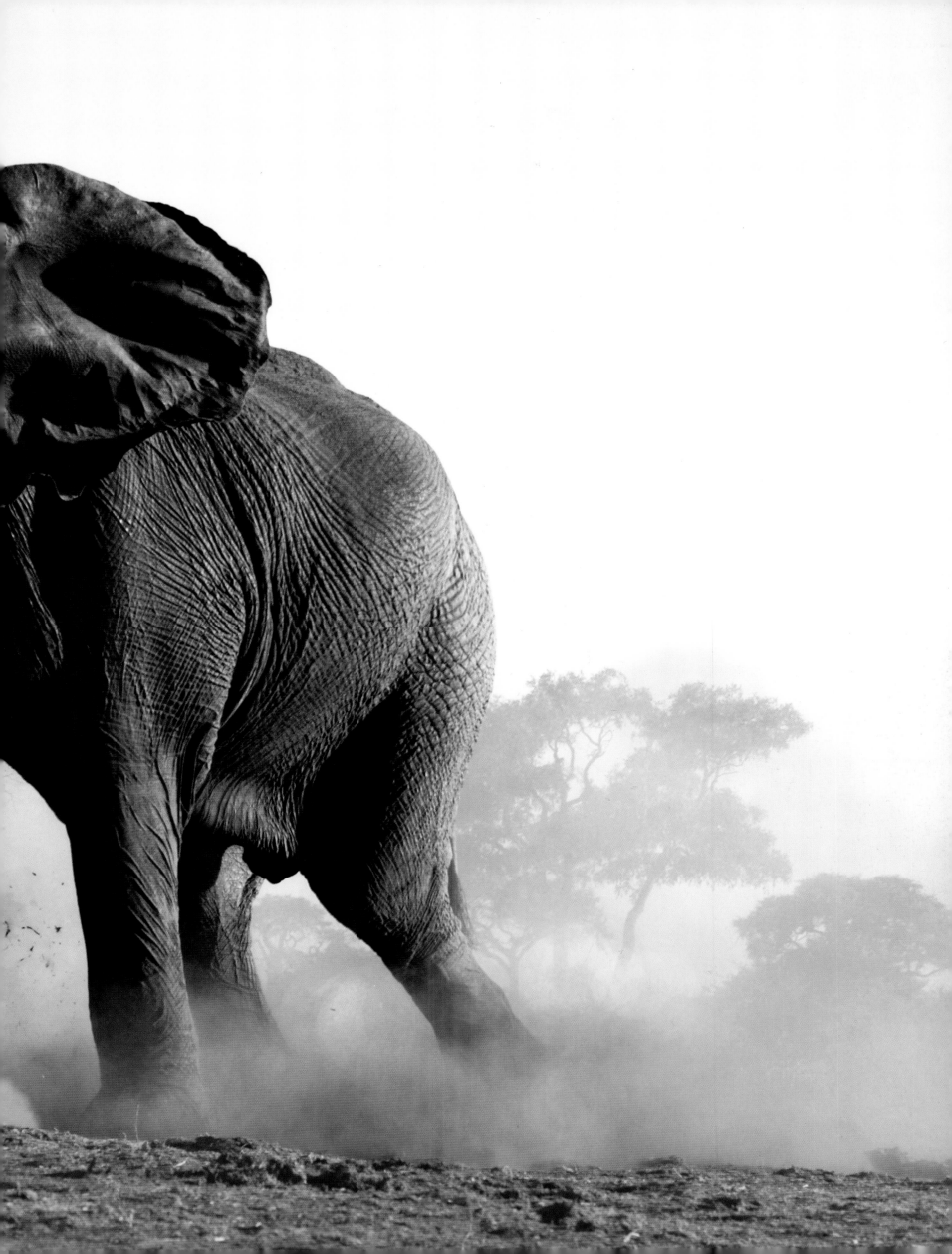

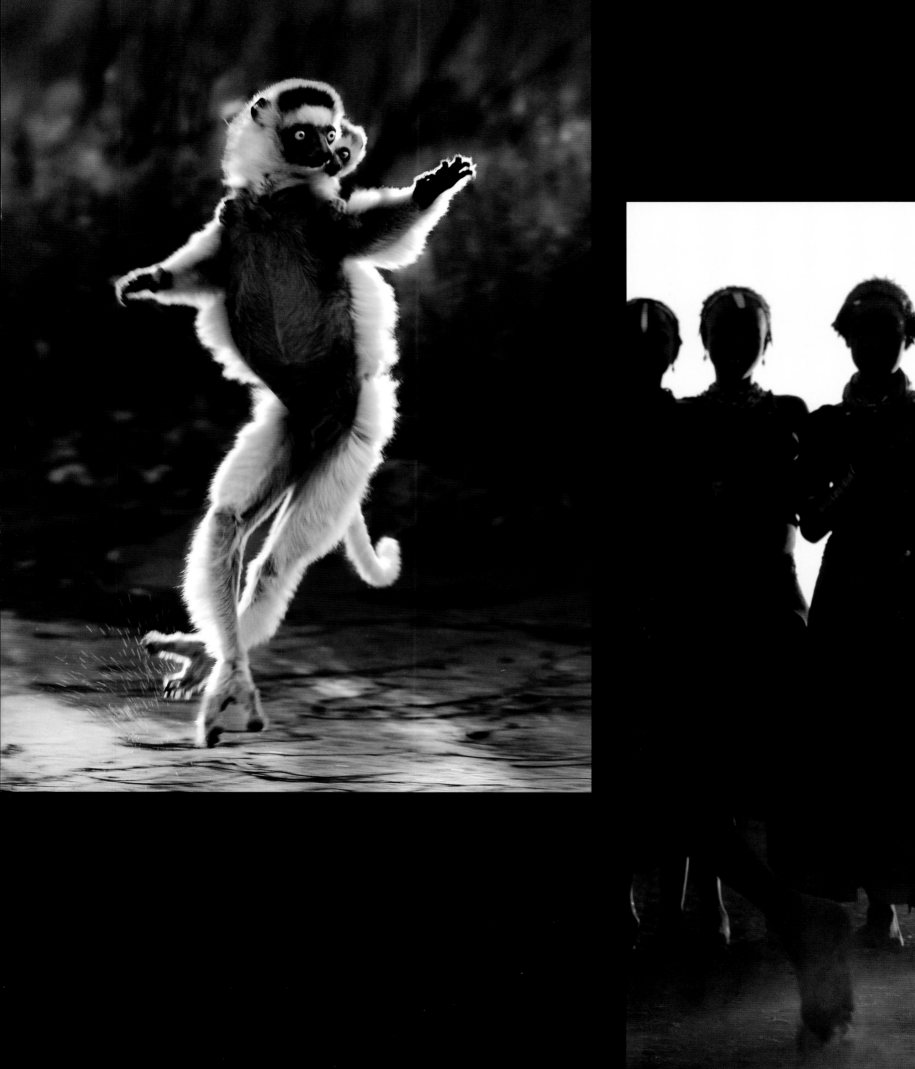

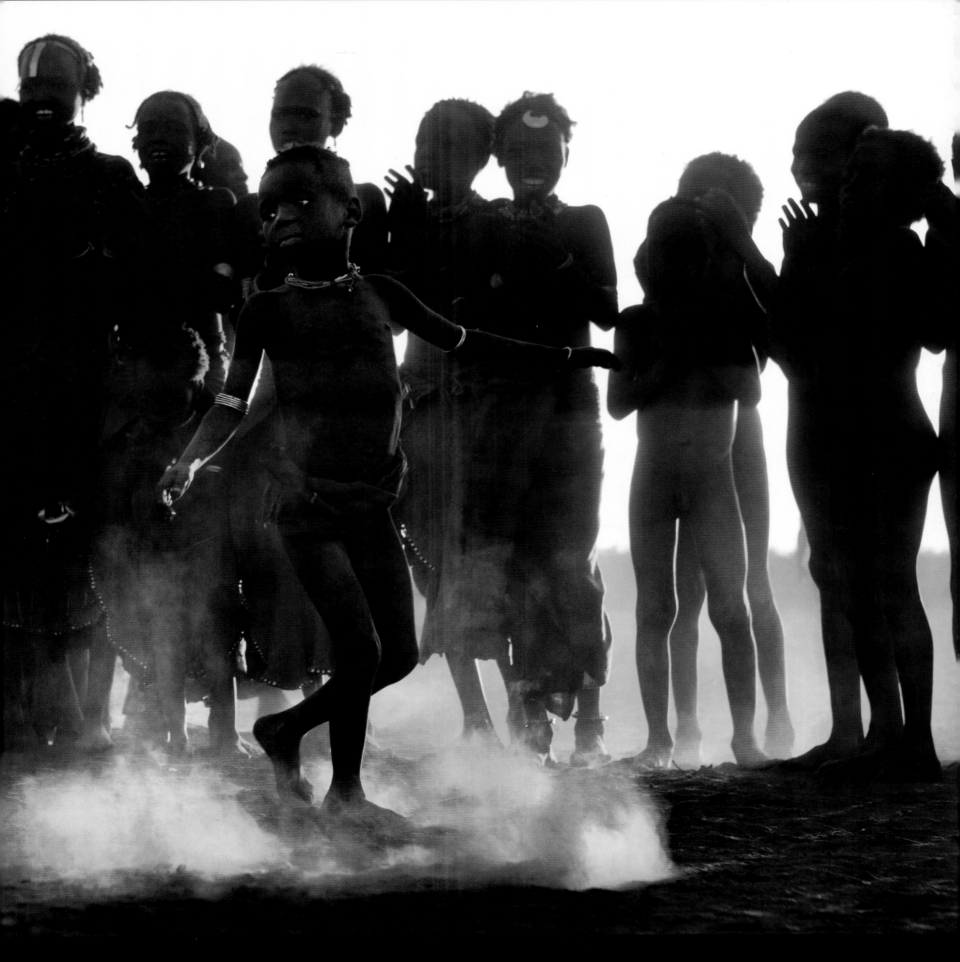

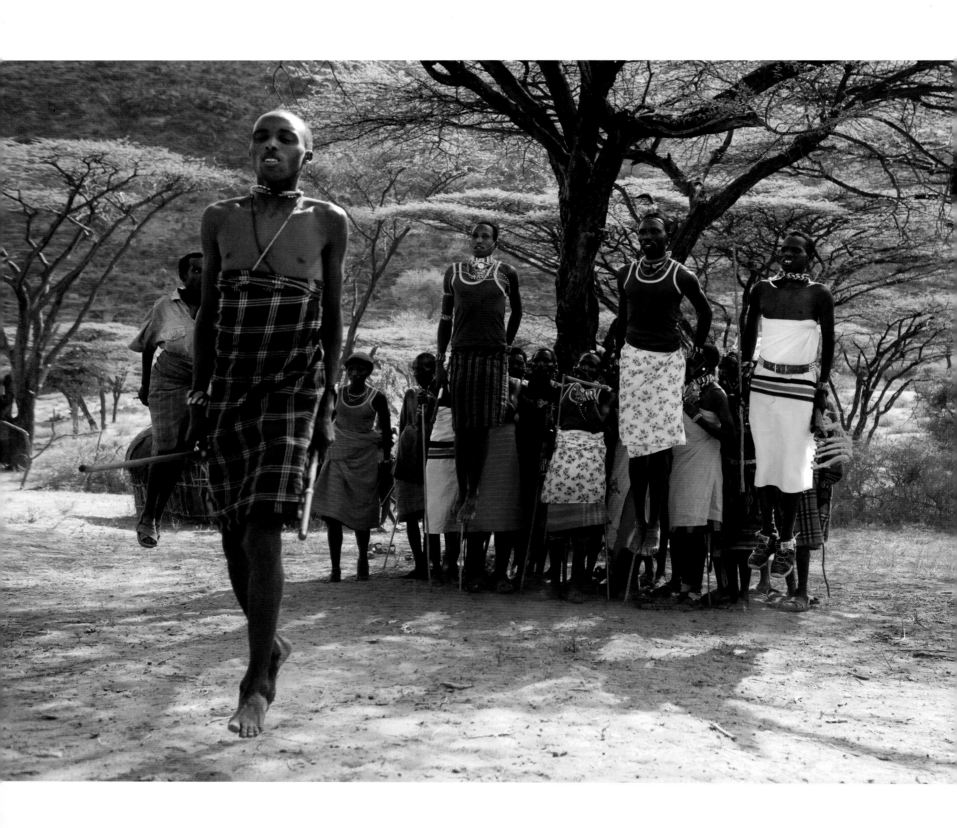

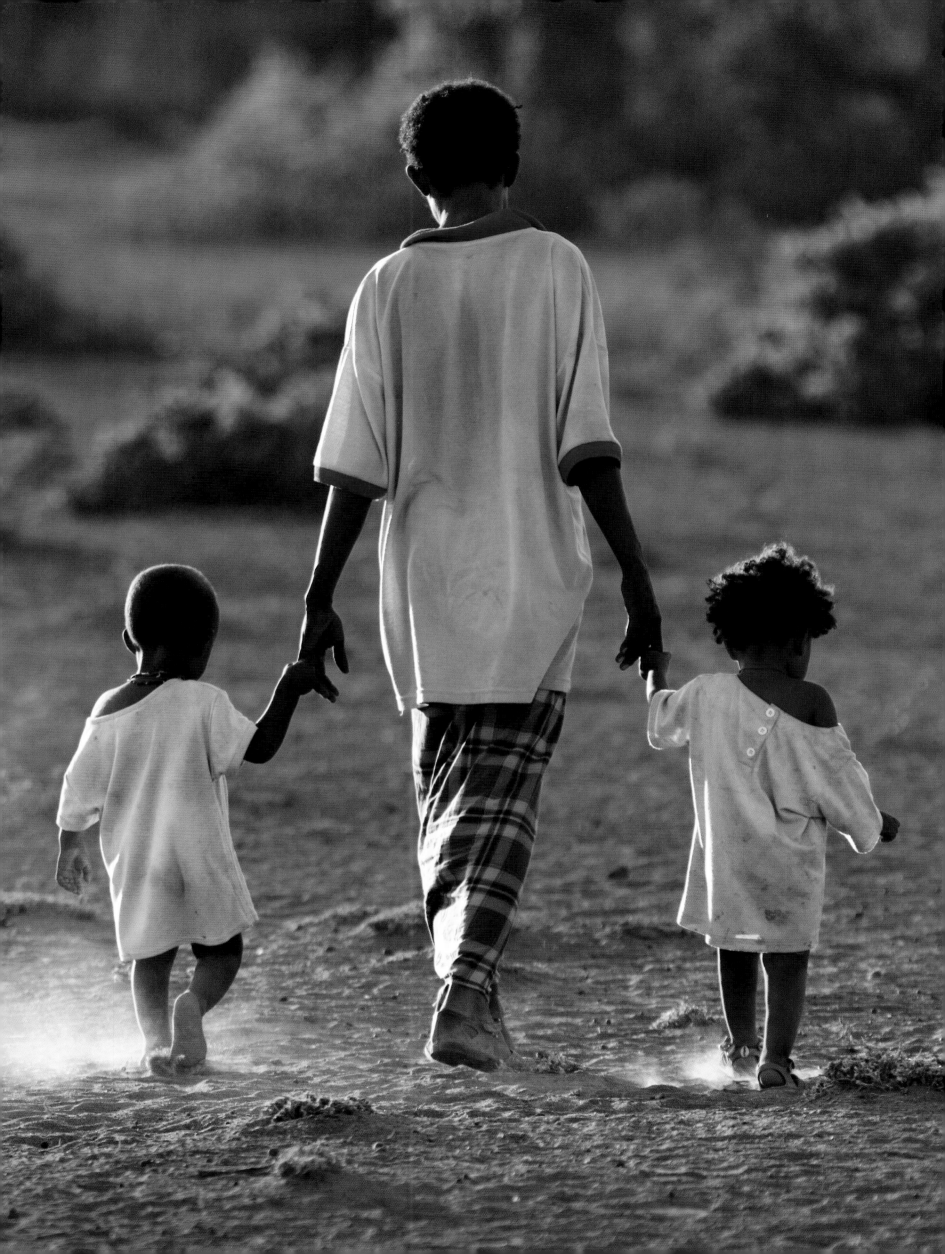

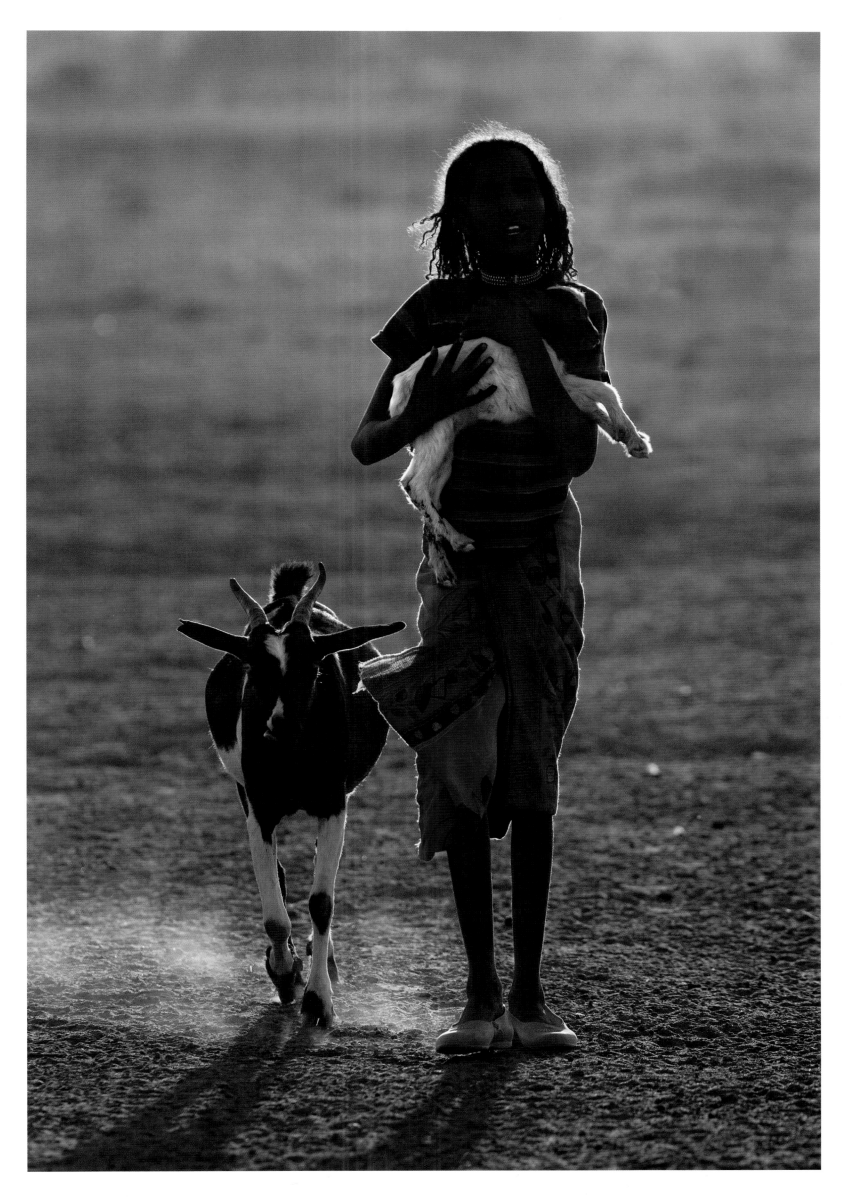

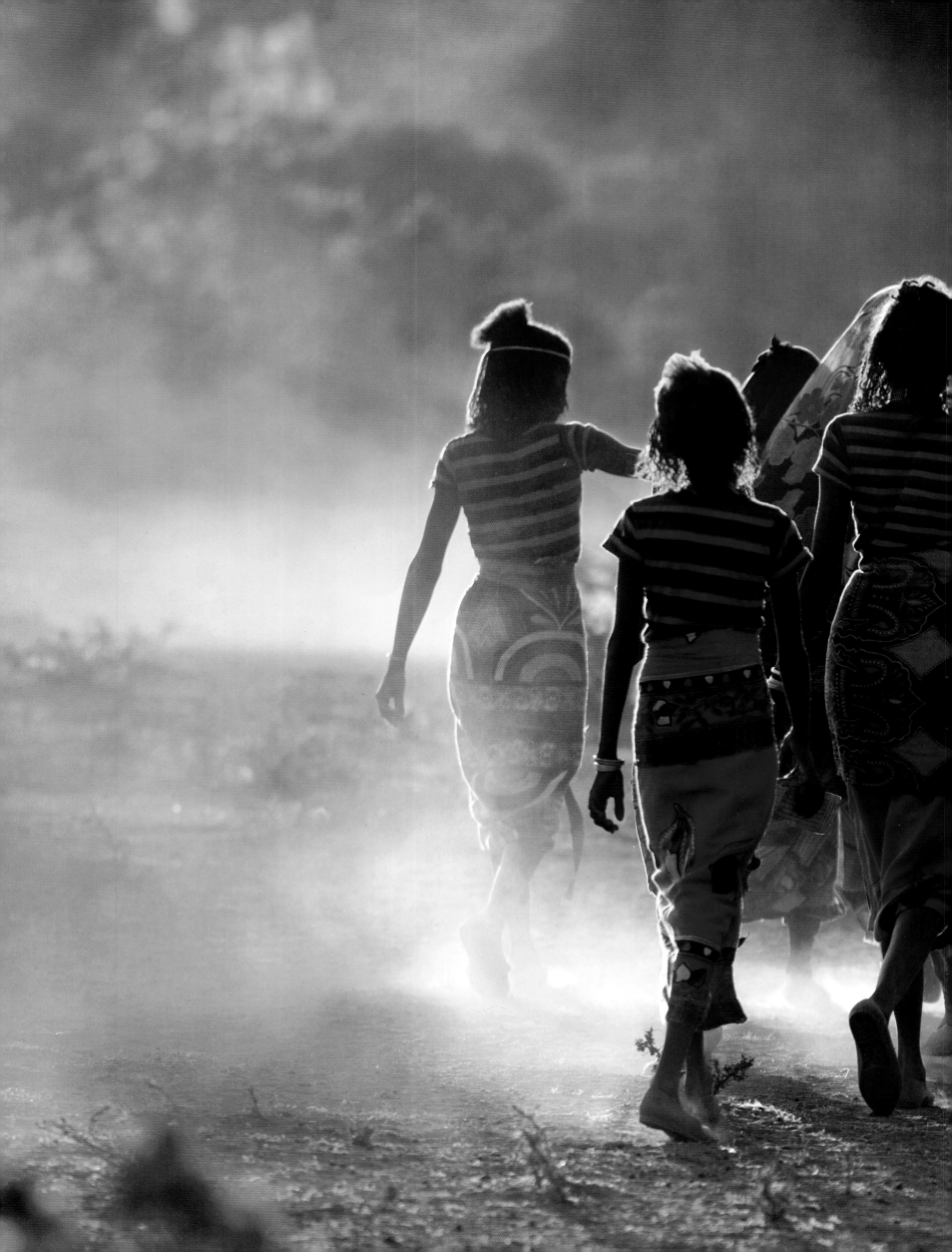

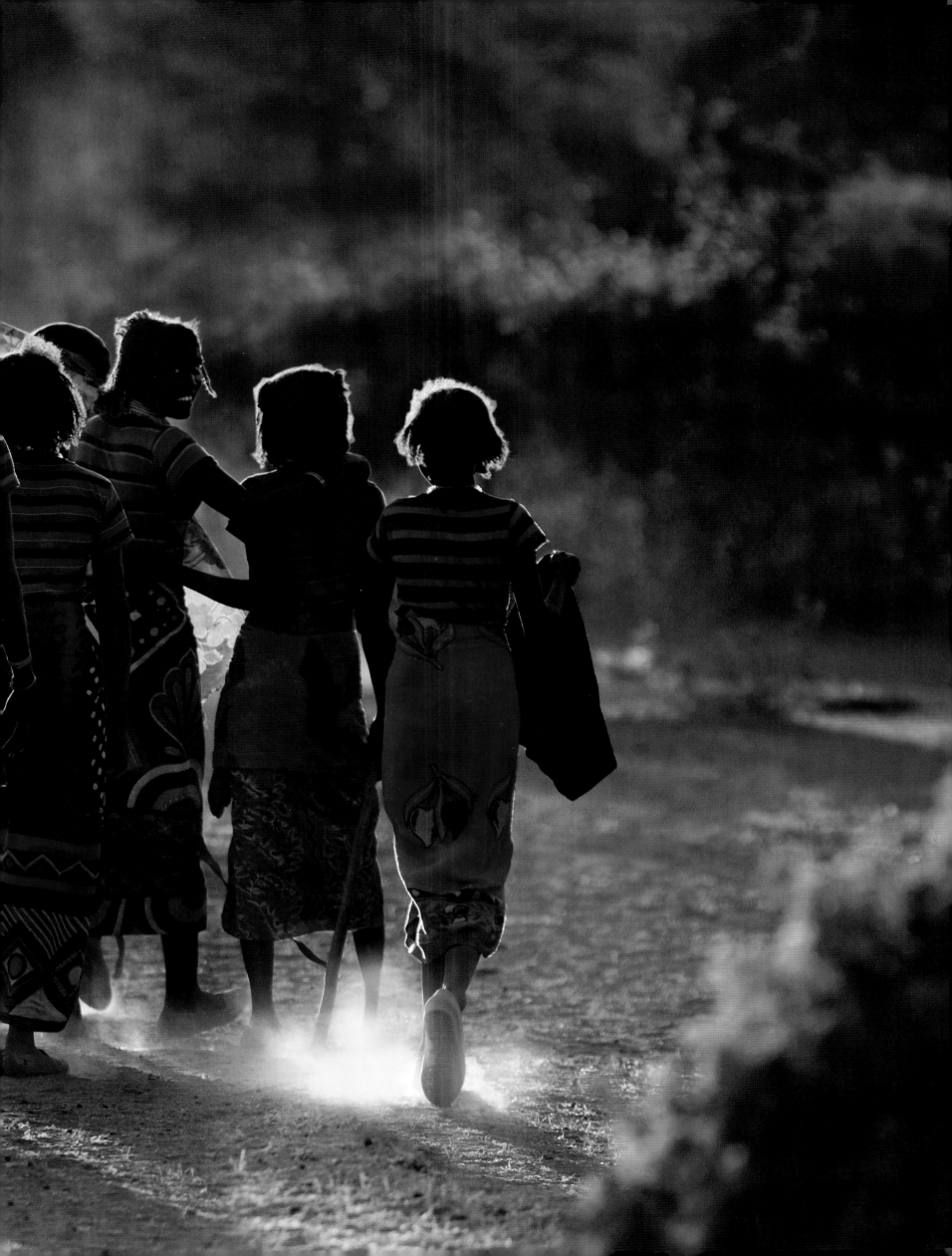

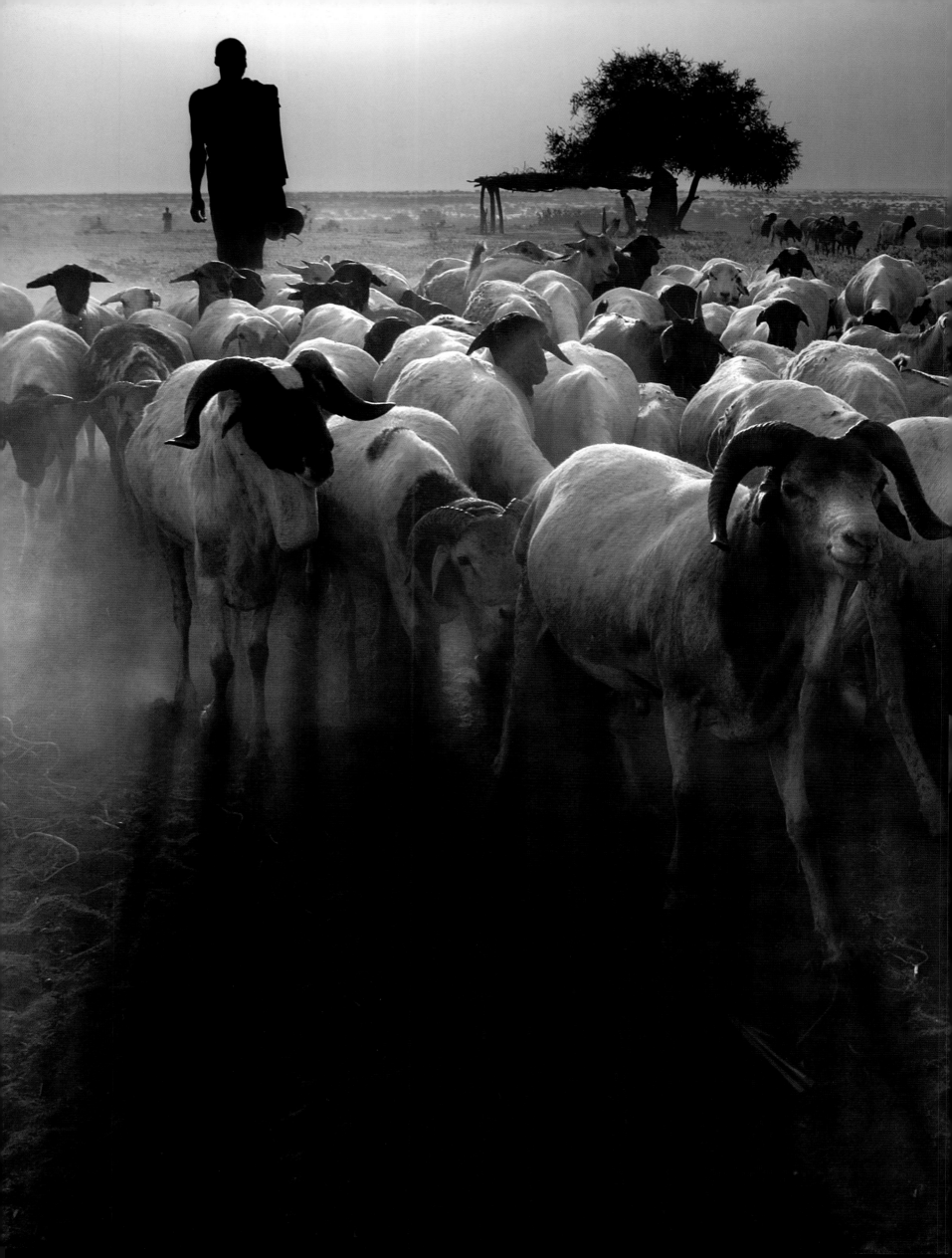

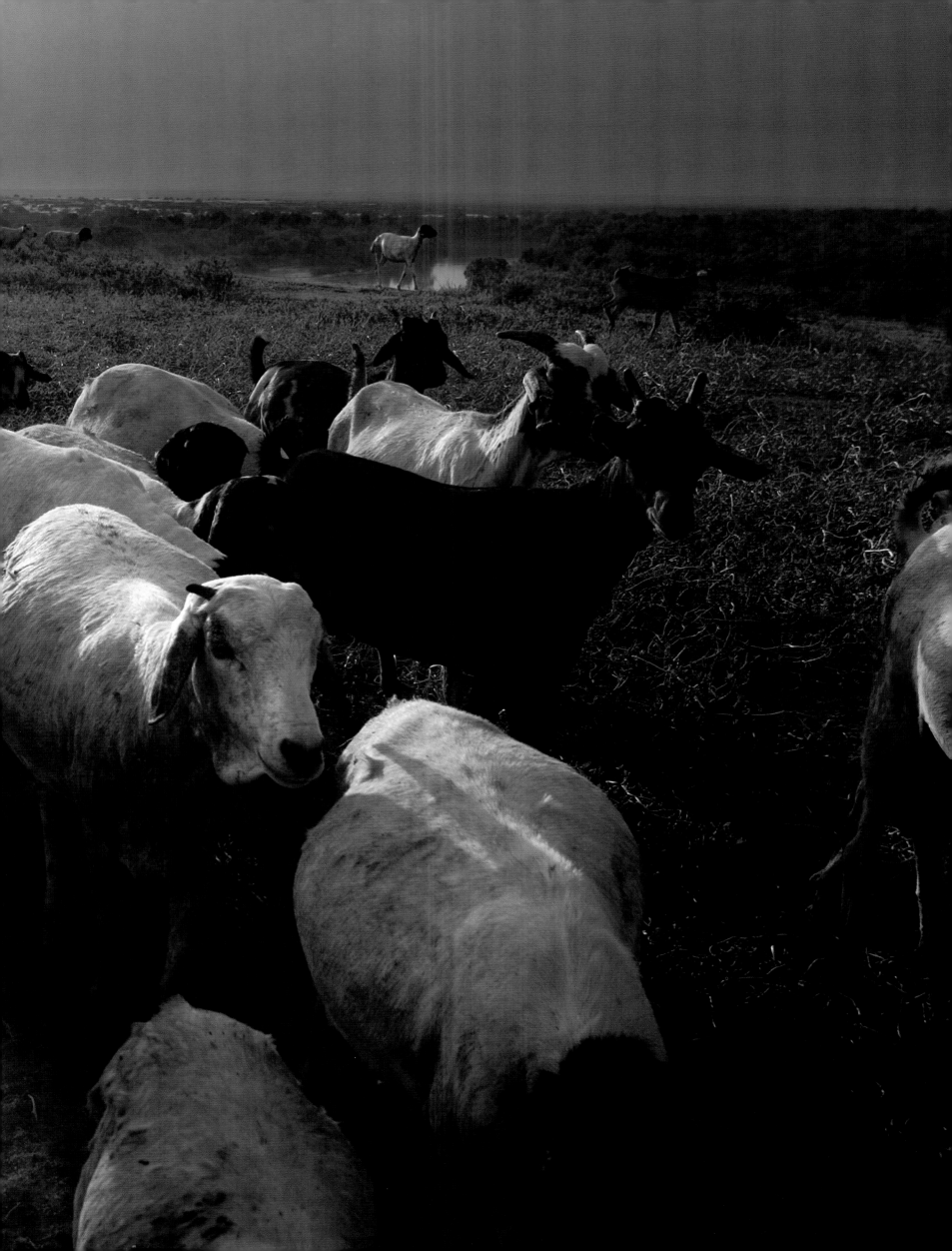

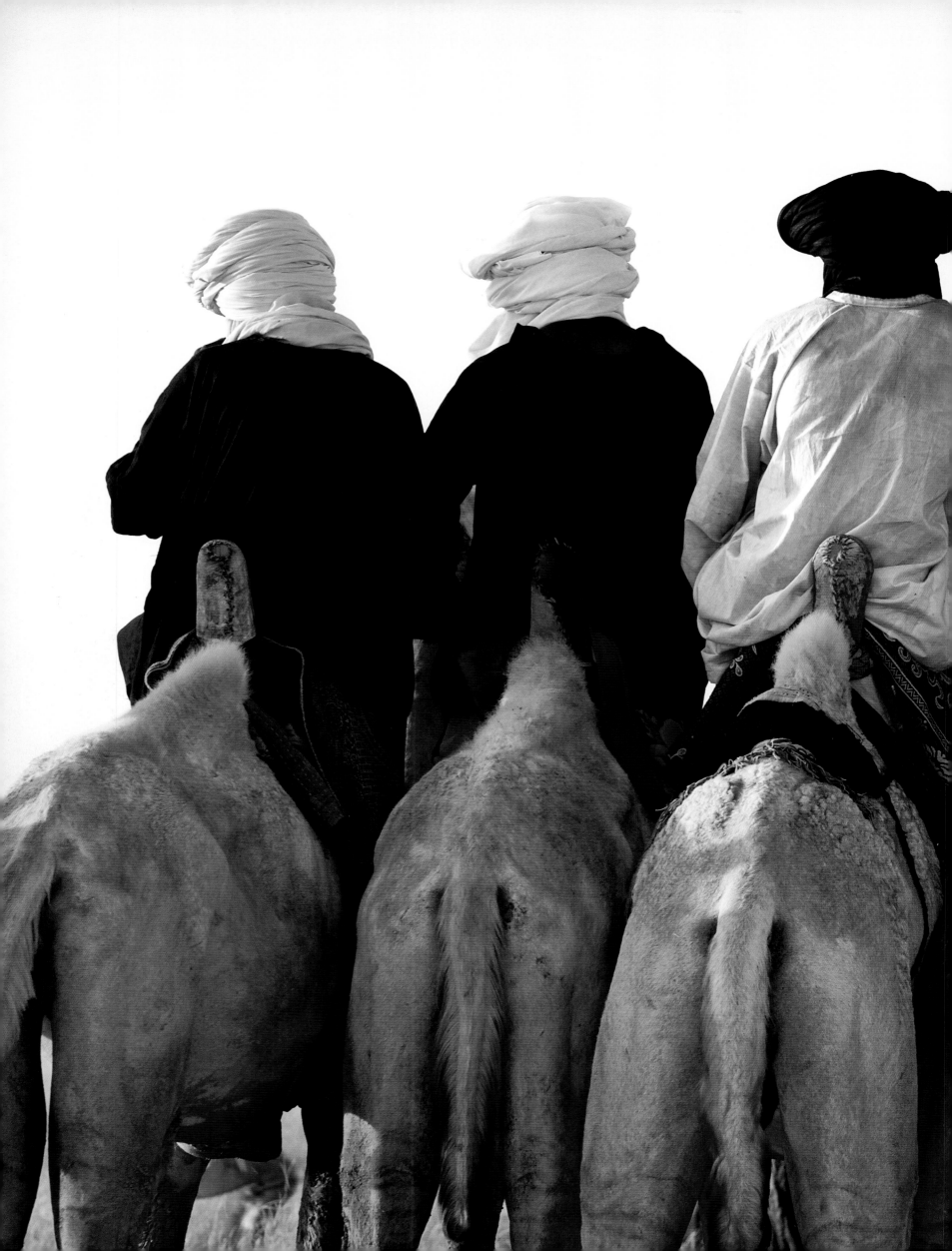

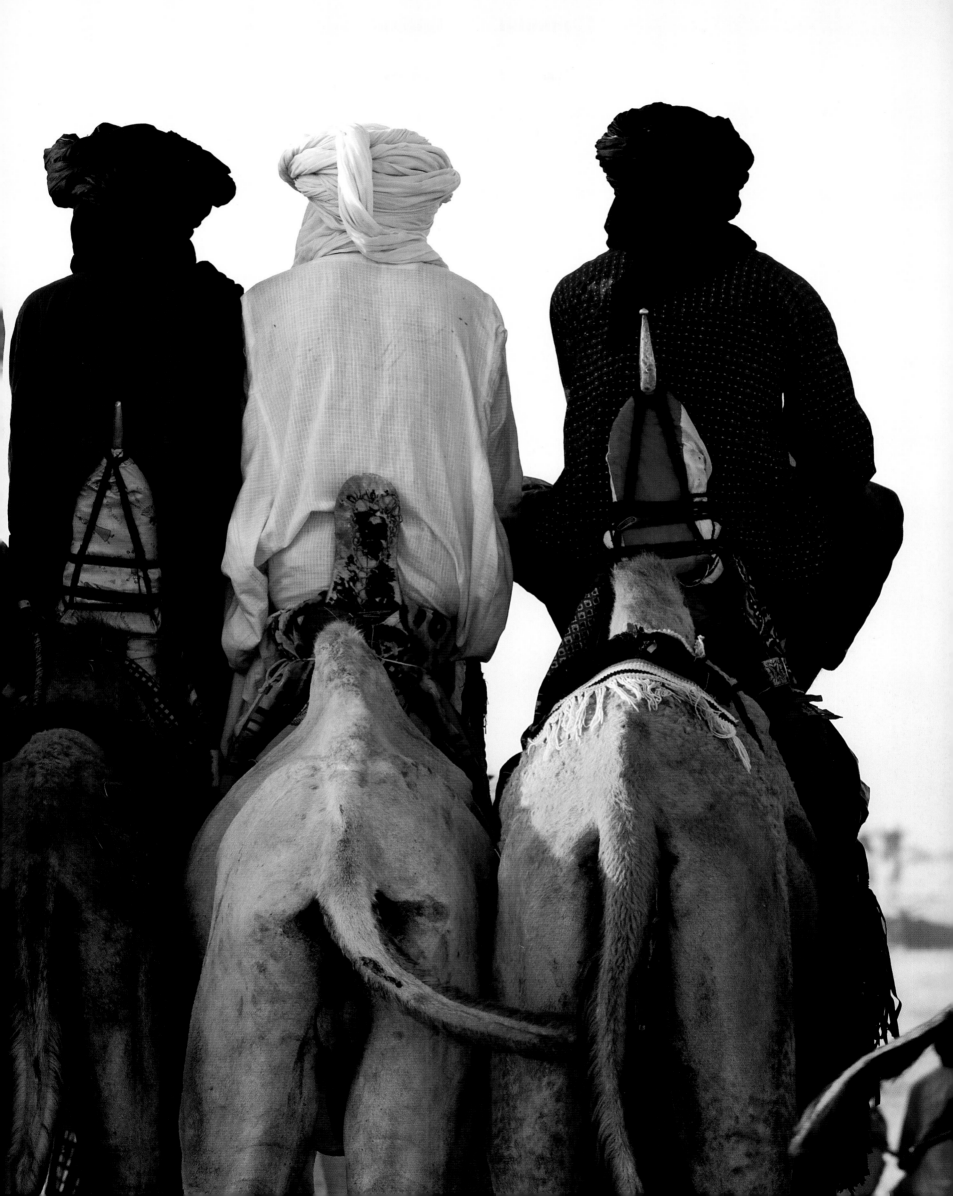

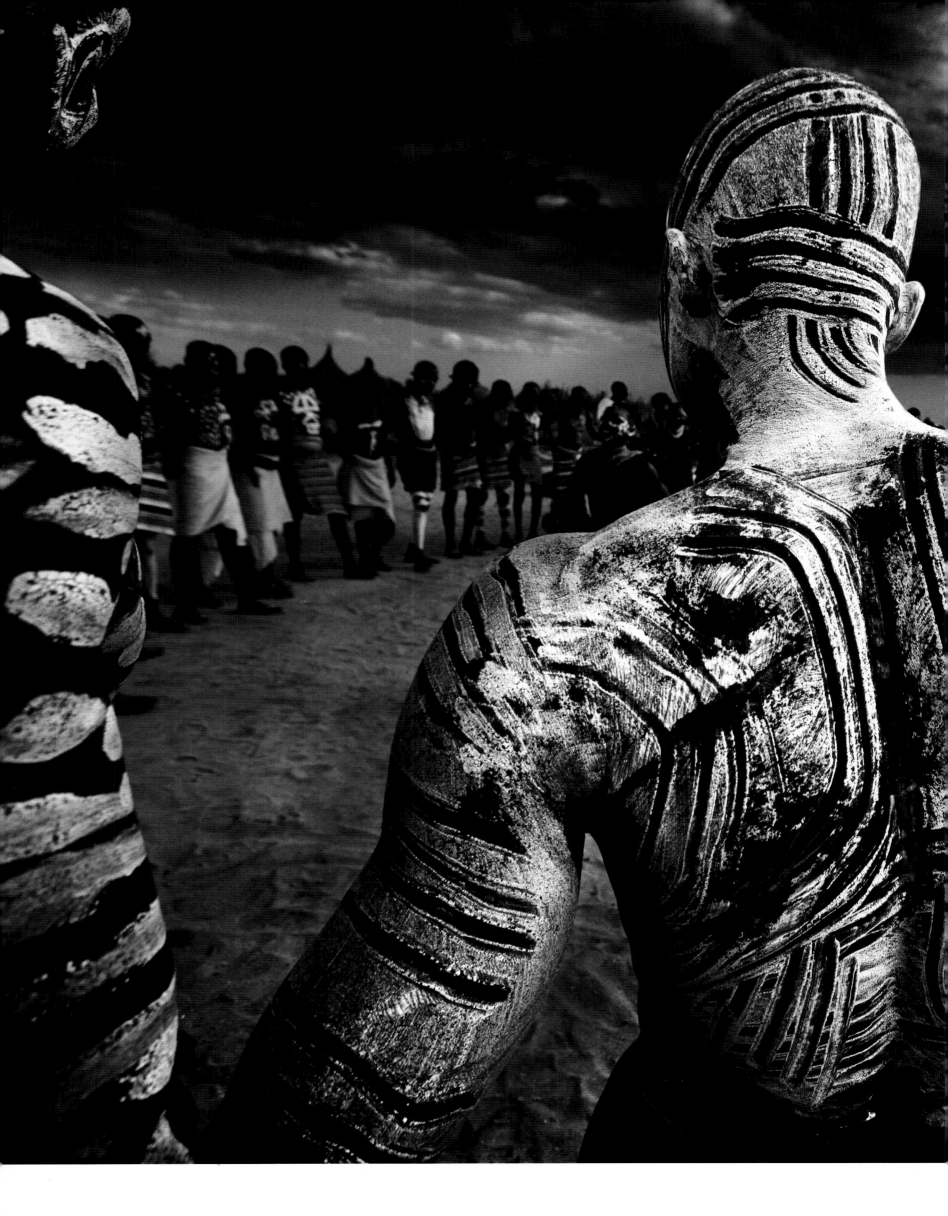

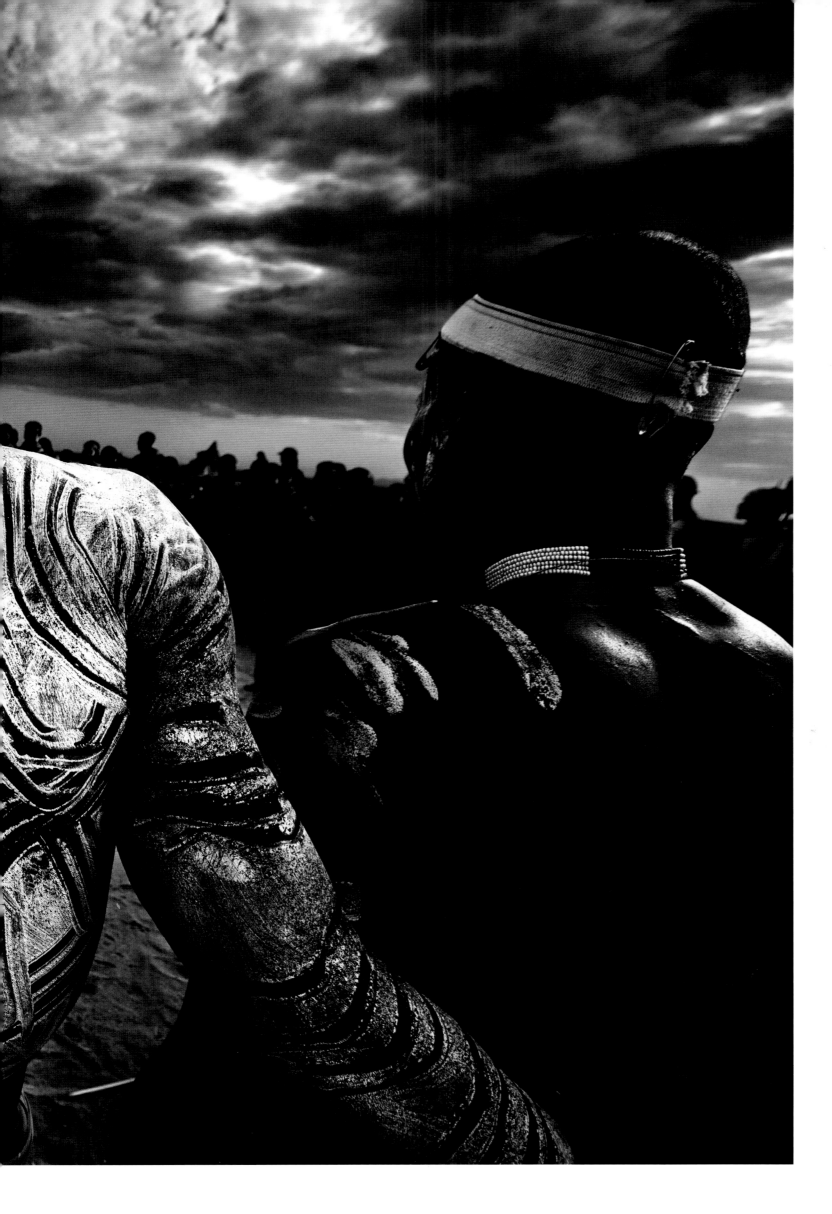

Modern air travel tends to delay the sense of *being* in Africa. Tourists are often whisked away from the airport in air-conditioned cars, straight to luxury safari lodges, seeing little of the character of the country they are visiting. Many go home with the impression that the continent is merely one large game park. An authentic arrival is a slower process. You encounter the temperament of a place by venturing onto the streets, discovering market stalls selling brightly coloured fabrics, street-side motor mechanics, traditional chemists, and above all, simple food cooked at the roadside, hot, steaming, fresh and served up in cones of torn newspaper.

My plane lands in Addis Ababa in darkness and I step out into the unfamiliar thick, warm air of the Ethiopian night, a stark contrast to the icy chill of the European winter I have left behind. I collect three of my four bags in the baggage hall and the carousel grinds to a halt. I am alone, the last remaining passenger in an empty room. My mobile phone rings. An irate United Nations official announces that he has taken my suitcase because it looks like his, and has phoned the number on the label. We meet outside and he thrusts it at me, indignant that I should have the audacity to own a similar bag. I leave him to his problems and head for the hotel where I check in at sunrise. Another UN official, from the same flight, is arguing vehemently with the reception clerk. He has been put in a non-smokers' room, but insists on his right to smoke anywhere he likes. My first encounters in Ethiopia are with grouchy custodians of world peace. But soon I will head for a different Ethiopia.

I plan to fly to Mekele, then drive on to Lalibela, but when I arrive at the airport I am told that our flight left four hours early. I spend the rest of the day in the terminal while the guide tries in vain to get us onto another plane. Four clocks on the wall indicate world time; the one labelled 'Rome' stays at two o'clock all day. Today it feels as if time itself has stopped. Ethiopia uses the Coptic calendar, in which the millennium is celebrated seven years later than the rest of the world. I learn that I will have to wait until tomorrow for a flight. It is only to Axum; but at least we are going

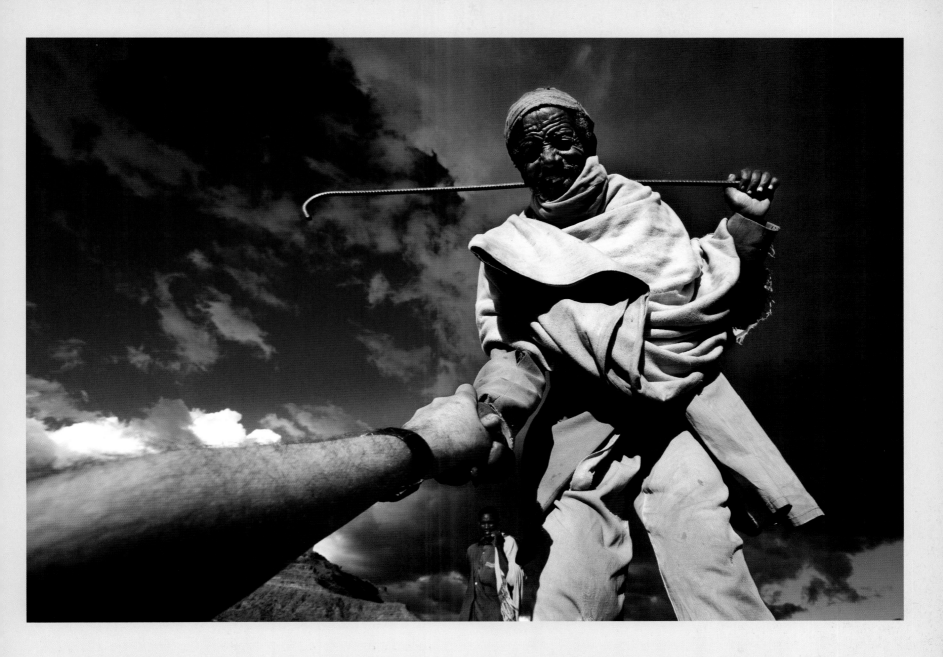

in the right general direction. Delays are an accepted part of the African travel experience: we in the West do not have a monopoly on the concept of time.

The sixteen-hour drive from Axum to Lalibela takes us through mountain passes, with each summit opening up a new vista of stunning scenery. The vegetation changes continually from cactus to alpine and back again as we climb and descend first one mountain then the next. We finally arrive at the ancient town of Lalibela, perched high on a hill.

Ethiopia is a profoundly religious country, and Lalibela, with its twelfth-century sunken churches, is a place of Christian pilgrimage. I stand on the ground, level with the roof of the monolithic Church of St George, which rises within a deep hole carved in the earth. All around pilgrims in white robes come and go.

Saturday is market day, and processions of traders labour up the steep hill to sell their produce in the busy little town. Heavily laden donkeys struggle up the incline and women carry tightly bound bundles of firewood; three men haul a large wooden bed up the mountain, complete with mattress. All around are brightly coloured umbrellas, shielding people from the hot sun. Later today many will trudge back down the mountain, wearily carrying their unsold stock.

Dark clouds gather in the late afternoon and the sun shines intermittently. I lie down in the road, waiting to photograph passing traders from a low angle against the dramatic sky. An old man approaches, grips my hand firmly and pulls me to my feet. He laughs, telling me that in Ethiopia it is customary to stop and help a person who is lying in the road. Such warmth is everywhere here.

The next day our flight to Addis Ababa is cancelled and after a six-hour wait at the airport we must return to Lalibela to seek accommodation for the night. Our driver, unaware of the cancellation, has left with our car, so the guide persuades a local taxi to take us into town. The driver speeds recklessly along the winding road in the twilight, for though he has accepted this unexpected job he is in a hurry to make another appointment. We turn a corner, suddenly facing a herder and his goats who occupy the full width of the road. The driver accelerates and blows his horn, scattering the animals. A goat runs into the car and I hear the sickening thud of impact. As the driver speeds away, the furious herdsman runs behind the car, clenching his fists in the air. Further along, several children waving sticks rush into the road, shouting, but we skirt around them, continuing up the hill. About half a mile on, the car skids to a halt. Large boulders block our way and we are surrounded by angry villagers wielding rocks and heavy poles.

Our guide, Firew Ayele, climbs out of the car and is immediately
surrounded by the mob. He holds up his hands in a gesture of
surrender and agrees to go back and pay compensation if we have
killed the goat.

We turn around and head back down the hill to find the
flustered herder. His goat is a bit stunned and limping slightly, but
is otherwise fine. We are offered a cursory apology and sent on our
way. The herders' world is without mobile phones, but they are still
able to communicate across mountains and valleys as quickly and
effectively as if they were using modern electronics.

<div style="text-align:center">* * *</div>

There are few tourists these days in Zimbabwe, a country in
economic freefall, and my two sons and I check into a cavernous,
empty hotel just a short ride from Victoria Falls. The reception clerk
seems genuinely pleased to see us and greets us with a broad smile
as he sits beneath the sinister gaze of a giant faded photograph of
President Robert Mugabe.

Victoria Falls roars in the distance like traffic on a busy
highway, growing louder as we drive towards the clouds of mist
and spray. The Falls, thunderous and spectacular, exceed my
expectations. We are in the very heart of Africa, standing in the
spray near the edge of a deep precipice, struck dumb, momentarily
detached from the problems of the collapsing country. In happier
times this place would be thronged with visitors, but now we have
it largely to ourselves. Park officials plead with us to spread the
word, to tell our friends to visit too.

Hawkers chase after our car, desperately waving carvings,
beadwork, wooden bowls, spoons, and anything else that can be
crafted from natural materials. They thrust their intricate creations
through the open car windows, bang on the bonnet, pleading for
pennies for their handiwork, pennies that will be worthless by
this afternoon. Their currency is plunging faster than the Falls.
Tonight's dinner costs half a million Zimbabwean dollars.

Wherever I go I see people struggling to survive in the most
inventive of ways. At Bujagali Falls near the source of the Nile in

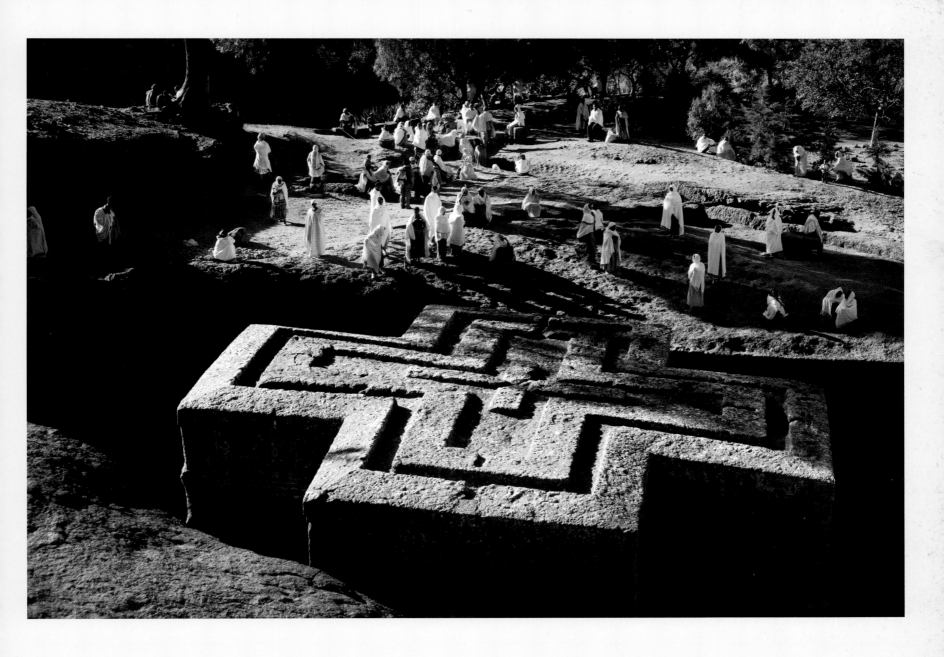

Uganda, a young man offers to climb into a plastic oil drum and throw himself into the rapids and over the falls, all for five US dollars. Dismayed, I offer him the money to stay on the shore instead and carry my camera bag. He misunderstands, takes the five dollars and plunges into the turbulent water.

Night comes quickly near the equator. I leave the Falls and drive to Kisoro as the sun is dropping. The heat of the afternoon wanes, yielding to a spectacle of colour that changes so fast it is missed in a blink. The rich green hills of Uganda are now swathed in a golden warmth, the sky is crimson, the cumulous clouds dark in their centres, fringed with orange, then pink. All around the land and sky reach a pinnacle of intensity before giving way to darkness and the first sign of a crescent moon. We pass the shadowy figure of a man on a bicycle, so heavily laden with bananas that I hardly see him in the dim light, wobbling beneath his weighty cargo.

Frenzied grasshoppers swarm around the glowing orange streetlamps of Kisoro, echoed by clusters of chattering children bearing long poles with crude nets attached. They wave these in a jerky dance, catching the bright green juicy insects, collecting them in bags, bottles and saucepans. No streetlamp is spared the flurry. The grasshoppers are freshly fried and sold at makeshift street stalls.

Along the coast of Senegal, thousands of fishermen work the rough Atlantic waters. I am on the shores of St Louis long before sunrise, where a trader washes his horse in the waves under the full moon. A flotilla of small, brightly painted boats appears on the distant horizon and he wanders off to hook up his cart. Steadily the boats move towards the shore in the gathering light. Traders wait on the sand, and when the boats come in, men run into the shallows with empty baskets on their shoulders, while horses pull high-wheeled carts into the water. Arms wave about, fish are thrown through the air, deals are done. Soon baskets and carts are filled. Women, gathered on the beach, sort and clean the fish; more traders fill the large open space near the car park; trucks are loaded with overflowing crates. An assembly line operates at fever pitch, from the sea to the trucks. When the boats are empty, they turn around to head back into the ocean where the fishermen will work until dusk.

I accept an offer of a ride in a small fishing boat. The skipper is friendly, but I am daunted by his shirt decorated with swastikas. Asked for an explanation, he tells me that he passionately supports a German football team, and loves everything else associated with Germany. He knows little about politics or history and is ignorant of the meaning of the symbol he proudly displays. But his fishing

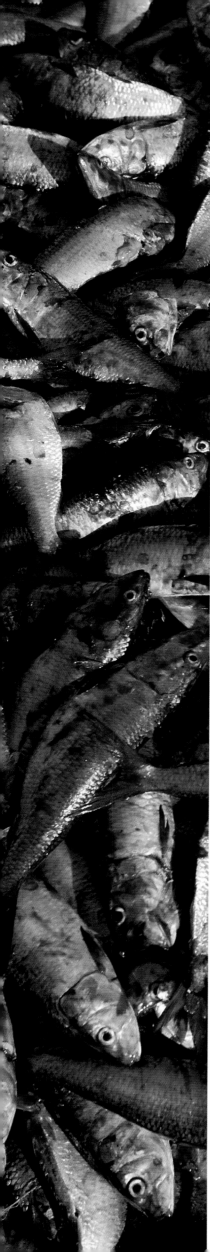

skills are expert, honed by the necessity of survival; he risks his life daily in a simple wooden boat, dependent on a few timbers holding together in the battering seas. We head off into the waves and are blasted by the spray. A scattering of boats dots the ocean; men stand erect in rows and cast their lines, balancing like acrobats in the swell.

A local man tells me that a close friend was among thirty people who recently drowned in an attempt to reach the Canary Islands. Their overcrowded boat sank after many days at sea. With foreign trawlers depleting fish stocks, desperate people are driven to become economic migrants. Despite the fact that some cannot swim, they cram into small fishing boats and head out into the treacherous ocean in search of a better life in Europe. There is a strong tradition of family support across Africa, and those that make it usually send money home. But many don't reach their destination; they die from exposure or illness on the journey. There is no limit to the risks people will take in their quest to survive and escape the slow death of poverty.

Small shopkeepers abound across Africa, working day and night, selling everything from hand-crafted shoes to human teeth to the hands and heads of monkeys. People sit on wooden boxes, in long lines at the side of the road, each hoping to sell their paltry collection of a few potatoes, pieces of firewood, cheap watches.

Early one morning while travelling between towns, we stop the car for a break in a desolate, empty part of Mali. On the sand is a small, lonely straw hut, appearing totally out of place in the desert. I wander over and meet four Tuareg women who are making tea. Their worldly possessions are no more than the clothes on their backs and a few simple cooking utensils. The eldest, a grandmother, sits cross-legged on the sand, watching her daughter pour filthy black water from a plastic oil container into a battered pot which she heats on a small fire. They have carried the water for half a day to their home, and now they boil it carefully, drinking the tea slowly, ceremoniously, respecting every precious drop.

LEFT
The daily catch, Joal, Senegal.

OPPOSITE
Fish trader in his horse-drawn cart, Joal, Senegal.

212

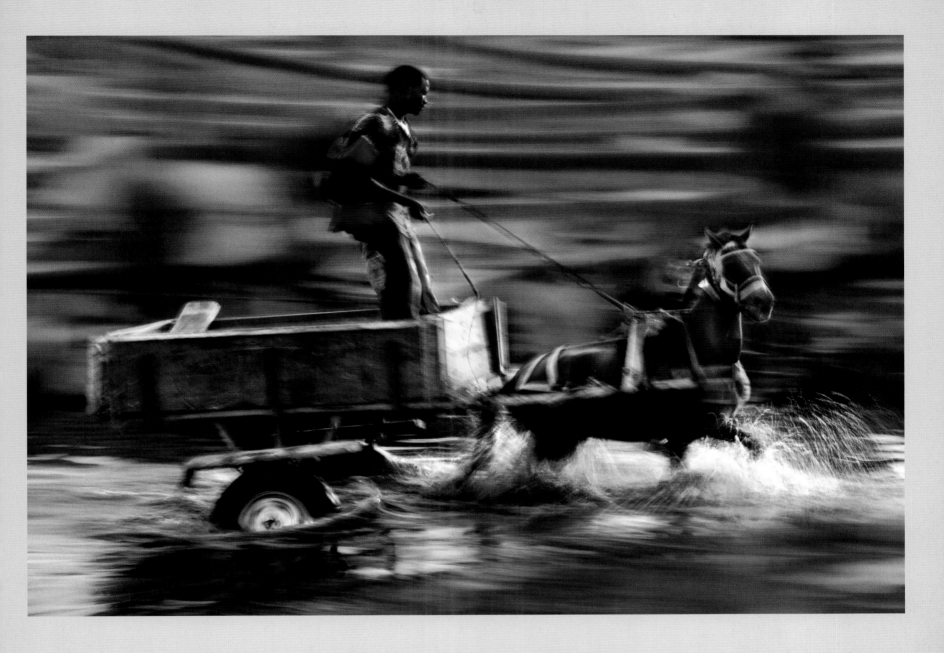

On the road the driver concentrates intensely on potholes, bumps and gaps in the tarmac. Occasionally he leaves the hard road for the dirt track that runs alongside it and immediately the ride is smoother. An impromptu roadblock appears, made from nothing more than a piece of string dangling coloured ribbons, strung across the road and tied to a post at one end. A man sits on the opposite side of the road and stops the traffic by raising the string and holding it taut. He peers into the car, then waves us on. We reach a broken bridge, half washed away by recent floods. Enterprising men rush forward, leading us to a shallow part of the river where we cross safely. We rejoin the road and encounter yet another roadblock. A uniformed officer tells us that because we left the road and drove through the river, we must pay a mandatory 'fine'.

The Gerewol Festival takes place in the southern Sahara once a year, a ceremony in which young Wodaabe women choose eligible partners from neighbouring clans. The location and timing are unpredictable, so when I hear that the festival is taking place in a remote area north of Abalak, in Niger, we head off in search of the event. We ask nomads for directions in the arid landscape, and they point vaguely to the north. We follow their advice, leaving swirls of dust in our trail, driving across the sand until, as if by a miracle, the indistinct shapes of camels and tents materialize in the distance.

After some negotiation, the chief grants permission to take photographs and I follow the distant sound of melodic chanting until I find fifty men in a line, swaying in waves, arms held out in front of them. Having spent hours applying make-up, they twist and contort their faces, bare gleaming teeth accentuated by lips painted black, and pop their eyes so wide open that the whites are quite dazzling. Dancing and singing, they grimace in the golden light of the early evening until a couple of nervous young women step forward to make their choice. The Wodaabe people believe that marriages are made through the power in the eyes.

Every twelve to fourteen years, Samburu boys in Kenya are circumcised in a group ceremony. All boys aged over twelve participate in this milestone in their lives, a rite of passage which begins their initiation as warriors. I arrive early to witness the gathering of the tribal elders in preparation for the ceremony. Each boy stands outside his mother's house, head shaved and draped in a black shawl. They are all circumcised by one man, a non-Samburu, who performs each operation with lightning speed.

A boy of fifteen waits at the entrance to his home, trying hard to conceal his apprehension. Today he must show no pain or fear, and may not even flinch during the operation, as this will bring dishonour to himself and his family. In the moments before the

elders arrive, he stands lonely and vulnerable. Now he is surrounded by elders and the women leave. He lies down on a cowhide given to him by his mother and milk is poured on his body. The men hold him and he shuts his eyes during the brief moment of excision, but he remains expressionless.

A cow is chosen from the herd, but she breaks free and runs frantically, hotly pursued by the village elders who catch her and pin her to the ground. A man draws a bow and shoots a small arrow into the cow's neck. Blood gushes out and runs into a leather flask which is handed to the boys to drink from, to help them regain their strength.

Each boy lies on his bed for a while, and later in the day they all walk together slowly, some with sticks, to a large tree where they sit quietly, grumpily. By nightfall they are laughing and joking with each other.

Each new adventure in this infinitely fascinating continent helps me to forget the frustrations of bureaucratic delays, heat-induced lethargy and septic insect bites. The challenge for the photographer is to engage with and understand the subject, yet the very act of raising the camera to the eye creates a physical barrier. The mind is absorbed in composition and style, and peripheral vision is temporarily lost. At the moment when the photograph is taken, the mirror blacks out the image and for a split second the photographer sees nothing. So wherever I go, I always try to enjoy some limited time without a camera, and allow my mind to open up to the surroundings without hindrance.

Changes are taking place in Africa at meteoric pace, just as in the rest of the world, with exploitation of the earth constantly intensifying. Traffic jams, once a rarity, are now commonplace in Africa's cities, cultures are threatened and animal habitats are imperilled by an expanding human population. But much of the old Africa continues in the slow lane. Here people do not think of the earth as exploitable but recognize it as a living mother. The small traders, subsistence farmers, lone fishermen, and remote tribes live life as it was always lived, in all its venerable simplicity.

LEFT
Wodaabe dancers, Gerewol Festival, Niger.

OPPOSITE
Samburu tribal elder attending circumcision ceremony, Mount Nyiru, Kenya.

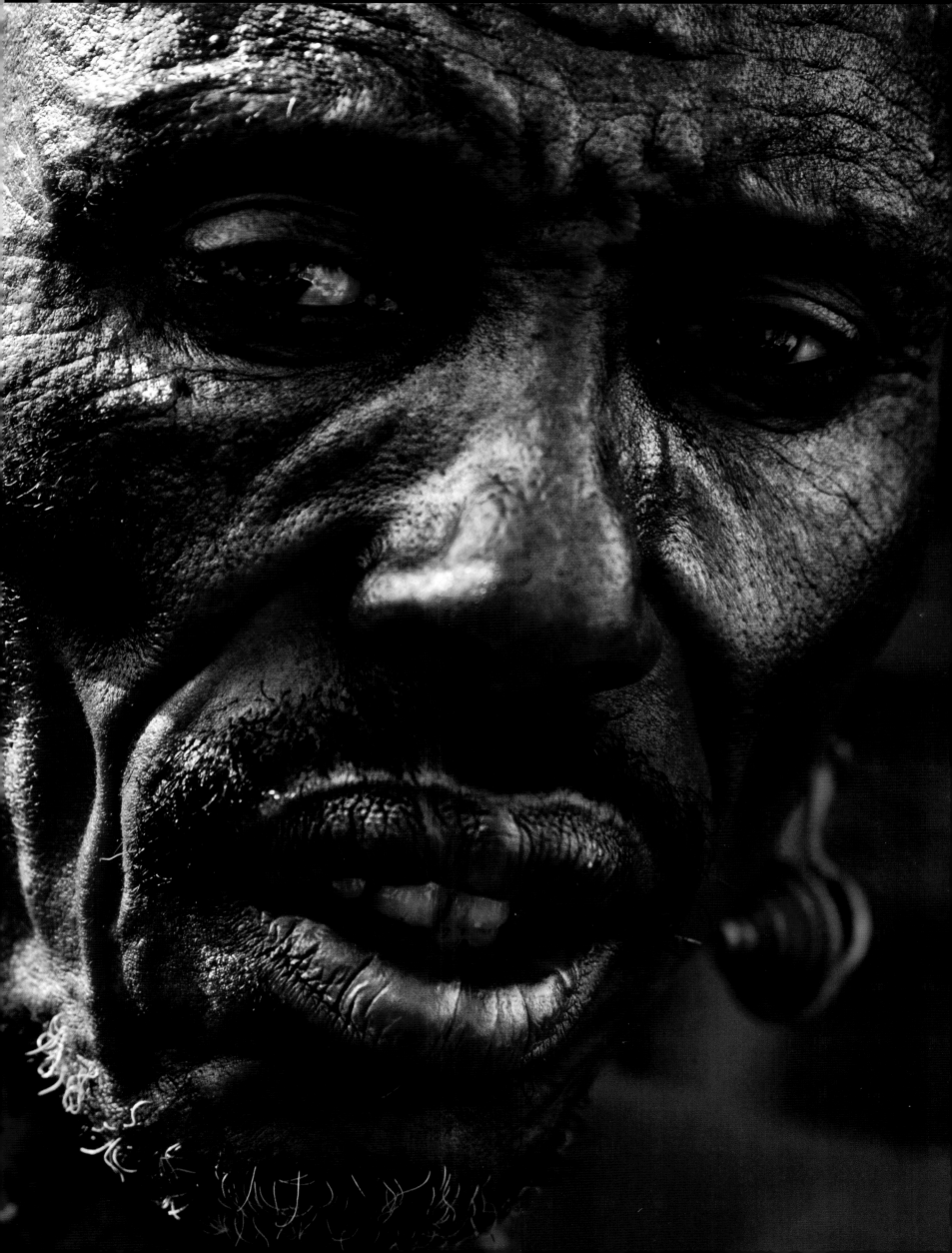

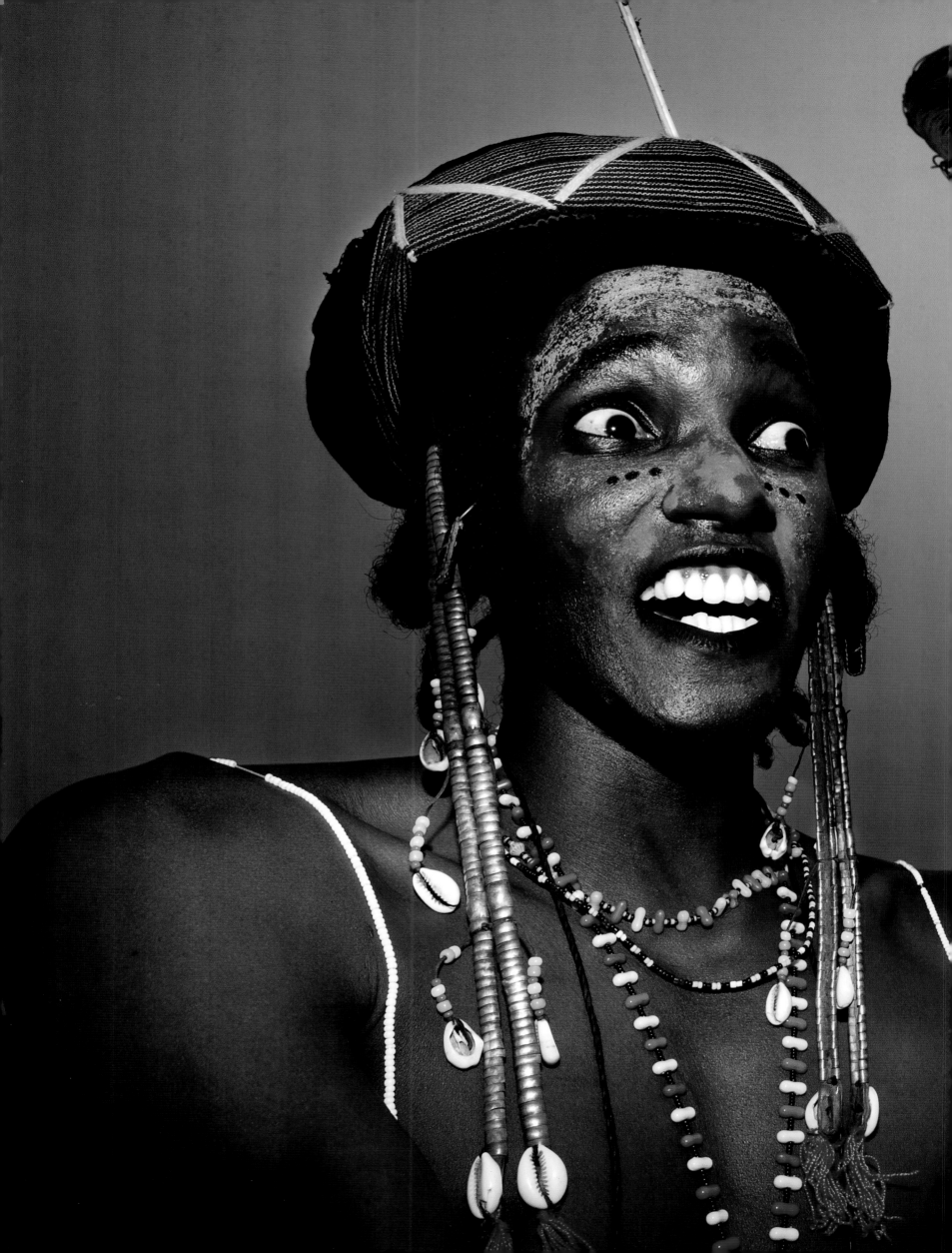

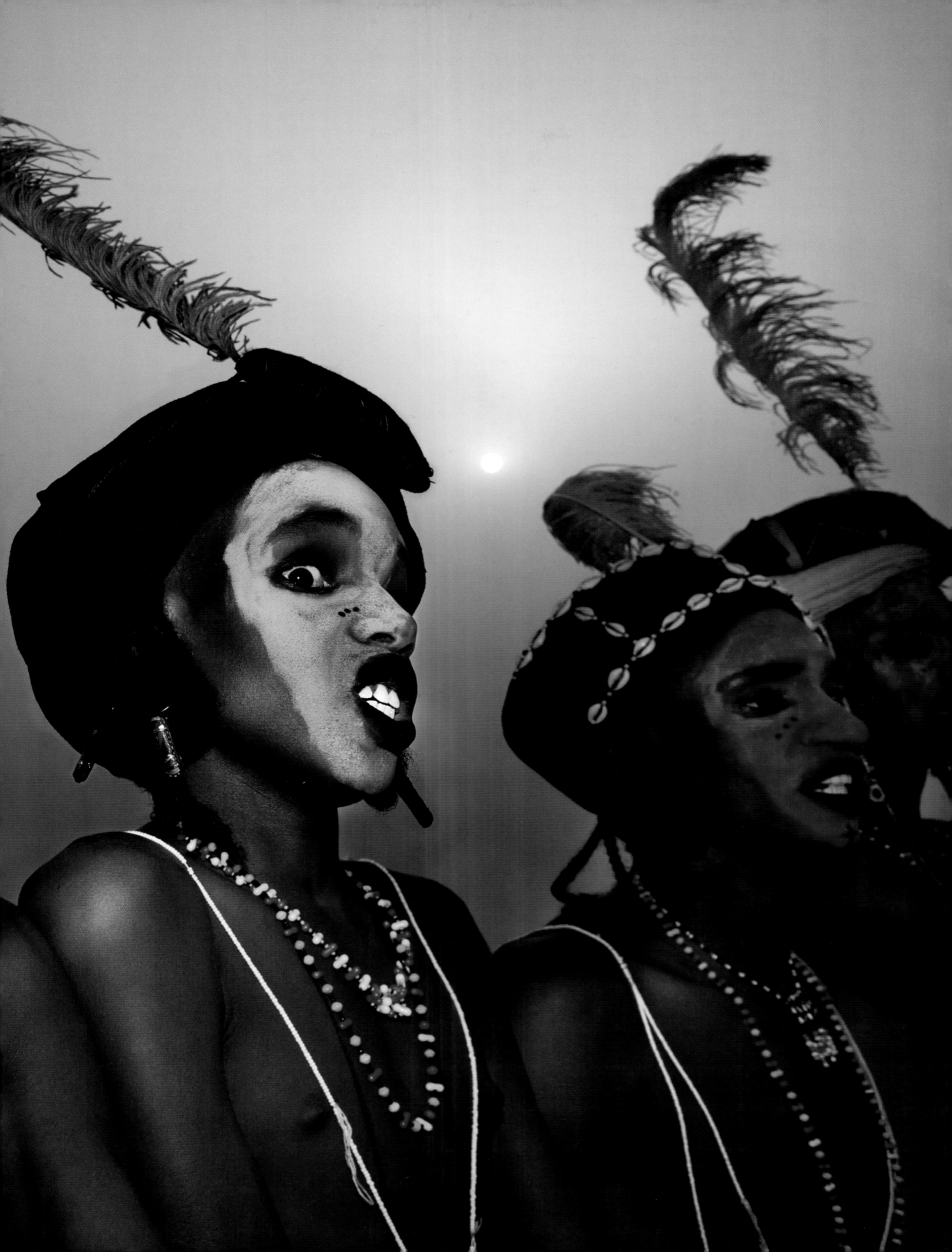

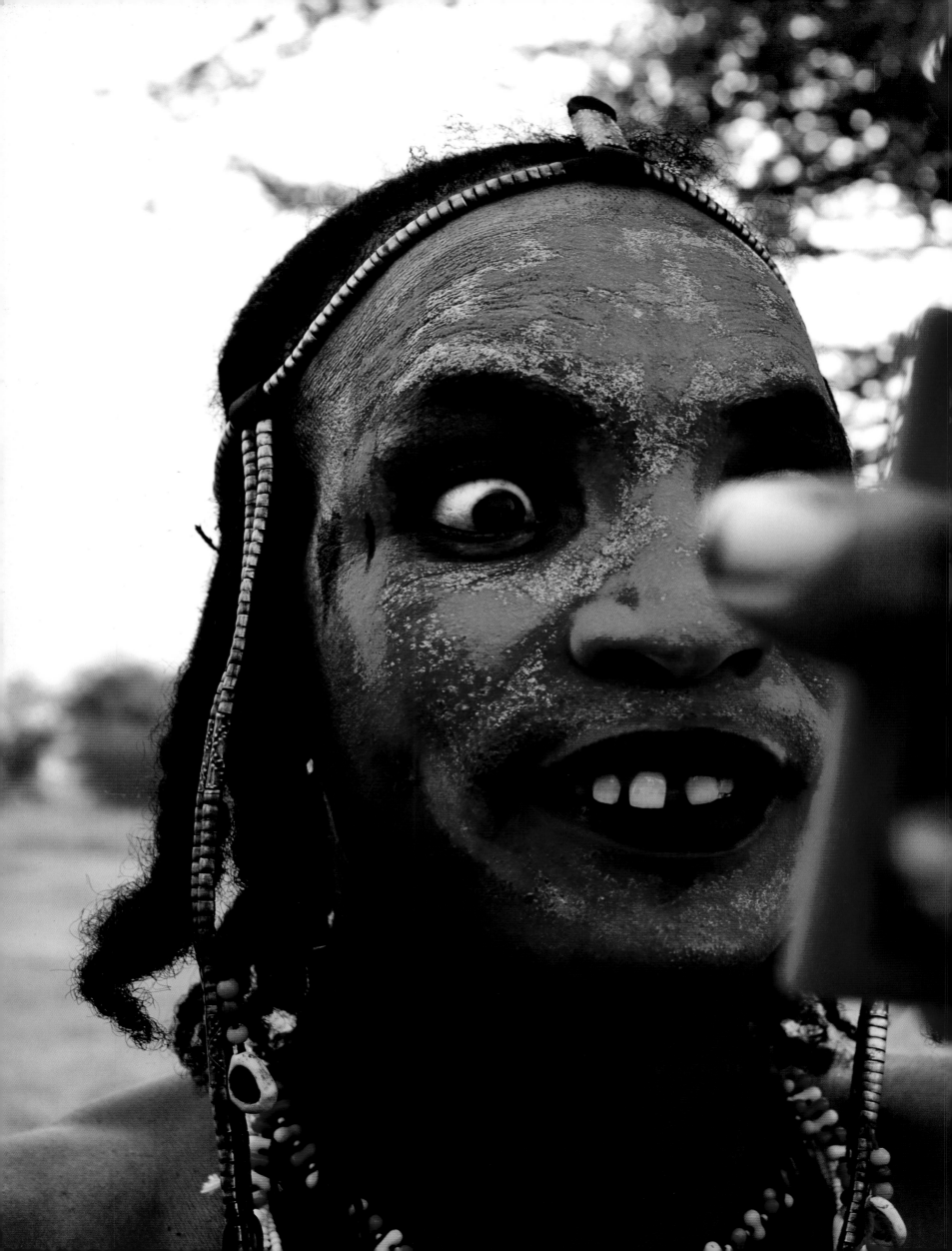

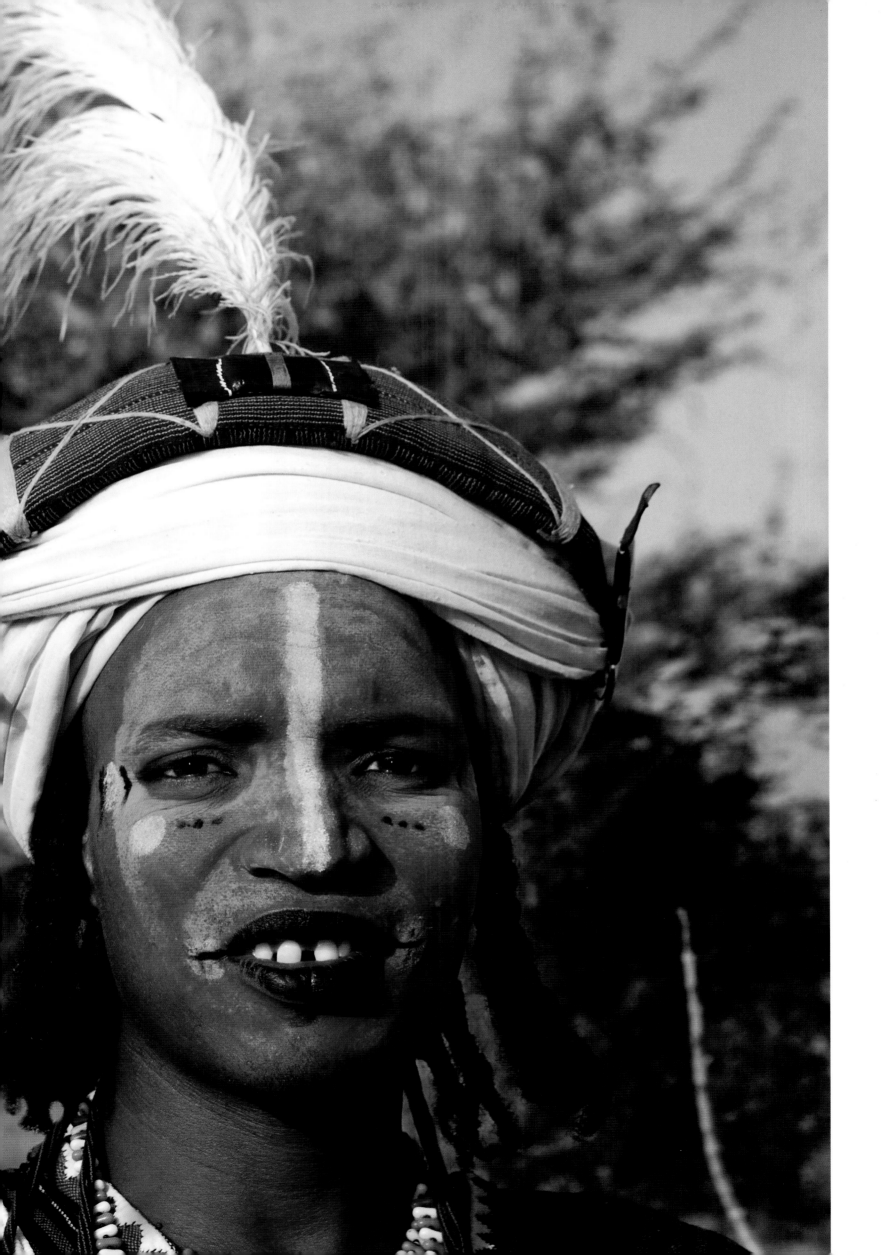

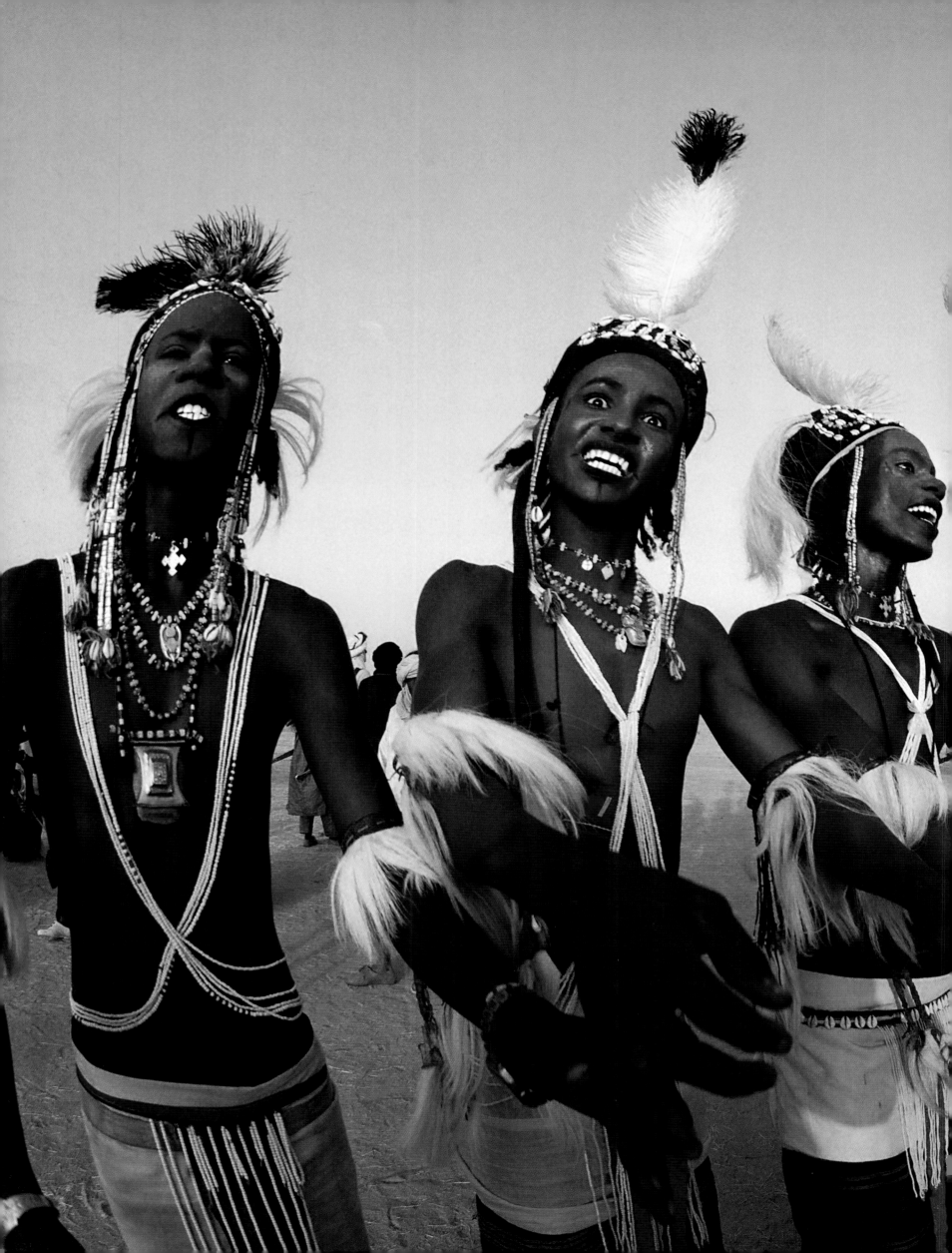

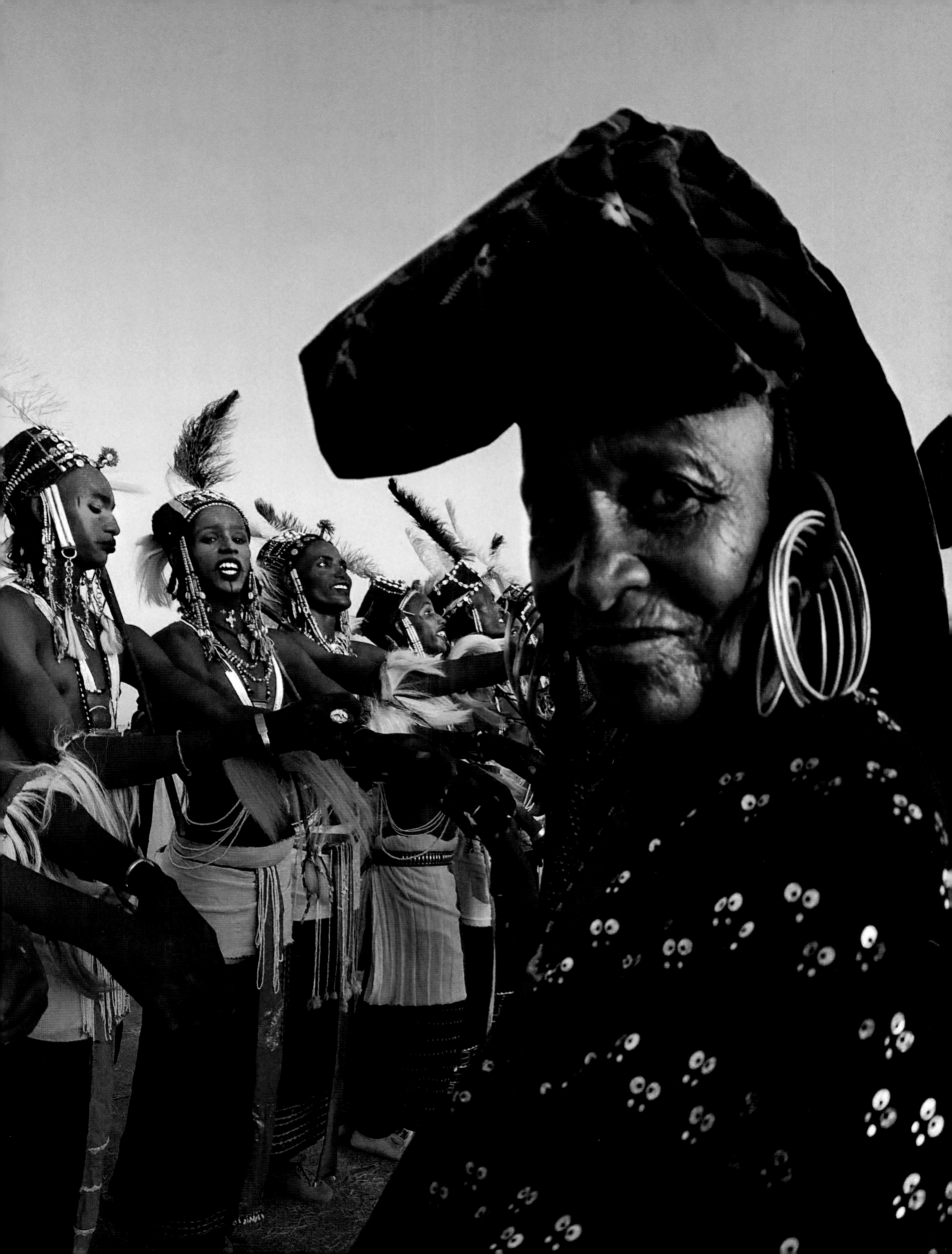

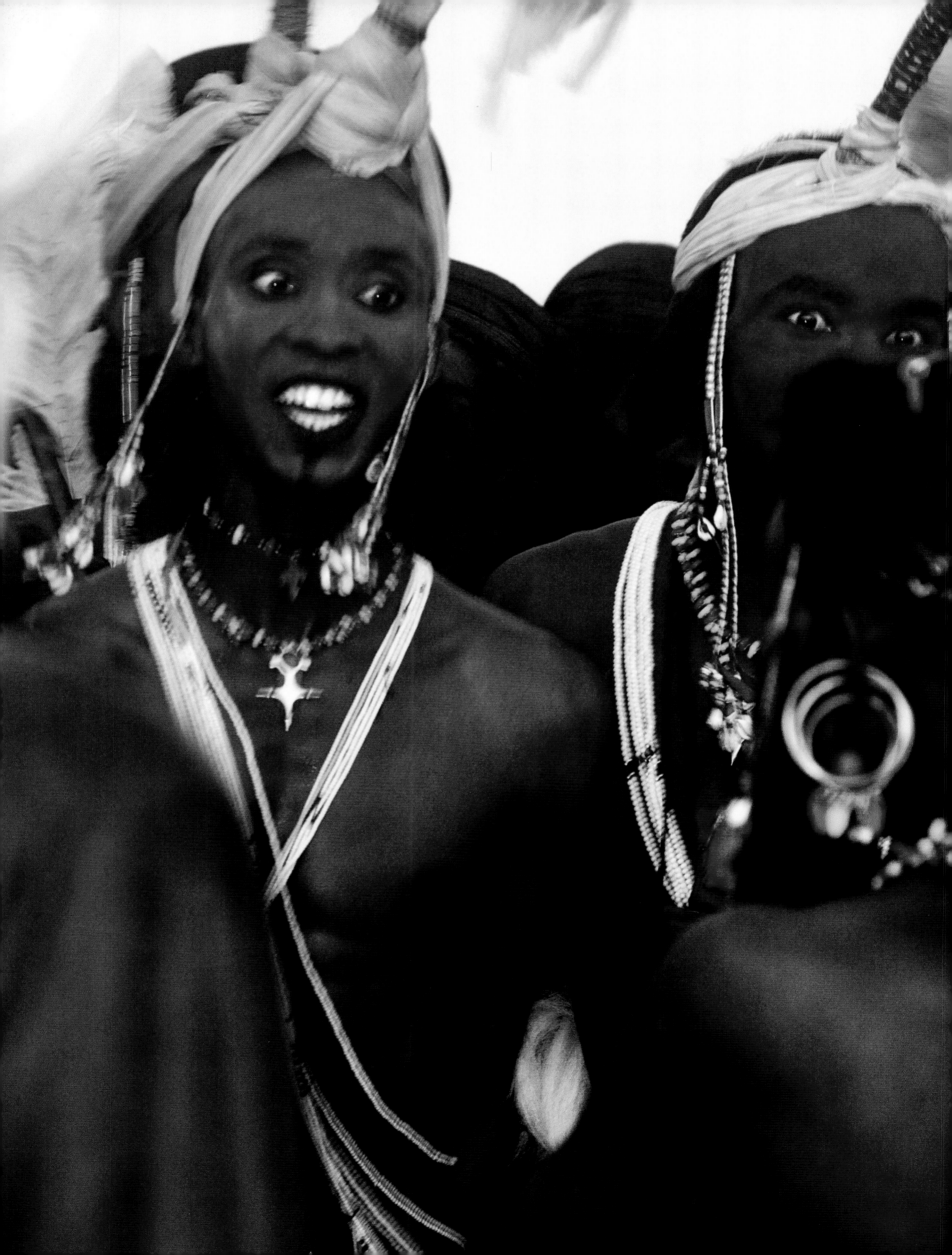

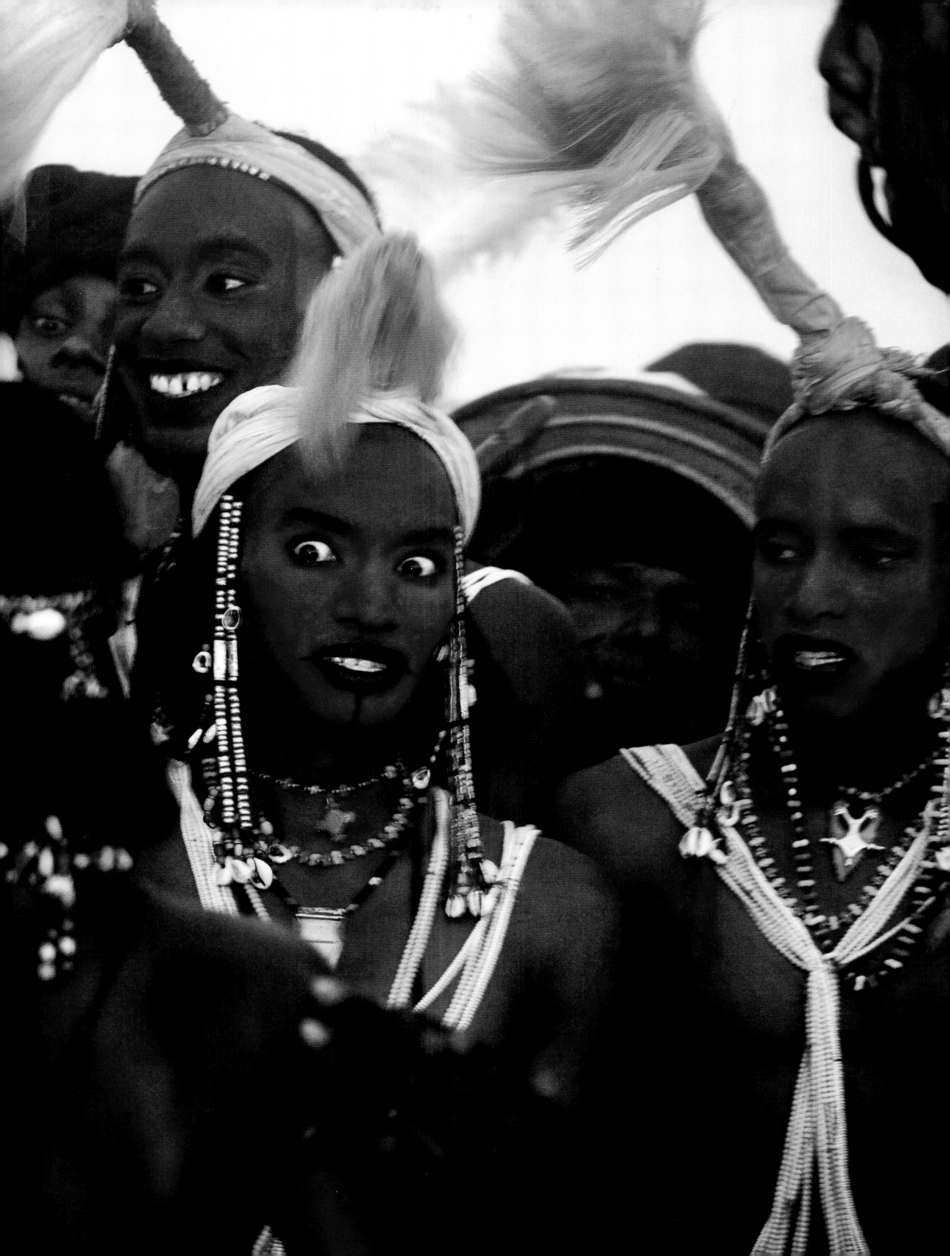

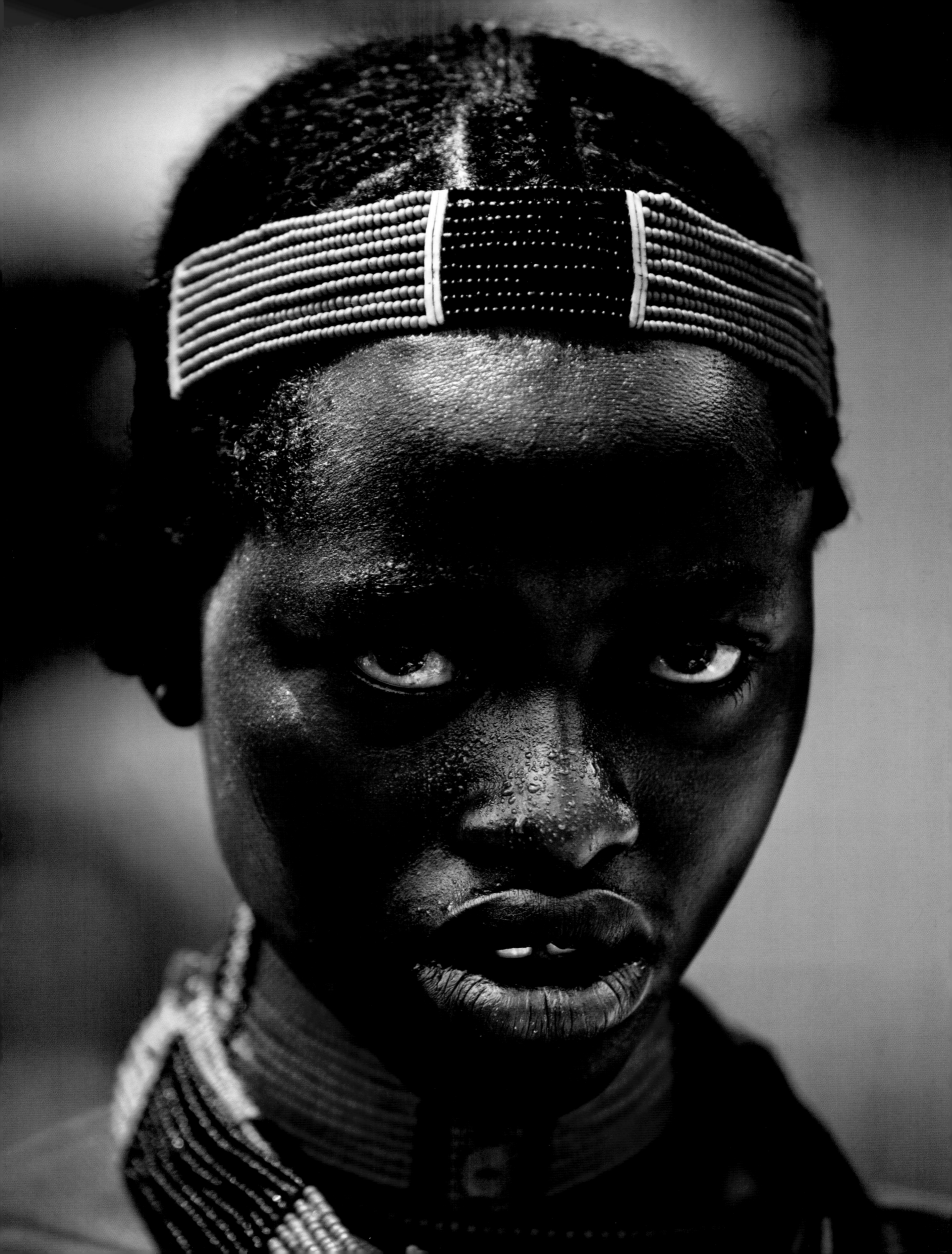

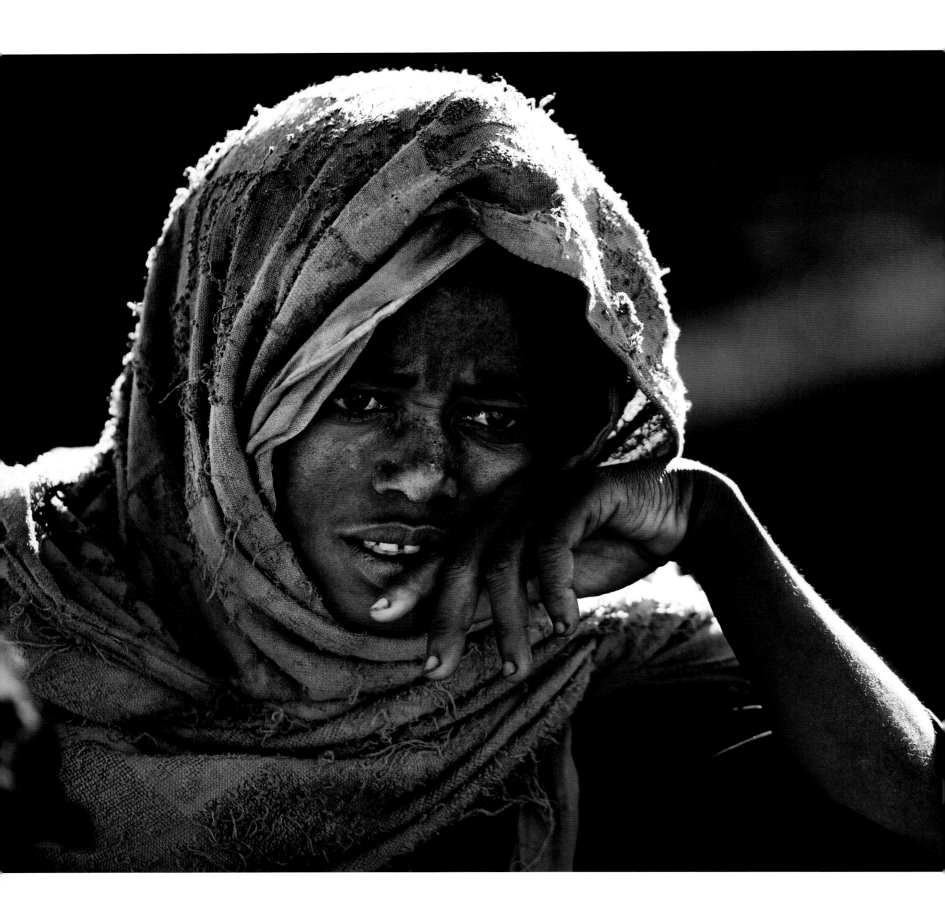

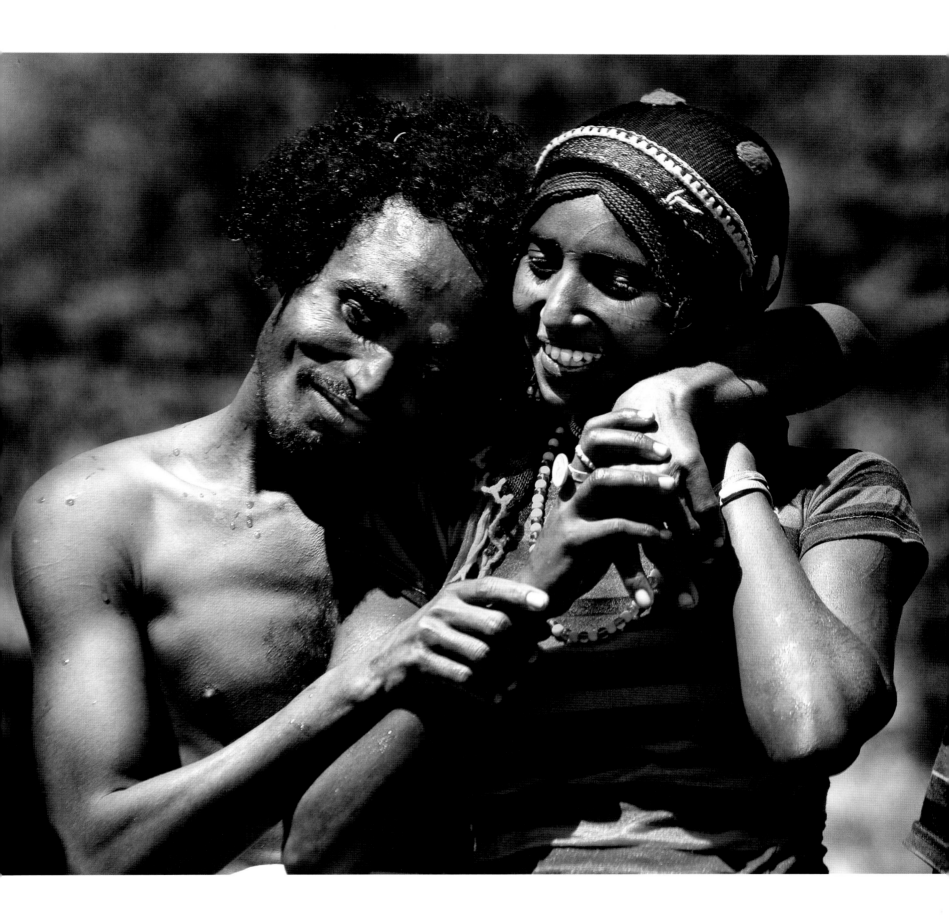

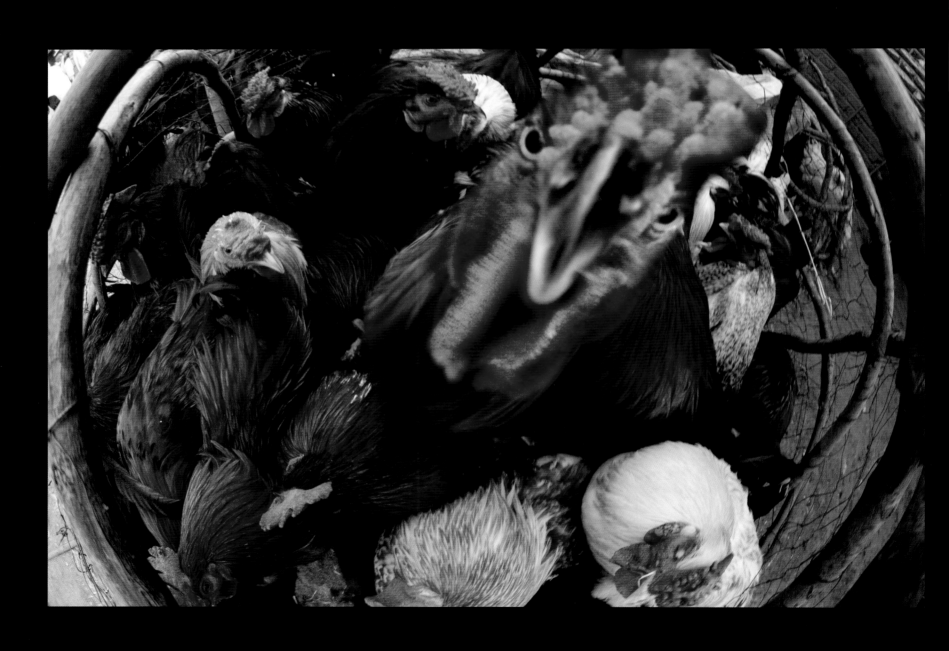

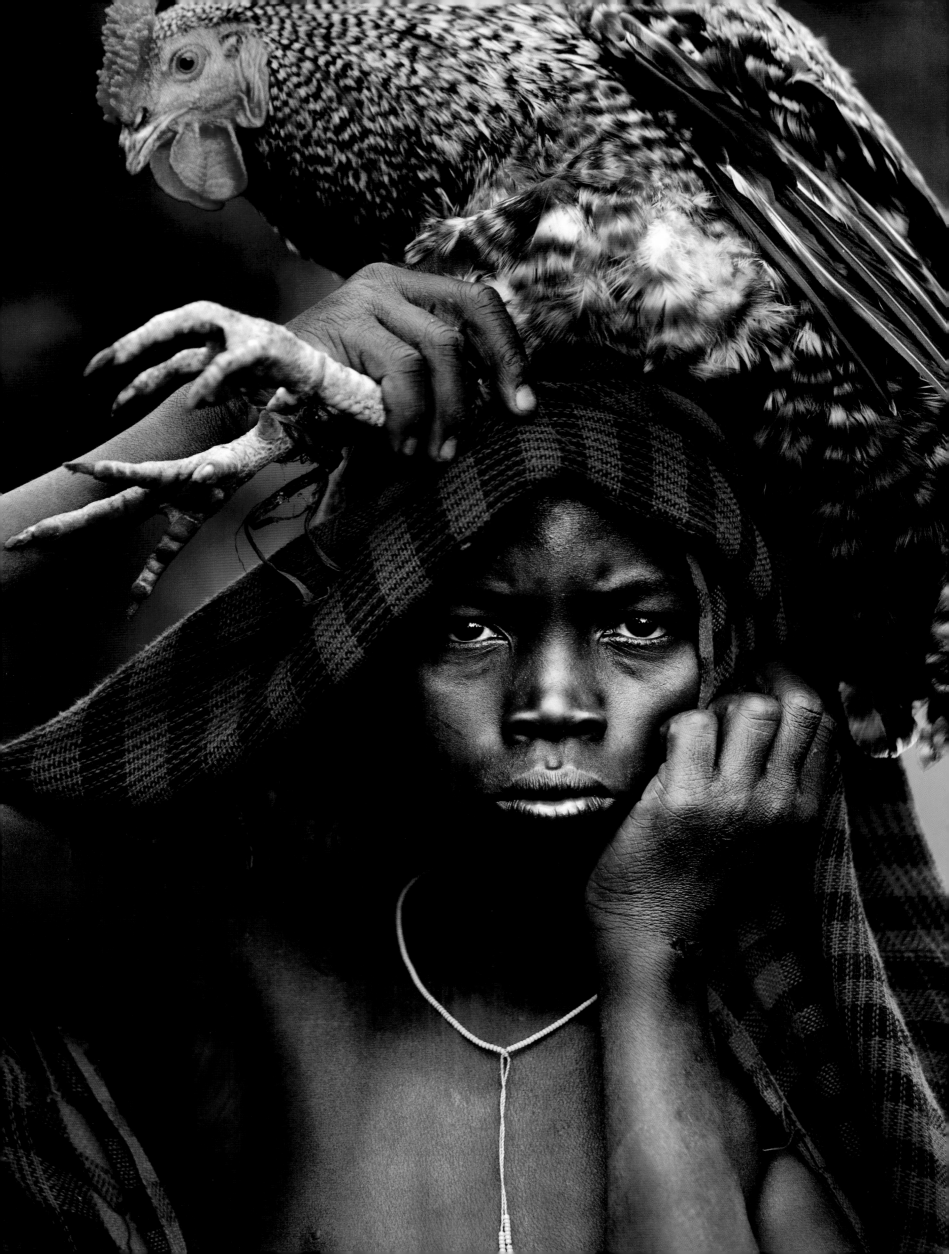

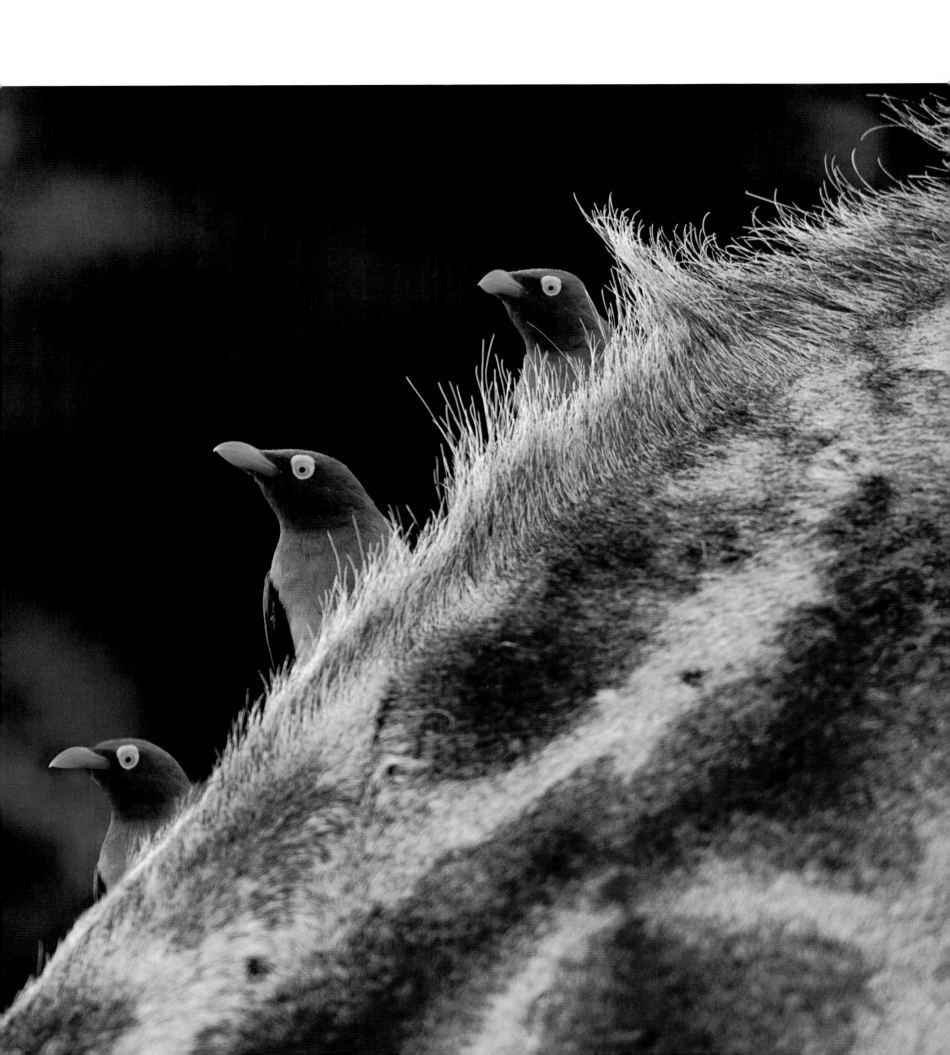

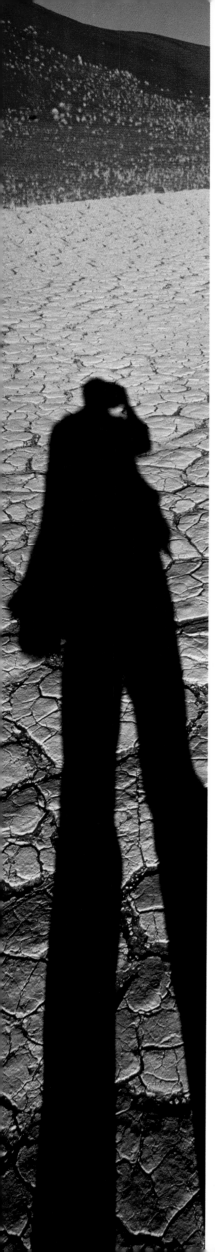

IN SEARCH OF TRANQUILLITY

From the air we scan for elephants. The pulse of the microlight and my insulating helmet make me feel detached. We are dwarfed by towering Kilimanjaro, Africa's highest mountain, paradoxically capped with snow in this thirsty, heat-scorched land.

The wind rumbles in my ears. My clothes flutter and flap. The pockets of my photographer's jacket bulge with film. Two cameras hang heavy from my neck. Their straps bite deep, making me stiff and constrained. Below my feet the landscape looks desolate from our high vantage point; but I know life is there, rich and abundant.

Alexis Peltier sits in front of me, flying his fragile aircraft. His home is the sky. He twists his head and shifts his body into each turn, as if riding a bicycle. He gestures towards a few tiny dots on the ground, waving his hand and pointing with excitement. As we plunge downwards, the elongated shadows of moving elephants betray their presence long before we discern their bodies. From up here we have no sense of height or size. The scene is two-dimensional. All we see are long black shadows, empty areas of shade.

Further on we see many elephants, moving in clouds of dust. As we sweep overhead, I lean out as far as I can, and track them through the viewfinder. Looking straight down I squeeze the shutter and capture nine frames in a single second.

Back on the ground it's another day and elephants bathe in the mud. Bliss is a tactile game with goo. They wallow and roll. They splash and spray with exuberant pleasure. Three elephants rise up, a glistening clay sculpture morphed from the earth's shiny mud in a triumphant pose of optimistic bliss. Reaching an ecstatic crescendo, they are briefly poised before plunging downwards – the moment gone forever. They abandon the mud and walk towards the tall grass.

A baby runs behind his mother, clumsy legs spinning, floppy trunk and ears flapping like a character in a pantomime. An egret watches the parade. The curious baby stops to investigate the strange white creature from the sky, before playfully giving chase. The bird has seen it all before and flies away from this minor irritation. The young elephant pauses and looks around. The bird has gone, but so has his mother. He runs back and forth, and back again. He stops,

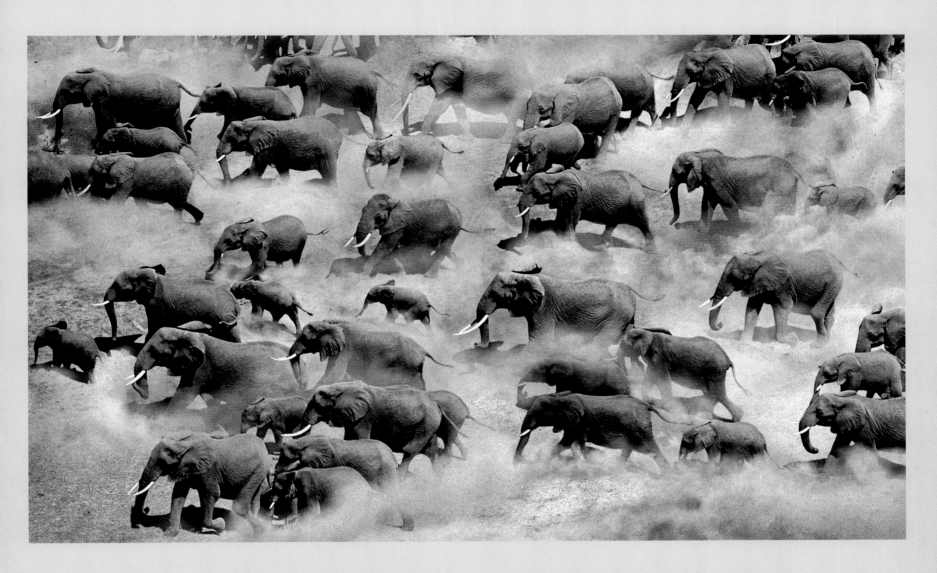

petrified. His anxious cry is initially soft, as if seeking reassurance, and then amplifies into a reverberating wail of total terror.

The cry of abandonment is one which transcends species. The sound touches me profoundly. I wonder how it is that hunters can wish to harm living creatures. But my failure to comprehend their actions is dwarfed by a greater, intuitive lesson about our shared world. The cry of a baby elephant teaches more than anyone could ever learn from a room filled with books.

The frantic mother crashes blindly through the tall grass, waving and shaking her searching periscope. As they embrace, she firmly secures her baby with a reassuring trunk, nuzzling his small body into the folds of her leg. He sobs softly during the

euphoric release of reunion. A moment later he suckles her teat, soothed by the warm milk.

I arrive on a remote airstrip near Kenya's Lake Magadi. The chartered Cessna bounces and rattles along the bumpy surface before stopping to spit me out, straight into the white fire of noon. The hot sand burns through the soles of my shoes. The anxious pilot checks his watch and quickly helps unload my bags. Another charter beckons. We forget to say goodbye.

I stand on the edge of the dusty runway, paraphernalia at my sides, watching the little plane taxi until it shimmers and wobbles in the distance. It turns around and buzzes towards me, growing larger and louder, then casually lets go of the earth, as if hurrying

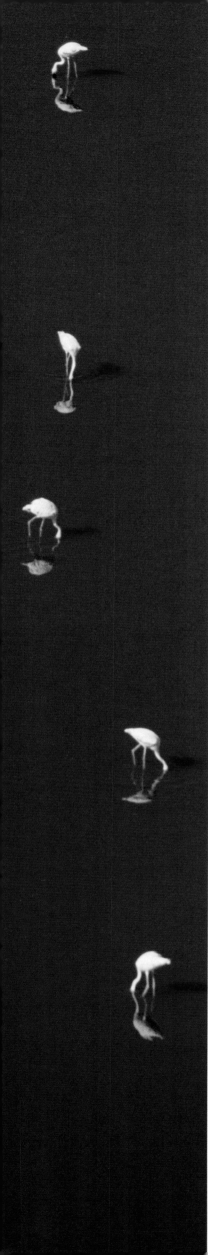

to escape from this inhospitable land and its alkaline soda lake. My lost security is the fading din of a disappearing dot in the sky. With the mechanical sounds of civilization gone, replaced by the monotonous shriek of insects, I clutch my water-bottle. My peaked cap and sunglasses give little protection against the elements. I am dismally ill-equipped for survival in this place. But I glimpse the distant Land Rover loaded with provisions, and as Alexis comes in from the sky in his giant bumble-bee, the world feels perfect.

After a short run the microlight is airborne and we turn steeply towards Lake Magadi. We approach the azure water, smooth as polished glass and speckled with the pink bodies of flamingos. The shore is a psychedelic blend of colours, merging with exquisite harmony. Alexis leans back and shouts, 'It's beautiful!' He's seen it a thousand times before and his passion only grows stronger.

The earth has coughed up salts and minerals from deep within her crust. The water, which occupies only a small area of the lake bed, reflects the sky like a deep-blue jewel and is surrounded by patches of white crystalline salt. Flamingos come and go in their search for nourishment, their wings spread wide as they glide below us. I am intoxicated by the colours and shapes which draw me down towards the lake. I am being seduced by a beauty most treacherous, for below the surface of the water lurks a stinking bed of sulphurous mud, covered by a deceptively thin layer of salt. We are at the bitter margins of survival where only flamingos dare to roam.

Congregating in tight groups, these birds are secure in their isolation; none of their enemies can tolerate such lethal levels of salt. Wading, heads upside-down, they sweep their bills from side to side to scoop up a rich soup of algae, diatoms and small crustaceans. We are like visitors from outer space, enchanted but alone as our tiny alien craft dents the peace. With the machine-gun clatter of the camera, I steal impressions of another world.

* * *

In Uganda it is night-time and I watch villagers near Kisoro catch grasshoppers which they roast on fires and eat like peanuts. An old man tells me that the village will soon have a telephone. He speaks

LEFT
Flamingos, Lake Magadi, Kenya.

OPPOSITE
Buffalo after a mud-bath, Queen Elizabeth Park, Uganda.

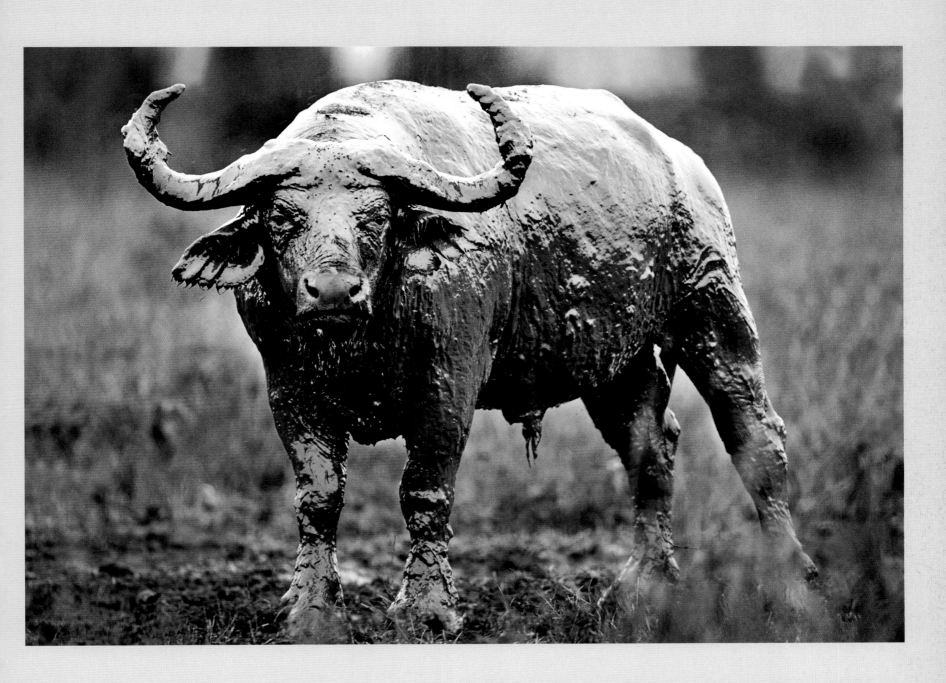

of the harshness of life, and I notice there are few old men left in the village. Later, I discover that the guide is the same age as me and we are both beyond the average lifespan for the region, yet in Europe I am considered to be 'middle-aged'.

I am keen to cross into the Congo in the hope of encountering mountain gorillas. It is still dark when we arrive at the border. Leaving my driver in Uganda, I walk with my translator across no-man's land towards Congolese territory. We run the gauntlet of boy-soldiers and

a hostile immigration official who is determined to extort a bribe.

Our new driver meets us as planned, undaunted by the prospect of driving his car over washed-out tracks. He has four helpers squeezed in the back. They are ballast, and will drag us from holes and ditches. My translator and I climb in the front, cramped together as my leg presses hard against the gear lever. We slide around for an hour and a half, saying nothing while the engine screams and the wheels spin. When we get stuck, the team in the back dive

out of the windows and enthusiastically free us. We pass only one other vehicle, the Coca-Cola truck, packed with rattling bottles.

We endure a gruelling walk into the mountains. First across open hills, then low forest and finally dense undergrowth which becomes increasingly impenetrable as we hack our way with machetes and crawl on our bellies. Something bites my arm and I tear at it, scratching deep red furrows in my skin. Rain batters the forest, drenching us with blobs of heavy water which spill from leaves like green ladles dangling above. Giant foliage steals the light and amplifies the drum-rattle of pounding water. Distracted, I brush my hand over some nettles; their razor-sharp blades lash back, slicing deep to draw blood which runs away in the muddy rivers that flow at my feet. We are condemned to the dark forest floor, my hand stings, my socks are soaked and my ankle throbs; but at least the ants don't bite while they are drowning. We struggle, as if trapped in a viscous fluid, through a hostile jungle which first tries to keep us out, then swallows us.

We reach the rim of an extinct volcano. Without pausing, we ease our way down the slippery slope, deep into the overgrown crater. The rain has stopped and the damp air is intensely still, as if we have reached the eye of a hurricane. I hear the sudden snap of a branch and look up to see an enormous silvery-black body facing me. His broad shoulders exude strength and his soft eyes glisten in the misty light. Droplets of water cling to his matted hair. Self-absorbed and comfortable, he nestles among the protruding roots and leaves, eating a wild banana.

A new cloudburst scatters its first raindrops, noisily. Without warning the gorilla races up the hill with the raw force of a cannon ball, brushing me as he hurtles by. I feel his power in the wind and briefly smell his body before he vanishes behind a curtain of vegetation. We find him easily, his path revealed by the sound of snapping undergrowth and the evidence of trampled leaves. He sees his partner wedged against a tree and joins her, settling quickly. They sit munching bamboo, intimately crouched on their green mountain bed. I stand on the steep slope watching them, rain streaming down my face.

Their jungle home is at the centre of a disintegrating forest laager. On the periphery are desperate people, refugees and soldiers

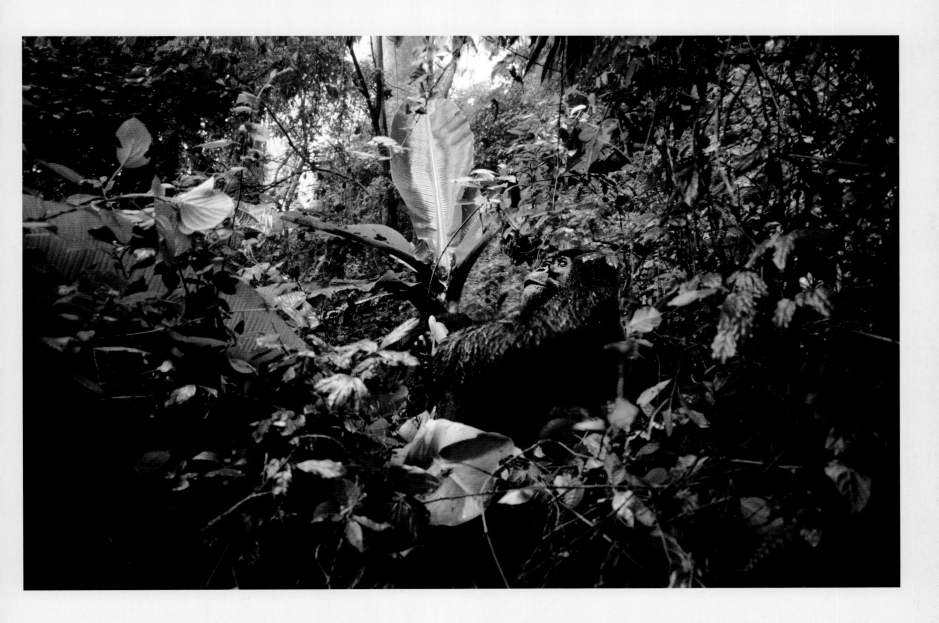

locked into the tragic business of human conflict. Smoke from cooking fires rises up in the surrounding hills where fear and hunger override compassion for other species. The gorillas' peace is sustained only by the tangled forest which slowly shrinks from the outside. Huddled together, they appear serene in their insular world.

On the way down we pass a gorilla with a severed hand, amputated by a snare in a brutal encounter with the human world. She struggles on, tearing food from branches, getting on with life.

Now we are further down the mountain. We see people returning from the forest with wood for burning and bamboo

for building. A child soldier, struggling under the weight of his Kalashnikov, asks for cigarettes. The guide taps out a handful of battered cigarettes from a crumpled packet and nervously hands them over. This is a crazy, terrifying world, far from the one I know, yet it is a world where you can still buy Coca-Cola.

Months later I learn from a traveller that the gorilla couple have separated. She joined a gorilla group and he now lives alone. I know that gorillas have relationships and that they feel the pain of bereavement – but do they fall in love? Do they know heartache? I wonder if he is lonely, or if he has found tranquillity in his solitude.

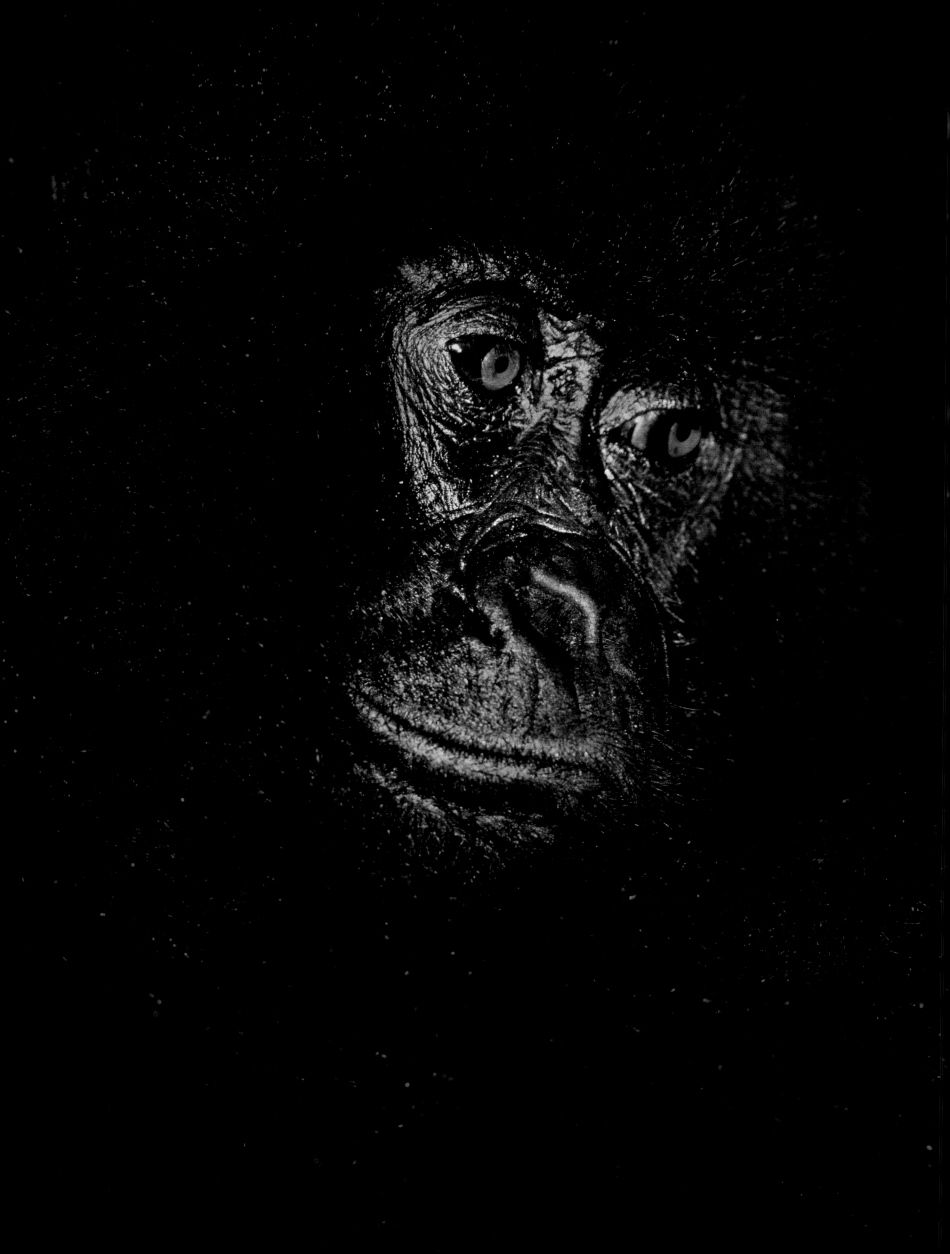

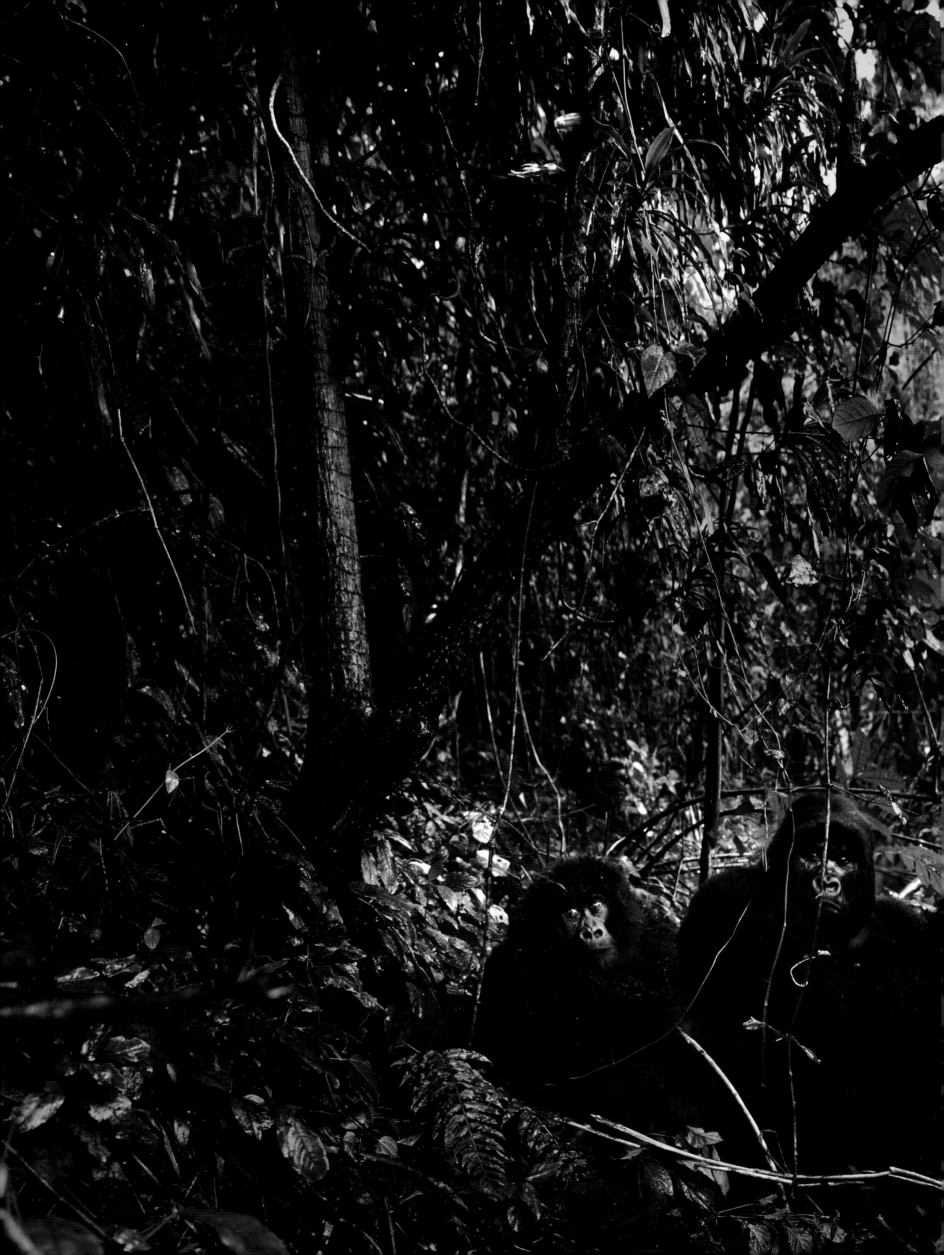

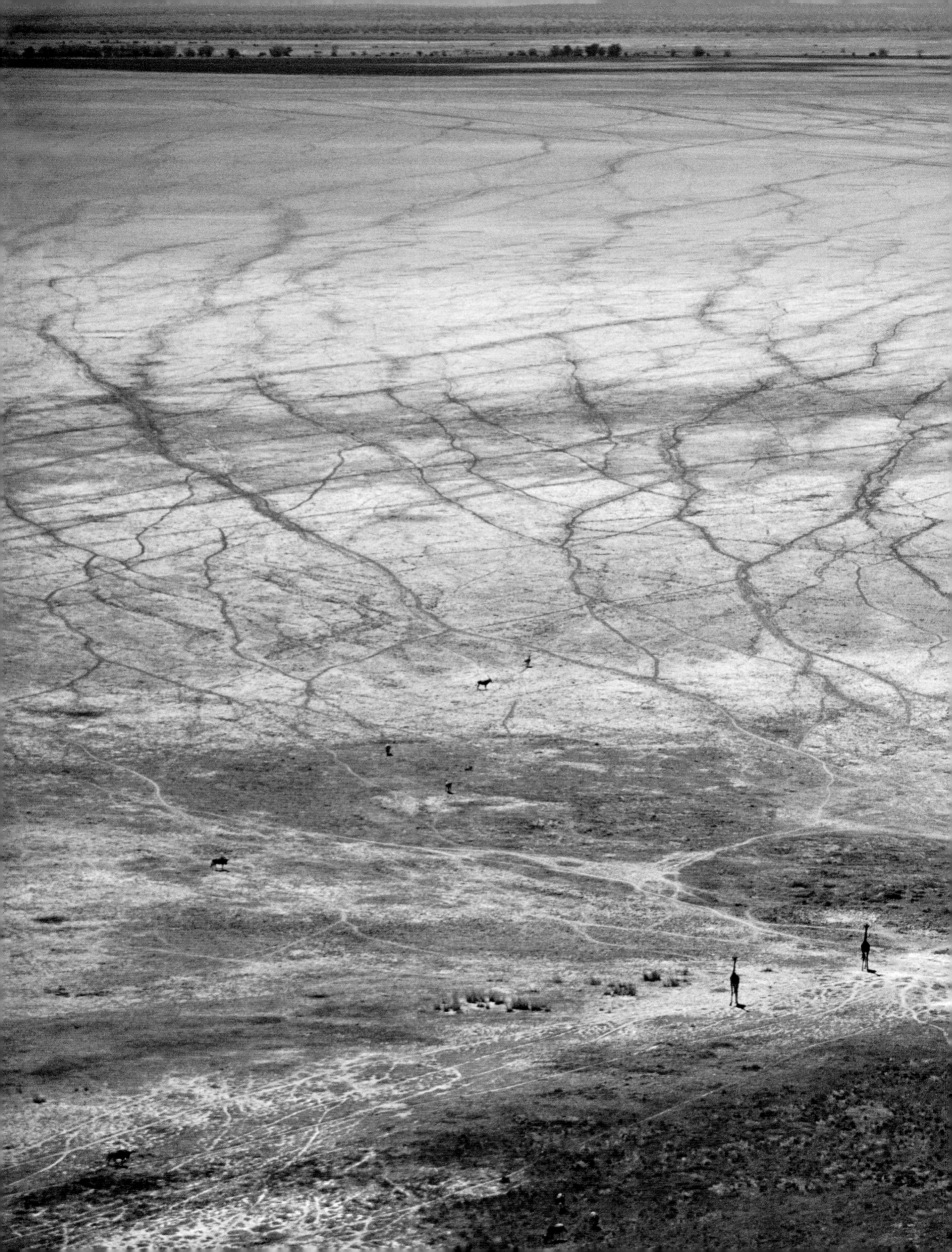

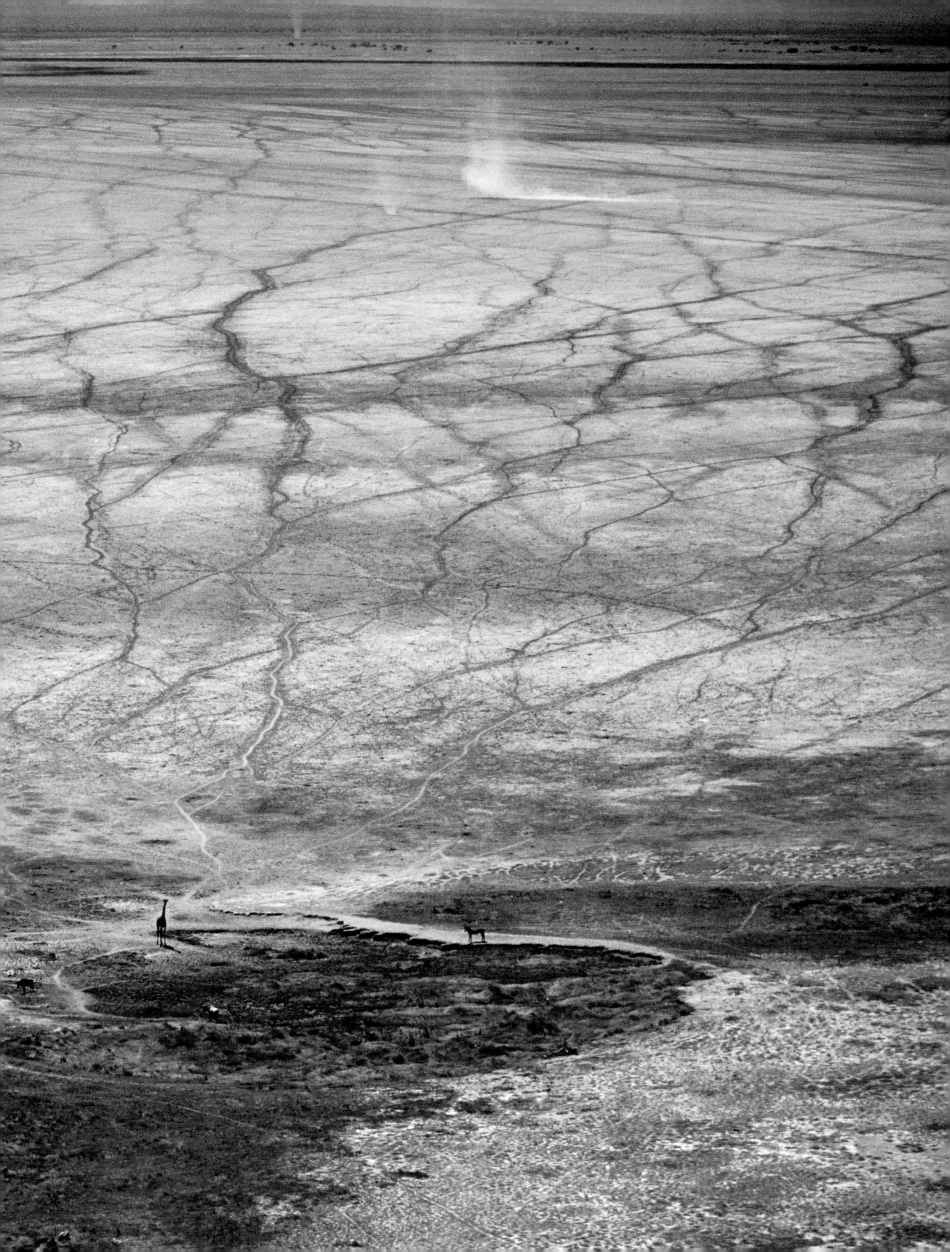

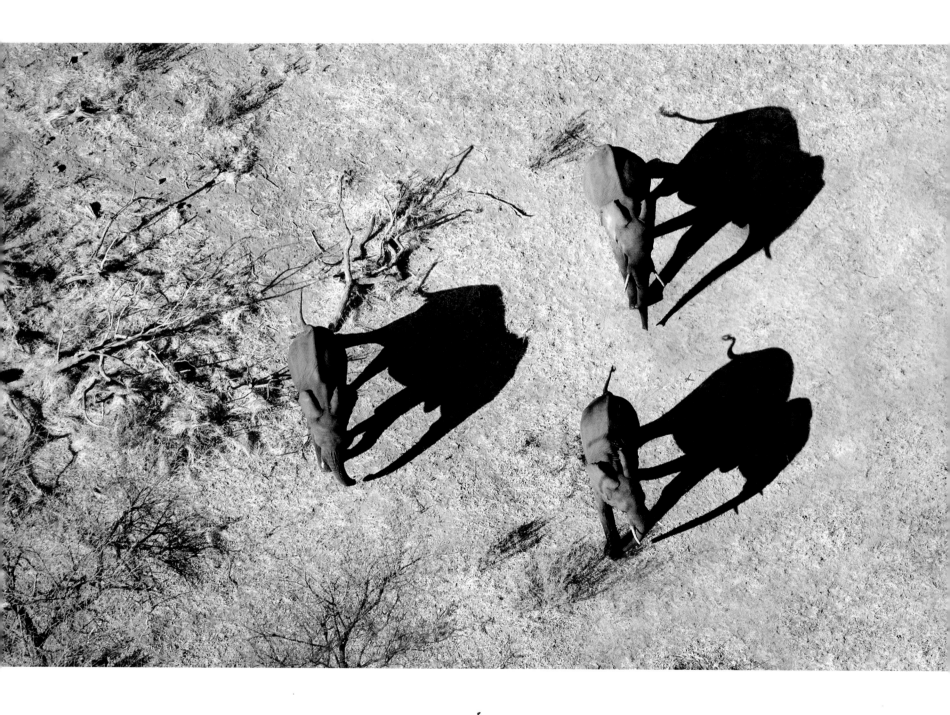

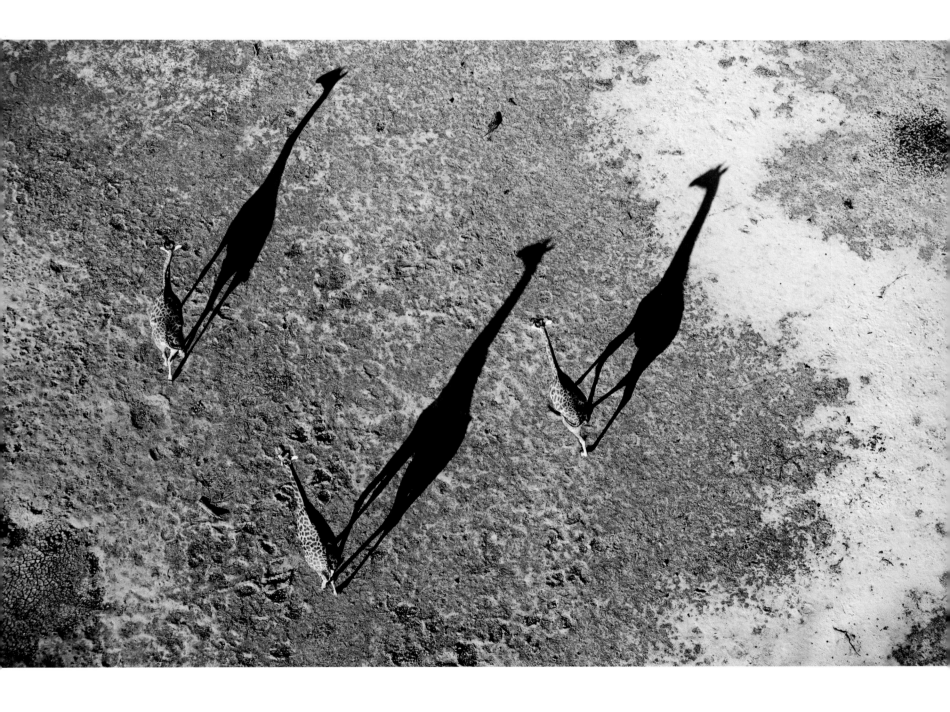

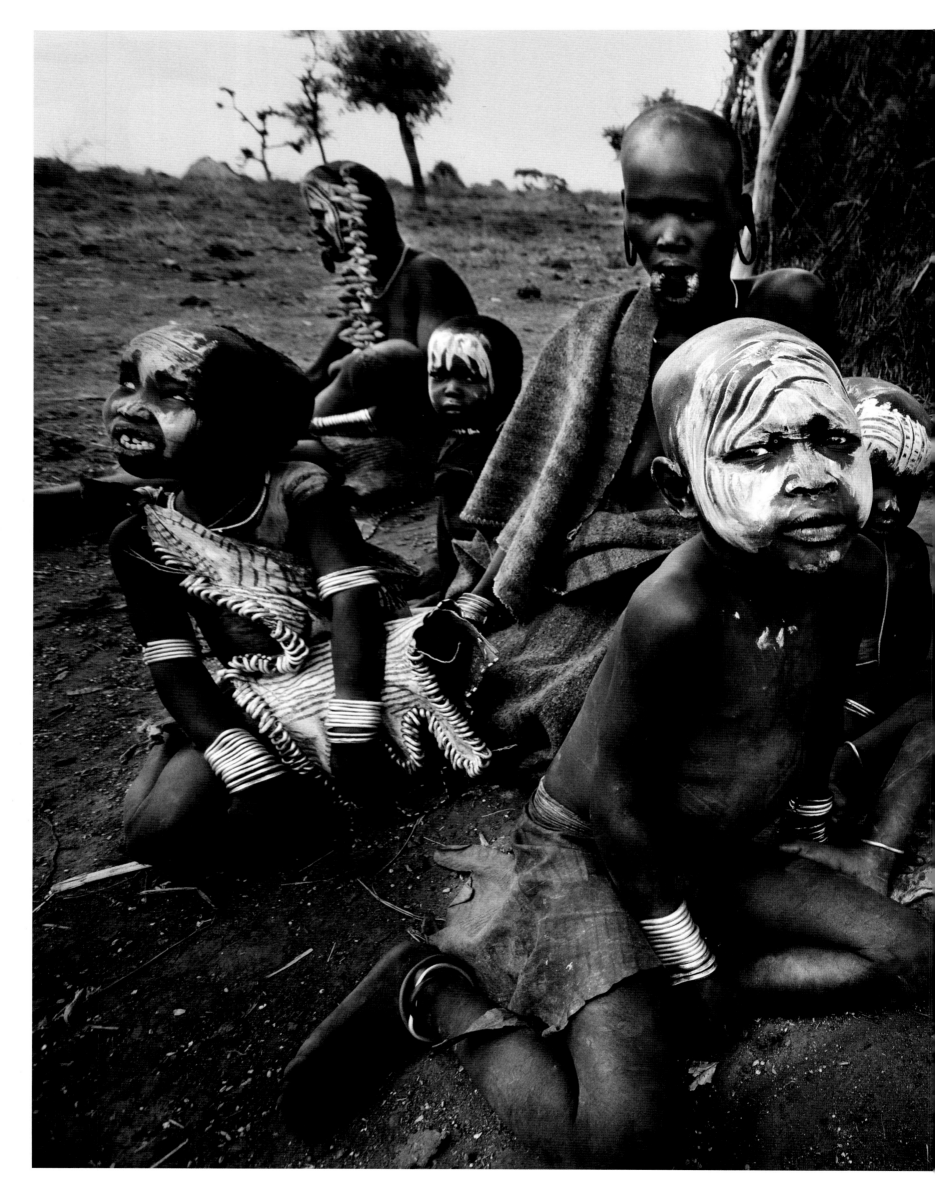

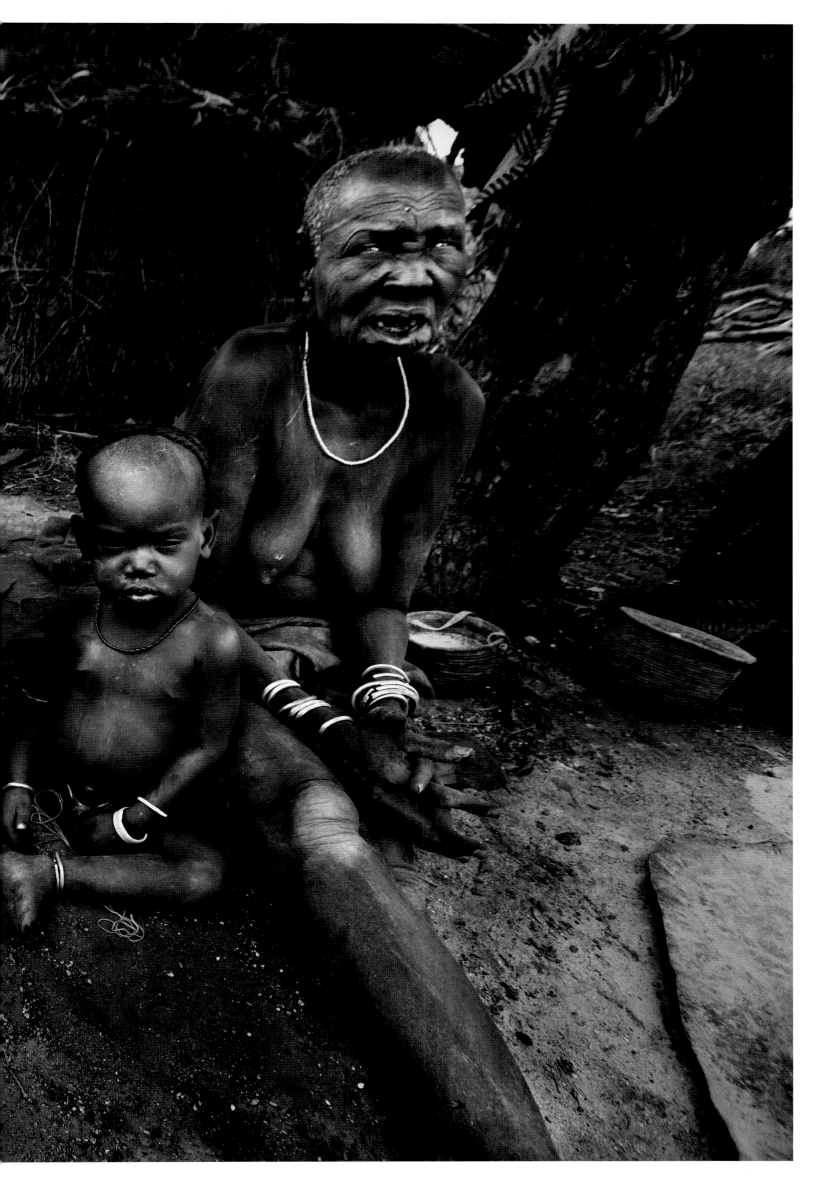

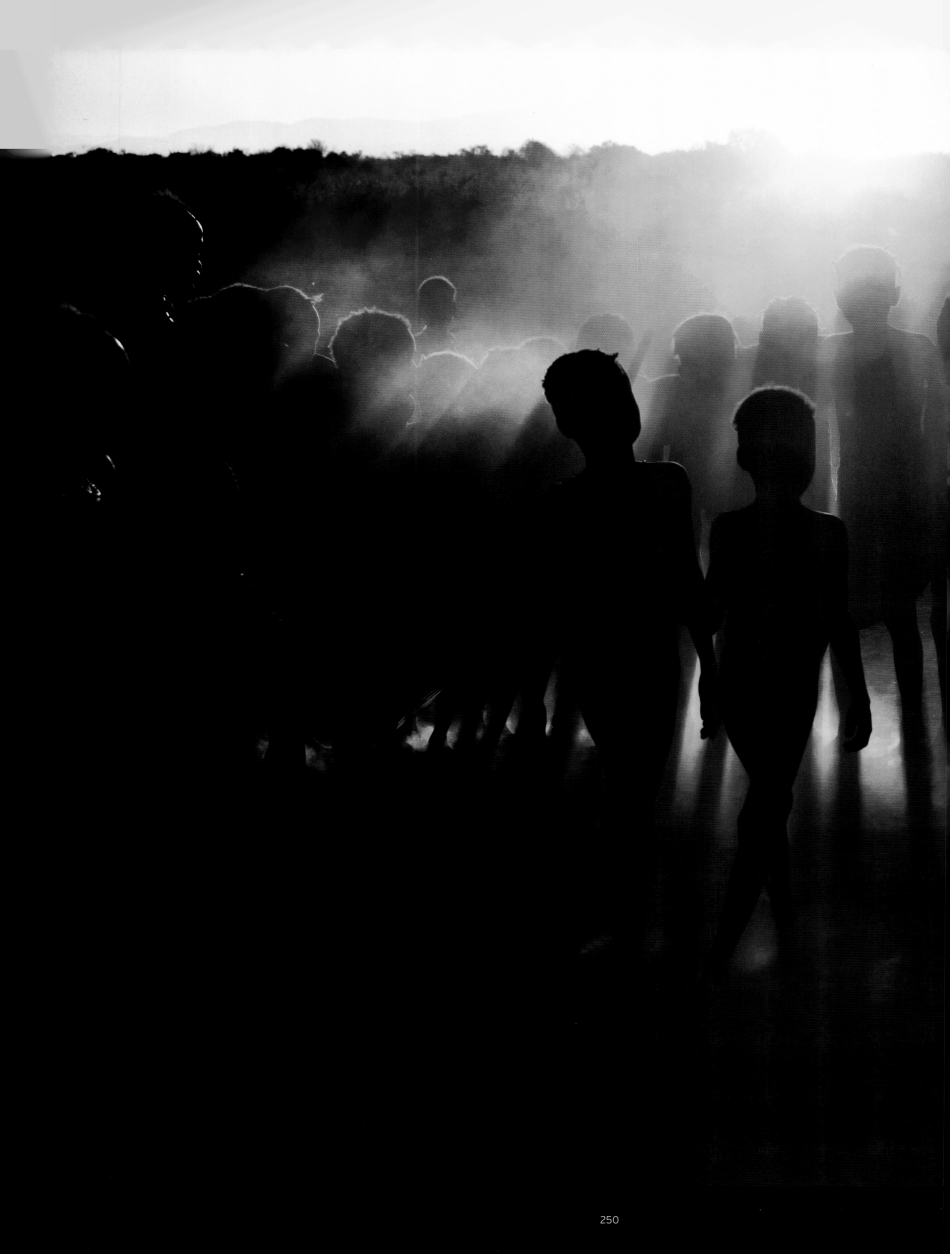

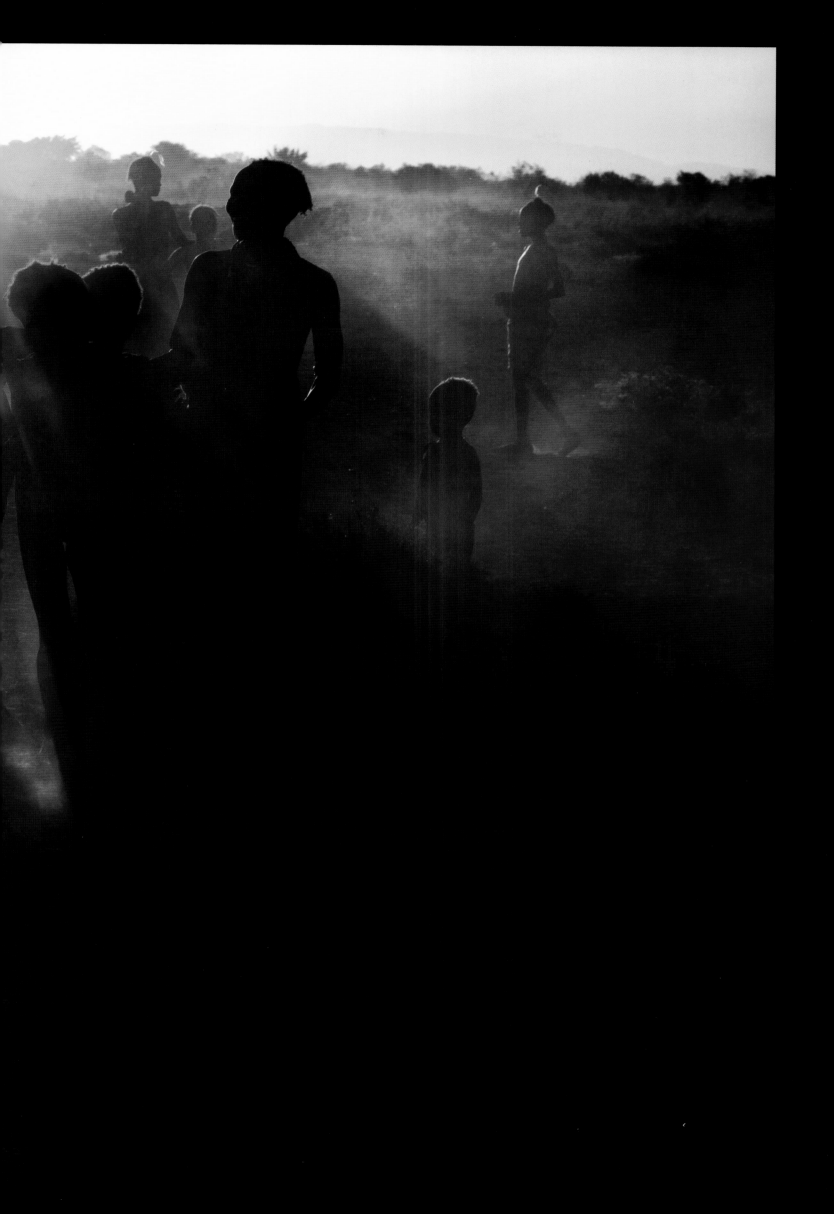

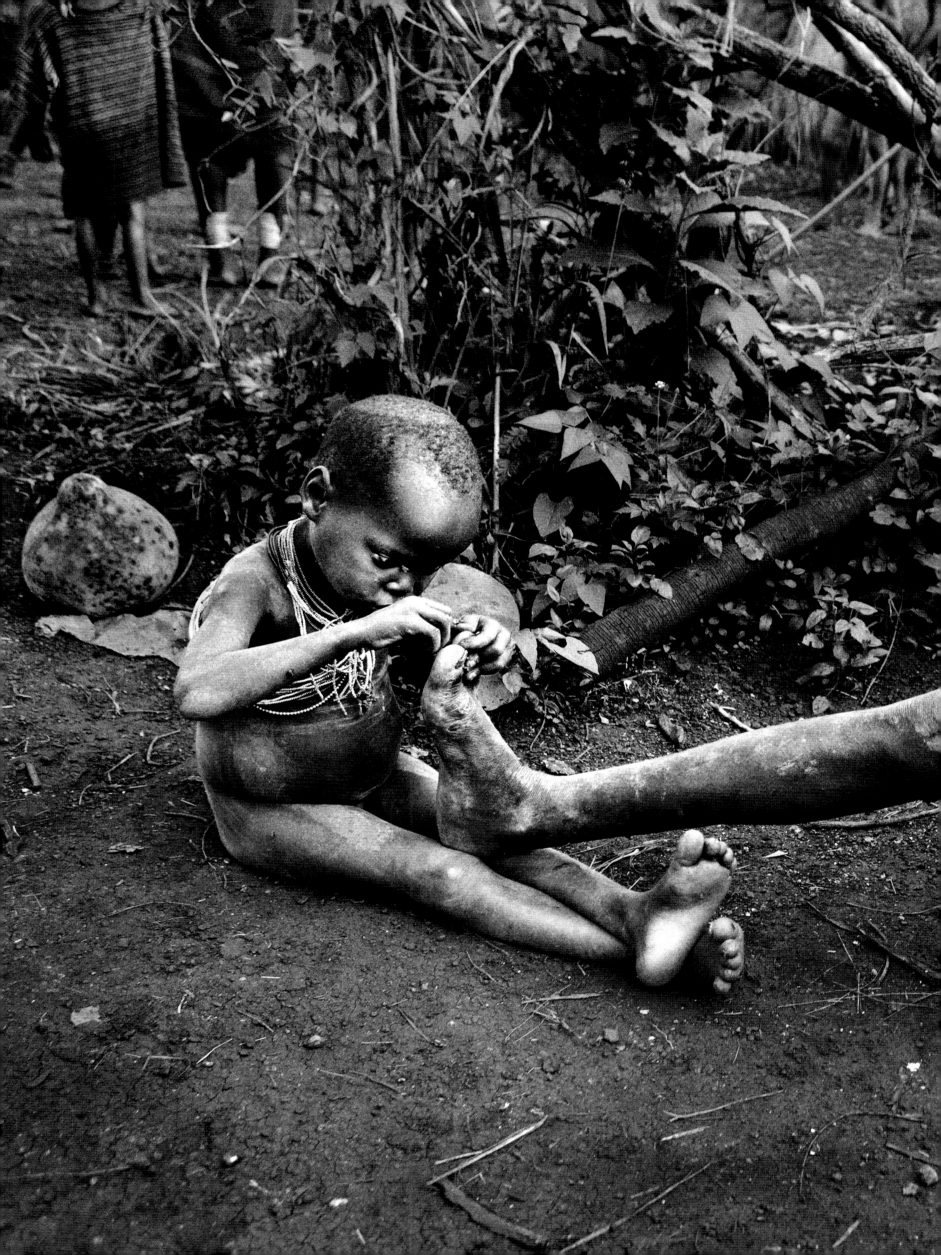

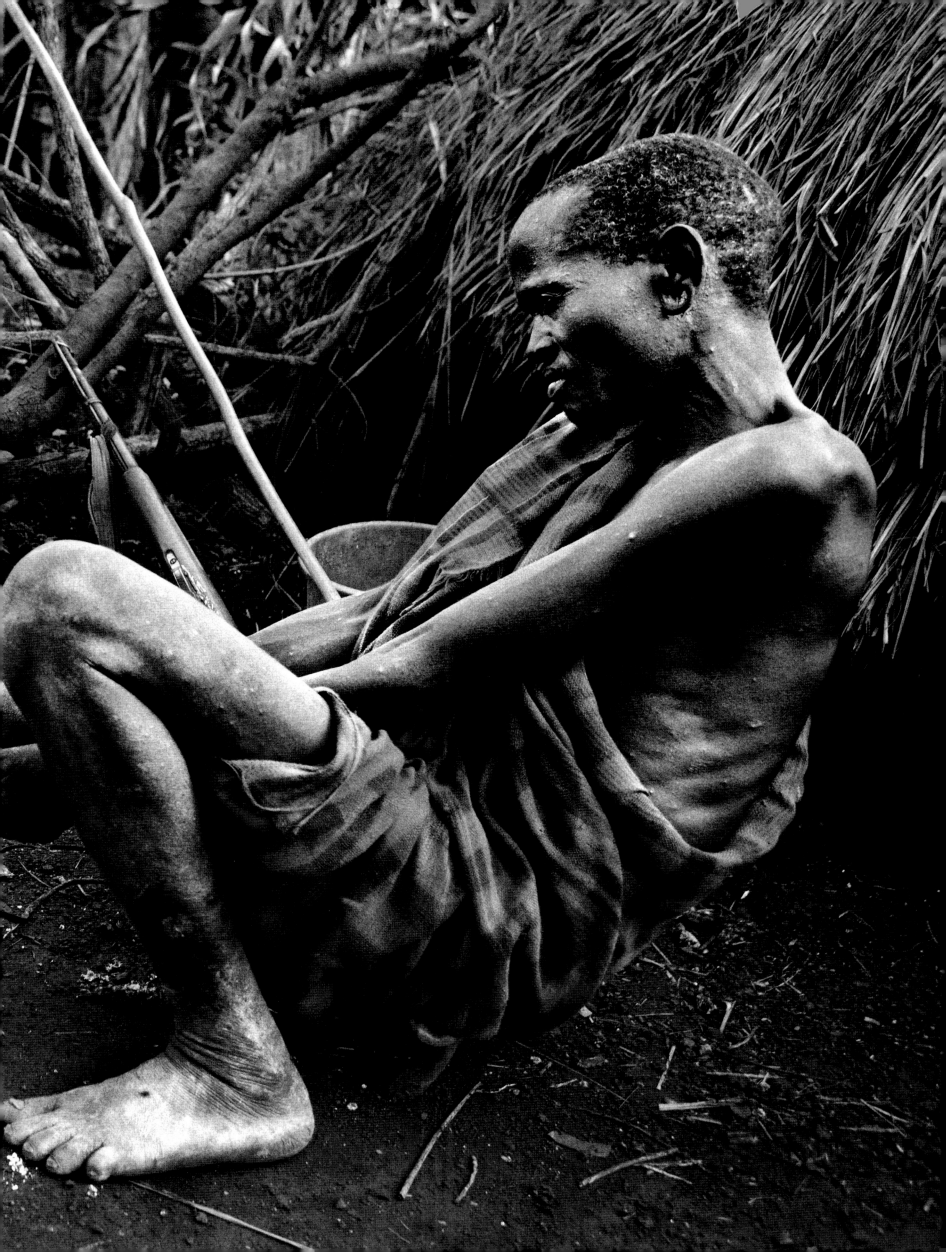

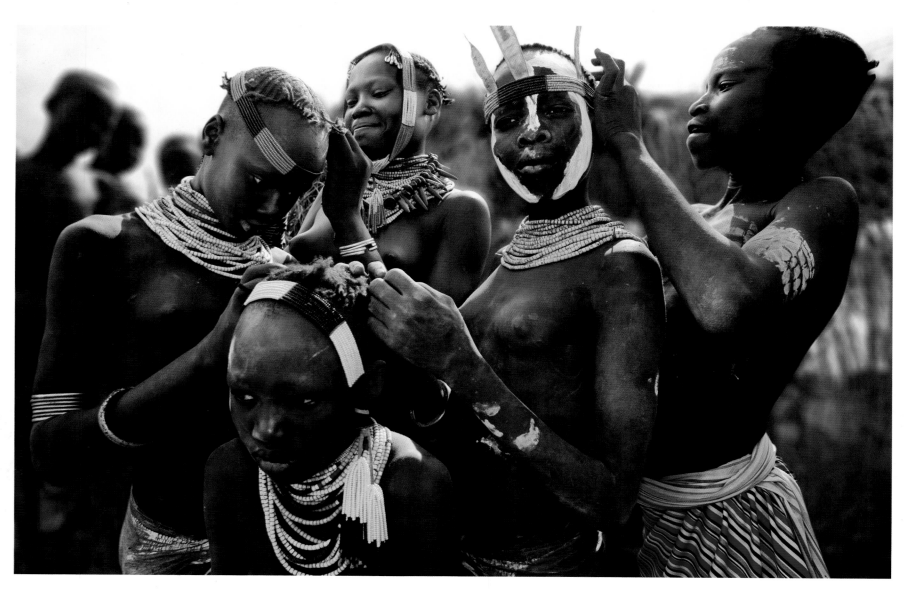

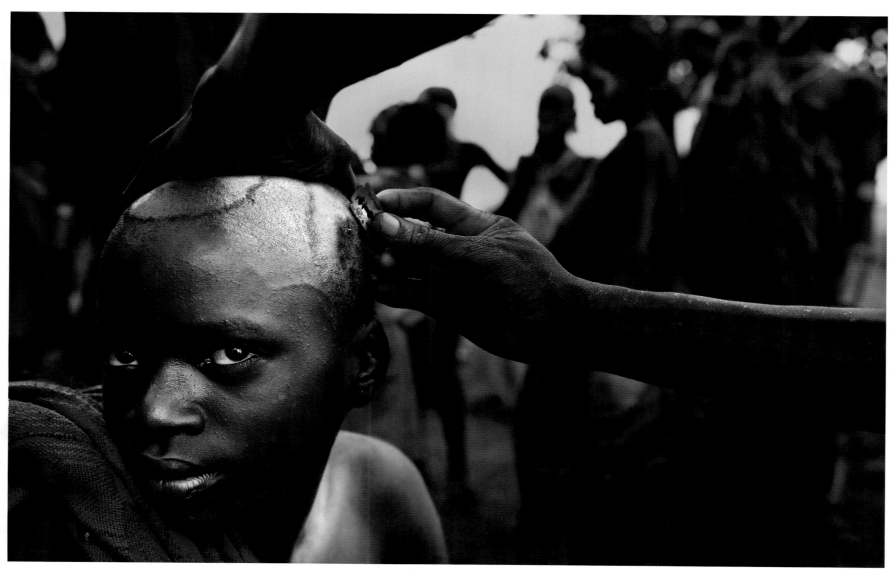

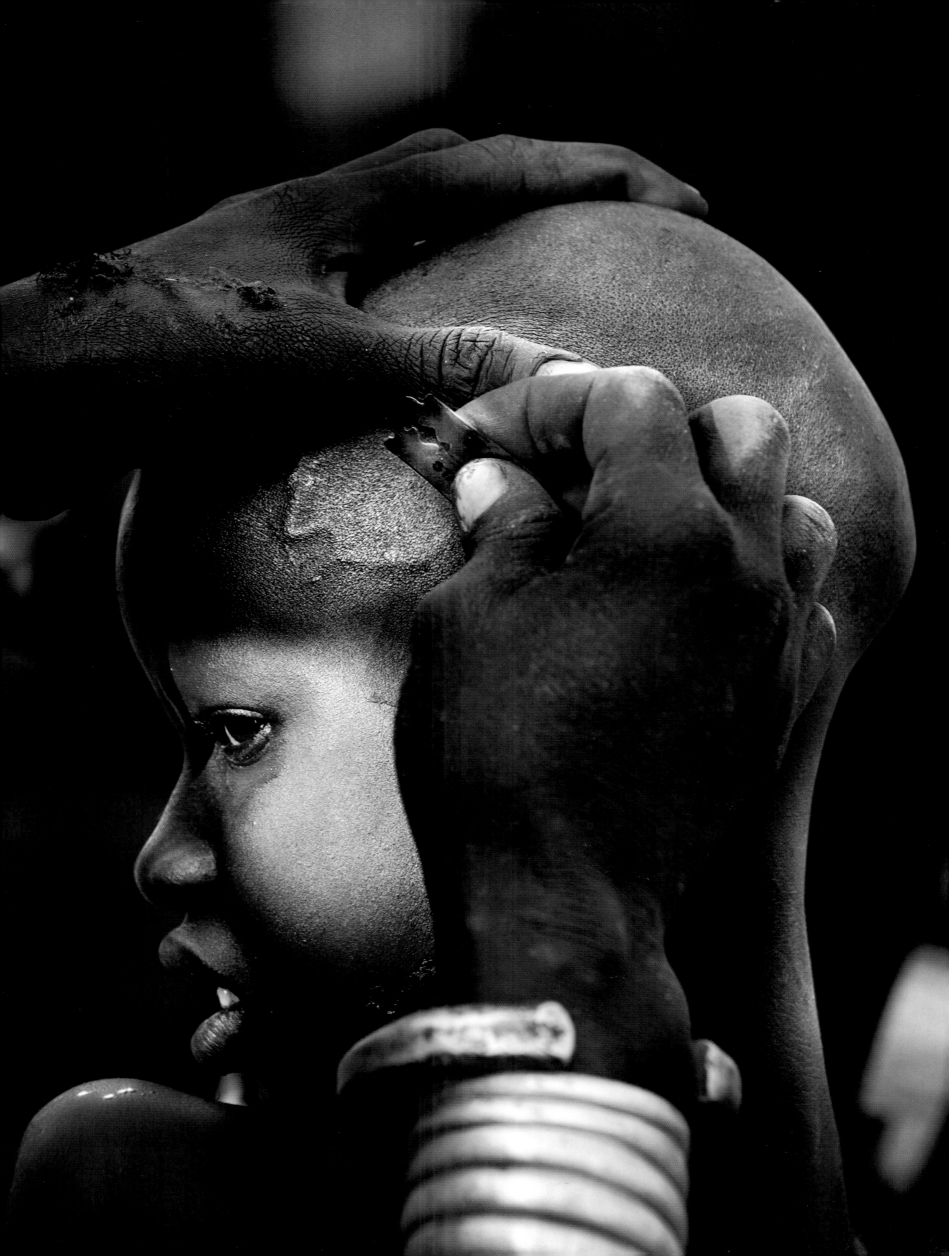

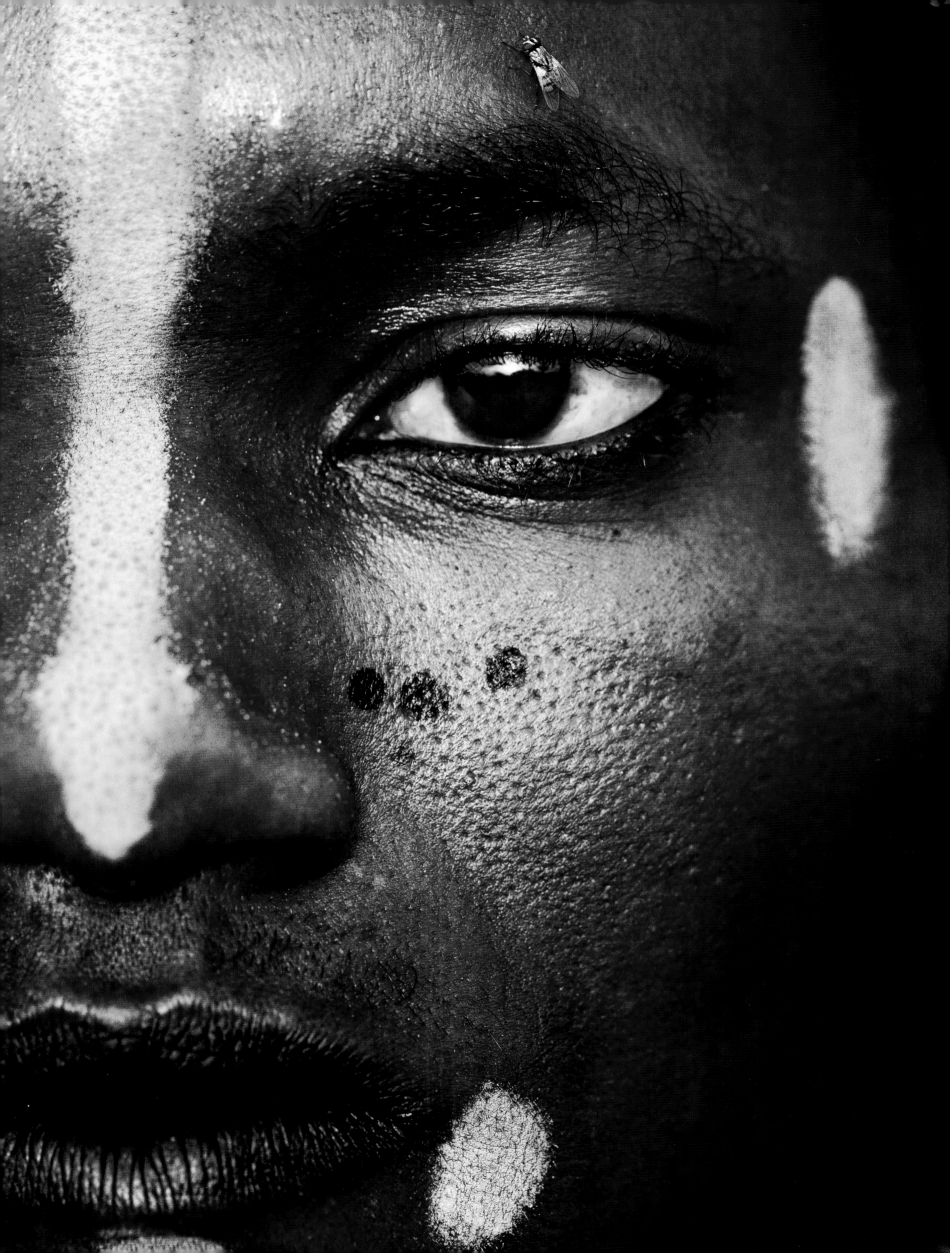

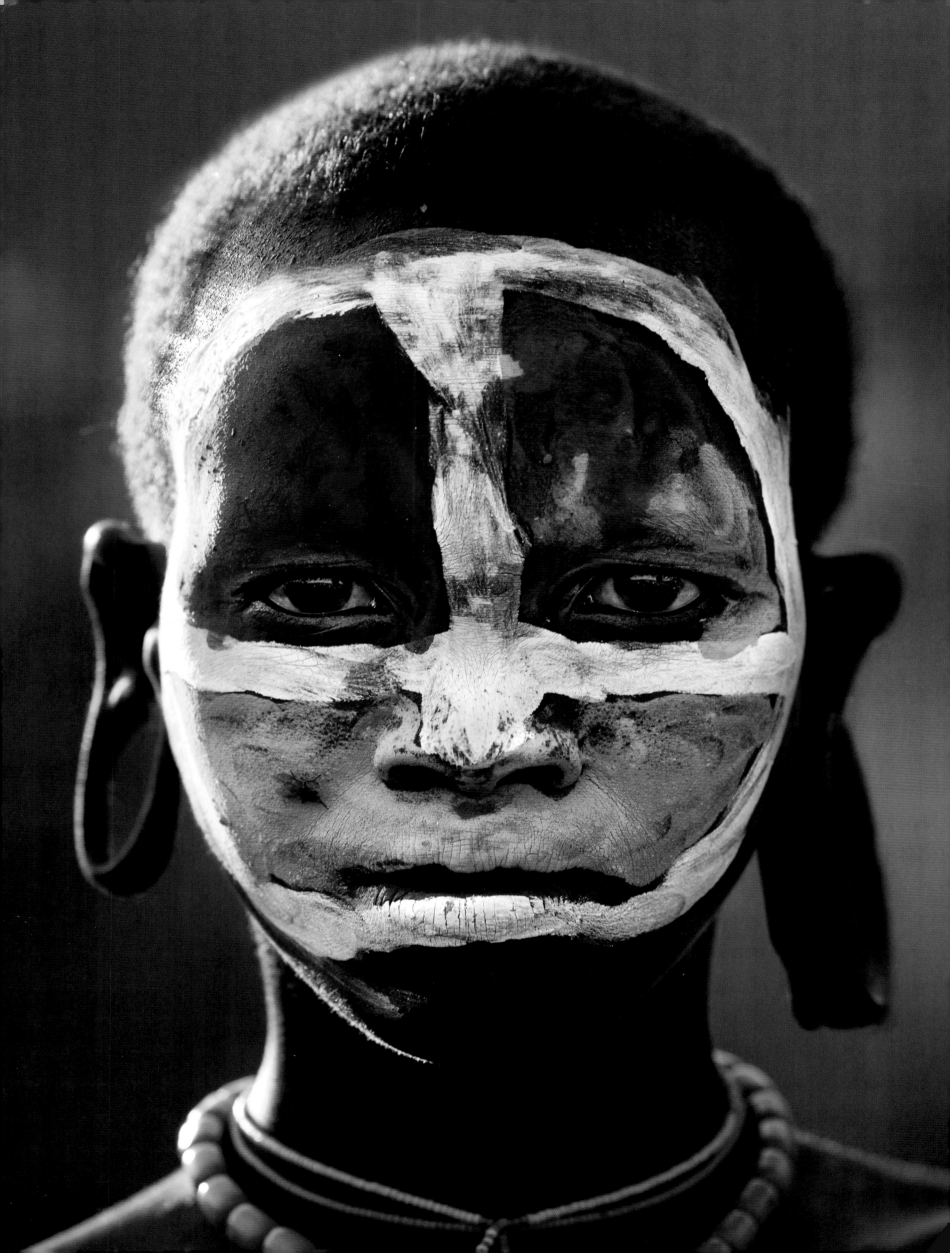

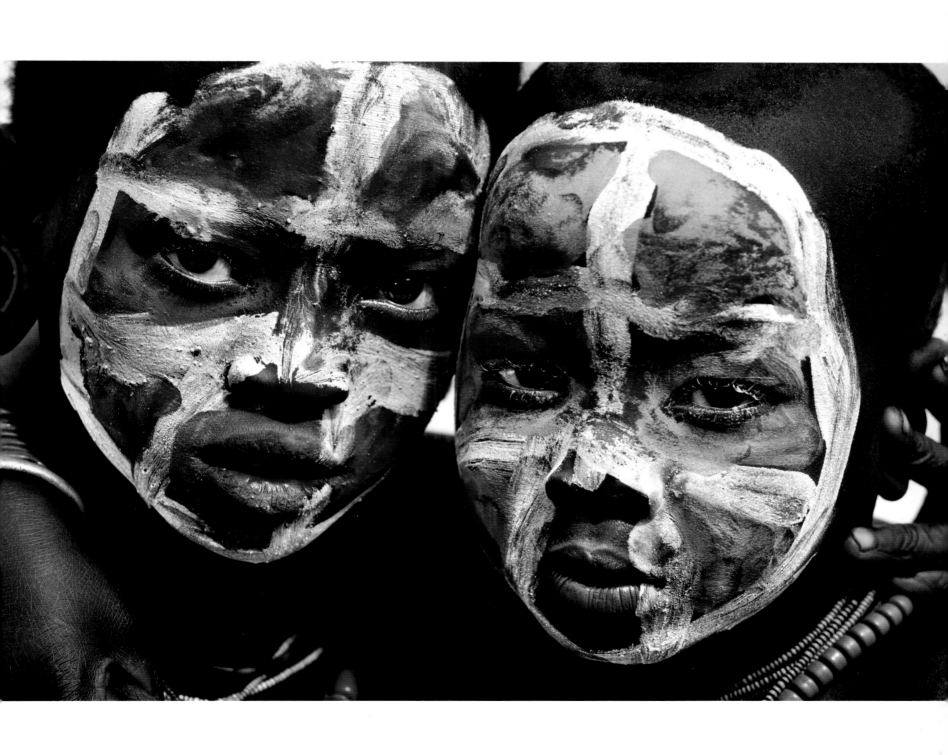

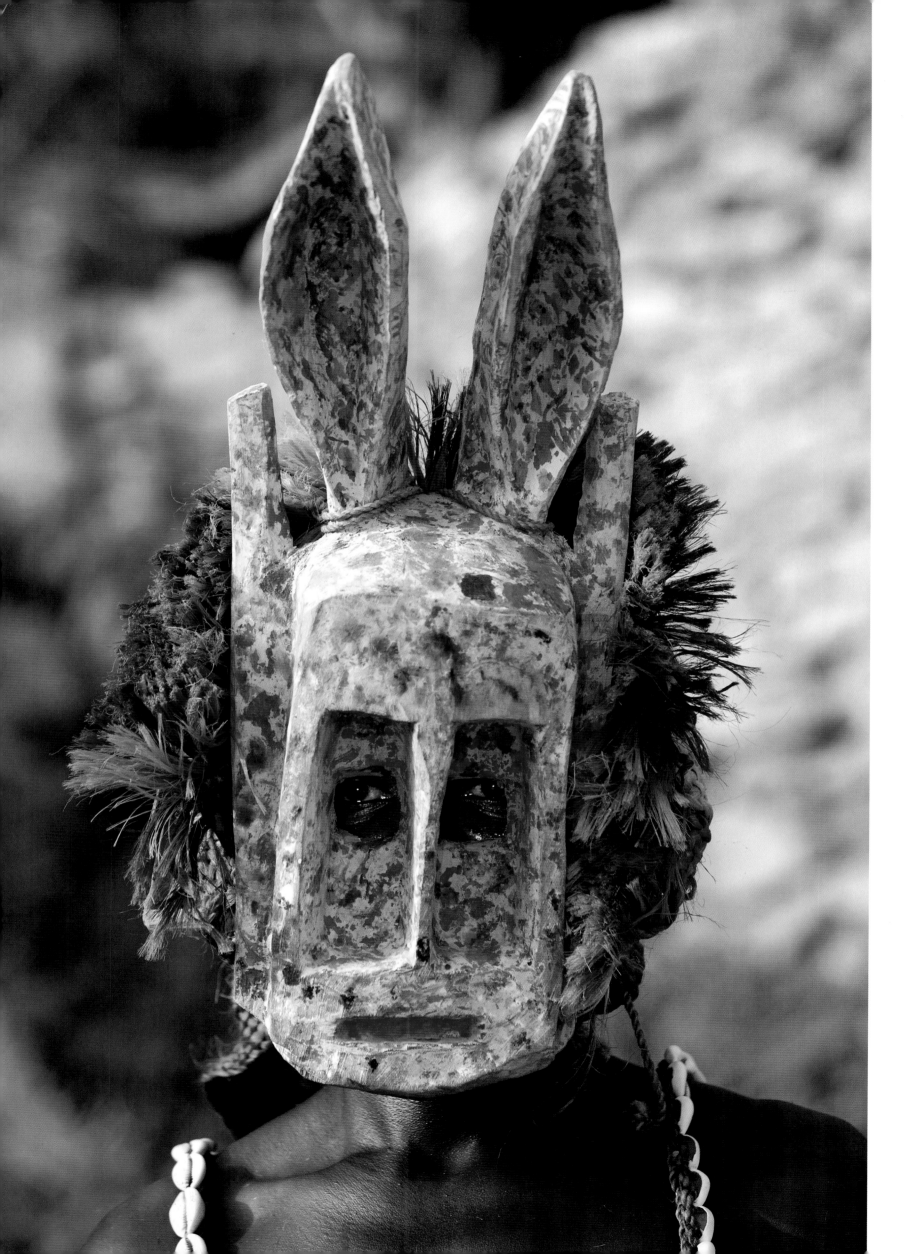

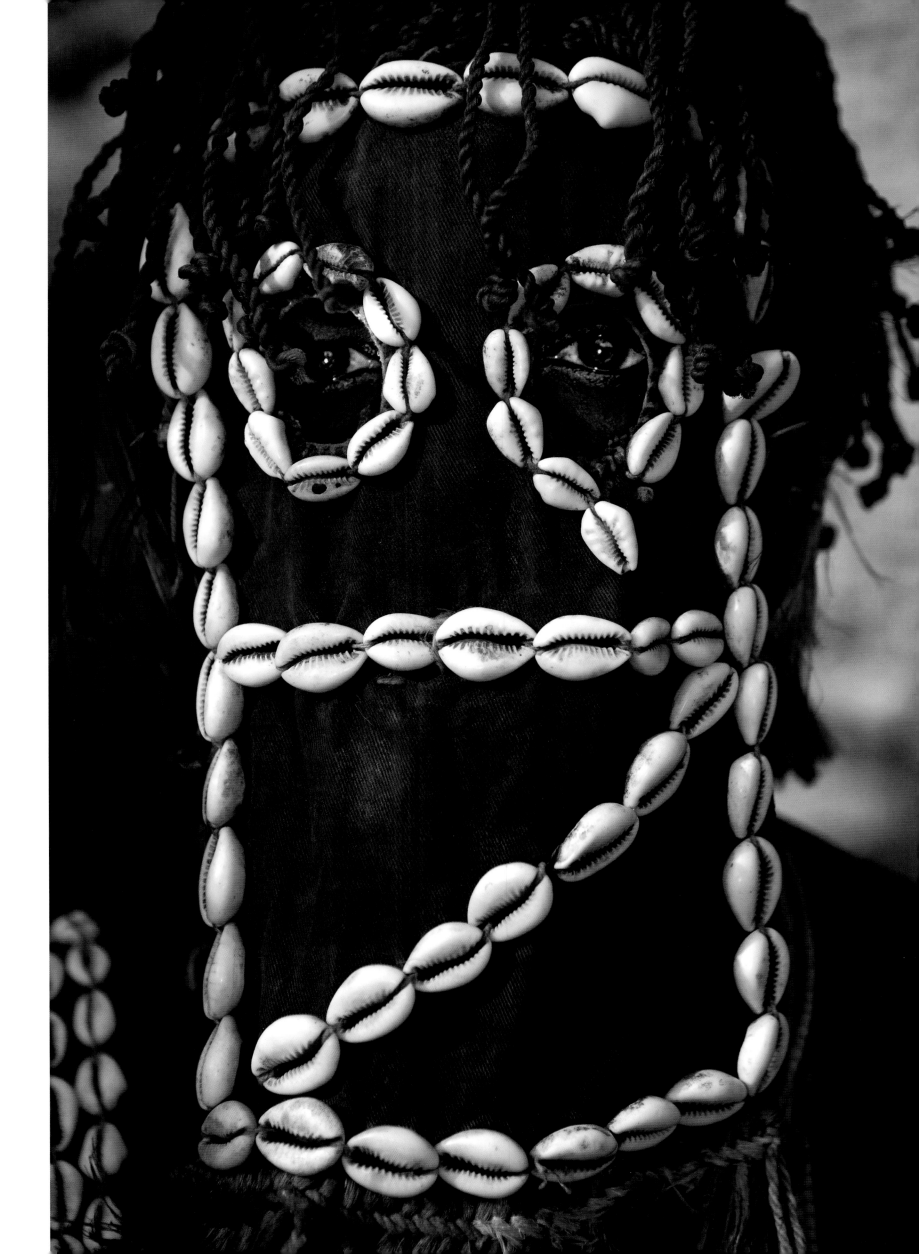

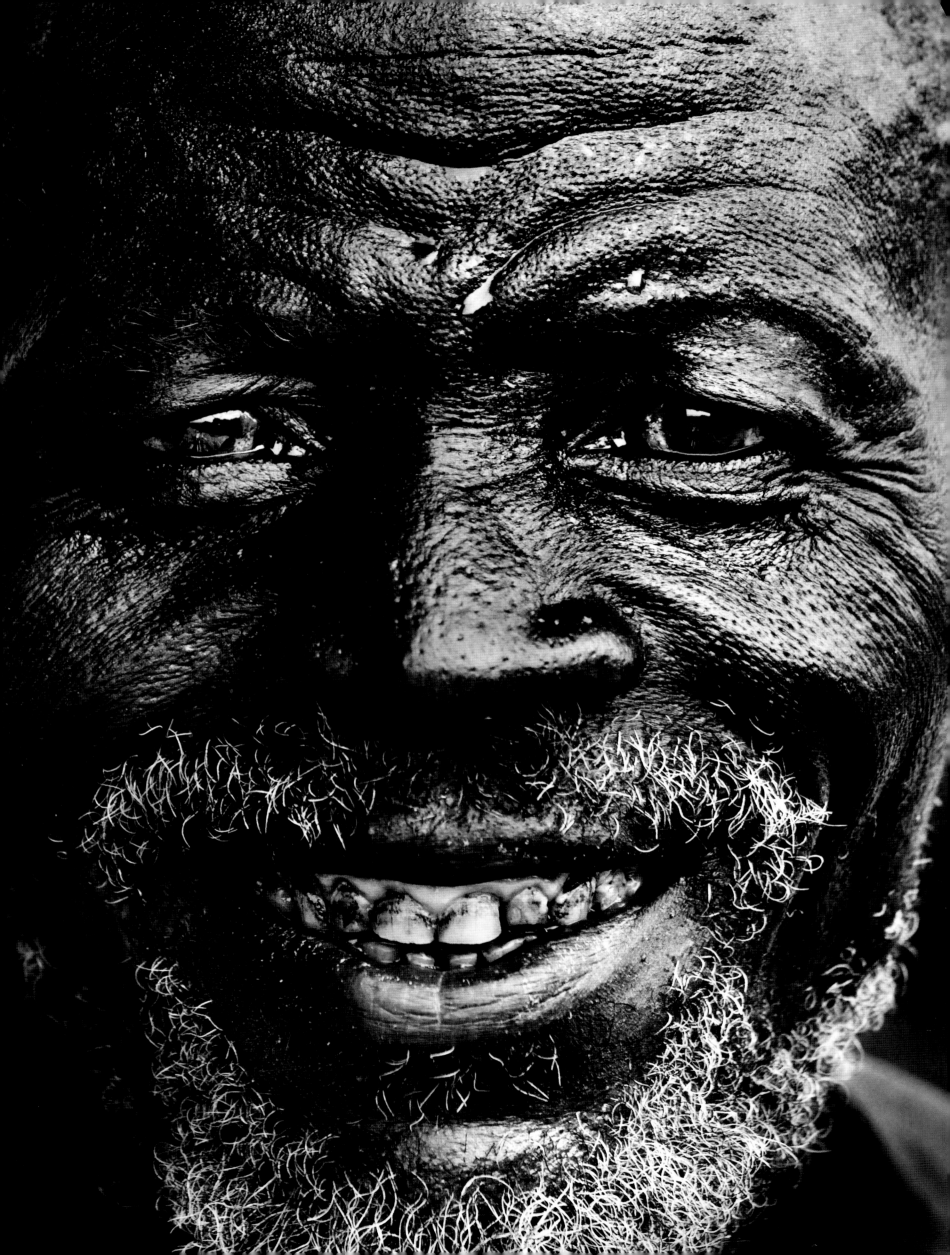

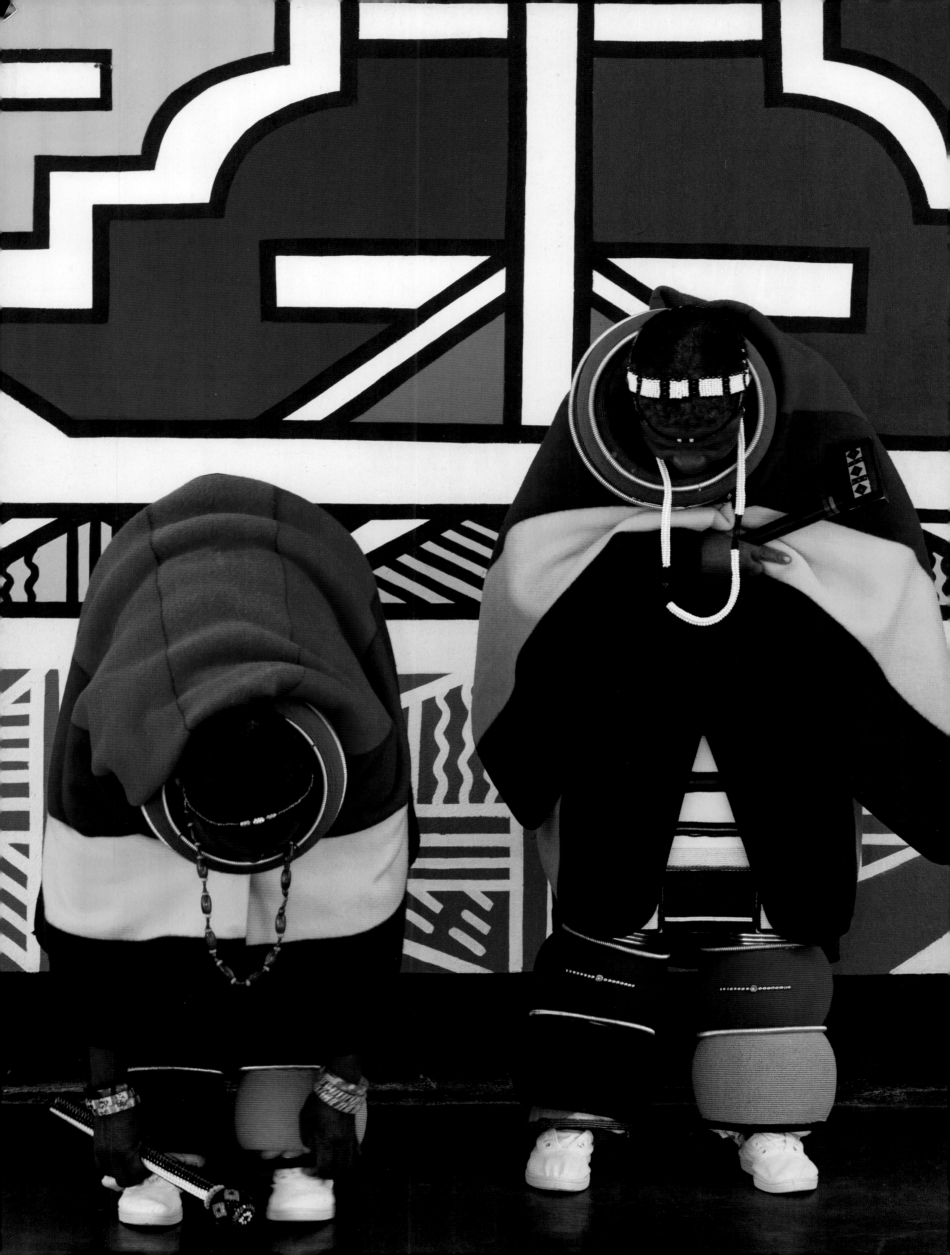

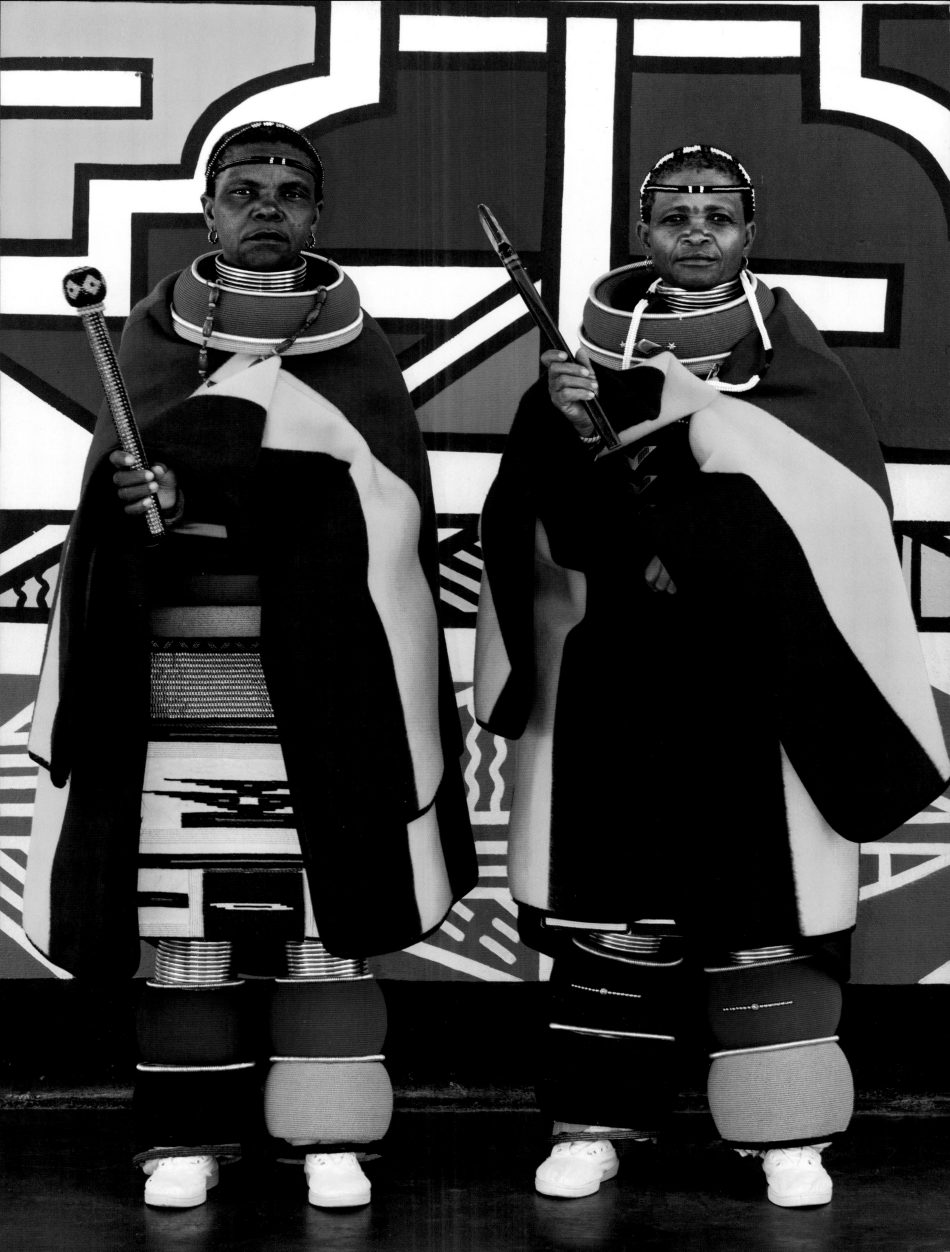

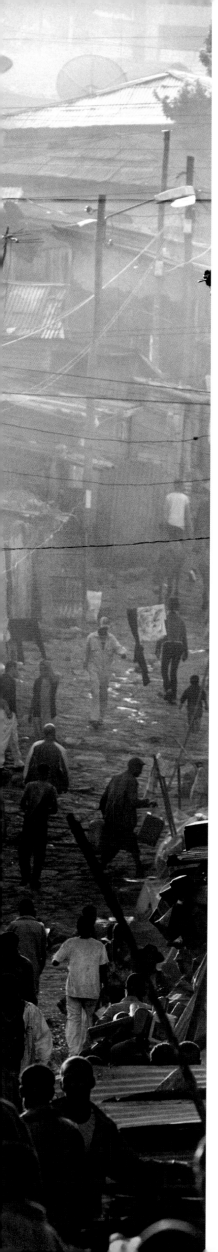

THE GOLD MINE AND CITIES

Johannesburg is much like any other modern city, with multi-lane highways, expensive shopping malls and restaurants serving salmon flown in from Scotland. But it also has a shadowy underbelly in the form of suburbs like Hillbrow, where, due to high unemployment and an influx of immigrants, streets throng with the dispossessed and small-time opportunists who sleep rough in a sea of urban decay.

The city was built on the wealth of gold, first discovered in 1886. Men still labour round the clock in dark tunnels beneath the surface, blasting the guts of the earth to extract the precious metal.

Preparing to visit the world's deepest mine shaft, I don regulation white overalls, black gumboots, a miner's hat complete with lamp, and a small metal box attached to my belt. The box holds thirty minutes of emergency air.

A group of miners shuffle through a turnstile at the start of the morning shift. I join them on a walkway which ends abruptly at a steel door on the edge of a hole nearly two miles deep. We are about to climb into a cage suspended over the void by cables, and plummet into the earth.

The door clangs open and we file in. Some of the men are joking, teasing one another; others have sombre, anxious expressions on their faces. These are among the toughest men in the world, yet in this crowd there are some who cannot conquer their fear of the cage. The door shuts, some water drips onto my shoulder, and we gradually descend until the last beam of outside light flies up and over us, going out with a flicker. In the new darkness our cage lurches and rattles as it gains speed, and then we plunge, over half a mile per minute, for three long minutes. I equalize the pressure in my inner ear, a practice learned from diving, for we are falling so fast that my eardrums hurt. With no visible point of reference in the blackness, it feels womb-like, with an uneasy calm, a false sense of security. When the brakes are applied my legs feel heavy, and we slow down until we reach our stop. The door slides open, cold artificial light floods in and we walk into a long and spacious tunnel.

Tight, steep passages recede into the tunnel wall, and I enter one; a winding snake of crude wooden steps, two hundred and eighty

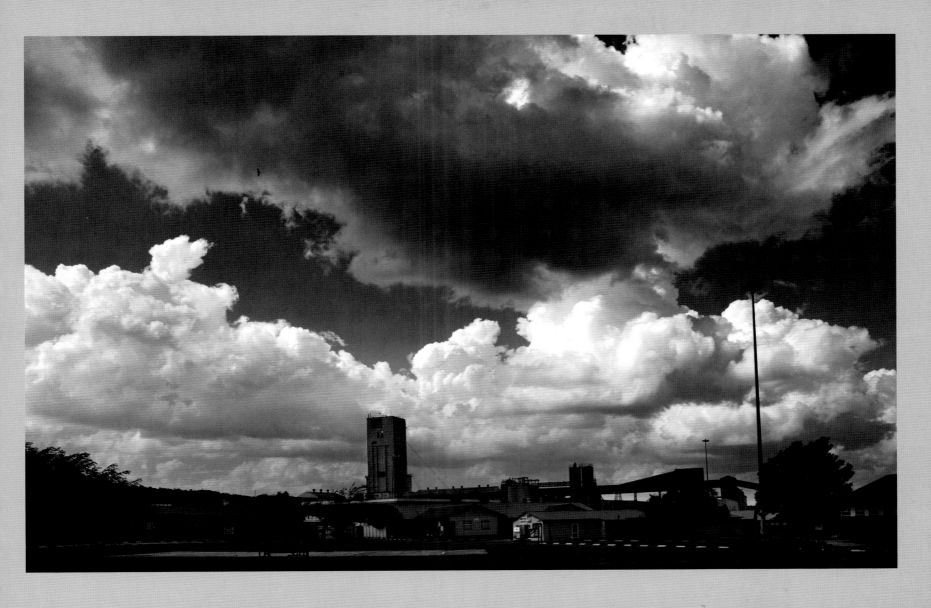

in total, near-vertical and narrow as a ladder. Guided by two young miners, I climb slowly, crouching, twisting, turning. My hard hat bangs repeatedly against the jagged rocks above my head. The top stair leads into another tunnel, flooded with water, and we wade through until we reach a narrow incline which we climb. Now it is hotter, much hotter than it was when we left the cage, and I am soaked through with perspiration.

Stooped and huddled, we are vague silhouettes in the dark, shuffling along towards the distant, rumbling sound of rattling drills and the hissing of pumps and sprays. We turn a corner, and are engulfed by a deafening clamour, screeching and pounding in the now intolerable heat and humidity. Ghostly figures of men move about in the dim light; hammering, sawing, cutting, drilling, lit only by the erratic movement of the lamps on their hats. Every now and then a beam shines momentarily on wide white eyes and sparkling beads of sweat on an unsmiling face. Many of these men are migrant workers from Mozambique, men who have made great sacrifices to feed their families, men performing one of the toughest jobs in the world.

I crawl to a corner where I wedge myself into position on the rocky ground. I lift my camera to my eye, but cannot see through the viewfinder. The lens has fogged in this black and gritty sauna, my eyes burn and scrunch up from the sweat that runs into them, my clothes are soaked through. I grope in my pocket for a cloth

to wipe the lens which stays clear for no more than five seconds before it fogs again, leaving mucky streaks on the glass. I must work quickly in the dark. The men toil ceaselessly, drilling holes to prepare the rock for blasting, each group motivated by the incentive of a team bonus, for they are performance driven and this is no place for the weak or slow.

Back in the main tunnel, we wait an hour for the cage to arrive to take us up to the surface. First it goes up and down on an empty dry run, to make sure everything is as it should be. Safety is paramount. All around me I see posters and signs promoting safety, and warning of the greatest danger, Aids. I comment to a shift boss that I have never seen men do such difficult work, and he tells me how much things have improved since the dark days of Apartheid, a poignant reminder of how wretched working conditions were in the past.

With a sense of relief, we feel the cage reach the surface. The door opens and the blinding sunlight burns our eyes as we adjust to the brightness. Never has a sunbeam been such a welcoming sight. I meet the cage operator, Philip, on whom our lives depended. He sits at his controls in a room overlooking the giant electric engine and enormous pulley. He talks enthusiastically about weights, measures, cable lengths, torques, and is as proud and responsible as the captain of a 747. He tells me that each ton of rock that is brought to the surface yields only a few ounces of gold.

Later, I walk through security gates and a turnstile into the hostel area in which thousands of miners live. There are shops, pubs and recreational facilities – I am genuinely impressed. The men live in small but comfortable rooms, two to a room, with a communal kitchen and living area for every three rooms. Family units are being introduced to allow workers to live with their wives and children, and so avert some of the consequences of forcing families to live apart. Aids is rampant, a devastating problem among mining communities. The reminders are everywhere; signs on the roads leading to the mine warn men to wear condoms and refrain from promiscuity.

I return to the city and dine with friends in a restaurant, where the relaxed ambiance is in stark contrast to the gritty darkness of my morning in the mine. On the way back to my lodgings I see a gold chain in a jeweller's window. Johannesburg, the city of my birth, lies in the province of Gauteng, which in the Sotho language means 'place of gold'. Without the men who toil beneath the surface, this city would simply not exist.

The next morning I drive through the streets in my rented car, and when I stop at the traffic lights people tap at the windows; beggars, street traders, a white man holding a sign saying 'Unemployed – please help'. Beyond the bustle and across the street stands a large billboard advertising a local brand of cigarette. It shows a young couple laughing beneath the line 'Life is Great'.

I am in the car with Denis Tabakin, who assists disabled people to participate in sporting events. We are on Jan Smuts Avenue on our way to meet seventy-one-year-old Ernie Brenner. It is news time, on the hour, and the radio tells of a man who was stripped naked and glued to his exercise bike by thieves who ransacked his house. This is the bizarre story of the moment, soon to be replaced by yet more tales of armed robbery, murder and hijacking – stories currently unfolding in the streets that surround us while we crawl in the traffic. But I feel safe, cocooned in the car, and everything outside looks normal.

We turn a corner and enter the leafy suburb of Houghton, where electrified fences and high walls conceal some of the most

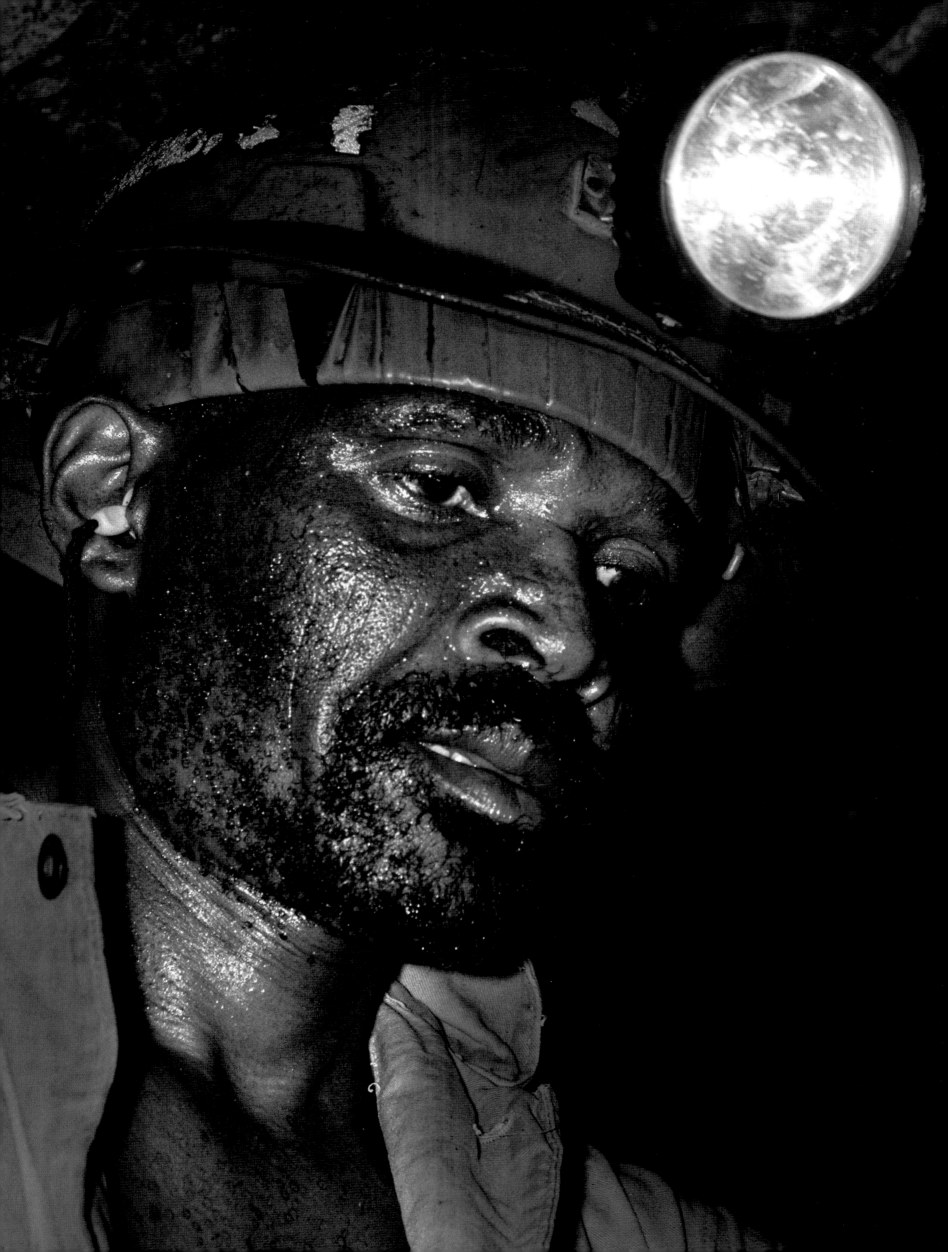

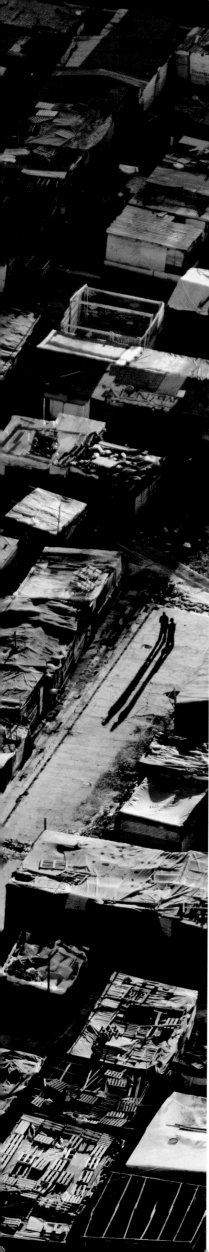

luxurious houses in the world. Bougainvillea and creepers cover the walls, interspersed with signs proclaiming 'Armed Response'. The inhabitants are refugees in their own homes, discreetly hidden from the outside world. We arrive at Ernie's gate and announce ourselves through the intercom. The remote-controlled electric gate swings open, under the watchful eye of a camera. We drive in, park in the shade, and make our way down a wide stone staircase to the front door.

Ernie is softly spoken, a man with a gentle smile who welcomes us with warmth and hospitality. He calls his helper who wheels him onto the veranda where he can watch the setting sun while we talk. Ernie is quadriplegic. Armed robbers held up his motor vehicle business and shot him. His wife Eleanor joins us and we drink tea poured from a silver pot and eat snacks of olives, herring and fine bread. Ernie speaks of his passion for competitive sport, and his recent participation in the New York wheelchair marathon. When I leave, I notice that the fence separating his house from his neighbour's is also high and electrified; a necessary precaution in case next door's defences are breached.

In the morning after breakfast we drive to the townships to meet Johnny Dumas, South Africa's leading blind marathon runner. He ran fifteen miles this morning while I indulged in toast and coffee for breakfast. Thirty-eight years ago a tragic case of mistaken identity changed his life. He was simply in the wrong place at the wrong time, was attacked with a long-bladed knife and had acid thrown in his eyes, blinding him totally. Now fifty-nine and with thirty marathons under his belt, he does not look a day over forty. He speaks only of his next marathon and his quest to find sponsors to send him there.

Johnny and Ernie embody the courage and optimism that can be found in the most unexpected places; people at opposite ends of the economic scale, united in both strength and misfortune.

I am invited to talk about my work on a radio show, and report to the studio's reception desk where I am asked to hand over my firearm. 'I don't have one,' I say, but my voice is drowned out by the

LEFT
Shanty town, Johannesburg, South Africa.

OPPOSITE
Rally, Johannesburg, South Africa.

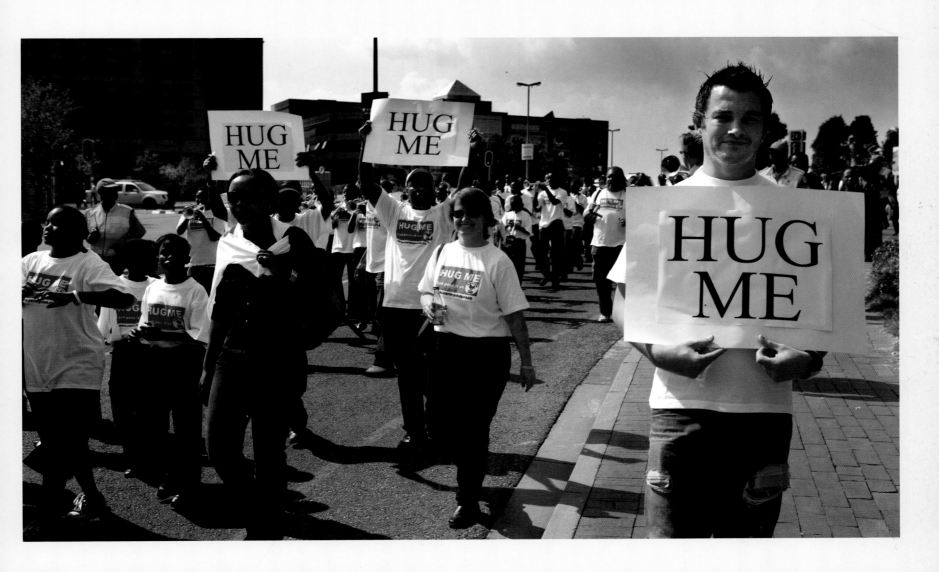

wail of police sirens outside the door. I rush out into the street to see what is happening and enter the mayhem. Police cars noisily escort a group of marchers who are waving placards high in the air. Each placard bears the message 'HUG ME'.

Africa's cities are growing at an unprecedented rate. Nairobi is a sprawling metropolis, epitomized by the Majengo district, an overflowing throng of shops and traders. I stop on top of a hill and peer through my long lens. My viewfinder is filled from corner to corner with bodies, trucks, cars, bicycles; a throbbing mass of humanity. Hawkers sell music systems, watches, cell phones, piles of potatoes, second-hand clothes, anything that somebody else may be persuaded to buy. Poorer people sift through rubbish at

the side of the road. Prostitutes ply their trade in an Aids-racked community. A shop selling coffins stands next to one selling wreaths; a sign on a door says, 'Welcome but no entry'.

Throughout Africa, millions of small traders create the huge diversity of urban streets and markets, in a world that remains largely free from supermarket domination. Merchants decorate and personalize their shops and stalls, each a unique and essential part of a giant web of interdependence.

In Bamako, the capital of Mali, cattle arrive at market having been driven in herds for up to ten days. They are thin and exhausted, but even so they command a better price here than in smaller towns. Carts laden high with heavy loads are pulled by

LEFT
Early morning in Johannesburg,
South Africa.

OPPOSITE
Table Mountain with its 'tablecloth',
Cape Town, South Africa.

downtrodden, luckless donkeys, many with festering sores from
constant whipping. Broken-spirited, they hang their heads low
as they plod wearily along, resigned to eternal punishment.

We stop at the side of the road near Ségou in Mali, and I
hear the pitiful cries of goats. A dozen or more are tied crudely,
like parcels, to the roof of a car, twisted legs protruding at painful
angles, no shelter from the scorching sun. Without refrigeration,
animals are kept alive as long as possible, and so are transported
long distances to market. Perhaps compassion for animals is a
learned attribute. It is certainly absent from the boy who sits
outside his house, plucking feathers from a live pigeon. Urban
life is competitive and divisive, while rural tribes who live off
the land tend to regard animals and people as components
of the same nature.

We arrive in Mali's dusty town of Goa as the sun is setting.
'This is one of the hottest places in the world,' says my guide,
Harber Kunta, 'hotter than Timbuktu.' He should know – he
grew up in Timbuktu.

We walk down the street and into the evening, searching
for something to eat. Insects swarm around streetlights and most
people sit outdoors. Wires trail out of houses, leading to small
television sets perched on tables and boxes. Groups of people
cluster around the flickering screens, watching football and soaps.
A giant toad leaps lethargically out of our way as we struggle in slow
motion through a wall of heat. We find a restaurant and sit near
its blue light; flies buzz everywhere. I cautiously ask the waitress
when the chicken was slaughtered. 'This afternoon, of course,'
she replies. 'We don't eat yesterday's meat in this place.'

Cape Town has become an international tourist destination and,
with its good light and spectacular scenery, a popular photoshoot
location for the advertising industry. Young models pose on the
white sands of Camps Bay beach, against the familiar mountain
backdrop of the Twelve Apostles, to create advertisements for
everything from luxury cars, to muesli, to banks: lifestyle fantasies
conjured on borrowed beaches.

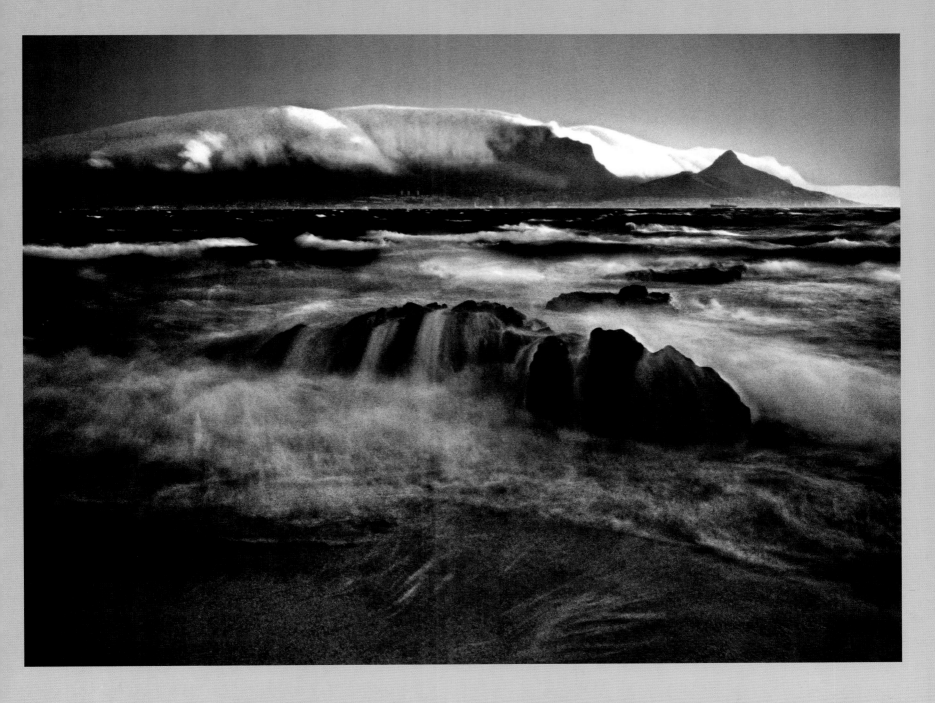

A cruel wind blows in from the south-east in the summer months, bringing havoc to the city. Windows tremble, cars shake; trees twist, bend and howl in violent gusts that tear off branches. People angle into the wind, struggling to stay upright, dodging flying debris. The south-easter is known as the Cape Doctor, for when it dies down the air is once again clean, the yellow haze of pollution gone, and Cape Town is left to bask in the stillness that follows the storm.

In the warm waters off the eastern coast of the Cape Peninsula, great white sharks leap out of the ocean in their hunt for seals, and Southern Right whales come close to shore to breed. Boulders Beach lies along this coastline, a sandy cove enclosed by giant rocks, rounded by millennia of waves; here in the 1960s I built sandcastles as a child. Twenty years later, a few Jackass penguins arrived, and decided to stay. Firmly staking their territory, numbers multiplied rapidly. They jostle for nesting sites on the idyllic beaches and in the gardens of cottages which clustered the shore long before their arrival. The area is now a protected nature reserve, and human residents have to tolerate their noisy neighbours. The feisty penguin has successfully colonized where people once dominated.

Look down from the top of Table Mountain and you see the sprawling city of Cape Town. Look a bit further, beyond the concrete structures and out to sea. There lies barren, windswept little Robben Island, one-time leper colony, then place of exile and imprisonment, now a tourist attraction. Nelson Mandela spent two decades incarcerated there. Shortly after his release I was invited to visit the island and spent some contemplative moments inside his tiny prison cell. Nowadays visitors file past his cell in their thousands, driven by political pilgrimage, spiritual inspiration or morbid curiosity. Whatever their motivation, few fail to be moved.

The island, once a place of institutionalized oppression designed to crush morale, has ultimately become a symbol of human ability to triumph against tyranny. Such inspiration and hope come not from the technological developments that give rise to towering skyscrapers on the mainland, but from a few sparse, bleak cells within the former prison walls.

Our human ancestors came from Africa. Here the earliest fossils were found. Here is where our very humanity developed: our capacity for war and violence, compassion and courage. Africa has it all.

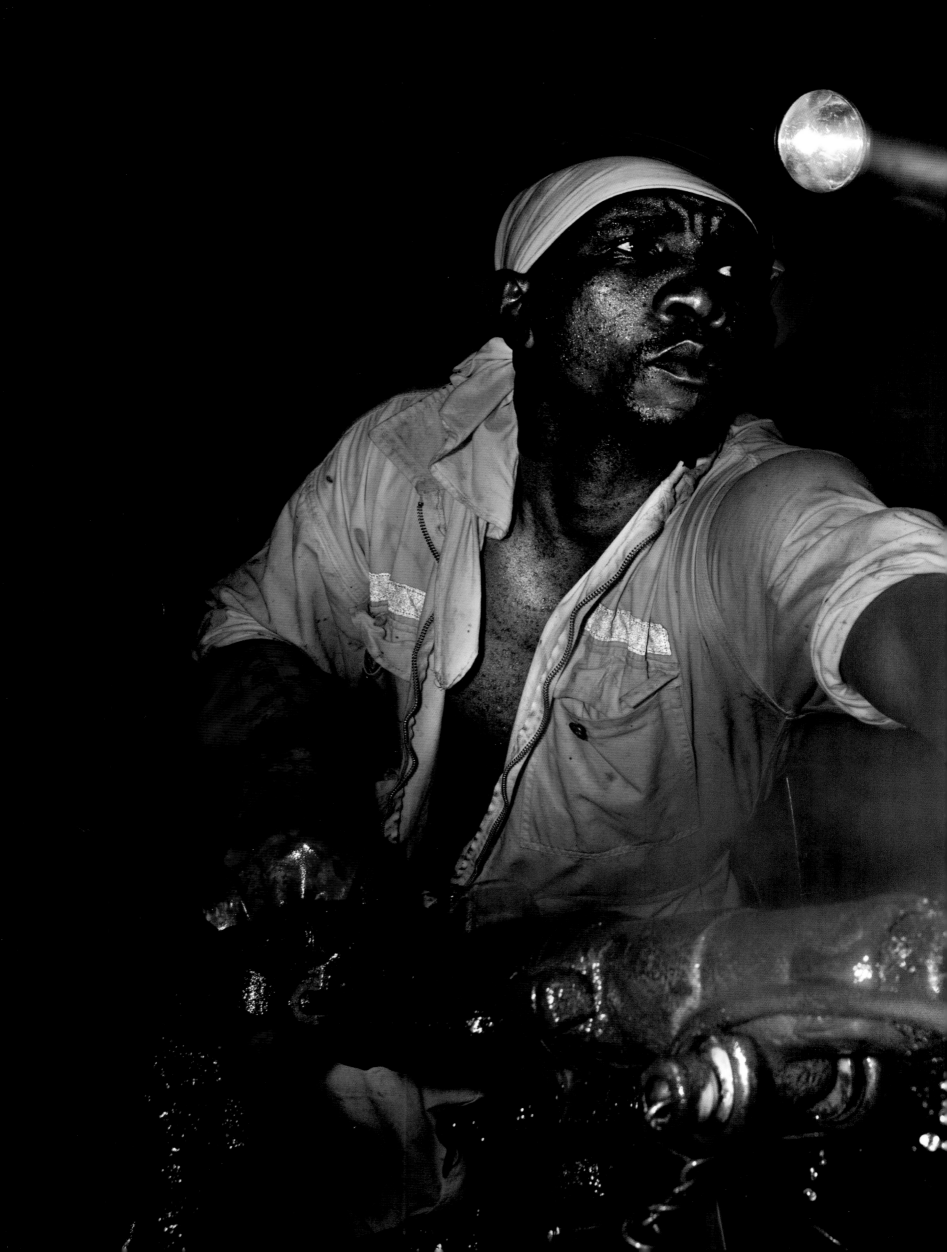

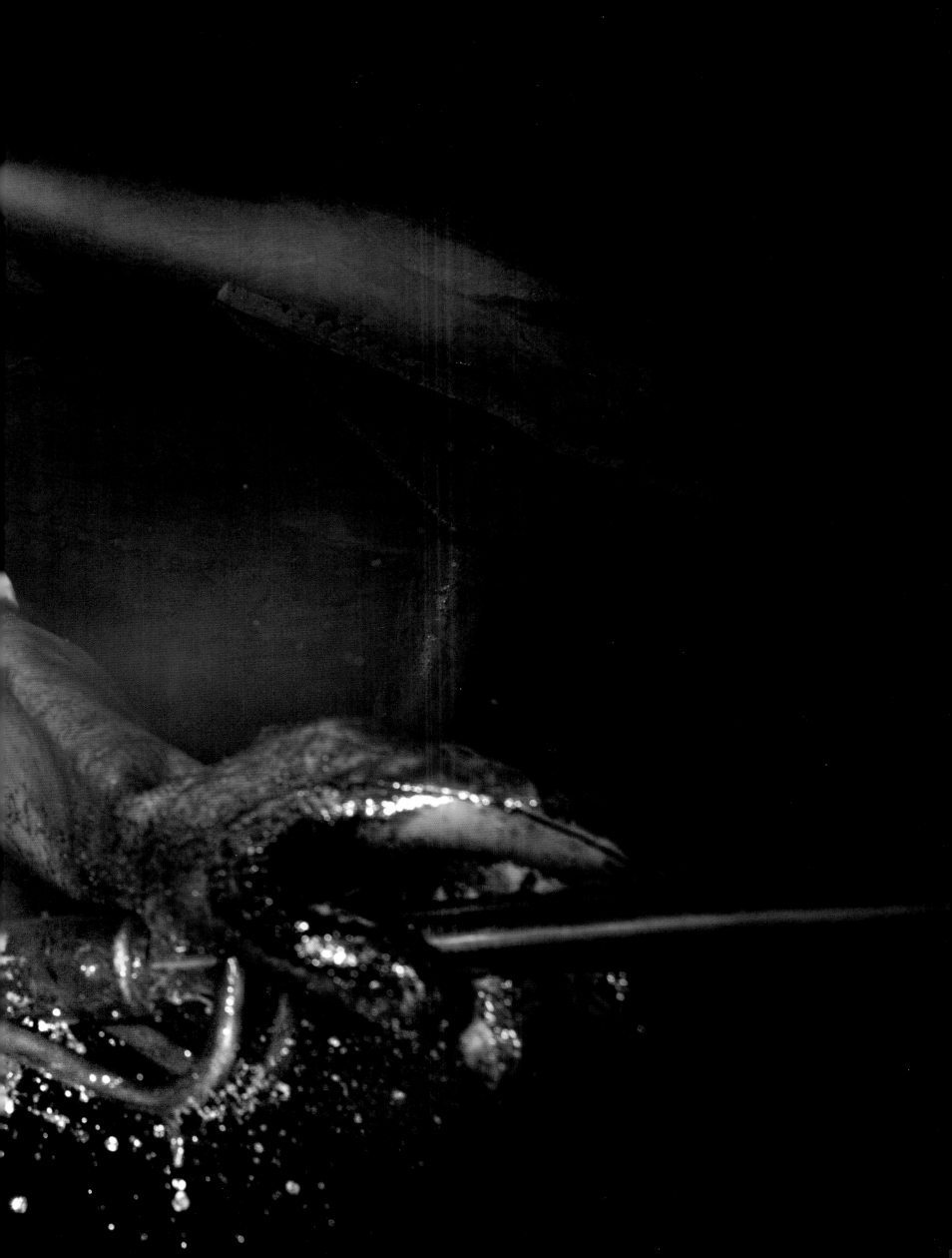

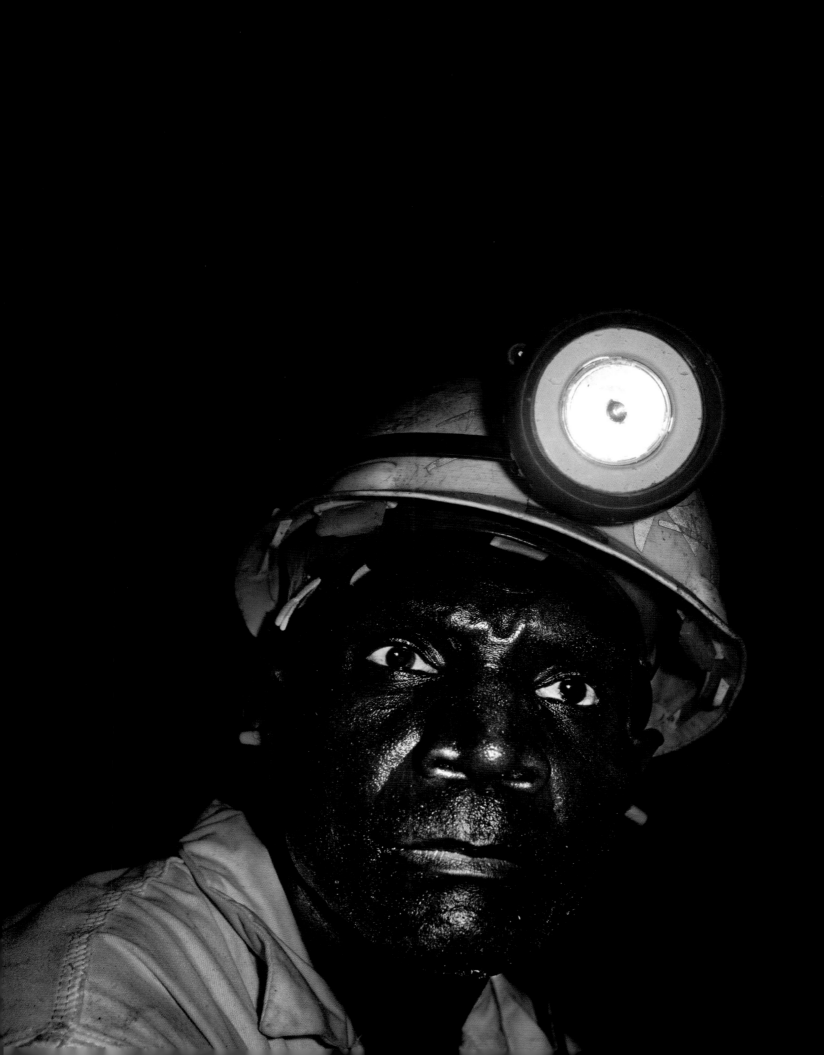

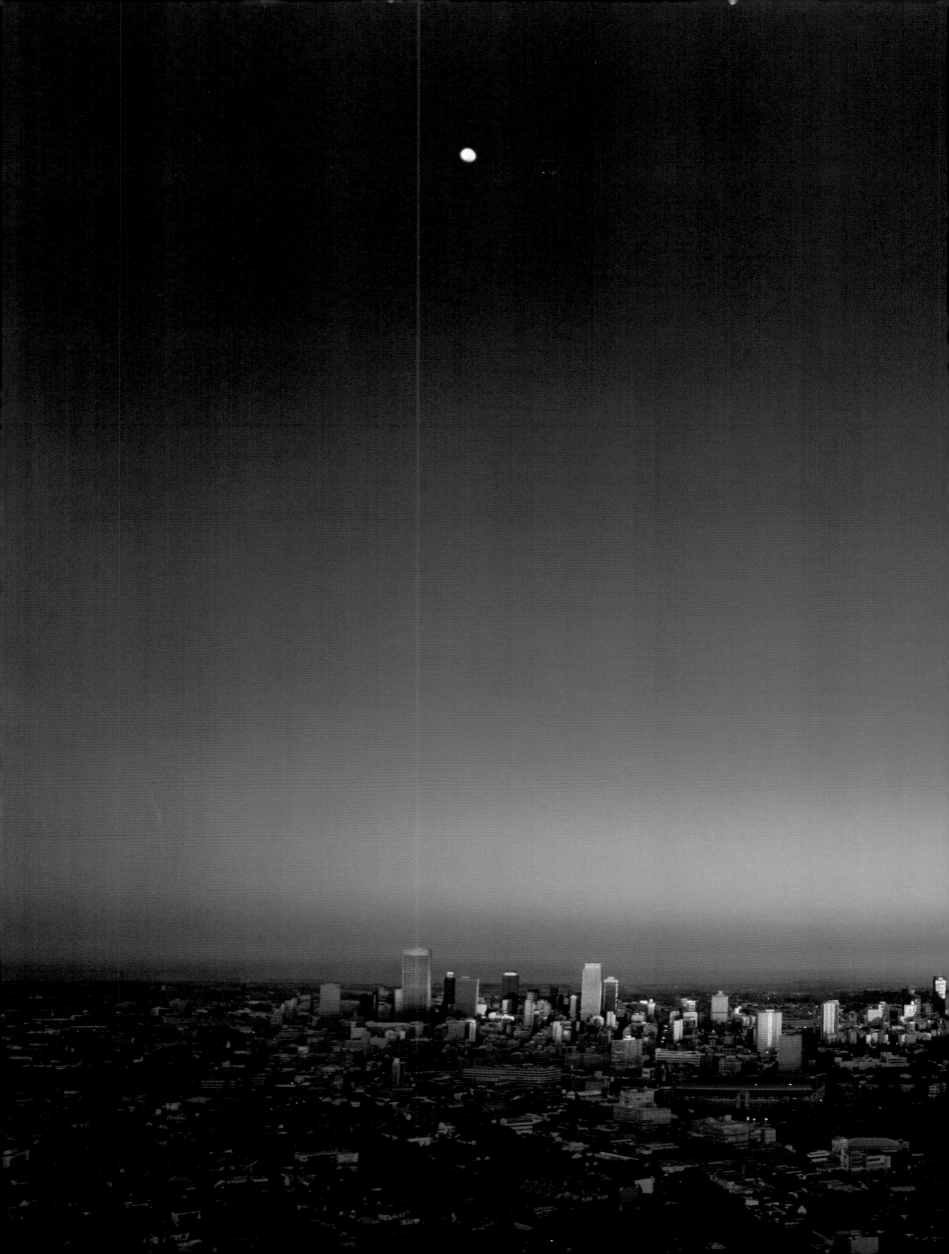

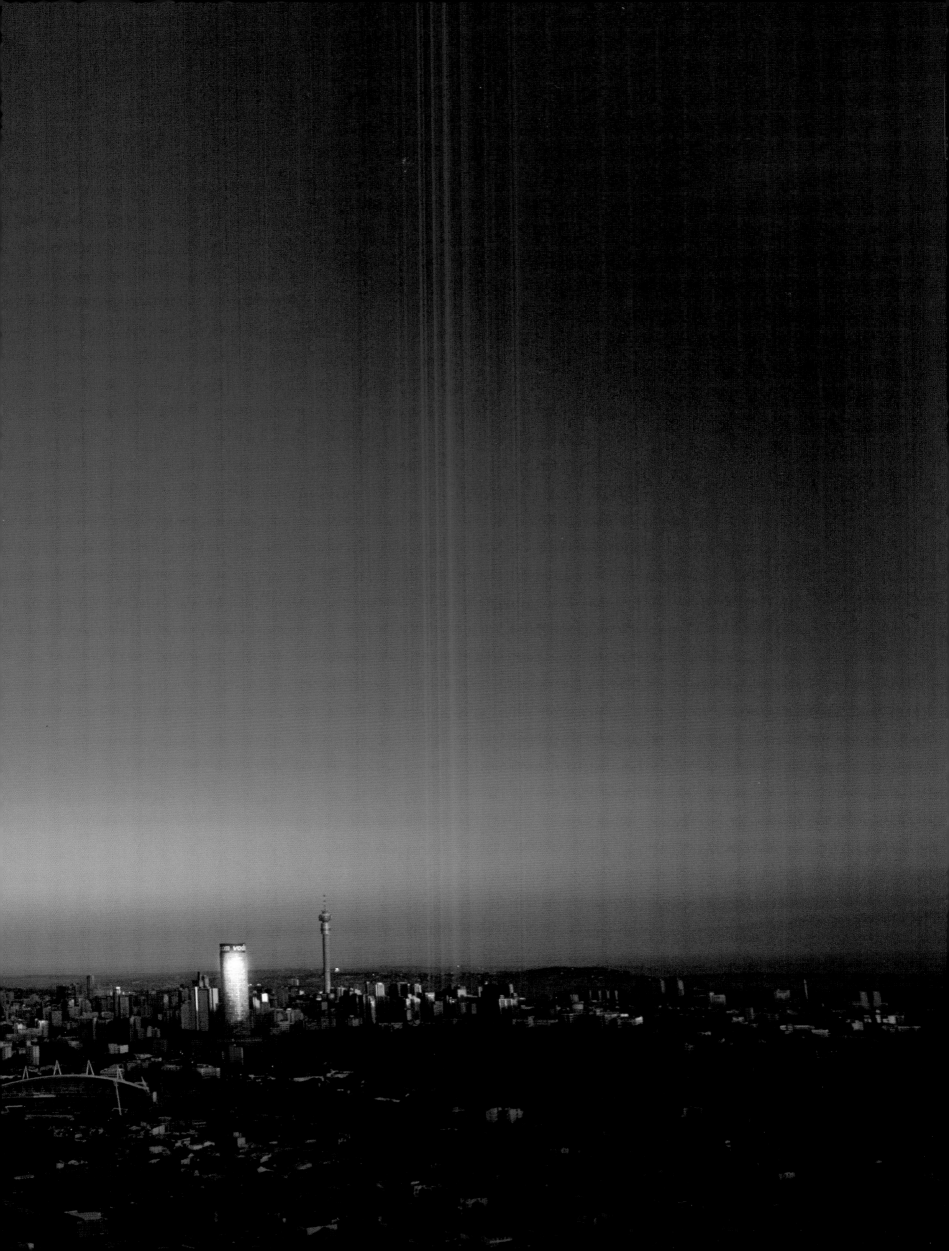

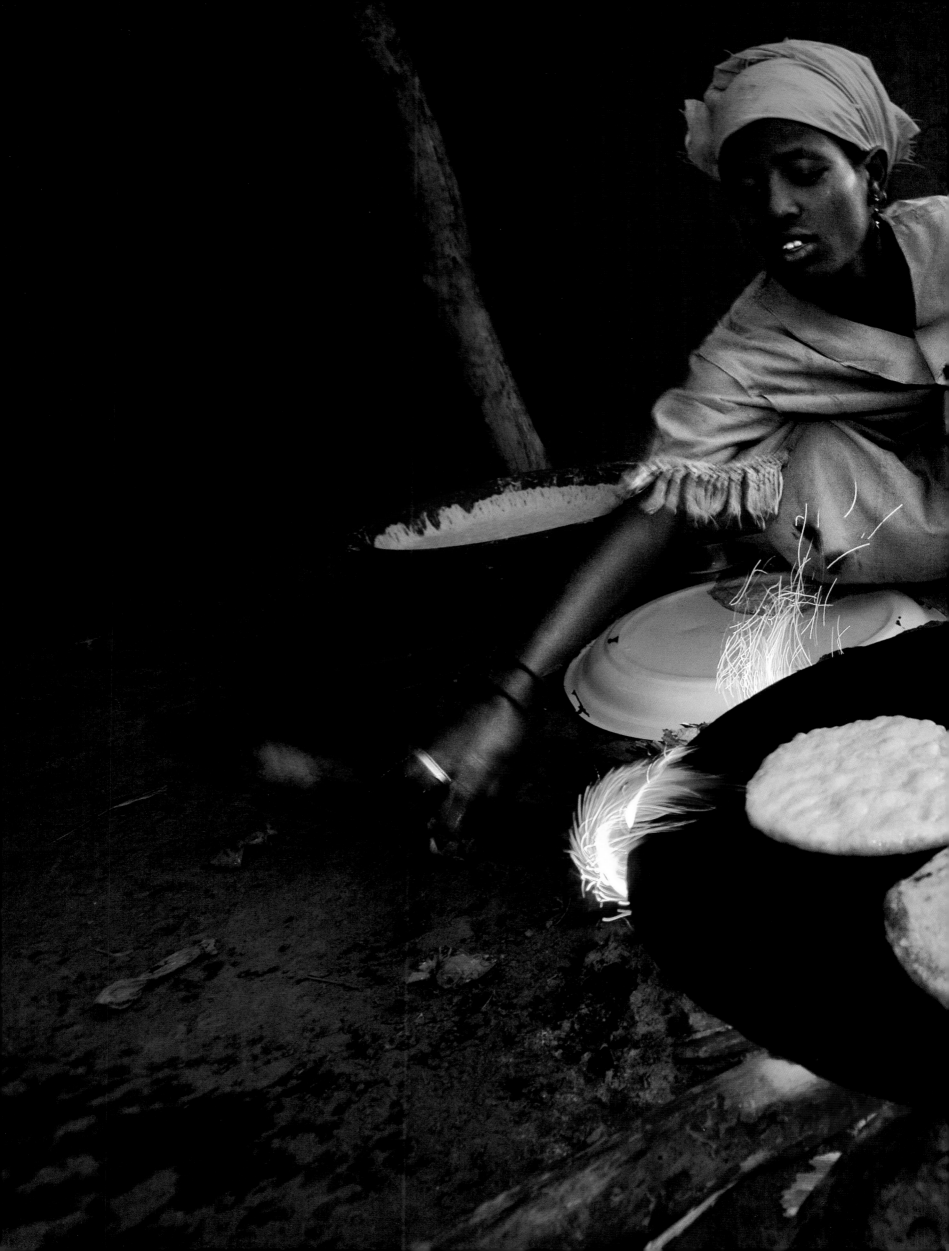

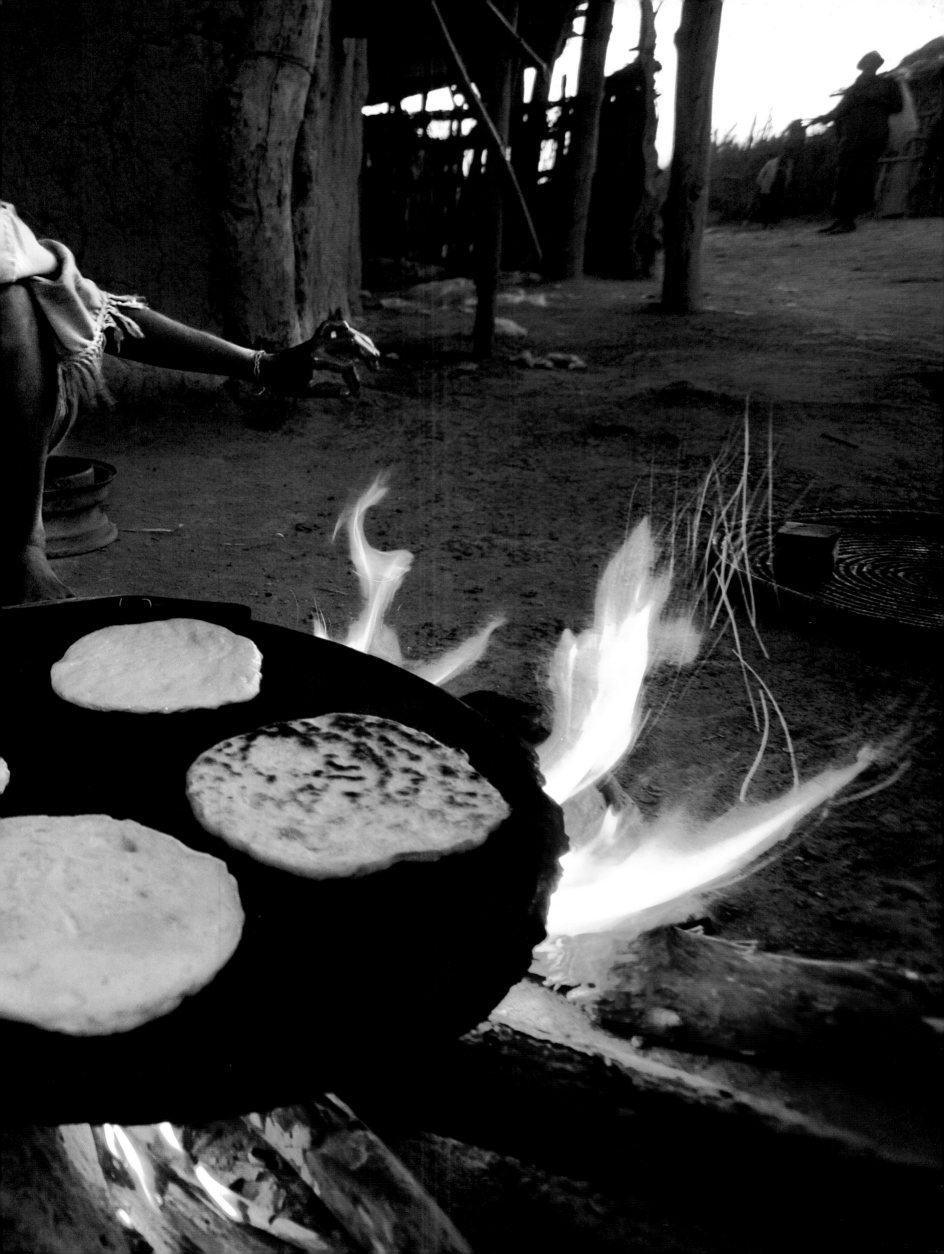

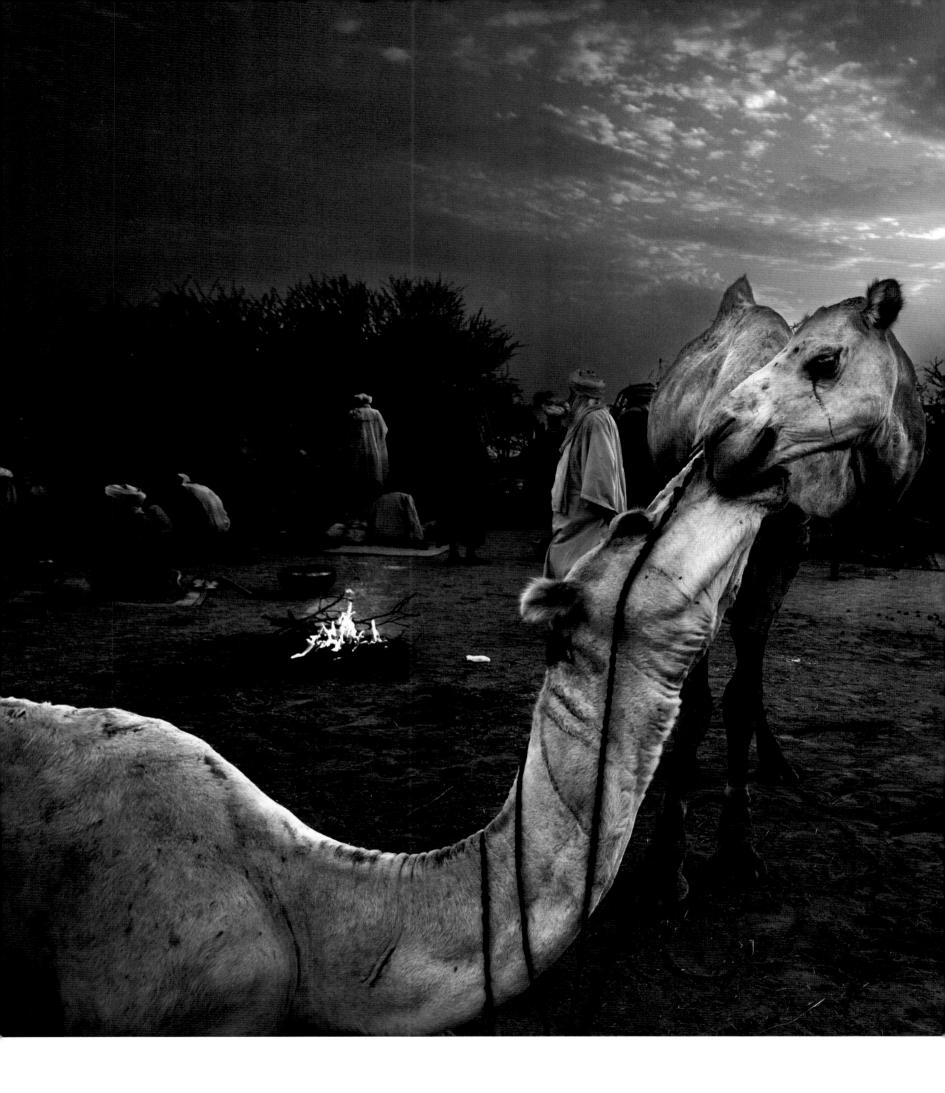

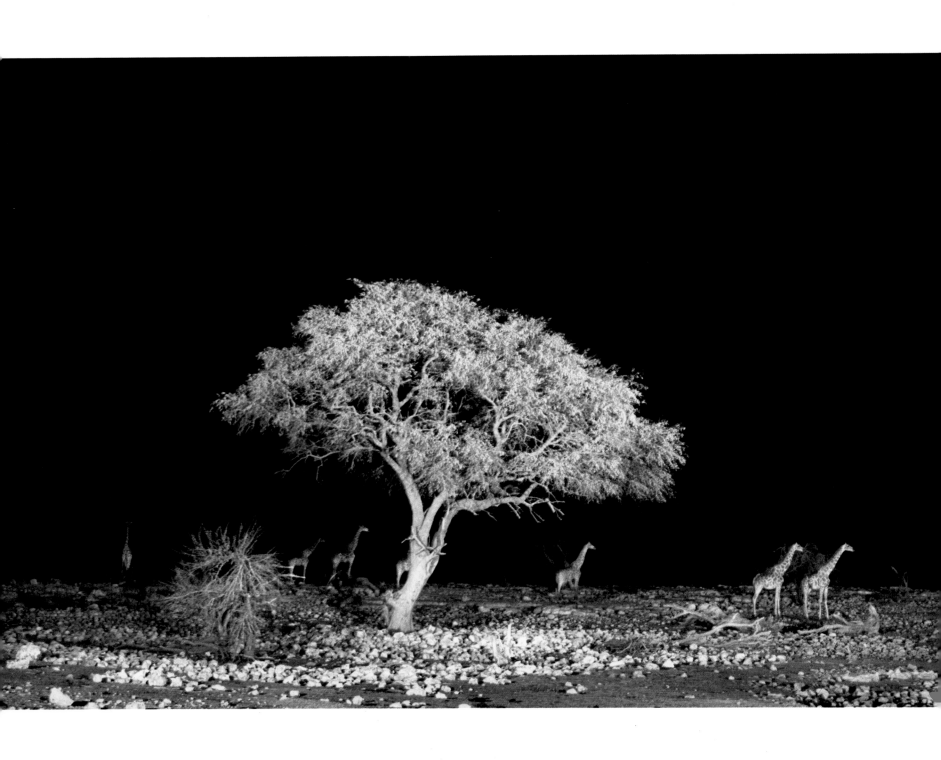

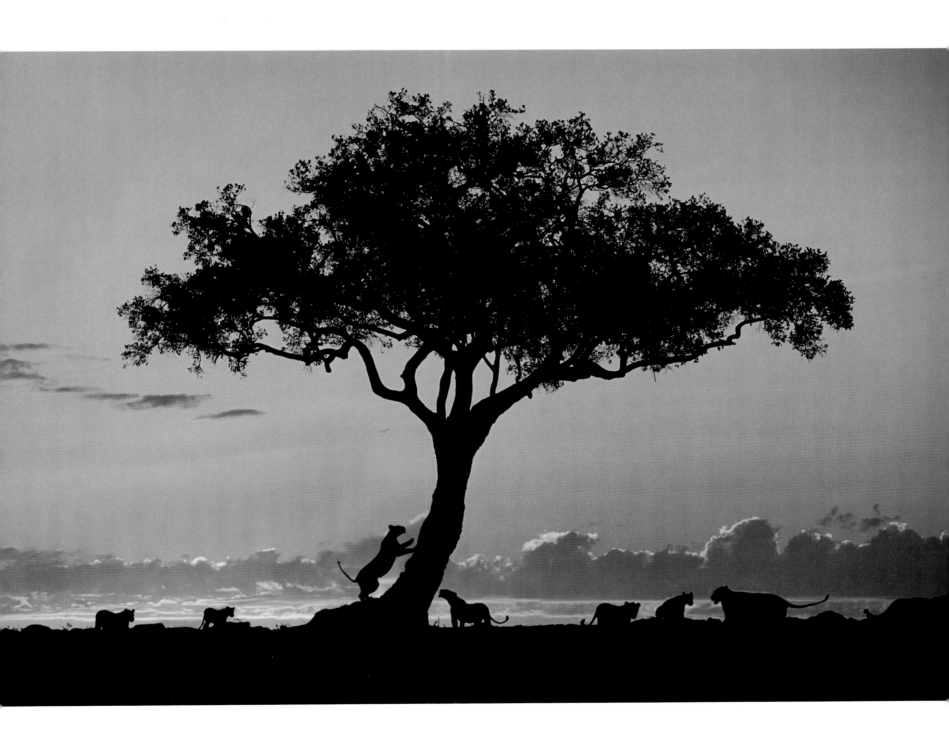

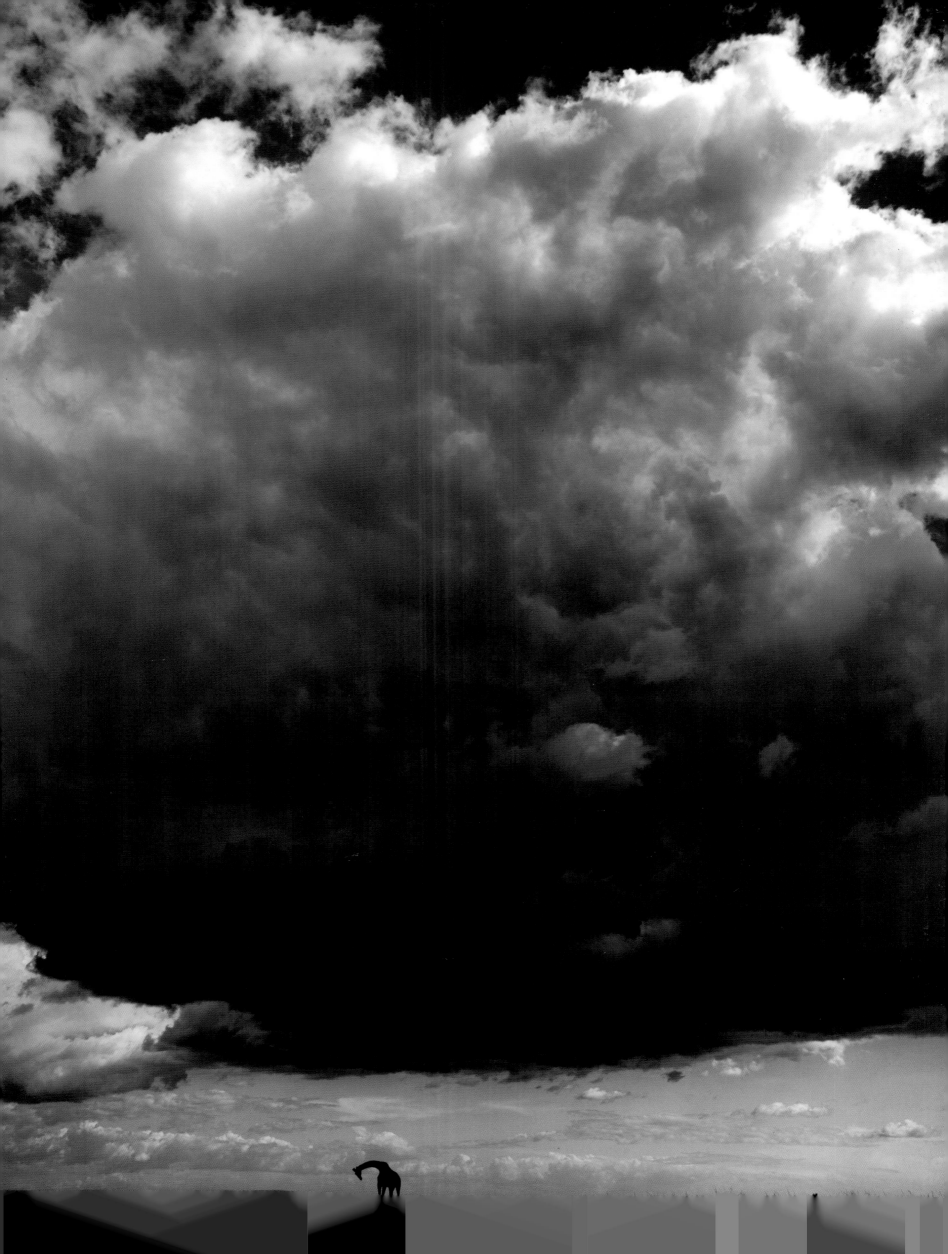

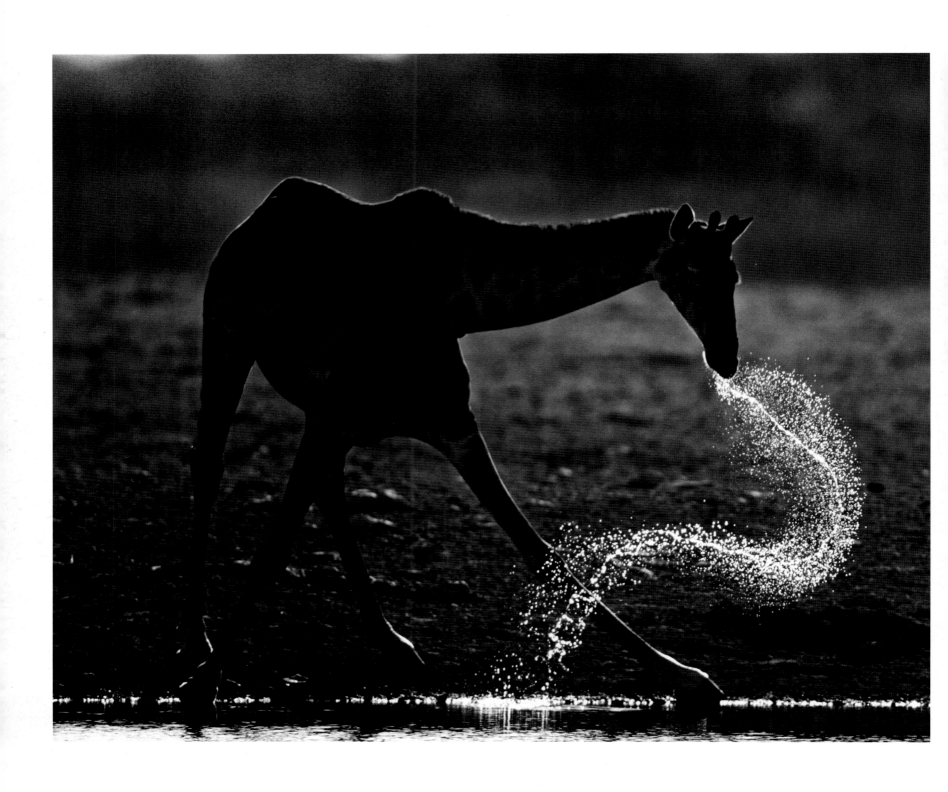

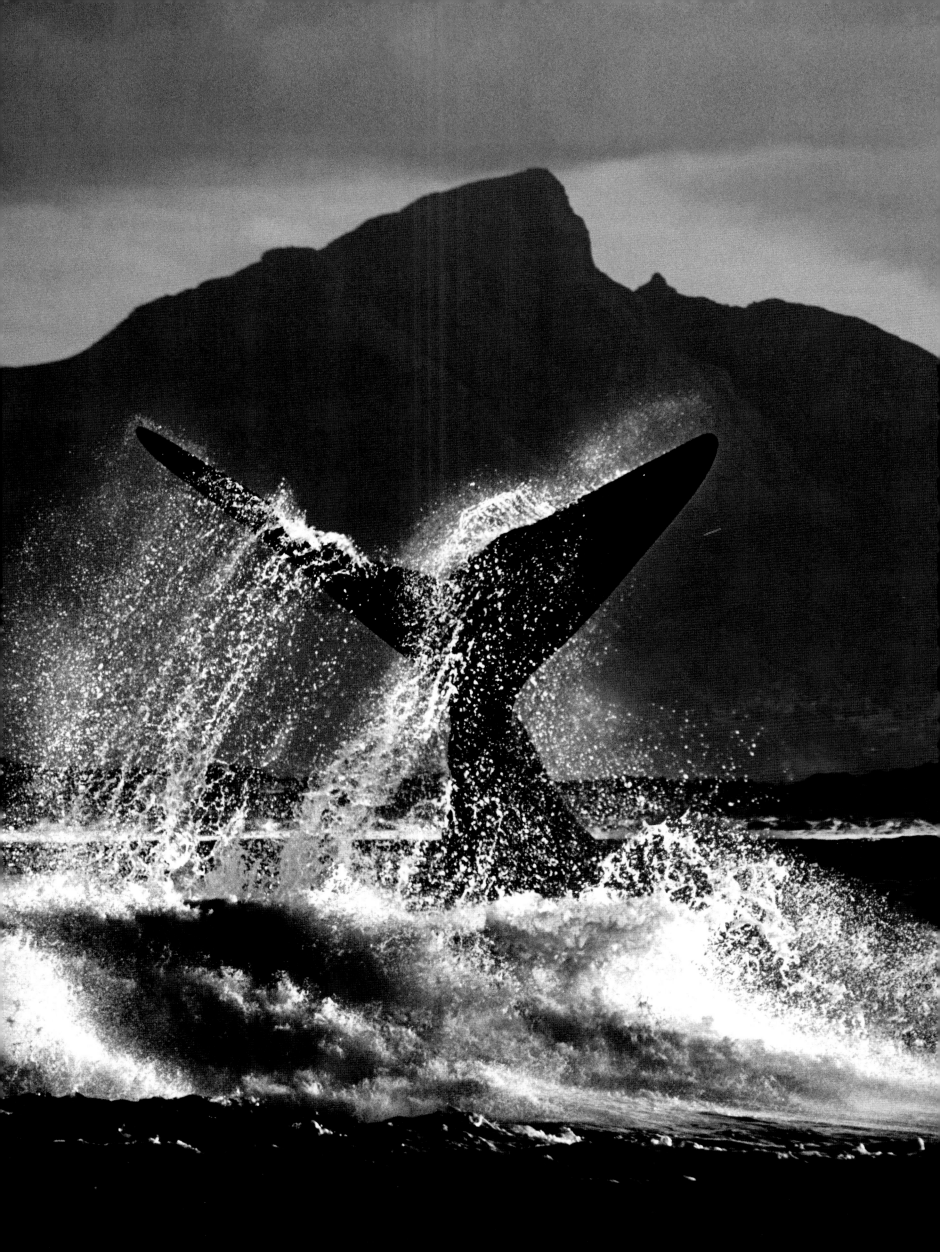

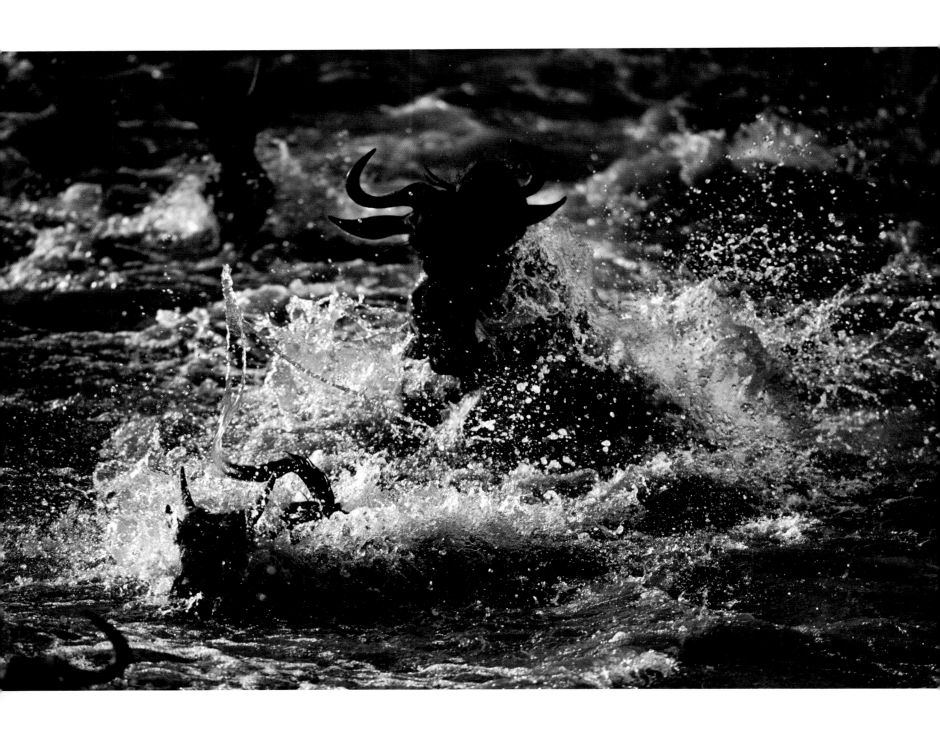

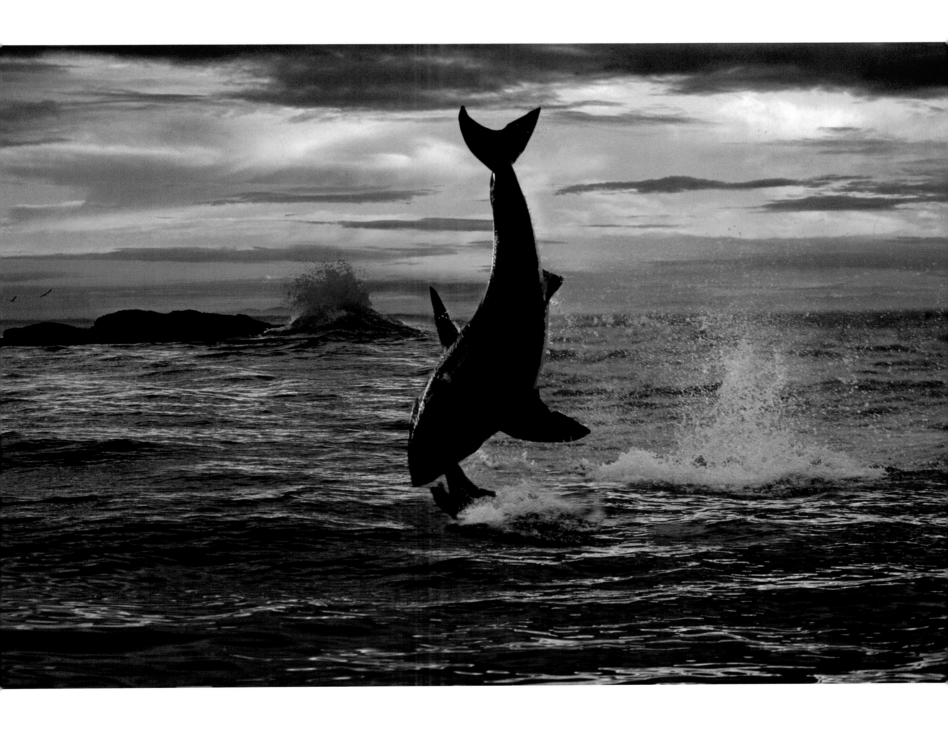

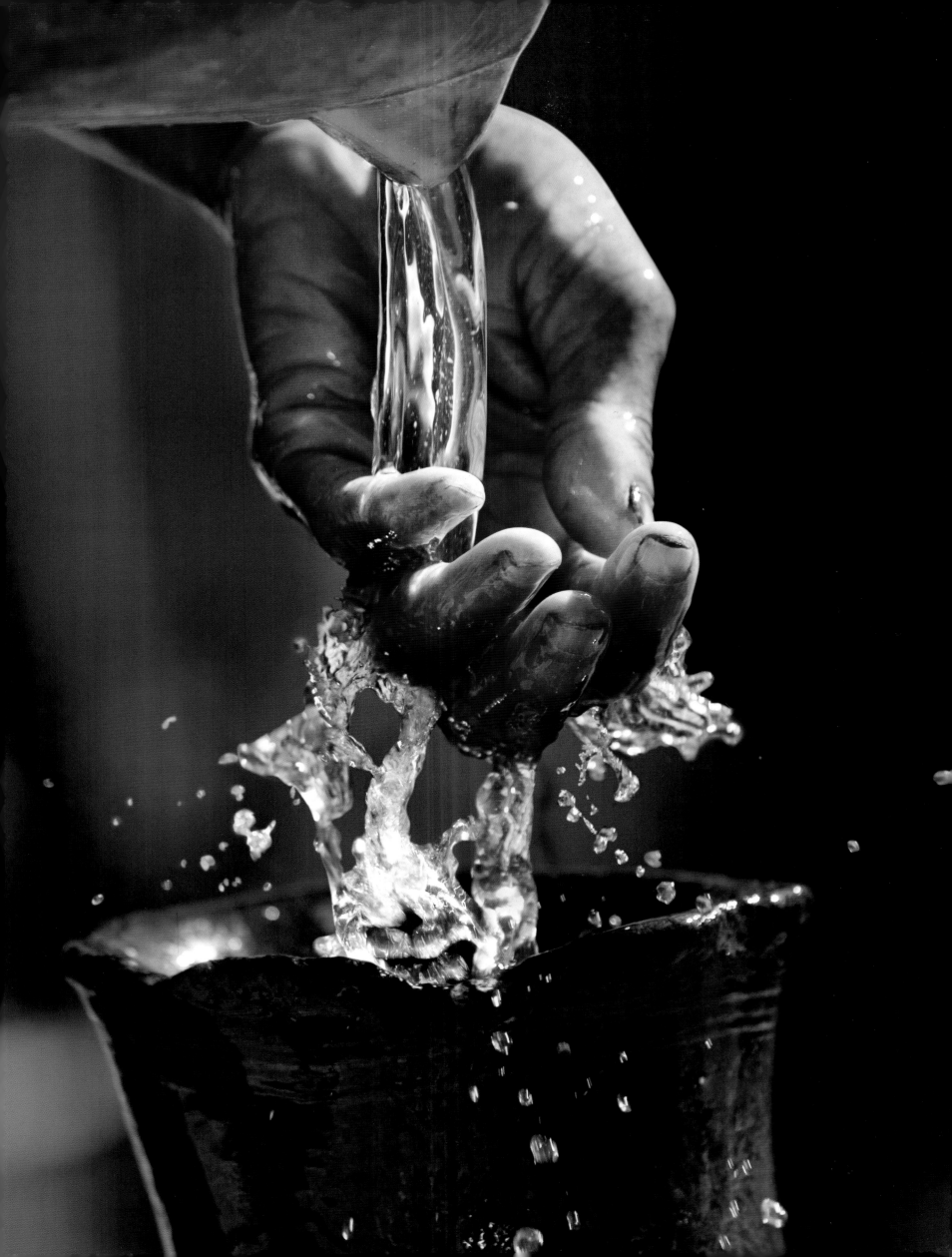

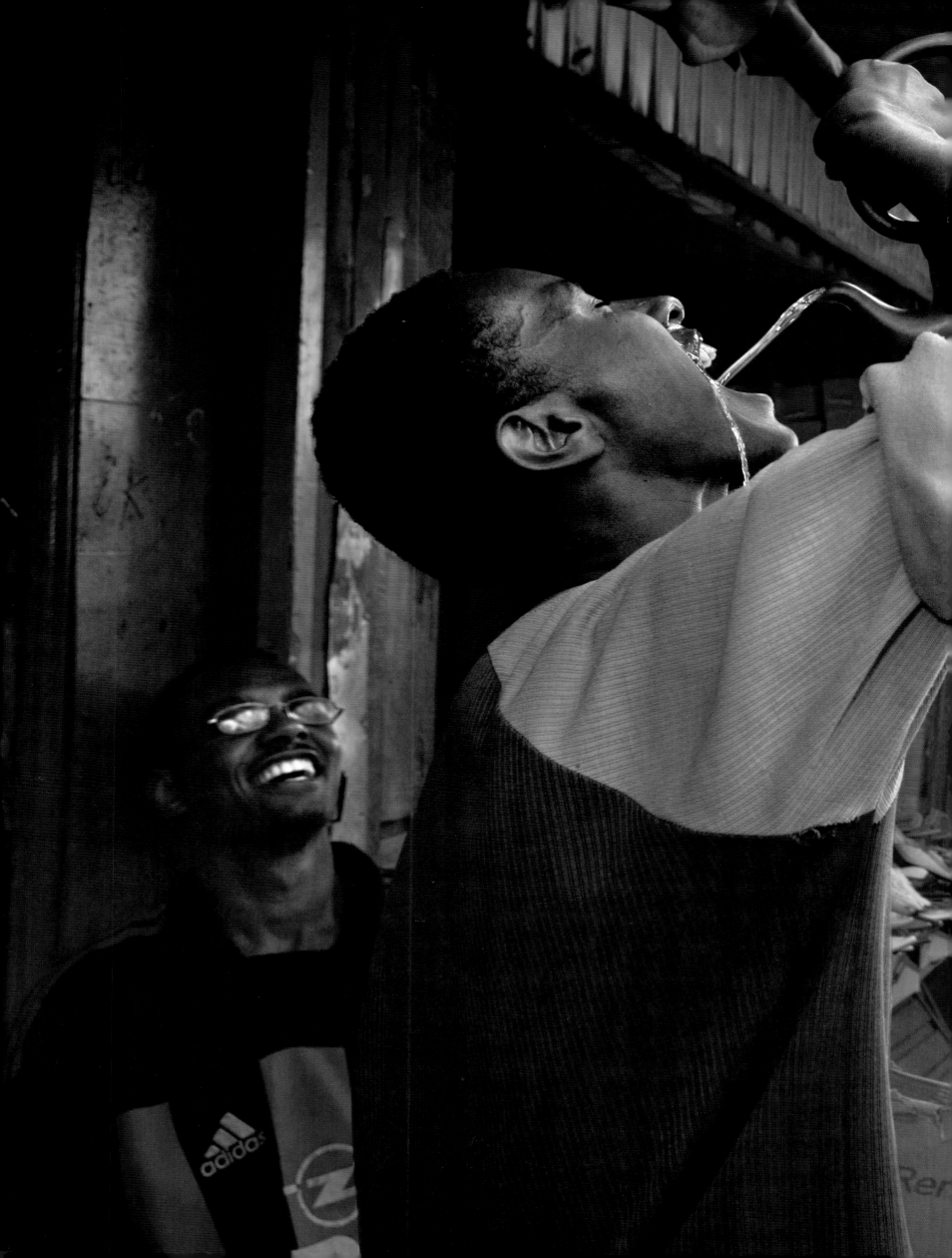

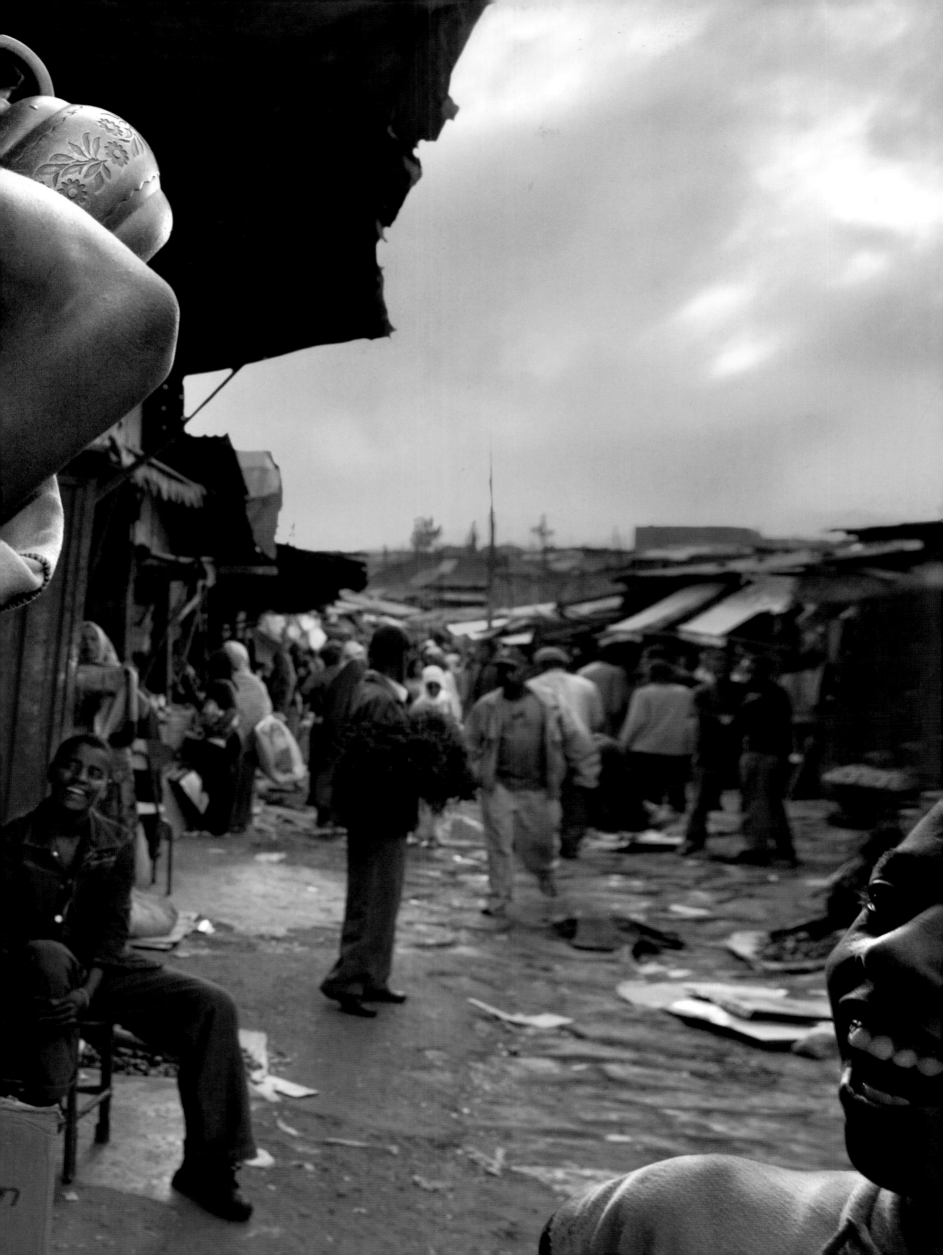

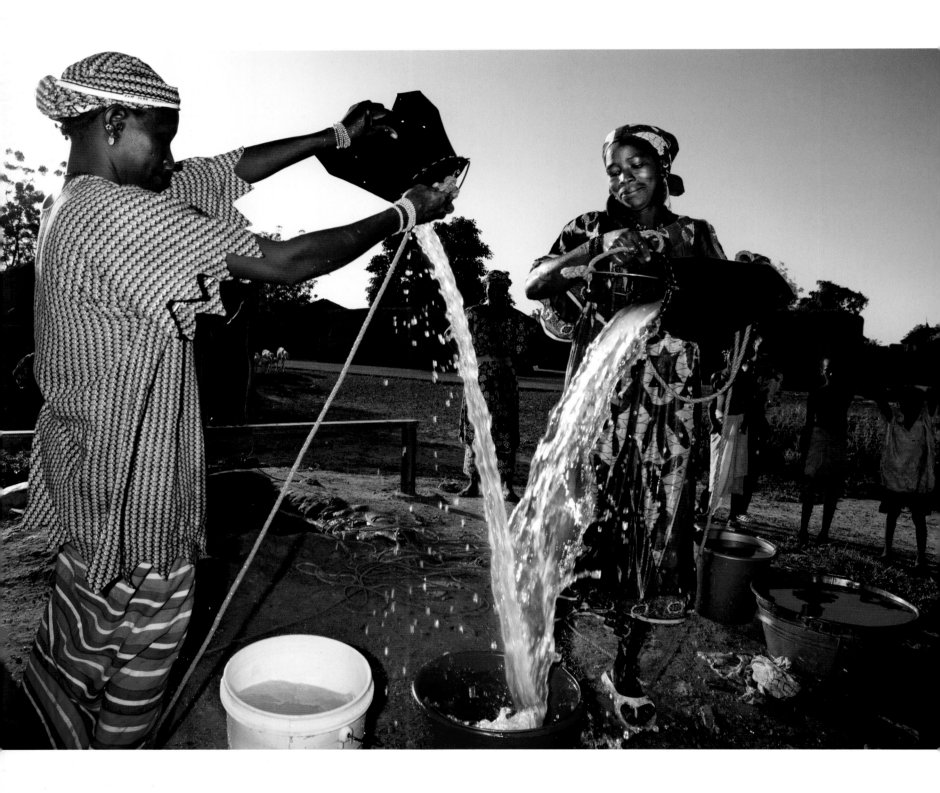

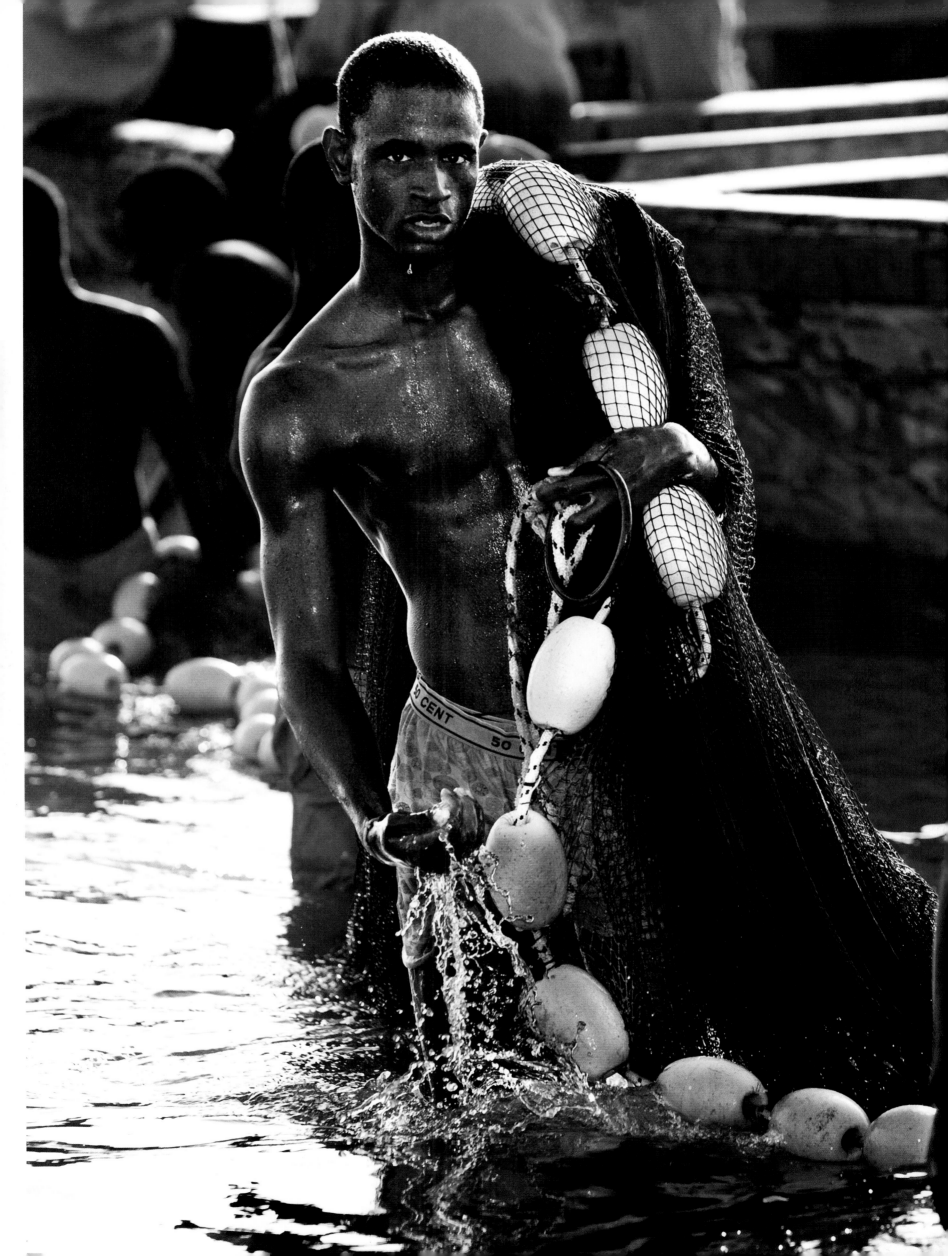

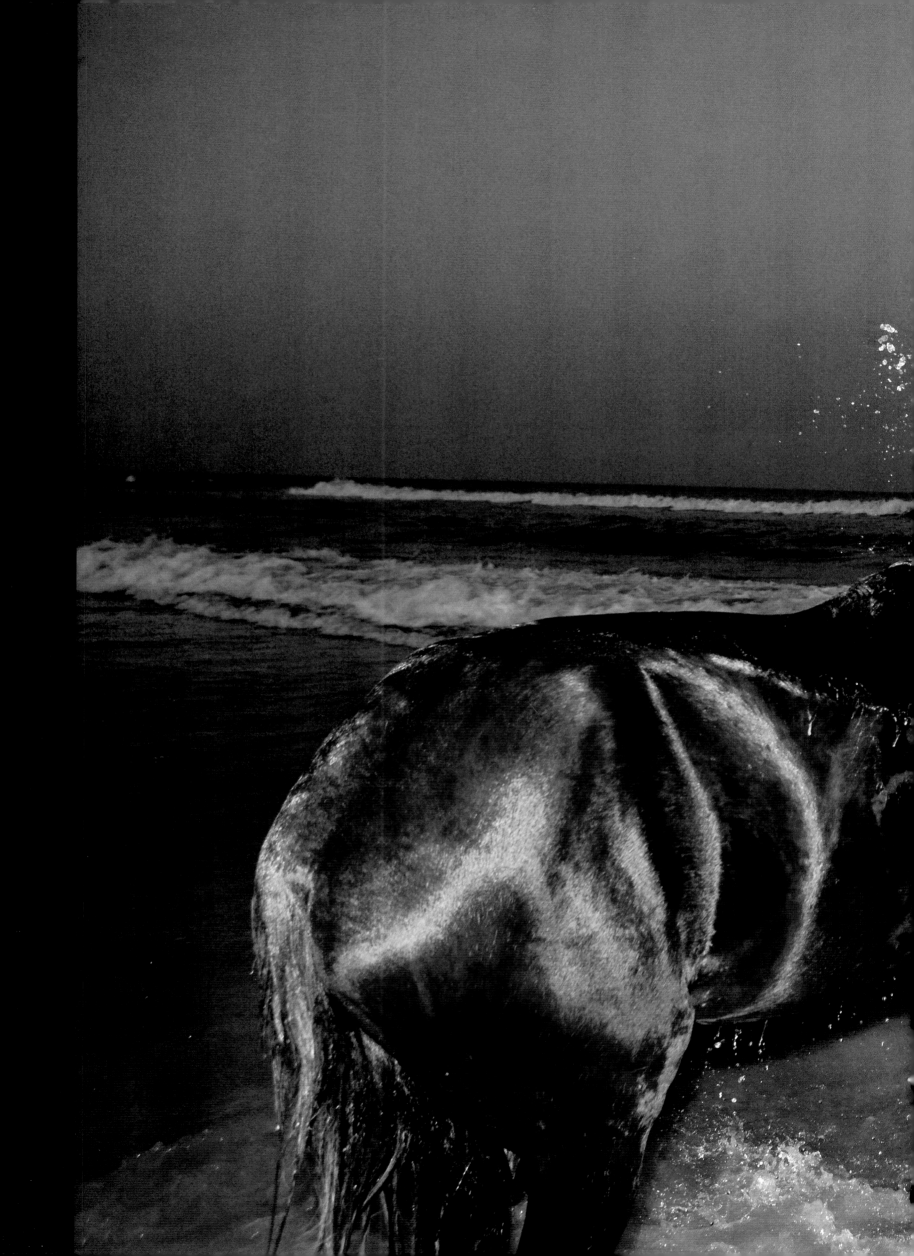

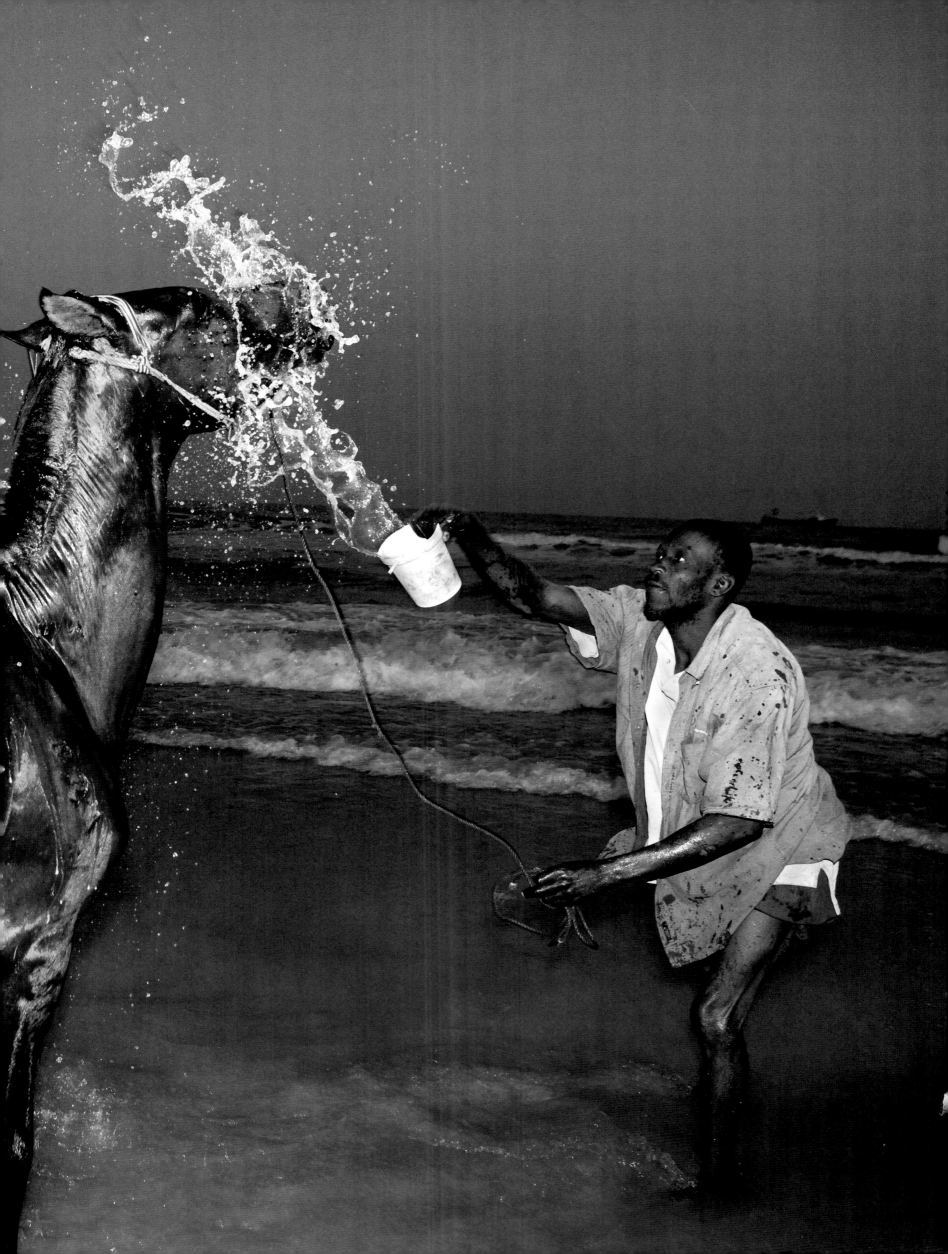

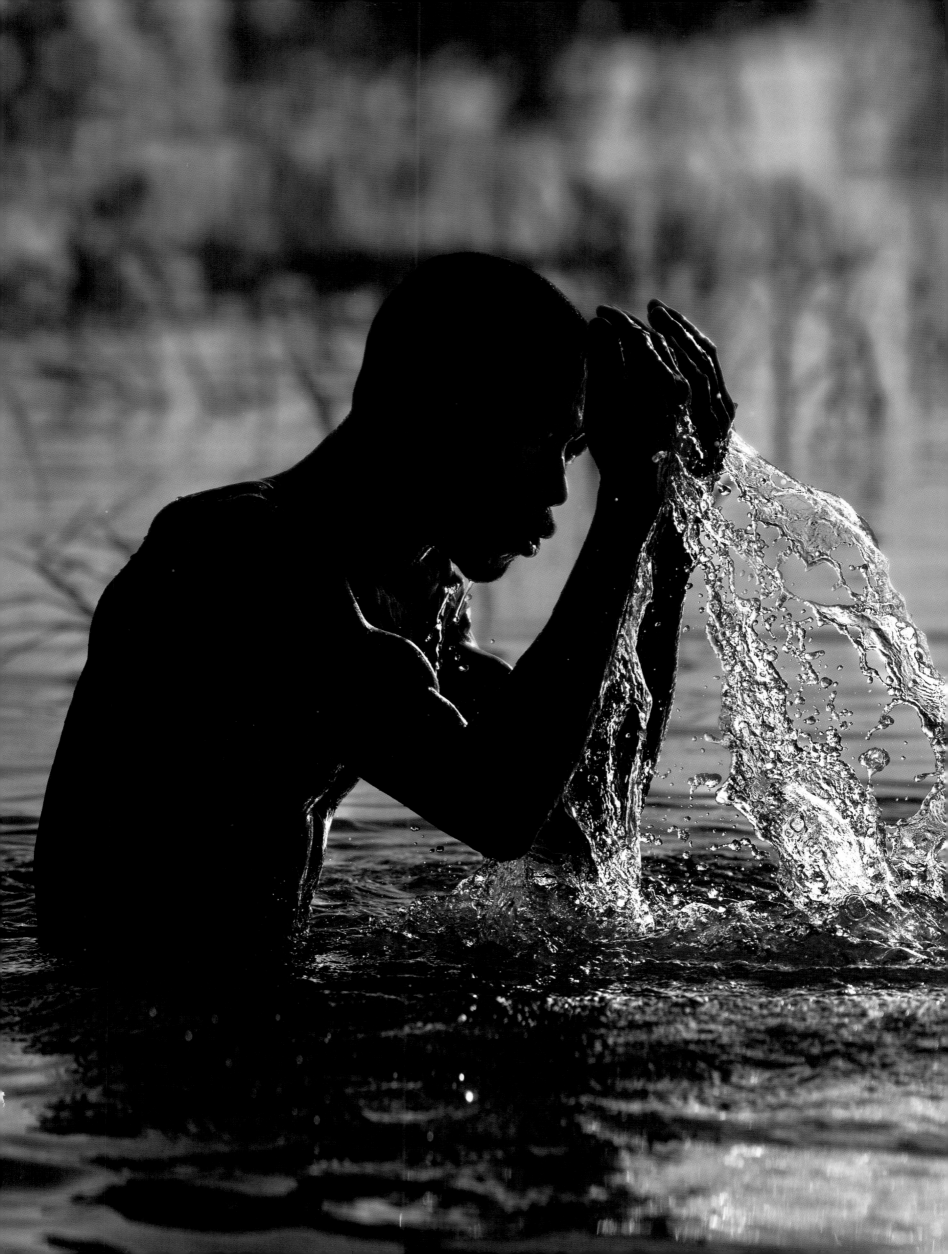

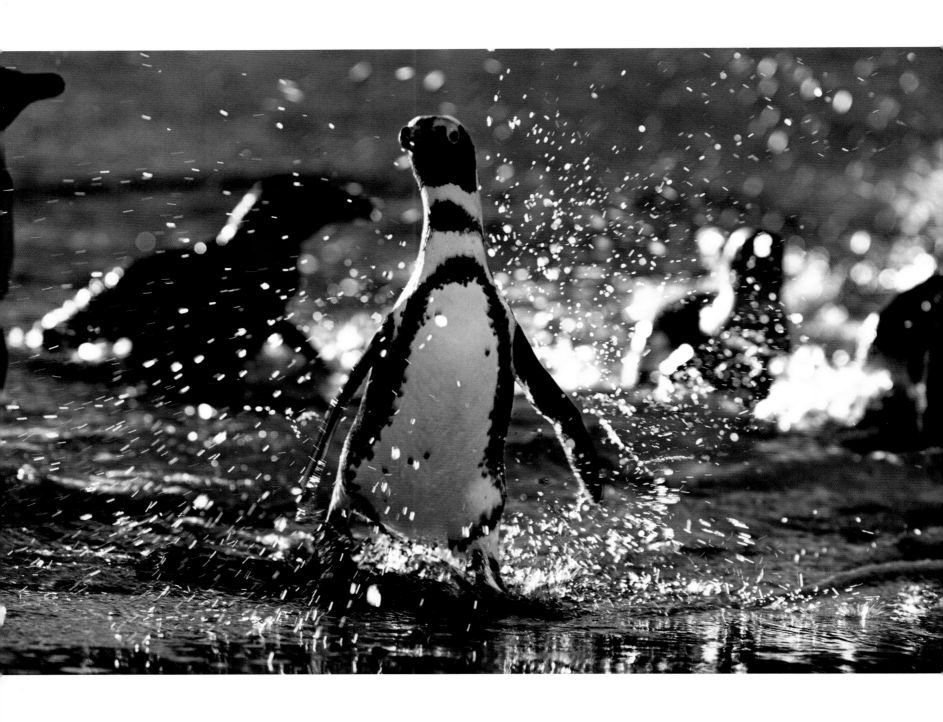

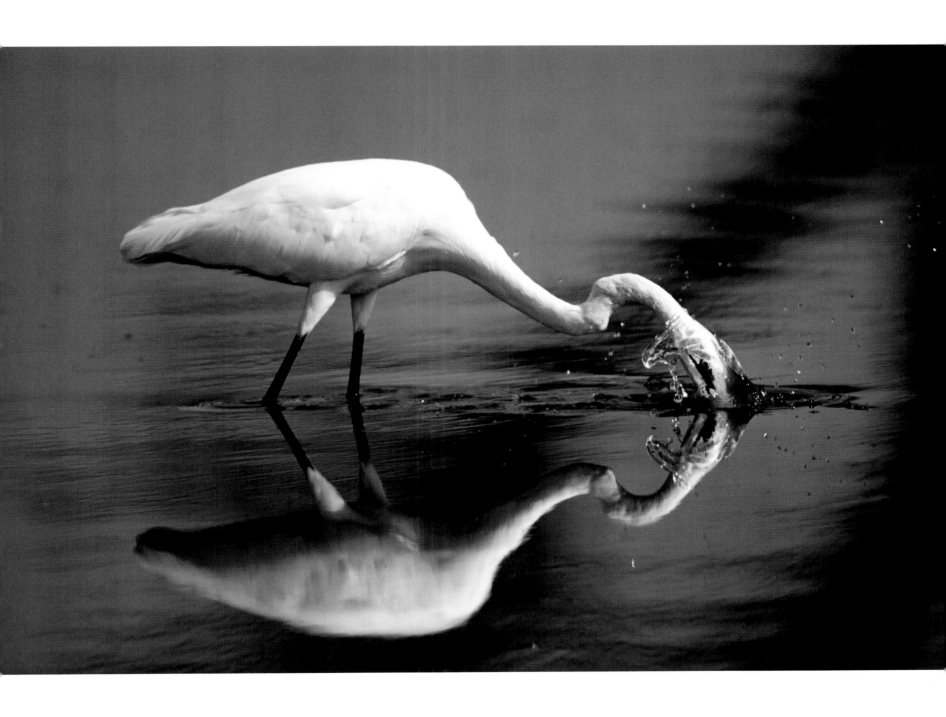

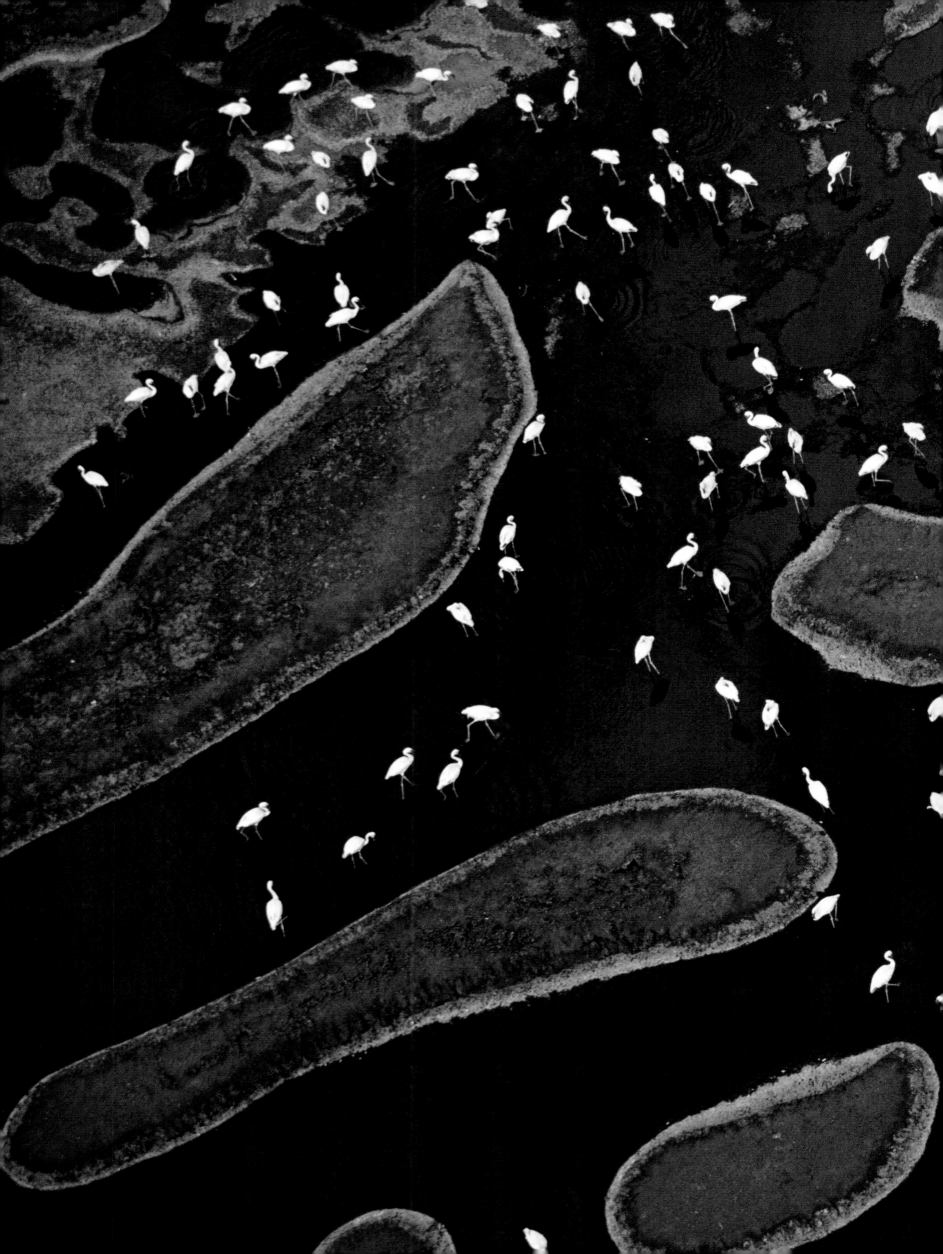

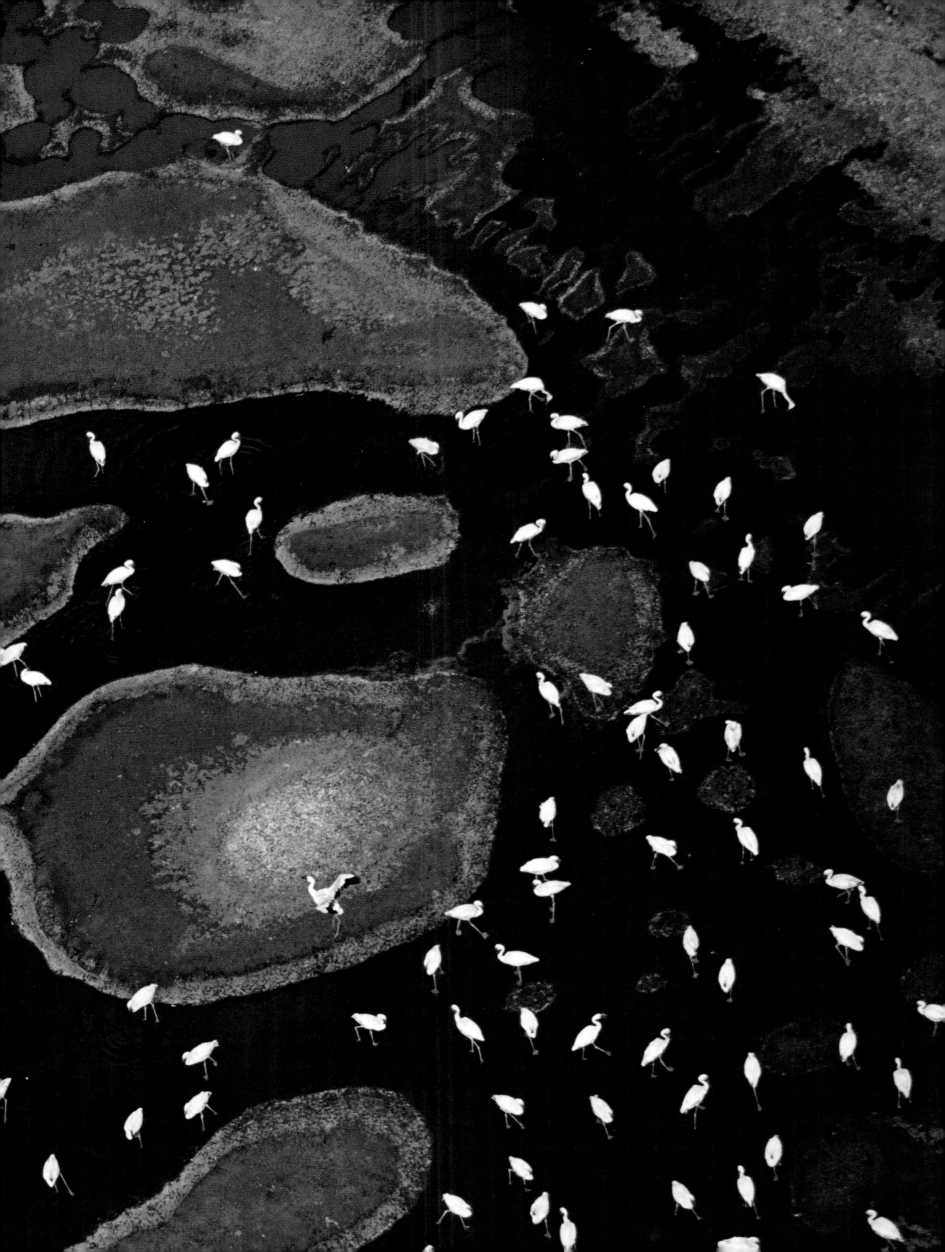

Through the blackness of night walks the leopard; a lonely hunter, maestro of stealth. The hare does not hear her move in the tall dark grass, nor does he see her pounce. He will never know what swept his life away. Soon the leopard is on her way again, gliding through thorny shrubs which brush her lightly. A thick curtain of clouds is drawn above, blackening the darkness, rendering her exquisite coat and gleaming eyes invisible. Black on black, her beauty lives on, if only in memory. No dark clouds can steal her splendour or erase her from my mind.

The wind blows, parting the clouds to expose patches of stars which subtly reveal her faint silhouette. The leopard walks alone in the night's vast landscape, with infinite stars for company.

How many stories unfold beneath the stars, unwitnessed, untold? We ride through South Africa's bushland, searching for our own personal stories. With our poor night vision, we must rely on a thirsty spotlight which will soon drain the faulty battery of our Land Rover. The beam of light points haphazardly into the void, searching for its own reflection in an animal's eye. Crazed insects rush to fill the yellow beam, dancing before dying on the hot glass. Soon the light flickers and dies, consuming the battery's last pulse of energy. We call on the radio for help, and our eyes become accustomed to the dark. The moon has not yet risen, stars punch through the darkness and the white mists of the Milky Way gently paint themselves across the sky.

Far from the distractions of artificially lit city skylines, we let time unwrap the night. Meteors fall like quick sketches in white chalk. Stars pulse and planets glow in a sky from which a veil has been lifted. Between the stars lies a blackness deeper and further and blacker than I have ever seen, yet I know it to be filled with substance. When the Hubble telescope was pointed at a distant spot that appeared to the naked eye the size of a speck of dust, a ten-day exposure revealed an image containing myriads of galaxies and stars.

I was a small child on the night that Yuri Gagarin, the first cosmonaut, orbited the earth. To celebrate, I was taken on my own special journey into space. With all the excitement of interplanetary

LEFT
Elephants, Chobe, Botswana.

OPPOSITE
Leopard, Masai Mara, Kenya.

306

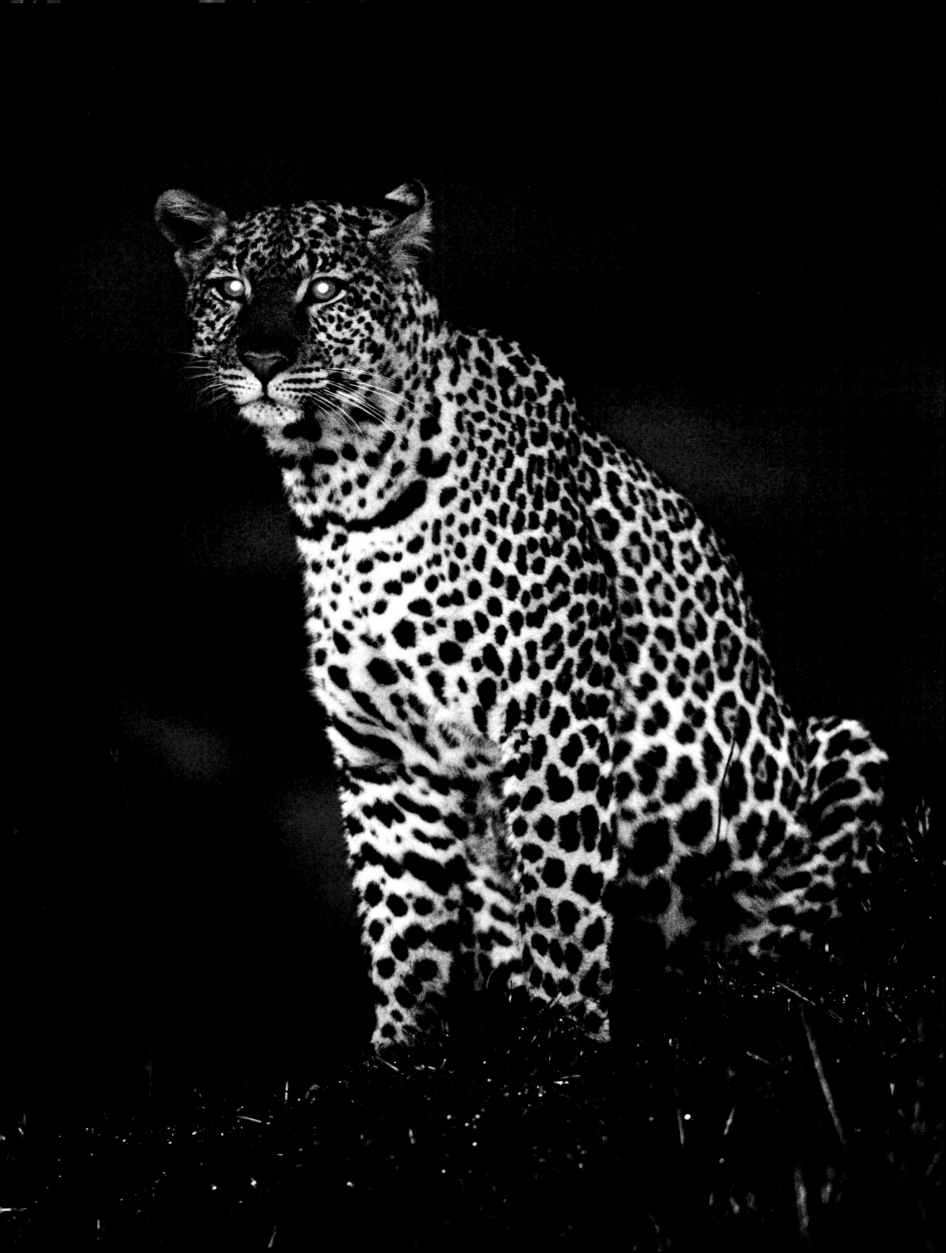

travel that only a child's imagination can bring, we rode up to the summit of Table Mountain in the cable car and gazed at the world below us. Evenings were spent scanning the sky, searching for those first rare satellites. Now the night is filled with many, each moving silently across the heavens before disappearing into its own individual sunset. The International Space Station glows brightly by comparison, doubtless the first of a new generation of space litter that will fill the skies of my children's children.

Sitting on the roof of the Land Rover under the night sky, issues such as habitat encroachment and climate change take on an enhanced significance. Whenever I fly over Africa's remote regions, I see scattered fires and clusters of electric lights filling a blackness which once belonged exclusively to the night. Like passing storms, civilizations stir everything in their paths before ultimately dying, leaving clues in their ruins for future archaeologists to ponder. All cities will ultimately fade, faster than stars, and let the light of the night back in.

* * *

The waterhole is the hub of activity, attractive and dangerous. We are in Namibia's Etosha National Park where elephants come to drink and bathe at the end of the day. They are swathed in the changing colours of sunset; colours which peak in saturation, then gently transform into the monochrome shades of night.

The elephants drink and frolic until darkness falls, while all around them creatures of the night wait cautiously in the shadows. When the elephants finally move away, giraffes tread delicately down towards the water. They are at their most vulnerable; their movement inhibited by trepidation. They take what seems like an eternity to reach the water, moving with all the urgency of stalactites. Their brief visit is soon interrupted by the approaching silhouette of a rhinoceros, and they rush back into the shadows. From afar thirsty animals watch and wait in the dark, each carefully choosing the right time to follow the many different footprints down to the water. When the lion reaches the water, he drinks alone.

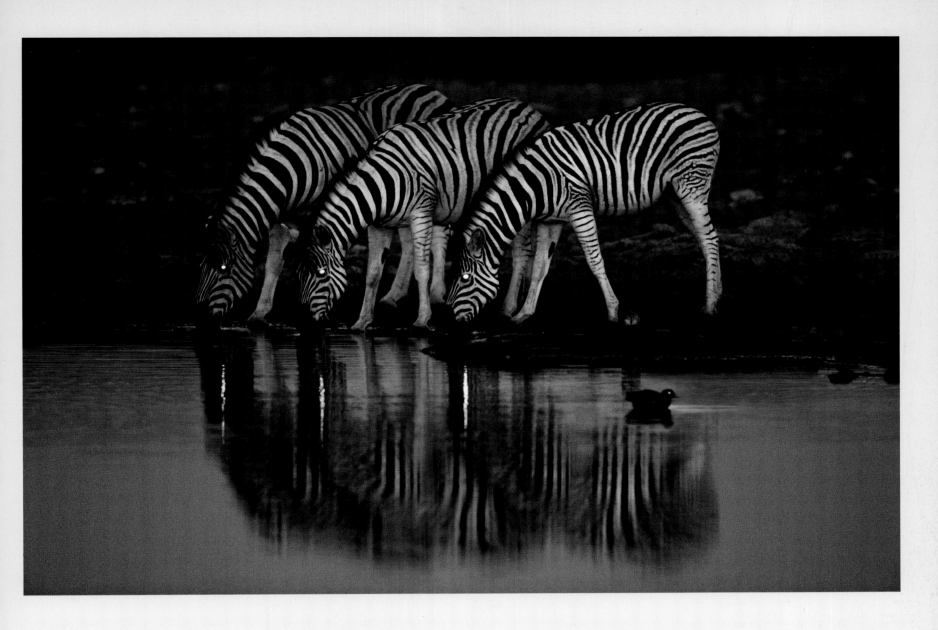

We have searched by day for the elusive chameleon; a master of disguise who imitates the patterns around him, blending invisibly into his surroundings. Here in the darkness we find him easily, serendipitously, a fluorescent green glow in the beam of our spotlight.

Through a hole in my tent I chance upon a star, a tiny pinprick of light peering in from the void. Like a loving smile, it is no more than a fleeting twinkle, no less than a universe overflowing with life. The imprint lingers into the glaring brightness of day, long after the sun has consumed all the light of the night.

I am alone in a hut in the Kalahari, protected from the night by four hot walls and windows covered with a mosquito mesh. Thick heat permeates the air, radiating oppressively from the masonry. Thunder rolls overhead, flashing and crashing on its belligerent journey across the plains. In its trail it releases swarms of flying insects – armies in all colours, shapes and sizes. Attracted by the light in my room, they pound against the mesh, desperate to invade my world. The drone is deafening and grows louder with time. I turn out the light for a moment, the pounding stops and they go away. When the light comes back, kamikaze insects once more hurl themselves furiously against the mesh.

Switching the light off and on, I discover I can control the drumming sound. Suddenly the insects pour into the room and I am bombarded by a hoard of flying missiles. I rush through the clattering kaleidoscope towards the mesh, where I find their point of entry – a small hole, below which lies a curled sticking plaster, the remains of a previous tenant's rushed repair job. I realize that I must now share my world with a multitude of hostile creatures and their incessant noise. It is only when the light is turned off, and stays off, and I open the window, that they drift out towards the moonlight. Only in darkness can I find peace from these demons.

Many years and trips to Africa have gone by since that night with the insects and I am now back in a tent in Kenya, cleaning cameras and lenses. It's a nightly ritual – an important part of a photographer's routine. I think about the day's pictures, about how waiting in the heat is even more exhausting than the brief moments of action. I turn out the light and drift off, my night torch at my side and my cameras primed and loaded for tomorrow. All too soon the cacophony of the night wakes me and I lie on my back, listening. Suddenly my nerves are shattered by the primeval howl of an enraged hippopotamus in full battle, behind the canvas of my tent. Another day is emerging in Africa.

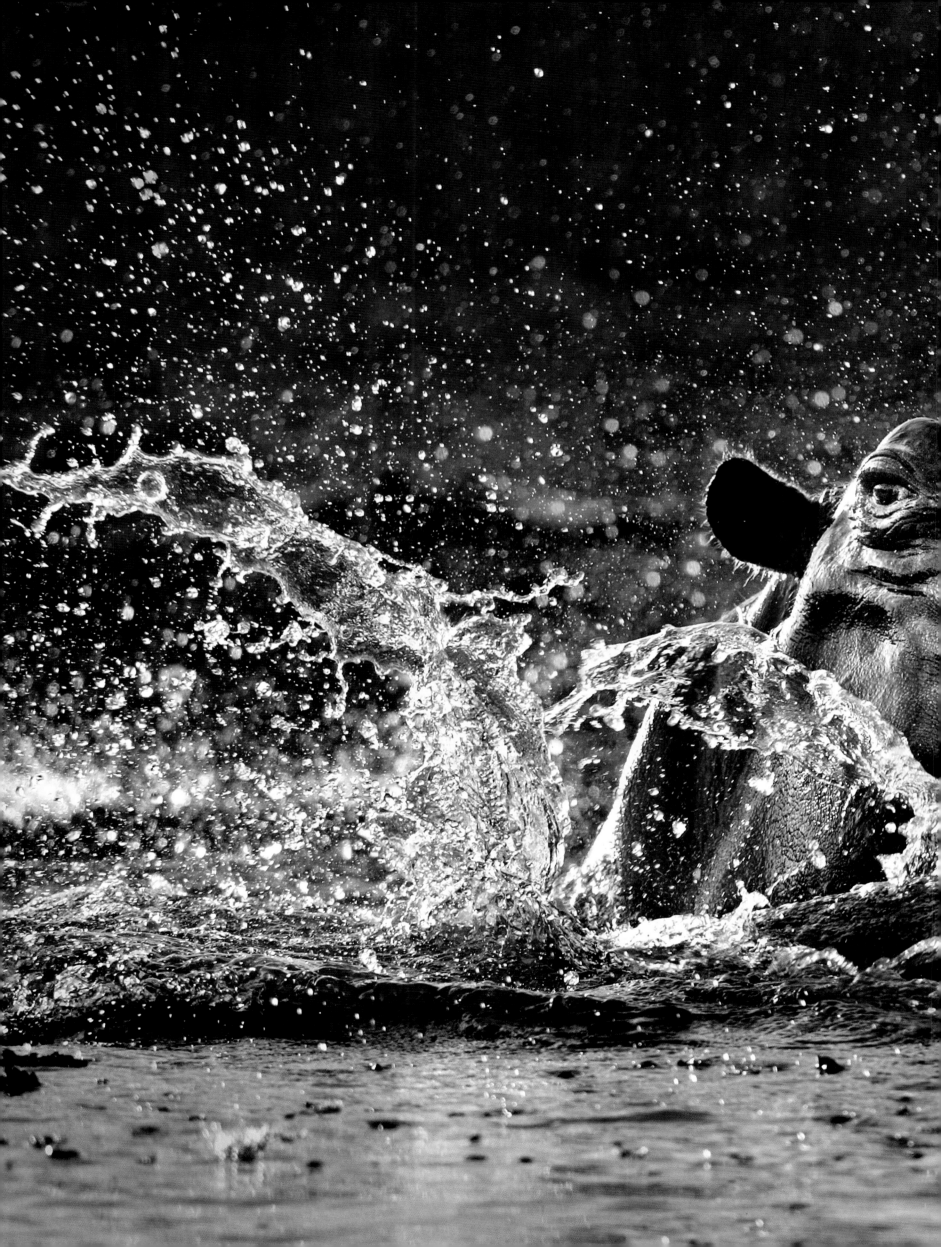

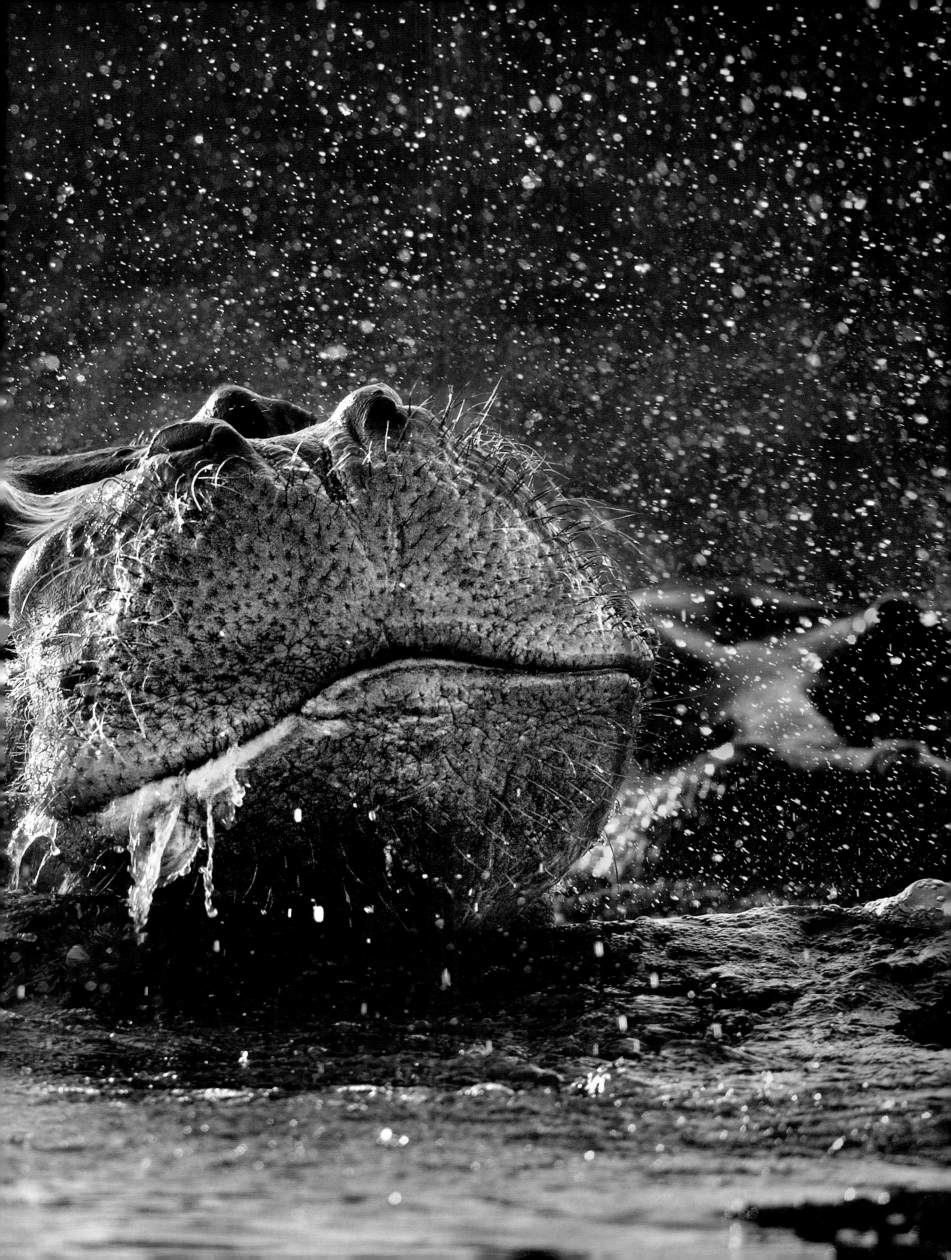

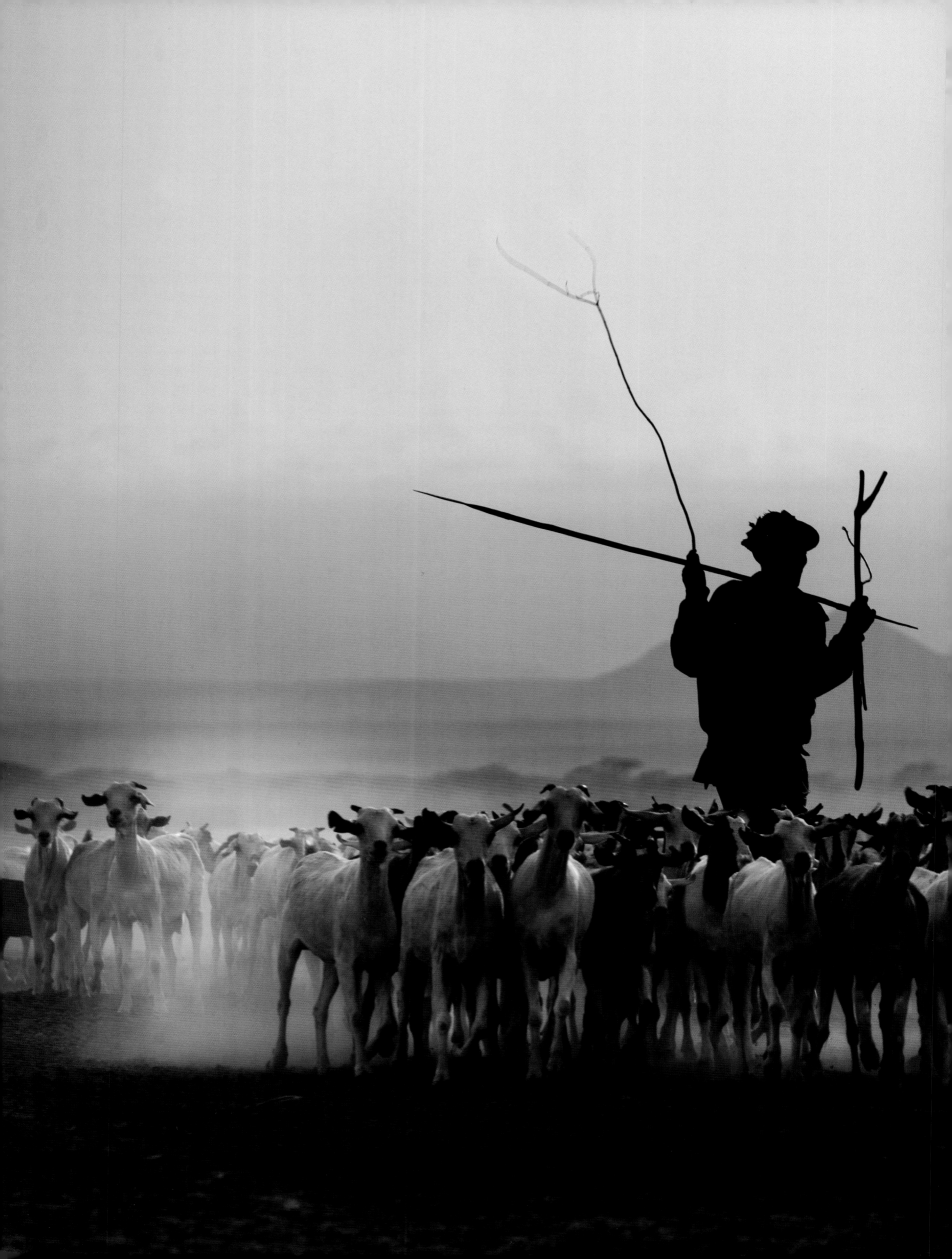

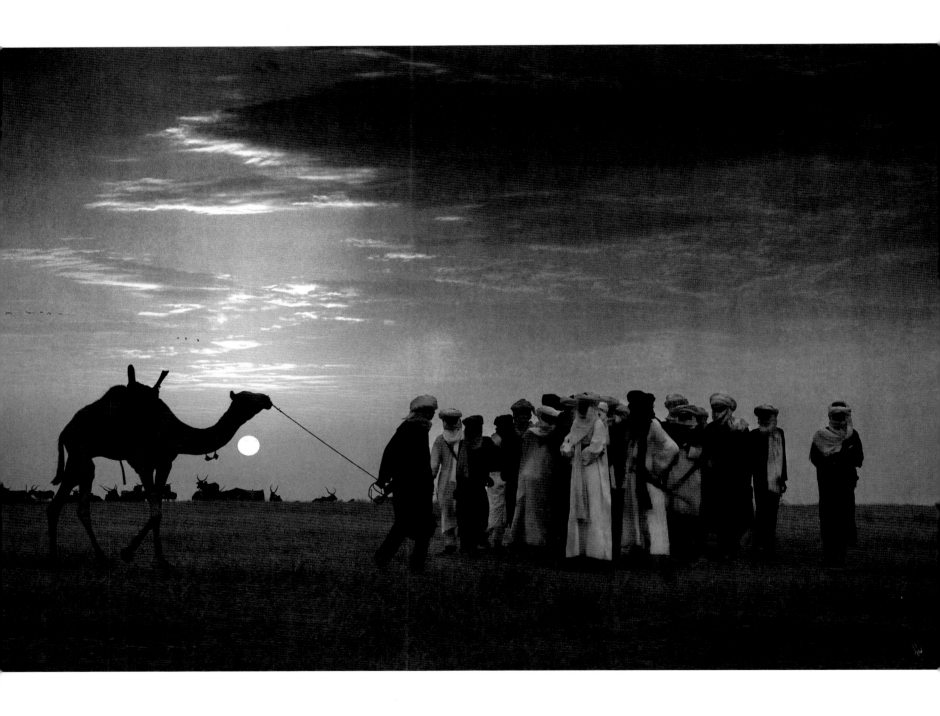

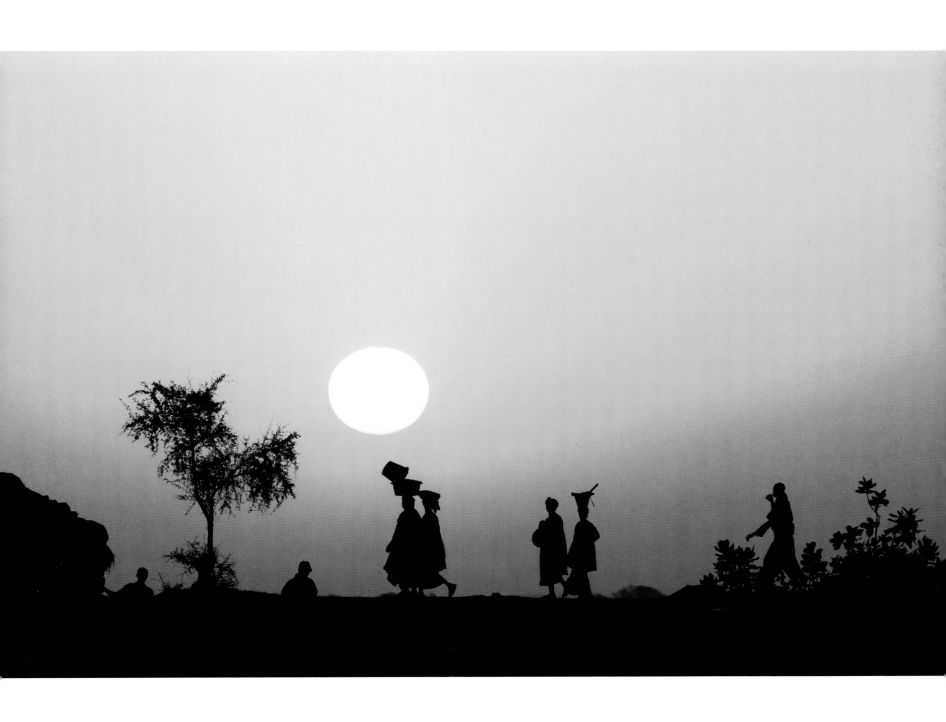

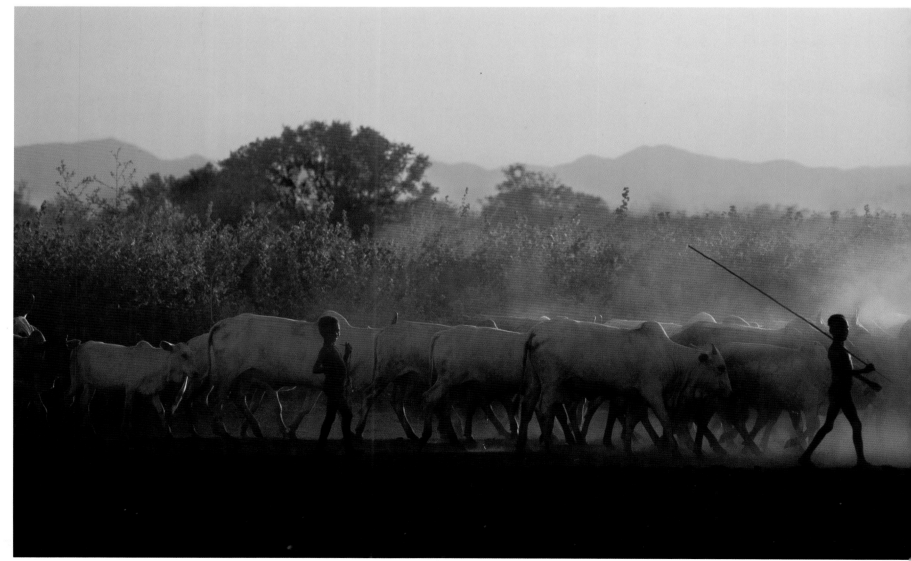

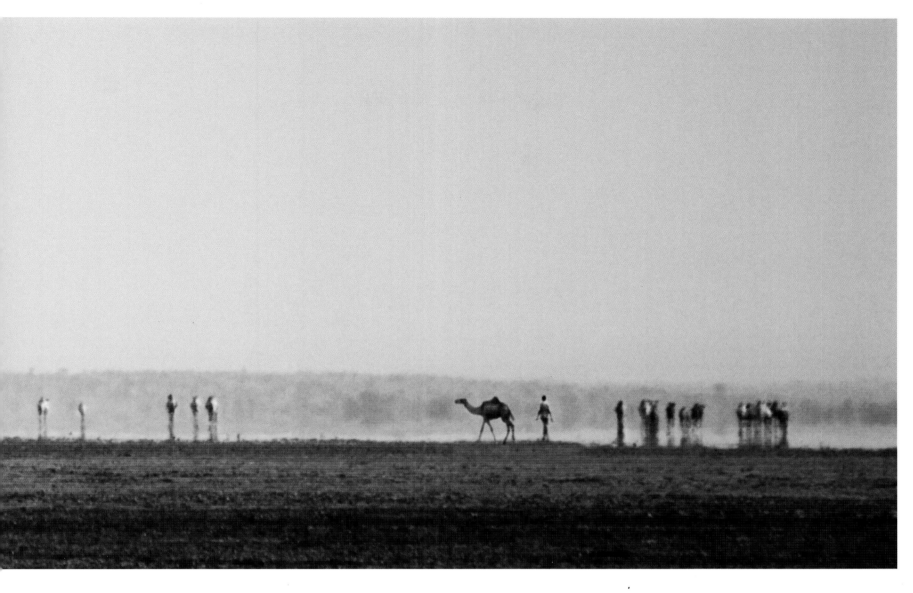

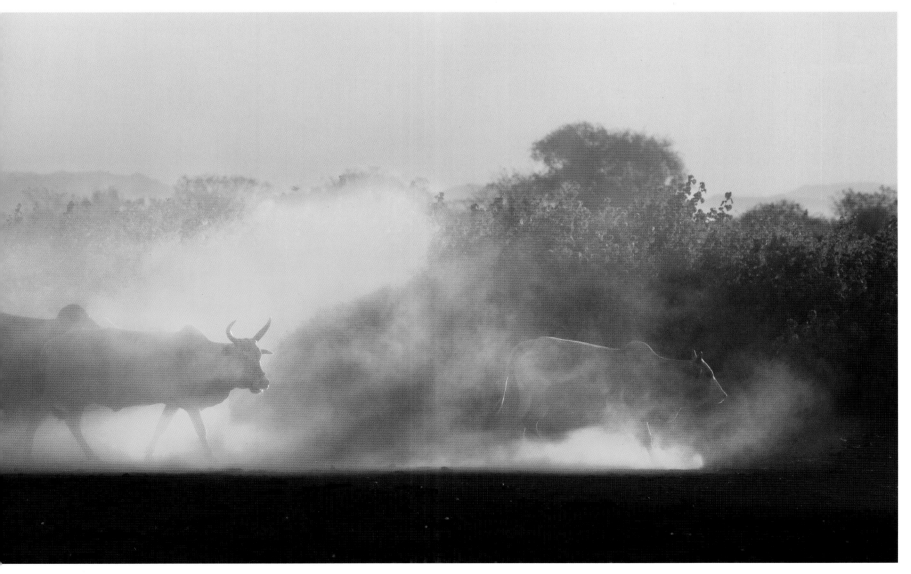

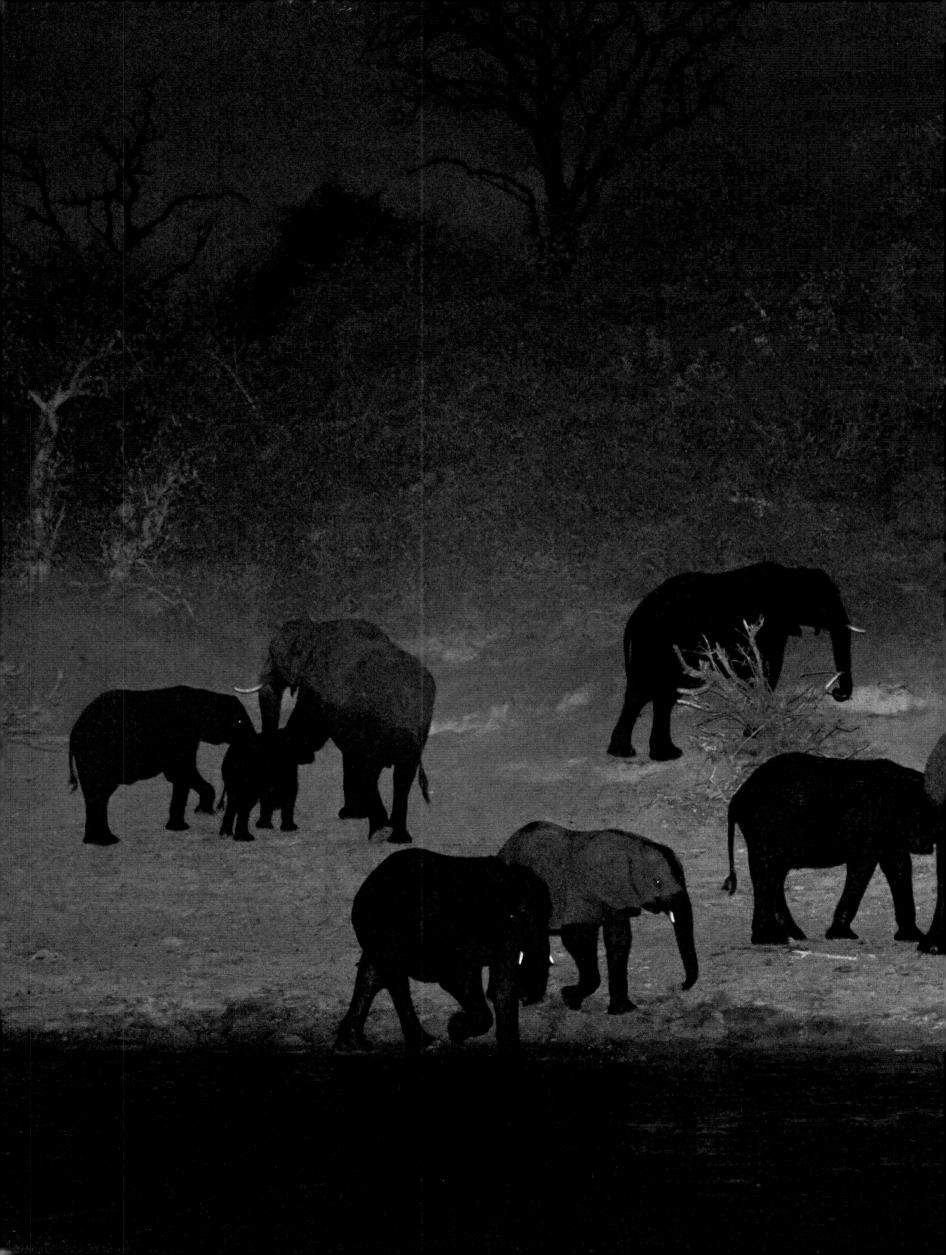

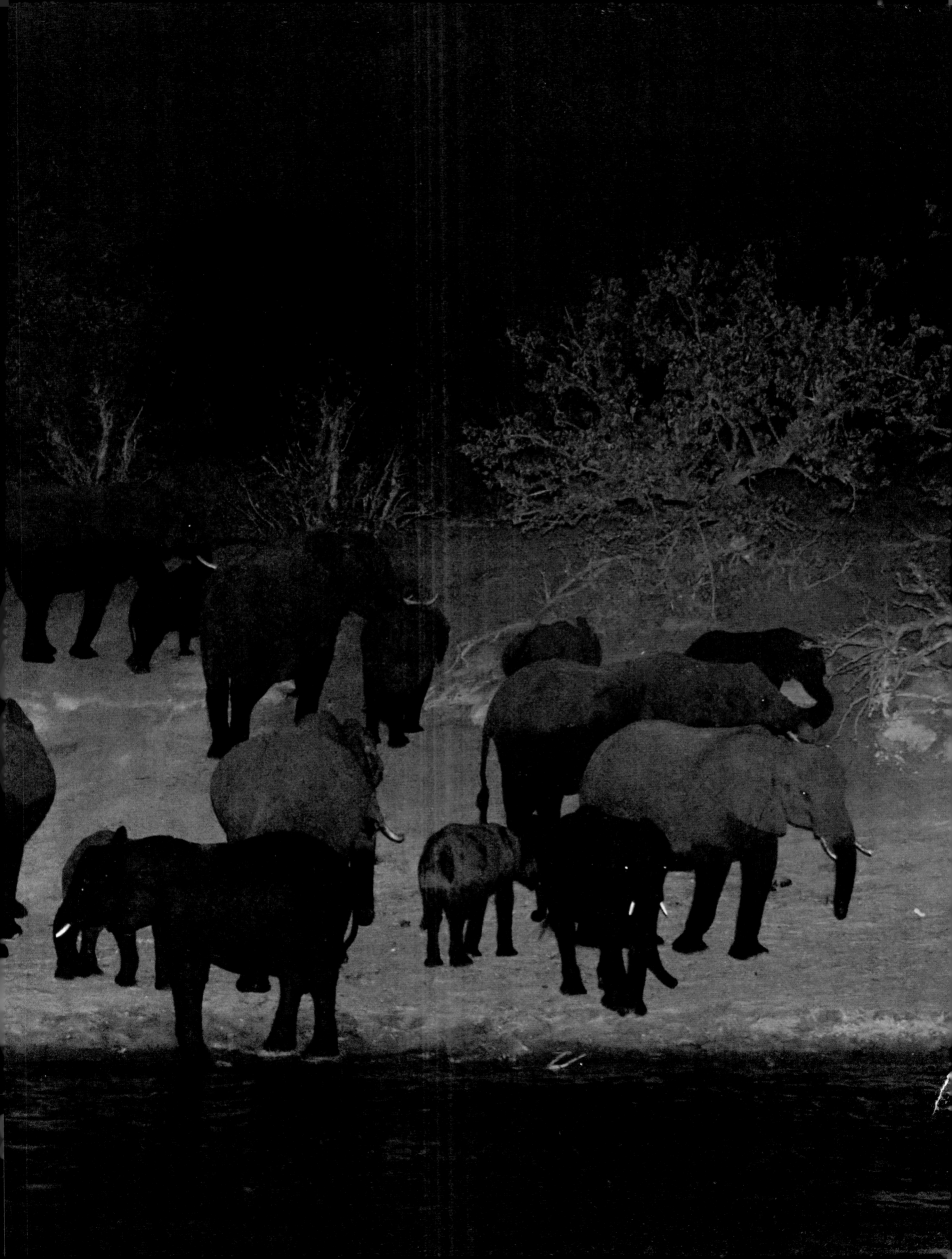

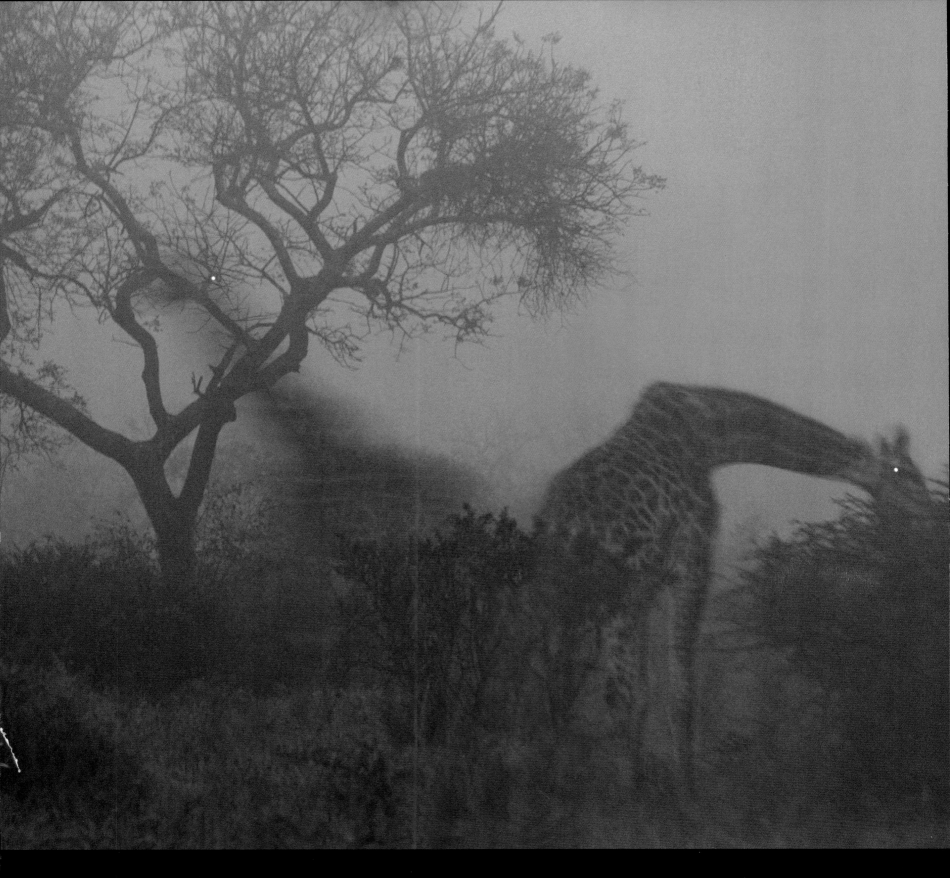

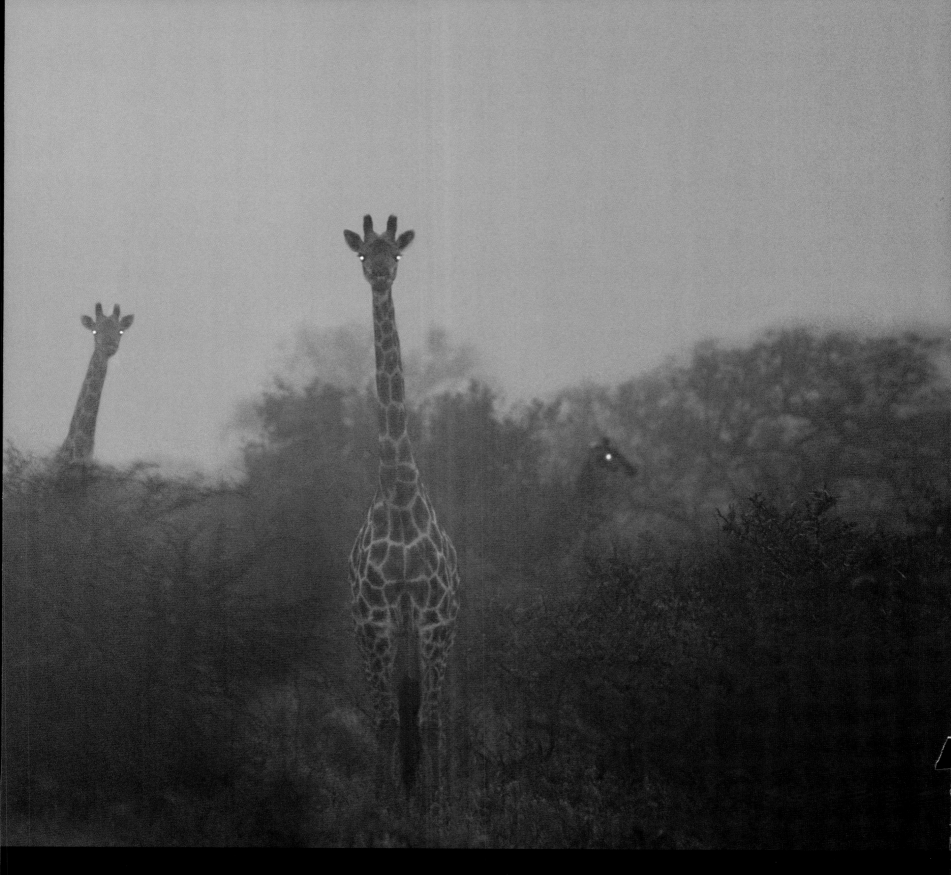

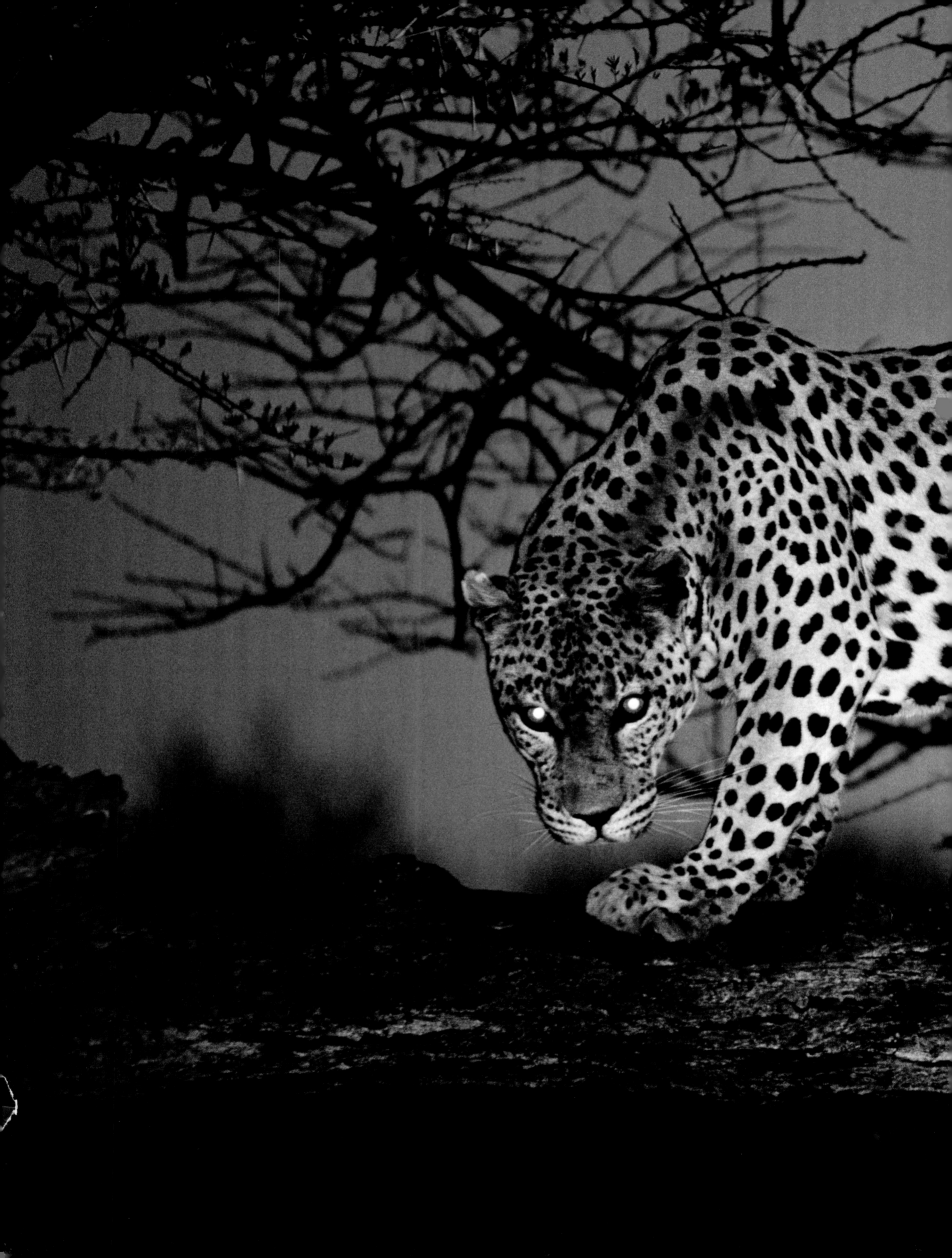

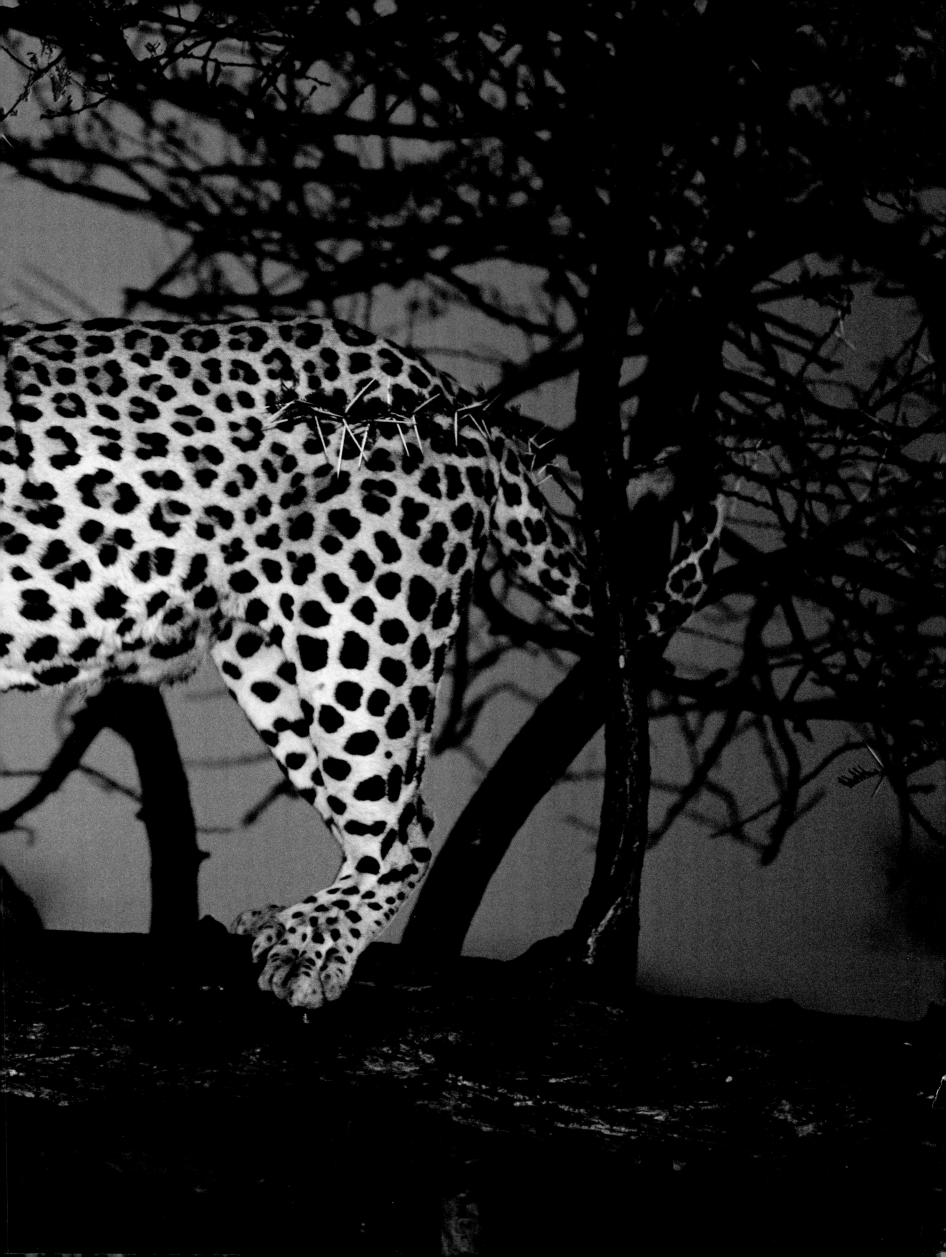

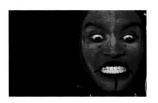

Wodaabe youth, Gerewol Festival, Niger
Face painted with striking red ochre, eyes and lips outlined with black kohl, a young Wodaabe man grimaces and contorts his face in order to show off the whites of his eyes and his exceptionally white teeth. Performed at the *Cure Salée*, also known as the Gerewol or Festival of the Nomads, the *Yaake* is an intensely competitive dance in which young men display their charm, defined by the number and intensity of different facial expressions they can generate. Crossed eyes, raised eyebrows, stretched lips and puffed cheeks all play a role.

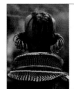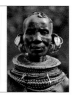

PAGES 14–15
Turkana woman, Northern Kenya
Coloured glass beads first reached Africa in the 1500s from central Europe as objects of trade, and elaborate beaded jewelry is now a rich tradition in African culture. Turkana women adorn themselves with coiled necklaces which form a high collar, covering their necks from the chest right up to the chin, as protection against evil. Mature women also wear earrings and leaf-shaped ear ornaments, carved from copper or aluminium.

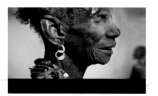

PAGES 16–17
Elderly Dassanech woman, Omo Valley, Ethiopia
An elderly Dassanech woman wears the metal ring-pull from a can as an earring. In Dassanech society women rule domestically, the most senior woman elder being in charge of her village. Women are responsible for constructing the family hut and moving it during migrations, and they claim its right-hand side and the outside porch as their own. A typical stick and grass hut contains a hearth, a sleeping area with animal skins to lie on, and a box-like store.

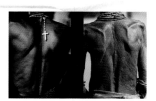

PAGES 18–19
Dassanech man and woman, Omo Valley, Ethiopia
On the left is the back of a young man, on the right that of an elderly woman. The Dassanech are divided into a number of different clans, each of which is linked to a particular territory, and has its own identity and customs. Members of the same clan may not marry, or even dance with each other. For a man, the biggest ceremony in his life is the blessing of his daughter for fertility and marriage, after which he becomes an elder.

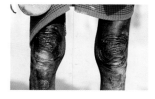

PAGES 20–21
Elderly Karo man, Omo Valley, Ethiopia
Dried clay stains the knees of a Karo man, contrasting with the bright red of his waist cloth. Comprising no more than about one thousand members, the Karo are a small tribe under constant threat from their neighbours, who have more rifles and greater numbers of warriors. They recognize the importance of maintaining peaceful co-existence with surrounding tribes if they are to survive as a unique culture.

PAGES 22–23
Dassanech children dance, Omo Valley, Ethiopia
Stirring the dust, children gather to dance. The Dassanech inhabit the driest and hottest part of the Omo Delta, where the Omo River enters Lake Turkana. Desert lies to the west and southwest and grazing is limited due to frequent drought, so survival in this arid land is precarious. Lake Turkana, one of the largest desert lakes in the world, is shrinking rapidly due to high levels of evaporation in the searing heat, and reduced water flow from the rivers that feed it.

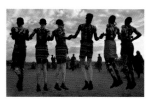

PAGES 24–25
Karo dancers, Omo Valley, Ethiopia
A group of dancers leap into the air in unison. The Karo share the tradition of the *Bula* or bull-jumping with the Hamar tribe, an initiation rite whereby a young man must leap and run across the backs of a row of up to fifteen cattle, smeared with dung to make them slippery. After successfully repeating the run four to six times without falling, he becomes eligible to marry, and will be allowed to appear publicly with the elders. A celebratory dance is held at the end of the ceremony.

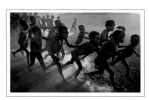

PAGES 26–27
Dassanech children, Omo Valley, Ethiopia
Children play, sing and dance in the dust of the late afternoon. Despite the harshness of life in the region, children exhibit a jubilant exuberance. Once they reach puberty both boys and girls will be circumcised, and this ceremony into adulthood will mark the end of their joyful dances together. Among the Dassanech, the circumcision ritual is performed on girls as young as ten or twelve, and they often marry shortly afterwards.

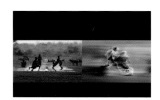

PAGES 28–29
Afar boys play football, Bilen, Ethiopia
A group of boys play a casual game of football on an uneven, dusty field near Bilen. Water is scarce in this region, and during the dry season most Afar people live alongside the lowland watering holes, moving to higher ground when the rains come to avoid flooding and mosquitos.

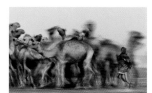

PAGES 30–31
Gabbra herder with camels, Chalbi desert, Northern Kenya
Camels are kept well away from Gabbra settlements, as these animals are unpredictable and destructive to vegetation. Men aged from about nineteen to thirty-three live in smaller satellite camps where they tend the herds. This practice typically delays the average age of marriage to the early thirties for both sexes, as the young men are excluded from political and social activities in the main camp.

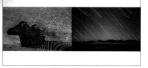

PAGES 32–33
Zebras, Etosha National Park, Namibia (left)
Zebras splash in an Etosha waterhole. Covering an area of more than 8,000 square miles (22,000 square km), Etosha is dominated by a vast dusty mineral pan, a lake which dried up thousands of years ago. Perennial springs around the edges of the pan attract large concentrations of wildlife.

Night sky, Namibia (right)
A long exposure records the trails of the stars as the earth slowly rotates. Clear skies and minimal light pollution in the wild areas of Africa make star-gazing an unforgettable experience.

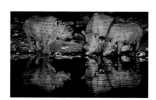

PAGES 34–35
Black rhinoceros, Etosha National Park, Namibia
Three black rhinos drink in the stillness of the African night, faint ripples on the water reflected as stripes on their grey bodies. Thick-skinned and short-sighted, black rhinos are highly endangered due to rampant poaching and the illegal trade in their horn, which is prized by some cultures for dagger handles and traditional medicine. Rhino horn consists of compressed keratin fibres, the same material that forms finger nails and hooves.

PAGES 36–37
Suri boy with painted body, Omo Valley, Ethiopia
A young Suri boy is painted with vertical stripes. In a society where clothing is minimal, body decoration is an important form of expression, and natural chalk deposits from the riverbank are often used to create the designs. Men tend to be the better artists, and paint each other, but also paint the children and sometimes young women. Body decorations are designed to attract the opposite sex, but are also used by Suri men to intimidate opponents during competitions.

PAGES 38–39
Scars on Hamar woman, Omo Valley, Ethiopia (left)
Women of the Hamar tribe are traditionally whipped during the bull-jumping ceremony which marks the coming of age for young men. Hamar women bear these scars with pride, as they are regarded as proof of their devotion to their kinsmen.

Hippopotamus skin, Kenya (right)
This hippopotamus gained its scars from the fierce territorial fights which take place between males, who use their massive jaws and incisors to inflict damage on their opponents.

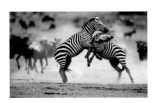

PAGES 40–41

Zebras, Masai Mara, Kenya

As with other species of wild horse, plains zebra live in well-defined social groups, consisting of a dominant stallion and several mares with their foals. A hierarchy exists among the mares, with the stallion's first mate at the top and the most recently acquired filly at the bottom. The stallion jealously protects his females from other males, kicking and biting any interloper.

PAGES 42–43

Karo women, Omo Valley, Ethiopia

Although the Karo are the smallest and poorest of the Omo Valley tribes, decorative jewelry is widely worn as an expression of prosperity. Women adorn their bodies with shells, beads, metal bangles, arm bands, and even the caps from pens. The strings of cowry shells draped around the necks of these young girls are symbols of fertility.

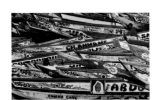

PAGES 44–45

Fishing boats, Mbour, Senegal

Brightly painted wooden fishing boats on the beach at Mbour in Senegal. The coastal economy is heavily dependent on fishing, and declining fish stocks are resulting in increased economic deprivation. Scores of people regularly risk their lives in such boats in desperate attempts to reach the Canary Islands and the chance of a better life in Europe. Unknown numbers have drowned, as the small open boats are frequently powered by inadequate motors and are dangerously overcrowded.

PAGES 46–47

Souk, Marrakech, Morocco

A shop in the souk adjacent to Marrakech's Djemaa el Fna square displays a colourful selection of shoes. A traditional North African bazaar, the souk is located in the myriad of narrow streets and alleys of the medina, or old city. Artisans such as sculptors, leather workers, weavers, dyers, carpenters, metal workers and jewellers practise their crafts in workshops, while sacks overflowing with chick peas, almonds and nuts jostle with baskets of sweet cakes, olives and dates.

PAGES 48–49

Scrap vehicles, Johannesburg, South Africa (left)

Old and wrecked cars are parked in rows before being processed by a scrap metal merchant. Heavy and congested traffic has become increasingly commonplace as Johannesburg expands.

Skyscraper, Johannesburg, South Africa (right)

One of the tallest residential skyscrapers in the southern hemisphere, this cylindrical tower block in the central suburb of Hillbrow has fifty-four floors. Once a sought-after exclusive address, it was later occupied by gangs, though recently improved security is again allowing for a higher standard of occupancy.

PAGES 50–51

Scarification, Omo Valley, Ethiopia

Scarification is practised widely by the tribes of the Omo Valley, as seen here on the torso of a Dassanech man (left) and Karo woman (right). For women the scars enhance beauty, but for men they convey important symbolism. The scarification of a man's chest indicates that he has killed enemies from another tribe, or that he has successfully hunted a large animal, and is therefore highly respected in his community. Lines of scars are representative of numbers killed, and some men have their entire chest scarified.

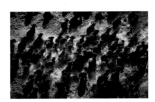

PAGES 52–53

Buffalo, Okavango, Botswana

A large herd of Cape buffalo runs through grassy swampland in the Okavango Delta. Buffalo herds can number several hundred, mostly females and their offspring, and these are very protective towards individual members. Males spend much of their time in bachelor groups, though older bulls often prefer to be on their own. Adult buffalo are capable of defending themselves against predators such as lions, occasionally even killing them.

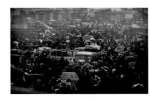

PAGES 54–55

Majengo district, Nairobi, Kenya

Crowds of people and vehicles force their way through a teeming street market in the Majengo district of Nairobi. Makeshift shops and stalls line the thoroughfare, where every vendor has a product to offer. Their noisy, competitive appeals fill the air that is heavy with fumes and dust. Despite lack of proper sewerage, schools or hospitals, slums such as Majengo are home to over half of Nairobi's nearly three million inhabitants.

PAGES 56–57

Shanty town, Johannesburg, South Africa

Aerial view of a shanty town or *imijondolo* on the outskirts of Johannesburg, South Africa's largest city. Such settlements are usually built without formal urban planning, accommodating residents who have to endure poor sanitation, little or no electricity, and very basic services. Housing a large proportion of the city's working population, the shanty towns are often very overcrowded.

PAGES 58–59

Red-billed queleas, Savute, Botswana (left)

A huge flock of queleas descends on a waterhole. Such flocks may contain hundreds of thousands of birds. They can do serious damage to cereal crops, and are considered by agriculturalists to be a pest.

Fish eagle, Victoria Falls, Zimbabwe (right)

A fish eagle glides above the spectacular Victoria Falls, Africa's largest waterfall. Known by the locals as *Mosi-oa-Tunya*, 'the smoke that thunders', the falls are situated on the Zambezi River, which forms the border between Zambia and Zimbabwe.

PAGES 60–61

Worshipper, Lalibela, Ethiopia

Robed from head to toe in white, a worshipper studies his Bible with silent concentration. Bet Giorgis, dedicated to St George, the patron saint of Ethiopia, is the most remarkable of Lalibela's Ethiopian Orthodox sunken churches. Dating from the twelfth century, this ancient place of Christian worship is hewn from volcanic rock in the shape of a cross. Set in a deep pit with perpendicular walls, it can only be entered via a hidden tunnel carved in the stone.

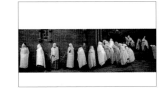

PAGES 62–63

Pilgrims, Lalibela, Ethiopia

White-robed pilgrims pray against ancient walls in Lalibela. This isolated town in northern Ethiopia is a centre of pilgrimage for members of the Ethiopian Orthodox Church. Situated high up in the mountains at an altitude of 8,800 feet (2,700 metres), the medieval monastic complex consists of eleven rock-hewn sunken churches. A bewildering labyrinth of shaded tunnels and narrow passageways, grottos and crypts adds to the mystique of this subterranean world.

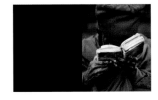

PAGE 65

Pilgrim, Lalibela, Ethiopia

A pilgrim reads from a well-worn prayer book near the church of Bet Giorgis. The most popular prayers among the Christian Orthodox of Ethiopia are the Psalms of David. Ethiopians are the oldest followers of Christianity on the continent of Africa. Many centuries of isolation from the rest of the Christian world have led the Ethiopian Church to develop its own distinctive interpretations of Christianity.

PAGES 66–67

Samburu boy, Mount Nyiru, Kenya

A Samburu boy waits apprehensively outside his mother's hut moments before being circumcised. As part of the traditional circumcision ceremony, he will be held down by senior members of the tribe while an outsider from a different tribe circumcises him. He is not allowed to flinch or show pain, or he will bring dishonour to his family. The boy will then give away his dark clothes and adorn himself in traditional red cloth to begin learning the ways of the warriors.

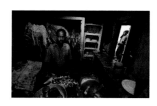

PAGES 68–69
Butcher, Lalibela, Ethiopia
A butcher in the Ethiopian town of Lalibela cuts and prepares meat in his shop. Ethiopia is well-known for its distinctive cuisine, which is often meat-based, although among certain sectors of the population the eating of pork and shellfish is forbidden. Throughout Ethiopia the needs of locals are met by small individual shopkeepers who serve the community.

PAGES 70–71
Man walking along street, Harar, Ethiopia
Bent under the weight of the load on his back, a man walks up one of the many hills in Harar. This ancient walled city is considered to be the fourth holy city of Islam after Mecca, Medina and Jerusalem. Founded in the tenth century, it has almost ninety mosques and over a hundred shrines. The combination of Islamic and African traditions of architecture and design give the city a unique character.

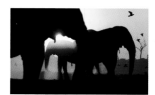

PAGES 78–79
Elephants, Savute, Botswana
Elephants, the world's largest land mammal, once lived over most of Africa. Now they are found only south of the Sahara, where their numbers were devastated by systematic poaching in the mid-to-late twentieth century. The international ban on the trade of ivory, though flouted in some countries, has aided their recovery, and elephants are now staging a good recovery in many protected areas, such as the Savute region in northern Botswana.

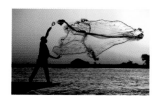

PAGES 80–81
Bozo fisherman casts his net, Mopti, Mali
In Mali, the River Niger flattens out into an inland delta known as the Pondo, which floods annually. The Bozo tribe, its oldest inhabitants, are highly skilled fishermen. They stand on the end of long, narrow pirogues to cast their nets into the water. Bozo villages are built on higher ground which forms islands when the river floods, but men spend months at a time away from their families, camping in temporary straw huts as they follow the fish that migrate along the river.

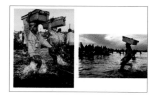

PAGES 82–83
Traders bring in the catch, Joal, Senegal
Competing to collect the best fish of the day, traders run into the water, crates carried on their heads, to transport the catch between the boats and the shore. Fish is a staple of the local diet, and the local economy depends on it. At the same time, much of the catch is exported, either fresh or processed, providing an important source of foreign income for Senegal. Canned tuna is a major export.

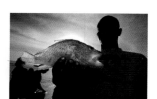

PAGES 84–85
Fish trader, Dakar, Senegal
A trader holds up a fish for inspection on the beach at Dakar, the capital of Senegal, which is located at the most westerly point of Africa. Fishing provides the principal livelihood in Senegalese coastal towns and villages, but is under increasing threat from over-fishing by large-capacity foreign trawlers and the growing number of African fishing vessels. Local fishermen have to work ever longer hours for smaller catches, and are forced to go much further out to sea.

PAGES 86–87
Salt collector, Lac Rose, near Dakar, Senegal
A solitary boatman collects salt from the bed of Lac Rose, the 'pink lake', near Dakar. Left behind when the sea retreated many thousands of years ago, the salinity of this saltwater lake is on a par with that of the Dead Sea. The pink colour, which is particularly evident around sunrise and sunset, is due to mineral deposits at the base of the lake. Local people make a living collecting and selling the salt.

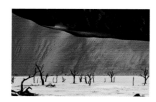

PAGES 88–89
Fossilized trees, Dead Vlei, Namib Desert, Namibia
Ancient fossilized trees stand in Dead Vlei against a backdrop of red dunes. The Namib Desert gives Namibia its name. It lies along the west coast of southern Africa, known as the Skeleton Coast, a bleak shoreline dotted with shipwrecks. Considered to be one of the world's oldest deserts, the Namib also has the highest sand dunes. These lie in the area surrounding Sossusvlei, a large shallow desiccated pan.

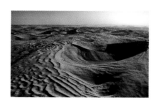

PAGES 90–91
Dunes, Namib Desert, Namibia
An aerial view of the Namib Desert shows the complexity of the dunes, sculpted by the wind. Stretching for 1,200 miles (nearly 2,000 km), the Namib is an extremely arid region comprised of shifting dunes, gravel plains and rugged mountains. The southern areas are rich in alluvial diamonds, and these are mined in large-scale opencast operations. Because the valuable diamonds can be found so close to the surface, public access to the diamond areas is totally prohibited.

PAGES 92–93
Ostrich, Namib Desert, Namibia
A male ostrich crosses the seemingly barren dunes of the Namib Desert. Rain is exceedingly rare in the desert, but moisture from fog which rolls in from the cold Atlantic supports a surprising range of plants and animals. Ostriches, though flightless, have long, powerful legs which enable them to sustain speeds of 30 miles (50 km) per hour for up to half an hour.

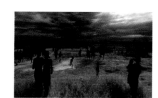

PAGES 94–95
Karo farmers, Omo Valley, Ethiopia
The Karo people are agriculturalists living in the lower Omo Valley, mainly along the banks of the Omo River. Subsistence farmers, they depend heavily on the seasonal flooding of the river, which brings rich silts from the highlands to their arid land. This enables them to grow sorghum, which is ground into porridge, a staple part of their diet.

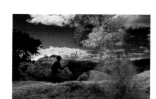

PAGES 96–97
Man winnowing, near Lalibela, Ethiopia
An Ethiopian man winnows grain in a field on a hillside near the town of Lalibela. The majority of Ethiopians live off the land, and though much of their produce is needed for subsistence, in recent years grain has become a small-scale export crop. Teff, barley, wheat, maize, beans, peas and lentils are grown in the highlands, and sorghum and millet are common at intermediate altitudes. Ethiopia is the original home of the coffee plant, and coffee is a major export product.

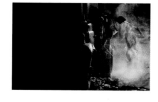

PAGE 99
Street cleaner, Ségou, Mali
A man clears rubbish in the streets of Ségou using a shovel. With population growth in Mali far outstripping resources, pollution from sewage and domestic, industrial and agricultural waste is an ever increasing problem. In urban areas, wells supplying water are often poorly constructed and situated close to latrines and sewers. Ségou, founded by the Bozo people, is one of Mali's larger cities and is situated on the River Niger.

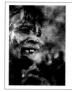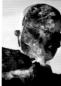

PAGES 100–101
Suri women smoke tobacco, Omo Valley, Ethiopia
Tobacco is one of the crops grown along the banks of the Omo River in the rich silt left by the annual floodwaters. Suri women remove their clay lip plates to enjoy smoking pipes. Because their lower incisors have been extracted to accommodate the large plates, women speak differently from men. Increasingly this painful procedure and uncomfortable ornament are rejected by the younger generations.

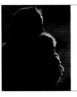

Afar mother and child, Bilen, Ethiopia (left)
Enjoying the last of the day's sun, a mother cradles her child wrapped in her richly coloured blue *shash*.

Street food, Harar, Ethiopia (right)
Freshly cooked food wrapped in torn newspaper is sold to hungry passers-by in the streets of Harar. A flat bread known as *injera* is one of the most popular street foods. Made from teff, a local grain, it is cooked on a large black clay plate over an open fire, and is a daily staple for many Ethiopians.

PAGES 102–103

PAGE 123

Fresh scarification wounds, Omo Valley, Ethiopia
Blood glistens on fresh, newly washed wounds on the woman's arm. Ash is rubbed into the wounds to slow down the process of healing, thereby causing raised scar tissue to form. Striking patterns can be formed by the scars.

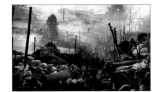

PAGES 104–105

The Mercato, Addis Ababa, Ethiopia
The Addis Ababa market, known as the Mercato, bustles in the smoky haze of early morning. Addis Ababa, Ethiopia's capital, is a relatively new city. Founded by Emperor Menelik II in the late 1800s, it lies at the foot of Mt Entoto, and is the third highest city in the world. Ethiopia's capital has shifted every few centuries over the last two thousand years, reflecting the nomadic nature of its people.

PAGES 124–125

Women of the Omo Valley, Ethiopia
Women of the Karo (left) and Hamar tribe (right) display similar patterns of scarification, though the Hamar woman is also wearing a distinctive beaded belt. The people of the Karo and Hamar tribes originate from the same lineage; they speak similar languages, and the many parallels in their traditional rituals and beliefs show that they share a rich cultural heritage.

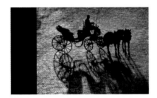

PAGES 106–107

Calèche, Marrakech, Morocco
A horse-drawn carriage known as a *calèche* waits in the Djemaa el Fna, the main square in Marrakech. Located in the medina or old city, the Djemaa el Fna is overlooked by the Koutoubia Mosque, and is the social, cultural and geographical centre of Marrakech. Street artists, musicians, storytellers, snake charmers, medicine men, and stalls selling freshly squeezed orange juice and dried fruit all offer their services to a varied clientele of both Moroccans and tourists.

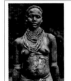

PAGES 126–127

Women of the Omo Valley, Ethiopia
Left: A woman of the Karo tribe wears iron armlets above her elbows, proclaiming her marital status. These are permanently fixed by a local blacksmith. Extensive scarification covers her belly. Right: Ochred for beauty, her whipping scars proudly displayed, a young Hamar woman wears her hair long, in the style of an unmarried girl. Hamar women participate in a tradition whereby their kinsmen whip them till they are deeply scarred.

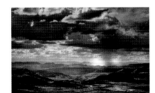

PAGES 108–109

Near Lalibela, Ethiopia
Much of Ethiopia is a vast, hilly plateau known as the Ethiopian Highlands. Bordered to the north by Eritrea, which lies on the Red Sea, the country is otherwise surrounded by desert. It is split into two sections, from Eritrea to the Kenyan Lakes, by the Great Rift Valley. Lalibela is perched among the wild, craggy escarpments of the Lasta Mountains. The highest mountains, the Simiens, lie to the north.

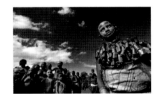

PAGES 128–129

Suri girl, Omo Valley, Ethiopia
A Suri girl wears a heavy collar of metal beads. Unmarried girls sometimes wear a similar garment as a modesty apron; called a *siriga*, it can weigh up to 10 pounds (4.5 kilos), and symbolically protects the girl's maidenhood by concealing her sexuality. She wears this cumbersome item until she marries, when it is replaced with a hide apron.

PAGE 117

Mursi woman, Omo Valley, Ethiopia
A Mursi woman sticks out her tongue, framed by her lower lip which has been stretched to accommodate a lip plate. When a girl is about fifteen, her lower incisors are removed, then her lower lip is pierced and a wooden plug inserted. This is replaced by progressively larger plugs, then plates, stretching the lip until it can accommodate a plate of 4 inches (10 cm) or more in diameter. The plate is removed when eating.

PAGE 131

Mursi woman, Omo Valley, Ethiopia
A Mursi woman adorned with animal horns, cowry shells and white clay paint. As with most tribes in the region, men are grouped into distinct age sets, passing through a number of grades in the course of their lives. Married women have the same age grade status as their husbands. Young men start in social adulthood as junior elders, the active warriors. Then they progress to senior elders, the community decision-makers, and eventually become retired elders.

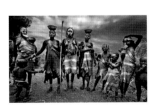

PAGES 118–119

Mursi women and children, Omo Valley, Ethiopia
A group of women and children gather in their village. Ceremonial duelling between young unmarried Mursi men is an important and popular social activity. These contests are treated seriously, and a great deal of advance planning takes place before groups of youths from neighbouring villages meet for the ritualized fights. Wooden poles, about 6 feet (2 metres) long, are used as weapons. Bouts are controlled by a referee, and the winner is paraded around on the shoulders of the other fighters.

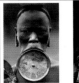
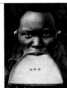

PAGES 132–133

Women with lip plates, Omo Valley, Ethiopia
Left: Mursi woman wearing a round clay lip plate. Right: Woman of the Suri tribe with an angular lip plate carved out of wood. Both the Suri and the Mursi have the unusual tradition of wearing lip plates. Made either of wood or clay and highly decorated, the lip plate is regarded as a symbol of maturity and identity. A growing number of girls now refrain from this practice as they are increasingly exposed to other cultures.

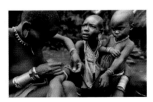

PAGES 120–121

Suri body art, Omo Valley, Ethiopia
A woman carefully cuts decorative patterns on the arm of her friend while a boy looks on apprehensively. The skin is lifted with a thorn and then sliced with a razor blade, leaving a flap of skin which will eventually scar. Scarification is a form of beautification for most of the tribes that inhabit the Omo Valley, a practice unchanged by the passing of hundreds of years.

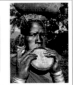

PAGES 134–135

Suri women, Omo Valley, Ethiopia
Left: A woman is caught unawares while playing with her lower lip, stretched to accommodate a lip plate. Right: Balancing a large jar on her head, a woman adjusts her lip plate. Suri households are each run by a woman. Though village decisions are made by a council of men, women make their opinions known in advance of these assemblies. Women tend their own fields, and the income they make from selling produce such as grain and beer is often spent as they wish.

Suri woman, Omo Valley, Ethiopia

This Suri woman wears a very large lip plate, worth many cattle in dowry to her family when she is married. Plates are usually about 4 inches (10 cm) across, though the lip can be stretched to accommodate plates of up to 10 inches (25 cm). These plates are fragile, and spares are made using locally dug clay to replace them when they fracture. Earlobes are stretched in a similar way to further enhance the women's beauty.

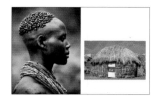

Karo woman, Omo Valley, Ethiopia (left)

A woman of the Karo tribe wears her hair styled into small round pellets using fat perfumed with herbs, and an ochre paste made of pigmented clay.

Turkana hut, Northern Kenya (right)

The dome-shaped houses of the Turkana people are well adapted to the hot, dry climate. They are built using a framework of sticks through which grass and other natural materials are woven. Settlements are moved frequently, and these huts are quick and easy to construct.

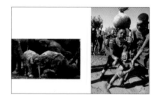

Elephants wallow, Masai Mara, Kenya (left)

An elephant family is entirely coated after wallowing in a mud pool. Bathing in mud helps keep elephants cool, and also maintains and protects their skin.

Suri child pulled from mud, Omo Valley, Ethiopia (right)

A small child is hauled, protesting, from the mud in which he plays. His mother skilfully balances a gourd on her head. These large inedible fruits are hollowed out and used as containers to carry maize and sorghum, a drought-resistant crop that is a mainstay for the people of the Omo Valley.

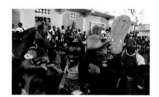

Children in street procession, St Louis, Senegal

Grinning with excitement, children vie for attention during a street procession. Founded in the 1600s, St Louis was the capital of the French colony of Senegal until independence in 1960, and much of the architecture reflects the French colonial influence. The heart of the old colonial city is located on an island in the estuary of the Senegal River, separated from the Atlantic Ocean by a long narrow sand spit known as the Langue de Barbarie peninsula, or 'Barbary Tongue'.

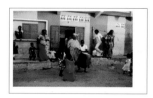

Street scene, St Louis, Senegal

People mill about, dancing in a colourful St Louis street in the wake of a procession. St Louis is renowned for its jazz music and colourful cultural life. It has been designated a World Heritage site for its important cultural and economic role in West Africa, and its characteristic colonial architecture. The Faidherbe Bridge, named after a former colonial governor, is a spectacular metal structure, integral to the identity of St Louis, which connects the island on which the old city is located to the mainland.

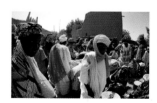

Market, Djenné, Mali

The colourful Monday market in Djenné is an important centre for trade, where everything from vegetables to clothes, animals to mosaics is sold. It is held outside the Great Mosque, the largest mud-brick building in the world. Djenné is situated on the flood plain between the Bani and Niger Rivers, and along with the more northerly city of Timbuktu, was founded on trans-Saharan trade routes. In the Middle Ages both cities were centres of Islamic culture and learning.

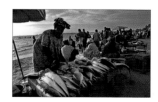

Fish trader, Dakar, Senegal

A woman cleans and stacks fish to sell to individuals and other traders on the beach at Dakar, Senegal. Women may not crew on the boats, but they work on the shore alongside the men, cleaning and sorting the fish, and also operating as traders. Much of the fish is packed in crates and transferred to waiting trucks, then driven away to supply the export market.

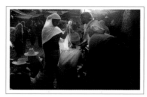

The Mercato, Addis Ababa, Ethiopia

A woman shops in the Mercato, her *shash* glowing in the delicate sunlight. The Mercato, located in the western sector of Addis Ababa, is held seven days a week. It is one of the largest and most colourful open markets in Africa, and is an important retail, wholesale and distribution centre for the city and its surrounding areas. The primary commodity passing through the Mercato is locally grown agricultural produce, most notably coffee, but it is also a hub for the sale of traditional handicrafts.

African shops

Throughout Africa, small shops and businesses serve local communities. These can be housed in mud or brick buildings, or even just shacks built of wood and corrugated iron. They are very often painted and individualized by their owners. Left above and below: Shops in Nairobi's Majengo district, Kenya. Right above: Beauty parlour, Mopti, Mali. Right below: Photography studio between Ségou and Bamako, the capital of Mali.

Man in shop doorway, Harar, Ethiopia

A man smokes in the doorway of a shop. Harar was once an important trade centre, and in the medieval period the government of Harar minted its own coins. The old city is surrounded by a wall which originally had five well-defended gates, representing the Five Pillars of Islam. Each gate played a distinctive role in the economy of the city, providing entry to caravans travelling to and from different regions. The city is well known for its handicrafts including woven textiles, silverware, and book-binding.

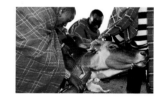

Masai collect cow's blood, Kenya

A cow is held still while her blood is collected in a gourd. A bow and arrow is used to nick the jugular, which is then closed up with ashes and allowed to heal. The blood is drunk on its own or mixed with milk. Cattle are a way of life for the Masai, a symbol of wealth and a source of pride. A common Masai greeting is 'I hope your cattle are well'.

Karo woman, Omo Valley, Ethiopia (left)

A woman from the Karo tribe wears many strings of beads and a colourful beaded band around her neck.

Masai warrior, Kenya (right)

A Masai warrior wears a watch among his other elaborate adornments. Each colour woven into the beads and fabric has a specific meaning for the Masai: white indicates peace; blue denotes godliness, reflecting the colour of the sky; and red, worn by warriors, is the colour of strength.

Wildebeest, Masai Mara, Kenya

In massed formation, dust rising in clouds as they thunder down the river bank, vast numbers of wildebeest plough into the Mara River during the annual migration. Following the rains in search of new grazing, they move across the plains of the Masai Mara in Kenya and the Serengeti in Tanzania. With each migratory cycle they must run the gauntlet of the Nile crocodiles that lie in wait in the Mara River.

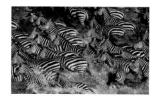

Zebras, Masai Mara, Kenya

Easily startled, zebras scramble to escape the water's edge. They are waiting for an opportunity to cross the Mara River which lies across their migratory route. Zebras are adaptable grazers, able to feed on the longer, coarser grasses shunned by other herbivores, thus opening the grasslands to more choosy species such as wildebeest and gazelles. Zebras and wildebeest often associate with one other.

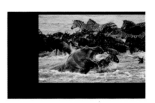

Hippopotamus attacks wildebeest, Masai Mara, Kenya
A hippopotamus attacks a wildebeest crossing the Mara River during the Great Migration. Though hippos are vegetarians, they are irascible creatures and do not like to be disturbed; this one was lying peacefully in the water when the thrashing herds of wildebeest and zebra intruded on its territory.

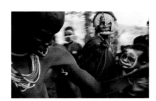

Suri woman and praying mantis, Omo Valley, Ethiopia
A Suri woman looks down in surprise at a bright green praying mantis which has landed on her upper arm. Named for its characteristic pose in which the front limbs are held together as if in prayer, this carnivorous insect preys on other insects such as flies, butterflies and crickets; the female sometimes devours the male after mating. Hundreds of different species of mantis are found throughout Africa.

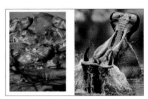

Hippopotamuses wallow, Masai Mara, Kenya (left)
Languidly resting their heads on each other, hippos wallow in the cool river water during the heat of the day. Mothers and calves tend to cluster together in large pods, in which care of the young is shared.

Hippopotamus threatening, Queen Elizabeth Park, Uganda (right)
Mouth wide open, a hippo threatens any potential rival. Hippos show their huge teeth in order to intimidate possible enemies; a noisy and aggressive display is often sufficient to deter less dominant males.

Impala, South Africa (left)
Impala are small reddish-brown antelope common in southern Africa. Females and young browse together in herds, while the adult males tend to have individual territories. Sensitive and vulnerable, they prefer to live in wooded areas and run off at the slightest provocation.

Turkana man dancing, Northern Kenya (right)
The Turkana region occupies north-west Kenya, with Lake Turkana forming its eastern border. Dry and inhospitable, this huge area is sparsely occupied by the nomadic Turkana people.

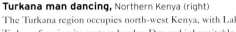

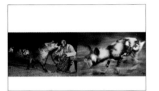
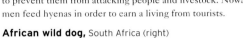

Man feeds wild hyenas, Harar, Ethiopia (left)
In the darkness, a man feeds wild hyenas with food from a stick held in his mouth. This tradition apparently dates back to the great famine of the late nineteenth century, when hyenas were fed to prevent them from attacking people and livestock. Nowadays men feed hyenas in order to earn a living from tourists.

African wild dog, South Africa (right)
Wild dogs, also called Cape hunting dogs, are severely endangered due to loss of habitat and extensive hunting.

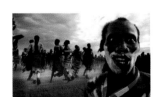

Karo dancers, Omo Valley, Ethiopia
A man dances energetically, captivated by the dynamic atmosphere. Physical expression plays an important part in the life of the Karo tribe. Passionate, frenzied courtship dances are held, and marriage partners are often chosen at these events. Specific rituals are held regularly within tribal communities, and people from neighbouring villages will sometimes travel all night to join in the celebrations.

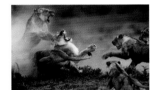

Lionesses, Masai Mara, Kenya
A group of lionesses aggressively fight off an intruder. They had been attacking a buffalo when the arrival of the stranger distracted them. The fortunate buffalo escaped alive, while the trespassing lioness slunk away licking her wounds. Male lions are even more fiercely territorial, and will often fight to the death; the winner either keeping or taking over the pride.

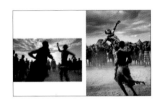

Karo dancers, Omo Valley, Ethiopia
An impassioned courtship dance takes place after harvest. The Karo people are known for using their bodies as a canvas for expression and communication, through body art and dancing. Motifs used for body painting range from simple stripes and stars, through to animal motifs such as guineafowl plumage, or countless hand prints covering the torso and limbs.

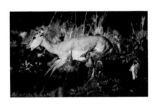

Wild dogs and impala, Botswana
A pack of wild dogs savagely tear apart an impala. Death is quick, as wild dogs work in highly organized groups and are very efficient hunters, killing and devouring their prey in a remarkably short space of time. They live in large sociable packs, rarely fighting among themselves. They all take care of the young, regurgitating food for them following a kill, and also care for old, sick or injured pack members.

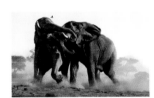

Fighting elephants, Savute, Botswana
Dust swirls around a pair of bull elephants as they fight. Serious clashes between bull elephants, though rare, involve head-ramming and wrestling with tusks. Sub-adult males leave the family herd when they are aged about twelve to join bachelor herds, only returning to the main herd to breed. The larger, more senior tuskers will be most successful at mating.

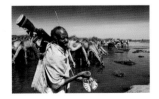

Afar camel herder, Bilen, Ethiopia
An Afar man brings his camels to a waterhole. Firearms have penetrated rural Africa rapidly in recent years, causing long-standing tribal feuds to take a sinister and deadly turn. Rifles are now seen as essential personal protection in a no-win situation; either everyone has one or no one does, with growing numbers of individuals aspiring to own them.

Verreaux's sifaka, Berenty, Madagascar (left)
A bright-eyed baby clings to his mother as she hops along in the sunlight. Sifakas belong to the lemur family, and have specially adapted hip bones which enable them to leap from tree to tree, or upright on the ground, using well-developed leg muscles.

Dassanech boys dance, Omo Valley, Ethiopia (right)
A Dassanech boy practises his dancing skills, encouraged by a circle of clapping children. In societies throughout Africa, dance plays a very important role, marking most social events and bringing people and communities together.

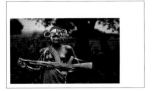

Mursi girl with rifle, Omo Valley, Ethiopia
A rifle slung around her neck, fingers lightly resting on the end of the barrel, a Mursi woman warily surveys her world. The wide-scale replacement of traditional weapons with modern firearms has had a devastating effect on conflict between clans in the Omo Valley. It is a reflection of a changing Africa that transactions such as the 'bride price' paid to a new bride's family, once paid mostly in cattle, may now include a semi-automatic rifle.

Samburu dancers, Mount Nyiru, Kenya
Samburu men compete in a dance ritual to see how high they can jump, keeping their arms by their sides. The warriors know that the highest jumper earns the respect of the women watching, and possibly their affections. The *Adumu* dance celebrates the circumcision of younger boys, aged between about twelve and fifteen. Once these boys are circumcised they become junior warriors, and must practise hunting birds and small mammals.

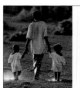

PAGES 198–199
The Afar, Bilen, Ethiopia
Left: Each gripping a finger, two small children walk with their older brother towards a clearing where they will watch a traditional dance. Right: Nomadic pastoralists, the Afar mainly raise goats, as well as sheep and cattle. Milk is considered an essential life source, so the meat of these precious animals is rarely eaten. Camels are used mainly for transport.

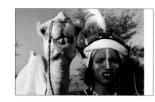

PAGES 220–221
Wodaabe youth, Niger
A young Wodaabe man, face decorated with ochre and kohl, heads for the Gerewol Festival with his camel. This annual 'Festival of the Nomads' is a gathering of both the Wodaabe and the Tuareg peoples. Held in the desert, the actual location differs from one year to another. It is an opportunity for different clans of the same tribe to meet and for inter-clan marriages to be arranged.

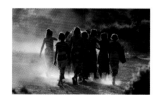

PAGES 200–201
Afar girls, Bilen, Ethiopia
A group of bare-headed young Afar girls, each wearing a brightly coloured *sanafil* or waistcloth. This traditional garment, tied around the waist and reaching to below the knees, is worn by both men and women, though the men's are typically not dyed. A head scarf or *shash* is usually worn by women once they are married.

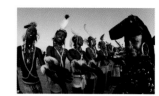

PAGES 222–223
The Gerewol dance, Gerewol Festival, Niger
A long line of young Wodaabe men perform the Gerewol dance while an elder woman alternately praises and mocks the dancers to encourage greater achievement. If a man's performance is exceptional, she lightly butts him with her head, yelling loudly. The men rhythmically rise up on tiptoe and sink back down to show off their tall, lithe bodies. Every few seconds they change expression, rolling their eyes and exposing their gleaming white teeth.

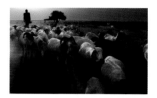

PAGES 202–203
Karo herdsman, Omo Valley, Ethiopia
Wildlife such as antelope and wild pigs were once plentiful in the Omo Valley, and the Karo used to be primarily hunters. Since these animals are now scarce, they have become successful cattle herders. The Karo are semi-nomadic, their lifestyles dictated by their livestock. During the dry season, families camp together, but when food and grazing are more plentiful, cattle and goats are moved as pasture is exhausted.

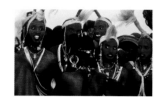

PAGES 224–225
A Wodaabe girl selects her man, Gerewol Festival, Niger
A girl chooses a partner from the dancing men at the Gerewol Festival. Women too have elaborate traditions of self-adornment, decorating their cheeks and lips with geometric tattoos, whitening teeth with traditional herbs, anointing their hair with oil, and wearing large silver or brass earrings. The most beautiful women have first choice of partner, and each woman invites the man she finds most attractive for a sexual encounter. These pairings can often lead to marriage.

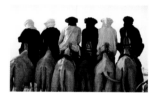

PAGES 204–205
Tuareg men on camels, Gerewol Festival, Niger
Men of the Tuareg tribe sit astride their camels in order to gain a grandstand view of proceedings at the annual *Cure Salée* Festival, in the desert north of Abalak. Long veiled turbans called *tagelmousts* are worn by Tuareg men. Most often white or indigo in colour, they wrap around the head and cover the mouth to protect from the sun and dust. Indigo is costly, so garments coloured with this blue dye are an indication of wealth and status.

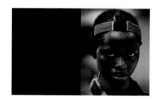

PAGE 227
Hamar woman, Omo Valley, Ethiopia
A young woman from the Hamar tribe attends the Dimeka market. In the past, the blue beads in her traditional head band and necklace had more than an aesthetic function; they were also used as a form of currency between neighbours and tribes. Held weekly, the Dimeka market is a place where a number of different tribes meet to trade, notably the Hamar and Karo.

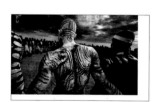

PAGES 206–207
Karo gathering, Omo Valley, Ethiopia
Karo people differentiate themselves from neighbouring tribes by excelling in body painting. They use ochre, chalk, charcoal and pulverized mineral rock to achieve a variety of colours which include orange, white, black, yellow and red. Body artists use vibrant designs to accentuate fine facial features and enhance their graceful movements.

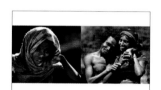

PAGES 228–229
Young woman, Lalibela, Ethiopia (left)
A young woman sits in silent contemplation near the church of St George in Lalibela. The holy city is named after King Lalibela who, according to legend, was inspired by a dream in which God ordered him to excavate the sunken churches at a place called Roha, the site of his birth.

Afar couple, Bilen, Ethiopia (right)
A young Afar couple embrace affectionately after a swim in a river.

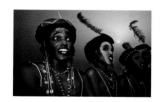

PAGES 216–217
Wodaabe youths, Niger
Young men, beyond the age of puberty but not yet the heads of families, are permitted to perform at the Gerewol. To prepare for the dance, the hairline is shaved to make the forehead look bigger, and heavy make-up is applied to the face in the form of red ochre, with kohl to emphasize the eyes and mouth. A headdress is worn, usually decorated with cowry shells and ostrich feathers, which are symbolic of fertility, and the chest is adorned with beads.

PAGES 230–231
The Mercato, Addis Ababa, Ethiopia (left)
Live chickens are confined in a small cage in the Mercato, Addis Ababa's huge open-air market.

Suri boy with chicken, Omo Valley, Ethiopia (right)
A Suri boy casually rests a chicken on his head. Soon he will become a junior warrior and must learn to fight and hunt.

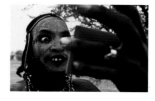

PAGES 218–219
Wodaabe youth, Niger
A hopeful participant in the Gerewol Festival checks his face in a mirror before the dancing begins. Wodaabe women choosing their partners will be looking for the tallest men with the whitest teeth, the largest eyes, the longest and straightest nose, the most elaborate face and body painting, and the most creative head gear and ornamentation.

PAGES 232–233
Ndebele girl, South Africa (left)
A young Ndebele girl with her hair tied into numerous pigtails using brightly coloured bands.

Red-billed oxpeckers on a giraffe, South Africa (right)
Oxpeckers are found across much of sub-Saharan Africa, usually in the company of large mammals such as giraffe, buffalo, antelope and domestic cattle. Feeding on blood-sucking insects such as ticks, flies and maggots, they clamber over their hosts, removing parasites in a mutually beneficial relationship, though occasionally they can keep wounds open, exposing the host animal to infection.

PAGE 240
Mountain gorilla, Democratic Republic of Congo
A female mountain gorilla in the Parc des Virungas. Gorillas are the largest and most endangered of the world's great apes, and live only in Africa. All four sub-species are at risk from habitat loss, hunting, and diseases such as the Ebola virus. Individual gorillas can be recognized by their unique nose patterns; no two are identical. Mostly vegetarian, gorillas eat a variety of plants including bamboo, roots, bark, berries and wild celery.

PAGES 242–243
Mountain gorillas, Democratic Republic of Congo
A mature male silverback gorilla sits with a female in the crater of an extinct volcano. Mountain gorillas live in the Virunga Mountains which lie on the borders of Rwanda, DRC and Uganda. Considered critically endangered, there are between six and seven hundred individuals left. Enormous efforts are being made to protect them, but in this politically unstable region they remain vulnerable to guns and snares.

PAGES 244–245
Giraffes, Amboseli National Park, Kenya
The vast, dusty plain is veined with animal tracks that lead to an isolated waterhole. Well adapted to arid conditions, giraffes only need to drink every two or three days, and can manage on less, as they get most of the moisture they need from food. The tallest land mammal in the world, a giraffe needs strong neck muscles and specially adapted veins and arteries to regulate blood flow to the brain when it bends down to drink.

PAGES 246–247
Giraffes and elephants cross scrubland
Giraffes and elephants cast long, distinctive shadows as they move across scrubland in different regions of Africa. Left: Giraffes in Botswana's inland Okavango Delta, a complex network of waterways and swampy grassland surrounding islands of dry land. Right: Elephants in Amboseli National Park, Kenya. Amboseli lies at the foot of Mount Kilimanjaro, and has permanent springs fed by melt-water from the mountain's snow cap. Much of the area is an ancient lake-bed which becomes a barren and dusty plain in the dry season.

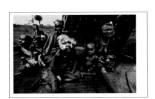

PAGES 248–249
Mursi women and children, Omo Valley, Ethiopia
Considered one of the most threatened of the Omo Valley tribes, the Mursi live in constant danger of encroachment from neighbouring tribes, and are also often affected by drought. Hoe cultivation usually accounts for more than half of their staple diet, with cattle herding providing the balance. In a good year they will gather two harvests; one along the banks of the Omo, watered by the variable annual flood, and a less predictable rain-fed crop in forested areas, cleared for planting.

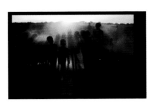

PAGES 250–251
Dassanech children at sunset, Omo Valley, Ethiopia
Children dance and sing at the end of the day. The Dassanech live near the edge of Lake Turkana; the area known as the 'Cradle of Mankind' lies in close proximity to the lake, which stretches down into Kenya. This region is rich in ancient hominin fossils, man's earliest ancestors. Both human and animal remains in the stratified sediments become exposed through constant erosion by the strong winds that sweep across the desert, and by water from occasional floods.

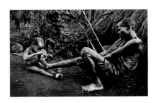

PAGES 252–253
Suri young boy and elder, Omo Valley, Ethiopia
A young boy, concentrating intensely, picks a thorn from a Suri elder's toe. Children start helping with the cattle when they are about eight years old, moving on to become cattle herders as they grow older. Still unmarried, herders are not yet considered to be warriors; they earn this right when they become young elders through their prowess at stick fighting, and their care of the cattle.

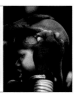

PAGES 254–255
Hair grooming, Omo Valley, Ethiopia
Left above: Karo girls braid each others' hair in a circle of reciprocation. Their heads are partly shaved, leaving only a ring around the crown, and the hair is tied into small knots before being coated with animal fat and an ochre mixture. Beaded head bands complete the picture. Left below and right: Boys from the Karo (left) and Suri tribes (right) have their heads shaved using a bare razor blade.

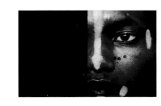

PAGE 257
Wodaabe man with painted face, Niger
A painted line elongates the nose of this Wodaabe man; black kohl outlines his eyes and lips. Supposedly of Arab origin, the Wodaabe people have straighter hair, narrower noses, thinner lips, larger eyes and longer faces than most of their neighbours. These characteristics are considered by the Wodaabe to be signs of beauty, and are emphasized wherever possible using techniques such as decorative facial scarring. Many strict codes of interaction are laid down by tradition; Wodaabe means 'people of the taboo'.

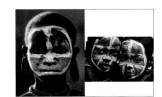

PAGES 258–259
Suri children with painted faces, Omo Valley, Ethiopia
As much a part of daily playtime as an ancient ritual, children of the Suri tribe paint their faces with coloured ochre and white clay. Friends will often paint each other's faces with identical designs to show their closeness. When they are old enough they will go to great lengths to decorate themselves to attract the opposite sex at ceremonial gatherings, so this is an important skill to practise.

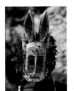

PAGES 260–261
Dogon masks, Mali
The majority of the Dogon people are animists, and many different designs of masks play an integral role in their ceremonies. They are believed by the Dogon to contain the life force or *nyama*. Left: Animal masks are worn by dancers in the *dama*, or funeral ritual, to chase away any lingering spirits of the dead and send them to rest in the ancestor world. Right: A black mask adorned with white cowry shells denotes wealth and beauty.

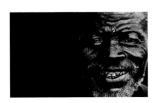

PAGE 263
Dogon man, Mali
The Dogon, who live around the Bandiagara escarpment in Mali, are known for their distinctive earthen houses and wooden sculptures. Harmony and tolerance are important in their society, and are reflected in a ritual where the women praise the men, who then thank the women, and the young convey their appreciation of the old, who in turn acknowledge the contribution made by the young.

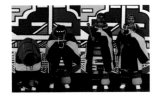

PAGES 264–265
Ndebele women, South Africa
Two Ndebele women stand outside a traditionally painted house. Traditional tribal dress includes a multitude of metal rings or *idzila*, worn around the neck, arms and legs, and beaded leg hoops called *golwani*. The beadwork on their skirts and on the blankets they wear around their shoulders all have symbolic significance. The Ndebele community in the north of South Africa work hard to keep the traditions of their distinctive dress and geometric artwork alive in the face of ongoing urbanization of the young.

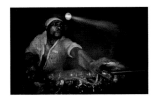

PAGES 274–275
Gold miner, South Africa
A migrant miner from Mozambique drills into the rock face in South Deep gold mine, nearly 2 miles (3 km) below ground near the town of Westonaria, outside Johannesburg. In conditions of extreme heat and humidity, he works relentlessly at the rock face with intense concentration, preparing the face for blasting. Yielding only a few grams of gold for every ton of extracted rock, the work is hard. The men work in teams, driven by the incentive of bonuses.

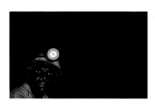

PAGES 276–277

Gold miner, South Africa

A miner pauses briefly in his work in the hot humid air in South Deep gold mine. One of the deepest mines in the world, South Deep is situated a short drive from the outskirts of Johannesburg. The mines attract migrant workers, who live in housing provided by the mine management and send the bulk of their income to families back home. The city of Johannesburg grew out of the mining industry.

PAGES 278–279

City skyline at dawn, Johannesburg, South Africa

The skyline of Johannesburg catches the first rays of the rising sun. One of the largest cities in Africa, Johannesburg lies in the province of Gauteng, which means 'place of gold' in the Sotho language. The city grew rapidly in the late nineteenth century after the discovery of gold in the region, and quickly became the most prosperous city in Africa. Now a magnet for immigrants, many from further north in Africa, it struggles to cope with continually increasing housing and energy needs.

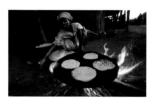

PAGES 280–281

Afar woman baking bread, Bilen, Ethiopia

A woman bakes flat bread over an open fire. In Afar society it is customary to eat maize flat bread, known as *ga'ambo*. Women run the home, cooking, milking goats and making butter. They are also responsible for setting up the tent house, made of sticks covered with mats, which is carried with them and reassembled at each temporary settlement.

PAGES 282–283

Tuareg desert camp, Niger

Camels nuzzle as they rest in a Tuareg camp in the southern Sahara. In the past, camels provided the only means of transport across the Sahara, allowing the Tuareg to dominate commercial trade in this area for a thousand years. They controlled the caravan routes across the desert, trading in luxury goods and transporting slaves from Africa to Europe and the Middle East. Today the Tuareg are forced to observe the international boundaries between Niger, Mali, Algeria, Libya and Burkina Faso.

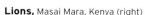

PAGES 284–285

Giraffes, Etosha National Park, Namibia (left)

Giraffes cautiously approach a water-hole under cover of darkness.

Lions, Masai Mara, Kenya (right)

Sharpening their claws against an acacia tree, a pride of lions prepare for the day after a night of hunting. Acacia trees dominate most sub-Saharan grasslands. The familiar spreading crown carries leaves which are superbly adapted to arid conditions. Divided into numerous tiny leaflets, they can either be held horizontally to maximize exposure to sunlight, or vertically to reduce loss of precious moisture.

PAGES 286–287

Gabbra camel herd, Chalbi desert, Kenya (left)

Gabbra cultural and religious beliefs are inseparably entwined with their animals, especially the camels. Traditionally, they believe in one god called *Waka*, though in some areas the Muslim influence is stronger.

Giraffe, Masai Mara, Kenya (right)

Beneath a dramatic sky, a lone giraffe walks across the African plain. The tallest living mammal on earth, a mature giraffe can often fend off potential predators with a savage kick of the hind legs.

PAGES 288–289

Giraffe, Etosha National Park, Namibia (left)

Drinking nervously, a giraffe repeatedly lifts his head to check his surroundings, each time spraying a curve of water into the air.

Southern right whale, False Bay, South Africa (right)

Originally named for being the 'right' whales to hunt, southern right whales are now protected around the South African coast. They spend the summer far south near Antarctica, moving close to the southern coastline in winter to breed and raise their young.

PAGES 290–291

Wildebeest, Masai Mara, Kenya (left)

Desperate to reach the opposite bank of the Mara River during the annual migration, wildebeest churn through the muddy water.

Great white shark, South Africa (right)

A great white shark, the largest fish predator in the world, shows its awesome power as it launches itself out of the water to toss its prey, a cape fur seal, into the air. Contrary to popular belief, great whites rarely attack humans.

PAGE 293

Pilgrim washing, Lalibela, Ethiopia

Water washes the hands of a pilgrim visiting the churches of Lalibela. Believed by the Orthodox church to cleanse the soul, water plays an important role in Ethiopian Christian theology. Religious ritual is central to the life of Lalibela, where processions with singing and dancing are held regularly. The extraordinary religious architecture, combined with simplicity of life, impart a sense of timelessness.

PAGES 294–295

The Mercato, Addis Ababa, Ethiopia

A man drinks from the spout of a kettle in the market. The name Addis Ababa means 'new flower' in Amharic. In the 1920s an ambitious project to provide firewood and fuel for the city resulted in the planting of thousands of eucalyptus trees on the outskirts, and today an area of forests and subsistence cultivation remains around the city. The Organization of African Unity was established in Addis Ababa in 1963, with Emperor Haile Selassie as one of the founding members.

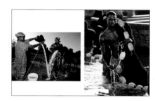

PAGES 296–297

Women collect water, Djenné, Mali (left)

Women fill their buckets from a well. Water is treated as a precious commodity, as the daily journey to collect it can often be several miles. The location of rural springs and wells in Africa plays an enormous role in the movements of its nomadic population.

Fisherman, Mbour, Senegal (right)

A man brings in the fishing nets at the end of the day. Most local fishermen come from families in which the sea has been a way of life for successive generations.

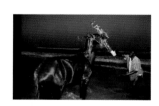

PAGES 298–299

Fish trader washes his horse, St Louis, Senegal

Shortly before sunrise on the beach of St Louis, a trader washes his horse in the sea under a full moon. When the fishing boats come in laden with their catch, traders in high-wheeled carts pulled by horses race into the water to collect the fish from the boats and transfer it to the beach, where it is sorted into crates and sold on.

PAGES 300–301

Bozo fisherman washes, Mopti, Mali

A Bozo fisherman takes a bath in the River Niger. The annual catch of the Bozo constitutes one of Mali's principal exports; their immense skill and deep understanding of the river is passed down from one generation to another. Fishing is the responsibility of men and boys, who also engage in some agriculture, with rice and millet as staple crops; women grow vegetables and tobacco, which they sell at market. As with most of the population of Mali, the Bozo are principally Muslim.

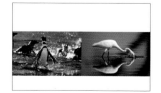

PAGES 302–303

Jackass penguins, near Simonstown, South Africa (left)

Jackass penguins are found only off the coast of southern Africa, and mostly breed on offshore islands where, as ground-nesting birds, they face less threat from predators. It is therefore fairly unusual that in recent years colonies have established in a couple of locations on the mainland.

Egret, Okavango Delta, Botswana (right)

An egret forages with its long, sharp bill, hunting in the shallow water for prey such as fish or frogs.

PAGES 304–305
Flamingos, Lake Magadi, Kenya
Flamingos wade in channels between soda islands. Spread out
at regular intervals to give each other space, heads upside-down,
they use their curved beaks to filter the mud for small crustaceans
and algae. Attracted by the high concentrations of food, they
nest in the alkaline lakes of the Great Rift Valley. The lakes are
a hostile environment to most other animals, so the flamingos are
relatively safe from predators.

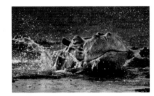

PAGES 310–311
Hippopotamus, Okavango, Botswana
Hippos wallow in pools of water during the heat of the day, when
red-pigmented sweat helps prevent sunburn on their hairless
skin. At night, when it is cool, they forage for food. The name
hippopotamus means 'river horse', and they can weigh up to three
tons. Hippo social life is centred on females and their dependent
young, and they form herds of up to thirty animals.

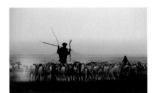

PAGES 312–313
Gabbra herder, Chalbi desert, Kenya
Gabbra herders roam with their flocks of goats, known for their
hardiness. Animals belong to the head of each family, but no
individual can own land, which belongs instead to the whole tribe,
and all have access to the water wells. Animals provide more than
just food: they are needed for sacrifice to ensure fertility, health
and cooperation from spirits. Gabbra philosophy is based on
respect for tribe members, living animals and the environment.

PAGES 314–315
Tuareg gather for a camel race, Gerewol Festival, Niger (left)
A group of Tuareg men gather against a rising sun to celebrate the
Cure Salée festival with a camel race. The festival originated as an
annual gathering at salt pools for herds to replenish their salt levels,
but has become an important social event. Camel races, a popular
form of entertainment, are usually accompanied by traditional
music and dancing.

Women collect water, Mopti, Mali (right)
Women carry buckets on their heads for collecting water in Mopti,
a town located at the confluence of the Niger and Bani Rivers.

PAGES 316–317
Gabbra with camels, Chalbi desert, Kenya (above)
The nomadic Gabbra periodically move camp in search of new
grazing for their camels. Women are responsible for moving the
houses, which consist of bent poles covered with skins and grass
mats, while men care for the animals.

Dassanech with cattle, Omo Valley, Ethiopia (below)
Cattle are extremely important to the Dassanech, both economically
and socially. If a family lose their cattle through disease or theft,
they become known as *Dies*, or poor people. They must live apart
from the community, hunting crocodiles or fishing in Lake Turkana
for survival.

PAGES 318–319
Elephants at night, Savute, Botswana
The dark and light grey figures beside the waterhole at night
are wet and dry respectively. Sociable animals, elephants live
in close-knit groups of related females and their young. Herds
are led by a matriarch, usually the oldest and most experienced
female. She remembers the location of waterholes and rivers,
invaluable information that is passed on to the younger members
of the group. It has long been recognized that elephants display
affection and consideration for other family members in a manner
strikingly similar to humans.

PAGES 320–321
Giraffes, South Africa
Giraffes forage in the blue mist of early morning. In a habitat
shared with many other herbivores, it makes sense to specialize,
so giraffes have evolved into the world's loftiest mammal, allowing
them to browse on acacia leaves and shoots which are well beyond
the reach of others. Yet their long necks are supported by only
seven cervical vertebrae, the same number as in humans. Mature
bulls can reach a height of more than 16 feet (5 metres).

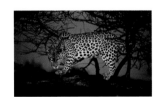

PAGES 322–323
Leopard, Namibia
Leopards are highly elusive, hunting by stealth, mainly at night;
although females with cubs may be forced to hunt by day.
Remarkably skilled and powerful climbers, they drag their kill
into trees where it will be out of reach of scavenging hyenas and
other predators. They frequently hunt smaller animals such as
antelope and bush pigs, but are also known to tackle prey up to
three times their own weight.

PAGE 336
Samburu boy, Mount Nyiru, Kenya
The shaven head of a boy who was circumcised earlier in the day.
Heralding the beginning of adult life, circumcision is practised
by both the Samburu and the Masai, closely related tribes which
share many beliefs and customs. The Samburu live in areas in
the centre of the country, while the Masai are found mainly in
southern Kenya and northern Tanzania.

ACKNOWLEDGMENTS

I am particularly thankful to my wife, Kathy, who worked tirelessly during the period it took to create the images, and to whom this book is dedicated. She wrote the picture commentaries, managed the photographic archive, arranged exhibitions, helped me edit the text and gave invaluable constructive criticism throughout the book's development.

I am most appreciative to everyone at Thames & Hudson for their commitment to publishing this book. Designer Aaron Hayden brought exceptional professionalism and passion to the project, for which I am especially thankful.

Many others helped too, in various ways, and I am deeply grateful to them all. I may have inadvertently omitted to include some names, but my gratitude to all who assisted me remains undiminished.

Firew Ayele, Ibrahim Bazo, Dan Bloom, Joe Botha, Tom Brakefield, Yoav Chen, Emma Chen, Paul Cisse, Estelle Coetzee, Reghard Coetzee, Dallas Dauth, Anna Dlambili, Heather Doherty, Mulugeta Dubale, Chris Fallows, Tim Flach, Ioan Gibbs, Joseph Gichanga, Phil Jones, James Kateeba, Aissa Khirani, Harber Kunta, Rob Lawrence, Gillian Miller, Bob Nelson, Tomanka Ole Selempo, Alexis Peltier, Peter Perlstein, Gareth Phillips, Des Pretorius, Ahmed Rajab, Lente Rhoode, Mike Routledge, Halewijn Scheurman, Cathy Singer, Leonard Singer, Denis Tabakin, Isma Tine, Djibril Tounkara, Steve Turner, Johan Vaatz, JJ Van Der Bergh, Justin Wateridge, Janice Wickenden

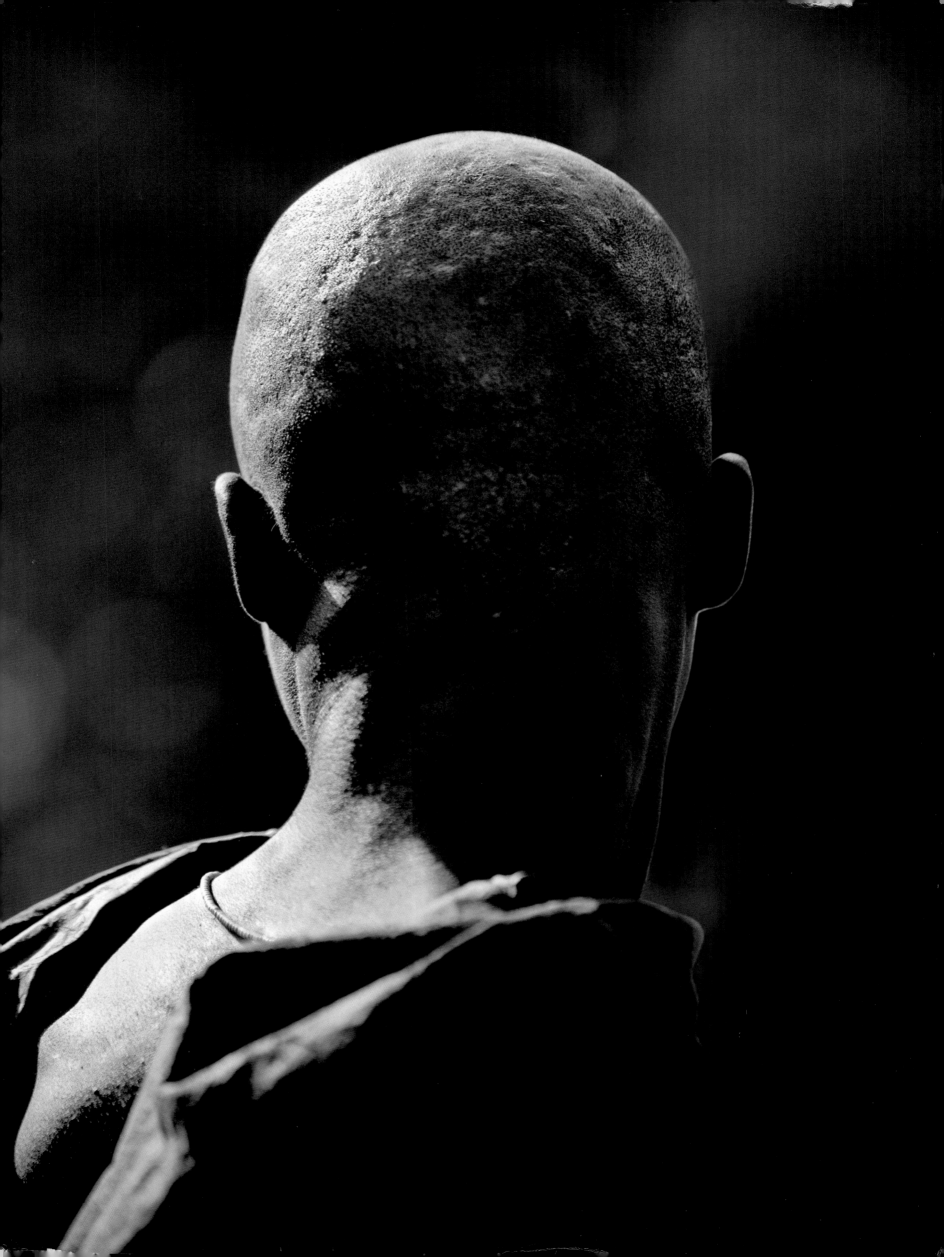